BECOMING
O'KEEFFE

BECOMING O'KEEFFE

The Early Years

Sarah Whitaker Peters

Abbeville Press Publishers
New York London Paris

To my mother and father
Margaret Allen Whitaker
Robert Burbank Whitaker
with love and homage

EDITOR: NANCY GRUBB
DESIGNER: JOEL AVIROM
PRODUCTION SUPERVISOR: HOPE KOTURO
PICTURE EDITOR: ADRIENNE AURICHIO
PRODUCTION EDITOR: PHILIP REYNOLDS
PICTURE RESEARCHER: KAREL BIRNBAUM

FRONT JACKET
Alfred Stieglitz (1864–1946).
Georgia O'Keeffe: A Portrait—with Watercolor Box, 1918. See plate 32.
BACK JACKET
Georgia O'Keeffe (1887–1986).
Petunia No. 2, 1924. See plate 133.
FRONTISPIECE
Alfred Stieglitz. *Portrait of Georgia O'Keeffe,* 1918.
Photograph. Virginia M. Zabriskie, New York.

Text copyright © 1991 Sarah Whitaker Peters. Compilation copyright © 1991
Abbeville Press, Inc. All of the paintings in this book are published with the
permission of the Estate of Georgia O'Keeffe. All rights owned by the Georgia
O'Keeffe Foundation are reserved by the Foundation. All rights reserved under
international copyright conventions. No part of this book may be reproduced or
utilized in any form or by any means, electronic or mechanical, including
photocopying, recording, or by any information storage and retrieval system,
without permission in writing from the publisher. For additional credits and
copyright information, see page 399. Inquiries should be addressed to
Abbeville Press, 488 Madison Avenue, New York, N.Y. 10022.
Printed and bound in Japan.

First edition, second printing

Library of Congress Cataloging-in-Publication Data

Peters, Sarah Whitaker.
Becoming O'Keeffe: the early years/Sarah Whitaker Peters.
p. cm.
Includes bibliographical references and index.
ISBN 0-89659-907-8
ISBN 0-55859-362-4 (pbk.)
1. O'Keeffe, Georgia, 1887–1986. 2. Artists—United States—Biography.
I. Title.
N6537.039P48 1991
759.13—dc20

[B] 91-560
 CIP

CONTENTS

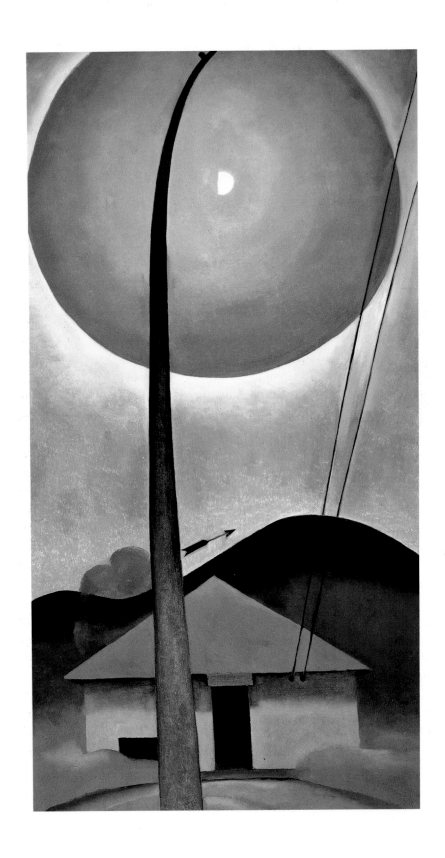

PREFACE

This book has been a long time in preparation. Nowadays, with considerable knowledge of Georgia O'Keeffe available from her many published letters and some new biographies, it is hard even to remember the dark-ages condition of O'Keeffe studies in 1976, when I began. Secrecy is power, as she well knew.

O'Keeffe died in 1986. During the last ten years of her life she had paid no attention whatever to my periodic requests to come interview her. In retrospect, this is easy to understand. She had never really taken an interest in scholarly examinations and evaluations of her work, especially by those not connected to the museum world. And despite the fact that her own writing has an amazing eloquence for one so reticent, she saw basic truth in the old Spanish phrase "words are like the wind." By the time I got to her O'Keeffe was in her eighties and fed up with the whole business. Not surprisingly. Reams had been written about her art since 1916 and she had seldom been pleased with any of it. Nevertheless, with what appears now to have been incredible innocence on my part, I believed what I wanted to: that she would wish to be helpful. Accordingly, in the spring of 1976 I sent her a letter describing my dissertation proposal and enclosed some examples of my soon-to-be-published writing on her work: short entry essays written for the catalog *Women Artists, 1550–1950* (for an exhibition organized by Ann Sutherland Harris and Linda Nochlin for the Los Angeles County Museum of Art). O'Keeffe did kindly take the time and trouble to answer. But through an unbelievable mixup at my local post office, her letter went undelivered and was returned unopened to Abiquiu, New Mexico. There it came to rest in O'Keeffe's files, unknown

1. Georgia O'Keeffe (1887–1986). *Little House with Flagpole,* 1925.
Oil on canvas, 35½ x 17½ in. (90.2 x 44.5 cm).
Private collection, San Antonio.

to me until after her death. I have it at last, however, and this is what she said:

> When these things you have written are read to me [she was by this time almost completely blind], what is said is complicated and is far from my way of doing and thinking. [I had, among other things, discussed some parallels between her early abstract watercolors and Wassily Kandinsky's Improvisations.] The use of the medium of watercolor was no problem for me so I really played with the material. I was free with it. If I had had any idea like what you have written, I probably wouldn't have been able to work at all. But I seem to have made those shapes that you could fasten your complicated ideas to. I never thought that way. Your mind works so differently from mine that I would never have been able to do anything if I tried to work as you think. For me it was easy. I didn't work unless it was easy to work. When it was easy to work, I never thought of all the complicated things you accuse me of. It's as if no one believes I'm just going along making a few marks once in a while.

Would I have been stopped in my tracks had I received this in 1976 —since it was clearly intended to do so? I like to think not. It was, after all, a brisk summation of familiar, and not untrue, statements she had made frequently over the years. In any event, after waiting for six months to hear, I wrote again. Her answer (this time) was brief. She simply wished me luck with my dissertation—no more, no less. And so I embarked. I had no idea the task would take so long to finish.

I took courage from two things: that there were now no strings and that what had not been given could not be taken away. (O'Keeffe had given permissions to others—Anita Pollitzer among them—then changed her mind and refused to allow publication.) It was also exhilarating in a way to know from the start that if I was going to write with any learning, clarity, and fairness, *everything* was up to me: what pictures I could find to see, who else would talk to me, and what primary documents I could discover to read as partial substitutes for the diarylike information contained in O'Keeffe's thirty-year correspondence with Alfred Stieglitz—officially sealed at Yale until 2011. Actually, to be thrown back on my own resources acted in my favor in the long run because it forced me to use my eyes first. In this, a bit ironically, I was doing exactly what she wished without realizing it: "I think I'd rather let the painting work for itself than help it with the word."[1]

In case there are any readers who want to know how I was formed

for this undertaking, O'Keeffe was not wrong about me. Our minds did work differently. I was not, for one thing, an artist. For another, I had always cared a great deal about words. But like O'Keeffe, I had been born and raised in Wisconsin and was therefore imprinted with the pastoral farm landscape. No small thing, in my view. In addition, I had made a special journey, while still quite young, to the Art Institute of Chicago to see her paintings and had never forgotten the experience, although I was then more interested in literature than painting. Later, unexpectedly inspired and encouraged by William Rubin at Sarah Lawrence College, I went on to take a master's degree in art history at Columbia University, concentrating on Greek and Roman archaeology and the late classical and early medieval periods. There was a fairly long time gap between this training and doctoral work at the City University of New York. By then my life had become divided between New York and Paris, and it seemed appropriate to switch my field of interest to nineteenth- and twentieth-century European and American art. After my orals I taught at the University of Long Island (C. W. Post) and, while casting around for a dissertation topic, I wrote critical reviews for *Art in America.* Georgia O'Keeffe never occurred to me as a topic until I worked on the *Women Artists* catalog. I kept seeing things in her work that she always said weren't there—especially photography—and decided quite suddenly to find out why. The rest simply followed.

In the summer of 1988, after twelve years of researching and writing —the dissertation was completed in 1987—I was granted the rare privilege of going to O'Keeffe's home in Abiquiu. The co-representatives of her estate made stringent directives for the visit that were very much in tune with O'Keeffe's habitual self-protection. I was to come for one hour only. No note taking, no photographs, no entry to the library (hence no idea of the books she liked and collected over the years), no crossing the threshold of her bedroom, and I was to be accompanied at all times by the caretaker. Hardly the circumstances for private contemplation. But I have always been susceptible to the "visitable" past—that curious and often productive joy described by Henry James as "the poetry of the thing outlived." As I drove from Santa Fe to Abiquiu that hot sunny morning in July, it crossed my mind more than once that very little of my academic training was going to be helpful in intuiting this encounter with the past. Anton Ehrenzweig, author of *The Hidden Order of Art,* would doubtless have recommended "utter watchfulness," and I decided to try for it.

The original settlement of Abiquiu—still a very small town—has been traced back to the fifteenth century. The adobe walls of O'Keeffe's

house were begun before the Civil War by General José María del Socorro Chavez, a United States Army Indian fighter, who lived there until he died at age 101. His son then sold the three-acre property with its five ruined structures to the Roman Catholic Church of Santa Fe for one dollar. O'Keeffe, who had had her eye on the site since 1930, bought it from the church for ten dollars in December 1945—the year before Stieglitz's death. She preserved most of the general's indigenous two-foot-thick foundation walls, but she had to knock a few of them down in order to make one dwelling place out of the five disparate buildings. The space she claimed for her bedroom had once been used to store wagons, and her studio had actually been the cattle shed. The most radical and important change she made was to put in many large windows.

Although the house stands alone on an isolated butte overlooking the fertile Chama River Valley, it is easy to miss from the road as you come toward Abiquiu because the pink adobe walls are low and blend perfectly with the surrounding sand hills. I knew pretty much what I would find there from published photographs and from O'Keeffe's letters to friends: the patio door she had painted so obsessively in the 1940s; the commanding view from her studio and bedroom; the abundant vegetable garden and apple orchard; the beehive-type fireplaces designed by O'Keeffe herself; the so-called Roofless Room with her 1945 cast-epoxy spiral sculpture in it; the disembodied Buddha hand, raised in the fear-not gesture of *abhayamudrā*, hanging on her bedroom wall. What I wanted to know was what this place—her special place on earth—*felt* like: "I've never wanted to make it look Spanish or Indian or anything like that. I wanted it to be my house."[2]

My allotted hour left me with the overriding impression that I had been in a miniature village, one having its own logical/illogical order and its own sacred and mundane spaces—as with most villages. At the near center of her autonomous, rectangular-shaped compound was the old patio, newly connected through a series of wings and passageways to a chain of quite small rooms. I was bidden to enter the house from the garden side. Just to the left of this entrance were the kitchen (which, alas, I never saw) and the ironing room. Next door to these was the L-shaped sitting-dining room, which seemed rather perfunctory because of its diminutive size and extreme plainness. (O'Keeffe, like William Morris, always refused to have anything around that was not useful or beautiful.) If memory serves, across a dark hall was the windowless Indian Room—named for its adobe wall ledges, traditionally used as beds by the Pueblos. How O'Keeffe used this strange, claustrophobic space I never discovered. Just in front of it was the open-air Roofless

Room. Across another passageway, parallel to these two rooms, was the library, which seemed like more of a storage area for books than a good place to curl up with one. Next came a guest room and bath.

Farthest of all from the entrance, like a holy of holies, and separated from the rest of the complex by an outside passageway and the patio, were O'Keeffe's studio (the largest area in the house) and her corner bedroom (almost the smallest). They were both situated right on the edge of the butte, with superb lookouts to "the Faraway." In the studio, now the office for the Georgia O'Keeffe Foundation, were the long tables that once held her canvases, stretchers, hammers, tacks, notes, and the like. But I don't remember seeing her two easels—or the palletlike bed she had placed under the picture window. Out of all her work done there over the years only a few of the pots thrown in her blind old age remained on the sills and shelves.

There were things I had not expected to see. Some were funny, humble housekeeping touches like the stocking filled with mothballs and hung in the patio against bats. Others were newly enlightening for their clear significance to her, as well as for their own intrinsic beauty. Hanging on the stark white walls of her studio were two African masks, probably from Stieglitz's original collection. They looked exactly right there. Many of the low, beamed ceilings (including the one in her bedroom) were made in native Southwestern crosshatch designs of alternating *vigas* (purlins) and *latillas* (poles). As a longtime student of universal pattern, O'Keeffe must have taken endless visual delight in them. So, too, the snake skeleton carefully arranged in a spiral. She always felt that snakes were her friends, and the spiral was one of the great motifs of her artistic life. Finally, there were the stones she had picked up over the years and arranged in patterns on every sill and available tabletop. She called them "treasures," and they were, for me, the true leitmotiv of the house. They carried her presence beyond death more than anything else I found at Abiquiu. Like the snake, the stone is well-known mythic material. Stone shapes have been associated with alchemy, with the individual, and with healing from prehistory down to the present. Perhaps she used stones to conduct her imagination into the profoundest sort of self-recollection. If so, she never spoke of it for publication.

It now seems to me the most natural thing in the world for O'Keeffe to have constructed a "village" of her own. Not only could she wander safely night and day through its spaces according to the needs of her body (and body sensations were always a major source for her art), it could also have been a way—consciously or unconsciously—to explore her psyche. One could even go so far as to diagram the Abiquiu house

according to Sigmund Freud's map of the mind: the ego (reason and deliberation) equals the large studio and the id (container of passions), her small bedroom. The relative sizes of these two spaces can also be thought of as significant in such a context since we are speaking of a woman who was already well into her sixties when she began living there. The garden, traditional and timeless, has parallels to the superego—the agent of life and of death. And the Indian and Roofless rooms, the patio door, and even the library act as different kinds of metaphors for the unconscious. She would, of course, have hated these observations. Certainly to connect one sphere of human experience with another can be dangerous. What makes it less so in this case, perhaps, is that Stieglitz was in touch with A. A. Brill, one of Freud's earliest translators, at just about the time he met O'Keeffe. We know, too, that he and she read both Freud and Carl G. Jung during the 1920s—and doubtless beyond. Furthermore, it is well accepted that even the unconscious, that most private of realms, is affected by the culture in which one finds oneself.

Did I actually glean anything new from Abiquiu, especially about O'Keeffe's creative process, her most carefully guarded ways of preparation, incubation, illumination, and verification? At first I didn't think so. My book is about the passionate, eclectic young artist that Stieglitz recognized and identified with during the Lake George and New York City years, and she seemed to be missing entirely here. But in recollecting that visit, with its visible and invisible chain of associations, two of the things that had puzzled me most about O'Keeffe became a lot clearer. First, her active resistance to interpretation. (Why, for example, she fought so hard to have her flowers and other subjects mean only the very little she said they did.) Second, her almost pathological secretiveness.

Even before Abiquiu I had come to think of O'Keeffe as one of those artists whom it is a mistake to understand too quickly. And after being there, yet another reason occurred to me as to why O'Keeffe so greatly resented those, myself included, who would use words to measure her images. I now think that O'Keeffe was a visionary Symbolist artist whose central concern was to cure people's minds and bodies with her paintings. And this is why she would not (or could not) divine what she did. While it may not do to press the matter too far, there is some hard evidence that by 1926 she really felt she had tapped the same primordial zone of therapeutic power devoutly believed in by Paul Gauguin and Henri Matisse. After 1929 she would become reacquainted with this "zone" in New Mexico, through the sand paintings, sings, and dances of the Southwest Indians.

Was O'Keeffe also familiar with Jung's statement in *Modern Man in Search of a Soul* (1933) that "a great work of art is like a dream; for all its apparent obviousness it does not explain itself and it is never unequivocal"?[3] Probably she was. But if so, Jung was, in a sense, corroborating her already hard-won findings. In some ways the long span of O'Keeffe's art can be seen as the very process of individuation. She could have found an earlier and more explicit reason to trust her intensely personal aesthetics in Kandinsky's *Art of Spiritual Harmony* (1914). By 1915 she had read, and absorbed, his radical notion that colors "awaken in the soul emotions too fine to be expressed in prose." It is very clear, even from the little she has said, that she wanted her paintings to work like visual poems, to resist the intellect almost entirely. Hence her forms were simplified to their essence and her colors were orchestrated for psychic resonance. Hence also her habit of denigrating her own superb intelligence with remarks like "my so-called mind." (And the ingenuous tenor of her first letter to me.)

O'Keeffe's secretiveness, while linked to her resistance to verbal interpretation, is in itself a subtle matter and one that may be buried permanently in biography. Perhaps it was ingrained—the Irish have always been masters at the language of concealment—and I would guess that as she got ever deeper into old age it intensified until it verged on paranoia. Not a rare thing for persons in their eighties and nineties. It resulted in watertight restrictions on the visual and documentary material vital to a sound understanding of the work she did. Her stern censorship, still largely in effect, has not served O'Keeffe—or her recent "retrospective" exhibition—well. Directly because of this, we may have been valuing or devaluing her art for the wrong reasons. Suspicious of analysis from the beginning, O'Keeffe most wanted people to see "the thing not named" (not there) in her paintings. In this productive paradox she seems close to the great American writer Willa Cather (a near contemporary, though not a friend). Cather spelled it right out: "Whatever is felt upon the page without being specifically named there—that, one might say, is created."[4]

In the case of a major artist, nothing is irrelevant or discreditable. The more we know about the creative process, the more we are enriched and the greater our regard for the artist. During her life with Stieglitz, O'Keeffe was part of a photographic culture, and this imposed on her a cognitive way of seeing that she learned, from her own volition, to transfer to painting. Where exactly did the blunt factuality of photography fit into her work? This was an agitating question at first, since I

constantly saw photography even in O'Keeffe's sheerest "fantasy" paintings. The main answer is that whatever she took—and her borrowings ranged through the entire photographic process—she immediately transformed for her own ends. Her intrinsic independence is visible even in this. Although O'Keeffe never lost her respect for Stieglitz's eye, she didn't hesitate to paraphrase photography that she liked and he didn't. A good example of this divergence of opinion is her aesthetic regard for Alvin Langdon Coburn, whom Stieglitz professed to despise. "Coburn is clever. But rarely a print of his wears. There is no soul in them. The prints are good but empty," he wrote to the English photographer J. Dudley Johnson in 1924.[5]

Why did photography interest O'Keeffe so much for so long? The answer may never be perfectly clear. It is true that when she first met Stieglitz, certain "photographic" characteristics, like the close-up and the fragment, were already familiar through her study of the Japanese-derived exercises in Arthur Wesley Dow's book *Composition*. But O'Keeffe was first and foremost a colorist, and the images made by Stieglitz and by the photographers of his circle were composed of monochrome shades of warm and cool tones. She was a master of expression in watercolor, pastel, and oil, whereas in photography the relation of hand to eye is very different. She could synthesize observation, emotion, and design, whereas the photograph is essentially disassociative, contingent, and static. Furthermore, the painter's "here and now" is quantitatively different from the photographer's. Painting registers changes of consciousness and creates substitutes for space, light, motion, and mass. Every mark put down must be related to every other mark. All of this is missing from the isolated instant that *is* a photograph.

Nevertheless, photography fascinated O'Keeffe. She always liked to find out what things looked like when they were photographed—even her paintings. And she often thought the results beautiful. These connections alone would be worth some investigation. But between 1919 and 1925 O'Keeffe's undeniably eccentric use of photography became the nexus of her mature style. One of the several reasons this went virtually undetected for so long is that photography did not tear down the edifice she had already built up out of Art Nouveau and European modernism. Rather, it was joined *to* them, and this synthesis is what enabled her to create "the new" in American art, so urgently called for by Stieglitz.

Despite the enormous amount of critical literature accumulating on O'Keeffe's art since 1916, comparatively little attention has been paid to

the interconnections between her paintings and photography. Obviously she herself was responsible for this. In her lifetime she made only four published statements on the camera as a source for her art: in *Manuscripts* (1922), where she wrote that photography had been "part of my searching"; in a 1962 interview with Katharine Kuh (*The Artist's Voice*), where she stated that photography had nothing to do with her enlarged flowers; in her limited edition of *Some Memories of Drawings* (1974), where she described using a camera to capture the odd angle in her 1963 painting *The Winter Road;* and in her autobiographical picture book, *Georgia O'Keeffe* (1976), where she again cited the use of one of her own snapshots for *Road Past the View I* (1964).[6]

Daniel Catton Rich may have been the first to state outright that O'Keeffe drew upon photography for her art. In 1943 he wrote that she was "unquestionably affected" by Stieglitz's "clean, new vision in photography" and went on to say, quite accurately, that "unlike certain other painters of this period, O'Keeffe avoided the *imitation* of photographic form in paint. Various qualities she simply translated into her own medium. . . . O'Keeffe made scrupulous use of the camera's suggestions but wholly in terms of pictorial design."[7] Among the relatively few later writers and critics to point out photographic aspects in O'Keeffe's work in specific ways are Milton W. Brown, Clement Greenberg, Martin L. Friedman, Bram Dijkstra, Barbara Rose, and Patterson Sims.[8] So far, the most serious and extended attempt to investigate O'Keeffe and photography has been that of Meridel Rubenstein.[9]

One of the most self-revelatory statements ever made by O'Keeffe about the complexities of her relationship to Stieglitz is buried in a 1923 letter to the critic Henry McBride. Describing her own "particular kind of vanity," she said she didn't at all mind being ignored or called names, "but I don't like to be second or third or fourth—I like being first—if Im noticed at all—thats why I get on with Stieglitz—with him I feel first—and when he is around—and there are others—he is the center and I dont count at all."[10] Stieglitz's relationship with O'Keeffe (he was exactly her mother's age) had its Pygmalion aspects. This is very evident in some of the portrait photographs he took of her during the late 1910s and early 1920s, particularly those linking her with some of his favorite famous artists—notably, Matisse, Auguste Rodin, and James McNeill Whistler. No less visible, if heretofore less documented, is O'Keeffe's artistic influence on Stieglitz. Although different in kind, this influence may have been even stronger in measure. For without O'Keeffe, Stieglitz's greatest work could never have happened: specifically, his twenty-

year cumulative portrait of her, the Lake George photographs, the cloud Equivalents, and the New York skyscraper series taken from the Shelton Hotel.

My investigations also deal with those photographers who were Stieglitz's close associates during the life span of his Little Galleries of the Photo-Secession, forever known as "291." Although O'Keeffe's painting evidently made a strong impression on Edward Weston, Paul Outerbridge, Ansel Adams, and Imogen Cunningham (and, perhaps, vice versa), their photography has not been included here because they were not, strictly speaking, 291 artists.

As an old-school art historian who regards the historical and critical processes to be one and indivisible, I was only a little startled, while pondering O'Keeffe's images, to encounter many of the issues that bedevil and enlighten the field today.[11] My approach can go by no single name or perspective. This is as true for the feminist viewpoint as it is for any other. From her own words and actions, O'Keeffe comes across as one who sincerely believed that to separate painting, or music, or literature, into two sexes is to emphasize values in them that are *not* art. Hence her determination never to be billed as a "woman artist." She was nonetheless acutely aware of the role played by gender in the making of all art—and of her own in particular. In early letters to her friend Anita Pollitzer, O'Keeffe calls it her "woman's feeling." And in 1925 she asked Mabel Dodge Luhan to write "something about me that the men cant. . . . I feel there is something unexplored about woman that only a woman can explore—men have done all they can do about it."[12] O'Keeffe made clear her true position on the issue of feminism in a 1930 debate with Michael Gold, editor of the *New Masses*. This remarkably forthcoming statement, elicited under pressure, is as revealing of her intelligence of vocation as anything she ever said publicly.

> I am interested in the oppression of women of all classes . . . though not nearly so definitely and so consistently as I am in the abstractions of painting. But one has affected the other. . . . I have had to go to men as sources in my painting because the past has left us so small an inheritance of woman's painting that has widened life. . . . Before I put a brush to a canvas I question, "Is this mine? Is it all intrinsically of myself? Is it influenced by some idea or some photograph of an idea which I have acquired from some man?"
>
> That too implies a social consciousness, a social struggle. I am trying with all my skill to do painting that is all of a woman,

as well as all of me. . . . I have no hesitation in contending that my painting of a flower may be just as much a product of this age as a cartoon about the freedom of women—or the working class—or anything else. And since the literary element will not blind the onlooker to the painting element, I think it is much more likely to be good art.[13]

It will also, I hope, become quickly apparent that I did not study O'Keeffe's work to find out how "progressive" she was: how flat-bed her picture plane, how advanced her abstraction. Rather, I consciously tried to de-idealize what she did in order to gaze on it as "bare" as possible, to open my mind.

With hindsight I can now see that my approach grew mainly out of my desire to get at the reasons O'Keeffe's art interested me—and kept me interested. I began with what Gauguin liked to call "the whys and wherefores." That is, I tried to find out about the social and political climate she worked in, what she meant to say, and how she achieved her meaning. One of my larger challenges was to deal coherently with the slippery Symbolist ideas she and Stieglitz were formed by. To do so sometimes required the extra–art historical, about which I felt little remorse, then or now.

O'Keeffe was, in fact, as rational as she was intuitive. Her colors swing back and forth between the descriptive and the imaginary. One of the great pleasures in looking at her work is trying to figure out which is which and then see how she balanced them for harmony and for meaning. She also knew perfectly well that certain things happen when a person stands in front of a picture—things not subject to reason. And that some of the strength of this impact comes from the many sources it draws on. Her eclecticism, which she never admitted to, has been one of the most unexamined facets of her work. Besides photography, she took knowledgeably from Chinese, Japanese, French, Russian, and Mexican art, and more. She was also extremely interested in primitivism (including the art of children) for its direct impact on the viewer. She made her own synthesis from them all, but her touch was so light that we have to look very hard to find any of them. Hers is not a simple art, despite her permanent desire to simplify her forms. It might well be described as a synesthesia of light, color, music, and poetry.

As a modernist, O'Keeffe made art that arose from her own interests, compulsions, and anxieties. And, it must be said, she had her unpleasant side. By all accounts she was capable of great warmth and great coldness in her relations with people. Enduring friendships—such

as she had with Louise March, the Stettheimer sisters, William and Dorothy Schubart, and Ansel Adams—were fairly unusual. Her silences and quarrels with many other old friends and associates, especially in the long years after Stieglitz's death, suggest that she felt obscurely threatened by persons who might know her, or her concerns, too well—particularly those for whom she was not "first." It is a truism that no great achievement was ever accomplished without ruthlessness, and O'Keeffe could be ruthless indeed, despite her deeply civilized heart. These swings between the warm and the cold are almost palpable in her paintings. Although the division can be said to begin with the New Mexico animal bone themes (which burgeoned after her mental breakdown in 1932–34), her abrupt shifts of mood are apparent even in the Lake George period of the 1920s. All the diverse elements of her makeup —the passion for concealment, the mystic sense of the spiritual, the irrepressible comic streak, the unpredictable capacity for outrage—are highly visible in her work, once we have been alerted to look for them. Yet O'Keeffe did not want us to find the artist in her pictures: "Where I was born and where and how I have lived is unimportant. It is what I have done with where I have been that should be of interest."[14] What she strove for up to the end was an immediate reaction from viewers to her images—images that she wanted to have the spiritual and timeless impact of music.

But O'Keeffe's revelatory vision is out of sync with our times. Paradoxically, as public interest in her life has increased, critical esteem for her work has fallen. The reasons are many, some more interesting than others. Art that seems good in one period can seem bad at another and vice versa. It is also well known that shortly after popular artists die their oeuvre is apt to sink in terms of attention and appreciation. O'Keeffe's pictures have always been received spectacularly well by the public. And, until recently, she was admired by most critics for first-class painting. But ever since the inadequate retrospective exhibition hurriedly organized by the National Gallery of Art in 1987 to honor the centenary of O'Keeffe's birth (which traveled to five other American museums), her critical fortunes as a painter have turned sour and unforgiving. She was newly described as a "gifted illustrator," "a bad artist," "only capable of limited artistic growth," "folkartish," "ice-cold," "airless," "a fundamentally provincial sensibility," "problematic," "stubbornly original . . . but minor," and the like. She was also said to have "little feel for oil paint," and one unobservant writer spoke of the "mechanistic anonymity" of her surface. (True of Charles Sheeler, yes. O'Keeffe, no.) Certainly there are some paintings by her about which

any or all of these things apply. But how much this general reassessment has had to do with the present market appreciation for the expressionist brush stroke (as exemplified by the prices obtained for paintings by Vincent van Gogh and Claude Monet) will not be known for some time. In plain fact, O'Keeffe could do anything she liked with oil paint. Not for nothing was she a prize-winning student of William Merritt Chase's. It is interesting to remember in this context that during the 1970 Whitney retrospective—when O'Keeffe was every critic's darling—Ellsworth Kelly and the Minimalists were riding high. One also has to wonder how many of the critics writing negatively about her work today are only too pleased to think they are bringing down a popular American icon said to be worth seventy million dollars at her death, and one who had been granted more media exposure over the years than should be anyone's due as an artist. The feminists' joyous embrace of O'Keeffe may also have acted as a lightning rod in ways both positive and negative.

High Culture is presently in dispute and disarray.[15] This, too, may have contributed to the downgrading of O'Keeffe's work. Certainly it is true that what we have seen and said over the last seventy years about her art has depended mostly on our own expectations. We valued and found meaning in what she did only within the context of her history and ours. One of the good things about the recent change of climate is that at long last some genuinely new questions are being raised about O'Keeffe's art. What is the *real* nature of her achievement? Is it perhaps not what we have been accustomed to think? How did photography fit into this equation? Did it help her natural powers of expression—or hinder them? Is she perhaps like Walt Whitman, in whose early work lies the whole story—in her case the presently acclaimed 1916–18 watercolors? (I don't think so.) Unfortunately, these are questions that cannot be fully answered. O'Keeffe's oeuvre cannot be radically revised until it is wholly known. And it is not yet. Although my work covers only a short time frame—her first fifteen years as a committed artist—there are paintings done in this period that I was refused permission to see by the co-representatives of her estate, and many others that have sunk from view into private hands. At present writing, the good news is that the Georgia O'Keeffe Foundation has announced as its priority the publication of a catalogue raisonné of her work.

I began by thinking of O'Keeffe's work as unique and profoundly interrogative. After my long scrutiny I still think so. What is necessary to understand better is what she chose to do—and not do. And why. Whether she is a great artist—one to whom people will turn in the future for "the widening of life"—only time can tell.

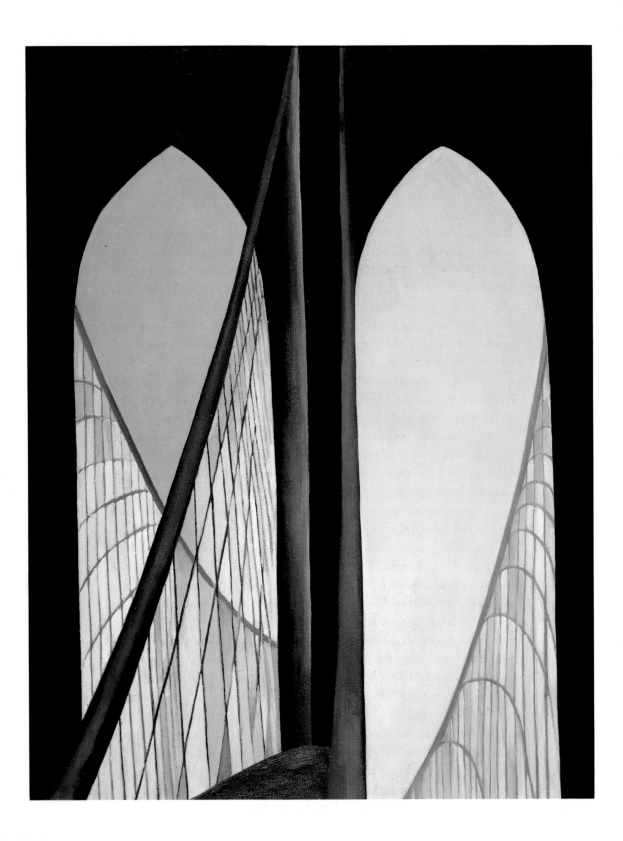

INTRODUCTION

In 1949, three years after the death of her husband, Alfred Stieglitz, Georgia O'Keeffe painted her first oil of the Brooklyn Bridge (plate 2). In this severely simplified yet numinous picture we can see an exceptionally rich mixture of the three major elements in her mature art: abstraction, photography, and Symbolist suggestion. That *Brooklyn Bridge* was thought out with extra care by O'Keeffe is clear from a rare full-scale charcoal sketch she made for it (plate 4). Although the artist had lived in Manhattan on and off since 1907 and had made many pictures of its buildings and streets—primarily during the late 1920s—she had never before represented this genuinely American cultural symbol. Nor had she painted the city at all since 1929. It is probable that *Brooklyn Bridge* was finished about the same time as her sad, self-imposed duty of dispersing Stieglitz's important collection of early twentieth-century art to American museums.[1] Shortly thereafter she went to New Mexico to live the rest of her long life. She was then sixty-one.

Why did O'Keeffe choose to paint this epical American motif at that particular moment? She was aware, of course, that John Marin and a host of other New York artists and photographers connected with Stieglitz had considered it to be *the* embodiment of the new. She must also have known that Lewis Mumford (who had written admiringly about her own work) considered the bridge to be a central monument in America's "usable past."[2] And she was surely familiar with Hart Crane's mystical poem cycle *The Bridge,* which was influenced, in no small part, by Stieglitz.[3]

The real motive behind O'Keeffe's *Brooklyn Bridge* may have been to create a visual history of the nearly thirty mutually inspiring years she

2. Georgia O'Keeffe. *Brooklyn Bridge,* 1949. Oil on Masonite panel, 47^{15}/$_{16}$ x 35^{7}/$_{8}$ in. (121.7 x 91.2 cm). The Brooklyn Museum; Bequest of Mary Childs Draper.

had spent with Stieglitz. Like so many of her works, it is at once accessible and hermetic. It reveals her large debts to the theorists of modern European abstraction (primarily Wassily Kandinsky and Francis Picabia) even while it presents a quintessential modern American theme: New York City. There is much to indicate that O'Keeffe intended this painting to be both a final salute to the half-century of Stieglitz's fight to have photography accepted as art in his own country and a secret farewell to their love and to their unique artistic relationship.[4]

Between March and October 1920 Charles Sheeler and Paul Strand shot and edited an experimental abstract film that became known as *Manhatta*.[5] Based on the broad theme of a day in New York City, it ran for seven minutes and included quotations (used as intertitles) from two of Walt Whitman's poems: *Crossing Brooklyn Ferry* (1856) and *Manahatta* (1860). Sheeler and Strand were believers in Stieglitz's goal for modern camera work: to unite straight photography with abstraction. To accomplish this goal they took sharp, clear pictures from extreme camera angles, chose predominantly geometric architectural motifs, and kept sightings of human activity to a minimum.[6] In 1922 *Vanity Fair* published a page with five stills from the film. One of them, titled *Brooklyn Bridge* (plate 3), bears such a remarkable resemblance to O'Keeffe's painting that she may have wished it to be understood (by the old Stieglitz circle at least) as a direct quote.[7]

The painting appears to be an abstract double portrait of herself and Stieglitz. The bridge itself is a universal symbol of unity. The ogive, like the Hellenic column, can be read as a summation of the human figure. The inner form created by the filigree of cables is easily perceived as a heart, the old familiar visual metaphor for love. And the diagonal effectively crosses out the space of the left arch, a particularly graphic way to suggest death. Her colors also contribute to this impression of a double portrait: graduated tones of black and white and the pale brown common to early twentieth-century photography are combined with blue —the first color that O'Keeffe chose to work with after her breakthrough black-and-white abstractions of 1915. This painting can also be regarded as a prototype of the sort of give-and-take that shaped O'Keeffe's art. Her work is, by her own account, autobiographical: "I find that I have painted my life—things happening in my life—without knowing."[8] And it is clear (but perhaps not clear enough) that Stieglitz —his ideas, his colleagues, his photography—was of singular importance to her artistic development.

It has often been suspected, although never actually spelled out, that the symbiotic relationship between these two artists caused them to

create many works of art that, on one level at least, were records of intimate conversations between them—in effect, a private visual code. The intimate and secret process by which one artist affects another's work can never be satisfactorily charted. With Stieglitz and O'Keeffe the usual difficulties are compounded. Not only are their mediums different, but the similarities between their artistic intentions and the strange resemblances between many of their pictures (especially during the early 1920s) keep raising the question "Who was the bear and who was leading the bear?"—to borrow from Gertrude Stein's apt vernacular.[9] (In 1926 Stieglitz even went so far as to say, "Whoever doesn't see O'Keeffe doesn't see my work either."[10])

Because O'Keeffe's signature style was hammered out during her early years with Stieglitz, it is not possible to consider her work from that period wholly apart from his. And to really see his work requires some fresh awareness of the theories that generated the exhibitions organized at his gallery as well as his own photography—since O'Keeffe was to profit artistically and personally from both. Historically, the origins of the Little Galleries of the Photo-Secession, which Stieglitz founded at 291 Fifth Avenue in 1905, go back to the Photo-Secession. This group of Pictorial photographers had been brought together by him in 1902 to present group exhibitions that would demonstrate to America that photography was an art form.[11] By using the term *Secession*, Stieglitz was deliberately linking his group of American and European photographers with the famous Munich Secession of 1892—the first in a series of catalytic movements by German and Austrian artists intended to free themselves from outmoded ideas of art by presenting exhibitions of the best modern tendencies.[12]

Stieglitz's idée fixe of individual artistic freedom shows up in his first published statement on the Photo-Secession, in August 1903. He described the group as "an active protest against the conservative and reactionary spirit whose self-satisfaction imbues them with the idea that existing conditions are akin to perfection . . . [and] an insistence upon the right of its members to follow their own salvation as they see fit."[13] The essential character of the gallery and of its "mouthpiece," *Camera Work*, "the illustrated quarterly magazine devoted to Photography" (published 1903–17), was determined by Stieglitz's unwavering view that progress in art was possible only through revolutionary action.

From the very beginning the intention was to exhibit at the Little Galleries *all* the fine arts, not just Pictorial photography. Stieglitz's reasons for doing so were printed later in *Camera Work:* "Photography, claiming to be a legitimate medium of personal pictorial expression,

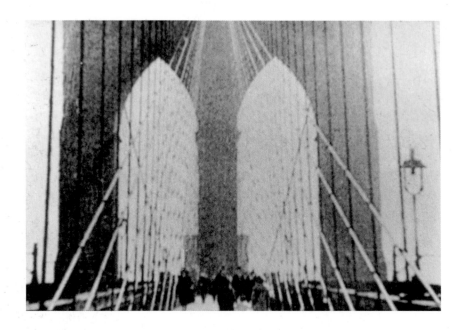

should take its place in open review with other mediums in order that its possibilities and limitations might be more fairly judged."[14] In April 1908 Stieglitz was forced to close the original Little Galleries because of professional and financial difficulties. Seven months later, with major support from the wealthy critic-photographer Paul Haviland, they were reopened in a new two-room space in the building next door. It is not known exactly when the new galleries (only fifteen feet square) began to be referred to as "291."[15] After 1910 photography exhibitions there were increasingly crowded out by avant-garde paintings and sculpture. This was due to Stieglitz's new interest in modern European art, with its revolutionary ramifications for photography in general and his own in particular.

Stieglitz was first exposed to the latest developments in modern European art in Paris during the summer of 1907. On this trip, however, neither he nor his Paris-based colleague Eduard Steichen was able to grasp the significance of Paul Cézanne's late watercolors: "nothing there but empty paper, with a few splashes of color here and there."[16] The radicalization of Stieglitz's perception over the next four years can be measured by his decision to exhibit Cézanne's watercolors (for the first time in America) at 291 in March 1911 and by a public statement he made later that year, "Without the understanding of Cézanne . . . it is impossible to grasp, even faintly, much that is going on in the art world today."[17] This shift in Stieglitz's visual thinking, which changed the direction of both 291 and *Camera Work* between 1908 and 1911, oc-

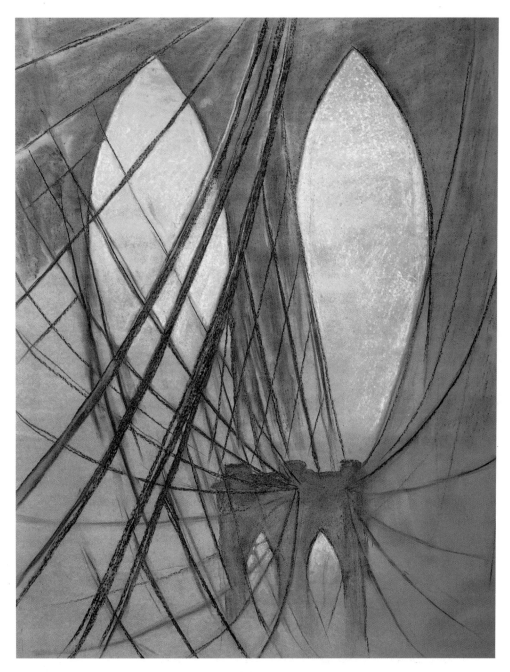

3. Charles Sheeler (1883–1965) and Paul Strand (1890–1976).
The Brooklyn Bridge, 1922. Still photograph from the film *Manhatta*.
The Museum of Modern Art, New York.

4. Georgia O'Keeffe. *Brooklyn Bridge*, 1949. Charcoal and chalk on paper,
40 x 29½ in. (101.6 x 74.9 cm). Doris Bry, New York.

curred under the tutelage of three men: Steichen; Marius de Zayas, whose caricatures were among the first nonphotographic works ever published in *Camera Work* (January 1910); and Max Weber, the first American painter to use Cubist geometric structure.[18]

By the middle of 1911, after Stieglitz made two more trips to Paris, his eye for European vanguard art had developed enough so he could rely on himself rather than Steichen, who had selected most of the modernist works shown at 291 from the 1907 Rodin exhibition on. In a December letter to the critic Sadakichi Hartmann, Stieglitz spoke revealingly of his three weeks spent in Paris with de Zayas and Steichen during the summer of 1911. "Paris made me realize what the seven years at 291 had really done for me.—All my work, all my many and nasty experiences had all helped to prepare me for the tremendous experience."[19] This trip to Paris apparently crystallized Stieglitz's long-range goals for 291. From November 1911 to May 1917 (when 291 closed after exhibiting "recent work" by Georgia O'Keeffe), he presented just three photographic exhibitions: his own work and that of the only two photographers close to him at the time, Baron Adolf de Meyer and Paul Strand. Their photography was presented as an equal partner to painting in revealing the true vision of modern life through the new medium of expression—abstraction.

Abstraction, it can accurately be said, was what first brought O'Keeffe to Stieglitz's attention. For he saw—and reacted to instantly —her charcoal abstractions on January 1, 1916, six months before they actually met. What was Stieglitz like when, at the age of fifty-two, he encountered (one might better say recognized) O'Keeffe? To begin with his own measurement of himself: "My teachers have been life—work— continuous experiment. Incidentally a great deal of hard thinking. Any one can build on this experience with means available to all. . . . I am an American. Photography is my passion. The search for Truth my obsession."[20] This credo comes across now as rather excessively evangelical, histrionic, aggressive, and visionary. Not unlike the man, but hardly the full story. To add some specifics: Stieglitz was a first-generation American. Born in 1864 to German-Jewish parents of considerable culture in Hoboken, New Jersey, he spent his earliest years there until the family moved to New York City in 1871. The eldest of six children, Stieglitz was both afraid and disapproving of his prosperous businessman father. He remained his mother's favorite until she died at age seventy-eight. He loved sports, horse racing, and music—especially Richard Wagner and Ludwig van Beethoven. His nine years of bohemian student life in

Berlin during the 1880s gave him a solid grounding in photochemistry and a lifelong devotion to German culture. He was a romantic anarchist who was honestly contemptuous of possessions, and an unrepentant womanizer who was coincidentally a feminist. (He thought women were absolutely necessary to the growth of American culture.) He was a utopian who believed that art could change the world.

Subsidized by others (his first wife and a brother), Stieglitz felt idealistically free to sell art to the "deserving buyer" rather than for crass profit. In art, as in life, he had complete faith in the democratic process. (*Camera Work* was editorially committed to presenting the reader with opposite points of view.) He trusted intuition over logic: "I find the keynote to whatever I have done to have been unpreparedness."[21] He had a bent for tyranny; in the later words of O'Keeffe, "He was the leader or he didn't play."[22] He was a perfectionist craftsman who thought of photography as "a weapon . . . a means of fighting for fair play, for tolerance of all those who want to do anything honestly and well."[23] He was a hypochondriac, a compulsive letter writer, and a nonstop talker who was alarmingly, even manipulatively, frank. A self-made mystic, he valued people most for their ability to grow spiritually. He knew his own worth.[24]

Stieglitz enfranchised O'Keeffe. He not only exhibited her 1915 breakthrough charcoal drawings short months after she had made them, he immediately wrote her a barrage of letters citing his own belief in what she had done. And, at the very moment she needed most to hear it, he reported that her drawings would bring a "greater awareness" to all who saw them.[25] Although O'Keeffe had received excellent coeducational training in her craft at the Art Institute of Chicago school and the Art Students League in New York, she can still be regarded as a classic example of the woman artist who was set upon her career by a man—with at least one difference. Stieglitz's own best work could never have happened without *her*.

By giving O'Keeffe the opportunity to paint full time in 1918, Stieglitz set her free to answer the one question that an artist must answer: Who am I? Like Emily Dickinson, O'Keeffe told the truth but told it "slant."

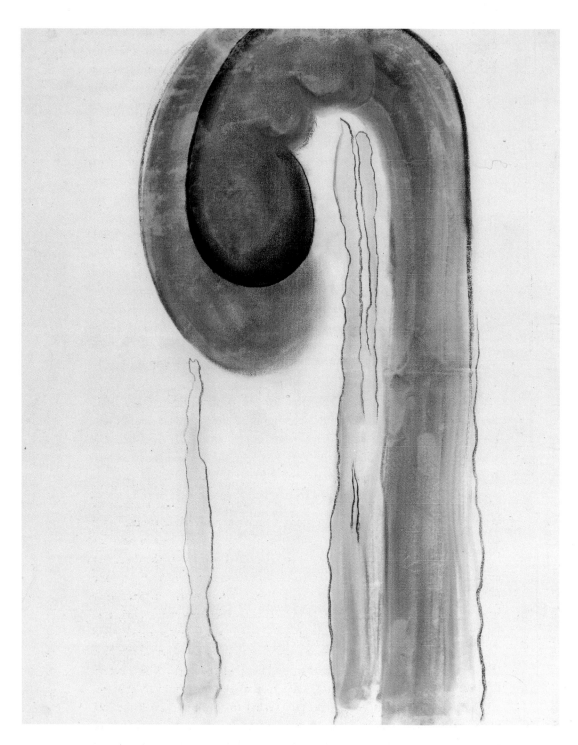

5. Georgia O'Keeffe. *Special No. 3*, 1915.
Charcoal on paper, 24 x 18½ in. (61 x 47 cm).
Estate of Georgia O'Keeffe.

1 Starting All Over New

I believe I would rather have Stieglitz like something
—anything I had done—than anyone else I know of—
I have always thought that—If I ever make anything
that satisfies me even ever so little—I am going to show
it to him to find out if it's any good—. . . . Still Anita
—I don't see why we ever think of what others think of
what we do—no matter who they are—isn't it enough
just to express yourself—

GEORGIA O'KEEFFE, OCTOBER 1915

Art, art, what is art? . . . Creating a picture without
models is art.

FRANCIS PICABIA, 1913

During the autumn of 1915 Georgia O'Keeffe, then a twenty-seven-
year-old art teacher in Columbia, South Carolina, rendered a series of
large charcoal abstractions on student sketch paper. They appeared as if
out of the blue. She could have had no real idea of their vast import for
her future, and yet in some way perhaps she did. For to alter the direction
of her academic training and to equate drawing with dreaming in one
fell swoop has a "Eureka" ring to it. Ten of these works in particular
have long, and rightly, been regarded as the cracking of her chrysalis:
lines and spaces created out of what she knew Wassily Kandinsky had
defined as "inner necessity." Nonetheless, very little is known about how
she came to do such potent, peculiar, and baffling drawings. The imagery
itself appears to be loaded with psychological and biographical content.
Although this content seemed wholly sexual to the first viewers at 291
in 1916,[1] it may be more accurate to read the drawings as intimations of
a less literal and more profound view of reality. There is much to be
learned about O'Keeffe's art from these singular, turning-point char-
coals, withheld from public gaze as a series by the artist for seventy-five

years now—even though they still add up to "a mass of unprovables," in E. H. Gombrich's classic phrase.

Fortunately, we have come to know something of O'Keeffe's activities and state of mind at the time of their making, thanks to the remarkably candid letters that passed between her and Anita Pollitzer, her classmate at Columbia University's Teachers College in New York during 1914–15.[2] These letters—especially the ones written between June 1915 and June 1917, before O'Keeffe joined her life to Stieglitz's —contain major clues to her artistic sensibility. And the free and easy voice that speaks to us from over the years is that of an intelligent, humorous, practical, emotionally vulnerable, obstinate, oddly reckless, and self-reliant individual—a self-starter, full of honest and shrewd opinions about herself, people, and ideas. She practiced the violin and tried her hand at poetry: "But the strongest card in the whole blame pack / was the fine sensation that paid men back. / For the finest feeling that's been furled / Is the feeling of fur on the tail of the world!"[3] She was well versed in some of the more advanced writing and thinking of her time, reading John Millington Synge's *Riders to the Sea,* H. G. Wells's *Tono-Bungay* ("so hopelessly true"), the Murray translation of *The Trojan Women,* Anton Chekhov's *Sea Gull,* Thomas Hardy's *Jude the Obscure* ("very interesting"), Dante (in the Henry Wadsworth Longfellow translation), Henrik Ibsen, Friedrich Wilhelm Nietzsche, Randolph Bourne's *Youth and Life,* and Floyd Dell's *Women as World Builders.* She was an avid subscriber to the *Masses*—the doctrinaire, leftist journal of politics, art, and propaganda that published such future luminaries as Max Eastman, John Reed, Sherwood Anderson, and Mabel Dodge. After she became Stieglitz's star protégée, his perfect exemplar of the purely intuitive female artist, O'Keeffe would conspire to cloak the high order of her intelligence by making mischievous references to "my so-called mind," but that time was still down the road.

In September 1915, for reasons financial and professional, O'Keeffe decided to accept a position teaching art at Columbia College in South Carolina—a small (150 students), two-year Methodist music school for women. She had known ahead of time that the job would be neither inspiring nor arduous. ("I have to make a living—I don't know that I will ever be able to do it just expressing myself as I want to—so it seems to me that the best course is the one that leaves my mind freest."[4]) Her teaching schedule was fairly light: four days a week, with classes over by midafternoon. And she soon found a small studio to paint in. But it was hard to be without the stimulations of New York student life, and at first she wasn't sure she could handle it.

It is going to take such a tremendous effort to keep from stagnating here that I don't know whether I am going to be equal to it or not. I have been painting a lot of canvases and boards white—getting ready for work—I think I am going to have lots of time to work, but bless you—Anita—one can't work with nothing to express. I never felt such a vacancy in my life—Everything is so mediocre—I don't dislike it—I don't like it—It is existing—not living. . . .

I'll be better for having told you and tomorrow can get out and take a long walk—that will probably help—I can always live in the woods. . . . maybe I'll have something to say then.

Write me quick—[5]

This isolation permitted O'Keeffe to attain, possibly for the first time, the state of reverie essential for achieving abstraction: the heroic task of symbolizing the essence of feelings. As it turned out, O'Keeffe did not proceed with the aforementioned canvases and boards. Instead, she hung a show for herself of her completed works, perceived that they had all been done under the influence of her teachers, and decided to take a different tack.[6] As she was to describe it eight years later: "I have things in my head that are not like what anyone has taught me—shapes and ideas so near to me—so natural to my way of being and thinking that it hadn't occurred to me [before] to put them down. [And] I decided to . . . accept as true my own thinking."[7] There is a letter to Pollitzer (still living in New York), written early in October, that confirms this. "I am starting all over new. Have put everything I have ever done away and don't expect to get any of it out ever again—or for a long time anyway. I feel disgusted with it all and am glad I'm disgusted."[8]

The first of the "new" works were sketches done on paper in several different mediums: watercolor, pastel, and charcoal. She also experimented with the monotype process. Very few of the October letters to Pollitzer are specifically dated, so we cannot know the exact order of these early experiments. One of the most informative has this to say: "You see I took the cart before the horse—drawing with no idea of composition. If I ever get this darned watercolor anything like I want it —maybe I'll send it to you—Today's is the 10th edition of it—and there it stands saying—'Am just deliciously ugly and unbalanced.'"[9] She had, in fact, already tried at least three abstract watercolors a few months before. Explaining the intention behind one of them, she wrote: "It is only a human document—that wild blue picture with the yellow and red ball in the corner—I made it during the summer when one of

his [Marcus Lee Hansen, an unloved suitor] letters almost drove me crazy—I just exploded it into the picture—it was what I wanted to tell him only didn't dare in words . . . —that little blue mountain with the green streak across it is what he expresses to me."[10] About Hansen himself, the same letter says, "If he were less fine—I would drop him like a hot cake—but he is too fine to drop—and too fine to keep."

On October 8 she mailed the following:

> I wish you could see the thing I made today—I am afraid I will get distorted with only seeing my own things that I will be more queer than ever—
>
> I don't mind—I would show it to you only it doesn't satisfy me even a little bit, so I must work longer—Fancy me working a whole week—all my spare time doing the same thing over and over again.[11]

On October 14 Pollitzer wrote to O'Keeffe ("Pat"):

> I saw [the abstractions] yesterday—and they made me *feel*—I swear they did—they have emotions that sing out or hollar as the case may be. I'm talking about your pastels—of course. . . . They've all got *feeling* Pat—written in red right over them— no one could possibly get your definite meanings Pat—that is unless they know you better than I believe anyone does know you—but the mood is there every time. . . . Your monotype that you did of me is a masterpiece.[12]

At some point toward the end of October, O'Keeffe switched over entirely to charcoal. As she put it to Pollitzer:

> The things Ive done that satisfy me most are the charcoal landscapes—and—things—the colors I seem to want to use absolutely nauseate me—[13]
>
> I don't mean to complain—I am really quite enjoying the muddle—and am wondering if I'll get anything out of it and if I do what will it be—I decided I wasn't going to cater to what anyone else might like—. . . and when you leave that element out of your work there is nothing much left.[14]

With the humble charcoal stick O'Keeffe was reverting to the most traditional tool for capturing quickly—and freely—the artist's personal

expression. In itself this is hardly surprising, since her academic training at the School of the Art Institute of Chicago (1905–6) had been rigorous, and her record there rated "exceptionally high." [15] What *is* surprising is that she put her sheets of paper on the floor to work, instead of using an easel.

> Did you ever have something to say and feel as if the whole side of the wall wouldn't be big enough to say it on and then sit down on the floor and try to get it onto a sheet of charcoal paper— and when you had put it down look at it and try to put into words what you have been trying to say with just marks—and then—wonder what it all is anyway.—I've been crawling around on the floor till I have cramps in my feet . . . —Maybe the fault is with what I'm trying to say—I dont seem to be able to find words for it—[16]

Why did she do it this way? We cannot know for certain, but it would seem that the motion of her body was a necessary conduit to the shapes in her mind. She could also have felt somewhat as Jackson Pollock did when making his poured paintings more than thirty years afterward: "On the floor I am more at ease. I feel nearer, more a part of the painting, since this way I can walk around it, work from the four sides and literally be *in* the painting." [17]

It is a further measure of O'Keeffe's courage and originality that she tried for self-expression without the help of her intrinsic gift for color. Prey to nerves and conflicting emotions, she swung from elation to hopelessness to panic—and back again. "You get mightily twisted with yourself at the tail end of the earth with no one to talk to—Then thinking gets more serious when you wonder and fight and think alone—. . . I don't know that my heart or head or anything in me is worth living on paper." [18] In mid-November, out of dire need for some kind of feedback, O'Keeffe sent Pollitzer a roll of just-finished charcoal drawings and received this reply: "They came today—I took them in an empty classroom—got thumbtacks and stuck them over the wall. First of all came your two moods—They are pretty fine I think but you know I'm crazy when it comes to things like that. . . . —I don't know what to say about it—I'd love to ask Mr. Stieglitz Pat. Of course I never should till you said the word & I don't feel the time's come yet—but keep on working this way like the devil." [19]

On November 15 O'Keeffe turned twenty-eight, and the work wasn't any clearer or easier. Still, she kept on. "It's a wonderful night," she wrote to Pollitzer. "I've been hanging out the window waiting to tell someone about it—wondering how I could—I've labored on the violin till all my fingers are sore—. . . but Im going to try to tell you—about tonight—another way—I'm going to try to tell you about the music of it—with charcoal—a miserable medium for things that seem alive—and sing."[20] Another factor may have contributed to the "music" of that night. Several of O'Keeffe's October–November–December letters tell of her fight against a romantic interest in Arthur Macmahon, a young professor of political science she had known "a long time" and had seen much of the summer before at the University of Virginia, where both were then teaching.[21] The two shared many interests, including feminism, "new Art," and above all, cross-country hiking. In an October letter to Pollitzer, O'Keeffe complained that she was nearer to being in love with Arthur than she wanted to be. After Macmahon had traveled to South Carolina to spend Thanksgiving with her, she wrote to Pollitzer: "We had a wonderful time . . . I feel stunned—I don't seem to be able to collect my wits—and the world looks all new to me."[22]

During the next few weeks, for reasons that are impossible to support by objective evidence, O'Keeffe found within herself an insistent ordering of her emotions she could express only in the language of abstraction. At the end of December she mailed another roll of charcoals to Pollitzer. Pollitzer's written response to this work makes a contribution to American art history in the immediacy and clarity of its reporting.

JANUARY 1, 1916

Astounded and awfully happy were my feelings today when I opened the batch of drawings. I tell you I felt them! & when I say that I mean that. They've gotten past the personal stage into the big sort of emotions that are common to big people—but it's your version of it. I mean if they'd been stuck on a wall & I'd been told XZ did them I'd have liked them as much as if I'd been told Picasso did them, or someone I'd never heard of. Pat —Well, they've gotten there as far as I'm concerned & you ought to cry because you're so happy. You've said something! I took them up on the 4th floor & stayed alone with them in one of the studios. And they spoke to me!!*!! I swear they did.

Then I left—flew down to the Empire Theatre with them under my arm & saw Maude Adams in Peter Pan—I hope you've seen her & if you haven't, I hope you will. Theatre was

over at 5 & Pat I had to do, I'm glad I did it, it was the only thing to do—I'd have—well I had to that's all.

I walked up to 291—It was twilight in the front room Pat & thoroughly exquisite. He came in. We spoke. We were feeling alike any way and I said, "Mr. Stieglitz would you like to see what I have under my arm." He said, "I would—Come in the back room"—I went with your feelings & your emotions tied up & showed them to a giant of a man who reacted—I unrolled them—I had them all there—The two you sent, with that work of Adelaide's [a young student of O'Keeffe's] before, & those I got today. He looked Pat—and thoroughly absorbed & got them—he looked again—the room was quiet—One small light —His hair was mussed. It was a long while before his lips opened—["Finally a woman on paper"—he said.] Then he smiled at me & yelled "Walkowitz come here"—Then he said to me—"Why they're genuinely fine things—you say a woman did these—She's an unusual woman—She's broad minded, she's bigger than most women, but she's got the sensitive emotion—I'd know she was a woman O Look at that line"—And he kept analyzing, squinting Pat—Then little Walkowitz came. His eyes got big & saucer like. "What do you think" Stieglitz asked him—"Very Fine"—and then he sat down & held them —Pat they belonged there & I took them down—I had to— They gave those men something—your pieces did—they gave me much. It's 11 at night & I'm dead tired in bed & they're with me—next to my bed—I left them alone—They lived thru them—Then Stieglitz said "Are you writing to this girl soon" —I said "Yes"—"Well tell her," he said "they're the purest, finest, sincerest things that have entered 291 in a long while"— and he said—"I wouldn't mind showing them in one of these rooms one bit—perhaps I shall—For what they're worth"— "You keep them—(he turned to me & said this) For later I may want to see them, and I thank you for letting me see them now."

Pat I hold your hand. I think you wrote to me once—'I would rather have Stieglitz like something I'd done than anyone else'—It's come true. I've written you only what I plainly remember—Those are mighty near his words—I've left out what I wasn't sure of—They do it to me too—Pat—or I wouldn't give a hang—You're living Pat in spite of your work at Columbia!!!!!South Carolina![23]

O'Keeffe's reply is enlightening. It reveals, on the one hand, that she was confident she had expressed the essence of herself through images; and, on the other, that she still felt the worry of all pioneer abstractionists, from Kandinsky and Mondrian to Arthur Dove and Marsden Hartley: could a personal visual language communicate meaning to others?

There seems to be nothing for me to say except Thank you— very calmly and quietly.

I could hardly believe my eyes when I read your letter this afternoon—I haven't been working—except one night all during the holidays—that night I worked till nearly morning—the thing seems to express in a way what I want it to but—it also seems rather effeminate—it is essentially a womans feeling— satisfies me in a way—I dont know whether the fault is with the execution or with what I tried to say—Ive doubted over it— and wondered over it till I had just about decided it wasn't any use to keep on amusing myself ruining perfectly good paper trying to express myself—I wasn't even sure that I had anything worth expressing—there are things we want to say—but saying them is pretty nervy—what reason have I for getting the notion that I want to say something and must say it—

Of course marks on paper are free—free speech—press— pictures—all go together I suppose—but I was just feeling rather downcast about it—and it is so nice to feel that I said something to you—and to Stieglitz. I wonder what I said—I wonder if any of you got what I tried to say—Isn't it damnable that I cant talk to you—If Stieglitz says any more about them —ask him why he liked them—

Anyway, Anita—it makes me want to keep on—and I had almost decided it was a fools game— . . .

You say I am *living* in Columbia—Anita—how could I help it—balancing on the edge of loving like I imagine we never love but once—[probably a reference to Macmahon]. [But] Columbia is a nightmare to me—everything out here is deliciously stupid—and Anita—I—am simply walking along through it while—something—that I dont want to hurry seems to be growing in my brain—heart—all of me—whatever it is that makes me—I dont know Anita—I cant explain it even to myself but Im terribly afraid the bubble will break—and all the time I feel so ridiculously secure that it makes me laugh Anita—I cant begin to tell you how much I have enjoyed that Camera Work.[24]

What works did Stieglitz actually see on that New Year's Day of 1916? Certainly included were the following: *Special No. 1, Special No. 2, Special No. 3, Special No. 4, Special No. 5, Special No. 7, Special No. 8, Drawing No. 9, Drawing No. 12,* and one drawing still recorded in O'Keeffe's notebooks as *Untitled*—all of 1915.[25]

What did they say to him? When O'Keeffe herself wrote to ask Stieglitz this, he told her that he couldn't put into words what he saw in the drawings, that he didn't know what she had in mind when doing them, and that they were "a real surprise." Above all, he said, they were "a genuine expression of yourself," and he would like, if possible, to show them someday.[26] In May 1916, without her knowledge or approval, he hung ten of the charcoals on the walls of 291.[27] The story is now legend of their "first" meeting, when she came to demand (without success) that he take them down.[28] Although it cannot be said for certain which drawings these were (installation photographs, presumably taken by Stieglitz, are missing), chances are excellent that he chose those listed above, since they are the ones that she preserved and recorded from her three-month venture into abstract expression.[29]

For Stieglitz, apparently, these drawings were somehow connected to everything he had been striving for at 291: "honesty of aim, honesty of self expression, honesty of revolt against the autocracy of convention."[30] Judging from his correspondence, they looked to his experienced eye like something that had never been done before. "A young girl of unusual sensibility has done some really personal abstractions," he wrote to Paul Haviland on April 19, 1916.[31] Out of this early judgment was born the popular and enduring legend of O'Keeffe as a native/naive American genius. It was one carefully nurtured by Stieglitz, by his immediate circle, and later by the artist herself, for a complex of reasons centering on Stieglitz's desire to foster an American modern art created out of American life. Naive O'Keeffe was not, but there are enough elements of truth in the legend to have discouraged serious challenge in her lifetime, for indeed she never did study in Europe (as had everyone else in Stieglitz's circle) and the basically European sources of her first charcoal abstractions—the core of her whole symbol system—have only recently been tracked down.

From the start, critics have taken two main lines in writing about O'Keeffe's work, both of them actively encouraged by Stieglitz: her art as the depiction of "feminine forms"[32] and her art as completely free from the influence of European modernism—a rather surprising appraisal in light of the great twentieth-century pioneers that 291 made it possible for her to see. In 1921 Hartley published an essay that estab-

lished the quintessential litany on O'Keeffe, which has been rewritten, with variations, ever since: "[O'Keeffe] sees the world of a woman turned inside out. . . . The pictures . . . are as living and shameless private documents as exist in painting. . . . She is modern by instinct and therefore cannot avoid modernity of expression."[33] The critic Paul Rosenfeld's summation of O'Keeffe as an American original appeared three years later and came to the same conclusion: "No inherited rhetoric interposes between her feeling and her form of expression. Her concepts . . . come out of general American life; not out of analyses of Cézanne and Picasso. They come out of the need of personal expression of one who has never had the advantage of the art treasures of Europe and has lived life without the help of the city of Paris."[34] In 1930 Dove (the only artist whose work O'Keeffe consistently admired) wrote to Stieglitz that "with O'Keeffe there did not happen to be any tradition."[35] And in 1963 the art historian Lloyd Goodrich summed up this prevailing opinion (clearly with O'Keeffe's blessing): "From the beginning, [her] art was a personal language, without discernible derivations; growing out of nature, yet attaining abstractions as pure as music. In her remarkable abstract creations from the late 1910s on, the concepts were completely original . . . the design daring and effective, the style absolutely clear cut, yet always with a sense of enigmatic depths."[36]

Authentically reticent, O'Keeffe truly hated the female sexuality readings of her early work.[37] (This may be why the ten charcoals were never again exhibited—or reproduced—all together.) But she never failed to support the spontaneous eruption theory of her abstractions, maintaining that they were "things in my head that others didn't have."[38] If, however, we assume with E. H. Gombrich that the innocent eye is a myth and with Nelson Goodman that an artist may often strive for innocence of eye in order to be rescued from traditional patterns of seeing, then it is imperative to ask how those "things" got into her head in the first place.[39] For O'Keeffe, as for James Joyce, imagination was memory—visual as well as emotional.

O'Keeffe's traditional art education has been pretty thoroughly recorded.[40] For a glimpse of the raw talent she took to Chicago, there is a pen-and-ink drawing from about 1905 of Jennie Varney, the great-aunt who helped to bring up the seven O'Keeffe children. Titled *My Auntie,* it is one of the very few works signed by the artist (plate 6). The salient stages of O'Keeffe's education are these: A life class with John Vanderpoel at the School of the Art Institute of Chicago, 1905–6, where she earned the "exceptionally high" recommendation. Portrait and still-life classes with William Merritt Chase at the Art Students League in New

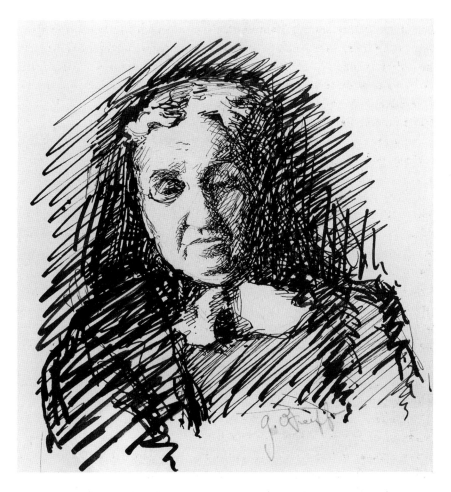

6. Georgia O'Keeffe. *My Auntie,* c. 1905.
Ink on paper, 6 x 5½ in. (15.2 x 14 cm). Museum of Fine Arts,
New Mexico; Bequest of Claudia O'Keeffe, 1988.

York, 1907–8, where she won Chase's first prize of a hundred dollars
for an oil still life (plate 7). A drawing course for elementary-school
teachers based on the Dow-Fenollosa method, which she took during
the summer of 1912 in Charlottesville, Virginia, from Alon Bement,
assistant professor of fine arts at Columbia University. And (at Bement's
suggestion) courses with Arthur Wesley Dow himself at Teachers Col-
lege in New York during 1914–15 and again in the spring of 1916.

O'Keeffe credited Dow with having had the strongest influence on
her work: "The way you see nature depends on whatever has influenced
your way of seeing. I think it was Arthur Dow who affected my start,
who helped me to find something of my own.... This man had one
dominating idea: to fill a space in a beautiful way—and that interested

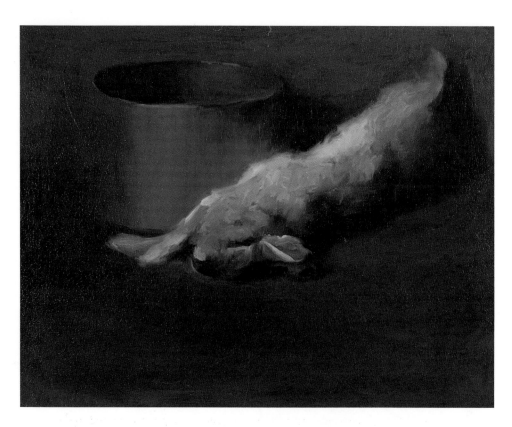

7. Georgia O'Keeffe. *Dead Rabbit with Copper Pot,* 1908.
Oil on canvas, 19 x 23½ in. (48.3 x 59.7 cm).
Art Students League, New York.

me."[41] Why did this interest her so much, and where did she find the "things" to fill her spaces?

Although O'Keeffe did not have "the help of the city of Paris," she certainly had plenty of other opportunities to develop a vanguard modernist eye. She first went to 291 in 1908—that crucial year when Stieglitz began to show avant-garde European art to America—and, by her own account, she saw the Auguste Rodin drawings there in January. (Eight years later she would make sixteen [known] watercolors of nudes that bear some startling similarities to the Rodins, in spite of her statement that the latter were of no interest to her at the time.[42]) The same winter and spring of 1908 she could also have seen Pamela Colman Smith's drawings to music (in February–March) and an Henri Matisse exhibition (in April) that included drawings, lithographs, watercolors, etchings, and one oil—although she did not record doing so. The official account skips to 1912, when she met Alon Bement, who put her in touch

with the Dow-Fenollosa method. He suggested she look at the drastically new paintings illustrated in Arthur J. Eddy's *Cubists and Post-Impressionism* (1914) and told her to read Kandinsky's *Art of Spiritual Harmony* (1914). During the 1914–15 season she went to 291 to see the Pablo Picasso–Georges Braque show of Cubist oils and charcoal drawings from the collection of Gabrielle and Francis Picabia ("I looked at it a long time but couldn't get much," she wrote to Pollitzer on February 10, 1916); three huge 1914 abstractions by Picabia himself (*Je revois en souvenir ma chère Udnie, C'est de moi qu'il s'agit* [plate 52], and *Mariage comique*); the work of Stieglitz's friends Marion Beckett and Katharine Rhoades (which she did not admire); and John Marin's oils and watercolors (which she did).[43] Missing from her remembrances of visits to 291 is the important November–December 1914 exhibition of eighteen African sculptures, organized by Marius de Zayas and billed by Stieglitz as "the Root of Modern Art." Nor has it been recorded whether she saw the Cubist watercolors exhibited at the Carroll Gallery in December 1914, Hartley's paintings at the Daniel Gallery in January 1915, or the Matisse show at the Montross Gallery in January–February 1915, although it is highly probable that she did.

Even though O'Keeffe later admitted that she "had gotten a lot of new ideas [in New York] and was crazy to be off in a corner and try them out,"[44] her first abstract drawings seem to be connected only secondarily with the European modernism she saw there between fall 1914 and spring 1915. What these drawings first call to mind are the myriad floral forms of Art Nouveau—the least acknowledged and very probably the most permanent and pervasive of all her sources.[45] Where did O'Keeffe first come in contact with Art Nouveau? For the answer, we must go back to her formative Chicago period: the year at the Art Institute school (1905–6) and the years between 1908 and 1910, when she returned to Chicago to work at two different fashion houses as a free-lance commercial artist, drawing lace and embroidery advertisements for newspapers. We know virtually nothing about her professional contacts and activities during those years, only that she lived in the city with her mother's older brother (Charles Totto) and sisters Lola and Ollie.[46] Fortunately, the record is rich about Chicago itself as one of the most important centers for the Arts and Crafts movement in America.

The Industrial Arts League was organized in Chicago in 1899 to provide work, instruction, exhibitions, and publications to benefit arts and craftsmen. The more prestigious Chicago Arts and Crafts Society, founded in 1897 at Hull House, was directly inspired by the English Aesthetic movement. Such distinguished figures as Walter Crane and

C. R. Ashbee had prepared the way by coming over from England to lecture at the Art Institute, and by the late 1880s William Morris fabrics, wallpapers, and furniture were available at Marshall Field Company. In 1902 Tobey Furniture Company held an Arts and Crafts exhibition in a re-created "Morris room" furnished with objects from Morris's own establishment. The William Morris Society was born in 1903, and by then numerous small Arts and Crafts groups flourished as well. The Art Institute was of paramount importance in disseminating a wide range of decorative-arts ideas. Annual craft exhibitions were held there from 1902 through 1921, and the Society of Decorative Arts of the Art Institute sold its members' work at a gallery right in the museum. Several Chicago-published periodicals were also extremely influential in spreading the message of Arts and Crafts, including *Builder and Woodworker* (1868–95), *Ornamental Iron* (1893–95), *House Beautiful* (founded in 1896), *Forms and Fantasies* (1898–99), *Fine Arts Journal* (1899–1919), and *Western Architect* (1902–31).[47]

When O'Keeffe attended the Art Institute school, the Department of Decorative Designing offered a stiff three-year course to prepare students to go directly into professional work. There were studies in "the theory of design and exercise in original designs for stained glass, wallpaper, rugs, bookcovers, metal work, carved wood, interior decorations, carpets and decorative work of all kinds (including embroidery)."[48] The name *Georgia O'Keeffe* is listed solely under the Academic Department section of the *Catalogue of Students* for 1905–6, and she herself spoke only of the life classes she attended that year.[49] Nevertheless, since she felt competent and interested enough to find paid work in the applied arts upon her return to Chicago in 1908, it is reasonable to assume that she had found ways to absorb instruction and information from the more practical curriculum offered by the Department of Decorative Designing. As an alumna in good standing, she probably had access to the Art Institute's Ryerson Library, which, to quote from the school's catalog, contained "many valuable books upon decorative art of which the students make constant use, each . . . setting up from the beginning a scrapbook of tracings which gradually form a reservoir of useful patterns."[50] Many of the instructors and lecturers were European trained,[51] and by 1903 Ryerson Library subscribed to the following periodicals: *L'Art décoratif, Art et décoration, The Artist, Brush and Pencil, The Craftsman, Deutsche Kunst und Dekoration, Gazette des Beaux-Arts, Pan,* and *Studio.* Although Ryerson did not accession the vitally important Munich periodical *Dekorative Kunst,* the independent Newberry Library did, beginning with volume I in 1898. With all this material available, it is not

surprising that O'Keeffe's 1915 charcoal abstractions contain such a remarkable knowledge of international Art Nouveau.

But why, after the passage of five years, did she turn back to that style for inspiration and guidance in her own first efforts at abstract personal expression? They were forms she had worked with during the first independent earning period of her life—and obviously they had gone deep. But it may have been Art Nouveau's dual aspect of imaginative form and rational construction that especially appealed to her, for she could work in freedom yet keep to the reasonably strict rules of logical design, in the approved Dow fashion (see chapter 2). Perhaps, also, the frank fecundity of Art Nouveau's subject matter seemed to her an appropriate way to equate abstraction with creation. If so, then she unwittingly joined the ranks of other pioneer abstractionists, such as František Kupka and Morgan Russell, who specifically tried to suggest connections between the birth of life and the making of new art forms. At the very least, her Chicago years made O'Keeffe aware that Art Nouveau was regarded as "art pure and simple, untrammeled by convention, and therefore in a sense original. Its proper expression must result rather from what is within a man, his sympathies, his nobler qualities and aspirations, than from studious effort; he must feel rather than know, sympathise rather than study."[52]

It is also tempting to think that O'Keeffe was exposed to the words of the famous art dealer S. Bing—the originator of the term *Art Nouveau* for applied art—who visited the United States in 1894. Bing published his admiring and perceptive views of Louis Sullivan's architecture, as well as of the many examples of American industrial and decorative design that he saw, in *La Culture artistique en Amérique* in 1895—the same year that his celebrated shop, L'Art Nouveau, opened in Paris. A section from his article appeared in translation in the American periodical the *Craftsman* in 1903:

America . . . will quickly cast off the tutelage of the Old World, under which she put forth her first steps upon the sunlit path of Art. . . . Her brain is not haunted by the phantoms of memory; her young imagination can allow itself a free career, and, in fashioning objects, it does not restrict the hand to a limited number of similar and conventional movements. . . . Her rare privilege is to profit by our old maturity and . . . to place all this practical and proven knowledge at the service of a fresh mind which knows no other guide than intuitions of taste and the natural laws of logic.[53]

It almost seems as if Stieglitz, not Bing, had written these words, and that the "fresh mind" to come was that of the young Georgia O'Keeffe.

The first point to be made about O'Keeffe's charcoal abstractions is that virtually all of them appear to be based on the unmistakable iconography of Art Nouveau: coiling, swelling, bending plant forms, and the rhythmic patterns of water and waves. Some drawings are much more abstracted than others, but *none* is without concrete references. And they come across as almost aggressively personal, not least because of their large size. It seems prudent to discuss these in the numbered sequence given by O'Keeffe, even though we do not know for certain whether they were actually made in that order.

Of all the 1915 charcoals perhaps *Special No. 1* (plate 8) and its variation *Special No. 2* (plate 13) tell us most about O'Keeffe's absorption of Art Nouveau. To begin with, there are the highly characteristic erotic, uterine, and phallic overtones. The New York critic Henry McBride must have been referring specifically to these ovoids penetrated by phalluslike forms when he wrote, "It was one of the first triumphs for abstract art, since everybody got it." [54] What they mainly "got," however, was a simplistic reading that ignored Art Nouveau in favor of the fashionable new interpretations of Freud's theories. [55]

Why O'Keeffe's primary sources escaped her contemporary critics remains something of a puzzle. There are at least two probable factors. The most obvious one is that the Art Nouveau aesthetic had generally come to be regarded as overcharged frippery long before 1916, driven from the art world's fickle attention by Post-Impressionism, German Expressionism, and Cubism. [56] And the other is that the sexual reading of O'Keeffe's artistic intentions by artists and critics was deliberately masterminded, and astutely controlled, by Stieglitz. [57] Visual proof for this statement exists in the photograph he made (plate 9) that shows O'Keeffe's 1916 phallic-form sculpture placed in front of her 1919 painting *Music—Pink and Blue, I* (Barney Ebsworth Collection, Saint Louis). The implication of intercourse in this photograph is as clear as it is contrived. And Stieglitz knew exactly what he was doing when he exhibited it in 1921, for he had long regarded sex and anarchism to be the energizing forces in what he called the "spirit of 291."

But O'Keeffe steadfastly refused to accept the "Aha!" interpretation of her charcoals as sexual expression. What, then, was it that she had expressed in them but could not name—to Stieglitz, or even to herself? It is not so difficult to see that their formal vigor comes straight from Art Nouveau. But we must also ask how, and in what ways, the abstract "landscapes and things" were analogous to her invisible feelings. Secret

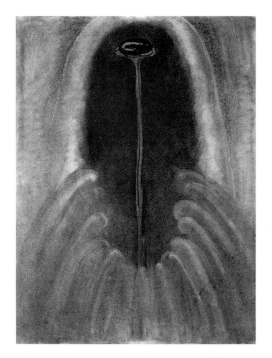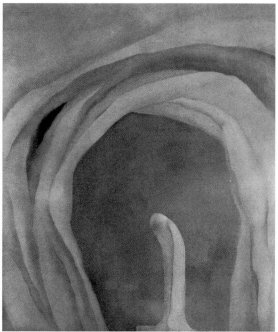

8. Georgia O'Keeffe. *Special No. 1,* 1915. Charcoal on paper, 25 x 19 in. (63.5 x 48.3 cm). Estate of Georgia O'Keeffe.

9. Alfred Stieglitz (1864–1946). *Georgia O'Keeffe: A Portrait—Painting and Sculpture,* 1919. Palladium photograph, 9¼ x 7⅝ in. (23.3 x 19.4 cm). National Gallery of Art, Washington, D.C.; The Alfred Stieglitz Collection, 1980.70.127.

as her analogies have remained, O'Keeffe inadvertently left us some picklocks. First, her early outrage against the Freudian readings of her images suggests that she believed she was exploring her whole psyche—not just her sexuality. Second, she was very aware that she worked best out of her unconscious—what she herself called "the unknown."[58] And third, there is the statement she made offhandedly to Dorothy Brett in 1932 about her favorite working method: "That memory or dream thing that I do that for me comes nearer reality than my objective kind of work."[59] (With all of O'Keeffe's images we should keep in mind that symbols not only express states of mind but also tend to induce them.)

The Art Nouveau characteristic most conspicuous in both *Special No. 1* and *No. 2* is the ornamental wallpaperlike patterning. The 1905–6 catalog of the Art Institute school reproduced several illustrations of decorative wallpaper by students, and one of the examples (plate 10) is built on the same symmetrically opposed design that appears in

TOP, LEFT

10. Maud Harnish (n.d.). "Decorative Design, Second Year—Wallpaper."
From *Catalogue of Students, The School of the Art Institute of Chicago, 1905–1906.*

TOP, RIGHT

11. Falize, after a design by Lucien Lévy-Dhurmer. *Flambeau,* c. 1910–14.
Bronze and alabaster, height: 71 in. (180.3 cm). The Metropolitan Museum
of Art, New York; Harris Brisbane Dick Fund, 1966.

ABOVE

12. Hermann Obrist (1862–1927). *Fantastic Shell,* c. 1895. Charcoal over
pencil, on transparent paper, stretched over cardboard, 10½ x 6¼ in.
(27 x 16.1 cm). Staatliche Graphische Sammlung, Munich, Germany.

OPPOSITE

13. Georgia O'Keeffe. *Special No. 2,* 1915. Charcoal on paper,
22¾ x 18½ in. (60.3 x 47 cm). Estate of Georgia O'Keeffe.

both these drawings: an ovoid shape penetrated from below by a vertical stalk. O'Keeffe's jewel-headed stalks are also similar in shape to the flambeau, a decorative candlestick greatly fancied by applied artists of the period (plate 11). In *Special No. 2* the more definitively rendered oblong "jewel" strongly suggests the scarab, a stone prized since ancient times for its eye symbolism. (Freud's famous link of the eye to the phallus was undoubtedly known to Stieglitz and many of the others who came to 291.) A favorite of Art Nouveau jewelers, the scarab was frequently used by Tiffany and Company in their metal and jewelry designs from the turn of the century on.[60] (It is also worth noting in this context that O'Keeffe studied jewelry design in 1914 with Professor

14. Georgia O'Keeffe. *Special No. 32,* c. 1914. Pastel on paper, 14 x 19½ in. (35.6 x 49.5 cm). Estate of Georgia O'Keeffe.

Edward Thatcher at Teachers College.[61]) O'Keeffe's elevated, centralized scarab-eyes are haloed with light, a type of encirclement reminiscent of the mandorla form in sacred Christian art. Even without this extra reading, *Special No. 1* and *No. 2* are unmistakably iconic in composition and effect.[62] Are they meant to symbolize the inner eye of the young artist—an eye striving to see and experience true reality? This meaning can never be proved, but it cannot be discounted either, given the choice and juxtaposition of the forms and O'Keeffe's already quoted intentions.

The oscillating tendrils that curve protectingly around the foot of each stalk—particularly in *No. 2*—suggest that O'Keeffe was familiar with the Munich Jugendstil work of Hermann Obrist. This familiarity is safe to assume since, for one thing, two of the Art Institute's professors had been trained in Munich.[63] Whether she actually knew Obrist's *Fantastic Shell* (plate 12) is not certain, but the sinuous linearity of her *No. 2* tendrils does have a remarkable similarity to his.[64] Also, the smudgy, indeterminate space behind both of her configurations is very like the watery-looking void surrounding *Fantastic Shell*. Even if O'Keeffe did

not scrutinize Obrist's charcoal at some point, the tendril itself was an old and familiar shape in Arts and Crafts designs, and one especially common in Art Nouveau embroidery.[65]

Special No. 3 (plate 5) and *Special No. 4* (plate 16) are twinned variations on another typical form in Art Nouveau decoration—the stylized fern. S. Tschudi Madsen has observed that the marked preference by artists in the 1890s for tall, slim stalks with curled heads reveals "interest in the structure of nature rather than her external splendor. . . . The bud, after all, symbolizes the future, concealing within its closed form the promise of the growth and beauty that will unfold."[66] And there are other distinctively Art Nouveau characteristics in these two drawings—namely, asymmetrical composition, or visual ambiguities between ornament and floral structures, and strong emphasis on surface rather than space. In addition, O'Keeffe's fern shapes give the amazing effect (through their shadows and force lines) of growing before our very eyes. They seem to have been caught in the act of pushing right through the top of the frame.

We know from O'Keeffe's October 8 report to Pollitzer that she edited and re-edited the first versions of her charcoals. With *Special No. 5* (plate 17) it is nearly impossible to retrieve the original source. Is it the twining roots of an aquatic plant? Or is this, as seems quite probable, a development of the more legible ebb-tide motifs in one of her pastels, *Special No. 32* (plate 14)? Whatever the original forms, they have been

15. Hermann Obrist (1862–1927). *Whiplash Tapestry* (also known as *Cyclamen*), c. 1895. Wool with silk embroidery, 46¾ x 72 in. (119 x 183 cm). Münchner Stadtmuseums, Munich, Germany.

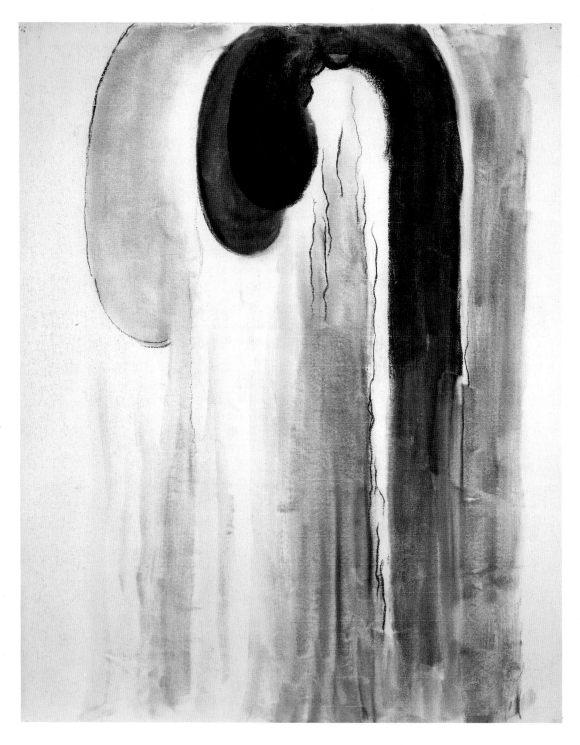

16. Georgia O'Keeffe. *Special No. 4,* 1915. Charcoal on paper,
24½ x 18⅛ in. (62.2 x 46 cm). Estate of Georgia O'Keeffe.

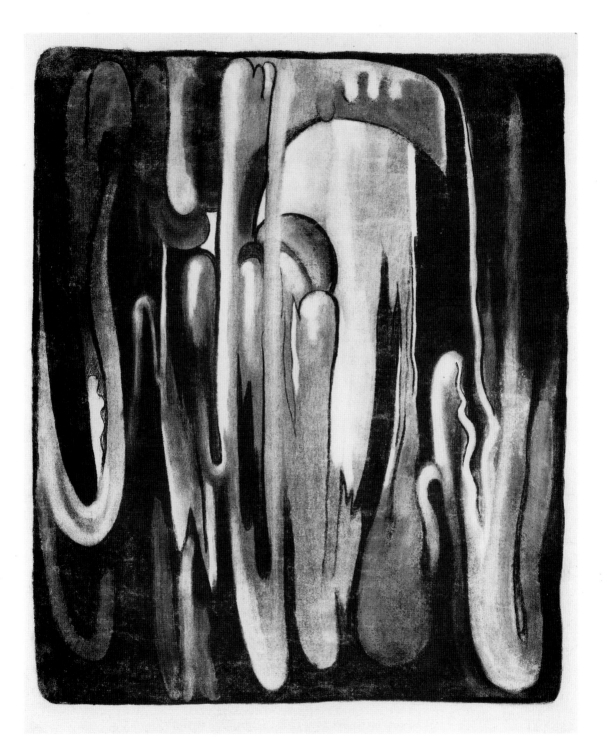

17. Georgia O'Keeffe. *Special No. 5*, 1915. Charcoal on paper,
24 x 18½ in. (61 x 47 cm). Estate of Georgia O'Keeffe.

culled and reassembled into a version of that paradigm of Jugendstil design, the whiplash. As a professional embroidery and lace draftsman, O'Keeffe would surely have been familiar with Obrist's influential masterpiece *Whiplash*—a silk embroidered tapestry depicting a cyclamen plant—for it was much reproduced in American periodicals (plate 15).[67] Yet even if her image of ghostly swirls and tentacles does owe a debt to Obrist's *Whiplash, Special No. 5* goes way beyond the aesthetic of decorative art. To look for any length of time at this marvelously illusionistic scribble is to sense that the design was put down first in some form of automatic writing, perhaps even horizontally instead of vertically. (It is well documented that O'Keeffe arbitrarily upended many of her later pictures to aid abstraction—a trick she picked up from Dow, who taught his students that a picture must look balanced from each of its four sides.) There is something almost seismographic about *Special No. 5*. In

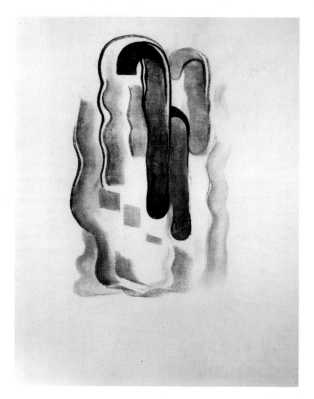

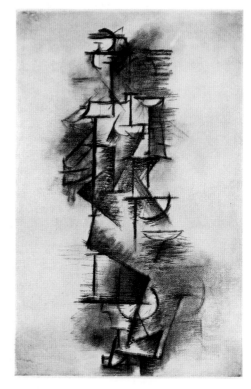

ABOVE, LEFT
18. Georgia O'Keeffe. *Special No. 7*, 1915.
Charcoal on paper, 24⅛ x 18½ in. (61.2 x 47 cm).
Estate of Georgia O'Keeffe

ABOVE, RIGHT
19. Pablo Picasso (1881–1973). *Nude*, 1910.
Reproduced in *Camera Work*, June 1913.

fact, the closest we may ever get to solving the intent of this complex image is to regard it as a sort of supersensitive linear recording of her psyche (a method of plumbing the unconscious for images that would be labeled "automatic writing" and embraced by André Breton in his Surrealist Manifesto of 1924, and taken still further by Jackson Pollock and the American Abstract Expressionists in the late 1940s). To describe it another way, these are lines and spaces ordered according to inner necessity, at once private and (she half-hoped) recognizable: "I always have a curious sort of feeling about some of my things—I hate to show them—I am perfectly inconsistent about it—I am afraid people wont understand—and I hope they wont—and am afraid they will." [68]

The next work in her numbered progression is *Special No. 7* (plate 18). (What *No. 6* looked like, and whether it still exists, is not known.) This drawing is apparently a later variant of *No. 3* and *No. 4,* with traces of *No. 5* as well. But its stylized fern shapes have been abstracted into a floating configuration of planar forms without any other connections to nature. It is perhaps the most "musical" of her ten abstractions: a harmony of shapes by threes. Robert Goldwater might have been describing what happened between *No. 3* and *No. 7* when he wrote, "The practitioners of Art Nouveau became conscious of the degree to which the abstract, rather than the associational, or representational, elements should constitute the character of a work of art—in van de Velde's words, 'in a life and soul which are proper to it, not in the life and soul of the model.' " [69]

There is also something modernist about *Special No. 7*. It suggests that O'Keeffe had looked extra-attentively at Picasso's 1910 *Nude,* which Stieglitz owned and reproduced three different times in *Camera Work,* where she probably saw it (plate 19).[70] Her configuration is less jagged, less geometric, and, in its roundedness, more feminine. But it, too, plays with converging planes and their echoing shadows. Even more tellingly, *No. 7,* like *Nude,* dissolves well before reaching the edges of the paper field. (Eight out of ten of the 1915 charcoals are "framed" by a thick-stroked charcoal border.) It is, in fact, quite possible that in some corner of her brain O'Keeffe was making this slyly "Cubist" drawing to catch Stieglitz's visual attention.

About *Special No. 8* (plate 21), O'Keeffe wrote, "I have made this drawing several times—never remembering that I had made it before—and not knowing where the idea came from." [71] The spiral was another of Obrist's favorite organic shapes for the expression of feeling, one he shared with the Symbolist movement in general and with the French artist Odilon Redon in particular. There is a strong stylistic similarity

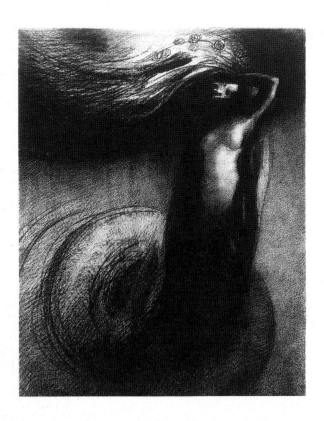

20. **Odilon Redon (1840–1916). *La Mort: Mon Ironie dépasse
toutes les autres!*, 1889. Lithograph, 10¼ x 7¾ in. (26 x 19.8 cm).
The Art Institute of Chicago; Stickney Fund.**

between O'Keeffe's huge, space-filling spiral and the serpentine shroud
in Redon's *La Mort: Mon Ironie dépasse toutes les autres!* (plate 20). Where
could she have seen this illustration for Gustave Flaubert's *La Tentation
de Saint Antoine*? In view of Redon's large and acclaimed representation
in the 1913 Armory Show, it is quite possible that O'Keeffe was alerted
to his work when she was in New York during 1914–15, although we
do not yet know how.[72] Certainly no one understood the tremendous
power of charcoal better than Redon; in 1895 he wrote to his young
friend Emile Bernard, "Black and white derives its source from the
deepest recesses of our very being." Redon never interpreted what he
drew, believing his images to be points of departure toward "the unex-
pected, the imprecise, the undefinable." His intent was, above all, to
welcome "the messenger of the unconscious, that most lofty and myste-
rious personage, who comes in her own good time."[73]

O'Keeffe's *Special No. 8* is without question the most poetically
resonate of her ten charcoals.[74] The spiral itself is a basic symbol of

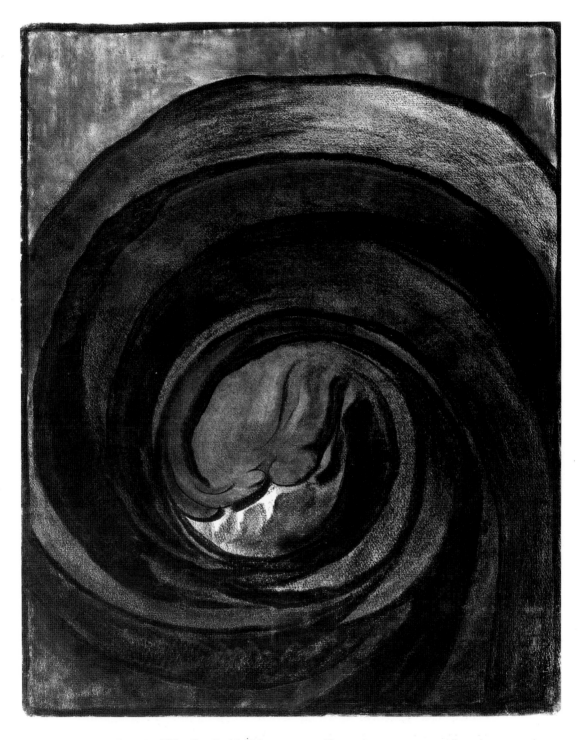

21. Georgia O'Keeffe. *Special No. 8*, 1915. Charcoal on paper on cardboard, 24¼ x 18⅞ in. (61.6 x 47.9 cm). Whitney Museum of American Art, New York; Purchased with funds from the Mr. and Mrs. Arthur G. Altschul Purchase Fund.

dynamic force that speaks equally of transition and transcendence because of its circular movement toward the center. Emerging mysteriously from the core of Redon's spiral is his long-haired figure of death; at the center of O'Keeffe's is a thickened form that reads most easily as an incipient fetus. Disparate as these drawings are in historical time, content, and intention, each connects, through symbol, to what is constant in human experience—the things people know in their bones. And each seems to exemplify Kandinsky's description of black and white as "the two great possibilities of silence—death and birth."[75]

With *Special No. 8* O'Keeffe again showed herself a true master of the charcoal medium. Her layered, textured, shiftingly transparent surface has been rendered by a versatile combination of stumping, rubbing, scratching, and erasing. In direct consequence, her spiral form is redolent of fancy and the shifting dreams of night. Perhaps no form is of a richer and more various appearance in O'Keeffe's total oeuvre than the spiral. It appears and reappears in such guises as her Evening Star watercolors of 1917, the abstract oils of 1918 labeled Series II (Estate of Georgia O'Keeffe), *Shell I* (1928; National Gallery of Art, Washington, D.C.), *Nature Forms, Gaspé* (1932; private collection), and *White Shell with Red* (1938; Art Institute of Chicago)—to mention a few of the most familiar.

In her 1974 commentary for *Some Memories of Drawings*, O'Keeffe wrote that *Drawing No. 9* (plate 22) depicts a headache: "It was a very bad headache at the time that I was busy drawing every night, sitting on the floor in front of the closet door. Well, I had a headache, why not do something with it? So—here it is."[76] The seashore motifs of wave, froth, and foam that are suggested so strongly in the drawing are almost perfect visual metaphors for the pounding ebb and flow of a headache. There are, as well, some interesting similarities between this O'Keeffe and a proto-abstract Jugendstil painting by Obrist's student Hans Schmithals, titled *Study (Dance of the Bacilli)* (plate 23), which O'Keeffe could have seen in *Dekorative Kunst* of March 6, 1904—as Kandinsky did.[77] The indeterminate space of both these works is similarly divided with a misty light area at the top. Schmithals's swirls of droplets and his diagonally stretched, webby figurations seem to be echoed (consciously or unconsciously) by O'Keeffe's more reduced and stylized wave and bubble patterns, although in reverse direction.[78]

Perhaps if *Drawing No. 10* and *No. 11* were still around, *Drawing No. 12* (plate 42) would not be quite so difficult to read. Shapes resembling feathers, tree trunks, buds, fruit, stones, and clouds have been reduced to a rhythmically balanced amalgam of swelling curves and

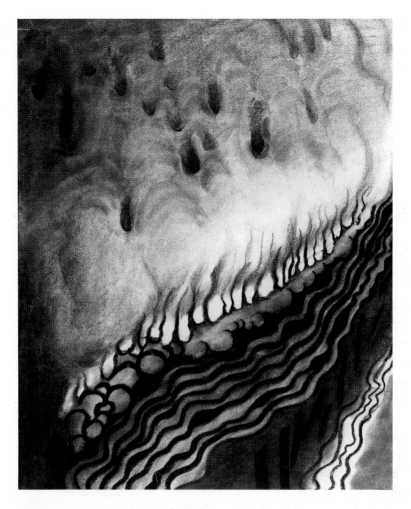

22. Georgia O'Keeffe. *Drawing No. 9*, 1915. Charcoal on paper, 25 x 19 in. (63.5 x 48.3 cm). The Menil Collection, Houston.

LEFT

23. Hans Schmithals (1874–1964). *Study (Dance of the Bacilli)*, c. 1900. Pastel and crayon on paper, 21⁵⁄₁₆ x 15⁷⁄₈ in. (54.2 x 40.3 cm). Illustrated in *Dekorative Kunst*, March 6, 1904.

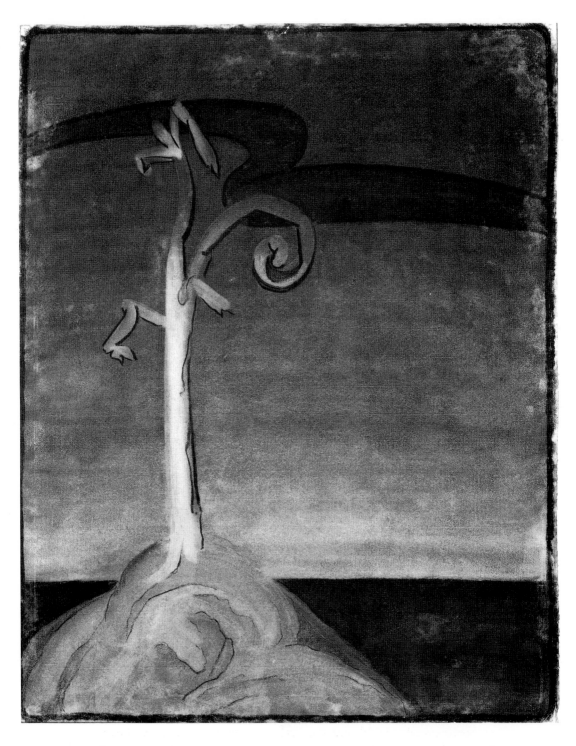

24. Georgia O'Keeffe. *Untitled*, 1915. Charcoal on paper, 24 x 18½ in. (61 x 47 cm). Estate of Georgia O'Keeffe.

calligraphic straight lines. A bird and an apple seem particularly insistent within the central, superimposed forms—an impression that may not be too farfetched, since both motifs would turn up, far more legibly, in O'Keeffe's later iconography. She would, for instance, paint some fifteen canvases of apples in 1920, and some of her apple paintings of the early 1920s may be abstract self-portraits. The wild bird is, of course, one of the most recognizable of all symbols of release and liberation. It cannot have been accidental that crows appeared in O'Keeffe's work during three of the most significant turning points of her life: at Canyon, Texas, where she had a breakthrough with abstract expression in color; at Lake George, New York, where she joined her work for a time, to Stieglitz's; and in New Mexico, where she regained, however sadly, her complete independence. *Drawing No. 12* is an important work primarily because it contains several embryos of O'Keeffe's future signature forms. It may also have been a major source for her supremely sophisticated Blue series of 1916 (plates 43–44).

 Untitled (plate 24) was first described in an unsigned critical article in *Camera Work* 48 as "a thin scarecrow . . . humorously victim for the elements."[79] It is probably best regarded as another of O'Keeffe's genesis images. Here, again, are the budding stalk and the spiral, this time uncurling from a seemingly pulsating mound. O'Keeffe's strange, composite form is at once anthropomorphic and androgynous, and it strongly suggests some familiarity with the sexually charged Symbolist work of Félicien Rops. The eerie landscape setting can be read three-dimensionally by taking the horizontal division of the picture plane for a low horizon line and the thick arabesque above for a cloud shape. But the overall effect remains that of a cleverly balanced linear design, one that combines many of the most familiar and ambiguous elements in Art Nouveau. These characteristics duly noted, what O'Keeffe was apparently trying to create in *Untitled* was an emotional, and possibly spiritual, space. This image is, in fact, the most explicit of her fantasy landscapes. But it also carries an intimation of secret religious power. The stalk/spiral/self, although completely merged with nature, has the aspect of a crucifix. And the dark arabesque cloud is very like a path to be followed. That the serpentine bend in the "path" connects with the spiral greatly reinforces this strong visual impression.

 Since we have it from O'Keeffe herself that she thought of these ten abstractions as "landscapes and things," it should be possible to tell, at least provisionally, which drawings fall into her two categories. For the reasons already cited, it seems fair to say that *Special No. 5, Drawing No. 9, Drawing No. 12,* and *Untitled* are "landscapes," and *Special No.*

1, No. 2, No. 3, No. 4, No. 7, and *No. 8* are "things." All ten are essentially iconic images. And their facture is unquestionably part of their meaning. They may be repetitious in some ways, but surely the technique of the unconscious is repetition. What these forms share most is their implicit struggle toward the light—a perfect metaphor for O'Keeffe's own psychic and artistic growth. If, as William Wordsworth said, "The master-light of all our seeing is childhood," then O'Keeffe's first twelve years on a Wisconsin farm could also have propelled their making: memories of the relentless upswing of nature itself. It is plain that she never lost her early belief in the regenerative power of these breakthrough images, because their forms would lurk beneath her compositions for the next fifty-six years.

The visual evidence leaves little reason to doubt that O'Keeffe's first abstractions were fueled by a still-vigorous Chicago offshoot of the fin-de-siècle Art Nouveau movement. What she saw in that city during the first decade of the twentieth century taught her firsthand that line, color, and form have independent powers. Moreover, her whole concept of iconography was to remain profoundly Art Nouveau in the enigmatic, poetic ambiguity of her form and content. Her future close-up views of plants and flowers not only hark back to Walter Crane, Eugène Grasset, William Morris, and Alphonse Mucha, among others, they may also be seen as latter-day examples of Art Nouveau's utopian efforts to cover the ravages of industrialization with renditions of the vegetable kingdom.[80] Even her fantasy cityscapes of the late 1920s are inclined to render skyscrapers as if they were warm plants instead of cold steel.

That O'Keeffe also had an interest in Art Nouveau typefaces and lettering is indicated by her virtuoso logo for Stieglitz's short-lived magazine *Manuscripts* of the early 1920s (plate 25). Very little has been said about how she came to do this almost forgotten work. In issue number 4, of March 1922, the following statement appeared: "For the cover design: apologies to 'Dada' (American), Marcel Duchamp, Man Ray, and acknowledgement to 'Anonymous' "—whom Dorothy Norman

25. Georgia O'Keeffe. Logo of *Manuscripts,* March 1922.
Yale Collection of American Literature, Beinecke Rare Book and
Manuscript Library, Yale University, New Haven, Connecticut.

later identified as Georgia O'Keeffe.[81] The visual pun of this design seems more Art Nouveau than New York Dada in its obvious desire to transform letters into new expressive forms. So cleverly are the negative and positive spaces combined that we are equally aware of the white forms between the three letters, which read as exquisitely simplified lily and leaf shapes floating in a black void. From her Chicago years O'Keeffe may have been familiar with Henri van de Velde's famous cover illustration for Max Elskamp's *Dominical* (1892) and his 1893 designs for *Van Nu en Straks*, which use distorted natural forms and letters to create rhythmic silhouettes. But none of these offers a specific precedent for her original and personal graphic design.

Finally, it is tempting to believe that O'Keeffe's subsequent use of photography in her painting was encouraged by Art Nouveau's embrace of modern technology and the machine in its mighty effort to create a new international style. And, further, that the expressivity inherent in the charcoal range between black and white prepared her eye well to appreciate, and utilize, photography.

Whether the meanings and motifs in O'Keeffe's earliest abstractions actually registered with Stieglitz as Art Nouveau remains undocumented. But he must have made the connection, since Jugendstil was a principal factor in his own evolution as a photographer.[82] Perhaps this is why he could write to O'Keeffe: "Those drawings, how I understand them. They are as if I saw a part of myself—Queer!"[83] Even the format of *Camera Work,* designed by Steichen, was made according to Art Nouveau principles of beauty, quality, and style, from its rectilinear cover design (which has marked parallels to that of the German periodical *Pan*), to its mise-en-page fusion of illustration and graceful typography.

For all its richness and diversity, Art Nouveau was just one of the sources separately mined by Stieglitz and O'Keeffe before they joined forces in 1918. O'Keeffe became "a being organized for art" after she accepted Stieglitz's offer of financial help, but when she came to him she was already in full command of her own vanguard artistic powers—later myth-making at 291 to the contrary. The 291 myth known to posterity as *Georgia O'Keeffe* was richly informed by late nineteenth-century Symbolism, which intended nothing less than the total spiritual and social reform of life through color, line, and form. And the imaginative force of this myth, created by Stieglitz, would come to serve O'Keeffe's life no less than her art.

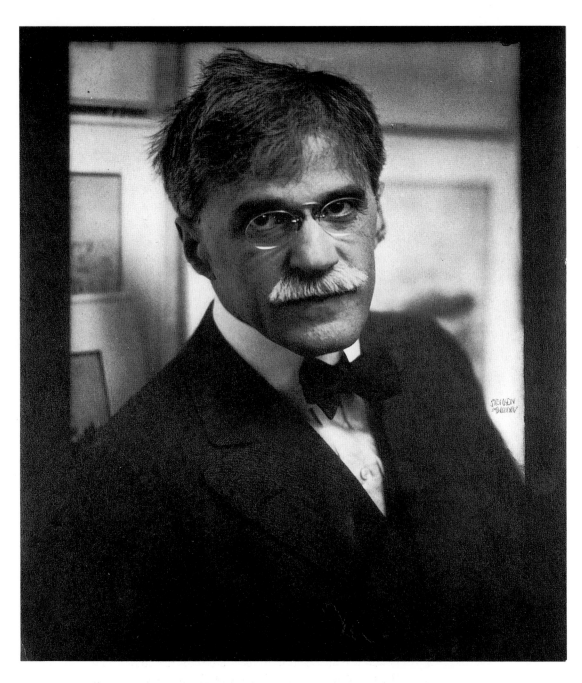

26. Eduard Steichen (1879–1973). *Alfred Stieglitz at "291,"* 1915.
Photograph. The Metropolitan Museum of Art, New York;
The Alfred Stieglitz Collection, 1933.

2 The Spirit of 291

I want her to live—I never wanted anything as much as that. She is the spirit of "291"—not I.

ALFRED STIEGLITZ, MAY 17, 1918

When they ask you what anarchism is, and you scuffle around for the most convincing definition, why don't you merely ask instead: "What is art?" Because anarchism and art are in the world for exactly the same kind of reason.

MARGARET ANDERSON, MARCH 1916

In late July 1918, shortly after O'Keeffe and Stieglitz began to live and work together, he wrote to Arthur Dove: "O'Keeffe is truly magnificent. And a child at that—we are at least 90% alike—she is a purer form of myself—the 10% difference is really perhaps a too liberal estimate—but the difference is really negligible."[1] Stieglitz's early recognition of O'Keeffe as the "spirit of 291" and a "purer form" of himself suggests far more than a lover's adulation. What the famous photographer apparently perceived in the unknown young painter was an aesthetic value system astonishingly connected to his own. The many threads of this shared worldview converge at abstraction: a concept that both had arrived at independently through the same European and homegrown sources. For Stieglitz, the route to abstraction through photography had been slow, intellectually demanding, and circuitous. For O'Keeffe, it was quicker and more intuitively direct—like her sensibility.

What was the "spirit of 291"? And how did Stieglitz and O'Keeffe come to understand and use abstraction in their different mediums? The answers to these closely linked questions begin with Symbolism, the most nuclear of their shared sources. Although Stieglitz himself did not always hold with his own opinions (he found such inner competition exhilarating), the Symbolist art theory of equivalence seems to have instructed

 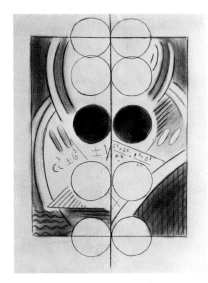

27. Marius de Zayas (1880–1961). *291 Throws Back Its Forelock,* 1915. Ink and wash on paper, 28½ x 22½ in. (72.4 x 57.2 cm). The Metropolitan Museum of Art, New York; The Alfred Stieglitz Collection, 1949.

28. Marius de Zayas (1880–1961). *Alfred Stieglitz,* c. 1913. Charcoal on paper, 24¼ x 18⁵⁄₁₆ in. (61.6 x 46.5 cm). The Metropolitan Museum of Art, New York; The Alfred Stieglitz Collection, 1949.

his work continuously from the late 1890s on. It also directed his subjective recognition and encouragement of the artists exhibited at 291 —beginning in 1905–6 with Annie W. Brigman, Alvin Langdon Coburn, Gertrude Käsebier, Eduard J. Steichen, and Clarence H. White, and ending with Georgia O'Keeffe in 1917. To see how Symbolist the 291 spirit was, it is necessary only to review Gustave Kahn's seminal "Réponse des Symbolistes" of 1886:

> As to subject matter, we are tired of the quotidian, the near-at-hand, and the compulsively contemporaneous; we wish to be able to place the development of the symbol in any period whatsoever, and even in out-right dreams (the dream being indistinguishable from life). . . . The essential aim of our art is to objectify the subjective (the externalization of the Idea) instead of subjectifying the objective (nature seen through the eyes of a temperament).[2]

Whether Stieglitz was directly familiar with Kahn remains undocumented, although his correspondence attests to the enormous variety of

his reading in English, French, and German.[3] In any case, the principles of French literary Symbolism were common currency on both sides of the Atlantic after the turn of the century—due, in good part, to the American Francophile journal *Mlle New York* (founded in 1895) and Arthur Symons's widely read *Symbolist Movement in Literature* (1889).[4]

If we juxtapose the gist of Kahn's principles with even a few selections from the sixty-eight answers that Stieglitz received to his question "What does '291' mean?" (the question was mailed to readers of *Camera Work;* the answers were published in issue 47, July 1914), the Symbolist roots of 291 emerge almost like pentimenti:

> I know a place
> where reason halts . . .
> where something takes the place
> in place of reason . . .
> a something felt by those who feel it
>
> JOHN MARIN

> "291" . . . is what the observer sees in it
> —an idea to the 7th power.
>
> ARTHUR DOVE

> To me "291" represents an Idea. . . .
> The soul of the Idea has been the liberty
> of spiritual growth.
>
> CHARLES H. CAFFIN

> It has been and still is a kind of many
> headed creature standing firm for every
> variety of truth and every variety of
> expression of the same.
>
> MARSDEN HARTLEY

> A cosmos-reflecting dew-drop, return-
> ing to each one of us his illumined
> spectre—is "291" to me.
>
> JOHN WEICHSEL[5]

On the flyleaf of a friend's copy of this same issue of *Camera Work,* Stieglitz wrote a dedication that suggests rather than describes his own

idea of 291: " '291'—what is it?—To me it is the expression of all that has been—all that is—and all that will be. That at least is its Spirit. All that it has been given an opportunity to accomplish—and possibly just a little bit more—it is this more that is '291.' "[6]

The psychological-metaphysical effect of this "Spirit" on the many who came in contact with it at 291 is far from easy to measure.[7] The basic reason for the difficulty lies in the subjective Symbolist character of Stieglitz's mission—and of his art as well.[8] Marius de Zayas, the brilliant Mexican intellectual and artist, may have been the first to publicly pinpoint—perhaps *skewer* would be a better word—Stieglitz's Symbolist doctrine with three caricatures of him (plates 27, 28, and 61), published in *Camera Work* and *291*.[9] For late nineteenth-century Symbolists, the dream was a favorite means to penetrate the world of the invisible, and Stieglitz frequently spoke of the artist's creation as a dream within a dream. His frankly confessional "One Hour's Sleep: Three Dreams," published in 1915, reveals some classic Symbolist obsessions —death, Woman (in her double role of temptress-destroyer), the kiss, and the color white:

I. I was to be buried. The whole family stood about. Also hundreds of friends. My wish was carried out. Not a word was uttered. There was not a single tear. All was silence and all seemed blackness. A door opened and a woman came in. As the woman came in I stood up; my eyes opened. But I was dead. All screamed and rushed away. There was a general panic. Some jumped out of the windows. Only the Woman remained. Her gaze was fixed upon me. Eye to Eye. She said: "Friend, are you really dead?" The voice was firm and clear. No answer. The Woman asked three times. No answer. As she asked the third time I returned to my original position and was ready to be buried.—I heard one great sob. I awoke.

II. I was very ill and everyone asked me to take a rest. No one succeeded to induce me. Finally a Woman said: "I will go with you. Will you go?" We went. We tramped together day and night. In the mountains. Over snow. In the moonlight. In the glaring sun. We had no food. Not a word was said. The Woman grew paler and paler as the days and nights passed by. She could hardly walk. I helped her. And still not a word was uttered. Finally the Woman collapsed and she said, in a voice hardly audible: "Food—Food—I must have food." And I an-

swered: "Food—Food—, Child, we are in a world where there is not Food—just Spirit—Will."—And the Woman looked piteously at me and said, half dead: "Food—Food," and I kissed the Woman, and as I did that there stood before the Woman all sorts of wonderful food—on a simple wooden table, and it was Springtime. And as the Woman began to eat ravenously—conscious of nothing but Nature's Cry for Food, I slipped away. And I continued walking. Onward.—I heard a distant cry. I awoke.

III. The Woman and I were alone in a room. She told me a Love Story. I knew it was her own. I understood why she could not love me. And as the Woman told me the story—she suddenly became mad—she kissed me in her ravings—she tore her clothes and mine—she tore her hair. Her eyes were wild—and nearly blank. I saw them looking into mine. She kissed me passionately and cried: "Why are you not HE? Why not?" And I tried to calm her. But did not succeed. And finally she cried: "What makes me kiss you—it is He I want, not you. And yet I kissed you. Kissed you as if it were He."—I didn't dare to move. It was all much too terrible for Fear. I stood there spellbound. Suddenly the Woman moved away—it was ghastly. Her look.—Her eyes.—The Woman stood immovable, her eyes glued on mine; when suddenly she screeched. "Tell me you are He—tell me—you are He. And if you are not He I will kill you. For I kissed you." I stood there and calmly said what I really did not want to say, for I knew the Woman was irresponsible and mad. I said, "I am not He." And as I said that the woman took a knife from the folds of her dress and rushed at me. She struck the heart. The blood spurted straight ahead, as if it had been waiting for an outlet. And as the Woman saw the blood and saw me drop dead she became perfectly sane. She stood motionless. With no expression. She turned around. Upon the immaculate white wall she saw written in Blood Red letters: "He killed himself. He understood the kisses."—There was a scream. I awoke.[10]

We may never learn how or when the French Symbolist writer Stéphane Mallarmé first came to Stieglitz's attention. In fact, no specific proof exists that Stieglitz ever read the work of Mallarmé. Nevertheless, it is hard to believe that such well-known poems as *L'Azur, L'Après-midi*

d'un faune, and *Un Coup de dés* would have been unfamiliar to Stieglitz, given his voracious and multilingual reading habits. Certainly Mallarmé was almost as frequently cited in the pages of *Camera Work* (if not quite as frequently discussed) as the Belgian Symbolist writer Maurice Maeterlinck. Very probably Stieglitz's interest in Mallarmé began through reading French and German periodicals during his all-important, and almost unknown, formative period in Germany.[11] Certain 291 colleagues of Symbolist persuasion—such as Steichen, Sadakichi Hartmann, Benjamin De Casseres, James Huneker, Francis Picabia, and (probably most of all) O'Keeffe—may simply have reignited for Stieglitz what was already inside.

Mallarmé regarded white—the presence of light and the sum of all colors—as the "nothingness of Truth." (Over and over Mallarmé referred to the "virginity of the white page," "milky white lace curtains," "white stars," "the hollow whiteness of the waterlily," "an animal whiteness at rest," and so on.) Similarly, Stieglitz thought it the highest form of approbation to call someone, or something, white. ("At the post office there was an unusually big mail for me . . . [that] happened to be very white from very white people." And, "Georgia is a wonder . . . if ever there was a whiteness she is that."[12]) White has had a long history as a symbol of purity, a symbolism that was particularly popular in turn-of-the-century literature and painting in both America and Europe. In the writings of Maeterlinck, for instance, whiteness invariably represents eternity or the eternal, which may point to a more specific meaning of the word for Stieglitz.

Mallarmé's chief aesthetic views were set forth in "Music and Literature," an essay written in English and published in *La Revue blanche,* October 1894. In this piece there are many marked similarities to Stieglitz's idea of photography—namely, to put his feelings about himself, America, twentieth-century technology, and even the weather into visible form. According to the French writer:

> It is not description which can unveil the efficacy and beauty of monuments, seas or the human face in all their maturity and native state, but rather evocation, allusion, suggestion. . . . At any moment in history, a man may appear who will be fully forgetful—and always remember he will be consciously forgetful —of the intellectual impedimenta of his contemporaries. Using the most elemental and elementary of means, he will try (for example) the symphonic equation of the seasons of the year, the habits of a sunbeam or a cloud. He will make one or two

observations analogous to the undulant heat or other inclemen-
cies of the changing climate, which are the multiple sources of
our passions. . . . And he will have a native land. . . . Nature
exists; she will not be changed, although we may add cities,
railroads, or other inventions to our material world.[13]

This paragraph reads like a catalog of Stieglitz's best-known photo-
graphs from 1890 to 1910 and beyond. His later photographic use of
the natural and the ordinary (such as trees and clouds) to represent his
experience and philosophy of life—which, in the mid-1920s, he came to
call Equivalents—is in the spirit of another of Mallarmé's most fre-
quently quoted statements: "Describe not the object itself, but the effect
it produces."[14]

Pure poetry, to Mallarmé, was "silent music," containing the pure
expressiveness of music without the necessity of sound.[15] Since one of
Stieglitz's most frequently expressed goals was to make "visual music,"
the parallels between the "silent music" of words on a white page and
the equally silent music of a photographic image on platinum or palla-
dium paper would hardly have escaped him. Certainly Stieglitz's aware-
ness of the powerful correspondence between art forms and human
sensations was what finally permitted him to eliminate the documentary
or narrative element from his photography even while holding on to a
full range of emotion.

By June 1917 the war, rising costs, and diminishing interest and
support (even from colleagues) combined to close 291. When, after the
armistice, Stieglitz again took up the fight in the Anderson and Intimate
galleries and, finally (until his death) at An American Place, his new
battle plan called for an American vanguard art formed from American
culture.[16] Although the spirit of 291 now stood for American rather than
European modernism, it was still largely fueled (as were Stieglitz's new
photographs) by the Symbolist aesthetic. One on-the-spot witness, him-
self steeped in European Symbolist literature, was Paul Rosenfeld, a
music and art critic who became the foremost interpreter of the Stieglitz-
circle artists during the late 1910s and early '20s. He described 291 as:

a place where people got very hot and explanatory and argumen-
tative about rectangles of color and lumps of bronze and re-
vealed themselves. . . . The little attic was a house of God
besides . . . [a] profane space, where every spirit stuff and rag
were shaken free, and anarchism and the essence of sex remained
ever present, was indeed . . . a church . . . perpetual affirmation

of a faith that there existed, somewhere, here in very New York, a spiritual America. . . . If ever American man brought American people into relation with people and trees, rocks and skies, brought the finite into tune with the infinite, it was this man of the black box and chemical bath. . . . Into a single living circle of relativity all people, rocks, and trees have been drawn and made to confess the single informing *one*.[17]

This description bears such a close resemblance to Arthur Symons's famous account of Mallarmé's legendary Tuesday evenings at the rue de Rome during the last twenty years of the nineteenth century that the parallel can hardly be coincidental: "Here was a house in which art, literature, was the very atmosphere, a religious atmosphere; and the master of the house, in his just a little solemn simplicity, a priest. . . . The questions that were discussed were never . . . other than essential questions, considerations of art in the abstract . . . of life as the amusing and various web spins the stuff of art."[18]

Even if Rosenfeld had not intended to compare Stieglitz with Mallarmé (which seems unlikely), there are some remarkably close similarities between the two men. Both were lightning rods for the artistic currents of their day, and both opposed commercialism. Both were spellbinding monologuists who were also able to release others to express themselves. Both gave lavish amounts of time to correspondence as well as to personal contact, which undoubtedly limited their artistic output. Both believed reality to be based on sensation and were highly practiced at what Mallarmé called "the demon analogy."

Two other aspects of Symbolism must be mentioned here because of their rich artistic uses by Stieglitz and, very probably, by O'Keeffe: anarchism and esotericism. During the 1890s and early 1900s many Symbolist writers on both sides of the Atlantic committed themselves to political anarchism as part of their own great cultural goal: a revolutionary art capable of regenerating humanity.[19] When, during the Third Republic, Paris was afflicted by a rash of anarchist bombers (one of whom tried to blow up the Chamber of Deputies), Mallarmé described such terrorist acts as done by "saints."[20] Stieglitz, too, was an anarchist —in word and work, if not in deed.[21] (His "bombs" went off on the walls of 291.) The Romantic-Symbolist character of Stieglitz's anarchistic beliefs is apparent in his constant railing against American philistinism during the 1910s and '20s.[22] The high-flown values peculiar to anarchistic Symbolism can also be seen in his instantly successful public invention of Georgia O'Keeffe: the Woman who embodied sexual free-

dom, spontaneity, and intuition; the unspoiled, unintellectual artist whose visually expressed emotions represented nothing less than universal truths; "The Great Child"[23] who was uncorrupted and unfettered by the past; the American who was an artistic law unto herself.

To the Symbolist artist, art was revelation—a belief directly related to the centuries-old traditions of esotericism, mysticism, and occultism.[24] These off-the-beaten-track explorations of inner reality were, along with psychology, vital elements in the development of early twentieth-century modernism in general and abstraction in particular.[25] The extent of Stieglitz's own interest in mystic and occult phenomena remains uncharted.[26] In his immediate circle, however, there were many true believers in the popular, pseudoscientific concept of the fourth dimension, which Max Weber described as

> the consciousness of a great and overwhelming sense of space-magnitude in all directions at one time. . . . It is real, and can be perceived and felt. It exists outside and in the presence of objects, and is the space that envelops a tree, a tower, a mountain, or any solid; or the intervals between objects or volumes of matter if receptively beheld. It is somewhat similar to color and depth in musical sounds. It arouses imagination and stirs emotion. It is the immensity of all things. It is the ideal measurement, and is therefore as great as the ideal, perceptive, or imaginative faculties of the creator, architect, sculptor, or painter.

Chief among other believers connected to 291 were Gelett Burgess, Benjamin De Casseres, Picabia, Gertrude Stein, and Mabel Dodge.[27]

Was O'Keeffe's mind ever captured by any of the mystical-occult ideas that invaded 291 during the 1910s and '20s? If so, which ones and when? Did they have a discernible impact—formal or thematic—on her images? Can we say she intended them to be understood esoterically, as Hartley and Dove did theirs?[28] (O'Keeffe's nature was, if anything, more private and enigmatic than either Dove's or Hartley's.) In the absence of any available comments by O'Keeffe herself, we can only make conjectures here, but the probability is that more was in play than will ever be known. The nature of esotericism, of course, is secrecy. It is intended to be understood only by those who are spiritually gifted or by the initiated.

O'Keeffe's exposure to metaphysical ideas may have begun in 1914, when she went to study at Columbia University with Arthur Wesley Dow, who had a long interest in spiritualism. During the 1890s he was

a frequent visitor to Green Acre, the religious colony founded by his friend Sarah Farmer, where the English Theosophist Annie Besant was a lecturer.[29] In 1903–4 he made a pilgrimage to India in the company of some swamis and English Theosophists. Although he was doubtless familiar with Madame Helena Blavatsky's ideas, Dow seems never to have become a formal Theosophist. By the time O'Keeffe came into his orbit, he was being sustained by "spiritualism," Christian Science, and the psychology of William James. While there is no good evidence that Dow proselytized his students, the occult belief systems he espoused were well known to those with similar inclinations, including Stieglitz's colleagues Max Weber and Alvin Langdon Coburn, who later became good friends with each other.[30] Coburn made what appears to be a spiritually loaded photograph of Dow during the summer of 1903, while studying with him at the Ipswich School of Art (plate 29). The master is posed as if in deep meditation, his head and right hand portentously encircled by a round, upended studio basin just behind him. This basin may be the key to the meaning of the photograph. The circle, as Coburn assuredly knew, is commonly associated with the ultimate state of Oneness in both Eastern and Western art—the two traditions brought together by Dow in his great teaching text *Composition* (1899).

Despite O'Keeffe's classroom contacts with Dow between 1914 and 1916, there is really nothing to suggest that he triggered an interest by her in the occult. He was, by then, a more remote figure to his students than he had been earlier to Coburn and Weber. (O'Keeffe described him as "a sweet old man" in a letter to Anita Pollitzer dated February 9, 1916.) Nonetheless, she would certainly have been aware of the spiritualist propensities of his life and work. And it was during the period of her training in Dow's principles that she first read Kandinsky, who may have been the one to introduce her to "Frau Blavatsky" and Theosophy, which he described as "synonymous with eternal truth."[31] Kandinsky's pictorial concept of vibration was derived directly from Theosophy: he claimed that nature causes the soul to vibrate, that these vibrations of the soul are the basis of all human emotion, and that it is the artist's task to stimulate these vibrations in the beholder. Even though Kandinsky's influence on O'Keeffe was a commanding one (see chapter 3), a direct artistic interest of her own in Theosophy has yet to be disclosed.

There are stronger signs that O'Keeffe had a genuine, if flickering, interest in the fourth dimension. As an avid reader, from 1915 on, of old *Camera Work* issues, O'Keeffe was undoubtedly familiar with Weber's 1910 essay on the fourth dimension. It is quite possible that she

could have received an intellectual permission of sorts from this essay to go ahead and express her own felt "space-magnitude," although she herself never wrote anything to support this connection. Another possibility is that the empathy with objects stressed by Weber helped to motivate her later self-identification with fruits, vegetables, and flowers.[32]

O'Keeffe's early, if unspoken, interest in the fourth dimension seems to have been freshly sparked by her acquaintance in the mid-1920s with Claude Fayette Bragdon, a tireless advocate for "the world of the wondrous." Bragdon was a successful architect, fiercely dedicated to the Arts and Crafts movement, who practiced in Rochester, New York, from the 1890s up to World War II.[33] He had other professional interests as well, including stage-set design, book printing (he founded his own Manas Press in Rochester), yoga, and serious experiments with "colour music." He was a vigorous promulgator of Louis Sullivan's architecture and writings, and he also translated sections of P. D. Ouspensky's *Tertium Organum* (1920). The most consuming interest of his life, however, was spiritualism—as his autobiography, *More Lives Than One* (1938), makes clear.

A man with an extraordinary gift for empathy, Bragdon had a host of friends from all walks of life, including Jiddu Krishnamurti, G. I. Gurdjieff, and Louis Sullivan. After the death in 1920 of his second wife, the "oracle" Eugenie Julier Macauley Bragdon, he left Rochester for Manhattan. On February 25, 1924, he moved into the new Shelton Hotel, where he was almost the first tenant and had his pick of the best

ABOVE, LEFT

29. Alvin Langdon Coburn (1882–1966). *Portrait of Arthur W. Dow*, **1903. Platinum photograph, 8½ x 10⅝ in. (21.5 x 27 cm). International Museum of Photography at George Eastman House, Rochester, New York; Coburn Archive.**

ABOVE, RIGHT

30. Claude Bragdon, c. 1890.

rooms, choosing one "high up, with a north window for a working light, and an east window for sun and view."[34] Stieglitz and O'Keeffe moved into their quarters at the Shelton in November 1925. Two months later, Bragdon received the following note from O'Keeffe's Chicago friend Blanche Matthias, who was then visiting New York: "Dear Claude Bragdon, at your hotel is a rare woman, a friend of mine, and a fine artist. She has seen you, and would like to know you. Will you please either speak to her or arrange some way to meet. She wishes it too. Her name Georgia O'Keeffe is perhaps well known to you. She has recently become the wife of Alfred Stieglitz. They are both rare and wonderful."[35] Bragdon must have made contact in fairly short order, for within weeks O'Keeffe wrote to Matthias, "We have seen Bragdon—just a little—we are very busy—and—I guess, I am particularly busy with myself—It must be so just now—"[36]

Despite Matthias's frank importuning of Bragdon on O'Keeffe's behalf, it was, typically, Stieglitz who responded most warmly to him. Almost exact contemporaries, the two men soon formed a lasting friendship. In Bragdon's later view: "I never met a man with a more maternal heart than Stieglitz. It is the very rock bottom of his character."[37] It's hard to tell what Bragdon really thought about O'Keeffe, and vice versa. In his letters to Stieglitz (written mostly in the 1930s) there are only a few general comments about her, such as: "Give my regards to O'Keeffe and tell her I'm glad she likes the book [Bragdon's *Introduction to Yoga*]" and "I hope Georgia is coming out of her eclipse all right [her mental breakdown of 1932–34]. I love you both, Amen."[38] Perhaps the most telling sign of O'Keeffe's rather detached regard for Bragdon appears in a 1936 letter from Stieglitz: "[Georgia] often remarked: 'I must have Bragdon come over.' But it never seemed to happen. Rush. Rush."[39]

Like Stieglitz, Bragdon had long been fascinated by the correspondences between art and music. He even attended the legendary color organ performance of Aleksandr Scriabin's Theosophical piece *Prometheus: The Poem of Fire* on March 20, 1915, at Carnegie Hall.[40] Bragdon never stopped tinkering with the ideas on the fourth dimension that he tabulated in *A Primer of Higher Space* (1913), which owed much to Theosophy. And the books and essays he published on this topic between 1909 and 1938 show that he drew on many other sources, including Plato; Henri Bergson; the mystical writers Jakob Böhme, Charles Howard Hinton, and Edward Carpenter; and later, a scattering of scientific "proofs" adapted from Albert Einstein's General Theory of Relativity.[41]

Since Bragdon often took breakfast with O'Keeffe and Stieglitz in the Shelton's sixteenth-floor cafeteria, it is easy to assume that she was

exposed to some of his favorite rhetoric about how artists and architects could apply the mystical notion of the fourth dimension to their design problems. Stieglitz may have been interested to hear that Bragdon's original interest in the philosophy of higher dimensions had been sparked by Gelett Burgess, who had contributed an article on the subject to *Camera Work* back in 1912.[42] Perhaps the simplest summary that Bragdon ever made of the vast range of his thinking on this hard-to-understand subject was a short chapter, "The Fourth Dimension," in his *Architecture and Democracy* (1918). And it is from this that we may be able to get the gist of some of those breakfast-table conversations.

Bragdon's unchanging contention was that "the basis for all effective decoration is geometry and number." The artist, he said, should try to precipitate these "fantastic forms" into the world of sensuous images so that they "make music to the eye." To do this, the artist "must conceive of a space of four mutually independent directions; a space, that is, having a direction at right angles to every direction we know." (Bragdon's writings show conclusively that he believed this four-dimensional existence to be reality, and the world of three dimensions to be illusion.) The four directions are found with the eyes not of the body but of the mind. And we may therefore, "with equal propriety, conceive of the fourth dimension as a 'beyond which is within.' "[43]

By the time she met Bragdon, O'Keeffe had been using geometric forms to depict nature for nearly ten years. Having doubtless been schooled according to the more traditional geometries laid out in Charles Blanc's far-famed compendium of optical precepts and techniques, *The Grammar of Painting and Engraving* (1867), as well as those in Dow's *Composition*, O'Keeffe was certainly prepared to ask that fine old nineteenth-century question: are the emotional effects of certain forms and colors eternal and predictable? On good days she thought she could tell, but that seems to be as far as it went. Her self-set task in abstraction, right from the start, was to make forms that were eloquent of universal feelings. To do this she reached into her own psychology—not someone else's. It is therefore unlikely that she ever consciously used occult illustrations (such as Besant and C. W. Leadbeater's "thought-forms") or the sacred geometries proposed by Bragdon. Nevertheless, the eccentric, composite nature of her spatial composition in such works as *Blue No. I* (plate 43) and *Lake George with Crows* (plate 104) suggests that she grasped the metaphorical possibilities of the fourth dimension for herself quite early on—possibilities that her contacts with Bragdon seem to have reinforced and revitalized (her New York City paintings are a case in point; see chapter 8). O'Keeffe's space almost always insinuates

"a beyond which is within." A space, in Weber's older words, that "exists outside and in the presence of objects . . . [that] arouses imagination and stirs emotion . . . [and] is the immensity of all things." In one of O'Keeffe's 1917 letters to Strand there is a tantalizing glimpse of her special receptivity to a cosmic "reality," perhaps of the fourth dimension, for she speaks of wanting "to go with [her new friend Ted Reid] out into space—more than I wanted anything—its queer." [44]

Was O'Keeffe inspired in any other venturesome way by Bragdon? Perhaps so. For it is a striking fact that during 1926—the year O'Keeffe really got to know Bragdon—she painted more New York City canvases than in any other year. [45] Equally striking, her vision of city architecture is extraordinarily close to that of Louis Sullivan. For his vision is also plantlike, emotional, dramatic, exalting, and above all, expressive of metaphysical meaning. Hence Bragdon's passionate admiration for Sullivan and his work may well have invaded her imagination at this time. Bragdon's own energetic homage went back at least to 1903, when, as a young architect, he first began to correspond with the successful older master. As Sullivan himself wrote to Bragdon, "Creative architecture is in essence a dramatic art, and an art of eloquence; of subtle rhythmic beauty, power, and tenderness." [46]

During her Chicago years O'Keeffe was exposed to the Art Nouveau ornamentation on Sullivan's Carson Pirie Scott store (plate 31).

31. Façade of the Carson Pirie Scott and Co. department store, by Louis Sullivan (1856–1924). Chicago, 1899–1904.

Judging from the spiral form in her *Special No. 8* (plate 21), she was especially familiar with his "wreaths" over the entrances, those fantastical amalgams of primal plant life that are the mark of his genius as an ornamentalist.[47] It therefore seems natural for her to have responded creatively to Bragdon's praises of Sullivan at the very moment she was looking for her own way to paint the city—a way utterly different from that of the men in Stieglitz's circle, and above all, American. In Bragdon's brief foreword to Sullivan's story of his life, *The Autobiography of an Idea* (1924), he coupled Sullivan with Walt Whitman and Abraham Lincoln for having declared certain vital and "necessitous" principles: "He is like them . . . in the untainted quality of his Americanism, having Lincoln's listening ear for the spiritual overtones amid the din of our democracy, and Whitman's lusty faith in the ultimate emergence into brotherhood and the beauty of the people of 'these states.' "[48]

Not without reason did Bragdon write that Sullivan "makes his most powerful and lasting appeal as author and teacher."[49] In a speech Sullivan made to young architects in 1900 lies an exhortation that sounds as if it could have been made personally to O'Keeffe:

> The architectural elements, in their baldest form, the desire of the heart in its most primitive, animal form, are the foundation of architecture. . . . Try to study a plant as it grows from its tiny seed and expands to full fruition. Here is a process, a spectacle, a poem or whatever you may wish to call it, not only absolutely logical in essence, because exhibiting in its highest form the unity and the duality of analysis and synthesis, but . . . *vital* and *inevitable:* and it is specifically to this phenomenon that I wish to draw your earnest attention, if . . . you wish to become real architects. . . .
>
> Some day, watch the sun as he rises, courses through the sky, and sets . . . note a wild bird, flying: a wave, breaking on the shore. . . . Whenever you have done these things attentively . . . there will come to your intelligence a luminous idea of *simplicity,* an equally luminous idea of a resultant organic complexity, which, together, will constitute the first significant step in your architectural education, because they are the basis of rhythm.[50]

In fact, Sullivan's ideas were deeply indebted to Symbolist art theory.[51] And like many other artists of his time, he was a Wagnerite.[52] Coming from very much the same artistic value system, O'Keeffe certainly didn't need Sullivan to tell her to "have thought for the integrity

of your own thought," although she might easily have said, with him, that "my real education I sought and found alone."[53]

Was O'Keeffe a Symbolist before she met Stieglitz, or did she become one after she knew him? The answer, it seems, is a little of both. The elements of style in Art Nouveau and Symbolism are, of course, profoundly interrelated since they draw upon many common sources. Nevertheless, as Robert Goldwater has pointed out, the ideal of Art Nouveau and the ideal of Symbolism are at different ends of an emotional scale: the swirling, self-generating Art Nouveau line is "expressive of nothing but itself, and so finally the very opposite of the personally expressive line of Symbolism."[54]

O'Keeffe's self-expressive abstractions of 1915 clearly reflect the Symbolist ambience—transmitted by her Europe-educated teachers at the Art Institute school and later by Kandinsky and Dow—but no real care for Symbolist aesthetics and philosophy. Apparently it was Stieglitz who interested O'Keeffe in aesthetics. As her correspondence with Pollitzer reveals, she dutifully read many books recommended by him— among them, the writings of Rémy de Gourmont, acknowledged in America as the spokesman for the new Symbolist literature. In her thoughtful answer to the question "Can a Photograph Have the Significance of Art?" written for *Manuscripts* 4 (December 1922), O'Keeffe concluded: "I can only agree with Rémy de Gourmont's Antiphilos that there are as many philosophies (I add ideas on 'Art') as there are temperaments and personalities."[55] Stieglitz had lost no time in urging the writers of his circle to stress the illustrious lineage of her particular Symbolism. For instance, in 1921 Marsden Hartley observed that "Georgia O'Keeffe's pictures are essays in experience that neither Rops nor Moreau nor Baudelaire could have smiled away."[56]

Did O'Keeffe hold with the radiant Symbolist belief in the curative properties of form and color? Absolutely. For proof positive there is a letter she wrote to Blanche Matthias right after meeting Bragdon: "I am learning something myself—I don't know exactly what it is—but if I did—If I could put it clearly into form it would cure you—that is worthy of a laugh—but I am sure it is true."[57] It could also be pertinent to the constancy of this belief of O'Keeffe's that two of her later close friends, Louise March and the black writer Jean Toomer, were both followers of Gurdjieff, who claimed that modern man's alienation from nature breeds sickness and malnutrition of the mind, body, and heart.[58]

Everything known about O'Keeffe suggests that she was a maverick mystic, for she never made a breviary of occult forms and ideas, as did both Hartley and Dove. Whatever the stimulus to her imagination of

Theosophy and the fourth dimension, their effect on her work remains incalculable. In the end, it may not be important what she thought of occult teachings. Her most permanent authority was the coherence of nature, and the deepest well of her creative inspiration was the unconscious. Above all, she seems to have believed with William Butler Yeats that the soul is self-delighting and that art has little to do with polemics.

To return to Stieglitz's mysterious Idea (or Ideal) of the "spirit of 291," which he saw incarnate in Georgia O'Keeffe: it was actually a cluster of many. The outer membrane, so to speak, was the search for spiritual and factual truth in both art and life. The rest of the idea-cluster seems to have included the notion of art as a curative for the individual and society; a strong, often zany, sense of humor (as Gelett Burgess put it in 1912, "truth does not always have to be couched in the solemn form"[59]); simplicity of means; continual experiment; a strictly noncommercial sales policy (art was sold to deserving or discerning buyers for the single purpose of enabling 291'ers to go on working to create the new); a trust in the intuition of the artist over reason and logic (an idea derived in large measure from Henri Bergson); "anarchism and the essence of sex"; honesty of self-expression; revolt against convention; and "the development of Today," by which Stieglitz meant abstraction.[60]

What exactly was abstraction in Stieglitz's view and practice? How did O'Keeffe envision abstraction for herself that autumn of 1915—and later, when she worked alongside Stieglitz at Lake George? The part these two artists played in "the development of Today" in American art is a fascinating, and mostly untold, story. Despite the frustrating gaps in it caused by O'Keeffe's long (and continuing) restriction of crucial documents, we can be sure that O'Keeffe and Stieglitz made their abstractions from a passionate belief and excitement—especially between 1915 and 1923. To them, as to D. H. Lawrence, the essential function of art was moral: "Not aesthetic, not decorative, not pastime and recreation. But moral . . . a passionate implicit morality, not didactic. A morality which changes the blood rather than the mind. Changes the blood first, the mind follows later."[61] To put some of the Lake George photographs and paintings side by side is to see that they fairly crackle with pictorial dialogue. With research gathered from diverse contemporary sources it is now possible to piece together a new understanding of these images. The visionary ideas behind them have some specific connections to the optimistic-pessimistic ferment that characterized the period surrounding World War I. But the emotions expressed in them were deeply personal and (in the view of both artists) universal.

32. Alfred Stieglitz. *Georgia O'Keeffe: A Portrait—with Watercolor Box,* 1918.
Gelatin silver print, 4⅜ x 3½ in. (11.3 x 9 cm). National Gallery of Art,
Washington, D.C.; The Alfred Stieglitz Collection, 1980.70.72.

*Sitting beside a Lake George flower bed, O'Keeffe makes a
watercolor sketch with her Japanese brush held in the exact manner
recommended on page 16 of Dow's* Composition.

3 Shared Sources

The work of art is born of the artist in a mysterious and secret way. . . . Absolute freedom, whether from anatomy or anything of the kind, must be given the artist in his choice of material. Such spiritual freedom is as necessary in art as it is in life.

WASSILY KANDINSKY, 1912

Anita, I cant begin to tell you how much I have enjoyed that Camera Work—It surprised me so much—and you know how much I love what is inside of it—That Picasso Drawing [*Nude,* 1910] is wonderful music isn't it —Anita—I like it so much that I am almost jealous of other people even looking at it—. . . the stuff simply fascinates me—I like it all—you know how much without my trying to tell you—The word—food—seems to express what it gives me more than anything else.

GEORGIA O'KEEFFE, JANUARY 4, 1916

As the history of art continually records, strong artists choose strong precursors, transforming the strengths of others for their own purposes. Obviously Stieglitz knew this, for he had chosen freely among old and modern masters for his pictures.[1] Nevertheless, as long as he lived, he presented Georgia O'Keeffe as a sourceless, "fabulously pure" artist. And as long as she lived, she adroitly continued this fiction. Why? The intimate reasons for it, which could simply have been her desire to develop along her own lines rather than those of the all-male European and American modernists, may someday emerge from their still-restricted letters to each other. The theoretical reasons seem to boil down to two. First, as converted modernists, both artists devoutly believed in

the mid-nineteenth-century notion that originality (what Stieglitz called "the new") is the essential condition of a work of art. And second, in his desire to create and foster an indigenous American art, with O'Keeffe in the forefront, Stieglitz was directly inspired by Walt Whitman's avowed sourcelessness for his visionary poem *Leaves of Grass*.[2]

By 1915 abstraction had come to equal originality for both Stieglitz and O'Keeffe. To arrive at abstraction, they had, in effect, to recapitulate the roots of modernism while remaining—and inventing—themselves. The sources they chose for this task (largely unbeknownst to each other) were Arthur Wesley Dow, Wassily Kandinsky, James McNeill Whistler, Auguste Rodin, Francis Picabia, Henri Matisse, and Pablo Picasso.

The widely taught Fenollosa-Dow system of art education in America prepared many artists for early abstraction in ways that were surprisingly parallel to vanguard European developments during the late nineteenth and early twentieth centuries.[3] This despite the fact that Ernest Francisco Fenollosa and Arthur Wesley Dow never threw out the recognizable motif but, rather, "synthesized" it through line, mass, and color. Their method was based on construction rather than imitation. It became the dream of both men to create the new American style out of a synthesis of Eastern and Western art. According to Fenollosa: "We are approaching the time when the art work of all the world of man may be looked on as one, as infinite variations in a single kind of mental and social effort ... which as easily subsumes all forms of Asiatic and of savage art and the efforts of children as it does accepted European schools."[4]

Between 1884 and 1889 Dow studied painting in Paris at the Académie Julian and spent his summers in Brittany working among the Synthetists at Pont Aven, who were themselves acutely aware of Japonisme. Two years after Dow's return to Boston he met Fenollosa, the brilliant Orientalist and philosopher, then curator of the Japanese department of the Museum of Fine Arts. Fenollosa not only introduced Dow to the radically individual Japanese masters of brush-and-ink landscapes but also enlisted his help in spreading the Japanese ideal of social betterment through artistic insight. Dow's zeal for developing an American system of art education based on "Beauty not Representation" came to exceed even Fenollosa's own.[5] In 1892 Dow began to teach the basic Japanese principles of picture making: harmoniously spaced linear design instead of realism and abstract arrangements of light and dark patterns (*notan*) instead of illusionistic effects of light and shadow (chiaroscuro). This "Synthetic Method" was, in Fenollosa's words, a "perfect marriage

on equal terms between the beauty in the subject and the beauty in the pictorial form . . . [with] every part and relation . . . absorbed in the new organic part without a remainder."[6] It was at his summer school in Ipswich, Massachusetts, and after 1895 at the Pratt Institute in Brooklyn that Dow gradually worked out a system of exercises in line, *notan,* and color, which his students came to know as "the trinity of power." He started work on his book *Composition* in 1896, and the first edition was published to immediate acclaim in 1899, going through three printings by the next year. Of considerable relevance to O'Keeffe is a comment in Dow's introduction: "[Fenollosa] believed music to be, in a sense, the key to the other fine arts, since its essence is pure beauty. . . . Space art may be called 'visual music,' and may be studied and criticized from this point of view."[7]

O'Keeffe always said that she first kindled to Dow's teachings in Alon Bement's art classes at the University of Virginia during the summer of 1912. Nevertheless, her earliest exposure to the liberating ideas and methods in *Composition* seems to have taken place in Chicago seven years before, somewhat by osmosis. As early as August 1899 the Chicago periodical *Brush and Pencil* published an enthusiastic thirteen-page article about *Composition,* with liberal quotes and illustrations from Dow's text.[8] In March 1900 Dow gave his first lecture in Chicago—at Hull House, the center for the Chicago Arts and Crafts movement—and that same summer the Prang Educational Company of Chicago exhibited the work of his students. A new curriculum based on Dow's principles of design composition was established at the Chicago Art Institute within the year by Mary Scovel, a former student of his. Dow gave another lecture there in December 1900, titled "Principles of Composition in Some of the World's Great Pictures." So strong was the sudden ground swell of public interest in his methods that he was nearly persuaded to leave the Pratt Institute to teach in Chicago.

How did the Fenollosa-Dow system motivate O'Keeffe? If the cognitive scientists are right in saying that creative work, at least on the conscious level, involves a far more orderly set of procedures than many artistic people like to think,[9] then the problem solving taught by Dow to release the artist's imagination and express his ideas seems to have been tailor-made for O'Keeffe. In six decades of work she never lost her fierce trust in the exercises, which provided the grammar of her forms.

In *Composition,* Dow redefined painting as essentially two-dimensional rather than the imitation of three-dimensional modeling it had been since Leonardo's time. He considered this new-old art of filling

space to consist of the three formal elements—line, *notan*, and color—plus five compositional principles:

1. OPPOSITION: The simple meeting of two straight lines in variations on the vertical and the horizontal.

2. TRANSITION: Two straight lines with an added third—which may be modified into curves.

3. SUBORDINATION: In which the character of the whole is determined by a single dominating element (or group) to which all smaller parts are attached, or related. In any line composition the arrangement of principal and subordinates may be made in three ways: (a) by grouping around an axis (as a leaf related to stem); (b) by radiation (as flower petals to the corolla); (c) by size (as in clusters of apples on branches).

4. REPETITION (the opposite of Subordination): Producing beauty by repeating lines in a rhythmic order in equal or unequal patterns. Repetition is also the basis of all music and poetry.

5. SYMMETRY: The placing of two equal lines or shapes in exact balance—three- and four-part groups may also be used. The effect produced is of repose and completeness.[10]

Dow never regarded these principles as recipes for art, and in his concise work of 1908, *Theory and Practice of Teaching Art* (which O'Keeffe purchased instead of the more extensive, and expensive, *Composition*[11]), the five principles of design were distilled into the two most important: Subordination and Rhythmic Repetition. The illustrations in both texts are similar.

Although Dow made every effort to stress the equal importance of his three form-building elements (line, *notan*, color), line was always to dominate his thinking and his teaching. It was with the concept of *notan* that he came closest to abstraction as later construed by modernism: "At the onset a fundamental fact must be understood, that synthetically related masses of dark and light convey an impression of beauty entirely independent of meaning."[12] As to color, Dow believed that it could be "taught like music," but he relied on an imperfect system, not of his own devising, for doing so.[13] Even while insisting that color obeyed principles that could be learned, he conceded that this aspect of painting was guided by instinct rather than intellect: "Color with its infinity of

relations is baffling; its finer harmonies, like those of music [cannot] be grasped . . . by reasoning or analysis. Color, in art, is a subject not well understood as yet. . . . [However,] a systematic study of line and tone is very profitable, as we have seen; [and] I believe that color may be approached in like manner."[14] He struggled for years to use Albert H. Munsell's invention of the photometer to scale each of the five basic hues (red, purple, blue, green, yellow) to its middle (gray) value. This standardization, which reduced all colors to an identical value and intensity, would enable the artist (or so Dow then believed) to make proper color harmony.[15] He discovered the vexing flaws in Munsell's system during 1911 and 1912, when he tried to paint the colored air of the Grand Canyon and found himself unable to render its wildly inconstant values and brilliance.[16]

The Armory Show of 1913 convinced Dow to re-examine his attitude toward color, and toward modernism in general. In handwritten notes from 1916 for his article "Modernism in Art" (subsequently published in the American *Magazine of Art* of January 1917) can be glimpsed his—only slightly—revised ideas and attitudes, which were then reformulated into the new Teachers College art courses given during the exact periods when O'Keeffe studied there.[17] In this revision Dow defined modernism as "an inclusive name applied to the many forms of rebellion against the accepted and the traditional. . . . A modernist likes to be thought a rebel."[18] And he went on to list the "things generally desired by modernists":

> The denial that beauty is worth seeking, as this seems opposed to the principle of evolution and is only negative, I do not see how it can be maintained. . . . Less attention to subject, more to form. Mass and color have pure aesthetic value, whether they represent anything or not. . . . Ceasing to make representation a standard, but comparing the visual arts with music. Finding a common basis for *all* the visual arts. . . . Convincing us that there are limitless fields as yet unrevealed by art. . . . New expression by color, not by colors of things or color in historic art. Seeking hitherto unexpressed relations of color.[19]

Dow took rather obvious pleasure in saying that some of the things on this list had been attained long ago and therefore were no longer new: "Matisse says 'I condense the significance of the body by looking for its essential lines' [but] . . . the Japanese found[ed] all their drawing on

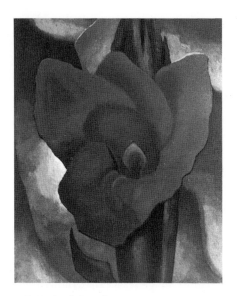 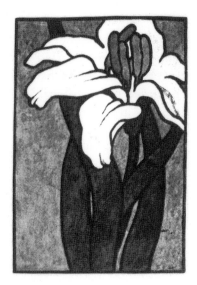

that. . . . Kandinsky does not equal Keisai Yeisin" because Chinese and Japanese artists had already realized more completely than any modern painter "a purely abstract language—a visual music."[20]

O'Keeffe's close attention to the European artists exhibited and extolled by Stieglitz suggests that she did not agree with Dow that the Chinese and Japanese had done modernism first and best, even though she was never to lose her admiration for Oriental art.[21] Her own natural gift for using color was reinforced by the optical brilliance achieved by Kandinsky and later Matisse, neither of whom believed that color could be taught like music. For them, color was always a matter of "inner need" or "feeling."[22] Nevertheless, Dow's basic principles, which O'Keeffe herself taught for nearly six years, are affirmed over and over again in her compositions.

Dow's exercises, each reduced for easiest readability, were composed of the following motifs: a simple rectangular house (singly or in clusters) and isolated architectural details such as spires, roofs, doors, and windows; a tree trunk with branches (singly or in clusters); flowers and fruit with stems and leaves rendered in vertical and horizontal formats; landscape designs such as mountain peaks against the sky, tree shapes against diagonal roofs, and road or river bends; objects in nature such as shells, stones, stumps, and loam; the symmetrical "wild rose" motif (exemplifying radiation from a center); textile patterns and variations on these motifs in different series; copies of Japanese landscapes by Hiroshige; and botanical brush-and-ink drawings of leaf and blossom enlargements from Japanese books. Dow's own color woodcuts (he considered woodcuts to be the acme of painting), oils, and photographs concentrate on

full-moon scapes, Ipswich shanties, road and river bends, flower close-ups, empty Atlantic beaches, the Grand Canyon, and the New Mexico mesa. All were well known to his students.

Dow regarded flower forms as prime subject matter for his so-called line schemes within a space. O'Keeffe's *Red Canna Lily* (plate 33) obeys Dow's directions almost to the letter: "Not a picture of a flower is sought—that can be left to the botanist—but rather an irregular pattern of lines and spaces, something far beyond the mere drawing of a flower from nature, and laying an oblong over it or vice versa."[23] O'Keeffe cut the space with the main lines of her canna stem just as Dow did in his flower compositions and in a fashion very similar to his no. 66, upper right (plate 34).

Filling a skinny vertical rectangle with a single plant is a typical Art Nouveau format and another of O'Keeffe's favorite space-cutting devices. Dow himself found it a special challenge in his frequently exhibited color woodcut *Lily* (plate 35), and O'Keeffe may have paid tribute to the problems he set up and solved with her own *Corn, Dark II* (plate 36). In these two images the central forms lean to the left in a curve that bisects the vertical field. This unusual curve is interrupted in both cases by a similarly formed central leaf (and in Dow's work by the flower as well). Even though Dow represented a naturalistic lily pad growing out of the

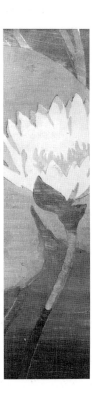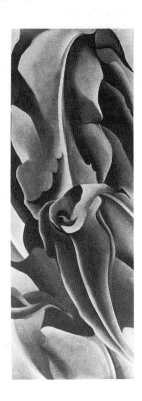

OPPOSITE, LEFT
33. Georgia O'Keeffe.
Red Canna Lily, 1919. Oil on canvas, 9½ x 6½ in. (24.1 x 16.5 cm). Private collection.

OPPOSITE, RIGHT
34. Arthur Wesley Dow (1857–1922).
"Exercise No. 66," from *Composition,* 1899.

RIGHT
35. Arthur Wesley Dow (1857–1922). *Lily,* c. 1914. Color woodcut, 9 x 2½ in. (22.9 x 6.4 cm). Ipswich Historical Society, Ipswich, Massachusetts.

FAR RIGHT
36. Georgia O'Keeffe.
Corn, Dark II, 1924. Oil on canvas, 27 x 10 in. (68.6 x 25.4 cm). Estate of Georgia O'Keeffe.

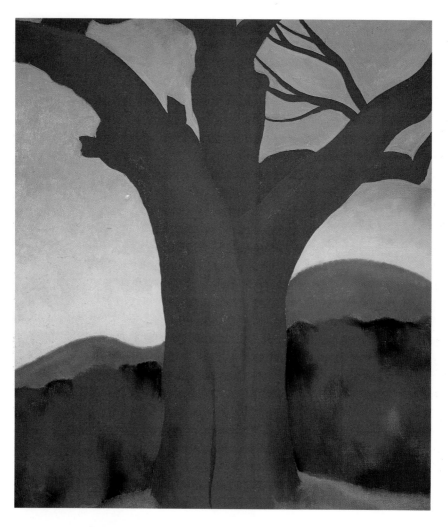

37. Georgia O'Keeffe. *The Chestnut Red,* 1924. Oil on canvas,
36 x 30 in. (91.4 x 76.2 cm). The Gerald Peters Gallery,
Santa Fe, New Mexico.

water and O'Keeffe abstracted her cornstalk into a veritable explosion
of floating conical shapes, their pictures share an essential overall design
and many common forms and patterns.

O'Keeffe once told Marsden Hartley, "I wish people were all trees
and I think I could enjoy them then."[24] This statement may be con-
sidered as a broad hint that she had come to see (and render) some trees
as people. Two works especially suggest abstract portraits of Stieglitz,
even while they hold most rigorously to Dow's principles—namely, *The
Chestnut Red* (plate 37) and *The Old Maple, Lake George* (plate 38). They
can even be regarded as a visual barometer of her changing ideas and
emotions toward her mentor and husband, who also liked to identify with

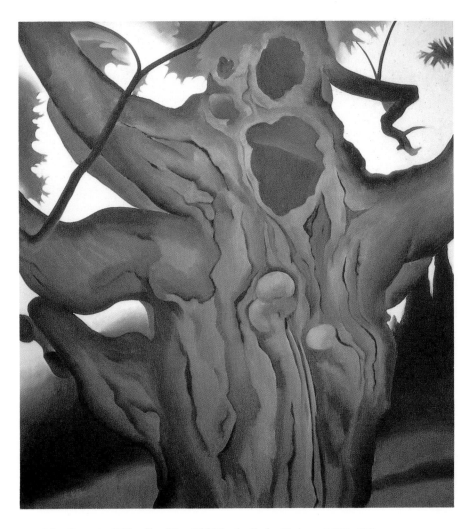

38. Georgia O'Keeffe. *The Old Maple, Lake George,* 1926. Oil on canvas, 32 x 36 in. (81.3 x 91.4 cm). Mississippi Museum of Art, Jackson; Funds provided by Mississippi Arts Commission and Operation Snowball.

certain trees on the family property at Lake George. (For instance, a 1926 photograph of his is titled *The Dying Chestnut Tree—My Teacher.*) *The Chestnut Red* was painted in 1924, the year of their marriage, when O'Keeffe still felt dependent on Stieglitz artistically, emotionally, financially, and perhaps even spiritually.[25] This tree, which so clearly demonstrates Subordination (to an axis as well as to a center) and Repetition, has become far more than an element of nature. Towering high above the earth in nearly the shape of a cross, the chestnut has been transformed into an icon of primeval strength and endurance. (This work may, in fact, be an early prototype for O'Keeffe's New Mexico crosses of 1929.) *The Old Maple, Lake George,* from just two years later, is

known to have been painted during a period of great strain between O'Keeffe and Stieglitz.[26] The obviously anthropomorphic characteristics of this tree (including the spermlike designs of the bark and the huge phallic form that acts as the composition's major dividing line) combine graphically to suggest sexual passion frighteningly out of control. It is known that Stieglitz's infidelities—whether emotional or physical—were of particular anguish to O'Keeffe during this period.[27] "One uses the facts of nature," wrote Dow, "to express an idea or emotion."[28]

Stieglitz never stopped thinking of the photographic print as a "picture"—that is, as a reflection of the individual photographer's preconceived ideas of beauty and truth instead of a mechanical recording of nature. In 1892, seven years before *Composition* was published, Stieglitz had written that "simplicity, originality, and atmosphere" were the main qualities necessary for the photographer to produce artistic pictures and that they were obtainable only by "the study of art in all its forms."[29] In his essay "Pictorial Photography" (1899), he stated that photographers "must be quite familiar with the laws of composition as is the landscape or portrait painter; a fact not generally understood."[30] In 1905 he enlarged on these beliefs in an article commissioned by Eastman Kodak, "Simplicity in Composition." After pointing out the difficulties of making a truly simple composition—one that forcibly communicates the dominant idea of the picture—Stieglitz compared the photographer-artist's problem with that of the musician: "Just as in music we find that the simpler the theme, the more thorough must be the knowledge of the musician in order to compose acceptable variations thereon." Stieglitz cited "elimination" as the greatest challenge in both photography and painting: "To exclude *everything* that is unessential to a clear statement of the dominant underlying idea." Finally, he offered three suggestions: observe the work of recognized artists, study the appearance of nature everywhere, and "avoid books on composition as you would the plague, lest they destroy in your mind all other considerations than the formula they lay down."[31]

Despite his last words, it is extremely likely that Stieglitz was familiar with Dow's principles and that he became increasingly respectful of them, although he never said so. Indirect evidence for Dow's considerable influence on Stieglitz's eye rests on his approval and support of a succession of Dow's pupils, ending, of course, with O'Keeffe. First in chronological order among the painters was Pamela Colman Smith (the subject of the first exhibition of painting ever held at 291), who took Dow's Life, Composition, and Design course at Pratt in 1896–97.[32] Second was Max Weber, who considered Dow the greatest teacher he

ever had. Weber met Dow at Pratt in 1898 and studied with him for three years. Weber's later photographic criticism, particularly his 1913 article "The Filling of Space," clearly shows that he believed Dow's principles to be just as valid for photography as for painting.[33] Not only had Dow long been a dedicated amateur photographer himself, but he was also responsible for adding art photography to the curriculum of Teachers College in 1907. As head lecturer for the new department Dow chose Clarence H. White, then one of Stieglitz's closest associates at 291. It was during that same year, 1907, that Stieglitz collaborated with White on an experimental photographic series of nudes.

Another early Photo-Secession photographer in close contact with Dow was Alvin Langdon Coburn. His own words tell the tale:

> My first one-man show was held at the Camera Club of New York in January 1903. How proud I felt when Stieglitz called my pictures "original and unconventional." . . . In 1903, I participated in the Summer School at Ipswich, Massachusetts, directed by Arthur W. Dow. . . . At the summer School we were taught painting, pottery and woodblock printing, and I also used my camera, for Dow had the vision, even at that time, to recognize the possibilities of photography as a medium of personal artistic expression. I learned many things at his school, not least an appreciation of what the Orient has to offer us in terms of simplicity and directness of composition.[34]

The last important photographer in the inner Stieglitz circle to have been exposed to Dow's teaching was Paul Strand, although just how much his first notions of abstract photography were influenced by Dow may never come to light.[35] Dow lectured at the Ethical Culture School in New York while Strand was a student there between 1904 and 1909.[36] He may also have absorbed Dow's basic principles from the critic Charles H. Caffin, with whom he studied art appreciation at the Ethical Culture School in 1907–8. Coburn, too, may have increased Strand's attention to Dow.[37]

Two of the major Photo-Secession critics, Caffin and Sadakichi Hartmann, frequently referred to Dow with knowledge and approval in their articles. Caffin appears to have borrowed liberally from Dow's *Composition* in writing his influential 1906 essay "Of Verities and Illusions—Part II" for *Camera Work*. Discussing the importance of "abstract expression" as exemplified in Japanese art, Caffin warned that "if painting is to maintain a hold upon the intelligence and imagination, as music does . . . it must find some fundamental motive other than the

appearances of the world."[38] In Dow's words, "It is the 'visual music' that the Japanese so love in the rough ink paintings of their masters where there is but a hint of the facts."[39]

Hartmann was often described as comparable to Stieglitz in intellect, imaginativeness, and temperament, and they shared a similar vision for developing a native American art.[40] Hartmann's Japanese-German heritage doubtless contributed to his acute interest in the arts of Japan, literary Symbolism, and decorative design.[41] In view of this background it is not surprising to find Hartmann a firm partisan of Dow's principles: "The two most helpful works on composition at the disposal of the American landscape photographer are at present, 'Pictorial Composition' by Henry A. Poore, and 'Composition' by A. W. Dow."[42]

In the summer of 1918 Stieglitz was to photograph O'Keeffe quite specifically as the pupil of Dow (plate 32), and there is some visual evidence to suggest that his tremendous respect for O'Keeffe's Dow-nurtured originality reinforced his earlier affinity with the basic principles of *Composition. A Portrait—Hands and Thimble*, for example, looks harmoniously balanced when viewed from any one of its four sides (plate 39). This was clearly intentional, for on the back of one print is written in Stieglitz's hand, "The photograph can be hung 4 ways—each a different picture. Oct. 2, 1939."[43] The same characteristic can be observed in Stieglitz's cloud Equivalents after they became disconnected from the hills of Lake George in 1925. And two 1922 photographs, *Apple and Raindrop* and *Apples and Gable,* bear some quite astonishing similarities to Dow's apple-branch-leaf exercises for his Subordination principle.[44] These photographs were first exhibited in 1923 in a sequence of three with the suggestive title *Birds, Apples and Gable, Death*. Stieglitz said they were the happy result of waiting until his own felt "impulses" joined with and "register[ed] the objective world directly."[45] Since he never photographed without exercising total choice in the matter, he must have had special reasons for referring to Dow in these early (perhaps first) precedents for his cloud Equivalents.

For Stieglitz at this time, as Sarah Greenough has brilliantly reconstructed, the apple tree was a symbol of the American artist, and the apple itself an expression of the artist's soul.[46] This visionary view of Stieglitz's held that the only way an indigenous American art could happen was if the American artist spoke from his own soul. Dow's design principles, as Stieglitz well knew, had one overriding purpose—to best express an idea or emotion. And by relying on two of Dow's exercise examples for these abstract and symbolic photographs, Stieglitz may have felt an extra assurance that their meaning was being communicated as

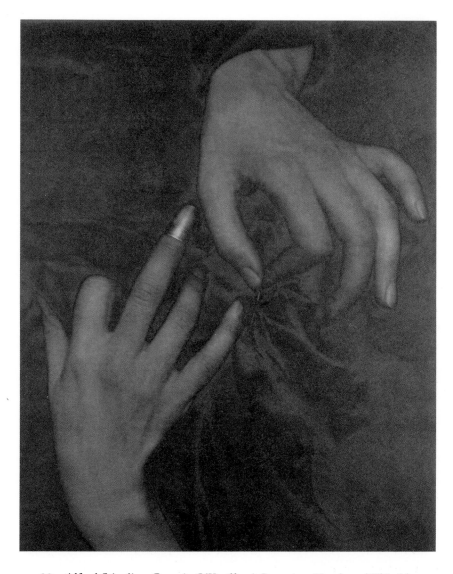

39. Alfred Stieglitz. *Georgia O'Keeffe: A Portrait—Hands and Thimble*,
c. 1919–20. Solarized palladium photograph, 9⅝ x 7¾ in. (24.4 x 19.7 cm).
National Gallery of Art, Washington, D.C.; The Alfred Stieglitz Collection,
1980.70.138.

clearly as possible. He could also have intended a subtle tribute to
O'Keeffe, for by the 1920s Dow's "Synthesis" had been transmitted by
teachers like her to a whole generation of Americans through the public
school system.

The influence of Wassily Kandinsky on Stieglitz and on certain other
members of his circle—Oscar Bluemner, Konrad Cramer, Arthur Dove,
Marsden Hartley, and Abraham Walkowitz—has been often and justly

cited.[47] Mentioned less often, and never closely examined, is Kandinsky's influence on O'Keeffe.[48] It is not easy to gauge the extent of Kandinsky's effect on O'Keeffe's abstractions. The reasons are several. First, O'Keeffe's habit was always to minimize or ignore her sources publicly. Second, she appears to have been more interested in Kandinsky's ideas than his images.[49] Third, she may have come to certain visual understandings of Kandinsky through the art of Dove.[50] And fourth, her studies with Dow seem to have prepared her for abstraction much more directly.

It is virtually certain that O'Keeffe learned about Kandinsky through Arthur Jerome Eddy's *Cubists and Post-Impressionism* (1914) and not from Stieglitz. This despite the fact that Stieglitz seems to have been the first artist in America to recognize the importance of Kandinsky's *Uber das Geistige in der Kunst*. He may have heard about it first from Cramer, who lived in Munich during 1910–11.[51] In any case, barely six months after the 1912 edition was published in Munich, "Extracts from 'The Spiritual in Art' " appeared in *Camera Work* 39. Stieglitz's choice of this short passage (which he may have translated himself) reveals what interested him most in Kandinsky's treatise. In good Symbolist fashion it begins: "These are the seekers of the inner spirit in outer things," and goes on to speak of Cézanne, Matisse, and Picasso, each of whom Stieglitz had already introduced to America at 291. And it concludes with the sentences: "Matisse—Color. Picasso—Form. Two great highways to one great goal."[52] Stieglitz's own early identification with "Picasso—Form" will be examined further on. His efforts to propel O'Keeffe onto the other great highway of "Matisse—Color" would be many—and will be cited later as well.

Since O'Keeffe missed the Armory Show (she was then teaching in Amarillo, Texas), it is likely that she did not see Kandinsky's *Improvisation 27* (plate 40) until long after Stieglitz purchased it out of the show for five hundred dollars, expressly to influence the American art world.[53] Her correspondence with Pollitzer does not mention this painting, but it specifies that she "got" Eddy sometime in 1914–15 and thus was familiar with his color reproductions of Kandinsky's work (namely, *Village Street, Landscape with Two Poplars, Improvisation 29,* and *Improvisation 30*). The correspondence also pinpoints the summer of 1915 as the time she finally obtained a copy of *The Art of Spiritual Harmony*—the first English translation (1914) of *Uber das Geistige in der Kunst,* by Michael T. H. Sadler—which included reproductions of *Impression No. 4, Moscow; Improvisation 29; Composition 2;* and *Small Joys*. By mid-1915, then, she not only had a fairly good idea of what Kandinsky was saying (her

September 1915 letter to Pollitzer mentions a second reading), she also had seen several examples of what he was doing—reducing and "veiling" his nature forms to conceal their origins.[54]

O'Keeffe never publicly admitted to having read *Cubists and Post-Impressionism*, just to having looked at the illustrations.[55] But a 1917 letter to Pollitzer shows that she was indeed familiar with Eddy's text.[56] Eddy's paraphrases of many of Kandinsky's most puzzling and poetic arguments in *The Art of Spiritual Harmony*, the Berlin journal *Der Sturm* (The Storm), and *Der Blaue Reiter* [The Blue Rider] *Almanac* must have been a great help to her, not to mention his copious quotations from Kandinsky's letters written to clarify the artist's radical intentions for his work. In fact, it is highly probable that Kandinsky's exegesis to Eddy of *Improvisation 30* was of particular importance for O'Keeffe's own groundbreaking watercolor *Blue No. I* of 1916 (plate 43). In this, and in the other three Blues of the series, we can see early (perhaps first) evidence of the important ways Kandinsky helped her to stretch Dow's method and cut away from his conservative views on color. *Blue No. I* appears to be an amalgam of shapes from two of her earlier works: *Drawing No. 12* of 1915 (plate 42), which uses calligraphic verticals and diagonals—probably reductions of tree trunks and roof lines—as well as similarly placed loamlike motifs along the upper borders, and the 1916 watercolor *House with Tree—Green* (plate 41). The bulbous shapes and vertical lines in *Blue No. I* look as if they were derived from the sun, treetops, and trunks in *House with Tree—Green* but repositioned to fill a new space differently. There is, however, a marked change of style between these two watercolors. The easily read *House with Tree—Green*, with its extra-wide outlines of forms and its "dug-out" type of brush stroke, has a woodcut quality about it. (Dow exalted the woodcut to his students.) *Blue No. I*, on the other hand, looks as if O'Keeffe had taken a large dose of Kandinsky. Like Kandinsky's Improvisations (so called even though carefully plotted by the artist), this work is neither spontaneous nor improvised. To look closely at the original is to see the clearly penciled composition underneath O'Keeffe's exquisitely controlled puddling of black, blue, and yellow. This is the same color antithesis stressed by Kandinsky as having powerful "spiritual appeal" in his chapter "The Language of Form and Color."[57] O'Keeffe also stripped her tree forms down to partial-ellipse outlines that are strikingly similar to the loops of smoke in *Improvisation 30*, which she knew from Eddy's color illustration. And she used color "veiling" to cut down on the instant legibility of her forms as well, whether or not her intention was to extend their "inner significance," as Kandinsky suggested.[58]

LEFT

40. Wassily Kandinsky (1866–1944). *Improvisation 27: The Garden of Love,* 1912. Oil on canvas, 47⅜ x 55¼ in. (120.4 x 140.3 cm). The Metropolitan Museum of Art; The Alfred Stieglitz Collection, 1949.

BELOW, LEFT

41. Georgia O'Keeffe. *House with Tree—Green,* 1916. Watercolor on paper, 19 x 13 in. (48.3 x 33 cm). Estate of Georgia O'Keeffe.

BELOW, RIGHT

42. Georgia O'Keeffe. *Drawing No. 12,* 1915. Charcoal on paper, 24½ x 18½ in. (62.2 x 47 cm). Estate of Georgia O'Keeffe.

The transition from *Blue No. I* to *Blue No. II* (plate 44) is extremely abrupt, compared to the rest of the series. Gone completely from *No. II* is the upper border of aquatic forms, with their delicate references to conch shells, sea foam, and ripples. Only two of the ellipses have survived, their outlines smoothed and rounded, and they are now suspended, one above the other, with a thick cluster of calligraphic diagonals acting as a base. What happened between these two works? The answer lies in a letter dated October 1916, which O'Keeffe wrote to Pollitzer in partial reply to her questions. "I recognized two of the drawings you spoke of. [Draws two sketches of them.] Number one [*Blue No. I*] is the first of a dozen or more you speak of—number two [*Blue No. II*] came next to

43. Georgia O'Keeffe. *Blue No. I*, 1916.
Watercolor on paper, 16 x 11 in. (40.6 x 27.9 cm).
The Brooklyn Museum.

44. Georgia O'Keeffe. *Blue No. II*, 1916. Watercolor on paper,
16 x 11 in. (40.6 x 27.9 cm). The Brooklyn Museum.

last. It didn't quite satisfy me so I tried again—the last one was so much worse than the one you like that I thought I had just about worn the idea out so quit."[59]

From these comments we know that she did not produce her paintings in the order in which they are numbered. We know also that *Blue No. I* and *Blue No. IV* (Brooklyn Museum) were hung side by side in O'Keeffe's 1917 show at 291.[60] Therefore, it is certain that O'Keeffe formed this final series well after the individual drawings were made. It is not known when she did so, however, nor is it known whether Stieglitz made any suggestions to her about it. But the series system she employed is not unlike looking at contact sheets and choosing the best-composed prints or the most meaningful progressions long after the actual photographic fact. Certainly the four Blues chart what she wished the viewer to regard as her method of reduction, or "selection," or "synthesis." Though O'Keeffe kept to Dow's principles of Subordination and Repetition throughout the series, the last three Blues are seemingly objectless, and each was constructed directly—not a pencil mark is to be seen. In all probability this would not have happened without Kandinsky's example. Furthermore, in choosing blue to predominate in this series, she certainly must have been aware of his comments:

> The power of profound meaning is found in blue, and first in its physical movements (1) of retreat from the spectator, (2) of turning in upon its own centre. The inclination of blue to depth is so strong that its inner appeal is stronger when its shade is deeper. Blue is the typical heavenly color. The ultimate feeling it creates is one of rest. . . . In music a light blue is like a flute, a darker blue a cello; a still darker blue a thunderous double bass: and the darkest blue of all—an organ.[61]

There can be little doubt that Kandinsky's strongly expressed trust in the psychic effect of colors converted O'Keeffe early to the belief that "the art of modernist painting equals the art of color," as Willard Huntington Wright was to put it in 1922.[62] Kandinsky may also have taught her how to soften her outlines and to be more resolute in abjuring vanishing-point perspective. Perhaps his art had something to do with her "unreal" light as well, a light that seems to come from within the core of the picture rather than a directional source.

Nevertheless, it was Dow to whom O'Keeffe owed the most, for he taught her first about the rudiments of reduction. The famous *Blue Lines X* (Metropolitan Museum of Art), from another connected group of

1916 drawings and watercolors, was drawn with a Japanese brush, Dow's preferred instrument for developing the power of expression. His directions for using it are almost a description of her painting: "Begin with straight lines, remembering that straightness of direction is the essential thing, not mere geometric straightness. . . . Slight waverings are not objectionable; in fact they often give character to a line."[63] Stieglitz was so fascinated by this work that six months before O'Keeffe's second exhibition at 291 (as Pollitzer was "thunderstruck" to observe in a letter to her), he hung it on the gallery wall nearest to his private room.[64]

What did O'Keeffe really understand of Kandinsky's mystical ideas about inner necessity, synesthesia, and color music? Although her correspondence of the period is silent on this topic, her work suggests that she was inspired and encouraged in her ongoing experiments with abstraction by some of Kandinsky's most adamant statements. For example: "Purely abstract forms are beyond the reach of the artist at present; they are too indefinite for him. To limit himself to the purely indefinite would be to rob himself of possibilities, to exclude the human element and therefore to weaken his power of expression."[65] In her long span of making art, O'Keeffe was never to limit herself to "purely abstract forms." Without exception, her abstractions were transcriptions from visual experience and from other works of art (including photographs). Even if she was encouraged by Kandinsky in this, her decision obviously arose from her own artistic temperament.

It is also striking that all her life O'Keeffe would adhere consciously, or unconsciously, to two of Kandinsky's most pronounced biases. First, that color had primacy in painting: "It is necessary for the artist to know the starting point for the exercise of his spirit. The starting point is the study of color and its effects on men."[66] And second, that Cubism had little to contribute to an art that would be "truly" monumental: "There has arisen . . . the tendency to inertia, to a concentration on this form (Cubism) for its own sake, and consequently once more to an impoverishment of possibility. . . . The search for constructive form has produced Cubism, in which natural form is often forcibly subjected to geometrical construction, a process which tends to hamper the abstract by the concrete and spoil the concrete by the abstract."[67] O'Keeffe never became a Cubist, despite her expressed admiration for Picasso's 1910 Cubist drawing in *Camera Work* and despite her early exposure to the several illustrations in Eddy and to the legendary Picasso and Braque exhibition at 291. She did, however, make some experiments with Cubist faceting, most notably in *Three Pears No. 1* of about 1924 (plate 138).

Two large questions remain to be asked. The first: How attentive was O'Keeffe to Kandinsky's bold statement that in the "new great epoch," starting with the work of Henri Rousseau, "The new naturalism will not only be equivalent to but even identical with abstraction"?[68] Although O'Keeffe did not pick up on this liberating equation in 1915, there is strong evidence (both visual and written) that she was encouraged to do so later by Stieglitz, who had, after all, been the first to show Rousseau's work in America, in 1910 at 291.

In O'Keeffe's *Red Barn, Lake George, New York* (plate 45) and *Little House* (plate 46), both of 1922, there is an enforced naïveté and iconicizing of forms very like Rousseau's own mode of static, frontal, and concentrated primitivism. (In the aesthetic of Symbolism, primitivism and children's art were *both* rated very high.)[69] That O'Keeffe was making a deliberate reference to him in these works is highly probable, and it is equally probable that she was inspired to do so by Kandinsky's eloquent tribute to Rousseau in *Der Blaue Reiter Almanac:* "Here lies the root of the new total realism. In rendering the shell of an object simply and completely, one has already separated the object from its practical

ABOVE, LEFT

45. Georgia O'Keeffe. *Red Barn, Lake George, New York,* 1922.
Oil on canvas, 14 x 16¹⁄₁₆ in. (35.6 x 40.9 cm).
Georgia Museum of Art, The University of Georgia, Athens;
Eva Underhill Holbrook Memorial Collection of American Art,
Gift of Alfred H. Holbrook.

ABOVE, RIGHT

46. Georgia O'Keeffe. *Little House,* 1922. Oil on canvas,
18 x 10 in. (45.7 x 25.4 cm). Private collection.

meaning and pealed forth its interior sounds. Henri Rousseau, who may be considered the father of this realism, has pointed the way simply and convincingly. . . . [He] has revealed the new possibilities of simplicity. At present this aspect of his complex talent is most valuable to us."[70] Stieglitz himself was especially mindful of the importance of this statement for O'Keeffe's work, since he saw to it that she was connected to Rousseau in articles by Herbert J. Seligmann, at just about the time of her first major exhibition, at the Anderson Galleries in 1923.[71] It is worthy of note that O'Keeffe's few nonabstract portraits of people— among them Beauford Delaney (c. 1940; Regis Collection, Minneapolis) and Dorothy Schubart (c. 1950s; New-York Historical Society)—have many affinities to the masklike portraits Rousseau painted between the 1880s and 1910s.

The second question: Even though Sadler hailed Kandinsky as the "visual musician" who had "broken down the barrier between music and painting," was Kandinsky the prime catalyst for the musical elements in O'Keeffe's art?[72] Her willingness to borrow from photography may have been encouraged by his belief that "the various arts of today learn from each other and often resemble each other. . . . They are finding Music the best teacher."[73] Even so, Kandinsky does not seem to have been the prime catalyst. O'Keeffe's connections with music were at once personal (like Matisse, she could play the violin), a matter of Zeitgeist, and tutored—she knew that music is a direct hit on the emotions. And she had, after all, been schooled in the Art Nouveau concept of melody as arabesque; in the famous words of Otto Eckmann, she knew exactly how "to borrow from the angry swan the rhythmic line and not the swan." Furthermore, like all of Dow's students, she was familiar with James McNeill Whistler's aesthetic theories based on musical analogy.

Because Whistler preached against mimetic art and for the fusion of Eastern and Western art principles, Fenollosa and Dow regarded him as the first great master, "the common nodule" between Asiatic and European cultures.[74] How directly did Whistler affect the elements of O'Keeffe's style and subject matter? The facts are few, but gathered together they take on considerable significance. In her letter to Pollitzer of October 8, 1915, O'Keeffe spoke familiarly of Whistler's need for sixty-two sittings for a portrait. She did not, however, mention seeing any of his Arrangements, Nocturnes, or Harmonies.[75] Nevertheless, during the years O'Keeffe studied in New York she had plenty of opportunities to do so. In March 1908 the Macbeth Gallery offered *Paintings by a Group of American Artists, Copley to Whistler,* and in April

1914 M. Knoedler and Company presented *Oils, Watercolors, Pastels and Drawings by J. McN. Whistler.* Also, by 1914 the Metropolitan Museum of Art owned six Whistlers—four portraits and two nocturnal paintings: *Nocturne in Black and Gold: The Gardens* (1876) and *Cremorne Gardens, No. 2* (1872–77).

Even though her sensibility and her times would lead O'Keeffe far from Whistler, there appear to be several important links between her work and his. Common to both is the use of musical nomenclature and the series concept—that is, the repetition of a motif with subtle variations, as in O'Keeffe's *Music—Pink and Blue, I* and *II*, and *Black Spot I, II,* and *III* of 1919. Whistler's penchant for designing and painting frames to carry beauty beyond the picture itself was an Arts and Crafts device that O'Keeffe also came to use.[76] Certainly Whistler's integration of English, French, Dutch, Greek, and Japanese forms and themes was a valuable example of eclecticism for any young artist attempting to digest modernism through Dow's methods. Whistler's synthetic approach to his art after 1865—its musicality, its renderings from memory and dream, and its ability to suggest mood through color—anticipated many of the methods and theories of pictorial Symbolism.[77] Like Whistler, O'Keeffe was given to titling (and retitling) works in the interest of antinaturalism, or abstraction. Whistler's *White Girl* became *Symphony in White, No. 1: The White Girl* (plate 48) almost ten years after the critic Paul Mantz first called it a "Symphonie du blanc" in 1863.[78] And O'Keeffe's *Flower Abstraction* of 1924 (plate 56), first named *White Iris,* was exhibited in 1925 as *Abstraction.*[79] Further, her early propensity for rendering the night and the sea from memory—with poetic intent— reflects the spirit of Whistler's landmark Nocturnes of the 1870s. Despite obvious differences in facture, her *Starlight Night* (1917; Estate of Georgia O'Keeffe), *Wave Night* (1928; Addison Gallery of American Art), and *The Lawrence Tree* (1929; Wadsworth Atheneum) owe a great deal to his rhythmic "arrangements" of line, form, and color.

But O'Keeffe seems to share even more with Whistler than meets the eye. Both were apparently torn by the same inconsistency: a need to reveal and a fear of being too well understood. Just as O'Keeffe felt "invaded" by the purely sexual interpretations of her 1915 charcoal abstractions, so Whistler was angry and mortified when critics read his *White Girl* as an illustration for Wilkie Collins's novel of the same name and, even worse, as "the bride's morning after . . . the absence of yesterday's virginity."[80] It was interpretations like these that led Whistler to throw up the smoke screen of his art-for-art's-sake letters to the press, the best known being one he wrote to the *World* in 1878:

As Music is the poetry of sound, so is painting the poetry of sight, and the subject-matter has nothing to do with harmony of sound or of colour. . . . Art should be independent of all clap-trap—should stand alone, and appeal to the artistic sense of eye or ear, without confounding this with emotions entirely foreign to it, as devotion, pity, love, patriotism, and the like. All these have no kind of concern with it; and that is why I insist on calling my works "arrangements" and "harmonies." . . . The imitator is a poor kind of creature. . . . It is for the artist to do something beyond this: in portrait painting to put on canvas something more than the face the model wears for that one day . . . in arrangement of colours to treat a flower as his key, not his model.[81]

It is unlikely that O'Keeffe fully agreed with this famous statement, which she surely knew. As she wrote to Pollitzer in the fall of 1915, "One can't work with nothing to express." Or, to put it in Kandinsky's stern and challenging words: "Beauty of Form and Color is not sufficient aim by itself. . . . The artist must have something to say, for mastery over form is not his goal but rather the adapting of form to its inner meaning."[82]

Stieglitz never acknowledged a kinship with Whistler, but his interest in Whistler's formalist ideas can be traced back at least to 1904, when *Camera Work* published "From Whistler's Ten O'Clock," including these catalytic statements: "Nature contains the elements in color and form of all pictures, as the keyboard contains the notes of all music. But the artist is born to pick and choose and group with science these elements that the result may be beautiful, as the musician gathers his notes and forms his chords, until he brings forth from chaos glorious harmony."[83] This reads like a written permission for Pictorialism, and surely Stieglitz considered it to be so—hence its inclusion. Appearing in the same issue was Sadakichi Hartmann's short essay "White Chrysanthemums," on the controversial topic of Whistler's opposition to realism: "Whistler was opposed to realism. The realists endorse every faithful reproduction of the facts. Also Whistler believed all objects beautiful, but only under certain conditions, at certain favored moments. . . . It was Whistler's life-long endeavor to fix such supreme and happy moments . . . upon his canvases."[84]

That Stieglitz related Whistler's art to his own Pictorialist picture making is evident from his 1905 article "Simplicity in Composition": "Taking now our single, simple object and introducing another simple

object into the composition, there immediately springs up a more complex sense of relation. The newly introduced object must now be studied not only in its relation to the three factors previously enumerated [light, shade, and spacing] and to object No. 1, but its relation to each one of the three factors operating upon our first object . . . —yet should all these relations be harmonious. The result, though seemingly simple, is wonderfully fascinating to the mature student of composition. An instance of this can be found in Whistler's 'Piano Room.' "[85] Even after Stieglitz turned toward straight photography, a Whistlerian simplicity of design continued to appear in his work, through a combination of camera placement, cropping (as in the different versions of *Winter Fifth Avenue* and *The Terminal*), and elimination (through some retouching of the negative).[86]

In 1905, in *Camera Work*, Caffin wrote somewhat warily of Whistler's attempt to get away from "the obsession of form."[87] By 1910 Caffin had come to consider Whistler as the prime source of modern abstraction:

> Whistler, unless we except Corot, was the first modern to attempt this abstract use of form. [By "this abstract use of form" Caffin meant detaching it from concrete actualities "to invite and stimulate the higher faculties of the imagination."] . . . It became the habit of his mind to view the particular in relation to the general, to see the type in the individual, to regard the personal and the local as manifestations of the universal. His portraits, to quote his own word, are "evocations" of the idea with which the personality had inspired him. In his nocturnes, forms lose their concrete assertiveness and become as presences, looming athwart the infinity of spiritual suggestion. But the nocturnes, after all, are beautiful evasions, wherein the artist has taken refuge from the obviousness of facts by immersing himself in the penumbra. Whistler left this new motive to be carried further by others who would view the facts of appearances in clear open daylight and yet discover how to render their abstraction.[88]

Perhaps, in this sense, the simplified reality of Stieglitz's late nineteenth-century cityscapes, taken at night with a soft-focus lens, are his own earliest abstractions. In any case, he was to be among the few "others" who would discover, through modernism, how to render the abstraction of appearances in daylight.

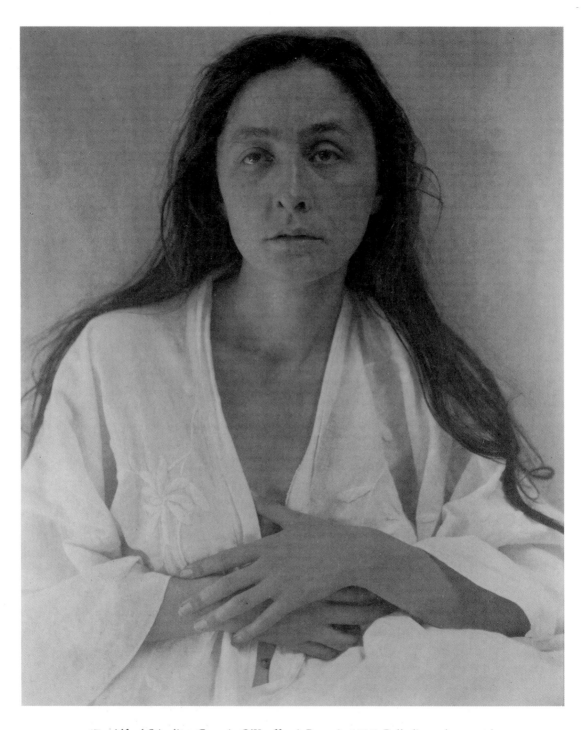

47. Alfred Stieglitz. *Georgia O'Keeffe: A Portrait,* 1918. Palladium photograph,
9⅜ x 7½ in. (24 x 19.2 cm). National Gallery of Art,
Washington, D.C.; The Alfred Stieglitz Collection, 1980.70.88.

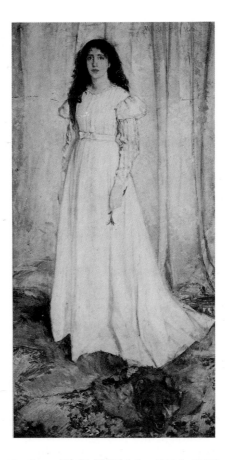

48. James McNeill Whistler (1834–1903).
Symphony in White, No. 1: The White Girl, 1861–62.
Photograph by Elliott and Fry, c. 1865–70. Prints Division,
The New York Public Library, Astor, Lenox and Tilden Foundations.

A close study of the essentially collaborative multiphotograph *Portrait of Georgia O'Keeffe* that Stieglitz made between 1917 and 1937 turns up some oblique—but unmistakable—references to Whistler, especially in the early years when Stieglitz was trying to make her name as an artist. Stieglitz had never stopped obeying his own 1890 injunction "to study art in all its forms," and this composite portrait contains many conceptual and compositional references to nineteenth- and twentieth-century art that have barely begun to be catalogued, let alone examined for meaning.[89] A 1918 close-up of O'Keeffe in a white kimono with her hair falling over her shoulders (plate 47) holds perhaps his richest and most creative references to Whistler. Inventively based on *Symphony in White, No. 1: The White Girl,* the photograph even contains a secret resonance connected with the painting's title. ("Georgia is a wonder. . . .

If ever there is a whiteness she is that."⁹⁰) It could not have been lost on Stieglitz that Whistler's famous model, Jo Heffernan, was also his companion and mistress, nor, perhaps, that the painting had been rejected by the establishment (the Royal Academy and the Paris Salon) before it became a *succès de scandale* at the Salon des Refusés in 1863.

Stieglitz could have seen *The White Girl* when it was exhibited in New York in 1894 and again in 1898–99, but it is likely that he came to know this work best through the widely circulated early photograph of it made in London by Elliott and Fry (plate 48). Taken before the artist did considerable repainting of the face and hands, the photograph was signed by Whistler in 1870. In this print *The White Girl's* face is thinner, the eyes larger, and the mouth smaller and more wistful, which increases her uncanny resemblance to O'Keeffe. Although the white curtain, the lily, the flowered carpet, and the bear-head rug are absent from Stieglitz's half-length photograph, he has closed in on *The White Girl's* troubled and troubling expression, as mirrored on the face of O'Keeffe. They share that strangely sorrowful stare (so shocking to Whistler's nineteenth-century viewers), which is accentuated by the lighting—causing one eye to appear much larger than the other—and by the slightly up-from-below angle of vision. Instead of the drooping lily, that Victorian symbol of lost innocence, Stieglitz has employed a much subtler and more personal visual metaphor: O'Keeffe's navel. According to a description of this photograph by Paul Rosenfeld in 1921 (who could have heard it only from Stieglitz): "Sorrowful and knowing eyes gaze out; the navel is the center of anguish."⁹¹ Nuanced variations on this "suffering" expression appear over and over again in the O'Keeffe *Portrait*. A clue to its meaning for Stieglitz may reside in a letter he wrote to Hartley in October 1923: "You were given your original show in 291 because of my reading 'Suffering,' spiritual anguish on your face. And because I felt a supreme worthwhile struggle of a Soul. No other reason. And that is why I have fought for you to this day and will continue to fight."⁹²

Although Stieglitz did not choose in this photograph to have O'Keeffe stand against a window with the light filtering through a transparent muslin curtain, like *The White Girl,* two other photographs taken the same year *do* show O'Keeffe's nude figure backlit in exactly this manner.⁹³ It may not be sheer fancy, therefore, to think that Stieglitz intended the embossed flower patterns of O'Keeffe's kimono to relate visually to the brocadelike patterns painted so exquisitely by Whistler on the white curtain. In a very real sense, this is a triadic portrait, for Stieglitz not only linked O'Keeffe with Whistler—the first American

artist to cause revolutionary change in painting—but with himself as well, in ways that are at once politic, intimate, and artistic.

It has been suggested that the partial views, countless angles, and shifting vantage points within Stieglitz's composite *Portrait* are indebted to Cubist faceting and Cubist theories of time and space.[94] Given Stieglitz's enlightened interest in Picasso, it is easy to understand the derivation of this hindsight theory. But on the basis of visual evidence alone, Stieglitz's attempt to document what was changing and changeless in O'Keeffe over a twenty-year period fits securely into the tradition of serial photography —that is, a factuality attained through the accumulation of evidence.[95] Rodin's influential concept of the partial figure (endowing body parts with an expressiveness equal to the face by animating them from every point of view) also seems to have informed Stieglitz's angled close-ups of O'Keeffe. Prime evidence for this observation lies in Stieglitz's unabating attention to the theatrical, or miming, action of her hands and fingers, one that recalls Rodin's similar obsession.[96]

Another striking example of Rodin's influence on the *Portrait* is an untitled photograph from 1920 that shows O'Keeffe enveloped in Stieglitz's black cape, standing statuesquely against the open sky (plate 50). She is presented in an obviously planned pose closely resembling Rodin's famous *Monument to Balzac* (1898). Steichen's night photograph of this sculpture titled *Balzac—The Open Sky, 11 PM* (plate 49), reproduced in the scandalous "Rodin number" of *Camera Work* (1911), may well be the source for the similarly tilted and cloth-bound form of O'Keeffe's body. Sadakichi Hartmann's essay "Rodin's Balzac," in the same issue, further illuminates this linkage. Hartmann considered the sculpture to be "a symbol of temporary accomplishment as well as new aspiration . . . perhaps the highest expression of . . . art convictions in modern times." He exulted in its "musical Form," its "orchestration by the blending of planes—and by the vibration of light on these planes." And he named it "a sculpture for the mind in search for the beautiful . . . an ideal struggling through matter." Hartmann's words suggest that Stieglitz intended this photograph of O'Keeffe to be both a prediction and his own recognition of her great talent.

In Texas, probably during the spring of 1918, O'Keeffe painted a series of nude watercolors from the model that are obviously informed by Rodin's late contour and wash drawings.[97] It is tempting to think that she was motivated by his 1905 comment to the sculptor Emile-Antoine Bourdelle: "As my drawings are more free, they will give more liberty to artists who study them, not in telling them to do likewise, but in

49. Eduard Steichen (1879–1973).
Balzac—The Open Sky, 11 PM, 1908. Photograph,
19³⁄₁₆ x 15³⁄₁₆ in. (50.3 x 38.6 cm).
Reprinted with the permission of Joanna T. Steichen.

showing them their own genius and giving wings to their own impulse in showing them the enormous space in which they can develop."[98] But in all likelihood what galvanized her experimental series was seeing eight of these drawings reproduced in a copy of *Camera Work* 34–35 sent to her by Pollitzer.[99] Between 1900 and 1917 Rodin drew, as he said, "to test to what extent my hands already feel what my eyes see."[100] His technique was to imagine the pencil traveling over the contours of the model's body and to put these lines down instantaneously, without looking at the paper. (Naturalistic color washes were applied later, mostly within the penciled outlines.) However much O'Keeffe may have learned about "liberty" from Rodin, her drawings differ considerably from his. Her forms are never outlined first. They assume a readable contour from the way the colors are allowed to run, a mixture of accident and control. She not only looked at the paper, she played freely with its

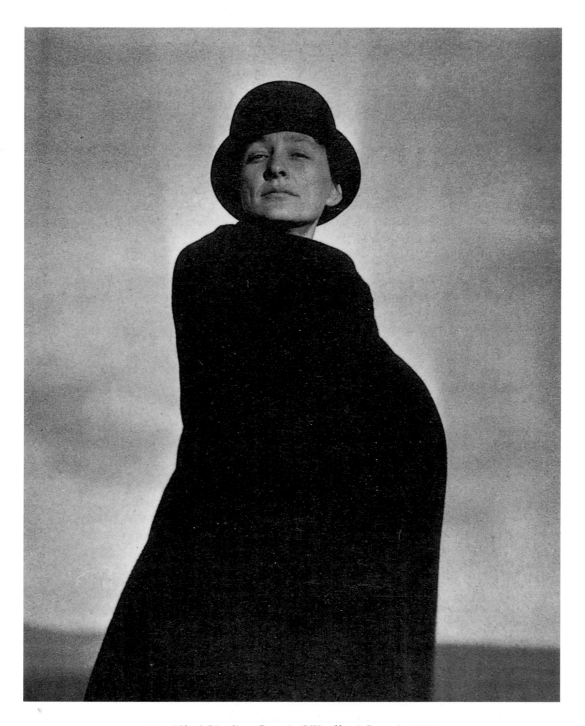

50. Alfred Stieglitz. *Georgia O'Keeffe: A Portrait,* 1920.
Palladium photograph, 4½ x 3½ in. (11.5 x 9 cm).
National Gallery of Art, Washington, D.C.;
The Alfred Stieglitz Collection, 1980.70.147.

unpredictable pictorial possibilities. Her skin tones range from approximate to arbitrary (from dark reds and hot pinks to blue), and they frequently bleed into each other, producing a variety of mottled patterns and transparencies. Although she, too, filled a bare sheet of paper with large, off-center, isolated figures, hers are seen closer to than Rodin's, and she did not try for his erotic, wide-ranging poses. (Twelve of her nudes sit, and four are seen in profile, severely abstracted.) What may have interested her most of all about his drawings was that he was striving for the essential: for what art could do *without*. In any case, with these sixteen works she apparently learned all she needed from Rodin, for O'Keeffe seems never to have rendered the female nude again (except suggestively, through flowers and landscapes).

Rodin's express trust in carnal energy was close to Stieglitz's own— a combination of sexuality and spirituality. And it is entirely consistent with his aims and intentions that Stieglitz should have drawn so deeply on the Symbolist art of Rodin and Whistler during the early years of the O'Keeffe *Portrait*.[101] That O'Keeffe herself had partaken of their work for her own artistic ends adds yet another dimension to our growing understanding of Stieglitz's great portrait of her.

Into the heady brew of early modernism that instructed the abstract paintings and photographs of O'Keeffe and Stieglitz must be added the unlikely, but potent, figure of Francis Picabia. Within a month of his arrival in New York on January 20, 1913, Picabia met Stieglitz and Marius de Zayas at 291. The three apparently got on well from the first, personally and aesthetically.[102] Picabia's on-the-spot New York Studies (many totally abstract) were exhibited at 291 just two days after Stieglitz's own photographs of the city were taken down, and Picabia's show was followed three days later by one of de Zayas's abstract caricatures. The aesthetic links among these exhibitions were calculated and multiple. Moreover, Stieglitz made it a point to inform the *New York Sun*'s critic Samuel Swift (among others) that the American ground had already been well prepared for Picabia's advanced work and ideas by Dove's earlier independent abstractions and by Marin's watercolors of New York, exhibited at 291 just before the Armory Show. Swift's faithful article to this effect was reprinted shortly afterward in *Camera Work*.[103] In that same issue Haviland urged the comparison of Marin's and Picabia's "newest and most advanced" renditions of New York with Stieglitz's photographs of the same subject over the last twenty years in order to afford "a clearer understanding of the place and purpose of the

FRANCIS PICABIA AND HIS PUZZLING ART
An Extremely Modernized Academician

Francis Picabia, from a photographic portrait by Alfred Stieglitz

FRANCIS PICABIA, who is now in New York on a fleeting visit, is regarded properly as a French painter. In the present war his sympathies are all with the French, in spite of his immediate Cuban, and remoter Spanish, ancestry. Though one of the most extreme of the moderns, he is not subject to the usual taunt of being unable to paint, as he had attained, before he took to "abstract" art, a very considerable recognition as a painter of the conventional school, and was, in fact, quite a pet of the Academicians.

At the age of twelve, Picabia was drawing; at sixteen, attending Les Arts Decoratifs, while at seventeen he exhibited his first picture, in the Salon des Artiste Français.

His early work was influenced by the Romantic schools. Fifteen years ago he was classed with the Impressionists. Until 1908 his work was still "objective," so called; then he joined the "Abstract" painters. A certain class of critics, following the process (adopted, perhaps, as a mental labor-saving device) of shoving everything and everyone into some neatly labelled pigeon-hole, have tagged him, at times, as an "Orphist" and a "Cubist." His work has been familiar to us since the

Armory Exhibition in New York in 1913, the most noticed picture of the four which he showed there being the "Procession, Seville."

"Seven years ago," Picabia says, "I tried to make a painting that would live by its own resources, like music. I was trying to make a psychic painting. At the present time I am doing research in art. My conclusions? I cannot explain my present researches until I have myself evolved out of them, that is to say, until I have gone further in my artistic evolution."

Judging from some of his recent drawings, he has gone, for his inspiration, to the sphere of engineering and machinery. For example, take his "Portrait of a Young American Girl," which might be a cut taken straight out of a book on physics, or take, again, the portraits of some of his friends, drawn in terms of mechanics. Picabia likes to make a picture of the interior of a motor-car and call it a portrait. A good joke, perhaps, but would it not spoil it to take it seriously?

Picabia served eight months with the French Army, in the automobile corps. He is now here on a mission for the French military department. He is subject to a call at any moment to return to his post on the firing line.

51. Alfred Stieglitz. *Francis Picabia*, 1915. Reproduced in *Vanity Fair*, November 1915.

two media.... Naturally, in view of the Marin and Stieglitz New York pictures, the interest in Picabia's abstract expression of New York was greatly intensified."[104] To add to his point, Haviland quoted the 291 catalog statements by Marin ("It is this moving of me that I try to express...") and Picabia: "Art is one of the means by which men communicate with each other and objectivize the deepest contact of their personality with nature.... Expression means objectivity otherwise contact between beings would become impossible, language would lose all meaning. This new expression in painting, is 'the objectivity of a subjectivity.' We can make ourselves better understood by comparing it to music."[105]

Much of the curious aesthetic compatibility between Stieglitz and Picabia may be accounted for by Stieglitz's ease in speaking French and by their common grounding in Symbolist theories of correspondence.[106] Not only did Picabia quote Gustave Kahn in the preface written for his 291 exhibition ("the objectivity of a subjectivity"), he tried consistently to make "the idea" a tangible one by emphasizing the mind over the senses, the inner (reaction) over the outer (visual impression). He also used analogies with music in an effort to create universal abstract symbols out of his own moods. Gabrielle Buffet, Picabia's wife, carried the old Symbolist notion of "musicality" a step further, with the implication that painting is superior to music. In her article for *Camera Work* (special

number, June 1913), titled "Modern Art and the Public" (written to clarify her husband's difficult "Preface" published in *Camera Work* 42–43), Buffet asserted that "the abstract idea in pure line and pure color is conveyed to our understanding more directly than in the music form, for . . . the deepest meaning of a musical composition will escape, in part, the comprehension of those listeners who are not educated in music."[107]

For Picabia, as for Stieglitz, New York City was the epitome of the modern. And modernism as a new pictorial language was, of course, an already familiar, if aggravating, idea to the readers of *Camera Work*. But Picabia was arguing for theories far more extreme than those of Marin and Dove: an art with no subject matter, no perspective, and no recognizable objects. In a word (Picabia's own), "abstractionism."[108] For Picabia, abstractionism had replaced Cubism as the latest thing in art. In a 1913 *New York Times* interview he stated that the Cubists were as intent on producing facsimiles of their original models as the old masters. "But my idea is not the same. You will find no trace of the original in my picture."[109]

Out of the sixteen watercolors and drawings exhibited by Picabia in his first one-man show at 291, ten were titled *New York*. Apparently done in his room at the Hotel Brevoort, they are among his earliest "abstractionist" experiments, despite the addition of titles. About these titles, a seeming contradiction to "pure" abstraction, Gabrielle Buffet wrote, "If [Picabia] calls some of his recent water-colors 'New York,' or 'Negro Songs' it is only because he did them when stimulated by his impression of the city, or by the bizarre rhythms of ragtime."[110] The whole point was to be "subjective"—meaning abstract. As Picabia himself put it, "The way in which we artists can best express what we feel is by the purely subjective, by the abstract."[111] Because this statement squares quite neatly with Stieglitz's own that "contemporary art consists of the abstract (without subject),"[112] the question arises as to what he actually picked up from Picabia. Impetus, for one thing, and example, for another. Nobody else had yet said, "I improvise my pictures as a musician improvises music,"[113] and then done it almost under Stieglitz's nose. As Caffin observed, Picabia's method "starts with a few forms, colored according to the key of the impression he wishes to create and combines and recombines these in a variety of relations until he has produced a harmonic composition."[114] Did Stieglitz find this system of composition close enough to his own to take new inspiration from it? This is hard to prove, although it is highly probable that he did, judging from the titles he gave to his earliest cloud photographs: Music: A

Sequence of Ten Cloud Photographs (or Clouds in Ten Movements) in 1922 and Songs of the Sky in 1923. Kandinsky may also be presumed to have been a root influence here, since Stieglitz almost titled the 1923 series "Music of the Spheres."[115] This pseudoscientific phrase was quite fashionable at the time for its Theosophical connotations, and as Stieglitz undoubtedly knew, Kandinsky had used it in his famous autobiography *Reminiscences* (1913) to signify creation, both artistic and cosmic.[116]

Picabia himself was familiar with Kandinsky's theories, probably through his contacts with Marcel Duchamp and La Section d'Or[117]— particularly the idea that a work of art must be slowly deciphered through clues in order to be meaningful to the spectator. Early examples of Picabia's experiments along this line are the anagrammatic titles he invented for his 1913 paintings *Udnie* (*jeune fille américaine; danse*) and *Edtaonisl* (*Ecclésiastique*)—images based on memories of America.

Although Stieglitz did not mention Picabia in "How I Came to Photograph Clouds" (1923), these photographs, and the Equivalents to follow, were clearly intended to be "improvised music" pictures—abstract forms of his feelings—as were the Picabias exhibited at 291. The significance of a photograph frequently became clear to Stieglitz only after looking at a print of it.[118] Certainly de Zayas had already contributed much to this working system, since it was he who first perceived, in 1910, the intrinsic modernism in *The Steerage,* a photograph Stieglitz had taken in 1907.[119]

Judging from the visual evidence, it seems that Stieglitz experimented with being an "abstractionist," in Picabia's sense of the term, in at least three different series of photographs before he finally came to the cloud Equivalents. First, in the 1915–16 camera views out the back window of 291. This series has been labeled Cubist because of the photographer's presumed intention to concentrate on analytic construction, on the planes and angles so pertinent to American understanding of Cubism at the time.[120] But it, and the two other series mentioned below, seem instead to be a patient exploration, through photography, of Picabia's newer methodology: the negation of perspective (by compressing or flattening space); the downgrading of subject matter (clued by the dry, almost scientifically precise titles); and the creation of allover patterns of ambiguous forms (by cutting shapes with the lens and by accentuating certain built-in optical distortions, particularly those caused by snow, darkness, and artificial light).

The second series consists of several 4-by-5-inch prints, c. 1916, titled Shadows on the Lake.[121] In *Shadow on the Lake: Self-Portrait,*

Picabia's new "rules" are recast in a most unusual (for Stieglitz) and inventive way.[122] Without the title it would be almost impossible to identify the photographer's crouched body with the arabesque of his water-distorted shadow—a configuration that divides the picture plane into three triangular forms. And because it is not always clear whether the sun's sparkling rays and flecks of seaweed are on top of the water or reflected on the shallow bottom beneath, pattern and depth are nearly indistinguishable.

Stieglitz's third experiment in this vein seems to have been with some of the extreme close-ups of O'Keeffe's torso taken in 1919, particularly a series of two titled *Georgia O'Keeffe: A Portrait: Breasts.*[123] In both of these images the frame is completely filled with the surprisingly ambiguous lines and curves made by her upper arms pressing against her breasts. As so often with Stieglitz's most abstract photographs, triangular forms predominate. (In one of them, plate 83, a powerful outer triangle drawn by her arms is echoed by an interior one that is only just suggested by the "dots" of her nipples and navel.[124]) This series contains perhaps the most subtle and advanced variations on Picabia's three rules for abstraction ever made by Stieglitz, with the exception of the Equivalents.

The blatantly autobiographical character of Picabia's work may also have acted as a creative spur to Stieglitz after his relatively fallow period between 1911 and 1915. And, as his grandniece Sue Davidson Lowe has recorded, Picabia was a direct influence on the increasingly sexual and scatological language used by Stieglitz during the late 1910s and early 1920s. She also states that when Picabia came back to New York in 1915, Stieglitz began to consider him a "collaborator."[125]

Even if O'Keeffe and Picabia had met—which they apparently never did—they would have been unable to converse.[126] Picabia could not speak English and O'Keeffe did not know French. She was certainly aware, however, of Stieglitz's warm correspondence with Picabia into the 1920s, and she also knew that Stieglitz never lost faith in Picabia's work and ideas, although some in his circle felt differently—Steichen in particular.[127] Dove, on the other hand, often took ideas from Picabia's work, starting in 1913, and Picabia's later machinist and post-machinist paintings are known to have influenced other 291 artists, particularly Morton Schamberg, Charles Sheeler, and Charles Demuth.[128]

In 1928, with the encouragement of Duchamp, Stieglitz presented one last Picabia exhibition at the Intimate Gallery. The catalog essay, by Meraud Michael Guinness, sums up why Stieglitz kept his old admiration

for Picabia's ceaselessly experimental art: "Picabia has caught and imprisoned in his pictures all the best things in life—spontaneous gaiety, happiness, a fearlessly clear insight into things, the spirit of adventure, of change and of the unexpected that is in the essence of all things that are alive. He has the courage to express life as he feels it, in complete disregard of all formulas, and he has the courage to change as all life changes. Nothing alive ever stays still; why should a painter invent a formula for himself and then sit down and expect it to last him forever?"[129]

O'Keeffe's first acquaintance with Picabia's painting was undoubtedly the work reproduced in Eddy as *Dance at the Spring* (now known as *Danse à la source I;* Philadelphia Museum of Art). Probably more important to her at the time, though, was Eddy's lengthy quotation from "An Interview with François Picabia" in the *New York Tribune,* which included the most energizing of all Picabia's statements: "I absorb these impressions [of New York]. I am in no hurry to put them on canvas. I let them remain in my brain, and then when the spirit of creation is at flood-tide, I improvise my pictures as a musician improvises music. . . . Art, Art, what is art? . . . I do not call [painting nature as it is] art today, because we have outgrown it. It is old, and only the new should live. Creating a picture without models is art."[130] Were these the words that launched O'Keeffe's first charcoal abstractions? There is no way, of course, to be sure, but the timing fits. And it therefore seems logical to consider these words, at the very least, as a reinforcement, or sanction, for her accomplishment that fall of 1915.

As noted earlier, O'Keeffe went to 291 in January 1915 to see Picabia's three huge 1914 paintings, the zenith of his experiments with total abstraction: *Je revois en souvenir ma chère Udnie, C'est de moi qu'il s'agit* (plate 52), and *Mariage comique.* Several of her later paintings suggest that she paid a good deal of attention to their morphology. Specifically, it seems that her *Black Spot III* (1919) and *Spring* (c. 1922; Vassar College Art Gallery) owe much to the right section of Picabia's *C'est de moi qu'il s'agit*—in particular, his hallmark juxtapositions of thick, straight bisecting lines with swollen biomorphic shapes.[131] Also, it could not have been lost on her acutely modernist eye that many of his entwined plantlike forms (especially in *Je revois en souvenir ma chère Udnie*) can be read simultaneously as phallic, as vulvalike, and as the pistil and stamen of a flowering plant.

That O'Keeffe also became familiar with some of Picabia's abstractionist New York charcoals and watercolors of 1913 is equally certain.

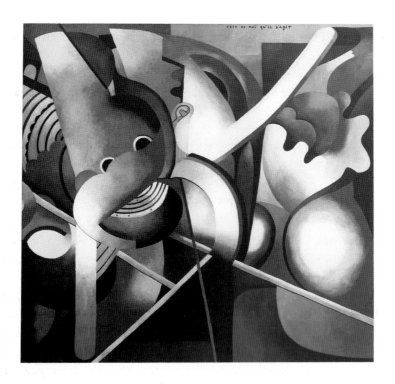

52. Francis Picabia (1878–1953). *C'est de moi qu'il s'agit (It's About Me)*,
1914. Oil on canvas, 78⅝ x 78⅜ in. (199.6 x 199.1 cm). The Museum
of Modern Art, New York; Eugene and Agnes E. Meyer Collection,
given by their family.

A letter from Stieglitz to Arthur B. Carles notes that Picabia had left
five of his "New York things [at 291] so we can use them as we see
fit."[132] All of them are large (approximately 21 by 25 inches), and all
seem to contain multiple-view vestiges of ships' hulls and funnels, church
spires, skyscrapers, and traffic signs. But these are phantom forms,
secondary rather than primary images. They are products of Picabia's
composition process and, by his own account, independent from direct
observation. Although there can be little doubt that in her early abstrac-
tions O'Keeffe used an improvised "musical" method without models,
based on her impressions of Art Nouveau, she did not stick with this
method very consistently or very long. Her own New York "things"
(1925–28) were not "abstractionist" but were abstracted from her ob-
servations of actual buildings and sometimes from photographs.

Did Picabia's "abstractionist," yet unmistakable, renditions of the
orgasmic aspects of sexual intercourse in his large-scale paintings of
1913–14 help trigger O'Keeffe's decision in 1924 to zero in on the
stamens and pistils of flowers? Was Picabia, in fact, the prime instigator

of her use of plant close-ups as visual metaphors for the human sexual act? For despite O'Keeffe's consistent, and defensive, denials that she intended to associate any of her flowers with sexuality, it is clear that she often did exactly that—and with increasing imaginative and innovative power. A vivid example is the great Jack-in-the-Pulpit series of March 1930, which she referred to as the "set of Jacks."[133] To see all six paintings hung together is to become freshly aware of how profoundly she transformed, modernized, and iconicized this almost banal, Symbolist-derived theme. And it seems a nearly perfect example of what William Rubin has called that "peculiarly modernist situation where iconography turns inward to engage style."[134] Each of the "Jacks" is essentially frontal and centric, but with its own highly decorative, Dow-like individuality; its own exquisitely nuanced color tones (especially notable are some of the minute gradations between black and white, the classic range of photography); and its own variety of textures (silk smooth to sandy to pitted) within the brush strokes, which unfailingly follow the ever-more-simplified outlines of her forms. According to O'Keeffe, "the last one in the set [had] only the Jack from the flower."[135] True. But this elongated phallic form, with its white aura and its echoing, seemingly pulsating outlines, gives the optical effect of exploding right out of its vertical format. And the image as a whole engenders a reading that seems closer to the votive power of a neolithic lingam sculpture than to even the most sophisticated and suggestive of botanical drawings. O'Keeffe's own primitivist phallic-form sculpture (plate 65) may have been a sort of prototype for this image, and *Drawing No. 13* of 1916 (location unknown) may have been as well.[136]

Final answers to the questions raised above may forever remain O'Keeffe's secret. But there can be little doubt that Picabia's work and ideas (especially his frequently expressed desire to make universals out of personal moods) helped to challenge and redirect her art in ways that were utterly distinctive from his influence on Stieglitz and the other 291 painters.

Despite the strategies of free play and sexual innuendo that she gleaned from Picabia, O'Keeffe's painting process was actually much closer to Matisse's, and so was her sensibility. As Caffin correctly observed in 1913: "Picabia's method . . . is the reverse of Matisse. . . . The latter's method involves a simplification that strips away as much as possible to the details of objective appearance. Picabia, on the other hand . . . does

not proceed from the concrete to the abstraction, but from the abstraction to a spiritual impression of the concrete."[137]

O'Keeffe had doubtless read the sober but radical statement made by Matisse in 1913 about the importance of seeking inspiration from the emotions, since it was quoted in full in Eddy: "A true artist . . . should not copy the walls, or objects on a table, but he should, above all, express a vision of color, the harmony corresponds to his feeling. And above all, one must be honest with one's self. If one feels no emotion, one should not paint. . . . While working I never try to think, only to feel."[138]

O'Keeffe almost never mentioned Matisse in her public statements, but the two best-known descriptions of her working processes do reveal how close many of her basic artistic values were to his. In 1958 she wrote to John I. H. Baur: "I think I would say that I have worked differently at different times. . . . From experiences of one kind or another shapes and colors come to me very clearly. Sometimes I start in a very realistic fashion and as I go on from one painting to another of the same thing, it becomes simplified till it can be nothing but abstract, but for me it is my reason for painting it, I suppose."[139] And in 1962 she told Katharine Kuh: "I rarely start anything that isn't pretty clear to me before I start. I know what I'm going to do before I begin, and if there's nothing in my head, I can do nothing. Work brings work for me."[140]

O'Keeffe saw the first American show of Matisse's work at 291 in 1908 and went "often" to see the Matisses exhibited at the Montross Gallery in 1915.[141] There is also little question that Stieglitz actively encouraged an aesthetic link between Matisse and O'Keeffe. Some visual evidence of this doubtless sincere (and shrewd) intention rests in a previously unpublished portrait of O'Keeffe taken by Stieglitz around 1921 (plate 53): in her left hand she holds Matisse's African-inspired bronze sculpture, *Small Torso with Head (La Vie)* of 1906, which Stieglitz owned at the time. Stieglitz may have considered the African aspects of the Matisse sculpture especially important to associate with O'Keeffe and her work. Having been in the vanguard of the American vogue for primitivism with his pioneer exhibition of African sculpture at 291 in 1914, he was well aware of it as a direct precursor for abstraction.

Despite all of this, very little has been written about O'Keeffe's Matisse connection. Probably the best-known article to couple her art with his is Lewis Mumford's "O'Keeffe and Matisse," originally written for the *New Republic* in 1927 and reprinted by Stieglitz for the catalog of her 1928 Intimate Gallery exhibition. Mumford did not offer a comparative analysis of each artist's creative process; instead, he presented two separate encomiums, concluding: "Miss O'Keeffe's paintings . . .

53. Alfred Stieglitz. *Georgia O'Keeffe: A Portrait,* c. 1921.
Palladium photograph, 9½ x 7½ in. (24.1 x 19 cm).
National Gallery of Art, Washington, D.C.;
The Alfred Stieglitz Collection, 1980.70.176.

would tell much about the departure of Victorian prudery and the ingrowing consciousness of sex in resistance to a hard external environment. . . . They reveal and refocus many of the dominant aspects of our time. It is the same with Matisse."[142]

O'Keeffe may never have paraphrased Matisse, but the two artists do seem to have shared a number of remarkably similar devotions, practices, and bents. As gifted colorists, both had a passion for flowers. Also a passion for light—to the extent that they each felt increasingly compelled to live where they could count on it daily, in Nice and in New Mexico. Both tried to extend the power of the decorative, but neither could stand to make an art that referred only to itself, for they were essentially Symbolists and sought endlessly to express themselves, often in self-portraits. Although acutely aware of the emotional and curative power of color, both used thin pigments. O'Keeffe never discussed why she did this, but Matisse said he liked his color to "breathe" through the surface. Both had a lifelong obsession with doors and windows, although O'Keeffe was primarily an outdoor artist and Matisse preferred to be inside, looking out. The images by both artists were profoundly informed by Japanese art principles.[143] Both made frequent use of an imaginary plumb line. As Matisse described it for himself in *Jazz* (1947): "Around this fictive line the arabesque develops. I have derived constant benefit from my use of the plumb line. The vertical is in my mind. It helps give my lines a precise direction. . . . I never indicate a curve . . . without a consciousness of its relation to the vertical."[144] In O'Keeffe's case, we have only to think of *Pink Moon and Blue Lines* (1923; Janet and Robert Kardon), *Corn, Dark I* (1924; Metropolitan Museum of Art), *Corn, Dark II* (plate 36), the Clam Shell series (1926; private collection), *Abstraction, Blue* (1927; Museum of Modern Art, New York), and *Black Place III* (1944; Estate of Georgia O'Keeffe), among others. Both artists strove to reduce nature motifs instead of inventing purely abstract forms, and both pursued a nonlinear artistic development—a backward and forward type of searching, and a self-conscious mining of their very first independent images for their later works. Both were intensely private about their work—fully convinced that it would speak for itself without the word—and neither was above a certain sardonic playfulness with the public.

Both Matisse and O'Keeffe were possessed of religious temperaments, but each took an isolated way toward the sacred and lived without commitment to an institution. They also shared a profound disappointment with the twentieth century and showed this by endeavoring to

record their perceptions and desires in forms meant to speak to, and through, the timeless. Both experienced ambivalent critical reception in their lifetimes—and immediately thereafter—and both reaped a certain disdain (even scoldings) from their contemporaries for their sometimes excruciating juxtapositions of color and for using themes irrelevant to modern life. Despite very real differences in their sensibilities—in ways deeper than gender—the protean Frenchman and the pioneer (but hardly provincial) American worked relentlessly to make images resonate enough to console and heal humanity.[145]

In 1908, at Stieglitz's request, Matisse wrote a short statement for *Camera Work* on photography. It bears repeating here:

> If it is practiced by a man of taste, the photograph will have an appearance of art. But I believe that it is not of any importance in what style they have been produced; photographs will always be impressive because they show us nature, and all artists will find in them a world of sensations. The photographer must therefore intervene as little as possible, so as not to cause photography to lose the objective charm which it naturally possesses, notwithstanding its defects. By trying to add to it he may give the result the appearance of an echo of a different process. Photography should give us documents.[146]

Like Matisse, O'Keeffe would use the "objective charm" of photography to further her studies of nature, but in visual language based on her own life experience.

54. Georgia O'Keeffe. *At the Rodeo, New Mexico,* 1929.
Oil on canvas, 40 x 30 in. (101.6 x 76.2 cm).
Private collection.

4 The Painter and the Photographer

I don't know what Art is. No one has been able to give me a satisfactory definition. Not being satisfied with the definitions, ideas, of what is Art the approach to photography has been fairly unprejudiced. It has been part of my searching and through the searching maybe I am at present prejudiced in favor of photography.

GEORGIA O'KEEFFE, 1922

Photography is not an art. Neither is painting, nor sculpture, literature nor music. They are only different media for the individual to express his aesthetic feelings; the tools he uses in his creative work. . . . [The photographer] who knows how to really photograph [can] channel the impulses of human beings and register the world directly.

ALFRED STIEGLITZ, 1922

For Stieglitz, as for O'Keeffe, the picture—whether a painting or a photograph—was made first in the mind, in the imagination. Yet each artist was profoundly aware of the core difference between their two modes of picture making: that painting is basically an art of suggested space and photography an art of literal time—i.e., the moment arrested by the speed of the shutter.

During the pluralistic decade in American culture between 1919 and 1929 O'Keeffe and Stieglitz were to borrow frequently, without saying so, from each other's medium to further their independent experiments in communicating through abstract form.[1] To get at the fullest content of the extraordinary pictures they made in this period, it is necessary to understand some of the richly contradictory ideas behind them. As Stieglitz wrote to Herbert J. Seligmann in 1923:

Photography can catch the essence of the moment. And if the photographer is synthetical in his choice of the moment he does something which the painter cannot do as well.—He achieves a sense of reality, an exactness of reality, a different kind of reality than a painter can put down when he synthesizes. What the photographer achieves is not greater. It is different in kind. It appeals more to the consciousness of today. . . . In short he deals with the problems related to those of the painter—the basic urge towards "art" being identical or very nearly related.[2]

The assertive tone here (not unusual with Stieglitz) belies his long, embattled efforts to prove that photography was a medium capable of having the significance of art. This letter also recapitulates some of 291's most cherished and productive distinctions between painting and photography—distinctions that O'Keeffe was absorbing during a watershed period in her art. The operative word is *synthetical.* Its use by Stieglitz not only assumes authorship as a given in photography, it implies that the hand and the mind are as necessary to photography as the machine.[3] He had always believed that emotion must precede form and took as a personal affront Eastman Kodak's famous promise "you push the button, we do the rest."

Despite all the vehement, thoughtful, and interesting opinions that appeared in *Camera Notes, Camera Work,* and elsewhere, nobody knew exactly what photography was or should be. Conventional wisdom held (then as now) that the camera "make[s] a picture of whatever it sees," as William Henry Fox Talbot first observed in 1844, and that the process is inherently modern, because it offers "cheap, prompt, and correct facts," as Lady Elizabeth Eastlake remarked in 1857.[4]

In his landmark essay "Pictorial Photography" (1899), Stieglitz chose first to pay tribute to his early mentor, the English Pictorialist Peter Henry Emerson, by a carefully selected quote from the latter's book *Naturalistic Photography* (also of 1899): "The painter learns his technique in order to speak, and he considers painting a mental process. So with photography, speaking artistically of it, it is a very severe mental process, and taxes all the artist's energies even after he has mastered technique."[5] With this courtesy out of the way, Stieglitz then disclosed his own imaginative answer to the perennial dispute at the heart of photography as art practice: he defined artistic photography as "the feeling and inspiration of the artist to which is added *afterward* the purely technical knowledge."[6] In 1901 Stieglitz was quoted by Charles H. Caffin

as saying (and not for the last time) that "unless photography has its own possibilities of expression, separate from those of the other arts, it is merely a process, not an art; but granted that it is an art, reliance should be placed unreservedly upon those possibilities, that they be made to yield the fullest results."[7]

The heroic newness of the 1911 Picasso show at 291 confirmed Stieglitz's worst fears that conventional photographs could never stand up to the abstract expression practiced by Cézanne, Matisse, and Picasso. Accordingly, for the next six or seven years he set himself the goal of reconceptualizing photography. This meant, on the one hand, a re-examination of the standards for optical truth, with special attention to lenticular space and to the process of creating a strong and readable composition with light. And, on the other hand, a full-scale exploration of the form-making innovations of early modernism.[8]

A characteristic action taken by Stieglitz toward this new goal appeared in the October 1911 issue of *Camera Work*. Sixteen gravures of his own, mostly recent "straight" photographs—including *Spring Showers* (1901), *The Hand of Man* (1902), and *The Steerage* (1907)—were presented in the company of a drastically simplified 1910 Cubist drawing by Picasso (plate 19).[9] By indirectly, but unmistakably, juxtaposing the echoing verticals and diagonals of *Spring Showers* with the straight lines and segments of Picasso's *Nude*, Stieglitz not only identified his image with Picasso's (making the photograph seem almost a precursor), he also deliberately set a new standard for straight photography as an expressive medium. This recognition, or conversion, resulted in his manifestolike reply to Heinrich Kühn in 1912:

You don't understand what Picasso & Co have to do with photography! . . . With Camera Work I will strive that once and for all one may get some idea of what has been accomplished artistically in photography . . . what *photography* essentially means . . . whether employed through the camera (photography in the purest sense) or through the painter with his brush (photography in an intellectual sense just as though a camera were used). Now I find that contemporary art consists of the abstract (without subject) like Picasso etc., and the photographic. . . . Just as we stand before the door of a new social era, so we stand in art too before a new medium of expression—the true medium (abstraction).[10]

Late in 1912 Stieglitz wrote to George D. Pratt, a member of the Photo-Secession: "Men like Matisse and Picasso, and a few others are giants. Their vision is anti-photographic. . . . It is this anti-photography in their mental attitude and in their work that I am using in order to emphasize the meaning of photography."[11] By his new term *anti-photography* Stieglitz apparently meant a downgrading of narrative content, using subject matter primarily to solve formal problems—as he thought Picasso and Matisse were doing. The term soon came to be linked specifically with abstraction—helped, no doubt, by Francis Picabia's presence at 291 early in 1913 and by such statements of his as this one (later printed in *Camera Work*): "Photography has helped art to realize consciously its own nature, which is not to mirror the external world but to make real, by plastic means, internal mental states. . . . The camera cannot reproduce a mental fact. It can only make real the immaterial or emotional fact: so that art and photography are opposites."[12]

Despite the camera's inherent literalness, every black-and-white photograph is an abstraction of sorts. It can generate and organize meanings independent of subject matter, due to a built-in potential for the illusionistic and the fictional. It can neglect everything not clearly visible on the surface of objects, as well as isolate forms unintelligible to the photographer's naked eye. It creates confusion about scale and gives contradictory spatial clues. And it transforms the colors of nature into a limited white-black range (or myriad tones of sepia, depending on the paper used). Stieglitz himself made only a few experiments with Auguste Lumière's autochrome color process shortly after it became available in 1907.[13] The black-white scale was, in fact, one of the more important distinctions and bonds between painting and photography at 291. As Paul Rosenfeld wrote in 1924: "Modern color, supposed to be anti-photographic, is indeed the close ally of Stieglitz's photography. The colorist in his medium, like the photographer in his own, is seeking in the phrase of Paul Strand 'to use the expressivity of the objective world for the end of fashioning there with subjective form.' He, too, is working from the rhythmic pattern established in him by his relationship to the object before him. And, in place of devaluating the art of the painter, the camera indeed sets him free to work with new intensity within his potential limits. . . . The struggle of the colorist is the struggle of the photographer . . . finely used and emotionally intensified against a world unwilling to read the language of the senses."[14]

For the major 291 artists and critics, abstraction became both the dividing line between and the common denominator for painting and

photography during 1913. To grasp the importance of this paradoxical fact, it is vital to understand what Stieglitz and the others meant by abstraction. Not an easy thing, for *abstraction* was an oscillating term, as was its designated opposite, *objectivity*. The fruitful pairing of these oddly matched concepts deserves a short history—not least because of the marked effect it would have on O'Keeffe's maturing style. Abstraction at this point meant "without subject like Picasso etc." That is, a concentration on form over subject matter.[15] Stieglitz's 1915–16 photographs, especially the 291 window series, all emphasize the essential lines and volumes of objects.

The next stage, already traced, was Stieglitz's brief but ardent encounter with Picabia's conviction that pure "abstractionism" was the natural tendency of modern thought. This was accompanied by parallel discussions with Marius de Zayas about the ability of photographed forms to reveal their own essence ("the plastic verification of fact").[16] It was also around this time that Stieglitz entered yet another stage of abstraction. Under the impetus of Paul Strand's new extreme close-ups of shadows, chairs, and crockery (c. 1916), Stieglitz began to move his camera ever closer to his sitters, isolating them from their backgrounds so that they became rhyming forms first and people second.[17] By 1918, when he began in earnest the cumulative *Portrait of Georgia O'Keeffe*, he was willing to let any part of the body stand for the whole. For Stieglitz, then, the close-up *was* abstraction. This is very clear from a letter he wrote to Sadakichi Hartmann in 1919: "I am at last photographing again. . . . All who have seen the work say it is a revelation.—It is straight. No tricks of any kind.—No humbug.—No sentimentalism.— Not old nor new.—It is so sharp that you can see the [pores] in a face —& yet it is abstract—All say that [they] don't feel they are conscious of any medium.—It is a series of about 100 pictures of one person [O'Keeffe]—heads & ears—toes—hands—torsos.—It is the doing of something I have had in mind for very many years."[18] This letter also seems to criticize the "tricks" of abstraction he had played with around 1916, allowing water reflections to cause a natural distortion in his *Shadows on the Lake* self-portraits.[19] In any case, he was never to distort form in the name of abstraction again.

In 1924, just before her only dual gallery exhibition with Stieglitz, O'Keeffe wrote to Sherwood Anderson: "My work this year is very much on the ground—There will be only two abstract things [in the show]—or three at the most—all the rest is objective—as objective as I can make it. . . . I suppose the reason I got down to the effort to be

objective is that I didn't like the interpretations of my other things."[20] Clearly, O'Keeffe was still in the process of changing her artistic goals —goals linked in new ways to photography.

The term *objective* has been associated with photography from its beginnings, even though the variations caused by camera position and different focal-length lenses make a completely unbiased objectivity impossible.[21] We do not see the world as the monocular camera does, even with one eye, because the scanning eye and the static camera have different optical systems, and because the brain makes compensations.[22] But for the 291 photographers and painters, objectivity was a working concept rather than a scientific term. It was Kandinsky who first conjoined the objective with abstraction in his influential essay "On the Question of Form" in the *Blaue Reiter Almanac*. As paraphrased and popularized by Arthur Jerome Eddy, Kandinsky's argument ran thus:

> Step by step the "objective," the photographic elements, are eliminated until in the end there may be no trace of any object, and with this elimination the spiritual content becomes plainer and plainer. . . . Objects need not necessarily be eliminated from a picture, but they should be used *not* for the sake of forcing their photographic likenesses upon the observer, but solely to more perfectly express the inner, the spiritual significance of a work. If a painter introduces a suggestion of a landscape or a bit of still life it should be for the purpose of making *his* meaning, *his* inner feeling plainer to the beholder, and not for the purpose of making a colored photograph of a field of flowers. Therefore it does not matter whether actual or abstract forms are used by the artist, so long as both are used to express spiritual values.[23]

Also at the crux of 291's concept of objectivity—for painting as well as photography—are the 1913 writings of Picabia and de Zayas published in *Camera Work* 42–43. In his "Preface," Picabia made a theoretical distinction between the "old objectivity" (the mechanical reproduction of the outside world, which no longer satisfies) and the "new objectivity" (the painter's representation of the complexity of his feelings before nature). De Zayas, in "Photography and Artistic Photography," defined "pure" photography as trying to get at the objectivity of form. And he concluded that an object was perfectly capable of standing for the artist's emotions.[24]

De Zayas's brilliant, if sometimes obscure, definition of objectivity

(which owed much to his own eye for caricature) was considerably reduced and clarified for photography by Paul Strand—in his words no less than his photographs. In his first article, "Photography," which appeared in 1917, Strand defined the essence of the medium as "an absolute unqualified objectivity" and called on the photographer to have "a real respect for the thing in front of him": "The objects may be organized to express the causes of which they are the effects, or they may be used as abstract forms, to create an emotion unrelated to objectivity as such."[25] This last sentence contains 291's concept of expressive straight photography at the zenith of its development. And when O'Keeffe wrote to Anderson about her intention to make her work "objective," it is quite likely that she meant the word in the paradigmatic sense that Strand presents it here. (The fact that she and Strand met at the time when his applauded piece first appeared adds to this likelihood.[26]) O'Keeffe's recognition that real objects could be represented as is, without abstraction, and still express her deepest feelings may therefore owe as much to Strand as to Stieglitz.

As her 1923 letter to Anderson makes plain, O'Keeffe's revived interest in depicting natural facts came out of her very real anger and resentment over the sexual interpretation of her abstractions by critics

55. Paul Haviland (1880–1950). *Marius de Zayas*, 1910.
Platinum print, 6⁵⁄₁₆ x 4⁹⁄₁₆ in. (16.3 x 11.7 cm).
Lunn Ltd., New York.

—to the point that she was regarded by the public as sex obsessed.[27] The close-up views of leaves and flowers that she began to paint in earnest in 1924 owe much to the same 291 synthesis of objective and abstract truth that had led Strand and Stieglitz to move their cameras ever closer to their subjects. By turning to photography in order to disassociate her painting from its sexual connotations, O'Keeffe was also being true to her own, extremely private, nature.[28] Although we know optical truth to have a variety of standards, the literal eye of the lens seems to have been ideally suited to a sensibility as reticent as hers, for it could combine intensity of feeling with a certain emotional detachment. For these reasons, and for others as well, she would become increasingly interested in combining the factuality of the straight photograph with what Picabia called "mental facts." Certainly the optical offered her a way to veil her subjective responses, to deny her body as the source for her vision. And she clearly hoped that the new accuracy of observation in her work would lead viewers away from their oversimplifications of her intentions. (O'Keeffe was not the first artist to turn to objectivity in order to get rid of overt sexual imagery.[29]) In addition, her traditional training may well have predisposed her to think of the camera's single-point perspective as truth, since it was similar to Renaissance linear perspective.[30]

The richly eclectic 291 concept of objectivity includes two other characteristics that would have recognizable effects on O'Keeffe's images. The first one is geometry. *Camera Work* critics, and Stieglitz himself, often stressed geometry as a means to attain universal truth in modern art—whether through objectivity or abstraction.[31] O'Keeffe had long worked with the ovoids and spirals of Art Nouveau, and Dow had seen to it that she was no stranger to geometry in composition. Nevertheless, in 1924 there does seem to be a sudden and marked concentration on ellipses and incomplete triangles—or, more accurately, on ovals containing, or contained by, V-shape structures. An excellent example is *Flower Abstraction* (plate 56). This work, as the title suggests, may be plausibly read as a pure abstraction or as an objective microscopic view of a flower's interior. It is structured on a series of repeating V shapes (petals), which unfurl from the bottom of the picture like a fan to reveal centralized clusters of oval forms. The composition's "aspiring" centricity (to use Rosenfeld's 1934 phrase about Stieglitz's photography) is enhanced by the vertical canvas itself and by the attenuated shape that divides the upper portion exactly in half, like some sort of tear or fissure. To be noted as well are the croppings of the forms by the frame, accentuating rather than diminishing the sense of the triangular and of

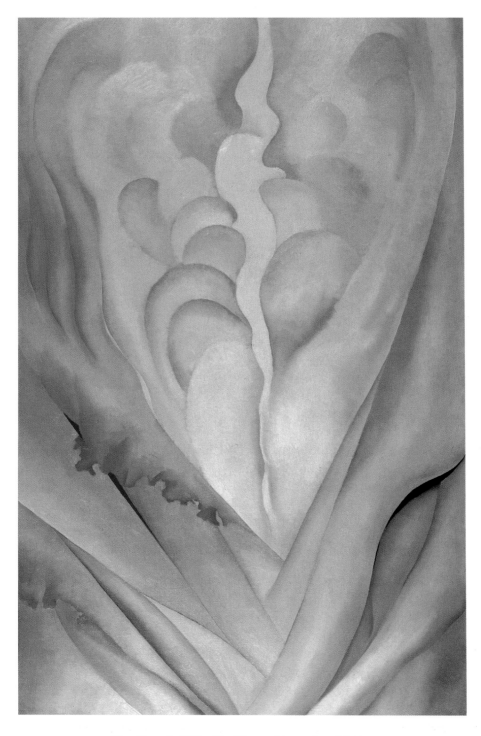

56. Georgia O'Keeffe. *Flower Abstraction*, 1924.
Oil on canvas, 48 x 30 in. (121.9 x 76.2 cm). Whitney Museum of
American Art; Fiftieth-anniversary gift of Sandra Payson.

botanical growth. As E. H. Gombrich, for one, has pointed out: "The incompleteness of familiar forms actually arouses our anticipations in an almost hallucinatory manner. Hence, perhaps, the increase in the impression of movement."[32]

The second characteristic of 291's concept of objectivity to have a recognizable effect on O'Keeffe's images is more complicated. It constituted an amalgamation of sorts with the rising American aesthetic of "place"—a new viewpoint that began about 1917 and culminated in the Precisionist movement in art and literature during the 1920s. The objectivist tenets of the Imagist poets were in great part responsible for this synthesis—mainly through the writings of Ezra Pound and William Carlos Williams.[33] Several of the key ideas from this experimental movement are cited here in their original form because of their direct effect on O'Keeffe's style and iconography—even though it is probable that she received them filtered through the words of others.

In his exhortatory article "American Painting" (1921) for the *Dial*, Rosenfeld called for more paintings like those by Albert Pinkham Ryder, which "speak to the American of what lies between him and his native soil."[34] Most influential of all on Rosenfeld, perhaps, was Williams's short-lived but well-circulated periodical *Contact*, published in four issues in 1920–21. Conceived for the purpose of spreading his conviction that the "art which attains is indigenous of experience and relations," *Contact* contained such important statements as: "We seek only contact with the local conditions which confront us. We believe that in the perfection of that contact is the beginning not only of the concept of art among us but the key to technique also. . . . If Americans are to be blessed with important work it will be through intelligent, informed contact with the locality which alone can infuse it with reality."[35]

The so-called rules of Imagism had been laid out by Ezra Pound in a 1913 issue of *Poetry* magazine. Urging the "direct treatment of 'the thing' whether subjective or objective," Pound asserted that "the natural object is always the *adequate* symbol [for poetry]."[36] Imagism's aims are graphically stated in a letter that Pound wrote in 1915 to Harriet Monroe (the founder of *Poetry*): "Objectivity, and again objectivity, and expression; no hindsight-beforeness, no straddled adjectives . . . nothing that you couldn't, in some circumstances, in the stress of some emotion, actually say. . . . When one really feels and thinks, one stammers with simple speech."[37] (Some ten years later Pound wrote to Stieglitz that they both "fought the same devils from different points of attack."[38])

The "local conditions" confronting O'Keeffe after 1918 were primarily those of Lake George, New York—Stieglitz's own locality—in

fact, the Stieglitz family compound. And the key to her unique objective technique was photography. It was at Lake George that her subject matter began to turn from the uterine-personal to shelter shapes of another order: namely the trees, barns, flowers, and fruit she saw around her. Just one example of her 1924 interest in particularizing the forms of ordinary things may suffice. It is *The Chestnut Grey* (plate 57), exhibited in the *Seven Americans* show. To compare this painting with Stieglitz's photograph *Dying Chestnut-Tree* (plate 58), exhibited in his 1921 Anderson Galleries show, is to see a rare instance of direct, and nearly untranslated, photographic influence in O'Keeffe's work. The tree is the same. And so is the angle. The compositions are nearly identical, although Stieglitz's camera was somewhat closer than O'Keeffe's eye, hence his croppings take off a little more of the branches. Only the season and the weather differ. Stieglitz's view must have been taken on a misty summer day (there are some leaves to be seen), whereas O'Keeffe's bare chestnut is in sharp silhouette against a cold blue sky. The formal impression made by these two images is so similar that it takes a while to see how cleverly the artists have reversed attitudes toward their mediums. O'Keeffe's painted tree is presented straight, with utter clarity and linearity, whereas the lines and details in Stieglitz's photograph are as blurred by mist and fog as if he had kicked the tripod. One can sense a certain satire in these two pictures—a tendency not uncommon to both artists. O'Keeffe was also, it is fair to say, re-examining and reaffirming Dow's old teaching that the essence of an object lies in its shape.

Stieglitz's cogent and idiosyncratic formalism is important to understand. It seems to have developed mainly, if unevenly, out of his mixed inheritance of Romanticism, Symbolism, and modernism—coming to full flower in the work he did from the mid-1910s through the early 1920s. Specifically, he was convinced of the purity, self-reflexivity, and absolute autonomy of the photographic work of art. He attempted, through his writings, to valorize the medium's most distinctive elements.[39] Furthermore, he regarded form and content as identical: "Shapes, as such, mean nothing to me, unless I happen to be feeling something within, of which an equivalent appears in outer form."[40] Stieglitz was also certain that photographs could convey revelation: " 'Songs of the Sky—Secrets of the Skies as revealed by my Camera' are . . . direct revelations of a man's world in the sky—documents of eternal relationship."[41] Reliable witnesses to Stieglitz's relentless talk in his galleries have stressed his democratic approach to viewing works of art, his belief that there should be an immediate response through the

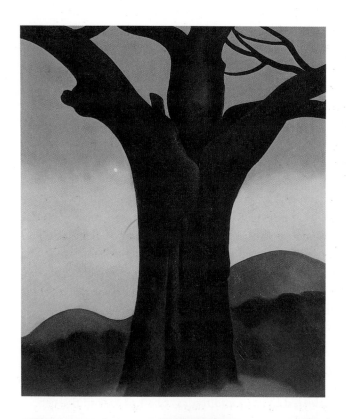

57. Georgia O'Keeffe.
The Chestnut Grey, 1924.
Oil on canvas, 36 x 30⅛ in.
(91.4 x 76.5 cm).
Private collection.

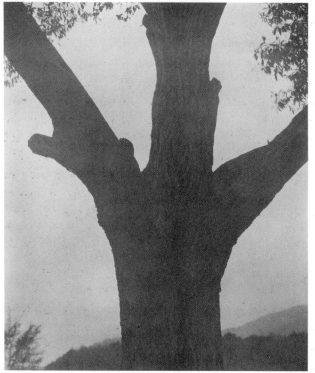

58. Alfred Stieglitz.
Dying Chestnut-Tree, 1919.
Palladium photograph, 9⅝ x 7⅝ in.
(24.5 x 19.3 cm).
National Gallery of Art,
Washington, D.C.; The Alfred
Stieglitz Collection, 1949.3.439.

eyes rather than through the intellect—a response that anyone, even a child, could have. "Art begins where thinking ends."[42] His understanding of the degree to which art lives in the viewer's response suggests that Stieglitz had come in contact with—and embraced—Leo Tolstoy's celebrated concept of the artist: "To evoke in oneself a feeling one has once experienced, and having evoked it in oneself, then, by means of movements, lines, colors, sounds or forms expressed in words, so to transmit that feeling that others may experience the same feelings—that is the activity of art."[43]

Stieglitz never summed up his views on photographic composition, but the writings of others close to him enable us to make an educated guess about his thinking on this slippery topic. Three statements, which span thirty years, seem particularly prescriptive, if somewhat conflicting. The first is an anonymous 1908 article from *Camera Work*, "Is Photography a New Art?"—parts of which sound suspiciously like Stieglitz:

[To] make a composition; it is essential that such elements should be present that some particular idea is conveyed to the mind of the spectator. . . . It is equally essential that no more elements than necessary shall be present. . . . [Composition] is a series of facts whose truth is purely dependent upon their special juxtaposition. . . . To compose is to give order. . . . All art is a matter of order, and nothing else, and where order has been produced, art has been produced.[44]

The author of the second is Sadakichi Hartmann, writing in about 1910: "Painting and Photography, true enough, are two entirely different propositions, but the fundamental principles of composition remain the same in all mediums of pictorial representation."[45] The last, by Edward Weston, is from his essay "Photographic Art," written for the 1941 edition of the *Encyclopaedia Britannica*. Stieglitz's favorable opinion of this essay can hardly be doubted, since he permitted the use of two of his photographs to illustrate it, much to Weston's amazed gratification.[46]

Nowhere has the painter's influence had a more lasting hold on photography than in the field of composition. . . . To compose a subject well means no more than to see and present it in the strongest manner possible. The painter and the photographer will have two different ways of doing this because of the basic differences between their mediums. Its capacity for rendering fine detail and tone makes photography excel in recording form

and texture. Its subtlety of gradation makes it admirably suited to recording qualities of light or shadow, and its ability to record sharply everything within the angle of lens-vision from the immediate foreground to the distant horizon carries it far beyond the painter's province. The photographer cannot depend on rules deduced from finished work in another medium. . . . An intuitive knowledge of composition in terms of the capacities of his process, enables the photographer to record his subject at the moment of deepest perception; to capture the fleeting instant when the light on a landscape, the form of a cloud, the gesture of a hand or the expression of a face, momentarily presents a profound revelation of life."[47]

Stieglitz was apparently in basic agreement with Dow, Hartmann, and Weston about what "good" composition was. Of greater interest to him, however (judging from his constantly inquiring and explaining presence at every one of the exhibitions he presented over the years), were the effects of composition on intelligibility and pleasure. It is composition, after all, that makes a picture a picture. And in photography, perhaps even more than in painting, it is the report of the event, not the event itself, that interests the viewer and causes him to think.[48] Thus, it is more than likely that composition's overriding purpose for Stieglitz was to enable a photograph to capture the viewer's attention and admiration for at least as long as a painting. (His own multiple and multivalent borrowings from paintings were carefully calculated to stretch the meaning of his photographs well beyond their exposed moments of time.) The fear that this might not be achieved may have helped to keep Stieglitz from hanging photographs side by side with paintings at 291, in spite of his forthright announcement in *Camera Work* in 1910 that "photography should take its place in open review with other mediums."[49] It would be O'Keeffe who finally inspired him to do so—with his own photographs of her at stake.

A dozen years later, with his old evangelical spirit still intact, Stieglitz founded yet another periodical: *Manuscripts*. Installing himself as adviser and Rosenfeld, Seligmann, and Strand as editors, he put out six issues of *Manuscripts* in printings of two thousand, from February 1922 through May 1923. In the spring of 1922 Stieglitz talked Strand into overseeing a fresh exploration of the perennial *Camera Work* question, "Can a Photograph Have the Significance of Art?" Believing that photography had achieved new significance since the Armory Show, Stieglitz and Strand invited forty friends and acquaintances in the arts who had

not previously written on photography to respond to the question in six hundred words or less. Thirty-one replies were received within a six-month period and were printed unedited in *Manuscripts* 4. Two respondents said they did *not* think photography could have the significance of art (Joseph Pennell and Kenneth Hayes Miller); three politely refused to comment (Charlie Chaplin, Charles Demuth, and Evelyn Scott); four dodged the question entirely (Sherwood Anderson, Arthur Dove, Marcel Duchamp, and Walter Lippmann); three chose to be equivocal rather than express their well-known commitments to the primacy of painting (Thomas Hart Benton, Oscar Bluemner, and Thomas J. Craven); and ten loyally asserted that only Stieglitz's photographs had so far attained the status of art (Ernest Bloch, Elizabeth Davidson [Stieglitz's niece], Alfeo Faggi, Waldo Frank [whose article "A Thought Hazarded" had so outraged Stieglitz that it served as his goad in "How I Came to Photograph Clouds"], Hutchins Hapgood, J. B. Kerfoot, John Marin, George Of, Georgia O'Keeffe, and Leo Ornstein). The other nine respondents did not speak to the issue at all.

A standout among the pieces was O'Keeffe's attempt to deal thoughtfully and analytically with the question:

> Photography is able to [register] the fleeting expression of a moment. . . . To me Stieglitz portraits repeat in a more recognizable way what he expresses with the photographs of trees, streets, room interiors, horses, houses, buildings etcetera. . . . They express his vision, his feeling for the world, for life. They are aesthetically, spiritually satisfying in that I can return to them . . . almost daily for the period of four years with always a feeling of wonder and excitement akin to that aroused in me by the Chinese, the Egyptians, Negro Art, Picasso, Henri Rousseau, Seurat etc., even including modern plumbing—or a fine piece of machinery. . . . [This last is clearly a reference to Picabia's mechanomorphic concerns.] Subject matter, as subject matter, has nothing to do with the aesthetic significance of a photograph any more than with a painting. . . . The object that is Art must be a unity of expression so complete that the medium becomes unimportant, is only noticed or remembered as an afterthought.[50]

The general consensus in *Manuscripts* was that photography's place in the creative arts was still a minor one. And, more specifically, that

photography was not truly aesthetic because it could only "isolate and register phenomena" instead of cause "new harmonious and sequential relationships out of memory and imagination," as Benton put it. It was O'Keeffe alone who cited the "new" photography of Strand ("he has bewildered the observer into considering shapes, in an obvious manner, for their own inherent value"); Charles Sheeler ("He is always an artist. He has done things with photography that he could not do with painting and vice versa"); and Man Ray ("I have not seen anything but reproductions of his work with the camera so have no definite idea of it excepting the fact that he seems to be broadening the field of work that can be done with it").[51]

There is ample proof in Stieglitz's correspondence with Strand that O'Keeffe's piece was an independent effort, that it was strongly felt, and that she strove hard to attain accuracy of expression. Stieglitz to Strand, August 18, 1922: "Georgia is still busy on her little piece on Photography. She writes and re-writes. Haven't seen anything yet—Naturally I'm curious to see what she'll evolve." And September 12, 1922: "Georgia is having an awful time getting something into shape for *MSS*. Working all day long for a week. She really ought to be painting. And still I suppose she needed this mental exercise."[52]

In her struggle to express her own aesthetic responses to photography, what O'Keeffe did, in effect, was to reduce a vast and contradictory array of 291 ideas and opinions down to three: (1) photography as "the fleeting expression of a moment"; (2) photography as abstract expression, with the potential to create "a music that is more than music when viewed right side up or upside down or sideways"; and (3) photography (Stieglitz's alone) as able to arouse the same daily "wonder and excitement" as ancient and modern art. Even today, these are still major and controversial issues in considering the aesthetic significance of the medium.[53] O'Keeffe also brought up an important point made by no one else in *Manuscripts:* "The painter as soon as he begins to paint almost unconsciously assumes himself the honored or unappreciated present representative of a glorious past tradition. The photographer has no great tradition. He must gain all the respect he is to have by what he himself can actually do." This deserves some comment because it shows O'Keeffe's special awareness of a generic, and too rarely considered, difference between the two mediums: although photography may use the formal characteristics and even the ideal of painting to create pictures, it does not belong to the millennia-old tradition of making manual transcriptions of meaningful reality. Like the modernist she was, however, O'Keeffe valued the lack of time-proven standards for photography.

What did the *Camera Work* and *Manuscripts* writers mean when they said photography was (or wasn't) art? Their general assumption appears to have been that art means the making of a picture as defined by the so-called Albertian tradition—that is, the presentation in linear perspective of a significant narrative seen as if going on inside a framed window. This Italian Renaissance notion of the picture lies at the heart of the rich concept of Pictorialism. It loosened radically for Stieglitz between 1908 and 1916, and even more radically with the Equivalents, but it never disappeared completely. It was while trying to absorb into his own photography the different ramifications of Picasso's and Picabia's abstraction that Stieglitz seems to have shifted to another early concept of picture making: that of the seventeenth-century Dutch painters, who tended to present the world as it is seen, on a small scale, instead of narrating significant human actions, as the Renaissance painters did. Northern pictures often look like fragments, with the view seeming to extend beyond the frame, thus giving the viewer a powerful sense of the picture as a surface rather than a "window" on the world.[54] From 1910 on, and particularly between 1915 and 1916, Stieglitz showed a new interest in taking straight photographs that were calculated to reveal "truth" about life and the world, as he grappled with what he called "the fundamental idea of photography."[55] Again like seventeenth-century Dutch paintings, these photographs may be said to add up to a world, but they do not aim to order or narrate it.[56]

The basic, and most devastating, criticism of photography as an art made by the *Camera Work* and *Manuscripts* writers was that "ideas of the imagination [are] outside the range of the photographic point of view," as Caffin (possibly paraphrasing Charles Baudelaire) put it in 1908.[57] Or as Picabia often said, "You can photograph as much as you like but you can't photograph what is in my head." While understanding that photographic meaning depends on context, Stieglitz found a way to bypass the seeming objectivity of the photographic process. Again inspired by Symbolist notions of correspondence and suggestion, he tried to make what he (and Dow) called "visual music."[58] Later he would even use the word *imagination* in discussing one of his photographs at the Intimate Gallery: "That—what you see—is not an apple tree nor raindrops nor a barn. It is shapes in relationships, the imagination playing with the surface. Perhaps the raindrops are tears."[59]

In his unshakable belief that photography could combine science and art, Stieglitz showed a profound, if instinctive, understanding of both art history and camera history.[60] As Leon Battista Alberti's *Della Pittura* (1435) attests, Renaissance linear perspective came about primarily

through the efforts of artists to represent what they thought we really see—i.e., "realistic pictures."[61] Many of the most highly regarded of Stieglitz's photographs are, without question, the direct result of technical experiments, such as the bad weather and nighttime views he took of New York City at the turn of the century and his later pictures of the landscape around Lake George.

With the arrival of O'Keeffe in his life came the greening of Stieglitz's old Symbolist concern with the image as an equivalent for his emotional state. And his pictures, which had already joined such opposites as objectivity/imagination and science/art, again became hybrids of opposite tendencies—this time of the descriptive and the suggestive. From then on, he would find universality and revelation in O'Keeffe's face and figure and in the Lake George countryside. In the end, perhaps, what finally stood Picabia's notion of "abstractionism" on its head for Stieglitz in the late 1910s were three things: 291's failure to interest America in the relevance of modernism, his subsequent decision to define and support a native American art rooted in American experience, and the rejuvenative effect of O'Keeffe on his own life and work. "Abstractionism" simply wasn't large enough, or flexible enough, for the creative tasks newly at hand. Besides, he was never really aesthetically indifferent to his subjects, even when he was trying hard to be. After all, the view from 291, O'Keeffe's body, and even the clouds above the hills of Lake George were very close to his heart.

Objectivity and abstraction first came together for Stieglitz during the summer of 1923 with his Songs of the Sky (see plate 59), in which he used clouds "to put down the philosophy of my life" in photographs that "look like photographs." He wrote to Hart Crane later that same year: "I know exactly *what* I have photographed. I know I have done something that has never been done—May be an approach occasionally [found] in music.—I also know that there is more of the really abstract in some 'representation' than in most of the dead representations of the so called abstract so fashionable now.—I have scientific proof to show the correctness of that statement. The camera is really a wonder instrument—if you give it a chance."[62] Stieglitz's representational clouds are "really abstract" primarily because he cut their moorings to the landscape. Without orientation in time or place they float freely in an infinite space as shapes and patterns. In 1925 Stieglitz would further the abstraction of his cloud photographs by calling them Equivalents—in effect doing away with the sky itself as a reference point.[63]

The three-way link between music, abstraction, and "scientific proof" in the letter to Crane is also significant. As early as 1911 Caffin

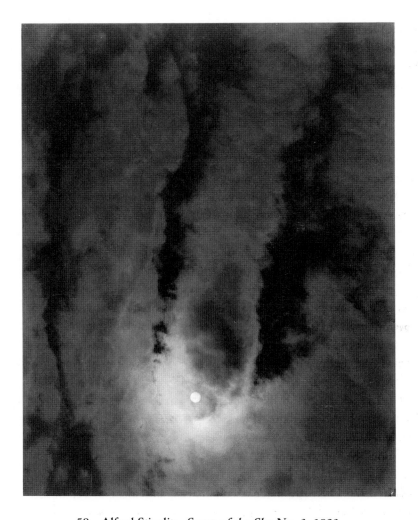

59. Alfred Stieglitz. *Songs of the Sky No. 3,* 1923.
Silver print, 4 x 5 in. (10.2 x 12.7 cm). Museum of Fine Arts, Boston;
Gift of Alfred Stieglitz, April 1924.

had written of Cézanne's "scientific attitude of mind," noting that he had "subjected his sensations to logical analysis, tried to formulate them on the basis of reasoning and to realize them in a manner that would stand the test of scientific scrutiny." [64] Music had, of course, long been regarded as "mathematical" and "scientific." And many American artists and critics were quick and eager to emphasize the relationship of abstraction to science and to progress in modern life[65]—a notion that came to perhaps its fullest visual and verbal expression in March 1916 with *The Forum Exhibition of Modern American Painters.*[66]

During the years 1918–25 abstraction and objectivity would be thoroughly, if differently, reconciled in theory and practice by Stieglitz

and O'Keeffe as they worked together at Lake George.[67] When Strand wrote a review of O'Keeffe's 1924 Anderson Galleries show, he stressed the unity of abstraction and objectivity in her work—further proof that a new tradition for the "native American artist" was being established:

> [O'Keeffe's] projection of experience is as often made upon objects which would be called "representative," a cana [sic] lily, a few apples or plums, as that which is miscalled "abstract" only because it is less easily recognizable. The hocus pocus of aesthetic lingo may have its value in aesthetics but in life it is evident that there is no such thing as "representation" in itself and that "abstraction" is merely quantitative extension, or simplification, not necessarily more potent, in the perception of objectivity. . . . Nor is it the method or way of perceiving objectivity which holds any particular virtue of itself, but only the quality and profundity of experience released thereby, that is of importance. It is this latter which is the true abstract, "significant form" or whatever you want to call it and it exists not less, as the enduring living element, in the "representations" of Memling or Dürer, as in the "abstractions" of Picasso or Marcel Duchamp. And like Picasso, O'Keeffe moves freely both in method and medium. Her work, like his, exhibits the same intensity of expressiveness whether it appears as "representation" or "abstraction."[68]

In 1976 O'Keeffe made a culminating statement of her own: "It is surprising to me to see how many people separate the objective from the abstract. Objective painting is not good painting unless it is good in the abstract sense. A hill or tree cannot make a good painting just because it is a hill or a tree. It is lines and colors put together so that they say something. For me that is the very basis of painting. The abstraction is often the most definite form for the intangible thing in myself that I can only clarify in paint."[69]

Each of the central 291 distinctions and connections between painting and photography seems to carry its own contradiction. No one quite managed to express in a concise way something Stieglitz knew perfectly well: that the "fleeting expression of a moment" (O'Keeffe's words) is actually a replication, or copy. And that the photographer is able to be an artist only before and after the camera clicks, not during, whereas the painter has *no* such creative interruption. To fill in this permanently missing gap, Stieglitz conceived perhaps his most imaginative and sci-

entific strategy: the narrative as told by a series of arrested moments. It was through his serial imagery (practically as old as the photographic medium itself) that he added most to photography by chronicling both the artistic and psychological evolution of O'Keeffe and his own "philosophy of life" in the cloud Equivalents.

Stieglitz's other strategies are best summed up by his own statements:

> What I'm after is the A.1.-1. from each negative. When I get that as I sometimes do, the print *lives*—it is ART. It satisfies aesthetic requirements.[70]

> It's just 40 years ago I began my photography—& over 35 years since I began consciously to work at the "liberating" of photography. . . . Photography is an addition in the scientific sense of the word addition. It doesn't *kill* anything that has ever contained *soul.*—. . . In trying to establish photography as an ideal I ran into the world—& good & hard up *against* it—. . . So . . . I ever moved ahead as a scientist. To establish & then try to destroy what I had established if it could be destroyed. If it couldn't something of value in the sense of addition had been established.[71]

> Yes there seems to be millions on millions of photographers, & billions of photographs made annually but how rare a really fine photograph seems to be. . . . Its a pathetic situation.—So little vision. So little true *seeing.*—So little *inness* in any print.[72]

Like many great aesthetes, Stieglitz was expert at having arguments both ways. O'Keeffe listened to him, and, for a time crucial to the development of her own art, she believed.

In November 1922 the aspiring young photographer Edward Weston noted in his *Daybooks* that when he took his work to New York to be reviewed by Stieglitz, O'Keeffe shared equally, and with marked perception, in the responsibility of evaluating it.[73] In December of that same year, O'Keeffe stated: "Nothing is less real than realism. . . . Details are confusing. It is only by selection, by elimination, by emphasis, that we can get at the real meaning of things."[74] By 1922, then, photography had become an unrivaled tool for simplification, objectivity, and abstraction in O'Keeffe's painting. In her ever-constant search for the essence of forms, she would use this tool with increased secrecy and virtuosity.

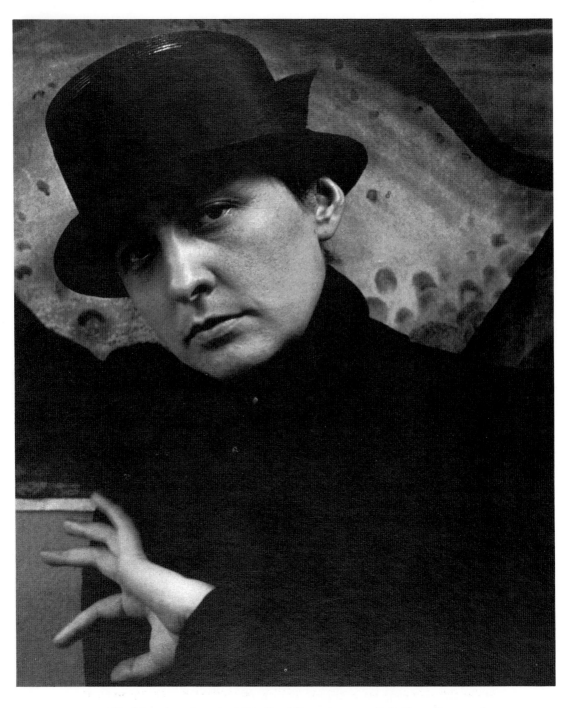

60. Alfred Stieglitz. *Georgia O'Keeffe: A Portrait*, 1918. Palladium photograph,
9½ x 7⅝ in. (24.2 x 19.2 cm). National Gallery of Art, Washington, D.C.;
The Alfred Stieglitz Collection, 1980.70.67.

5 Portrait of Georgia O'Keeffe

Man, the male, has thus far been the sole creator of ART. *His* art—as until most recently he looked upon Woman as *His.* . . . If . . . Woman produced things which are distinctively feminine can live side by side with male produced Art—hold their own—we will find that the underlying aesthetic laws governing the one govern the other—the original generating feeling merely being different. Of course Mind plays a great role in the development of Art. Woman is beginning —the interesting thing is *she has actually begun.*

ALFRED STIEGLITZ, 1919

When I look over the photographs Stieglitz took of me —some of them more than sixty years ago—I wonder who that person is. It is as if in my one life I have lived many lives. . . . His power to destroy was as destructive as his power to build—the extremes went together. I have experienced both and survived, but I think I only crossed him when I had to—to survive. . . . His eye was in him, and he used it on anything that was nearby. Maybe that way he was always photographing himself.

GEORGIA O'KEEFFE, 1978

For a good twenty years, beginning in 1917, O'Keeffe worked as an artist while being the subject/object of Stieglitz's camera. In the essentially allegorical *Portrait of Georgia O'Keeffe* she is often presented, at one and the same time, as his muse and her own. In fact, the more we look at these photographs—especially the early ones—the more uncertain we become about whose portrait it really is. What seems clearest about the series is that it was intended to be read on several registers, as all allegories are. How, over half a century later, are we to understand and evaluate it? Since the major documentary source (the Stieglitz-O'Keeffe correspondence) is still restricted, answers to these questions

can be only provisional. But there may, in fact, be more self-disclosure in the photographs than in the letters, and certainly much can be learned from studying them chronologically—particularly those made during 1918, when "the sweet hell within" (as Walt Whitman called it) drove Stieglitz to make images that he hoped would capture his vision of O'Keeffe.

What was this vision? Not an easy one to grasp, assembled as it was from bits and pieces of honest thought, deep emotion, Symbolist ideals, "scientific" beliefs, domestic realities, pictorial conventions, and the books Stieglitz was reading. (Prime among these were Goethe's *Faust;* Gustave Flaubert's *Madame Bovary,* which he read aloud to O'Keeffe the summer of 1920; D. H. Lawrence's *Lady Chatterley's Lover,* sent to him by Lawrence; Sherwood Anderson's *Winesburg, Ohio;* and Waldo Frank's *Our America.*) There is, nonetheless, an eerie exactitude about this series that helps us decipher it. Perhaps the first thing to grasp is that the *Portrait* is a palimpsest of Stieglitz's most cherished ideas, especially about art and women. The second is that the *Portrait* is, in a sense, a pictorial creation myth: Georgia O'Keeffe as the "spirit of 291" transformed into "Georgia O'Keeffe, American." Because of the documentary lacunae and, most of all, because of the metaphoric nature of this material, it seems best to take a pluralist approach to it. The most vibrating issues (particularly those raised by the nude photographs) seem to fall all too neatly within the purview of current feminist thought, but the *Portrait,* seen in its entirety, is far from being a gross misconception of the feminine.[1] Rather, it is full of a range of human truths (including comicality)—some, it must be said, easier to swallow than others.

The photographs and paintings made by Alfred Stieglitz and Georgia O'Keeffe during the first eighteen months of their relationship were shown together by him to a highly select audience beginning in January 1919. The setting for these works was not a gallery; Stieglitz had been without one of his own since the closing of 291 in 1917. It was a small two-room studio, where the couple was then living, located on the top floor of a brownstone on Fifty-ninth Street, just behind the Anderson Galleries. There is much we do not know, and may never know, about this informal presentation: Were all the works framed? Were they presented side by side or in separate groupings? Were they hung, hand-held, or propped against the walls? That they were on view in the same small room is fairly certain since, as O'Keeffe has written, "the studio was bright with a north skylight and two south windows . . . [whereas] the room back of the studio had a rather narrow window opening into a small court so it was not very light."[2]

Stieglitz's letters to Strand that winter and spring convey his own pride and excitement over the success of the experiment:

> 114 East 59th quite a centre. Seeing Georgia's work. And mine. Everyone surprised greatly at both. Great strides forward. [Leo] Stein very much impressed.—And others of repute and value equally moved. [Specifically, Arthur B. Davies, who had helped to organize the Armory Show, and Frank Crowninshield of *Vogue*.]

> Visitors galore all coming to see our work. There has been but one opinion—opinion is not the word—All say our work is unlike anything they have ever seen.—And it is—Both very direct—very powerful—very beautiful.

> Is it a madness to produce as we are producing—and living as we are living—in the center of the maddest city that ever happened—mad—soulless—cruelly heartless?[3]

Although a precise list of these photographs and paintings has not been found, it is safe to assume that paramount among Stieglitz's photographs were his earliest portraits of O'Keeffe, including those that presented her posing in front of her own work. Some of these come across as a weird mix of private poetry and public advertisement, for in them the strange beauty of the artist is extolled (by her lover) and identified with the strange new beauty of her art (by her dealer).

One highly charged 1918 portrait (plate 62) is a good case in point, revealing some of the unique ways O'Keeffe inspired Stieglitz's renewed rush of picture making. It is an entirely different kind of abstraction from the Picabia-type "abstractionist" pictures that Stieglitz had exposed from the window of 291 during the winter of 1915–16. Here he has taken his compositional cue from O'Keeffe's own large, undeniably erotic abstraction in the background.[4] And the ways Stieglitz has insisted that this drawing be seen as an extension of the artist herself tell us much about his ability to generate emotional meaning by relating subject to background in a very shallow space. Consider first the curious, almost conjuring pose of her arms. The zigzag diagonal caused by this gesture effectively divides the composition into two echoing tiers. The shapes of her left hand and the pale oval of her face surrounded by dark hair in the lowest tier are repeated in the one above by her right hand and the light ovoid form of her drawing. Did Stieglitz mean O'Keeffe's highlighted left thumb to be read as if it were an arrow pointing to her head,

the place where she had always said her abstract images came from? And did he intend the linear dialogue between O'Keeffe's deeply incised palm lines and the dynamic lines of her drawing? Both are in equally clear focus, and the implication for the viewer is that they are both connected to her personal identity. Judging from other pictorially sophisticated photographs of his that go back as far as *Sunlight and Shadows: Paula/Berlin* (1889), these speculations and observations are valid ones.[5] Finally, the optical image of O'Keeffe as a kind of modern sorceress projects a Symbolist meaning similar to de Zayas's caricature *L'Accoucheur d'idées* (plate 61), which presents Stieglitz as a seer. Stieglitz's image is an expression, perhaps, of the "oneness" with O'Keeffe that he felt during this period and often mentioned in his correspondence.

From this complex, conspiratorial photograph we can begin to understand how insistently and with what emphases Stieglitz was shaping his vision. More was to come. During the summer and fall of 1918 he made approximately ninety-five finished prints that measured up to the standards he had set for a projected photographic "diary" of O'Keeffe.[6] It is by far the richest year of the *Portrait*, in number and in iconography. The categories, or groups, into which these photographs fall are significant for Stieglitz's purposeful tally of O'Keeffe's many "selves." The largest group, some twenty photographs, presents her, or parts of her

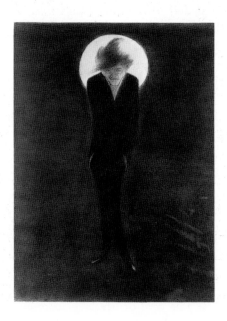

61. Marius de Zayas (1880–1961). *L'Accoucheur d'idées,* c. 1909. Charcoal on paper, 24½ x 18¾ in. (62.2 x 47.8 cm). The Metropolitan Museum of Art, New York; The Alfred Stieglitz Collection, 1949.

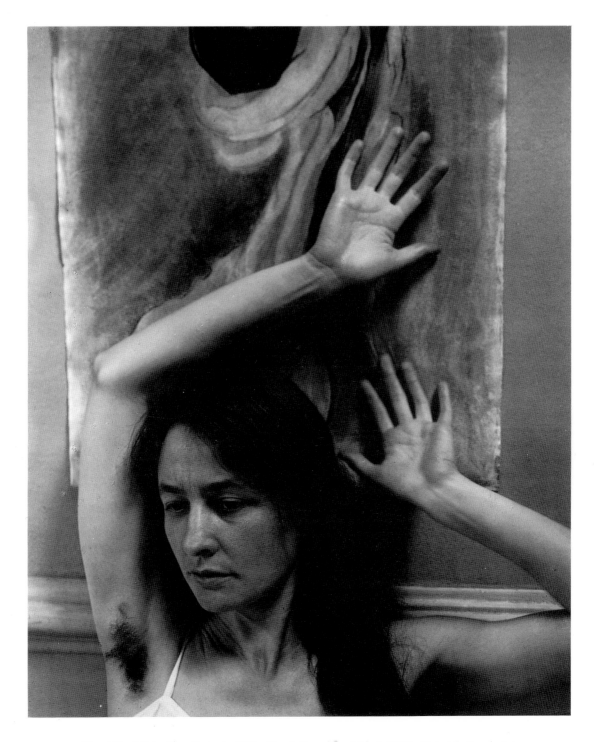

62. Alfred Stieglitz. *Georgia O'Keeffe: A Portrait—Head,* 1918. Gelatin silver print,
9¼ x 7¼ in. (23.5 x 18.4 cm). National Gallery of Art, Washington, D.C.;
The Alfred Stieglitz Collection, 1980.70.19.

body, in front of her work. There are eighteen nude photographs: three full nudes, ten torsos, and five head-and-torso views (two of these with her hands on or over her breasts). The dubious taste of passion almost never intrudes on their dignity or their particularity. There are fifteen close-ups of the head alone; fifteen of the head framed by gesticulating hands; nine of hands alone; four extreme close-ups of hands pressed against face; two of hands and feet, one of arms and legs, and one of legs alone. Three photographs show her in the same seated pose, from slightly different angles, holding some branches of leaves. Two others catch her (like a snapshot) sitting at the edge of a flower bed, with her paint box, at work (plate 32).

Even allowing for Stieglitz's purely visual impulses before a face and body as distinguished as O'Keeffe's, there appear to be several major and minor themes within these categories, and they often intersect, or elide. Some seem clear; others do not. To work in two minds, often adding contradiction to contradiction, was normal for a Symbolist artist like Stieglitz. Of overriding importance are the many images celebrating O'Keeffe in front of her work. This physical link of the artist with her

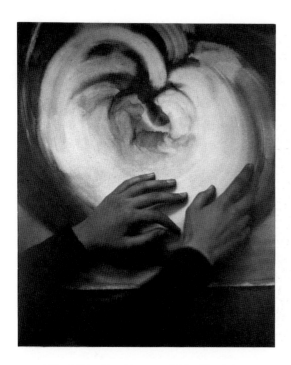

63. Alfred Stieglitz. *Georgia O'Keeffe: A Portrait— Hands and Watercolor, June 4, 1917,* 1917.
Platinum photograph, 9⅝ x 7⅝ in. (24.6 x 19.5 cm).
National Gallery of Art, Washington, D.C.;
The Alfred Stieglitz Collection, 1980.70.3.

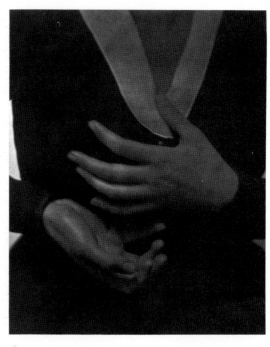

64. Alfred Stieglitz. *Georgia O'Keeffe: A Portrait—Hands,* 1917. Platinum photograph, 8½ x 6¾ in. (21.6 x 17.2 cm).
National Gallery of Art, Washington, D.C.;
The Alfred Stieglitz Collection, 1980.70.4.

art was established in the first photographs Stieglitz ever took of her, in June 1917. Of the four 1917 portraits in the key set at the National Gallery of Art, three show O'Keeffe in front of a fetuslike abstract watercolor (still unidentified) in her one-person show at 291. Two of these photographs are close-ups of her hands: in one (plate 63) they are placed directly against the fetus form, and in the other (in which the painting itself is not visible), her hands are positioned as if to summon up exactly the same configuration (plate 64). The rather explicit subject matter in this watercolor suggests that Stieglitz took his major ideological cue directly from O'Keeffe that the art of women was "differentiated [from that of men] through the difference in their sex make-up," and that "Woman receives the World through her Womb . . . the seat of her deepest feeling"—as he would write in 1919.[7]

The fourth 1917 photograph (plate 65) may be said to presage a second (and related) theme of the *Portrait*—the artistic joining of the male principle with the female. It shows O'Keeffe's plasticene phallic-form sculpture placed close to *Drawing No. 12* of 1917 (location unknown), with their sexual connection unmistakably implied. It is es-

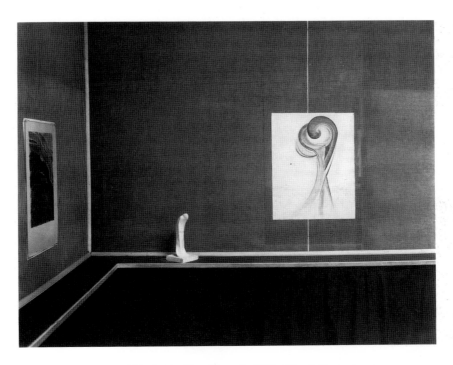

65. Alfred Stieglitz. *Georgia O'Keeffe: A Portrait,*
Show at "291," 1917, 1917.
Gelatin silver print, 7½ x 9⅝ in. (19.1 x 24.4 cm).
National Gallery of Art, Washington, D.C.;
The Alfred Stieglitz Collection, 1980.70.5.

pecially revealing that this photograph was made before Stieglitz and O'Keeffe became lovers, since some of the more explicit 1918 and 1919 photographs on this theme (for example, plates 9 and 62) were shown by Stieglitz in 1919 and 1921 and were almost immediately interpreted as proof that O'Keeffe had created her abstract images from the specificity of her own sexual experience. (Hence Hartley's description of her pictures as "living and shameless, private documents," and Rosenfeld's comment that "her great painful and ecstatic climaxes make us at last to know something the man has always wanted to know," both of 1921.[8]) There can be little question that Stieglitz encouraged—even orchestrated—this none too subtle form of "arousal by image" (in David Freedberg's telling phrase[9]) to alert the New York art world to Georgia O'Keeffe. That said, however, the *Portrait* as a whole is a complex and intimate dialogue between two gifted artists who never denied the erotic aspect of true understanding between men and women.

One of Stieglitz's first, and most constant, claims for O'Keeffe was her originality. How better to suggest this than by presenting the woman artist as both self-referential *and* self-fertilizing? What was nascent in the 1917 photograph of her work (plate 65) became a major theme, with many variations, throughout the *Portrait,* perhaps manifesting itself most fully in the frankly androgynous character of some of the images.[10] Among the oddest, or most esoteric, of these is the close-up *Feet and Sculpture* (plate 66). In combining O'Keeffe's phallic-form sculpture with her feet (not the likeliest of formal compositions), Stieglitz must have been aware, semiconsciously at least, of the foot as a symbol. Frequently regarded as phallic (particularly in Freudian terms), the foot, because it serves to support the body, is also a familiar transcultural symbol of the soul. A somewhat clearer example of this self-fertilization theme is a

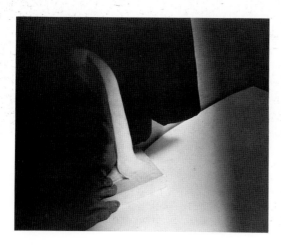

66. Alfred Stieglitz.
Georgia O'Keeffe: A Portrait—
Feet and Sculpture, 1918.
Gelatin silver print,
7½ x 9 in. (19 x 22.9 cm).
National Gallery of Art,
Washington, D.C.; The Alfred
Stieglitz Collection, 1980.70.56.

67. Alfred Stieglitz.
Georgia O'Keeffe: A Portrait—Sculpture, 1920.
Palladium photograph, 9⅝ x 7⅝ in. (24.4 x 19.6 cm).
National Gallery of Art, Washington, D.C.;
The Alfred Stieglitz Collection, 1980.70.149.

68. Auguste Rodin (1840–1917). *Standing Female Nude, Squeezing Breasts Together,* c. 1900. Ink and wash on paper, 14 x 9½ in. (35.6 x 24.1 cm). The Rodin Museum, Philadelphia; Gift of Jules E. Mastbaum.

69. Alfred Stieglitz. *Georgia O'Keeffe: A Portrait—Hands,* 1919. Gelatin silver print, 9⅜ x 7½ in. (24 x 19 cm). National Gallery of Art, Washington, D.C.; The Alfred Stieglitz Collection, 1980.70.119.

70. Alfred Stieglitz. *Georgia O'Keeffe: A Portrait—Hands and Grapes,* 1921. Palladium photograph, 9⅝ x 7⅝ in. (24.4 x 19.6 cm). National Gallery of Art, Washington, D.C.; The Alfred Stieglitz Collection, 1980.70.164.

1920 close-up of O'Keeffe's left hand holding her phallic sculpture toward the camera so that it almost fills the picture frame (plate 67). Perhaps the clearest photograph of all in this mode is the 1918 torso-length photograph of O'Keeffe in her kimono in front of *Drawing No. 15* of 1916, squeezing her exposed breasts together. This unusual erotic gesture, which comes straight from a Rodin drawing (plate 68) exhibited at 291 in 1908, strongly suggests that her hands (the makers of her art) are receiving direct nourishment from her breasts.[11] During 1919 and the early 1920s there are other, more abstract, examples on this same strange theme, with close-ups of O'Keeffe's fingers ostentatiously squeezing, or plucking at, applelike forms and grapes (plates 69 and 70), both symbols for breasts used by artists over the centuries.[12] (Lucas Cranach the Elder, for example, equated apples with the breasts of the

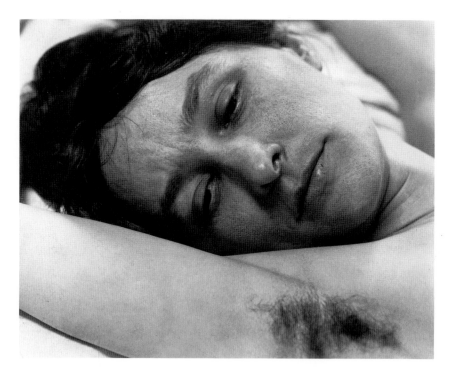

71. Alfred Stieglitz. *Georgia O'Keeffe: A Portrait—Head,* 1918. Gelatin silver print, 7½ x 9⅛ in. (19 x 23 cm). National Gallery of Art, Washington, D.C.; The Alfred Stieglitz Collection, 1980.70.17.

nursing mother in his painting *Caritas,* a work that Stieglitz could have seen in the Weimar Schloss Museum during his years in Germany.)

The androgynous character of many of Stieglitz's photographs of O'Keeffe has often been noted, to the point of taking them as evidence that she was bisexual.[13] Whether she was, or was not, it is highly probable that Stieglitz stressed the androgynous in the *Portrait* for his own purposes—prime among them being the idea of self-fertilization. Among the earliest of this type are two images of her standing before her work (plates 60 and 73). Her long hair is completely hidden by the bowler hat jammed over her eyebrows, and her clothes are so unisex that she could be either a boy or girl.

The androgyne is a tricky archetype, regarded differently in different cultures. Androgynes can be good or bad in a moral or symbolic sense, but male androgynes are generally regarded as positive and female ones as negative. The major source for the androgynous myth, and its attendant symbolism, is not the rare physiological hermaphrodite but the psychological androgyne. According to the mythologist Wendy Doniger O'Flaherty, the latter condition may be achieved in three ways: by a

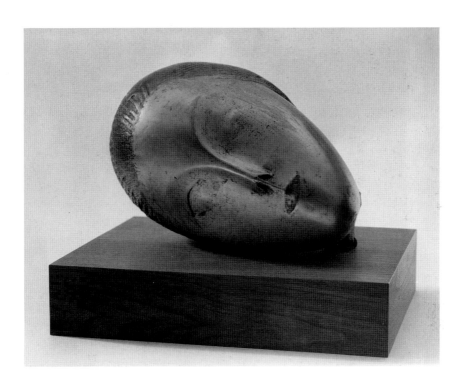

72. Constantin Brancusi (1876–1957). *Sleeping Muse,* 1910. Bronze,
6¾ x 9½ in. (17.1 x 24.1 cm). The Metropolitan Museum of Art;
The Alfred Stieglitz Collection, 1949.

"splitting," where the individual must learn to be one sex or another in order to become truly human (aided by surgery and/or psychoanalysis); by a "fusing," a sort of mystical or religious realization of nonduality in order to become psychologically whole; or by "the two-in-one"—a man and woman who join in the ecstatic union of perfect love.[14] It is this last, and most widespread, concept of androgyny as a profound human truth that Stieglitz seems to have expressed, consciously or unconsciously. It was, in any case, what apparently moved him to see and feel O'Keeffe as a "purer form of myself" (the spirit of 291), and to portray her, especially in 1918–19, as if he and she were two bodies with one mind. Later, during the 1930s, when she had gained full psychological independence from him, he would image her in ways astonishingly close to the current feminist meaning of androgyny: that is, as a person able to be "rational and emotional, strong and nurturant, assertive and compassionate, depending upon the demands of the situation."[15]

Even as Stieglitz stressed the self-referentiality and self-fertilization of O'Keeffe throughout the *Portrait,* he was simultaneously recording his own past history as a crusader for "the new"—hence all of his visual

connections of O'Keeffe to the titans of European modernism he had introduced to America. An ingenious example is a 1918 horizontal close-up of O'Keeffe's head, with her eyes half-closed, taken as she lay in bed with her cheek pillowed on her upper arm (plate 71). The visual parallel to Constantin Brancusi's egglike sculpture *Sleeping Muse* (plate 72) is as apt as it is striking, since Stieglitz had given Brancusi his first one-man show anywhere just four years earlier.[16]

In sizing up the aesthetic pleasures and sociological discomforts of the nudes in Stieglitz's *Portrait,* the first question that comes to mind is why did O'Keeffe, already a master-spirit in her thirties (who was also a committed feminist and suffragist), pose for them? One answer might be that "symbolic power is invisible and can be exercised only with the complicity of those who fail to recognize either that they submit to it or that they exercise it," as Linda Nochlin has written in another context.[17] But there are other answers as well. O'Keeffe was deeply in love with Stieglitz and knew he was in love with her; she believed in his art; she was being supported and housed by him so that she could at last devote herself to her own art. But none of these reasons really satisfy or suffice. It may be somewhat closer to the bone to say that O'Keeffe sincerely believed herself to be participating in a classic situation of art making—one she could understand from both sides, having taken life classes herself. Further, she surely knew, and in some way accepted, that to represent the female nude was, for the male artist ever since Titian, to represent the quintessence of beauty. (As she wrote more than sixty years later, "I put up with what seemed to me a great deal of contradictory nonsense because of what seemed clear and bright and beautiful."[18]) But the bottom line may be that she believed she was helping Stieglitz to image the new Woman, one whose sexuality and creativity were valued as highly as any man's. Is this, then, why Stieglitz linked O'Keeffe and her art exclusively to that of men in the *Portrait?* There is no photograph that implies a connection with the likes of Mary Cassatt, Suzanne Valadon, Marie Laurencin, Sonia Delaunay, Natalia Goncharova, or Gabriele Münter. Because Stieglitz regarded sex and anarchism to be the forces energizing the spirit of 291, nothing could have been more logical for him than putting the female on a par with the male. In the *Portrait* he says this in myriad ways.

There can be little question that even the nudes were a lover's dialogue between equals. If the issues raised by these photographs are those of power, desire, trespass, obsession, and celebration, so are they the stuff of life, of art. All of which both O'Keeffe and Stieglitz understood very well indeed. As Rosenfeld wrote in 1916: "Life, life, a thou-

sand times, is the important thing for Stieglitz. Yourself, your own experiences, your own reactions—and art is only of value as it helps you to attain them. . . . It is his lofty conception of art, not as a divertissement, a refuge from the world, but as a bridge to consciousness of self, to life, and through that, to new life and new creation again."[19]

None of the above is calculated to deny that the old Symbolist–Pre-Raphaelite misogyny (so evident in Stieglitz's poetry) slips into the *Portrait* through some of the poses O'Keeffe was asked to take.[20] And not just in the nudes—consider the disembodied heads, hands, torsos, and limbs. That they were informed by what Rodin called his "giblets" can hardly be doubted; nor that synecdoche (in this case, a body part that stands for the whole) was, in Stieglitz's view, a new and valid form of abstraction. Some of these photographs can certainly be rated as dehumanizing, even voyeuristic. (It must also be said that the most erotic of the torsos are so printed down that they are remarkably chaste.[21]) What did O'Keeffe think of these partial-figure close-ups that come very close to fetishism? We do not know. But whatever her feelings she was not disempowered by them, for some of these photographs later found their way into her own form language—the abstract self-portraits in particular (see plate 119). It is plain enough, however, that she was often mentally and physically uncomfortable at being photographed without clothes—so much so that she apparently turned her mind off what she was doing: "There were nudes that might have been of several different people—sitting—standing—. . . I was photographed with a kind of heat and excitement and in a way wondered what it was all about."[22] That Stieglitz didn't always have it all his way either is clear from a letter written to Strand in the fall of 1918: "I often see what a Merry Dance she must have led you—and others too at times—Fortunately I understand her thoroughly. At times it has been anything but easy."[23] Stieglitz evidently chose her poses: "I was asked to move my hands in many different ways—also my head—and I had to turn this way and that."[24] But her facial expressions were her own, and they are completely at odds with the Symbolist-type "femme fatale," ranging from proud to anxious to grave to amused. Sometimes she even looks slightly grumpy and put upon.[25] By far the greatest number of photographs taken throughout the whole *Portrait* are of O'Keeffe's head, with the traditionally masculine principle of mind strongly (and increasingly) implied. As Stieglitz would put it in 1919: "In the past a few women . . . attempted to express themselves in painting. . . . But somehow all the attempts I had seen, until O'Keeffe, were weak because the elemental force and vision back of them were never overpowering enough to throw off the Male Shack-

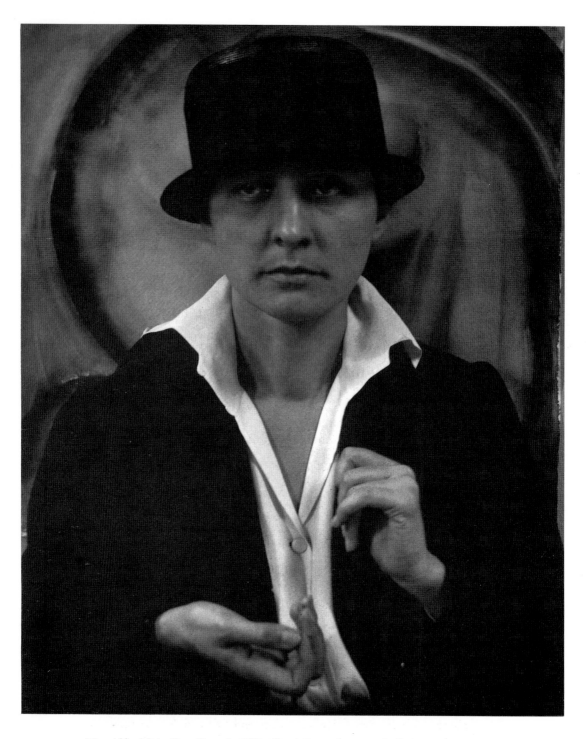

73. Alfred Stieglitz. *Georgia O'Keeffe: A Portrait,* 1918. Palladium photograph,
9⅝ x 7⅝ in (24.5 x 19.6 cm). National Gallery of Art, Washington, D.C.;
The Alfred Stieglitz Collection, 1980.70.86.

74. Alfred Stieglitz. *Georgia O'Keeffe: A Portrait—Hands,* 1918.
Palladium photograph, 7⅝ x 9⅝ in. (19.3 x 24.4 cm). National Gallery
of Art, Washington, D.C. The Alfred Stieglitz Collection, 1980.70.48.

les. Woman was afraid! She had *her* secret. Man's Sphinx!! In O'Keeffe's
work we have the Woman unafraid." [26]

The second-largest category of photographs made during 1918 is of
O'Keeffe's hands. The old idea of the artist's touch as revelatory of
genius is obviously implicit in the often Rodinesque gestures of her
hands. But that is not all. Early on, especially in the 1917 and 1918
photographs, O'Keeffe's hands are directed into pantomimes of the
shapes of the drawings and paintings hanging just behind her (plates 60
and 73). In others, where her work is not present, the hands become
charged with drama.[27] Many other photographs are so mediated by
Stieglitz's vision that it is still impossible to decipher their meanings.
Not all, of course, are so hermetic. There are several close-ups of
O'Keeffe's hands at work in the traditional woman's crafts of sewing and
cooking (plates 39 and 74), both of which she did well. Perhaps the most
important thing to consider in trying to read the more enigmatic of the
hand photographs is that Stieglitz understood O'Keeffe's desire to ex-
perience her environment through touching or being touched by it, to
sing the wisdom of "the body electric," according to Whitman. Her
letters constantly describe how nature *feels,* the various sensations of

wind, sun, and sound. Many of Stieglitz's photographs of O'Keeffe suggest this, and none more so than plate 75. Here, a tree takes up half of the depicted space. O'Keeffe leans against it, with all ten fingers touching the gnarled trunk. Did Stieglitz intend the tree to be a pantheistic symbol of O'Keeffe as a force of nature? (The tree's knothole has a form suspiciously close to O'Keeffe's *Drawing No. 12* of 1917.[28]) Very probably, for in the late nineteenth-century iconography he had been formed by, women were often linked with trees as the personification of mother earth.[29] But Stieglitz could also have thought of the tree as himself, since he identified with certain trees at Lake George. The image continues to tease the viewer's mind, just as he intended. It was always his artistic premise that the viewer must be tested.

During 1918 the *Portrait* was a mirror of Stieglitz's desires more than O'Keeffe's, despite the seeming freedom and intimacy of their dialogue. By 1919 the psychological balance appears to have shifted, for the photographs are less obsessive and more objective. "O'Keeffe and I are really a queer team—more like a couple of pal tramps in spirit— and in fact too perhaps—than anything else," he wrote to Strand early that year.[30] We are made far more aware of O'Keeffe's individuality. How much of this was Stieglitz's grasp of her fast-growing autonomy and how much came from her own assertiveness may never be determined. The nude photographs are not only fewer, they are a good deal less frank. Also, she is increasingly pictured at the domestic tasks, pleasures, and events of her own life: doing up her hair; laughing under a wide-brimmed sun hat; sick in bed; going off to paint for the day, lugging a big canvas; clowning it up over eating corn on the cob; swimming in the buff; and so on.[31] Even so, the photographs of her at work and play are consistently outnumbered (and outclassed) by the infinitely subtle close-ups of O'Keeffe's head and hands—two motifs that remain the most expressive right through the twenty years of the *Portrait.*[32]

By 1919, then, Stieglitz's vision of O'Keeffe as the spirit of 291 had changed perceptibly as she became less "idea" and more a real person, with a real person's desires and complexity. Henceforth she would be imaged by him quite specifically as "Georgia O'Keeffe, American," and the fit of *this* idea and fact would be a close one. Three years earlier, in the first issue of the *Seven Arts,* the French novelist Romain Rolland had offered American artists his blueprint for a national art: "You have been born of a soil that is neither encumbered nor shut in by past spiritual edifices. . . . Your true model is within yourselves, your approach to it

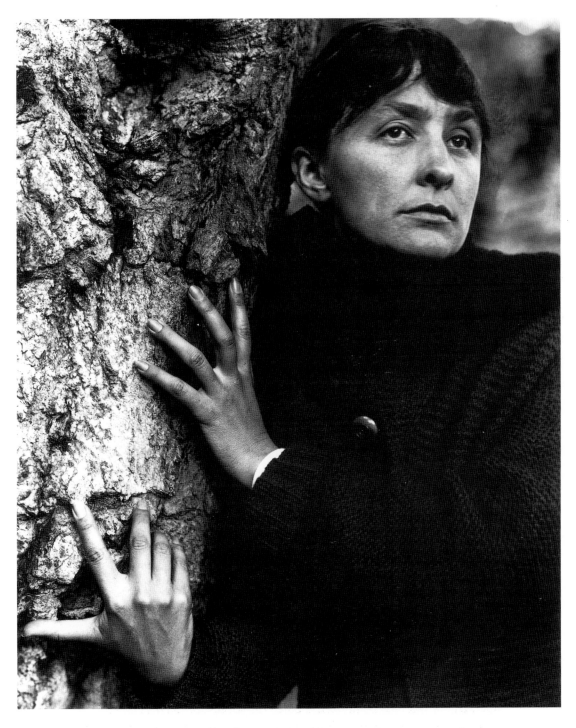

75. Alfred Stieglitz. *Georgia O'Keeffe: A Portrait,* 1918. Gelatin silver print,
9⅛ x 7⅛ in. (23.2 x 18 cm). National Gallery of Art, Washington, D.C.;
The Alfred Stieglitz Collection, 1980.70.85.

must be the understanding of yourselves. . . . Give voice to your soul and you will find that you have given birth to the soul of your people."[33]

In the years between the closing of 291 in 1917 and O'Keeffe's next one-person show at the Anderson Galleries in 1923, Stieglitz did everything he could to keep her name and work up front, in spite of being without a gallery and pinched for funds. He continued to show his photographs of O'Keeffe beside her paintings until they left the Fifty-ninth Street studio in the summer of 1920.[34] And the positive viewer response to their work (cited in the letters to Strand) encouraged Stieglitz to arrange a small two-medium *Exhibition on Modern Art* in March 1919 at the library of the Young Women's Hebrew Association in New York. The flyer for this almost-forgotten show of American artists (all with ties to Stieglitz) lists fifteen pictures, including two O'Keeffe paintings, two photographs of her hands by Stieglitz, and an unspecified photograph by Strand.[35] Perhaps the most important thing about it was that finally two of Stieglitz's photographs and one of Strand's took their place in open public review side by side with some of the most advanced examples of American modernist painting.[36]

What really alerted the New York art world to the name of Georgia O'Keeffe was a cleverly chosen and carefully publicized retrospective of Stieglitz's photographs—the first since 1913—at the Anderson Galleries in February 1921.[37] Titled simply *An Exhibition of Photography by Alfred Stieglitz,* it presented 145 of his prints, only seventeen of which had ever been shown before. Each of these prints contained, in Stieglitz's words, "the sharp focusing of an idea."[38] The sensation of the exhibition was forty-five portraits of O'Keeffe taken from 1918 through 1920. These were presented in several different series of two to eight prints each, titled: A Woman: Hands; Feet; Hands and Breasts; Torsos (partial-figure nudes); and Interpretations. Exactly which photographs of her were shown is not known, but Sue Davidson Lowe has documented that nearly half of these had her paintings in the background and that Stieglitz withheld some of the most intimate nudes on the advice of "family and friends" who feared censure.[39] What O'Keeffe herself thought ahead of time about this public exposure of her body is not known and does not seem to have been a factor in the planning. As a close (and approving) observer of explicit sexuality in early twentieth-century art, Stieglitz was obviously aware of its built-in appeal to masculine virility. He also understood the links between sexuality, glamour, and purchasing power long before the reign of Madison Avenue. He clearly felt no compunction whatever about using her nude photographs to arouse new public interest in her work or about selling them (for her sake, of course) at

the highest prices possible. Lowe reports that he "would not part with a particularly sought-after nude photograph for under $5,000," and that he "revelled" in Georgia's "stardom."[40] A dangerous double game, and it worked. But O'Keeffe was to suffer from her unwonted notoriety almost immediately and for a long time thereafter. As mentioned earlier, the nude photographs spawned a series of articles that celebrated and exploited her sexuality at the expense of everything else in life.[41]

At the time O'Keeffe seems not to have recorded either her distress or her indignation over attaining instant sexual "stardom" in the New

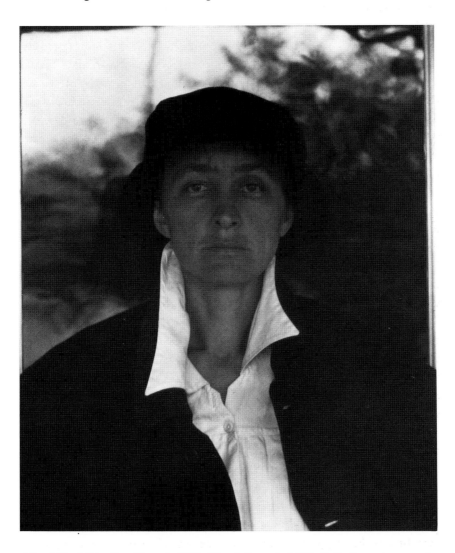

76. Alfred Stieglitz. *Georgia O'Keeffe: A Portrait,* 1921. Palladium photograph, 9⅜ x 7½ in. (23.7 x 19.1 cm). National Gallery of Art, Washington, D.C.; The Alfred Stieglitz Collection, 1980.70.168.

York art world. But the *Portrait* for the rest of 1921 speaks volumes. Only twenty-four photographs from that year are in the key set. There are just two nudes, which were apparently never exhibited. There is a definite concentration on her androgynous persona (see plate 76). There are five photographs of her hands with grapes (as in plate 70), a greatly defused abstraction of the breast self-fertilization theme. There are three photographs of her with apples, the apple also being Stieglitz's recalibrated folk-art symbol for the American artist's soul.[42] There is an image of O'Keeffe holding on to Matisse's sculpture *La Vie* (plate 53), with a look of steely resolve on her face that implies a new testing of herself against the French giant of modernism. And, as if all of this weren't enough "damage control" by Stieglitz, there is the extraordinary close-up of her neck, composed of ingenious variations of the triangle (plate 77). For Kandinsky, as Stieglitz well knew, the triangle was a symbol of the soul. From 1921 on, as the *Portrait* distinctly registers, O'Keeffe took a purposeful interest in the image of herself *she* wished to project, one that leaned toward the "intellectual and introspective—for an artist, a curiously austere type," as she would be described in a 1922 interview for the *New York Sun*.[43]

Although Stieglitz sent three of her paintings to an exhibition in April 1921 at the Pennsylvania Academy of the Fine Arts,[44] it was not until the end of January 1923 that he was able to present *One Hundred Pictures: Oils, Water-colors, Pastels, Drawings, by Georgia O'Keeffe, American* at the Anderson Galleries. Ninety of the works had never been exhibited before. The show ran for two weeks, attracted huge audiences (five hundred people a day), and received extremely favorable attention from nine major critics.[45] It also netted O'Keeffe three thousand dollars in sales. Exactly which one hundred pictures were exhibited is unrecorded. (In the Anderson Galleries flyer they were listed by number and date, but without titles.) Presumably most, if not all, of the work she did from 1918 through 1922 was on view. That her abstractions were shown side by side with flower paintings and landscapes is certain from some installation photographs found in the papers of the gallery's owner, Mitchell Kennerley (plate 78).[46] It also documents that O'Keeffe's large and small paintings were hung in vertical stacks, or clusters resembling a Maltese cross, exactly the way Stieglitz and Joseph Keiley had hung the first exhibition of the Photo-Secession, *American Pictorial Photography*, at the National Arts Club in March 1902.[47]

Not one of the nine reviewers attributed the stylistic advance in O'Keeffe's work since 1917 to photography, although this show con-

77. Alfred Stieglitz. *Georgia O'Keeffe: A Portrait—Neck,* 1921. Palladium photograph,
9⅝ x 7⅜ in. (24.4 x 19.4 cm). National Gallery of Art, Washington, D.C.;
The Alfred Stieglitz Collection, 1980.70.159.

78. O'Keeffe's 1923 exhibition at Anderson Galleries, New York.
Photograph by Alfred Stieglitz. The New York Public Library,
Astor, Lenox and Tilden Foundations, Rare Books and Manuscripts
Division; Mitchell Kennerley Papers.

tained some of her earliest assimilations of it. To cite one example: *Zinnias* (plate 91), seen in the Kennerley installation photograph (bottom row center), owes a private but visible debt to Sheeler's *Zinnia and Nasturtium Leaves* (plate 90). Only Rosenfeld, in his 1922 article for *Vanity Fair*, seems to have noticed something of the kind, although he did not refer to photography by name. "The color of O'Keeffe has an edge that is like a line's," he wrote, then added, "Rounds are described as by the scratching point of a compass."[48]

Most of the critics, especially Herbert J. Seligmann, praised O'Keeffe for her highly original use of "color music."[49] And no one has ever improved on Rosenfeld's masterful description of O'Keeffe's color intentions and effects. A music critic, he was able to find language for what he saw that was as concise as it was ardent:

> Fused in her painting there exist tenderest, rose-petal gradations and widest, most robust oppositions of color. The most complexly varied contraries of tone are juxtaposed with a breathtaking freshness. . . . Through [O'Keeffe], polyharmonies of the compositions of Stravinsky and of Leo Ornstein seem to have begotten sisters in the sister art of painting. . . . She appears to have a power, like the composers, of creating deft, subtle, intricate chords and of concentrating two such complexes with all the oppositional power of two simple complementary colors. . . . Many modern painters have perceived the relativity of all color; have felt that every hue implies the presence in some form or other of its complement, its ideal opponent that gives it force; and have expressed those complements in their works. But few have dared place a sharp triad based on red in as close juxtaposition to one equally sharp based on green as this American. . . . Most often the greens and blues will . . . be implied rather more than definitely stressed. . . . A major triad of full rose, orange and violet will be played against one on green in which the yellow and the blue will be scarcely more than the shadowed fourth in yellowish green and bluish green. . . . Oblique, close harmonies are found throughout her work; to them are due much of its curious, biting, pungent savor. . . . Dazzling white is set against tones of pearl; arctic green against the hues of tropical vegetation; violet abuts upon fruity tomato-orange. It is as though O'Keeffe felt the same great width between minor seconds that Leo Ornstein, say, perceives.[50]

Although Rosenfeld was a little worried about how his piece would "strike Lake George," he was soon reassured from that quarter.[51] "I am very happy the article struck you so well," he wrote to Stieglitz in late September. "I am glad Georgia is going to write. She writes always very nice and thrilling letters. I wonder whether my attempted analysis of her art interested her at all."[52] Alas, none of O'Keeffe's letters to Rosenfeld seem to have survived. Although it is well known that she disliked Rosenfeld's 1921 piece on the female sexuality in her painting, there is some epistolary evidence that she was appreciative of this one.[53] And not least, perhaps, for his conclusion: "Her base seems to lie high up the line of progress. Her consciousness is akin to something that one feels stirring blindly and anguishedly in the newest men and women all through the land. And in that fact there lies the cause of her high importance."[54]

Barely two months after O'Keeffe's show closed, Stieglitz presented his *Second Exhibition of Photography* at the Anderson Galleries (April 2–15, 1923). It consisted of 116 prints—all but one never before publicly shown. Included were portraits of nine men and twelve women (including twenty new ones of O'Keeffe); landscapes (including trees and barns); a series of three entitled *Birds, Apples and Gable, Death;* and Music: A Sequence of Ten Cloud Photographs.[55]

In March 1924 sixty-one of Stieglitz's photographs and fifty-one of O'Keeffe's paintings were exhibited jointly at the Anderson Galleries. A letter from O'Keeffe to Sherwood Anderson in February describes the daring plan:

> Stieglitz and I are both showing our work of this year in the rooms I had last year. They are to be two separate exhibitions —He in the two smaller ones—I in the larger one. There are to be two separate catalogues—His prints of this year are all 4 by 5 inches all of the sky. They are very wonderful—way off the earth—all but four or five that are of barns and snow—He has been writing on the statement for his catalogue for two days —it is like his others—very direct—with a real kick to it . . . I wanted to have an exhibition . . . to confirm what started last year [probably her increasing attention to objectivity] . . . instead of a small exhibition of my own it has developed into two small exhibitions.[56]

Stieglitz's show was billed as *The Third Exhibition of Photography: Songs of the Sky—Secrets of the Skies as Revealed by My Camera and Other*

Prints. In a mock-serious third-person statement he wrote: "Stieglitz once more. . . . His modesty tells him that his most recent [sky] photographs are not only an addition to his past achievements but that they are something not before accomplished in any medium—as expression —as scientific fact." And he then went on to connect them to the Symbolist value system of his earlier art: "Songs of the Sky . . . are tiny photographs, direct revelations of a man's work in the sky—documents of eternal relationship—perhaps even a philosophy. 'My' camera means any camera—any camera into which [my] eye may look." [57]

Under the rubric Songs of the Sky were eight different series, including three abstract cloud portraits of "G.O." (among them plate 115) and "KNR" [Katharine N. Rhoades]. The "other prints" consisted of Lake George landscapes, a single "realistic" portrait of O'Keeffe (undated), and six of his late nineteenth- and early twentieth-century masterworks. [58] As he wrote to the British photographer J. Dudley Johnson a year later, "The *spirit* of my 'early' work is the same spirit of my 'later' work." [59]

The themes concentrated on by O'Keeffe for the 1924 show were alligator pears (seven), calla lilies (seven), other flowers (eleven), leaves (eight), fruits (five), Lake George and Maine landscapes (five), birch trees (three), seaweed (one), and *Apple with* [African] *Mask*. There were only three named "abstractions." For her catalog, titled *Alfred Stieglitz Presents Fifty-one Recent Pictures, Oils, Watercolors, Pastels, Drawings by Georgia O'Keeffe, American,* she had originally hoped to persuade Sherwood Anderson to write a short introduction, "because you are read— this part of the world is conscious of you . . . [and] the picture has to send out the printed word to get people to come and look at it." [60] But Anderson declined, and O'Keeffe fell back on a brief and simple statement of her own. "I feel my work this year may clarify some of the issues written by the critics," she wrote, and then forthrightly included a selection from both the complimentary and the derogatory reviews of her 1923 show by Henry McBride, Alan Burroughs, and Royal Cortissoz. All of these excerpts expressed admiration for her color, but Cortissoz, no fan of abstraction, complained about the lack of "intelligible elements of design."

A fair sampling of the critical response to this simultaneous exhibition shows it to have been amazingly astute. The critics were helped, no doubt, by Stieglitz's continual availability at the Anderson as "village explainer"—to borrow a phrase from Gertrude Stein. Henry McBride sensed an occult meaning behind O'Keeffe's callas: "Miss O'Keefe [*sic*]

has been studying . . . a calla lily . . . and finding in it the secrets of the universe. . . . The best of her new pictures, to me, was a flaming arrangement of yellows, very spirited and pure. Just where yellow comes in the occult scheme of things I forget, but I used to know."[61] Helen Appleton Read noted rightfully, and for the first time, that "each picture is in a way a portrait of herself."[62] And Forbes Watson observed: "[O'Keeffe] is like Mr. Stieglitz in her ability to make a spectator feel the character of the object represented, in its essential form, more acutely than the reality itself."[63] Perhaps the most perceptive and accurate was Elizabeth Luther Cary's piece:

> Alfred Stieglitz has written philosophy with his camera and . . . gives elaborate explanations and follows [Songs of the Sky] intellectually through from one state of struggling to another. Pictures must speak for themselves, however, and without his verbal analysis there is a question just what descriptive conclusion one would come to. There is no question of their smashing appeal, of their suggestion of worlds beyond, of an instant made eternity controlled by esthetic structure unsentimental and unsensational. . . . He has let imagination work out two future possibilities—a happy and an unhappy ending, as it were. . . . Even though each plate of Stieglitz is a solved mathematical problem, there is a curious suggestion of other problems to come. In every composition of Georgia O'Keeffe, with a greater simplicity and more direct power, there is something more satisfying and complete. . . . Georgia O'Keeffe's arrangements grow, but complete themselves in their growth.[64]

Not only did this joint exhibition receive a good press, with the pictures in both mediums compared as if they were equals, but Stieglitz and O'Keeffe sold some of their work at unexpectedly good prices.[65] That financial success was responsible for Stieglitz's next, and most ambitious, plan: to present a group exhibition of paintings and photographs by the artists in his immediate circle. Although the original impetus came from the practical hope of financial gain for all concerned, Stieglitz's goals for the show kept multiplying, becoming bigger and more complicated as he went along. With the title *Seven Americans: 159 Paintings, Photographs & Things Recent & Never Before Publicly Shown by Arthur G. Dove, Marsden Hartley, John Marin, Charles Demuth, Paul Strand, Georgia O'Keeffe, Alfred Stieglitz,* the show opened March 9, 1925, on the top floor of the Anderson Galleries.[66]

Despite the grievous lack of installation photographs, it is possible to posit one or two things about Stieglitz's master plan for the hanging of the show. One of his concerns seems to have been to stress the equality of the paintings and photographs. Even if it was not Stieglitz's prime intention to foster analogies between the two mediums, he was certainly aware of the following: that the way an object is installed affects how it is interpreted; that certain groups of forms hang together better than others; and that the "rightness" of a successful hanging is usually governed by formalism, since it aims for the immediate level of understanding. Stieglitz was also acutely conscious that photographs in general —and the fastidious platinum, palladium, and gelatin silver prints of his era in particular—lack the immediacy, the scale, and the eye-riveting color-and-form synthesis of paintings, and that they therefore require closer looking from the viewer. The sum of these simple, inescapable facts accounts for why he so rarely exhibited the two mediums together, despite his often-expressed determination to "test" photography's value as expression by placing it beside the "best" paintings.

It is from Forbes Watson that we learn most about how the show was hung, with the works grouped separately according to artist and medium.

> Charles Demuth introduces the visitor to the exhibition with three mildly entertaining posters and a still life [there were actually six, and the "still life" was probably the abstract portrait of O'Keeffe, which consisted of the leaves, fruits, and vegetables of her most familiar subject matter], while directly facing the entrance is a well framed and beautiful Marin who, in the large gallery, is so completely shown. Each of the painting exhibitors is represented in the entrance hall by a small group, and this room in itself makes a choice exhibition. Going into the main gallery, the voluminous designs, in sweeping color movements, by Georgia O'Keeffe immediately hurl themselves upon the eye of the spectator.... Turning to the left, the visitor is faced by the handsomest wall in the Galleries, which is made of a beautifully arranged group of the work of Marsden Hartley.[67]

Although Watson described Strand's group of photographs as "quite magnificent," he neglected to mention that they were hung in a room well apart from the others—a decision by Stieglitz that Strand resented, then and later.[68] Once the space was allocated, Strand hung his own work. Probably the others did as well, with two exceptions.

Hartley was in Europe. And O'Keeffe, who was to take over the task of hanging nearly all of Stieglitz's later exhibitions, seems to have had surprisingly little voice in this one. By her own account: "My large flowers were shown [in 1925] for the first time. At the end of the hall just outside the door of the show was a perfect place for my first 'New York' [a cityscape, *New York with Moon*, plate 141]. It carried well and would have been seen when you stepped out of the elevator to go toward the show. But 'New York' wasn't hung—much to my disappointment."[69] Instead of an O'Keeffe for that special place, Stieglitz chose the "well framed and beautiful Marin."

A month before the show opened Stieglitz wrote to the American Symbolist painter Jennings Tofel: "I'm arranging an exhibition which I have no way of escaping. Its either the end or the beginning.—It is not one of initiation but has come about, inevitably—most naturally. Yet I don't like the exhibition idea. But there's no escape."[70] Stieglitz's subsequent letters to Sherwood Anderson tell the tale of the *Seven Americans* show from his own point of view. Two days after it opened, he wrote:

It is a thousand pities you couldn't have remained to see the show. It is overwhelming. And there is much resentment and many people. Even Paul [Rosenfeld] the first day was so bewildered he didn't know the difference between heads & tails. Waldo [Frank] . . . says the spirit of 291 never burned so intensely. . . . There were many "celebrities" . . . they all sang the praises of life—Life—again at last—My own blood they really feel—the blood of the Seven. It is terrific . . . [the rooms] breathe a Cathedral feeling—a finest feeling.[71]

Just before the show ended, he wrote to Anderson again:

It's an odd world turn it as one will. Another big day of visitors. . . . Everyone acclaiming O'Keeffe—yet so far in the two weeks but one picture placed—at $200! . . . So far there have been about 2500 visitors with the press not much with us considering what we are really giving. . . . All I see is a spiritual fight—money—as important as it may be is not even secondary. —The fellows are very brave and O'Keeffe as always very white —very helpful. But I feel I am still needed on the bridge. Never more needed.[72]

The show was the largest that Stieglitz would ever present. There were twenty-five paintings, drawings, and collages by Dove, twenty-five canvases by Hartley, twenty-seven watercolors by Marin, six portrait posters by Demuth (his first showing with Stieglitz), thirty-one paintings by O'Keeffe, eighteen photographs by Strand, and twenty-eight of Stieglitz's own Equivalents. (It is not known exactly which works were shown by Hartley, Marin, O'Keeffe, Stieglitz, or Strand.[73])

Not one of the critics commented on the extreme rarity of exhibiting paintings and photographs together.[74] According to an account by Edmund Wilson, he and the others were given "a ribbon of talk [by Stieglitz] that was as strong as a cable—and . . . influenced the mind of the listener in a way that was not accidental."[75] Another critic, as reported by Wilson, even wondered at the time "whether it hadn't been a case of the innocent young serpent being swallowed by the wily old dove."[76] Stieglitz's Equivalents, which he then called his "innocent little photographs," were uniformly well received. Margaret Breuning said they were "worth a show in themselves"; the *Dial* described them as "characteristically interrogatory"; and Wilson said Stieglitz was "an amazing genius . . . pushing his mastery of the camera . . . closer and closer to the freedom of plastic art."[77]

O'Keeffe's work was generally acclaimed, and she had only one poor review.[78] Even Cortissoz (no great admirer of O'Keeffe's) said "she shows more [craftsmanship] than she has ever shown before. . . . The technical quality that commands respect." As in 1923 and 1924, however, none of the critics saw the influence of photography on O'Keeffe's painting, although this was the first appearance of her enlarged flowers —an understandable oversight, perhaps, since the use of mechanical methods was still regarded as an artist's dirty little secret. The widespread use of photography by earlier American artists—such as Fitz Hugh Lane, William Sidney Mount, Frederic Edwin Church, Albert Bierstadt, Frederic Remington, Winslow Homer, and Thomas Eakins— is relatively recent knowledge.

The most irritated cavils were for the "talky" catalog. What the reviewers did not seem to grasp was that Stieglitz believed the art of the Seven to be completely original, and hence a brand-new set of terms had to be articulated—"the hieroglyphics of a new speech," as Egmont Arens had described Stieglitz's own photographs in 1924.[79] This catalog, with texts by Stieglitz, Sherwood Anderson, Dove, and Arnold Rönnebeck, was a precursor for the explanatory writings of Clement Greenberg and Harold Rosenberg about the Abstract Expressionists in the 1950s.[80]

But no one in 1925 thought such words necessary, and the catalog's heraldic claims for the Seven Americans escaped the press (and, one assumes, the public) entirely, much to Stieglitz's bitter disappointment. The problem was, apparently, that neither the catalog nor the works themselves, on view for only three weeks, generated what Stieglitz really wanted to find out: "The pictures are an integral part of their makers. That I know. Are the pictures or their makers an integral part of America today? That I am still endeavoring to know."[81] In his view, he was presenting the very best that Americans could turn out: "America without that damned French flavor."[82] As Rönnebeck was pleased to put it: "I believe their creative self-discovery means nothing less than the discovery of America's independent role in the History of Art."[83]

Long years after Stieglitz's death, O'Keeffe said something that adds to the suspicion that he did a little coaching from the wings as to the subject matter used by the artists in his circle: "Stieglitz liked the idea of a group. He wanted something to come out of America—something really important—and he felt you couldn't do that alone."[84] What, in fact, *was* so American about these 159 works of art, quite apart from how they were perceived at the time? Any full-scale appraisal has to wait for a new gathering of the works themselves. Nevertheless, a few observations are in order here, not least because they may further our understanding of O'Keeffe's intentions for her painting at one of the peak moments of her artistic life with Stieglitz. To survey the subjects in the show, even just by title, is to suspect that Stieglitz himself didn't realize how closely these paintings and photographs were intertwined with the American experience and the American vernacular tradition. As Barbara Novak has pointed out in her important study *American Painting of the Nineteenth Century,* the qualities of form and modes of procedure most commonly denoted as American in painting from the time of John Singleton Copley were frequently a combination of indigenous properties and transformed European traditions.[85] Novak has also isolated several traits that might be called national, since they have kept reappearing in new contexts through the nineteenth century and into the twentieth. These are the concentration on literal fact, the close relation of object to idea, a preoccupation with *things,* and a strong folk-art tradition.[86]

The idea of an indigenous American art had, of course, been in the air for some time. Many of the governing metaphors and intellectual assumptions embraced by Stieglitz in the name of the Seven Americans are quite similar to those preached earlier by Robert J. Coady in his independent periodical *The Soil: A Magazine of Art* (published in five numbers from December 1916 through July 1917):

By American Art I mean the aesthetic product of human beings living on and producing from the soil of these United States. By American Art I mean an American contribution to art. . . . Our art is, as yet, outside of our art world. . . . It's in the skyscraper . . . the East River, The Battery . . . The Tug Boat and The Steam-Shovel . . . The Steel Plants . . . Aeroplanes . . . Rag-time . . . The Crazy Quilt . . . The Cigar-store Indians.[87]

Landscapes accounted for well over half of the entire *Seven Americans* exhibition. Although these landscapes originated from five uniquely American locales—Maine, New Hampshire, Vermont, New Mexico, and Lake George—the painters did not (during this period) concern themselves with the indigenous as such. Rather, they were especially preoccupied with the world of summer: sea and sky, sun and moon, wind, rain, trees, clouds, and (in the case of Dove and O'Keeffe) gardens. The garden is itself a familiar image of American abundance that goes back to the eighteenth century—and whether this actually occurred to either Dove or O'Keeffe does not alter the point. Stieglitz's Equivalents, although not individually identified, are in the same general landscape category, since they included "pictures of natural objects, clouds [and] a poplar tree, its leaves shimmering in wind and sunlight," according to Herbert J. Seligmann, who went to the show.[88]

These concrete, localized expressions of nature, so suggestive of revelation, may be regarded as direct descendants of the "ideal" American landscapes of Frederic Edwin Church and Fitz Hugh Lane—but with a new difference. In terms of subject matter, if not in style (and frequently that as well), these paintings are abstractions. Specifically, they are abstractions of nationalistic symbols. Although Gertrude Stein never saw the *Seven Americans* show, she knew, just as well as her old friend and admirer Stieglitz, that: "After all anybody is as their land and air is. . . . Anybody is as the sky is low or high, the air heavy or clear and anybody is as there is wind or no wind there. It is that which makes them and the arts they make and the work they do and the way they eat and the way they drink and the way they learn and everything."[89]

Because the show included ten pictures of New York City (five Marin watercolors and five Strand photographs) one might argue that the flip side of the American pastoral tradition was also being presented: what Leo Marx has called "the rhetoric of the technological sublime."[90] Strand's close-up photographs of machines as a counterforce to the weather and garden images seem also to belong to the double character of American pastoralism.[91] Not only had the machine long been regarded

as the most telling sign of modern life, but Stieglitz himself often referred to New York City as a machine, which may have influenced his choice of Strand's photographs for the show.

Among the approximately thirty-eight still lifes in the show were fifteen by O'Keeffe, with a concentration on familiar vegetables, leaves, and flowers. The ideographic aspects of these paintings have hardly begun to be explored in relation to the American folk-art tradition, and to the art of children as well. Several of her watercolors (for example, *Chicken in Sunrise* of 1917 and *Trees and Picket Fence* of 1918; both Milwaukee Art Museum) suggest that she picked up a certain way of simplifying form from her contact with Mexican and American children while teaching in western Texas.

If the *Seven Americans* show was so well connected to the past, why did the *New Yorker* describe it as "pioneer stuff"? In a word, style.[92] Oddly, though, none of the critics found accurate words for the Seven Americans' new "system" of forms. Although they were certainly aware of the many and different stylistic debts owed by the Seven to European modernism, why didn't any of the critics speak of Kandinsky, Picasso, Matisse, Picabia, Synthetic Cubism, or Futurism? One reason, surely, was that the Americans had adapted European modernism to their own native subject matter with unmatched straightforwardness, fertility, and individuality. Yet another was Stieglitz's watchdog presence, incessantly reminding the people who came of the Seven's originality, and of the essential unity of art and life. In 1914 Hartley had summed up this last link for himself so compellingly that it seems now as if he were speaking for all the Stieglitz painters, even for the still-to-appear O'Keeffe. In a foreword to the catalog of his 291 show for that year he declared:

> The intention of [my] pictures separately and collectively is to state a personal conviction—to express a purely personal approach.... Its only idea and ideal is life itself, sensations and emotions drawn out of great and simple things.... A picture is but a given space where things of moment which happen to the painter occur.... It is essential that they occur to him directly from his experience, and not suggested to him by way of prevailing modes. True modes of art are derived from modes of individuals understanding life.[93]

One more unanswered question: Why was so little sold when (by Stieglitz's account) more than twenty-five hundred people came to see the show? The persistent worship of French art by American collectors,

which began with the Barbizon School, was undoubtedly a factor. Another was the innate conservatism of the American art world, which preferred "the aesthetic of the picturesque" well into the twentieth century. "Art in America [is still] like patent medicine, or a vacuum cleaner. It can hope for no success until 90 million people know what it is," Hartley had observed sourly in 1921.[94]

It was O'Keeffe's opinion, expressed a year after the *Seven Americans* show, that "one . . . [can't] be an American by going about saying that one is an American. It is necessary to feel America, live America, love America and then work."[95] If the quintessential American experience involves yea-saying to personal experience, the self as a spiritual attribute, a refusal upon principle of the old values derived from history and society, a fascination with the wilderness, and a fellowship with nature, then Stieglitz was quite right about the Americanness of the Seven Americans in 1925.[96] Certainly this measurement fit O'Keeffe from beginning to end.

Not surprisingly, O'Keeffe had some words of her own to say about whether photographs carry well when they are hung beside paintings. In a typescript filed with her collection of Stieglitz's "wastebasket" prints, donated to Yale in 1970, she wrote: "It is my intention that [these photographs] only be looked at in the hand like a book and never be hung on the wall. I even think that maybe all photographs are better looked at that way to really appreciate them."[97] Clearly O'Keeffe felt no compunction at all about looking seriously at photography for her own artistic ends. How and when she did so, and what kinds of photographs interested her, will be discussed in the following chapters.

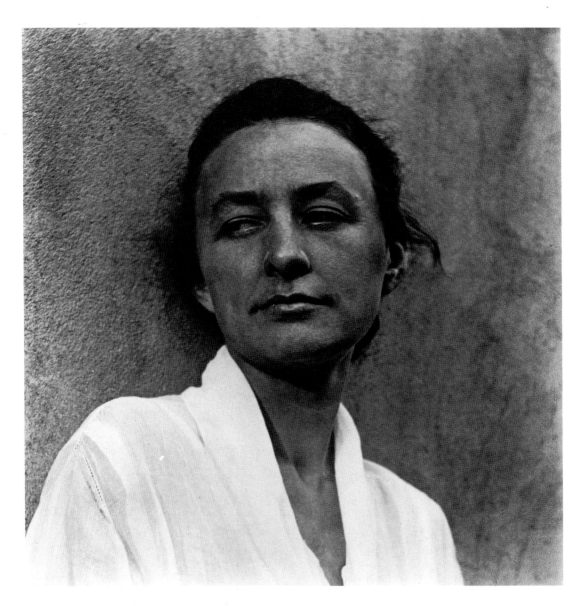

79. Paul Strand (1890–1976). *Georgia O'Keeffe, Texas,* 1918.
Platinum print, 7⅜ x 7½ in. (19.3 x 19 cm).
Copyright © 1976, Aperture Foundation, Inc., Paul Strand Archive.

6 O'Keeffe's Encounters with Strand, Sheeler, and Steichen

Your print came at noon . . . —a glance once in a while told me it was there—and it was like a quieting person in the room—often I looked and laughed that my imagination should play me such a trick—but it did —Thank you.

GEORGIA O'KEEFFE TO PAUL STRAND, 1917

Charles Sheeler, one of America's most distinguished young modern painters (this includes all under 60), also photographs. No one considering his work questions his paintings and drawings as ranking amongst the most interesting of their type in America today. To me his photographs are of equal importance. He is always the artist. He has done things with photography that he could not do with painting and vice versa.

GEORGIA O'KEEFFE, 1922

I shall always stick to photography for there are, in my opinion, certain pictorial ideas that can be expressed better by photography than by any other "art" medium.

EDUARD STEICHEN, 1902

Between 1919 and 1929 Georgia O'Keeffe would take many different qualities and values from photography and bend them, sometimes out of recognition, to her own purposes. Although Stieglitz's work and ideas were unquestionably the most powerful sources for her art during this period, she also looked hard at the photographs of his three greatest photographer colleagues: Paul Strand, Charles Sheeler, and Edward Steichen. Her references to their work seem to have been made for formal and thematic reasons rather than iconographic ones, but they still add greatly to our understanding of the different interests and needs she had while developing her mature style.

There are at least three significant categories that can be identified in O'Keeffe's borrowings from photography. These can be termed the

adoptive (using a photographic viewpoint for compositional purposes, such as the close-up, the overview or aerial, and the telephoto); the *adaptive* (using a single photograph or a series as a theme on which to make painted variations); and the *innovative* (using her highly sophisticated knowledge of the photographic process and its quirks—such as compression, convergence, halation, and flare—for abstract or expressive purposes). The use of even such rudimentary categories as these requires a good deal of delicacy, however, because O'Keeffe was not progressive about these divisions but moved back and forth between them. Pure examples are, in fact, quite rare.

O'Keeffe's first real attention to photography seems to have begun with Paul Strand. He had visited 291 as a student in 1907, but it was not until 1913–14 that Strand became attentive to the exhibitions there of modern European masters and began to experiment with their formal solutions in his photography. During 1915 Strand took his photographs to Stieglitz for criticism, and by 1916 he had become a full-fledged member of the 291 circle. Stieglitz gave him a one-man show at 291 that March and as a follow-up published six of his photographs in *Camera Work* 48 and eleven more in *Camera Work* 49–50.[1] Strand's last, and most radical, experiments with abstraction apparently took place during the summer of 1916 at Twin Lakes, Connecticut. As he said: "The simplest of subject matter, or maybe object matter would be a better term in this case—such as kitchen bowls, cups, plates, pieces of fruit, a table, a chair, the railing of the porch, the shadows of the railing of the porch—things as simple as that were my material for making experiments to find out what an abstract photograph might be, and to understand what an abstract painting really was."[2]

O'Keeffe met Strand for the first time at 291 in late May 1917. She was twenty-nine and he, twenty-six. It happened this way. O'Keeffe had made a sudden trip to New York from Canyon, Texas, because of a desire to see Stieglitz and to view the first solo show he'd given her. The trip was difficult to arrange because of her teaching job, and O'Keeffe somehow failed to inform Stieglitz of her plans. When she got to 291 the show was over (it had run from April 3 to May 14), and her pictures had already been taken down. But Stieglitz willingly rehung them for her and also saw to it that she met two of his current favorites among the 291 painters and photographers—Abraham Walkowitz and Paul Strand. It was at this consequential time, as well, that Stieglitz first asked her to pose for his camera. Whether he was aware of the instant attraction that sprang up between Strand and O'Keeffe during those few days in New York is not clear. What *is* clear is that O'Keeffe tried hard to keep

80. Alfred Stieglitz.
Portrait of Paul Strand,
New York, 1917, 1917.
Photograph.
Copyright © 1958,
Aperture
Foundation, Inc.;
Paul Strand Archive.

Stieglitz from knowing it. And for a long time she apparently succeeded.

None of Strand's letters to O'Keeffe appears to have survived, but she received his first one (which included one of his prints) on, or just before, June 12, soon after she returned to Canyon. Not only did this inspire an immediate ten-page answer (in uncharacteristically small handwriting), but she also mailed off three sealed letters she'd already written to him.

> I havent an idea of what is in them—would have sent them when they were written but I didnt know where to send them— 291 to be sure—but I didn't want to send them there. I dont know why I minded—you understand. I knew you would write I knew the day I saw Walkowitz['s] work that I meant something to you—it was just a look in your eyes that made me turn away quickly. . . .
> Then
> the work—
> Yes I loved it—and I loved you. . . . There you were beside me really and the same thing in front of me on paper. I feel like thanking you for living. . . . And its so funny the way I didnt even touch you when I so much wanted to. . . . Anyway meeting you was great—knowing that you are is great—and I think Ill love your print more than you do.[3]

In one of the earlier letters (written on the train from New York to Texas the third of June), she is remarkably forthright about the effect of his photographs on her eye and mind. "I believe Ive even been looking at things and seeing them as though you might photograph them—. . . making Strand photographs for myself in my head . . . I think you people [it is probable that she meant Strand and Stieglitz] have made me see— or should I say feel new colors—I cannot say other yet but think Im going to make them."[4] And in another she tells him easily (and with pride): "I sang you three songs in paint. If I had your address, I think Id send them to you right away."[5] Only one of these paintings is identifiable at this time: *Untitled Abstraction* (plate 81). (It is cataloged in the Whitney files as a watercolor, 12 by 8⅞ inches, dated c. 1917.) The central shape bisecting the picture field can easily be read as a female figure with long dark hair in profile. It is turned toward a carefully puddled shape in the upper left-hand margin that comes into partial focus as a torso with outstretched arms—a man's profile, judging from its suggestion of short hair. These two forms appear to be touching with their heads. Considering the real-life circumstances, the work can almost be read as a love philter.

It is impossible to separate O'Keeffe's strong emotional response to Strand from her certitude that he and his work were one, a goal she had long sought for herself. "You would not be what you are to me at all if I had not seen the part of you that is in the big prints" she tells him again two weeks later.[6] And she tried to make sure he was under no false illusions as to the real O'Keeffe:

> If you knew more of me you would probably be disappointed. I feel that in a way I am spoiling—maybe—a person you had made up that gave you pleasure—Honesty is a mercyless thing I dont know whether its worthwhile or not—still I have never had any choice in the matter. I seem to like many people enough to make them miserable—no one enough to make them happy. . . . [Men] never understand me—unless maybe Stieglitz does—dont know that I understand myself. . . . As I see it— [being] a woman . . . means willingness to give life—. . . to give up life—or give other life—Nobody I know means that to me —for more than a minute at a time. I seem to see way ahead with the years—always—to see folks so clearly.[7]

In late July she told him again: "Ive been looking at your Camera Work [48]—read your article again [*Camera Work* 49–50]—and I like

81. Georgia O'Keeffe. *Untitled Abstraction*, c. 1917.
Watercolor on paper, 12 x 8⅞ in. (30.5 x 22.6 cm).
Michael Scharf, New York.

it—think its fine—. . . I love the little snow scene / Why you know I love it all The prints you sent me—the bowls—the shadows / . . . I like your letter—your work—the same to me."[8]

By mid-August, Strand's drastic impact on her sensibility seems to have lessened somewhat, and she wrote with surprising candor about her new romantic friendship with Ted (James W.) Reid, a student at West Texas State Normal College, where she taught: "Its queer—I just like being with him. . . .—He is really great . . . —Ive said I wouldnt marry him again and again still—he is so funny—I dont know—I just like him—. . . I am ordered to think about it. . . . I have a notion that I really care the most—though Ive never dreamed of it Im sure."[9] Reid, president of the Dramatic Club, was eight years younger than O'Keeffe, but they had many interests in common and spent much of their free time together until his enlistment that fall in the Air Service Signal Corps. They shared a deep love of the Texas landscape, and before O'Keeffe left Canyon for good she gave Reid twenty-eight of the radically original watercolors she had painted during the fifteen months she lived there— all small (12 by 14 inches) and all landscapes.[10]

Even so, O'Keeffe was not quite ready to let go of her emotional feelings for Strand. Two months later she wrote to him with some of her old warmth: "Your letter this morning and the article on 291 made me feel it to tell you that I love you like I did the day you showed me your work—. . . or is it what you say that I love—Anyway its great— and I hope it goes into print quick."[11] The October and November letters were more infrequent and less candid, but she continued to express genuine interest in Strand's work and to tell him about her own. "I will see your prints sometime wont I—the new ones and the others again too. I havent worked since I returned [from Colorado, Arizona, and New Mexico] in September—Ive simply been dumb."[12] Almost two weeks after this she wrote: "The outdoors comes nearer bringing me to life—making me feel something. . . . It seems the first life Ive felt in ages. . . . The plains are wonderful—mellow looking—dry grass—the quiet and the bigness of it—anything that makes you feel quiet and bigness like that is marvelous—wouldnt it be great in a person—why cant I make it into shapes—I wish I could want to try."[13]

By December, barely six months after her first outpourings to Strand, she was starting to know what she could not yet articulate: Strand's letters were just not as satisfying to her as those she had been receiving, almost daily, from 291. Furthermore, it vexed her that she was not able to give Strand what he first gave to her: a strong desire to

work. That miraculous artistic mutuality she would later come to know with Stieglitz.

> Ive been wishing sometimes lately that I
> could talk to you
> like I can to Stieglitz.
> You have made me very still
> Something reaching out to you
> Something that
> only to touch you with it once
> would give to all after—
> another color—
> The reaching out is fragile
> grower of feeling—of something all apart from reason. . . .
> Yet how could so much grow in me and none in you—its as
> if a stronger reaching out [is] in you than is in me. . . .
> It isnt work I feel—. . . maybe the hand reaching out to you
> grasped in yours would quickly fade to nothing cease
> to be there—. . . I do not know.[14]

There is some piquant irony here, for O'Keeffe clearly had no idea that she did have an artistic influence of sorts on Strand, albeit of a very different order than she was to have on Stieglitz.

Barely three weeks after this letter she sent him a batch she hadn't "had time" to mail before, along with an explanation: "Maybe some of them are unkind—they may hurt—but I some way feel that you wont mind the hurt—that you would rather have them than not—. . . we have hurt I guess because the other meant so much so its alright."[15] In another one from this batch she attempted to tell him what she thinks went wrong between them.

> I asked Stieglitz for a print of his photograph of you that he
> took last spring. I wanted so much to bring you to life—I was
> tempted for a moment to put my hand on your cheek . . . but
> you looked so vile and cold and critical . . . the photograph is
> just like all the rest Ive felt of you . . . that the way you are
> thinking and feeling is hardening . . . making a crust over the
> thing in you that makes me want to put my arms around you
> and give you life . . . I have only put down what you have made
> me feel [it's] your fault as much as mine.[16]

By mid-January she ended a brief letter with "I dont know—but I have a notion that maybe I wont write you any more."[17] Despite this, she did continue to do so sporadically. But the letters contained almost nothing of import, and by early March she complained again that he had "grown into something to me that is very hard to write to."[18] Although she made a few last-ditch efforts at the end of April to recall her old feeling for him, her heart clearly wasn't in it, and her spirits seemed to be low. She had been jobless since February, and the blighting atmosphere of the war, even in rural western Texas, was also taking a toll.

> I seem to be loosing connections with everyone not immediately around me—except maybe 291—and that is very disconnected —Im living in such a queer way—I wonder if it matters— When I first came down here—I wished very much that you would come down and work—so many things are very wonderful to look at—but I didnt say anything . . . [This letter is unsigned, and the bottom torn off as if she had added more and changed her mind.][19]

A day later she tells him she's been reading August Strindberg; she speaks of the beauty of the night, and on the last page of yellow scratch paper she writes:

> Its a quiet evening . . . Paul—
> Its one of the nights when it seems that
> wishing—wanting must draw me through space—
> the thing I want—warm human touch that loves me
> My lamp is going out
> Goodnight.[20]

This was the last letter Strand received from O'Keeffe before he was dispatched to Texas by an alarmed Stieglitz (who was doubtless receiving similar accounts of malaise) to ascertain the state of her health and her finances.

Almost nothing is known from O'Keeffe about what passed between the two young protégés during this visit, which took place from the second week of May through the first week of June. Stieglitz's own letters to Strand indicate that he had little or no idea of the affections, strained or otherwise, between the two. (For much of this time O'Keeffe was ill and confused.) On May 17 he wrote to Strand in Texas: "The first consideration is Her Health. . . . For isn't she 291—take care of

yourself—you ought to know that you too mean a great deal to me."[21] Approximately a week later he wrote to Strand: "The coming or not coming [to New York] is entirely in her hands—There must be no suggestion or interference one way or another. . . . Your position is a difficult one—a nearly impossible one—you have done all you could are doing all you can . . . —Health is the first thing to be considered— Under no conditions must it be rushed—I have written to O. herself."[22] Soon after this he again summed up for Strand exactly how he saw O'Keeffe and her situation:

> The throat condition—the idea of teaching in Canyon—sum-
> mer classes—the lack of funds not stated but existing—the
> need of quiet (which means the need of some funds)—the
> Nature easily frightened—all the childlike pure loveliness—all
> that as I saw it—see it. . . . Rest—a simple home—peace of
> mind whoever can give her that will give her what she needs
> above all things. . . . If she wants to come—really wants to—
> feels the necessity—and feels she can stand the trip physically
> —all else would arrange itself. . . . I'm glad you made some
> photographs [of her].[23]

Some clue as to how difficult Strand's position actually was—for apparently he was still in love with O'Keeffe—may reside in the only known survivor of those Texas photographs (plate 79). In this image her eyes glance to one side and her body leans to the other, almost as if she were impatient to get away from him. Complete frontality with unmistakable eye contact needs a subject's cooperation, unless a false lens is used. By comparison, it is significant that O'Keeffe had no trouble gazing into Stieglitz's camera from the very beginning. On or about June 10, 1918, O'Keeffe arrived in New York, escorted by Strand. She had decided, for a time at least, to put herself under the aegis of Stieglitz. As she'd earlier written to Strand, "I seem to feel that I dont need what many women seem to want or need from men I dont need much—yet what I need I need—want till it makes me feel physically ill.[24]

Judging from the ebb and flow of O'Keeffe's letters, the spurt of psychic energy caused by her feelings for Strand lasted a bare three months. What did she receive from him artistically during that time, and what did she take from his photography for her painting? The two are not the same, although they are connected. As the letters document, meeting Strand caused O'Keeffe to feel an intense inner excitement.

They also suggest that he increased her awareness of the prime source for her early art: a powerful physical reaction to nature and to individuals. This kind of "body sense" permeates the rhapsodic beauty of her Texas watercolors from the summer of 1917. For in the sequenced sunrises over the plains, the cometlike evening stars, the suggestively layered mountains, canyons, and mesas, there seem to be more vestiges than ever of female forms, interior as well as exterior. It is as if she had decided to inhabit the earth and the sky around her. Although O'Keeffe had been experimenting with what might be called "gender landscape abstraction" for at least a year, the rainbow explosions of color within and around these Texas shapes during that summer are much more fantastical than before. Whether or not they were intended to be metaphoric of sexual desire, it is clear that for a short while Strand did make her "see" and "feel" new colors.

But what exactly did O'Keeffe mean when she told him that she'd been seeing things as he might photograph them? We cannot be sure, but she probably meant that his prints inspired her to visualize her nature motifs as if cropped by a lens—a slight but significant conceptual variation on what she had already been taught by Dow. In any case, there can be little question that when she looked at "the little snow scene . . . the bowls—the shadows," she grasped immediately that the camera, too, could be a modernist image maker. The freshness of this discovery is also implied in a letter she wrote at the time to Pollitzer: "Did you ever meet Paul Strand? . . . He showed me lots and lots of prints— photographs—and I almost lost my mind over them—photographs that are as queer in shapes as Picasso's drawings."[25]

But O'Keeffe never told Strand, or anyone else, what made her instantly recognize his "big prints" as art.[26] Picasso's Cubist drawings aside, what she may have seen at work in Strand's arbitrarily tilted and divided spaces were Dow's principles of composition. It is significant that she herself had been concentrating for at least a year on rendering real landscape as abstract spatial structure, based on her Dow training. This is particularly noticeable in the 1916 watercolors painted in Mount Elliott Springs, Virginia. They include the *Blue Hill No. 1* (Estate of Georgia O'Keeffe); *Blue Hill No. 2; Hill, Stream and Moon; Evening;* and *Morning Sky with Houses* (all in private collections). Despite Strand's very different themes and motifs, his flattened linear designs are also composed of Dow-like oppositions of curves, straight lines, and diagonals.[27]

Did O'Keeffe take anything that we can actually identify from Strand's photographs during those energized three months, or afterward? The available evidence is largely circumstantial. Regrettably, she

destroyed a lot of her Texas work when she decided, in 1918, to stay in New York. But just as O'Keeffe apparently intended a reference to Stieglitz's celebrated print *The Hand of Man* (1902) in two of her 1916 pictures of an advancing locomotive, so she may have made similar references to Strand's work. Her 1917 watercolor *Abstraction* (Mr. and Mrs. Gerald P. Peters) could owe its curiously shadowed, round forms to Strand's *Abstraction—Bowls;* and her charcoal drawing *Set II* (1917; location unknown) might be formally related to Strand's *Abstraction, Porch Shadows* in the placement of its cropped curves and eccentric diagonals.[28] She could also have made a glancing reference to Strand's *White Fence* (1916) in her watercolor *Trees and Picket Fence* (1918; Milwaukee Art Museum).[29] But all of these are little more than shape and subject matter tributes. O'Keeffe was not quite ready to use, and re-create, the distinctive stopped reality of camera art, with its misshapen translations of light, compressed spaces, and tonal descriptions of form.

Strand has habitually been cited as the primary source for O'Keeffe's cropped, close-up plant forms, but very little supports this claim.[30] O'Keeffe had long known, from Dow's exercises, how to compose by cropping, and her 1915 charcoals are rife with judicious croppings. Whatever influence Strand had on the first enlarged leaves and flowers was indirect, since it came to her filtered through Stieglitz. (It is now well accepted that Stieglitz's early close-ups of O'Keeffe, which did most to direct her artistic attention to the up-front image, were to a large degree triggered by Strand's new "brutally direct" prism portraits and abstract still lifes.[31]) Furthermore, all of the visual and datable evidence suggests that Strand's nature-form close-ups followed, rather than preceded, O'Keeffe's earliest ones.[32]

In all likelihood, however, it was Strand's prints that first showed O'Keeffe that a photograph can reflect the temperament of the photographer. And without intending to, for his own practical sensibility did not require it, Strand may have galvanized O'Keeffe's lifelong search for correlations between the facts of the visible world and her own inner emotions. Strand's most visible legacy to O'Keeffe seems to have been conceptual, in the sense that his straight photography was the first to awaken her to the possibility of taking an objective approach to her own motifs. But this did not occur in Texas during 1917–18. It happened at Lake George in 1923, where, as she told Sherwood Anderson, she first "got down to an effort to be objective" because "I didnt like the interpretations of my other things" (see chapter 7).

O'Keeffe's formal, and perhaps emotional, influence on Strand's photography has received very little attention. Some examples of this are

worth examining, even though more may be revealed about Strand than O'Keeffe in the process. Again, much is owed to Stieglitz. There is, for instance, Strand's *Rock, Port Lorne, Nova Scotia* (plate 82), about which he wrote: "I couldn't have done the rocks without having seen Braque, Picasso and Brancusi."[33] Though he did not mention O'Keeffe or Stieglitz, the compositional similarities between *Rock* and Stieglitz's 1919 "abstract" portrait of O'Keeffe's breasts and torso (plate 83) are so close they must have been deliberate. The tubular shapes made by O'Keeffe's cropped arms, the breasts themselves, and even the dark region of her pubic hair are echoed by Strand's rock forms in a manner that seems as calculated as it is uncanny. In fact, it is arguable that *Rock* is Strand's own abstract portrait of O'Keeffe, once removed but with new, if disguised, resonance.

The real question is why Strand chose to make a photograph like *Rock*. We may never know for certain, but there must have been a combination of reasons. First, Stieglitz constantly urged Strand to photograph from his own inner experience and worried increasingly that he wasn't.[34] Even though *Rock* may have been based on one of Stieglitz's own pictures, the actual subject, O'Keeffe, did have a deep personal meaning for the younger photographer. Second, Strand's goals for himself at the time were essentially those of 291, as his contemporaneous writings show: "Above all, look at the things around you, the immediate world around you. If you are alive, it will mean something to you, and if you care enough about photography, and if you know how to use it, you will want to photograph that meaningfulness. . . . There are no shortcuts, no formulae, no rules except those of your own living."[35] Finally, there can be little doubt that even while Stieglitz was calling for self-expression within his circle of artists, he was also calling for communal expression —an effort that culminated in the *Seven Americans* show. Strand may therefore have felt something of an obligation to refer to the work of Stieglitz and O'Keeffe once in a while.[36]

That Strand was disappointed with his treatment in the *Seven Americans* show has already been noted. Perhaps by this time he was also becoming aware that trying to conform to the Romantic-Symbolist spirit of 291 went against his own more positivist grain. Certainly this was becoming increasingly plain to Stieglitz. "I realize more and more how far removed I am from what Strand is doing," he wrote (not without censure) to Seligmann in 1927.[37]

Some of O'Keeffe's later paintings appear to have thematic affinities with Strand's photographs—perhaps, in part, because of her growing determination to attain objectivity. For instance, both artists were at-

tracted to the same spare type of man-made structure: solitary buildings (such as barns and churches), crosses, the isolated details of windows and doors. They were also quite partial to gardens, driftwood, storm clouds, trees, and the complicated intersections between earth and sky. Neither took a long-term interest in imaging the nude. And both tended to identify American art first and foremost with the American landscape. Several of their most pivotal images were done in the same locales, although not at the same time. It was Strand who went first to Nova Scotia (1920), but O'Keeffe knew and loved New Mexico (1917) and Maine (1920) before he did. There is some evidence that Strand continued to refer to O'Keeffe's work until well into the 1930s. One familiar comparison may suffice to make the point: O'Keeffe's *Ranchos Church* (1930) and Strand's *Ranchos de Taos Church* (1931).[38] This is, in fact, a special case, because the compositional similarities are so close.

Despite the dearth of visual evidence, there can be little question that Strand helped O'Keeffe's abstractions to become increasingly rooted in reality. She might have been speaking of herself when she wrote for *Manuscripts* 4 (December 1922) that Strand "has bewildered the observer into considering shapes in an obvious manner for their own inherent value." She may also have gleaned from his work that describing things accurately doesn't make them any less mysterious. As the letters make plain, what O'Keeffe learned about herself from her brief love for Strand was catalytic to her emergence as an artist. In that fraught time she also learned which man her independent spirit needed most. Even though she chose Stieglitz, with his strenuously free morality about art and life, she always kept a "real respect" for Strand and his work.[39]

That O'Keeffe saw some of Charles Sheeler's early abstract art photographs before Strand showed her his own "queer" Picasso-like prints at 291 in June 1917 is confirmed by a letter from Stieglitz to Sheeler, written that March: "Of course I received the beautiful prints long ago on time. And the young lady was delighted with them.... When you come to New York will you bring along the negatives as I'd like to pick out a few from which I'd like to have photogravures made for *Camera Work*."[40] The "young lady" referred to is almost certainly O'Keeffe, whose drawings and watercolors Stieglitz had planned to feature along with Sheeler's photogravures in a last issue of *Camera Work,* which never came off. Although he was unable to finance this hoped-for tribute to his newest protégés, he did ask Sheeler (by then an experienced photographer of artworks) to record O'Keeffe's solo exhibition at 291 in the late spring of 1917.[41] Largely because of circumstances brought on by

the war, Sheeler's photographs were never shown by Stieglitz at 291. But his admiration for them was genuine, and in 1918 he awarded Sheeler with a first and fourth prize when judging the annual Wanamaker exhibition in Philadelphia.[42]

It is not known specifically which "beautiful prints" O'Keeffe saw. But given Stieglitz's priorities, the chances are good that they consisted of Sheeler's most recent, most abstract work: his drastically pared-down views of Bucks County (Pennsylvania) architecture.[43] Chief among these may have been the increasingly flat and geometric compositions of barns taken during 1916–17 and perhaps one or more of the interior studies he had begun to make of his eighteenth-century farmhouse in Doylestown, Pennsylvania.[44] Sheeler's artistic interest in the colonial architecture of Bucks County started about 1910, the year he and Morton Schamberg decided to rent the house at Doylestown as a weekend workplace. Built in 1768 by Jonathan Worthington, a Quaker, this humble building came to hold particular imaginative power for Sheeler, which persisted long after he ceased to go there in 1926. Although Strand's audacious 1915–16 experiments with Picasso's Cubism in such photographs as *Bowl and Pear* and *Porch Shadows* were familiar to Sheeler, he himself never wished to turn china bowls and porch shadows into first-glance nonobjective shapes.[45] An unrepentant classicist by temperament as well as by training, Sheeler preferred to keep his Bucks County architecture abstractions true to their original forms. Even when his motifs are greatly flattened and geometricized by frontal focus, cropping,

84. Charles Sheeler
(1883–1965)
or Morton Schamberg
(1881–1918).
Charles Sheeler, c. 1916.
Gelatin silver print.
Museum of Fine Arts, Boston;
The Lane Collection.

and the calculated use of raking or artificial light, their essential identity is rarely, if ever, in doubt.

We can be reasonably certain that O'Keeffe saw Sheeler's photographs well before she met the man, through Stieglitz, in late 1918.[46] His photographs apparently interested her without causing the same sort of emotional aesthetic response that Strand's prints did. This is hardly surprising, for not only was there no personal chemistry between O'Keeffe and Sheeler, but he went about the task of combining abstraction with straight photography very differently from Strand. Nevertheless, the sharply distilled photographic images that Sheeler made between 1917 and 1920 left traces in O'Keeffe's art that are at once more complex, and more visible, than the traces of Strand's abstractions. This is partly because by 1919 she was looking at photography with a more acquisitive eye.

Real work on the many sources and influences shared by O'Keeffe and Sheeler has scarcely begun, and much of it lies beyond the scope of this discussion.[47] Still, a few observations can be made as to the nature and significance of Sheeler's photography for O'Keeffe's painting. We already know from her 1922 article for *Manuscripts* that O'Keeffe rightly considered Sheeler's photographs of "equal importance" to his "most interesting" paintings and drawings. And since he remained committed to both mediums, she doubtless felt a special curiosity during the first crucial years of her own creative synthesis. What, then, did O'Keeffe appropriate from Sheeler's camera work? Before tackling this question, it may be instructive to consider Sheeler's strongly held opinions on the distinctions between painting and photography. He declined, in 1922, to express his opinion on whether a photograph could have the significance of art: "For me it would be like a fish who, wishing to demonstrate his pleasure in seafaring life, came out on the beach."[48] But Sheeler did put down some thoughts on the matter fifteen years later in his unpublished autobiography: "Among other qualities peculiar to it photography has the capacity for accounting for things seen in the visual world with an exactitude for their differences which no other medium can approximate. . . . Photography is rather seen from the eyes outward, painting from the eyes inward."[49]

About 1910 Sheeler decided to become a commercial photographer so that he could afford to go on painting. His early professional work consisted of documenting exteriors and interiors for a Philadelphia architectural firm and, more lucratively, of photographing works of art for dealers and collectors—the Knoedler gallery and Albert Barnes among them.[50] When de Zayas opened the Modern Gallery in 1915, he hired

Sheeler as an assistant to record the gallery's holdings. Sheeler published a portfolio of photographs of African wooden sculpture from de Zayas's personal collection in 1917, and during that same year the Modern Gallery twice exhibited Sheeler's creative photographs. The first time (in March) was a group show with Schamberg and Strand; the second (in December) was a solo presentation of twelve prints of his Doylestown house.[51] That Sheeler himself considered these prints to be art (as opposed to his ongoing commercial photography) is clear from a letter he wrote to Stieglitz late in 1917: "About the photographs of my house, which I am glad to hear you liked—de Zayas was quite keen about them and proposed to make a show of The Set (12) following . . . the present Derain show. I decided that because of something personal which I was trying to work out in them that they were probably more akin to drawings than to my photographs of paintings and sculptures and that it would be better to put them on a different basis—to make only 3 sets."[52]

Made, in all likelihood, between March and November of 1917, these twelve Doylestown-house interiors contain the earliest sustained evidence of Sheeler's individual vision, one that was fully intended to be objective *and* abstract. (Steichen's often-quoted statement from the 1930s that Sheeler "was objective before the rest of us were" seems quite accurate.[53]) The critics who first saw these photographs in 1917 understood clearly what he was about: "Charles Sheeler, a disciple of modernism, has evolved a new advocacy for that cult by submitting typical pictorial puzzles to the exactions of the camera. Strange forms employed by the modernists, regarded generally as abstract, fantastic or imaginative, find now a kindly mechanical interpreter, for the photographs shown are surely real and sane things, true in line and graceful in form and otherwise good, plain pictures. Sheeler says his object has been to prove that the principal elements in modern art are sensorial and exist in nature; and that the impersonal lens has furnished proof of fundamental truths in modern art. It is an instructive exhibition."[54]

The first painting of Sheeler's based on a photograph that O'Keeffe could have seen was his early 1916 abstraction *Lhasa* (Columbus Museum of Art, Columbus, Ohio), one of thirteen paintings and drawings that Stieglitz invited him to show in the *Forum Exhibition of Modern American Painters,* held during March of that year. *Lhasa* was based on a photograph by John Claude White of a hill town in Tibet; Sheeler does not seem to have used his own prints for his art until 1917, when traces of them began to appear in his Conté crayon drawings of Bucks County barns.[55] Despite Sheeler's avowed creative intent for the Doylestown-house prints—and despite their being a turning point in his development

—it is reasonably certain that none of his own paintings was based on them until 1923 at the earliest.[56] The first painter to experiment with some of the visual ideas in this watershed series of photographs was, in fact, O'Keeffe. If we compare O'Keeffe's *Fifty-ninth Street Studio* (plate 86) with Sheeler's *Stairwell* (plate 85), which Stieglitz owned at the time, it is clear the painting owes a great deal to the photograph.[57] To start with, the subject matter is the same: an isolated detail of the artist's studio, a theme often used by their early master William Merritt Chase. Sheeler presents a view of the underside of his wooden staircase and O'Keeffe, a small windowed room seen from her workplace.

Sheeler used a longer-than-normal focal length lens for his Doylestown series to minimize the perspective of convergence, and he trained a spotlight on his interiors with the frankly Cubist intent of emphasizing hard-edged geometric planes and equalizing positive and negative space.

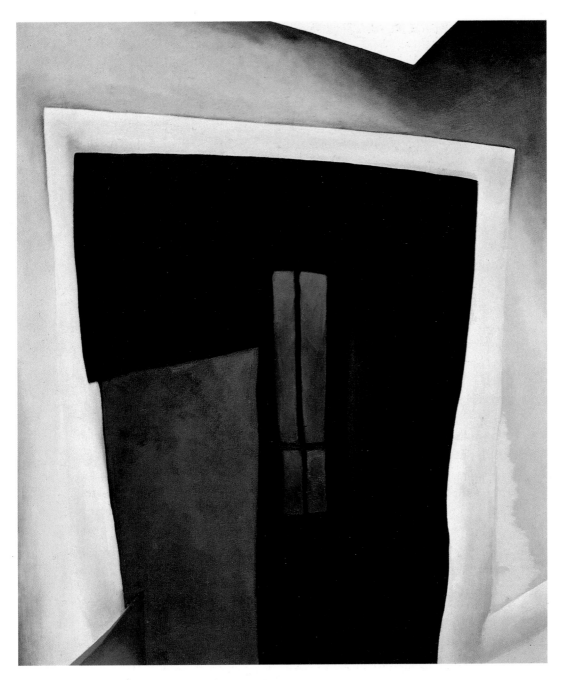

85. Charles Sheeler (1883–1965). *Stairwell (Doylestown House)*, c. 1914.
Photograph, 9¹⁄₁₆ x 6⁷⁄₁₆ in. (23.1 x 16.3 cm).
Museum of Fine Arts, Boston; The Lane Collection.

86. Georgia O'Keeffe. *Fifty-ninth Street Studio*, 1919. Oil on canvas,
35 x 29 in. (88.9 x 73.7 cm). Private collection.

The forms in *Stairwell* have been made so ambiguous, through lighting and forced perspective, that it is difficult to distinguish up from down, inside from outside. O'Keeffe's painting is also an ambiguous image of intimate space. And she has turned her motif into abstract pattern by using the same type of spatial compression as Sheeler. For instance, she seems to have deliberately reversed his spotlighting: the core of her picture is dark and its framing elements are light. She has also revised the blackness of his flat L-shaped shadow, enlarging it and turning it upside down so that it reads as the dark area surrounding her window.

Much remains ungraspable about O'Keeffe's experimental work. Why are the upper and lower regions so contradictory in their use of perspective? The top part is two-dimensional, but the bottom suggests deep space—due to the arbitrary, and perplexing, convergent forms. Why does the apparent door frame curl away from the wall at its edges, as if it were a poster or a matted photograph? Did she, in fact, hang a print of *Stairwell* upside down on the wall—the better to contemplate its tight polarity—and then transpose her own findings? This is entirely possible, since Sheeler had given one to Stieglitz and since we know from her letters to Strand that she had hung one of his photographs on her wall somewhat earlier for just such study purposes. Also, by 1919 O'Keeffe was obviously aware that view cameras present their images upside down on the ground glass, which often purifies a photographer's eye for abstract design. In any case, she seems to have understood what Sheeler was after. By basing the structural design of her painting on his empty L-shaped shadow form, she was making her own investigation of his theory, as a photographer, that "light is the great designer."[58] Later, in his unpublished autobiography, Sheeler would write that he considered shadows to be "concrete forms as essential to the structure of a picture as the solids appearing in it rather than being projections from the solids denoting the absence of light."[59]

From all of the foregoing, there can be little doubt that *Fifty-ninth Street Studio* was directly inspired by Sheeler's *Stairwell*. But it was also an independent invention, not least because of O'Keeffe's use of color. Whereas the actual Fifty-ninth Street studio was yellow and orange, O'Keeffe constructed her painting on a bold and atypical harmonic balance of black, gray, red, and blue.

During 1920 Sheeler received a great deal of fresh and positive critical attention. In February the de Zayas Gallery presented an exhibition of his photographs and watercolors on Bucks County barn and flower themes, with both mediums shown together on an equal basis.

Reviewing this show, Henry McBride commented that Sheeler's art was "as ascetic as the early Dutch painters" and went on to say: "All who look on photography as a means of expression should see these photographs of barns. They rank among the most interesting productions of the kind that have ever been seen here. . . . This artist . . . emphasizes the things a machine can do better than hands."[60] Everything considered, it is little wonder that O'Keeffe's creative interest in Sheeler's photography rose even higher in 1920. Stieglitz's enthusiasm for it was also at a peak then, as a letter of his to the *Sun and New York Herald* well illustrates: "As a fanatic on photoplay I was naturally deeply interested in what you [McBride] said about Sheeler's very fine photography. Sheeler is always the artist."[61]

During the early 1920s O'Keeffe made at least three charcoals of New York, her first known pictures of the city.[62] As precursors of her cityscapes of the later 1920s, they deserve further study. As stunning drawings in their own right, they take some of their immediate impact from her formal references to Sheeler's own first photographs of New York. By comparing her charcoal *New York* of about 1921 (plate 87) with Sheeler's print of the same title and slightly earlier date (plate 88), we can glimpse a few of O'Keeffe's earliest efforts to mix and match photography with her art.

Sheeler's *New York* was probably taken during, or just after, the filming of *Manhatta* in lower New York with Strand, who described their joint efforts as "the abstract organization of reality."[63] One of a series of seven photographs taken with his view camera from the Equitable Building, it is a picture redolent of Sheeler's particular understanding of Analytic and Synthetic Cubism: that is, juxtapositions of crisp geometric planes and abstract surface patterns. It would be easy enough to call O'Keeffe's drawing "Cubist" for these same reasons, but Cubism per se does not seem to have been her intention. Although her drawing also presents an all-encompassing view from a high vantage point, it is solidly anchored on a Dow-type diagonal. The photograph, on the other hand, maintains its two- and three-dimensional tension through arbitrary geometric patternings. What seems to have interested O'Keeffe most about Sheeler's picture is his abstract use of shadow to obscure, and even blot out, architectural outlines and detail—in a word, simplification. As with the Doylestown-house series, although in a less controlled way, Sheeler relied on light to design the most important areas of positive and negative space. That O'Keeffe's picture has light and dark shapes in places similar to his photograph, beginning with the large shadowed area in the right

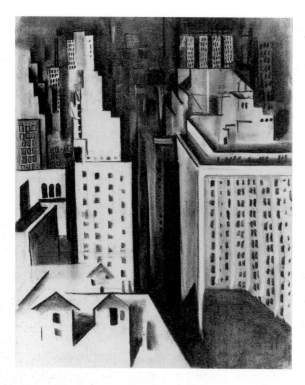

87. Georgia O'Keeffe. *New York*,
c. 1921. Charcoal on brown paper,
24⅞ x 18⅞ in. (63.2 x 48 cm).
Doris Bry, New York.

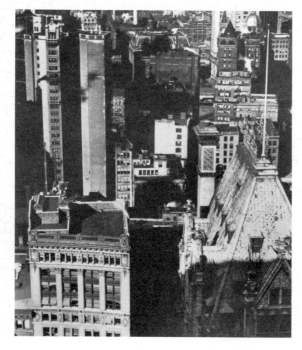

88. Charles Sheeler (1883–1965).
New York, c. 1920. Photograph.
Museum of Fine Arts, Boston;
The Lane Collection.

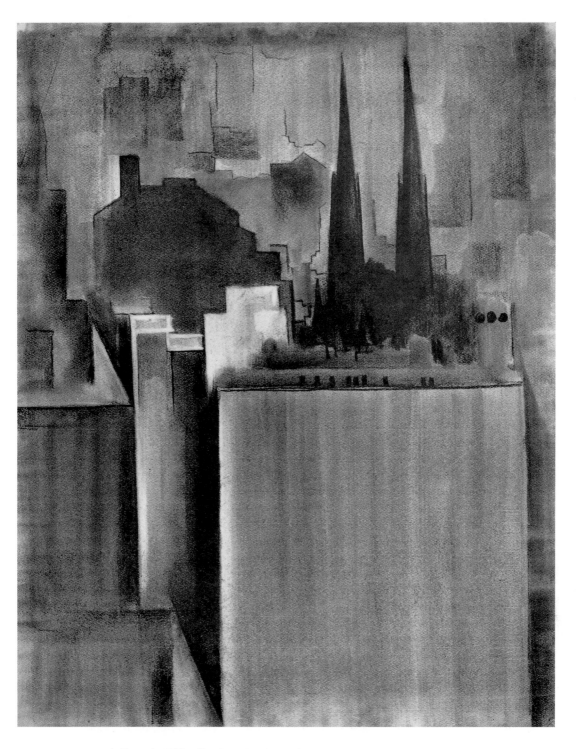

89. Georgia O'Keeffe. *New York Rooftops*, c. 1920s. Charcoal on paper,
24½ x 18¾ in. (62.2 x 47.6 cm). The Fine Arts Museums of San Francisco,
Achenbach Foundation for Graphic Arts; Gift of Mrs. Charlotte S. Mack.

foreground, can hardly have been accidental. Sheeler's concentration on the jagged surface rhythms caused by window patterns may also have been an influence on O'Keeffe's drawing, although her windows sometimes seem to take on the imaginative character of musical notation. This last would be seen later, in a more developed form, in *The Shelton with Sunspots* (plate 147) and *Radiator Building—Night, New York* (plate 151).

New York Rooftops, another of O'Keeffe's charcoals from this period, seems the most daring in its composition (plate 89). Most of the action is at the top, with the bottom consisting of a few bare, monolithic rectangles and one small triangle. In several of the divisions between her middle-ground forms, slightly to the left, we can see one of Sheeler's favorite tricks with light—wide, white-rimmed outlines.[64] She has also taken an interest in the unadorned backs of city buildings for their abstract design, as he often did.

In a 1920 interview published in *Vanity Fair,* Sheeler spoke publicly for the first time about the uses of photography in painting, obviously from his own experience. Certain problems baffling to the modernist painter could, he said, be "partially solved by photography—particularly those having to do with selection, arrangement, mass, texture and line."[65] The article was accompanied by a reproduction of Sheeler's photograph *Zinnia and Nasturtium Leaves* (plate 90). If we compare it with O'Keeffe's small *Zinnias* (plate 91), there can be little question that she recast Sheeler's image and that she did so with complete understanding that a photograph is no less of a convention than a painting. Interesting as she found his photograph, she seems to have been looking for ways to edit and reinterpret it rather than imitate it. First of all, she moved her eye even closer to the motif than Sheeler's lens, cropping his bowl entirely. She kept a portion of his rectangular table, but tilted hers at an angle. Although she subtracted his two nasturtium leaves, she added another zinnia in the exact position of the missing lower one. She paid attention to her own shadow design, not Sheeler's, and she ignored his straight, high-contrast presentation of detail. Her focus is almost Pictorial, being soft and diffused. Despite all these changes, it would be hard to dispute the fundamentally photographic character of *Zinnias.*

Aside from O'Keeffe's respectful remarks about Sheeler's work in 1922, there is little or nothing to suggest that they ever formed a friendship of their own, even during the years between 1918 and 1923 when Sheeler was a member in good standing of Stieglitz's circle. (The warm collegial relationship between the two men became a casualty, in Stieglitz's view, of their increasingly opposed value systems.[66]) This is

odd, in a way, since it is well recorded that O'Keeffe remained on good terms with Demuth, Dove, Hartley, and Marin. Although Sheeler and O'Keeffe both valued sensibility over intellect, he was perhaps even more reticent and secretive than she.[67] Apparently, too, he was not at all interested in her paintings; there are no visual signs that *she* ever influenced *him*.

The aesthetic reasons for Sheeler's lack of interest in O'Keeffe's work are clear: his philosophy of color and abstraction was completely

90. Charles Sheeler (1883–1965). *Zinnia and Nasturtium Leaves,* 1916–17. Gelatin silver print, 10 x 8 in. (25.4 x 20.3 cm). Museum of Fine Arts, Boston; The Lane Collection.

91. Georgia O'Keeffe. *Zinnias*, 1920. Oil on canvas,
12 x 9 in. (30.5 x 22.9 cm). Private collection.

opposed to her own. Not long after making his frankly experimental abstract landscapes of 1914, Sheeler returned to recognizable, if reduced, forms, never to leave them again. Sometime later, when considering the question "Am I a colorist?" he said: "If you want to look at it in one way I am not. Values undoubtedly come first with me—those relationships of light and shadow by which form is achieved. Color wouldn't mean very much to me if it didn't have the structure of values to support it. I mean to use color to enhance form."[68] O'Keeffe's palette was based on chroma rather than values, and she used abstraction interchangeably with representation throughout her career. Furthermore, Sheeler's mature art, photography included, was primarily nourished by the still-life tradition, whereas O'Keeffe was, above all, a true Symbolist landscape painter, spiritually committed to the idea of a specific and local place.

Critics over the years have described the craftsmanship of both O'Keeffe and Sheeler as "clean-cut," "immaculate," "lucent," "transparent," "impersonal," "slick," "photographic," and the like. Although Sheeler was pleased to say that he sought the old masters' "concealment of means" rather than the "painty,"[69] O'Keeffe's paintings are another, more complicated matter. Her conception of painting was never that of a uniform chemical layer laminated on its supporting surface, as has sometimes been remarked, especially by those critics who would link her work to Precisionism. Even though her use of the oil medium inclines to be spare and thinly applied, the subtle syntax of her brush marks is nearly always visible. These range from the directional (following the outlines and angles of her forms) to the textural, from the emphatic to the feathery to the (infrequently) layered. Her facture, in short, deserves much more attention than it has received.[70]

O'Keeffe never lost her admiration for Sheeler's photography, but his painting, as she put it years later, "just wasn't my cup of tea."[71] "I try," wrote Sheeler, "to arrive at an organization . . . in nature. There I stop without trying to give expression to any hid [sic] or underlying meanings."[72] With O'Keeffe, what you see is never all of what you get, just as she intended. But did she, perhaps, think back to Sheeler when, in the 1960s, she began to use some of her own snapshots as "fixatives" for her vision?

> The [Abiquiu] road fascinates me with its up and downs and finally its wide sweep as it speeds toward the wall of my hilltop to go past me. I had made two or three snaps of it with a camera. For one of them I turned the camera at a sharp angle to get all the road. It was accidental that I made the road seem

to stand up in the air, but it amused me and I began drawing and painting it as a new shape.[73]

Which photographer made the greater contribution to O'Keeffe's art, Sheeler or Strand? This may be a wrong question, for what we see most is a contrast of emphasis. Perhaps Sheeler gave her the most to think about in a purely formal way. But it was Strand who caused her to see the world differently and to paint it in a way she never had before. Fundamentally, O'Keeffe learned by emotion, as Ezra Pound once said of William Butler Yeats. And, indeed, her visionary Texas watercolors are nothing if not poetic in their implicit claim to see great truths in ordinary things.[74]

It is certain that O'Keeffe's artistic sensibility operated in a very different sphere from both Sheeler's and Strand's. With Edward Steichen, however, the emotional gap was much narrower. He, too, had been formed by Symbolist principles, and these show up in his photography no less than in his painting, although he was very slow to embrace modernist abstraction in spite of his early exposure to it.[75] In fact, Steichen's early use of the two mediums was often so interchangeable in style and content (except for his photographic portraits) that in 1904 Sadakichi Hartmann dubbed his photographs "photopaints" or "paintographs."[76]

What permanently redirected Steichen away from the old 291 concerns—including photography as a noncommercial, individual artistic expression—was his remarkable experience in World War I. In an anguished and prophetic letter to Stieglitz from France dated August 27, 1914, Steichen wrote about the terrible carnage that had already taken place (his home at Voulangis was only a few miles from the northern front):

> [Germany's] crime is against Humanity. But she will pay—the dearest—and ultimately Humanity will win out. . . . This blood is not flowing over our souls to deaden us but to give us new life—and faith in humankind—in the genius of man's soul not in the calculative side of this intellect. If it lasts long and now I fear it will—we will all be ground down in one way or an-other. . . . I have never felt as close to my friends as I do now—nor wanted to feel them as close.[77]

This could not have been an easy letter for Stieglitz to receive, with his profound regard for German cultural values. Indeed, it would be the war

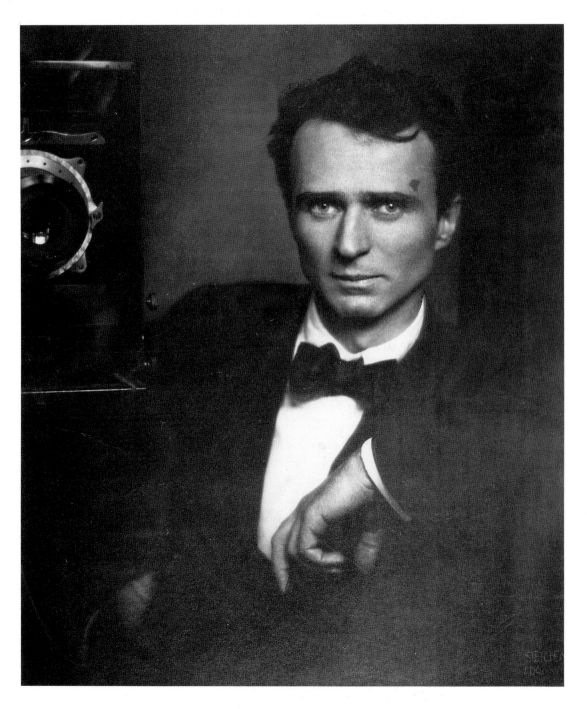

92. Eduard Steichen (1879–1973).
Self-Portrait, 1917. Photograph.
National Archives, Washington, D.C.

—and most of all, perhaps, the postwar temper—that finally destroyed their extraordinary friendship.[78]

Before 1914 was over, Steichen returned to America with his family and did what he could to help Stieglitz with the exhibitions, despite his strong feeling that 291 was "marking time" instead of making itself "a vast force."[79] By his own account, he was present when a roll of 1916 drawings arrived, addressed to Stieglitz. As he remembered it: "We all looked at them. We were dumbfounded. They were a batch of charcoal drawings by Georgia O'Keeffe. In these abstract drawings was a woman who spoke with amazing frankness of herself as a woman."[80] Steichen volunteered for military service, and in 1917 he was commissioned a first lieutenant in the American Expeditionary Force. He was sent to France shortly afterward and there commanded the Army Signal Corps's pioneer efforts to furnish aerial photographs of combat zones for strategic and intelligence purposes.[81] Steichen's little-known letters to Stieglitz over the next few years do him credit, for they honestly try to keep the lines of communication open with his estranged and seemingly sidelined old friend. They are revealing, as well, for their glimpses into Steichen's new concerns and for their polite references to O'Keeffe.[82]

Steichen to Stieglitz, January 1917:

Well here I am in the famous somewhere in France—hard at it, in a way living through the old experiences of getting 291 on the map—fighting the same kind of battles and games—and once again for photography—only this time it had photography & plus, a surprise that means the lives of men—I wish I could tell you all about it but naturally that is tabooed. . . . [Arrived] in time to drop a handful of earth into Rodin's grave—a few days later to stand near Haviland at his marriage to a daughter of Lalique—the same fine Haviland . . . full of the fullest appreciation and the realest friendship for you—I have slept to the rumble and whiz bang of bombardment, seen the men who have lived it for three years and marvelled at them—passed through Voulangis—with a peep into bygone days.

From Paris, about 1920:

Art—ah art in Paris is exactly the same funeral thing it is in N.Y. The best men have a virility and opulence however that is totally lacking with american [sic] artists—I saw an exhibition the other day by two guys there [sic] names sounded Italian.—

Well theres [sic] was a most puerile and painfully futile attempt at what Georgia O'Keeffe gloriously accomplished at least six or eight years ago. So much for European progress.—Matisse is doing some fine things and like all the others of worth is getting fabulous prices for everything before the paint is even dry. . . . Brancusi is as fine as ever—a regular Diogenes. Lives by himself & within himself. . . . He is still struggling on those few things we showed at 291 years ago. . . . Picasso is doing all kinds of things, some very fine some childishly stupid—all successful beyond imagination—he'll be a millionaire if he keeps it up. Photography—wow—it's awful.

On board the SS *Olympic,* October 1921, headed for Voulangis:

It was nice to get your note with its whiff of Lake George Autumn. . . . I felt particularly worried about O.K.'s eyes—It seems a particularly serious trouble when eyes of people that see are afflicted. But I hope it's over.—I did not trust myself up at the Lake [George] realizing how small the place was and how much family there was to occupy and permeate it.—But with you and O.K., and the autumn alone, 'twould have been *great.* . . . Have had a few nice jobs this summer and made a little money to clear up about half of my debts and then keep things going for another 6 months or so.

From these letters it is certain that O'Keeffe had at least some contact with Steichen during her early years with Stieglitz and that it was amiable enough, despite the ever-worsening strains between the two men.[83]

Steichen's three-year artistic crisis in Voulangis right after the war is best, if dramatically, summarized in his 1963 photo-biography *A Life in Photography:* the burning of his "wallpaper" paintings; the decision to participate and communicate "with the world only through photography"; the experiments with photographic abstraction based on "universal symbols"; and the new relevance for his work of Albert Einstein's "time-space-continuum" and the golden section, as well as such pseudoscientific writings on "the laws of art" as Theodore Cook's *Curves of Life* (1914) and Jay Hambidge's *Diagonal* (1919–20).[84] Steichen later believed that he accomplished the most valuable work of his life between 1919 and 1922, that "the inexorable discipline gave me a new kind of freedom."[85] During this same period he made several trips back to New York in order to earn money by exhibiting and selling his paintings.[86]

His efforts were not successful enough, however. In March 1923 he changed tactics completely and joined Condé Nast Publications in New York as chief photographer. With this entry into the fashion world, his contacts with Stieglitz virtually ceased. (Steichen hired Sheeler to work for Condé Nast that same year.) From then on, Steichen would act on his strong belief that "If I can't express the best that's in me through . . . advertising photos . . . then I'm no good."[87]

What Stieglitz thought about Steichen's defection from all that had been held sacred by them both during the 291 years should be recorded here, even though we do not yet know how much of his attitude was shared by O'Keeffe.

Stieglitz to Rosenfeld, October 21, 1923:

I realize more & more why poor Max Weber suffered so when he saw Steichen's paintings and imagined I thought them the alpha & omega of art—which of course I never did. I did feel something fine in them not as paintings but in spirit . . . much hidden by a youthful brazen lack of real knowledge—that to a man like Weber such painting was an insult. But the joke is Weber although always an artist—when Steichen was not—St. was always artistic—sometimes approaching art perhaps—was lacking in a quality which kept him from being that which he so eagerly asserted he was. I often think of Steichen & Weber & my relationship to them & theirs to me. What a youngster I was —so much younger than they.[88]

Steichen always believed that his work as a photographer had a greater influence on his painting than his painting did on his photography. It is therefore quite logical to ask what he thought of O'Keeffe's art, with its widening array of photo-optic characteristics. Nothing seems to have been recorded on this subject by Steichen (perhaps old loyalties forbade it), but the chances are that he was not interested enough in her work to follow it closely. Was this because she was a woman artist? Nothing Steichen ever wrote or said would suggest it. He had, after all, never learned to like abstraction; this was as true in regard to Dove as it had been to Picasso and Picabia.[89] And, of course, he had had nothing to do with the sensational discovery of O'Keeffe at 291 months earlier, which could have accounted for some of his lack of enthusiasm.

The delicate issue of whether O'Keeffe ever borrowed from—or was inspired by—any of Steichen's paintings may never be resolved. There are a few rather curious, if substantive, similarities. For instance,

Steichen often depicted the sun with a large circular halo around it, as in *Landscape with Avenue of Trees* of 1902 (formerly Lunn Gallery, Washington, D.C.) and *Grand Canyon* of 1909 (Mary Steichen Calderone). This same convention appears in a few of O'Keeffe's paintings—most notably, in *Red Hills and Sun* of 1927 (Phillips Collection). Also, Steichen's triangular "Radio Gull" from *The Oochens* (1919–20), carefully calculated according to the golden section, may have had some effect on her triangular birds in *Lake George with Crows* (plate 104) and even on her much later *Black Bird Series* (*In the Patio IX*) (1950; Estate of Georgia O'Keeffe). Although Stieglitz never presented a solo show of Steichen's paintings, they were frequently exhibited in New York. O'Keeffe could have seen what may have been the most prestigious of his painting shows in 1915 at M. Knoedler. It included twenty-one of his canvases and seven mural decorations titled *In Exaltation of Flowers*, painted for Mr. and Mrs. Eugene Meyer, Jr. (These last works, lost for years, were recently found again and now belong to the Museum of Modern Art, New York.) It should be noted, however, that O'Keeffe, like Stieglitz, was known to disparage Steichen's painting. Still, the fact that he was a painter-photographer for so much of his life might have caused her to take an interest in his canvases, at least briefly.[90]

It seems inevitable, on the other hand, that O'Keeffe would have found Steichen's photography of interest. Whether she knew it or not, he had put in a youthful stint designing advertisements in Milwaukee, just as she had in Chicago.[91] More important, he was well schooled in the decorative two-dimensionality of Art Nouveau and had chosen, in 1901, to photograph Alphonse Mucha standing before one of his celebrated posters of Sarah Bernhardt, *La Dame aux camélias* (1896). Further, O'Keeffe would certainly have been aware of Steichen's many photographic identifications of women with flowers.[92] Despite all of this, and despite Steichen's long and formidable reputation as an artist-photographer, O'Keeffe seems not to have looked at his camera work for her own ends until 1926–27. Why she did so at that particular time is still unknown. Much of the archival material needed to write cogently about the extent of his influence on her painting is, and may always be, missing. Therefore this section is briefer than it should be. The visual evidence rests mainly with two paintings and two photographs, but it is very strong.

In 1914, at Voulangis, Steichen made one of his most masterly palladium prints, *Heavy Roses* (plate 93). Although it was never formally exhibited at 291 and never published in *Camera Work,* O'Keeffe could not have been ignorant of this distinguished early close-up. Steichen

brought it back to New York with him at the beginning of the war, and it was surely well known to everyone connected with 291. Nonetheless, the question persists as to how *Heavy Roses* came to O'Keeffe's creative attention in 1926.[93] Visual proof that it did so lies in her *Calla Lily with Roses* (plate 94).

In Steichen's photograph his highly trained horticulturalist's eye joined with his Symbolist sensibility to compose a work doubly rich in analogy and botanical detail. Steichen may have believed with Maurice Maeterlinck that "the flower sets man a prodigious example of insubmission, courage, perseverance and ingenuity."[94] And by choosing a motif as charged with meaning as the rose, he was doubtless aware of the many historical and literary reverberations the word itself had for his time, ranging from the mystical Salon de la Rose + Croix (founded in 1892 by Sâr Péladan and Antoine de la Rochefoucauld) to Gertrude Stein's "A rose is a rose is a rose" (from her 1913 play *Sister Emily*) to its traditional attributions—such as Venus, Eros, the Virgin Mary, and Dante's paradise. All we see in Steichen's print is roses and one small

93. Eduard Steichen (1879–1973). *Heavy Roses,* 1914. Silver print,
7¹⁵⁄₁₆ x 9¹⁵⁄₁₆ in. (20.2 x 25.3 cm).
Collection of Grace Mayer.

leaf. They fill the frame, with nothing to indicate whether they are growing in a garden or amassed in a bowl. The overt theme is the life span of this particular species: bud, to half-open, to full-blown, to overblown. Every detail is in sharp focus, and the emphasis is on the behavior of the petals—how they fold, curl, droop, or crumple. (This passage-of-time theme would remain a favorite of Steichen's, culminating in his Shad-Blow Tree series of 1955.)

Calla Lily with Roses seems to be O'Keeffe's first rose painting, which may be one reason why she chose to look so closely at Steichen's print.[95] Although the huge white calla dominates—and nearly obliterates—the roses in this work, if we look at them attentively we can see that they are almost painted analogies of Steichen's. Especially comparable are the heavy bulbous buds (similarly placed) and the scalloped curls of her petals. She, too, has included just one definitive leaf. And her forms, like his, appear to be floating in empty space. Despite these samenesses, the two pictures suggest very different meanings and intentions. Steichen's is a fin-de-siècle image with origins in the Aesthetic movement, with all

94. Georgia O'Keeffe. *Calla Lily with Roses,* 1926.
Oil on canvas. 30 x 48 in. (76.2 x 121.9 cm).
Private collection.

its elegant insularity, ambiguity, and obsession with the decorative arts. No doubt these were flowers that he grew himself and, as such, directly related to the late nineteenth-century's deliberate cultivation of taste.[96] It is also possible that the covert theme of "heavy roses" may have been a carefully conceived elegy to a world that changed forever with the 1914 guns of August.

O'Keeffe's scarcely naive use of the timeless erotic symbolism connected with the "male" calla and the "female" rose can be said to combine the old freewheeling spirit of 291 and the newly sophisticated Freudian preoccupation with sex during the 1920s. But it is of even greater significance that the emphatically phallic calla lily almost blocks our visual access to the roses. This powerful double image may be as bitter a feminist statement as O'Keeffe ever allowed herself to make. Not for nothing had she addressed a dinner meeting of the National Woman's Party in Washington, D.C., in February of that year.[97] Nor should it be discounted that O'Keeffe's personal relationship with Stieglitz held increasing stresses and strains in 1926. For one thing, she was finding the conditions for living and working within his family at Lake George more and more intolerable—so much so that by the end of August she left. "Georgia has gone to York Beach [Maine]," he wrote to Seligmann. "She has suddenly decided. She has lost 15 pounds and was terribly nervous. . . . Its too bad. Please don't mention it to anyone —either her going or her being run down. It's no one's business."[98] O'Keeffe was gone a month, despite Stieglitz's pleas for her return. That a certain iron entered her soul during that summer is clear from a letter she wrote to Waldo Frank several months later:

> My exhibition [of the work done in 1926] goes up today or tomorrow—It is too beautiful—
> I hope the next one will not be beautiful
> I would like the next one to be so magnificently vulgar that all the people who have liked what I have been doing would stop speaking to me—My feeling today is that if I could do that I would be a great success to myself—. . . . I haven't felt like making even half a step toward anyone—.—Maybe—partially because I am not clear—am not steady on my feet.
>
> I have come to the end of something—and until I am clear there is no reason why I should talk with anyone—[99]

During 1927 O'Keeffe is known to have rendered at least three canvases of poppies, including the breathtakingly beautiful *Poppy* (plate

95).[100] It is a work that at first looks to be as realistic as any flower she ever painted. But if we compare *Poppy* with the photograph that in part inspired it, we can see what an abstraction it really is. The photograph is Steichen's silver print *Lotus, Mount Kisco, New York* (plate 96).

A theme common to both these images seems to be what Steichen called "the charlatan light." Up through the period when this photograph was made, he used light primarily for the expression of emotion (according to Symbolist suggestion) rather than for design, as Sheeler did. And the color values of O'Keeffe's *Poppy* petals are modified in ways very like *Lotus's* subtle moves from black and white, caused by the optical and chemical action of light. It is entirely possible that O'Keeffe deliberately set herself this challenge. She may not have been thinking specifically of Steichen's early statement that "there are certain things that can be done by photography that cannot be accomplished by any other medium, a wide range of finest tones that cannot be reached in painting,"[101] but this was an article of belief shared by Stieglitz and all the 291 photographers. There is, in any case, ample visual evidence that O'Keeffe consciously, and conscientiously, added to the photographic qualities of her enlarged flower pictures as she went along.[102] Further testimony toward this particular comparison rests with the observation that O'Keeffe's poppy has been stage-managed for viewing from an angle and distance very similar to Steichen's lotus. And the flattened space and abstract patterns of her background seem to function like gentle reminders of his background forms, which have been so cropped and printed down that we can't be sure whether they are leaves, shadows, or reflections. *Heavy Roses* and *Lotus* may not be the only photographs of Steichen's that O'Keeffe used as referents for her paintings.[103] But they are quite sufficient to demonstrate her immense esteem for the work of Stieglitz's oldest and most important colleague at 291.

In 1941 Steichen wrote a graceful and nostalgic article for *Vogue* titled "The Fighting Photo-secession," tracing the group's remarkable history:

> Some forty years or so ago, Alfred Stieglitz began to be called the Father of American Photography, and I am speaking here as a son in this movement. . . . In 1902, we were fighting for the recognition of photography as art.
>
> In 1908, we were fighting for the recognition of Art that was not photographic.
>
> Out of all this work and struggle, and out of deep faith and belief came many clarifications.[104]

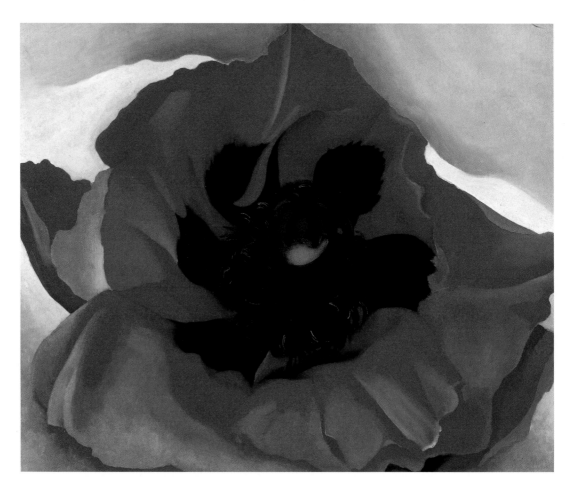

95. Georgia O'Keeffe. *Poppy,* 1927. Oil on canvas, 30 x 36 in. (76.2 x 91.4 cm).
Museum of Fine Arts, Saint Petersburg, Florida; Gift of Charles C. and Margaret
Stevenson Henderson in memory of Jeanne Crawford Henderson.

Stieglitz was deeply pleased: "What can an old fellow like me say except
that if you were here I'd grasp your hand and stand before you—you
and I together . . . you have gladened the hearts of very many.—I'm still
fighting—So are you. Its one fight.—Again I say what you have written
is glorious & gloriously generous.—My love to you.—Ever your old
Stieglitz." [105] And the two founders of 291 were at last reconciled.

O'Keeffe learned a great deal from the Photo-Secession "fighters."
Strand, Sheeler, and Steichen each furthered her understanding of the
photographic picture. Their images of immensity in small formats stoked
her endless fascination with the differences between size and scale. And
their experiments with light gave her new ideas for simplification and

96. Eduard Steichen (1879–1973). *Lotus, Mount Kisco, New York,* 1915. Gelatin silver print, 9½ x 7½ in. (24.1 x 19.1 cm). Reprinted with the permission of Joanna T. Steichen.

abstraction. Like them, as well, she frequently chose to image highly structured forms with a complete order in themselves: leaves, shells, barns, flowers, and so forth—forms that already resemble a work of art. As the French poet Paul Valéry has written: "[These] are privileged forms that are more intelligible to the eye even though more mysterious for the mind, than all the others we see indistinctly."[106]

O'Keeffe never allowed her uses of photography to reduce truth to fact. Her paintings are memory images in the Egyptian as well as the camera sense, for they are distillations of what is meant to endure, even while they are seizures of a felt moment.

From no one did she learn more about all of this than Stieglitz.

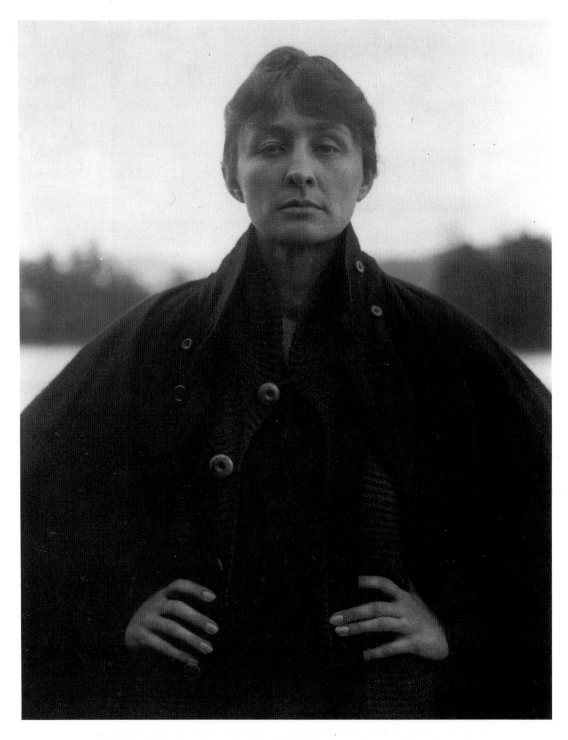

97. Alfred Stieglitz. *Georgia O'Keeffe: A Portrait,* 1918. Gelatin silver print,
4⅝ x 3½ in. (11.7 x 8.9 cm). National Gallery of Art, Washington, D.C.;
The Alfred Stieglitz Collection, 1980.70.76.

O'Keeffe and Stieglitz at Lake George

O'Keeffe and I have had a week that we can call 100. Really very wonderful. Full up. In the healthiest, sanest manner imaginable. Painting—printing photographs —cooking (she is quite a cook, loves experimenting— is in everything she does what she is as a painter)— dishwashing—occasional walks—a row or two on the Lake—long ones when we do take them—weather 100%.

ALFRED STIEGLITZ, SUMMER 1920

I do know that if I dont cook the dinner we wont have any and when it is eaten if I dont wash the dishes—well Stieglitz always tries but he is so absent minded. . . . I have to laugh—He tries to help because he has a theory about doing things for yourself—But it isn't really worth putting his mind on it—He just doesnt know how—. . . . I am very busy—because I know things have to be done—just the ordinary drudgery that goes with living. . . . I can do it—and I dont mind—As a matter of fact I rather like it.

GEORGIA O'KEEFFE, JUNE 11, 1924

The dictum that the conditions for creativity are social as well as solitary is almost never associated with O'Keeffe. It should be. For what happened to her work and Stieglitz's at Lake George constitutes one of the oddest, most self-sustaining, and most edgily poetic partnerships in modern art. Making representations of the world and of themselves, what they also did, it now seems, was to recapitulate nearly seventy-five years of ambiguity between their two mediums. For Stieglitz, robbing painting to pay photography was an old and complicated story going back to the 1880s, when he had first begun to think of the photograph as a picture

and a work of art. For O'Keeffe, the reverse process was brand-new. Consequently, everything in her art—style, subject, content—was freshly at stake. A letter from Stieglitz to Strand during the summer of 1919 may pinpoint her own acute awareness of this crisis: "G. has not done much painting. She is doing a heap of thinking—my photography and manner of working are affecting her."[1]

O'Keeffe's choice of subjects began to change dramatically in 1919. Not surprisingly, the changes seen over the next few years are directly related to the inner and outer changes in her life—with Stieglitz as mentor, protector, and fulcrum. First, there was the geographical shift from her Texas to his New York City and Lake George. There was also Stieglitz's powerful hope (and undoubted pressure) that O'Keeffe take a significant role in the creation of a native American art. And, most important, there was her own intuitive decision to transform the "uterine personal" subject matter of her first charcoals into shelter shapes of a more covert and objective order: barns, shells, fruit, vegetables, trees, flowers, and skyscrapers.

To this last germinal idea should perhaps be added another. The key to it lies in Stieglitz's statement for his third Anderson Galleries exhibition, in early 1924, in which he described his Songs of the Sky as "direct revelations of a man's world in the sky." In a letter to Sherwood Anderson written during that exhibition O'Keeffe described these prints, taken the summer and fall of 1923, as "way off the earth." Her work of the past year, she said, was "very much on the ground."[2] It therefore appears that she and Stieglitz had come to some sort of profound, if temporary, agreement about their separate artistic spheres: namely, earth (female) and sky (male). If so, where did this idea come from? It is a division of psychic territory that reaches back into prehistory, when Neolithic signs, symbols, and images of divinities tell us that the sky was considered part of the masculine or active principle and associated with things of the spirit, whereas the earth was regarded as the Goddess-Mother Creatrix.[3] Very probably Stieglitz's interest in this ancient sexual imagery of heaven and earth originated in his reading of D. H. Lawrence's *Rainbow* (1915).[4] In any case, it is quite clear that through an age-old metaphor system—the sexualization of nature—Stieglitz and O'Keeffe developed an iconographic code for their Lake George pictures that was as personal, and perhaps as mystical, as the contemporaneous New York Dada images that passed between Picabia and Duchamp.

It is true that O'Keeffe had often chosen the sky as a theme before 1923 in such works as *Starlight Night* (1917; Estate of Georgia

O'Keeffe), *Evening Star No. V* (plate 116), *Light Coming on the Plains I* (1917; Amon Carter Museum), *Orange and Red Streak* (plate 100), *A Storm* (1921; Metropolitan Museum of Art), *Lightning at Sea* (1922; Lane Collection). During and after the summer and fall of 1923, however, her country-sky motifs dwindle appreciably. The few that do exist seem to have had intimate and powerful connections with Stieglitz: for example, *Little House with Flagpole* (plate 1), which depicts his studio-darkroom on the Lake George property,[5] and *A Celebration* (1924; location unknown), which was first titled *Cloud Forms*. This last work may have been painted as a special tribute to ten particularly happy weeks of fruitful work for both artists during the autumn of 1924.[6] Although the motif of the sky never completely disappeared from O'Keeffe's Lake George paintings of the mid- to late 1920s, and may still be read as one of the most telling barometers for her emotions, it was no longer a major country theme for her. With the advent of her cityscapes in 1925, the sky began to figure more prominently again, but it was not until O'Keeffe went to New Mexico in 1929 that the sky theme re-emerged in her work with new force and new meaning.

Like Stieglitz, O'Keeffe believed the camera to be an instrument of "objective" truth. The first of her works to show a direct stimulus from Stieglitz seem to be her 1916 charcoal drawing *Train in the Desert at Night* (private collection) and a 1916 watercolor (Museum of Modern Art, New York), similarly titled, of the same motif.[7] Both were apparently inspired by his photograph *The Hand of Man* (1902), for not only is the locomotive-advancing-under-a-plume-of-smoke motif unique in O'Keeffe's oeuvre, we know from her correspondence with Pollitzer that she was receiving copies of *Camera Work* from Stieglitz during this period. (*The Hand of Man* was reproduced in two issues—no. 9, January 1903, and no. 13, October 1911.)

Despite this probable early reference and despite her excited response to Strand's prints, it is reasonably certain that what brought photography most forcibly to O'Keeffe's creative attention was becoming the prime focus of Stieglitz's camera lens herself. His earliest exposures of her, taken in the spring of 1917 at 291, were sent to Texas some weeks later for her to see. "[His] photographs of me came—two portraits of my face against one of my large watercolors and three photographs of hands. In my excitement at such pictures of myself I took them to school and held them up for my class to see. They were surprised and astonished too. Nothing like that had come into our world before."[8] A year earlier Stieglitz had made installation photographs of her first

291 show of charcoal drawings. Her reaction upon receiving them, as expressed to Pollitzer, is also worth noting: "Did I tell you that Stieglitz sent me 9 wonderful photographs of my exhibition—that he had taken himself—would you like to see them. . . . Isn't it funny that I hate my drawings—and am simply crazy about the photographs of them."[9]

Another thing that helped to bring photography to O'Keeffe's attention was watching and, on occasion, helping Stieglitz print his negatives under the most intimate, crowded, and elemental conditions in the Fifty-ninth Street studio and at Lake George. "G. is a great companion," he wrote to Strand in November 1918 from New York. "She is getting a liberal education—a real 291er. Yesterday for instance I printed from 9 til 2:30—roof—backroom—bathroom—whole room full of dishes, bottles, clotheslines."[10] Six months later he told Strand, "Georgia hasn't painted much—she is torn with the desire to do different things—so is apt to do nothing but be with me."[11] From Lake George in the fall of 1920, he wrote to Rosenfeld: "All morning I've been at it again—just trying all over again to learn the ABC of working. And now G. is at the Lake—in the Lake (had painted all morning after having counted wash for weekly laundry and helped me preparing to develop)."[12] In another letter to Rosenfeld, sent in the summer of 1922, he commented: "Printing ever remains a gamble. . . . Georgia was busy spotting some [of my] prints—and I laughed and said I really didn't know why I worked like one possessed to achieve prints . . . [it was] to satisfy myself. No one else . . . none were for any other purpose."[13] O'Keeffe herself wrote in retrospect: "Each print, even when printed from the same negative, could say something different when Stieglitz printed it and mounted it. As he developed negatives and prints I began to learn about a print—to choose the best prints from among the others."[14]

From all of the above, there can be little doubt that by the early 1920s O'Keeffe had come to understand how the chemical beauty of photography happened and, more important, to regard it as a heritage available to her own work. What she had to do first was to identify the elements that she, as a painter, could extend or reinvent. Her most anxious, most experimental period appears to have been between 1918 and 1925. It is significant that Stieglitz himself made more photographs during those seven years than in all his previous years combined.[15]

O'Keeffe began to shift from watercolor to oil late in 1918.[16] In November 1918 Stieglitz wrote a description of her new oils to Strand: "I think they'd stagger you—no matter what you might expect. Loveliness—Savage Force—Frankness—the Woman—all is there—Beau-

tifully expressed. Her medium is very much more under control and full of quality—more like her watercolors and pastels—that is the oil quality is nearly equal to the charcoal quality—In other words, oil is becoming a real part of her—the struggle with medium is disappearing. Still no strength or directness is disappearing."[17] Two examples from this important period, *Series I, No. 1* (1918; American National Bank) and *Series I, No. 4* (1918; Estate of Georgia O'Keeffe), show that at least some of these new oils were abstractions.

Stieglitz was clearly delighted with her return to oils; perhaps he had even suggested it. (He often gave her advice, but she did not always take it. For example, in 1917 he told her, fortunately in vain, that she ought to stick with black and white.[18]) In any case, her production of watercolors dropped off sharply, although she kept making them for another year. The switch over, if not the reasons for it, can be glimpsed in a letter that Stieglitz wrote to Dove: "Georgia has been having an awful time with the watercolors. She has done a few things, oils, which are worthy to be added to her good things of last year. . . . She claims to be having a hellish time getting her mind clarified."[19] To work in watercolor is to work in the realm of chance. Perhaps this was what made it so unsatisfactory to O'Keeffe at a time when she was trying hard to "clarify" her mind. She continued to use pastel, however, and some of the most exquisitely colored and spontaneous of all her works were done in this medium in 1922. That year Stieglitz wrote to Dove: "Georgia is pastelling just at present. She's certainly most at home in that medium. That is, most free to put down just what she wants to."[20]

The visual and epistolary evidence strongly indicates that O'Keeffe began her serious, and increasingly sophisticated, synthesis of painting and photography in 1919. The first characteristic to show up on her new agenda seems to have been the close-up. O'Keeffe's firsthand experience as subject-object for Stieglitz's camera may have been the prime factor in her 1919 decision to bring her eye closer to her own motifs. Two letters in particular support this view. In March 1919 Strand wrote to Stieglitz: "Your photographs and her [O'Keeffe's] work are part of me —they are great. . . . I am seeing the grey painting and the portrait— they seem somehow related."[21] Six months later Stieglitz and O'Keeffe received the following from Dove: "Dear people . . . have you done more with the close-ups? And were they more satisfying? And the paintings. I am wondering if they do not abstractly feel the same force. Am anxious to see them."[22]

Although the exact sequence and dating of O'Keeffe's 1919 works

must await further scholarship, three large close-ups from that year give us some idea of how she was conducting her experiments. Perhaps the most advanced example, because of its size (22 by 17 inches) and its abstraction, is *Inside Red Canna* (plate 98), exhibited in 1923 at the Anderson Galleries. It appears to be a severely simplified study of a canna based on Subordination, Dow's major design principle. All the lines and spaces radiate out from the corolla, and the composition has the asymmetrical symmetry typical of Art Nouveau—with everything moved up front. Present as well is the familiar "aspiring centricity" of O'Keeffe's early charcoals. The second close-up, *Red Flower* (Warner Collection of Gulf States Paper Corporation, Tuscaloosa, Alabama), is nearly as large (20 by 17 inches). In this work a quite naturalistic flower almost fills the entire canvas, its petal edges considerably cropped by the frame. In both paintings the magnified bee's-eye view of O'Keeffe's later leaves and plants is clearly presaged. The best known of the three, *Music —Pink and Blue, I* (Barney Ebsworth Collection, Saint Louis), commonly regarded as a pure abstraction, was apparently based on the enlarged segment of a shell. Even though she was already aware of the picture's edge as a cropping device, thanks to her Dow-Fenollosa training, O'Keeffe's use of synecdoche here must be considered in light of the fact that fragments of her own body were being isolated by Stieglitz's camera during this period.

Between 1919 and 1929 the work of O'Keeffe and Stieglitz swung between the poles of nature (Lake George) and civilization (New York City). This ancient contrast will therefore serve as the basis from which to examine their paintings and photographs in this chapter and the next. Stieglitz and O'Keeffe were obviously not the first American artists to project states of mind upon the landscape or to make landscape a state of mind. In fact, Henry David Thoreau's boast that he had "travelled a good deal in Concord" might easily have been said by Stieglitz about Lake George—particularly after 1918, when O'Keeffe started to share the time he spent there. Although Lake George was not the first landscape he ever photographed, it was almost surely the first one to register autobiographically on his artist's eye.[23] Stieglitz described his personal identification with this place and the profound significance of its topography for his later work to Sherwood Anderson in 1925: "I have been looking for years—50 upwards—at a particular skyline of simple hills —how can I tell the world in words what that line is—changing, as it does every moment—I'd love to get down what 'that' line has done for me—maybe I have—somewhat—in those snapshots I've been doing the last few years."[24]

98. Georgia O'Keeffe. *Inside Red Canna,* 1919.
Oil on canvas, 22 x 17 in. (55.9 x 43.2 cm).
Michael Scharf, New York.

What O'Keeffe thought about Lake George that extraordinary summer of 1918 is still unknown. But how Stieglitz felt about sharing it with her is revealed in a letter he wrote to Strand in August:

> Time and space seem to have disappeared for me—It's an incredibly wonderful life [O'Keeffe and I] have been leading up here . . . —It's all so real and so full of peace and intensity—of great livingness that I often feel it must be a trance—as there has been but [one] 291—one Camera Work—I feel "this" is fully equal to those—quite as full and rich—a oneness all the way through. . . . It is impossible to give you any picture of what we are living—the Day is sufficient unto itself—not as theory —but as actual feeling from within.[25]

There is a telling photograph (plate 97), taken by Stieglitz that first summer on the Stieglitz property, of O'Keeffe wearing his familiar black loden cape (in very truth his "mantle"). It seems to illustrate this report to Strand, and something else besides.[26] Over her shoulders we see the lake, the line of the hills, and the sky—one of the earliest examples of Stieglitz's "particular skyline," even though it is shown out of focus. She stands arms akimbo, her eyes looking complicitly into those of the photographer, an obviously challenging posture. It is as if she were the mirror image of Stieglitz himself.

There is absolutely no information, visual or otherwise, to suggest that O'Keeffe ever felt "a oneness all the way through" with Stieglitz, even when she was most dependent on him emotionally and financially. O'Keeffe and her paintings are, in fact, generally more visible in Stieglitz's work than he and his photography are in hers. She refers to them both in her pictures, certainly, but her references are almost always hidden, multivalent, and radically, often poetically, transformed. A good case in point is her *Red and Brown Leaf* (1921; private collection), which Stieglitz cited publicly as an intended portrait of himself and O'Keeffe.[27]

In some ways the collaboration between Stieglitz and O'Keeffe at Lake George can be likened to the relationship between the artist-seer Prospero and his daughter, Miranda/Ceres, in Shakespeare's fantasy play about the new world of America, *The Tempest*. There is an astonishing similarity between Stieglitz and Prospero, the civilized ruler who renews and re-creates himself through the protection of an innocent, spontaneous, and natural woman who has the gift of wonder. Continuing with this comparison, we might say that in Stieglitz's mind, and even for a time in O'Keeffe's, Lake George came to be the place where "music"

sounded from the air, the earth, and the water, just as it did on Shakespeare's magic island. Although no record exists that Stieglitz ever thought of himself as Prospero, the fact remains that he was a generation older than O'Keeffe and that he guarded and guided her like a Miranda until 1929, when she exchanged his Lake George for her New Mexico. There were also times, particularly in 1920, when he photographed her almost as if she were "Ceres, most bounteous lady," holding cobs of corn, apple boughs, and the like, in her hands.[28]

O'Keeffe may have been a major catalyst for Stieglitz's interest in photographing the Lake George landscape, the place of their first lyrical happiness. It is also highly probable that she was directly responsible for his burgeoning fascination with nature per se. Compositions based on trees, hillside, clouds, and water had hardly ever appeared in his photography before late 1918. And by this time he was well aware of O'Keeffe's nature-based watercolors, such as *Hill, Stream and Moon* (1916); *Morning Sky* (1916); *Sunrise and Little Clouds* (1916; Estate of Georgia O'Keeffe); the Pink and Green Mountain series (1917); *Trees* (1917; Mark Carlineer); and *Trees and Picket Fence* (1918; Milwaukee Art Museum). It would have been very natural for him—always hospitable to painters' ideas—to take inspiration from the work of someone he had come to identify with so closely. The earth, water, and sky of the Lake George surroundings thus became fresh artistic territory for Stieglitz and O'Keeffe at almost the same time.

It was at Lake George, in 1919, that O'Keeffe would paint her first abstract pictures with music titles: *Blue and Green Music* (plate 118; originally called *Music—Black, Blue and Green*) and the series entitled Music—Pink and Blue. Also among her major oil abstractions of 1919 is *Orange and Red Streak* (plate 100). This work, which looks as if it had been abstracted from a rainbow arched across the sky and lake, might well have influenced Stieglitz's photograph *Rainbow, Lake George* (plate 99). There are several strong formal similarities between them. Both have vertical-rectangle picture fields divided into uneven thirds. O'Keeffe's frame-cropped arc, or "orange and red streak," cuts across her three divisions (presumably the sky, shoreline, and lake), whereas Stieglitz's rainbow (in reverse curve from O'Keeffe's arc) is cropped by the trees of the lower foreground. It is quite possible that with this photograph Stieglitz was attempting to make his own version of "color music"—a concept of Kandinsky's that he and O'Keeffe had both come to apply to her painting[29]—since the total spectrum of color is implicit in his black-and-white exposure of a rainbow. If so, it was certainly a logical progression. In 1918, just before O'Keeffe came to New York

at his urging, he wrote to Strand about a perfect 291 afternoon, when "the O'Keeffe's [her watercolors] never sang so wonderfully."[30] A few months later, with her by his side, he wrote of his work to Strand: "Well I have a few prints which when finished will sing the high C."[31]

None of this is to say that O'Keeffe's painting was the inspiration for Stieglitz's *Rainbow*. The landscape itself was that.[32] It is, rather, to suggest that her work acted as an intermediary for him, offering and confirming certain formal ideas. By 1920 he seems to have become acutely aware of her abstract shapes and of her "music" methods as a source for his photography. In this he could also have found support in the words of Kandinsky: "The borrowing of method by one art form from another can only be truly successful when the application of the borrowed methods is not superficial but fundamental. One art must learn first how another uses its methods."[33]

Stieglitz's abundant letters to Strand, Rosenfeld, and Seligmann offer a ringside seat on what he and O'Keeffe were experimenting with during the early 1920s, as well as an invaluable look at their increasingly similar

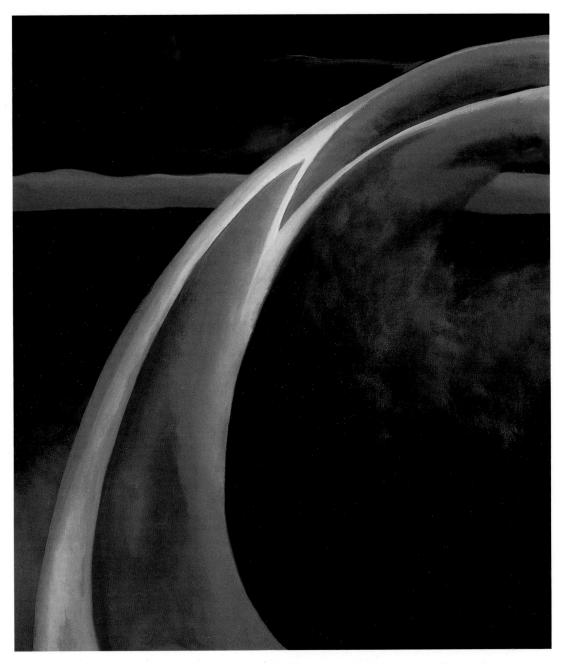

99. Alfred Stieglitz. *Rainbow, Lake George,* c. 1920. Gelatin silver print,
4½ x 3½ in. (11.5 x 8.9 cm). National Gallery of Art, Washington, D.C.;
The Alfred Stieglitz Collection, 1949.3.456.

100. Georgia O'Keeffe. *Orange and Red Streak,* 1919. Oil on canvas,
27 x 23 in. (68.6 x 58.4 cm). Philadelphia Museum of Art;
The Alfred Stieglitz Collection, Bequest of Georgia O'Keeffe.

rhythms and methods of working. It is apparent that Stieglitz wished his closest colleagues to be impressed with the originality and forward motion of his latest protégée. "G. has started to paint," he wrote to Strand during August 1920. "Has got to get 'started' before [striking] a gait —her gait—Lake George is not visually exciting as you know—not until autumn—and G. needs excitement of some kind to get her going." To Strand, September 20, 1920: "Georgia is painting some—not as much as other summers. And neither of us knows whether what she has done is good or not.—She has primarily tackled summer greens.— Perhaps the autumn will put a little bit more ginger into both of us." To Strand, September 21: "Georgia continues to paint—I wonder what you will think of her new work—the color is as fresh—as pure—as ever. As she is herself."[34]

To Rosenfeld, who was almost his alter ego with regard to American culture theory during the early 1920s, Stieglitz often wrote in more intimate detail. In a letter dated August 28, 1920, he described how O'Keeffe acquired her own studio, "the Shanty," at Lake George:

There is an old shanty on the place.—It has been going to pieces—was half dismantled. . . . Georgia had always had her eye on it. . . . Within a few days, with virtually no outlay—doors and hinges salvaged from—or in old barns, old windows fished out of old woodpiles etc. etc., Georgia had her dream in concrete form—. . . and you should have seen G. up on the roof astride the top—working away with hammer and brush like an old adept. . . . This building activity seemed to put life into G. and she soon was apaint.[35]

On September 20 he wrote to Rosenfeld: "I have been experimenting with portraits—family mostly.—Have done nothing of Georgia as yet. —It hasn't worked out that way. . . . [She was clearly too absorbed in her own work to pose for him.] [G.] is busy with preparing canvases in her shanty. . . . Has a few very interesting things. Not as many as last year.—And different.—I am not able to judge them.—I'm much too close to really see them here."[36]

During the summer and fall of 1920 Stieglitz began the richly symbolic series of American "apple portraits," seven of which featured members of his circle—among them O'Keeffe. In two of these portraits she is pictured with her fingers portentously touching specimens of a bounteous apple harvest.[37] The year 1920 was also when O'Keeffe's own subject matter began to show a new and decided shift from abstraction

101. Alfred Stieglitz. *Elizabeth Stieglitz Davidson and Georgia O'Keeffe on Roof*, 1920. Photograph, 3⅝ x 4⅝ in. (9.2 x 11.7 cm). Virginia M. Zabriskie, New York.

to the fruits of the Lake George soil. "Georgia is painting apples," Stieglitz wrote to Marie Rapp Boursault, his former secretary at 291. "She has the apple fever. They are really marvelous [on the Hill] this year."[38] This sudden concentration on apples by them both raises the question again of "who was leading the bear." The idea of a series was one that had interested these artists long before they met, although their early reasons for working in this way were different. Right up to the end O'Keeffe liked to say that her variations on a theme stemmed from her feelings that what she had already done was not good enough.[39] Rather than repainting the process of her seeing on the same canvas, she would start another and went on this way until the "excitement" of the motif wore itself out. Stieglitz, on the other hand, had believed ever since the

1890s that a series of photographs could convey a meaning far greater than any one image.[40] It is highly probable that his form of narrative sequencing had an enormous influence on O'Keeffe, for her Lake George themes and variations became charts of her own interior growth.

Judging from Stieglitz's correspondence, the 1921 season at Lake George was not as productive for him as it was for O'Keeffe. Early that October he grumbled to Rosenfeld, "I haven't had much luck with my recent attempts at photography . . . —In short I know that this year I seem to be anything but a Master."[41] To Seligmann he wrote often of his pride in what O'Keeffe was accomplishing: "Went out on the Lake at 5:30 and got back at 7. The beauty of the water and hills—the forms—colors—ever changing—every second—indescribable. Perhaps Georgia's work will reflect it."[42] And to Seligmann again, two days later, on September 18, 1921: "The weather continues beyond description. No 2 moments is the landscape the same. Georgia is putting experiences into paint . . . A new note. Quite extraordinary. Very different." To Seligmann, October 14, 1921: "We had just gone down to the lakeside to look at a red maple by the water. Georgia is painting it. A most hilarious, yet sombre, picture. Every fall she has painted that tree." Just two months before, Stieglitz had complained to Strand: "Have the tree subject still up my sleeve. May stay there for a long while."[43]

What *was* the "very different" note in O'Keeffe's painting? Stieglitz may have been referring to her extended series of apple still lifes. The rather obsessive quality—and quantity—of her canvases painted between 1920 and 1922 on this theme suggests that they may be among the very earliest of her newly abstract-objective self-portraits.[44] That all fruits are female must surely be taken into account here. And so must a strange close-up photograph of O'Keeffe, made by Stieglitz about 1920, which has a disembodied stem of two apples (ovaries?) hanging right next to her face in the left foreground (plate 102).

Despite the ground-breaking importance of her apples as personal "experience," it is more likely that Stieglitz's September 18 letter to Seligmann refers to *Lake George with Crows* (plate 104). For this painting was certainly the most "extraordinary," and radical, of the twenty-five canvases O'Keeffe did during that incredibly productive autumn of 1921. For one thing, it introduces the aerial view, which she would use off and on for the rest of her artistic life, most notably in the plant close-ups during and after 1924. In Texas, in 1917, she had painted *Canyon with Crows* (plate 103), a small watercolor, seemingly from the motif. It is by comparing these two works with similar titles that we can see some of

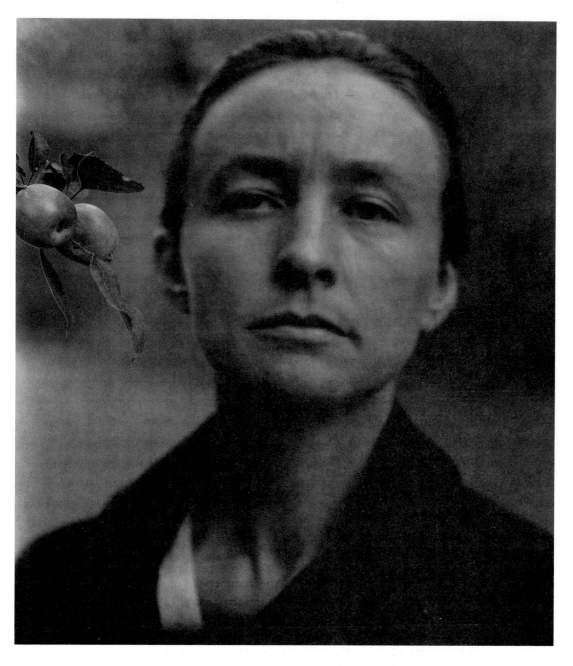

102. Alfred Stieglitz. *Georgia O'Keeffe: A Portrait—Head,* c. 1920.
Gelatin silver print, 9¾ x 7⅝ in. (24.9 x 19.3 cm). National Gallery of Art,
Washington, D.C.; The Alfred Stieglitz Collection, 1980.70.10.

the ways her vision changed and expanded during the three years spent with Stieglitz. The perspective of her watercolor is essentially an oblique and earthbound view, whereas in *Lake George with Crows* there is a real sense of being suspended in space. By this time O'Keeffe had surely seen Coburn's angled aerial view, *Octopus, New York,* taken from a new skyscraper in 1912. And she was well aware of Stieglitz's own longtime interest in views looking down from tall buildings, going back to *Snapshot —From My Window, New York* of 1900–1902.[45]

Unlike these photographs, however, and unlike her *Canyon* watercolor, *Lake George with Crows* was not based on personal experience, for O'Keeffe did not fly in an airplane until 1929, nor did Stieglitz. What else might have served as a model for her eccentric construction of space? One possibility, certainly, is the commercial aerial photograph. After World War I, aerial views of resort areas like Lake George became extremely popular through postcards and the like. But *Lake George with Crows* seems to be a composite image from at least three different viewpoints: the aerial; the high oblique (as if seen from nearby Prospect Mountain, since it includes the far side of the lake); and the low oblique (as from, say, an upper window of the Stieglitz farmhouse on The Hill).[46] The possibility of a second-story view is reinforced by the long, grayish, transparent shape at the extreme right of the building,

OPPOSITE
103. Georgia O'Keeffe. *Canyon with Crows,* 1917. Watercolor on paper, 9 x 12 in.
(22.9 x 30.5 cm). Ex-Collection Georgia O'Keeffe; Private collection.

ABOVE
104. Georgia O'Keeffe. *Lake George with Crows,* 1921. Oil on canvas, 28 x 25 in.
(71.1 x 63.5 cm). Estate of Georgia O'Keeffe.

which can be read as a window frame or even as an organdy curtain hanging from it. If so, there is yet another dimension to O'Keeffe's complicated space—that of being inside looking out. Further evidence that this landscape was built in the artist's imagination from layers of factual information lies in the colors (chalklike tones based on red and yellow fall foliage), the reduction of her three crows into free-form triangular patterns, and the enlarged, centralized oval of the lake.[47]

Judging by the significant leap forward made by both Stieglitz and O'Keeffe in 1922, this was the peak year of their collaboration, which seems to have been at its most fertile from 1919 through 1924. By 1925 factors such as health, age differences, and O'Keeffe's growing visual and psychological boredom with Lake George conspired against the powerful resonance between their two minds. After that, they started to pursue independent, if still related, aesthetic concerns. Three letters, in particular, chart these changes: O'Keeffe to Ettie Stettheimer, August 6: "Stieglitz passed a kidney stone and is feeling better—when he wasn't busy with that he was busy with that other hot water heater we had . . . before we got the new one.—And once in a while he ran after a cloud —and sometimes he caught it. . . . I have decided that next summer I am going to tent on that 366th island they talk about here—the one that only comes up for leap year—with the hope that there won't be anything on it to tend to."[48] Stieglitz to Waldo Frank, August 25: "Georgia is painting some—but has not found her 'swing' as yet—. . . She still dreams of the plains—of real spaces—Lake George is [too] pretty.—If I were strong enough I guess I'd take her to Texas for a while."[49] Stieglitz to Strand, September 15: "Our summer has been anything but inspiring for work. First there were the months of illness. . . . Then, although there has been perfect peace on The Hill you know Georgia's inner yearn for big spaces."[50]

A combination of visual and epistolary evidence from 1922 makes it reasonably certain that this was the year O'Keeffe began her unique and ongoing contribution to the apex of Stieglitz's art: his abstract-expressive cloud photographs. Stieglitz mentioned O'Keeffe's name twice in his famous account "How I Came to Photograph Clouds" (1923).[51] In the article he says that he told her he wanted a series of photographs that would make the great composer Ernest Bloch exclaim, "Music! Music! Man, why that is music!" Since she had been making "visual music" pictures, with clouds as a major element, from at least the time of her 1916–17 watercolors and since she was as steeped as he in the ideas of Kandinsky and Picabia, it is likely that his project Music: A Sequence

of Ten Cloud Photographs had been thoroughly discussed between them. Such discussion was, in fact, their standard practice.[52]

When and why did the clouds over the Lake George hills suddenly become visual music for Stieglitz's camera? The closest answer to "when" comes from his 1922 correspondence: letters to Strand dated July 26 and September 7 speak of "battling with the barn" on The Hill —trying unsuccessfully, in his view, to expose its interior shadow and exterior sunlight simultaneously. There is also a frustrated letter to Rosenfeld written in mid-August: "I continue to tinker. It frightens me to see how much material I use to get a print or two that finally seem to be something alive. . . . Georgia is painting. Doing curious things.— Curious colors. I do hope autumn will give Georgia the real chance she is hoping for. Summer is really nothing but a sort of preparation for that as far as she is concerned."[53] Yet another to Rosenfeld, dated October 4, mentions that O'Keeffe is painting "a remarkable apple" and goes on to complain, with some bitterness, about a recent visit from Strand: "While Strand was here I virtually did no photography. He photo-ed like one possessed—shooting right and left—forward and backward— upward and downward—and in directions not yet named."[54]

From all this it seems that it was not until well into October that Stieglitz began to work "daily for weeks" on the clouds. On October 29 he reported to Seligmann: "As for ourselves we are madly, madly busy. You really have no idea with what intensity O'Keeffe and I work—and over what periods. I put in nearly 17 hours yesterday."[55] We also know that over and beyond his indignant intention to refute Waldo Frank's description of his photography in *Manuscripts* as "the power of hypnotism" by choosing "free clouds," Stieglitz (like Stéphane Mallarmé) had had a longtime interest in the weather as an influence on, and indicator of, his emotions.[56] He was also steeping himself in everything to do with music: a letter to Rosenfeld speaks of reading Mozart's and Beethoven's correspondence: "I'm always amazed at the simplicity, the directness of these men.—Direct like their music.—Ever refreshing."[57]

It is quite possible that the germinal idea for his first "cloud" picture, *Music No. 1* (plate 105), came from the aesthetic impact on Stieglitz of two different paintings: Hartley's *Dark Mountain* (plate 106) and O'Keeffe's *My Shanty* (plate 107). To take the Hartley first: not only did Stieglitz own this particular work, he had been an admirer of Hartley's Maine cloud and mountain motifs, painted from memory, since 1909—the year they were exhibited at 291. Perhaps nothing better reveals the profound and lasting impression that Hartley's paintings

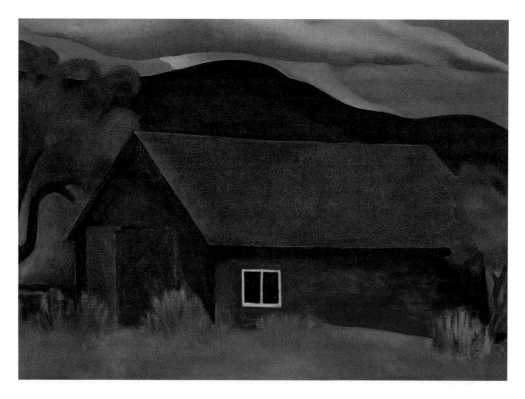

OPPOSITE, TOP
105. Alfred Stieglitz. *Music No. 1*, 1922. Silver print, 8 x 10 in.
(20.3 x 25.4 cm). Museum of Fine Arts, Boston; Gift of Alfred Stieglitz.

OPPOSITE, BOTTOM
106. Marsden Hartley (1877–1943). *The Dark Mountain*, 1909.
Oil on composition board, 19¼ x 23¼ in. (48.9 x 59 cm).
The Art Institute of Chicago; The Alfred Stieglitz Collection.

ABOVE
107. Georgia O'Keeffe. *My Shanty*, 1922. Oil on canvas,
20 x 27 in. (50.8 x 68.5 cm). The Phillips Collection, Washington, D.C.

made on Stieglitz than his letter to Rosenfeld of November 5, 1920. In
it, he describes a Lake George walk taken with O'Keeffe just before
sundown: "Hartley's black landscapes—there they were before us. Only
much deeper—more tremendous. . . . Everything clear cut—intense—
clean. . . . As for the incompleteness of some of the Hartleys—I don't
always know if that is a shortcoming. . . . Of course all his pictures are
autobiographical to a very great degree."[58] What undoubtedly struck
Stieglitz about the "black landscapes" was their obvious sense of place;
The Dark Mountain renders some far-off white farmhouses encircled by
mountains and trees so dark that their vaguely anthropomorphic shapes
are nearly indistinguishable from each other. Despite obvious differences

in composition and meaning, Stieglitz's *Music No. 1* presents a similar motif in a markedly similar fashion: trees and mountain shapes nearly obscured by darkness, jittery massive clouds blown by a high wind, and in the lower distance, one inexplicably illuminated dwelling in very clear detail. (In Stieglitz's key print every roof slate and clapboard can be made out; even the windowsill is visible.)

The visual links between *Music No. 1* and O'Keeffe's *My Shanty* are stronger still. Although her beloved studio almost fills the canvas, and Stieglitz's dwelling (actually The Hill's farmhouse) is dwarfed by the sky and mountains, the theme of the two works is the same: a single building in landscape. That both buildings are presented in their most triangular aspect may be yet another instance when these artists made objective fact coincide with their secret spiritual intentions. In Stieglitz's photograph there are two very subtle triangular forms. The second is made by branches against the sky just above the horizon line.[59] Stieglitz's sky takes up two-thirds of his picture, and O'Keeffe's roughly one-fourth. Her clouds, with their outstretched tendrils, are as somber and menacing as his dark rolling masses. At some point during that same autumn of 1922 O'Keeffe made a Rousseau-like picture of Stieglitz's newfound studio, *Little House* (plate 46), nearly half of which is occupied with clouds. Did she perhaps intend it as a visual act of praise for his new subject matter?

The other nine photographs in Stieglitz's Music: A Sequence of Ten Cloud Photographs are absolutely pure Edenic landscapes without any man-made structures. The series has an even more significant theme: the sun. One of the hardest of all subjects to photograph, the sun is an almost palpable presence in each of these ten images. Its disk shape is directly visible in half of them (numbers 4, 5, 8, 9, and 10), and indirectly visible, as a prime source of illumination, in the rest. The entire sequence may have been intended by Stieglitz as a definition of, or homage to, the photographic process itself: the sun equals light equals photography.[60]

During the summer and fall of 1923, and consistently thereafter, Stieglitz took cloud photographs with his four-by-five-inch Graflex. He titled these images Songs of the Sky, and he made more of them in 1923 than in any of the years to follow.[61] Although some of these photographs include portions of trees and hillsides, most of them are indeed "way off the earth," as O'Keeffe had expressed it. Just before they were exhibited in 1924, she wrote an extremely revealing letter about them to Sherwood Anderson: "He has done with the sky something similar to what I had done with color before—as he says—proving my case—He has done consciously something I did most unconsciously—and it is amazing to

see how he has done it out of the sky with the camera——."[62] Even with this documentary proof of Stieglitz's intentions, it *is* "amazing" to find O'Keeffe's 1916–18 abstract watercolor forms in many of Stieglitz's four-by-five cloud photographs of 1923.

The process leading to this accomplishment seems to have been a triple one and not always straight—to judge from Stieglitz's correspondence as well as from the prints themselves. The first step was based on his original idea of "the moment": the very instant when cloud patterns in the sky seemed to him to stand for something he was feeling, or thinking about, or was perhaps reminded of. "It's a wild glorious morning. Maddeningly beautiful. . . . I ought to be skying but I'm not going to—the negatives are too easy to make."[63] Nine days later: "I have really gotten the breathing of moments down.—Georgia gets all excited when she looks at the tiny things."[64] The second step was identifying the most significant contact prints—those "more real than reality," as he described them to Anderson that August 15. A couple of weeks later he wrote, again to Anderson: "I have been busy with clouds . . . I believe I have a few very wonderful pictures. I can never tell though *what* I have until I am through with it. Do I ever get quite through with It?"[65] The third vital step consisted, in his words, of "Mounting—spotting. Spotting—mounting. Mounting—spotting—Placing—Trimming—Spotting—Mounting."[66] As a small number of the prints show, sometimes Stieglitz even spotted out whole clouds in order to make a given configuration more emotionally definitive, or more like an O'Keeffe abstraction.[67]

Prime examples of his earliest references to O'Keeffe's work exist in a 1923 series of Songs of the Sky. (Apparently Stieglitz considered these five Songs especially important ones, for they were part of his gift that year of twenty-seven framed photographs to the Boston Museum of Fine Arts.) *Songs of the Sky No. 1* (plate 108) has strong formal similarities to two of O'Keeffe's Texas watercolors, *Red and Blue*, numbers I and II (plates 109, 110).[68] The pincerlike configuration issuing from the left of his horizontal photograph is similar to the dominant forms in O'Keeffe's vertical series—especially to the looser version, *No. I.* Whether the nebulous, puffy shapes in both watercolors originated from her own observations of the sky is not known but does seem likely.

In *Songs of the Sky No. 4* (plate 111) the concentric clouds expanding out from the sun disk look as if they had been motivated by the similarly cropped concentric color rings in another of O'Keeffe's 1916 watercolors, *Blue, Green, and Red*—but in reverse (plate 112). In *Songs of the Sky No. 5* (plate 113) the windblown, misty clouds seem gradually to

108. Alfred Stieglitz. *Songs of the Sky No. 1,* 1923. Silver print, 4 x 5 in. (10.2 x 12.7 cm). Museum of Fine Arts, Boston; Gift of Alfred Stieglitz, April 1924.

My photographs are ever born of an inner need—an Experience of Spirit. I do not make "pictures," I never was a snap-shotter in the sense I feel Coburn is. I have a vision of life and I try to find equivalents for it sometimes in the form of photographs. It's because of the lack of inner vision amongst those who photograph that there are really but few true *photographers.*

Alfred Stieglitz to J. Dudley Johnson, April 3, 1925.

BOTTOM
109. Georgia O'Keeffe. *Red and Blue No. I,* 1916. Watercolor on paper, 12 x 9 in. (30.5 x 22.9 cm). Private collection.

OPPOSITE
110. Georgia O'Keeffe. *Red and Blue No. II,* 1916. Watercolor on paper, 12 x 9 in. (30.5 x 22.9 cm). Private collection.

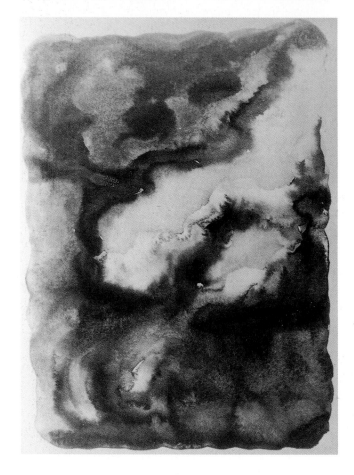

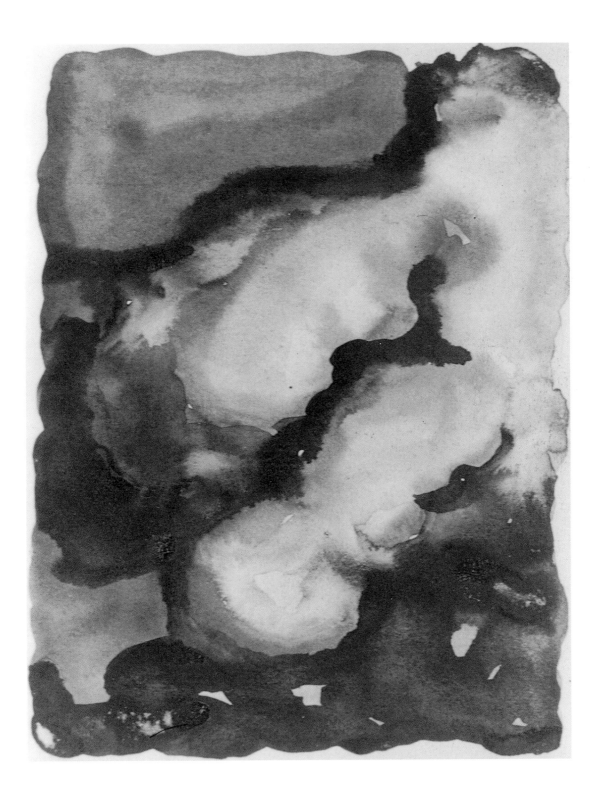

111. Alfred Stieglitz. *Songs of the Sky No. 4,* 1923. Silver print, 4 x 5 in. (10.2 x 12.7 cm). Museum of Fine Arts, Boston; Gift of Alfred Stieglitz, April 1924.

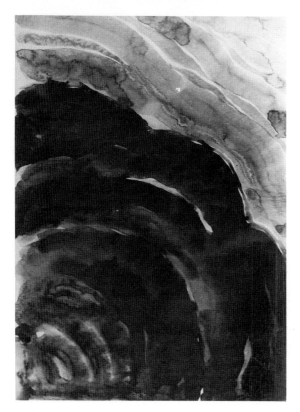

112. Georgia O'Keeffe. *Blue, Green, and Red,* 1916. Watercolor on paper, 6 x 11 in. (15.2 x 27.9 cm). Private collection.

113. Alfred Stieglitz. *Songs of the Sky No. 5,* 1923. Silver print, 4 x 5 in. (10.2 x 12.7 cm). Museum of Fine Arts, Boston; Gift of Alfred Stieglitz, April 1924.

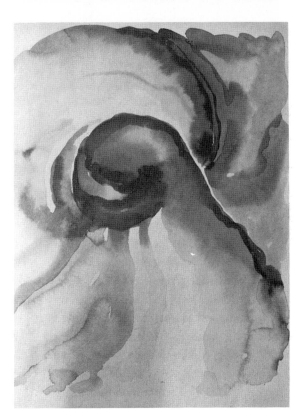

114. Georgia O'Keeffe. *Cerise and Green,* c. 1918. Watercolor on paper, 11¾ x 8¾ in. (29.8 x 22.2 cm). Private collection.

115. Alfred Stieglitz. *Songs of the Sky No. 2,* 1923. Silver print,
4 x 5 in. (10.2 x 12.7 cm). Museum of Fine Arts, Boston;
Gift of Alfred Stieglitz, April 1924.

assume the double-spiral shape of her watercolor *Cerise and Green* of
about 1918 (plate 114). This shared configuration becomes quite unmis-
takable when the watercolor is turned upside down—a practice common
to both artists. Adding to the pictorial and personal significance of these
watercolors for Stieglitz is the fact that all three were shown in
O'Keeffe's 1917 show at 291.

Songs of the Sky No. 2 (plate 115) is the one in the series that holds
the clearest visual reference to O'Keeffe's work, specifically to *Evening
Star No. V* (plate 116). This is a logical link for two unassailable reasons:
first, because written on the back of the National Gallery of Art print,
in Stieglitz's hand, is "Portrait of Georgia."[69] And second, because a
more perfect choice for an abstract cloud photographic portrait of
O'Keeffe can hardly be imagined than re-presenting her own early sky
material.[70] In both pictures we see a spiral shape with a cometlike tail

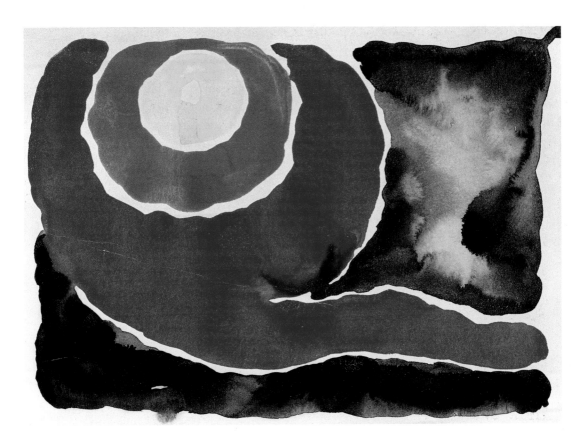

116. Georgia O'Keeffe. *Evening Star No. V*, 1917.
Watercolor on paper, 9 x 12 in. (22.9 x 30.5 cm).
Private collection.

that is perhaps as expressive of spiritual emotion as similar forms in Vincent van Gogh's *Starry Night*.[71] (The portentous nature of the comet is well known to have influenced literature, religion, warfare, and perhaps even the beginnings of life.)

As for *Songs of the Sky No. 3* (plate 59), there is a strong likelihood that its space-filling phallic form was intended by Stieglitz as an abstract self-portrait. Toward the end of October 1923 he wrote to Hartley with somewhat ironic pride: "I have gone through a great deal this summer. That's why 'clouds' (really the Sun) and I became fast friends.—And in spite of being merely a photographer I think I have gotten some things down I haven't seen anyone else do."[72]

One of the larger questions about this material is why Stieglitz chose to make so many references to O'Keeffe's subjective abstractions in his equally subjective Songs of the Sky. The answer that this series is yet

another of his joinings of modern American painting with photography —the most original of them all—is surely correct, as far as it goes. But there are some extra dimensions to consider. He may have been trying, yet again, to make "color music" with photography, since all his references in the Songs are to O'Keeffe's watercolors, not to her charcoals. Further, it is probable that he meant some of the Songs to be visual conversations with O'Keeffe—coded messages, or tributes, on the order of her painted ones to him. For some proof toward this last, there is Stieglitz's own statement, recorded by Seligmann in 1926: "Sometimes I have been talking with O'Keeffe. Some men express what they feel by holding a woman's hand. But I have wanted to express the more, to express the thing that would bring us still closer. I would look at the sky, for the sky is the freest thing in the world, and when I would make a photograph from clouds and the sky and say to O'Keeffe, 'Here is what we were talking about,' she would say, 'That's incredible, it's impossible.' "[73]

These formal and emotional references in the Songs of the Sky to O'Keeffe's work persisted long after 1923. One of the most "incredible" is to be found in a photograph best known as *Mountains and Sky (Lake George)* (plate 117).[74] There can be little doubt that Stieglitz was referring specifically to her 1919 oil *Blue and Green Music* (plate 118). Like the painting, the photograph is a study in large acute-angled triangles— Kandinsky's purposeful simile for the "life of the spirit." Stieglitz's exposure caught a cloud cluster floating above his "particular skyline of simple hills" in a formation astonishingly like the geometric configuration in O'Keeffe's painting. Her central triangle appears to have been abstracted from a favorite group of birch trees on the shoreline—that same one that appears in *Lake George with Crows* (plate 104)—but the rippled forms at bottom left are easily recognizable as some of her earliest shorthand for clouds. In a certain sense, Stieglitz's photograph could also have been titled *Blue* (sky and lake) *and Green* (trees and mountains) *Music*. And this raises another logical question: why would he have wanted to make color music through photographs such as *Rainbow* and certain of the Songs—if that was indeed his intention? Again, the answer may rest with Kandinsky, who wrote about "chromotherapy," or the therapeutic effect of color, and how it could exercise influence on the body and the soul.[75] In documentary support of the above suggestion there is a letter from Stieglitz to Rosenfeld dated November 14, 1923: "You say I'm the greatest artist in America. May be, may be not. I feel it's an unnecessary challenge and emphasizes something you really don't care to sacrifice at the expense of your whole

'statement' about me [in *Port of New York*], so I'd change that. Georgia agrees with me. . . . It isn't modesty on my part. I know my worth. But I'm not sure about being as much an artist as one of the leading spiritual forces in this country. That they may challenge."[76] There can be little doubt that Stieglitz's working idea of abstraction was, and remained, close to Kandinsky's—profoundly Symbolist, messianic, and utopian.

The summer and fall of 1923 were also extremely creative for O'Keeffe. She was testing new ground with the symbolic-abstract portrait, and mostly, it would seem, with still-life portraits of herself. The Renaissance artist's concept of a self-portrait was to look in a mirror, but that was hardly necessary for O'Keeffe, since she was already being immortalized by Stieglitz's photographs of her many "selves." The advent of photography had driven many painters to experiment with modelless variations on the self-portrait, and O'Keeffe's concept seems at once nineteenth century and new. She may have been unfamiliar with such realist symbols of the artist's presence as Gustave Courbet's *Trout* (c. 1872), but she definitely used Stieglitz's close-ups of her body as models for some of her own abstract-objective self-portraits.

One of the most revealing of these is *Alligator Pears* (plate 119). To compare this 1923 painting with a diagram (plate 120) of Stieglitz's often-reproduced 1919 photograph of her breasts, bisected by the flowerlike shape of her left hand, is to see an unmistakable kinship in form and composition. The alligator pear is also a powerful symbol of the full womb. She may have intended to convey, in yet another guise, Stieglitz's favorite notion (really her own) that "Woman receives the world through her womb. . . . The seat of her deepest feelings."[77] To this loaded equation a sad biographical factor might be added: there are eight known alligator pear canvases from 1923, a rather large number on a single theme for O'Keeffe. It is entirely possible that they have a direct connection to the sudden, and final, loss of her long hope of having a child with Stieglitz, due to the tragic postpartum illness of his daughter, Kitty.[78] If so, this adds much to our understanding of the artist's own comments on her alligator pears some forty years later: "The first alligator pear I became acquainted with I didn't eat. I kept it so long that it turned a sort of light brown and was so hard that I could shake it and hear the seed rattle. I kept it for years—a dry thing, a wonderful shape. Later I had two green ones—not so perfect. I painted them several times. It was a time when the men didn't think much of what I was doing. I was an outsider. My color and form were not acceptable. I had an alligator-pears-in-a-large-dark-basket period. One painting is dark with a simplified white scalloped doily under the basket. There was

117. Alfred Stieglitz.
Mountains and Sky (Lake George), c. 1924.
Gelatin silver print, 9⅜ x 7½ in. (23.7 x 19 cm).
National Gallery of Art, Washington, D.C.;
The Alfred Stieglitz Collection, 1949.3.916.

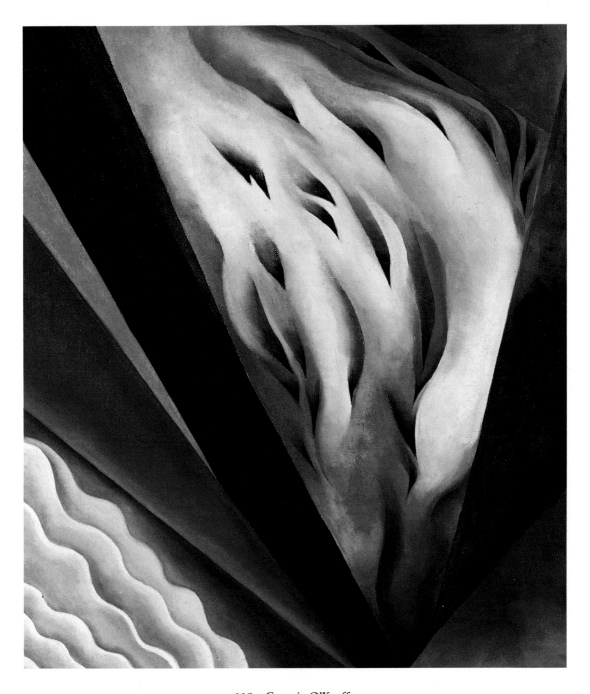

118. Georgia O'Keeffe.
Blue and Green Music, 1919. Oil on canvas,
23 x 19 in. (58.4 x 48.3 cm).
The Art Institute of Chicago;
Gift of Georgia O'Keeffe to the Alfred Stieglitz Collection.

a painting of pears in the basket with a pink line around the outside as a sort of frame." [79]

In 1923 O'Keeffe was also concentrating her mind on calla lilies and leaves. At least eight of the callas are known to have been painted during this year. [80] Perhaps no flower has had a wider range of associations in America than the calla lily. During the nineteenth century it was commonly associated with feminine modesty and with mortality, becoming a familiar symbol in Victorian death and funeral scenes. Its exotic appearance also attracted such still-life painters as John La Farge, George Cochran Lambdin, and John Henry Hill, particularly during the 1870s and '80s. [81] During the first two decades of the twentieth century the calla acquired a whole new fascination for artists, due largely to its

blatantly sexual configuration and its abstract form. For the first Freudian generation the calla's connotations seem to have run a gamut from the purely feminine to the heterosexual to the homosexual. The calla motif, with its prominently phallic "yellow rod," had already been picked up during the late 1910s by Hartley and Demuth, possibly with private homosexual implications for them both.[82] But what caused O'Keeffe's intense preoccupation with the calla in 1923? To research this deceptively small question is to come to grips with the very stuff of O'Keeffe's mature art, with what makes it personal, profound, and unique.

In fastening on the calla O'Keeffe was alternating, as usual, between two visions: the moral—in the D. H. Lawrence sense of giving form to some felt aspect of her life—and the aesthetic. Flowers had always given her "a curious feeling of satisfaction"[83] and they outnumber every other category in her work between 1915 and 1930. Up to 1923, however, the flowers that O'Keeffe had chosen to paint were sturdy, high-colored, common garden varieties without any special visual or symbolic history: the canna in particular, but also the zinnia, spirea, and dahlia.[84] The intensity and precision of twentieth-century American flower painting are commonly thought to have derived from the nineteenth-century artists' objective and scientific desire to document the landscape of the New World. But whereas O'Keeffe's cannas, zinnias, and the like can easily be considered as natural facts that speak for themselves, her callas really cannot. There is something extra about them.

The history of flower symbolism is generally characterized by two quite different considerations: the flower in its essence (as an archetypal image of the eternal human life cycle and the soul's immortality) and the flower in its shape. All floral plants are, of course, designed by nature for the purpose of sex. Most species have both male and female organs that are more or less visible, but the calla's sexual stratagems are laid so bare that it is easy to see them as erotically suggestive. O'Keeffe obviously did so. She may not have known, or cared, that the name *calla* derives from the Greek word *kallōs*, meaning "beauty." But as a child of her time she would certainly have been aware of flower dictionaries. Popular American literature from the turn of the century is infused with the idea that flowers were carriers of emotional and spiritual truths. Whether O'Keeffe, as a sophisticated twentieth-century artist interested in objectivity, did or did not practice disguised flower symbolism is a debate that can go either way, which may mean that she *sometimes* did. In the so-called language of flowers, the calla stands for "magnificent beauty."[85] Further, the lily as a species had been a cultural metaphor for purity and immortality in Christian art since the Middle Ages. It also

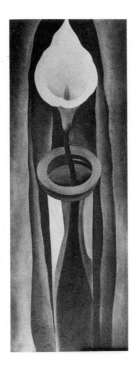

appeared frequently, in this context, in Pre-Raphaelite paintings and photographs, but with a new, and secular, urgency.

Even if, as seems probable, that extra something about O'Keeffe's callas has emblematically to do with sex, beauty, and the generic female, there are other points of origin to consider before we can get at the core of their significance in and for her art. Almost without exception, whenever O'Keeffe broke new ground it was to Dow's exercises that she looked for support and ballast. If, for example, we take two of her best-known calla paintings, both of which appeared in the 1924 Anderson Galleries show—*Calla* (plate 121) and *Calla Lily in Tall Glass No. 1* (plate 122)—and put them beside one of Dow's "flower lines in space" compositions in *Theory and Practice of Teaching Art*, the relationship between the three is immediately visible. Although Dow's calla (plate 123) is reduced to decorative divisions of space, the asymmetry of a flower within a vertical rectangle was closely followed by O'Keeffe in both her paintings.

Hartley also appears to have been an influence, but mostly in terms of style. If we compare her *Calla Lily in Tall Glass No. 1* with his well-known *Blue Cup* (or *Color Analogy*) (plate 124), we can see several stylistic connections. These include the centralized iconic format; the quasi-geometric circles and triangles; the dark contour lines; the flat,

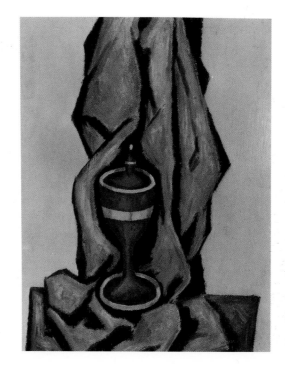

rhythmically patterned backgrounds; and the angular, simplified orna-
mentality characteristic of American folk art. There is also a distinctly
anthropomorphic quality about O'Keeffe's three-tier callas in their vases,
as there is about Hartley's *Blue Cup*. (All of these relationships are
easiest to see in black-and-white reproductions, for O'Keeffe's use of
color is utterly opposed to Hartley's.[86]) It is this quality of anthropo-
morphism—quite new to her flowers in general—that leads one to
suspect that the 1923 calla lilies in vases are the earliest of O'Keeffe's
floral self-portraits. Traditional iconography had long worked against
women's attempts to represent themselves, as O'Keeffe well knew: "I
have had to go to men as my sources in painting, because the past has
left us so small an inheritance of women's painting that has widened
life."[87] The vase is one of the most ancient symbols for the female
principle—i.e., the woman as life vessel. And the flower was certainly a
less esoteric, and more legible, metaphor for O'Keeffe to choose than
the apple or the alligator pear, since the association of women with
flowers had been a longtime favorite in Symbolist and Art Nouveau
analogies.[88] *Camera Work* was riddled with Symbolist images connecting
women to flowers; especially notable are Steichen's photograph *Cyclamen
—Mrs. Philip Lydig* and his painting *The Lotus Screen—S.S.S.*[89]

 To what extent did O'Keeffe's idea of making floral self-portraits

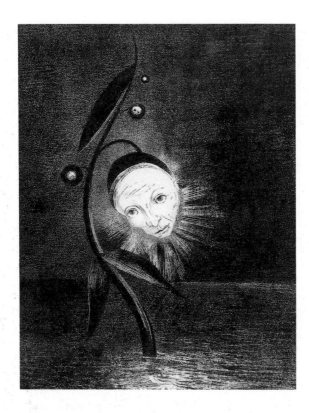

125. **Odilon Redon
(1840–1916).**
*La Fleur du marécage, une
tête humaine et triste,* **1885.
Lithograph,
11 x 8¼ in. (28 x 21 cm).
The Art Institute of Chicago;
Stickney Collection.**

come from Stieglitz? Though he rarely posed her *with* flowers, there are
several reasons to think that he was, at the very least, a psychological
influence.[90] Chiefly, there is the visual fact that he often photographed
parts of her body as phytomorphic forms. One of the earliest examples
of this may be an image of her head and shoulders against the sky, like
a blossom on a stem (plate 126). Only her face is visible: a circular hat
hides her hair, and the identifying outlines of her neck and shoulders are
obliterated by the black cape she wears. This ingenious photograph so
closely resembles Odilon Redon's flower-head lithograph, *La Fleur du
marécage, une tête humaine et triste* (plate 125), that it can hardly be a
coincidence. Sometimes Stieglitz composed O'Keeffe's hands so that
they would resemble floral forms—mostly the water lily and the tulip.[91]
But perhaps the least known, and most abstract, of all his phytomorphic
conceptions of her body are the singularly beautiful photographs of her
buttocks made in 1922.[92]

What all of the foregoing suggests is that during 1923 the visually
androgynous calla—possibly the most simplified and rigorous of all
flower forms—came to stand in O'Keeffe's mind for a newly conscious
decision: to create "magnificent beauty" instead of the child she had
hoped to have with Stieglitz. It would be hard to imagine a more perfect

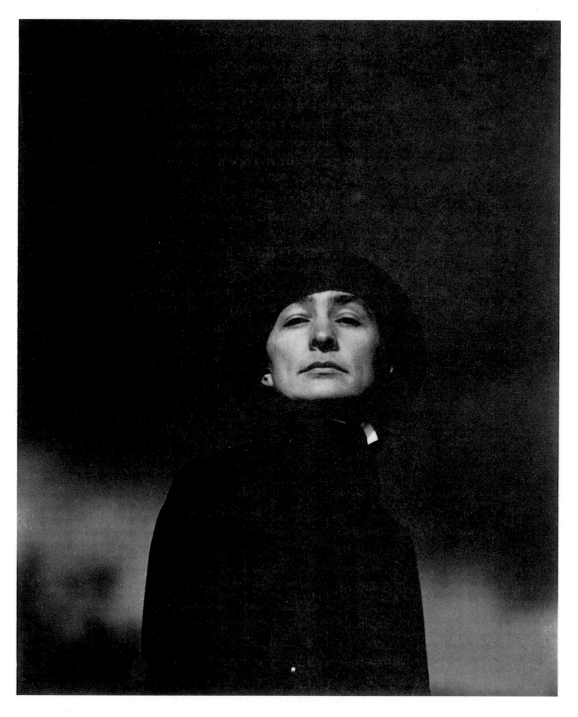

126. Alfred Stieglitz. *Georgia O'Keeffe: A Portrait—Head,* 1923.
Gelatin silver print, 4⅝ x 3⅝ in. (11.6 x 9.2 cm).
National Gallery of Art, Washington, D.C.;
The Alfred Stieglitz Collection, 1980.70.191.

choice for the first of her floral self-portraits than the calla's waxy, uterine shape, with its subtle implications of immortality. These alter images of O'Keeffe's, with their use of nature's artifacts to express both psychic states and physical characteristics, are direct descendants of de Zayas's "soul-state" caricatures of 1912–15, Picabia's mechanistic "object-portraits" of 1913, and Hartley's symbolic German officer paintings of 1914–15. But why the abstract portrait received such sudden and simultaneous attention from O'Keeffe and Stieglitz, in the guise of callas and clouds, during the last half of 1923 remains a question. Demuth's composite "poster portraits" of the mid-1920s and Dove's portrait collages of 1924–25 are obviously linked to this same rich and puzzling resurgence.[93]

There is strong evidence that O'Keeffe increased her experiments with magnifying her plant studies in 1923. Without being able to compare all of her leaf canvases of 1923–24 with the flowers she painted during the same period, it is not possible to state categorically that she magnified leaves to a large scale before she did flowers. Nevertheless, this does seem to be the case. At least nine leaf canvases are known from 1923, eight of which appeared in her 1924 Anderson Galleries show.[94] All of these leaf canvases seem to be small ones, except for *Pattern of Leaves* (plate 127), clearly an experimental work, in which she filled a large canvas with superimposed leaf forms painted nearly parallel to the picture plane. This painting is interesting on two counts: its large dimensions (22⅛ by 18⅛ inches) and the obvious magnification of its forms.[95] This enlarged close-up point of view became yet another type of abstraction for O'Keeffe: the object that is singled out from its ordinary reality to take on a conceptual life of its own. It was a transformation that never ceased to interest her.

Confronting yet another major shift in her work, O'Keeffe again seems to have turned to Dow for a lead. If we compare her *Pattern of Leaves* with a *notan* drawing exercise of "Japanese botanical work" in *Composition* (plate 128), Dow's inspiration becomes apparent. It looks, in fact, as if she combined most of the elements illustrated on this page, which range from her blown-up leaf to the overlapping of forms and background to the free and arbitrary croppings. O'Keeffe's dark oak leaf has a distinct similarity in outline to one of Dow's (at lower left), but she renders it with a central vertical tear: her own innovative way, at once natural and abstract, to cut space—and express emotion.

The leaf was not wholly new to O'Keeffe's canon in 1923; she had painted *Green Leaves* in 1921 and *Purple Leaves* (locations both unknown) in 1922. One of the subject's earliest appearances can be found in her

ABOVE

127. Georgia O'Keeffe. *Pattern of Leaves,*
c. 1923. Oil on canvas, 22⅛ x 18⅛ in.
(56.2 x 46 cm). The Phillips Collection,
Washington, D.C.

RIGHT

128. Arthur Wesley Dow (1857–1922).
"Exercise No. 52: Japanese Botanical Work,"
from *Composition,* 1899.

1916 charcoal drawing *Abstraction IX* (plate 129). The source for this abstraction was identified by the artist herself as the head and arms of a young girl.[96] In it she combined figurative with landscape imagery: the "mouth" is unmistakably an elm leaf and the "arms" clearly resemble a winding riverbed. This type of dual imagery would remain one of the most durable characteristics of O'Keeffe's art.

Why leaves? O'Keeffe seldom discussed the choices she made for her symbolic system, and certainly never in terms of meaning. We therefore have to get at her rhetorical approach from other sources. Leaf forms, with their myriad organic patterns and intrinsic flatness, were an almost perfect subject for a painter as schooled in the surface design of Art Nouveau as O'Keeffe. And it may be significant that Stieglitz had himself considered the leaf when, in 1922, he was searching through nature for a worthy container to hold and express his feelings.[97] There is also a literary factor to be considered—namely, Thoreau's extraordinary paean to the leaf in *Walden*.[98] Having observed the patterns made by the thawing ice and sand around Walden Pond during early spring, he wrote:

> No wonder that the earth expresses itself outwardly in leaves, it so labors with the idea inwardly. . . . The overhanging leaf sees here its prototype. . . . The feathers and wings of birds are still drier and thinner leaves. . . . The whole tree itself is but one leaf, and rivers are still vaster leaves whose pulp is intervening earth. . . . Is not the hand a spreading palm leaf with its lobes and veins? The ear may be regarded, fancifully, as a lichen . . . with its lobe or drop. . . . The Maker of this earth but patented a leaf. . . . The earth is . . . but living poetry like the leaves of a tree, which precede flowers and fruit,—not a fossil earth, but a living earth.[99]

Two of O'Keeffe's leaf canvases in particular suggest that she knew this passage. The first is *Leaf Motif No. 2* (plate 130), one of the largest of all her magnified leaves. In this work, which appeared in the *Seven Americans* show, abstracted oak leaves have been carefully composed into the dominant shape of a human ear. Even more illustrative is the second one, *Red and Brown Leaves* (plate 131), a vividly colored painting of fall foliage.[100] A giant maple leaf is presented against a background of sky and clouds, its edges slightly cropped by the frame. Superimposed on it is a smaller poplar leaf, with veins like branches and a stem as sturdy as

129. Georgia O'Keeffe.
Abstraction IX, 1916. Charcoal
on paper, 24¼ x 18¾ in.
(61.6 x 47.6 cm).
The Metropolitan
Museum of Art, New York;
The Alfred Stieglitz Collection, 1949.

a tree trunk—recalling Thoreau's observation that "the whole tree itself is but one leaf."

Only recently have we learned for certain which of O'Keeffe's 1924 flowers was the first to be enlarged. It is *Petunia No. 2* (plate 133).[101] By comparing it with *Petunia and Coleus* (plate 132), formerly *Petunia No. 1*, we can see what a major breakthrough it was. And even though exactly what triggered this pictorial development may never be known, it is safe to say that chance was a very small factor and photography a large one.

In both paintings the flowers are seen, somewhat magnified, from above. The petunia in *No. 1* is rendered with clarity and completeness in an actual, if indeterminate, space. In *No. 2* three blown-up petunias take over the entire canvas—their details somewhat blurred, as if out of focus, and the edges of two of them cropped by the frame. It is a camera's version of a bee's-eye view in nearly every respect. This is a strange—not to say fabulist—concept of O'Keeffe's: the top flower rising like the sun over the tilted "horizon" and the stemless blossoms below it floating balloonlike in an irrational space. The strongly indicated horizon line suggests that she was not quite ready to give up depicting three-dimensional space, something that disappears in an extreme photographic close-up. She would, however, quickly learn to take advantage of this view, with its spatial ambiguities and built-in abstract patterns.

Stieglitz's correspondence offers some important clues about the timing of *Petunia No. 2* and about the magnified flowers that followed right after it. To Strand, June 1924: "Georgia is in fine shape. Happier than I have seen her in a great while. . . . She is on the 3rd canvas. All

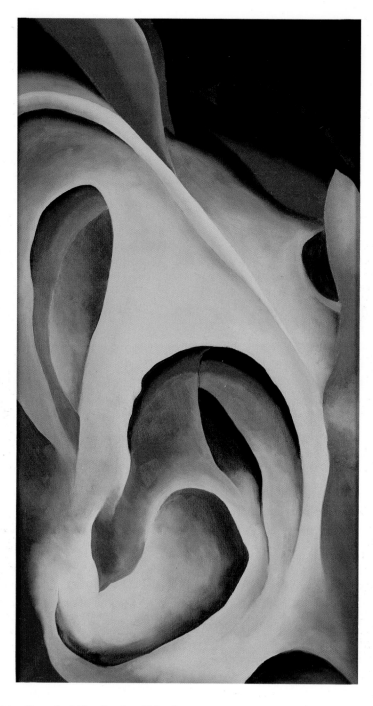

130. Georgia O'Keeffe. *Leaf Motif No. 2*, 1924. Oil on canvas, 35 x 18 in. (88.9 x 45.7 cm). Marion Koogler McNay Art Museum, San Antonio; The Mary and Sylvan Lang Collection.

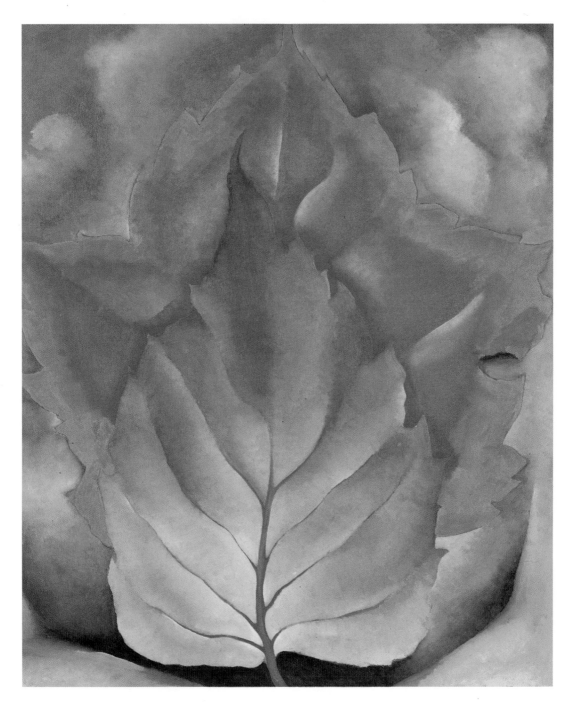

131. Georgia O'Keeffe. *Red and Brown Leaves*, c. 1925. Oil on canvas,
25 x 19¾ in. (63.5 x 50.2 cm). Elvehjem Museum of Art,
University of Wisconsin–Madison; Private collection.

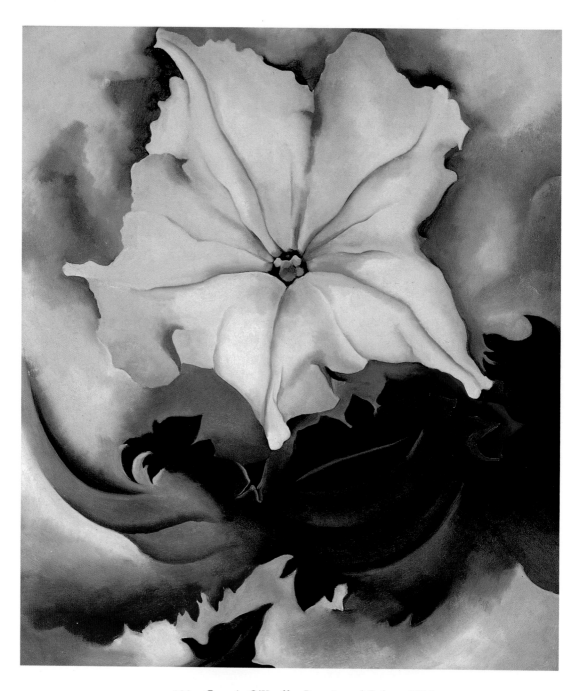

132. Georgia O'Keeffe. *Petunia and Coleus,* 1924.
Oil on canvas, 35¾ x 29¾ in. (91.4 x 76.2 cm).
Mr. and Mrs. Gilbert H. Kinney.

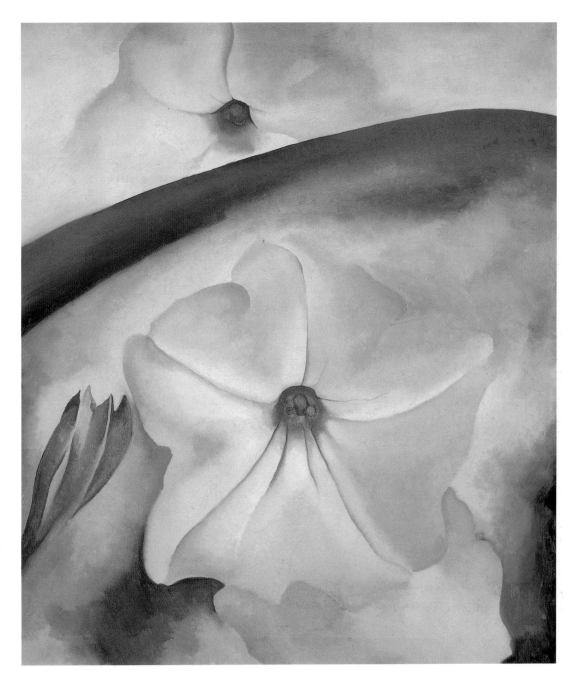

133. Georgia O'Keeffe. *Petunia No. 2*, 1924.
Oil on canvas, 35½ x 30 in. (90.2 x 76.2 cm).
Mr. and Mrs. Gerald P. Peters, Santa Fe, New Mexico.

very amusing. Larger than last year. She's at a whopper now."[102] To Rosenfeld, September 6, 1924: "Georgia completed an amazing large picture—real red—'abstract'—as she says, not a picture anyone will want to purchase."[103] To Strand, September 14, 1924: "Georgia ... has produced two large canvases—amazing ones—abstract. On her 'old' order.—Really extraordinary."[104] The enthusiasm of the last two letters represents a distinct change in Stieglitz's own opinion of O'Keeffe's magnified flowers. When they first started, he described them to Rebecca Strand as "silly but lovely."[105] Whether their increased abstraction helped him to see them in terms of the "new" (as indeed they were) is not a matter of record.

O'Keeffe's disingenuous reply to Katharine Kuh's 1962 question, "Has your use of isolated, blown-up details been influenced by photography?" also has a place in this discussion:

I'll tell you how I happened to make the blown-up flowers. In the twenties, huge buildings sometimes seemed to be going up overnight in New York. At that time I saw a painting by Fantin-Latour, a still life with flowers I found very beautiful, but I realized that were I to paint the same flowers so small, no one would look at them because I was unknown. So I thought I'll make them big like the huge buildings going up. People will be startled, they'll *have* to look at them—and they did. I don't think photography had a thing to do with it.[106]

It is never wise to discount any of O'Keeffe's sparse explanations, but she was clearly not above having her own little joke at public expense, especially when it could be used to cover some of the tracks of her artistic process.[107] What else did this photographic viewpoint offer O'Keeffe as a painter? Certainly she found in it a range of new opportunities for rendering surface details: the rough and the smooth, the hard and the soft, the rigid and the limp, the hairy and the slick, the damp and the dry, and so forth. (There is a wide array of fastidious brush strokes in *Petunia No. 2.*) Her magnified flowers would become increasingly full of these distinctions, even when they emphasized a "licked," or sleek, surface. The close-up view also offered her new kinds of shadow patternings—an extension of Dow's *notan* principles. A very early case in point is her 1922 pastel *Single Alligator Pear* (plate 134), which appears to have been richly informed by a still-life photograph by Baron Adolf de Meyer, *Hydrangea* (plate 135).[108] Despite his grounding in nineteenth-

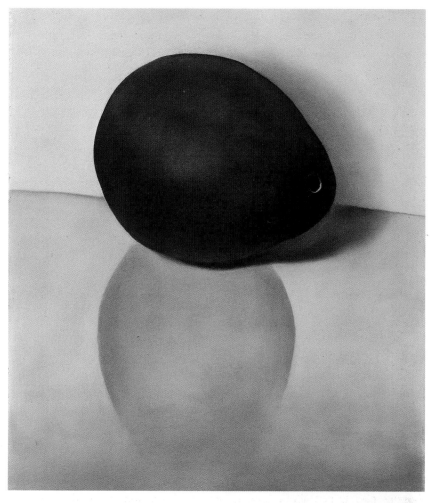

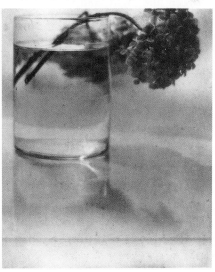

ABOVE

134. Georgia O'Keeffe.
Single Alligator Pear, 1922.
Pastel on paper,
12 x 10 in. (30.5 x 25.4 cm).
Private collection.

RIGHT

135. Baron Adolf de Meyer
(1868–1949). *Hydrangea*, c. 1907.
Reproduced in *Camera Work*,
October 1908.

 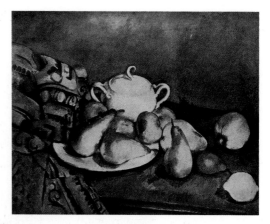

136. Pablo Picasso
(1881–1973).
Woman with Mandolin, 1910.
Reproduced in *Camera Work*,
June 1913.

137. Paul Cézanne
(1839–1906).
Still Life, 1893–94.
Reproduced in *Camera Work*,
June 1913.

century aesthetics, de Meyer often translated his material into what Charles H. Caffin described as "a fantasy of abstract beauty."[109] And it could not have been lost on O'Keeffe that Stieglitz always held de Meyer in high esteem, as an artist and as a human being.[110] By comparing *Single Alligator Pear* with de Meyer's *Hydrangea*, which O'Keeffe doubtless knew from *Camera Work* 24 (October 1908), we can get a fair idea of her "adaptive" use of photography—that is, using a photograph as a theme on which to make her own painted variation.

Both pictures are painstaking explorations into the relationships between line, light, and shadow. Both are similarly top-heavy in composition, with dark forms at the top, light ones on the bottom. O'Keeffe's precisely illusionistic alligator pear takes up nearly the same portion of her space as de Meyer's precisely focused flower occupies in his. O'Keeffe has rendered two shadows. The background one is "true," because it obeys a logical light source, and the foreground one "false," in that its shape is completely arbitrary. De Meyer's shimmering, ambiguous glass shadow dwindles away in a manner very like her pear's foreground shadow. His own "abstraction" has much to do with allowing reflection to create the optical illusion that his glass is swollen on its right side. The major distinction between these two pictures, their mediums and their subject matter aside, is that de Meyer's hydrangea is radically cropped and O'Keeffe's pear is not cropped at all. There is also a balanced centrality in her picture, whereas his is asymmetrical. In fact, considering how early it was made, the photograph seems far more

daring and eccentric than the pastel. O'Keeffe, however, called this the "best" of her alligator pears: "I have always considered that it was one of the times when I did what I really intended to do. One isn't always able to do that." [111] In any case, it is hard to believe that *Single Alligator Pear* could have ended up looking the way it does without the impetus, and challenge, of de Meyer's photograph.

There is also some strong visual evidence that toward the end of 1923, and well into 1924, O'Keeffe did some rather agitated searching through *Camera Work*'s hallowed halls of modernism before she arrived at magnification.[112] Two paintings from this searching period deserve attention because of what she rejected. The first is *Three Pears No. 1* (plate 138). If we compare it with Picasso's *Woman with Mandolin* (plate 136) and Cézanne's *Still Life* (plate 137), as reproduced in *Camera Work* (special number, June 1913), several of O'Keeffe's sources become visible.[113] Although she has isolated and enlarged Cézanne's pears—pushing them all together and reversing the direction of the horizontal one—their common shapes and positions are easy to recognize. And the

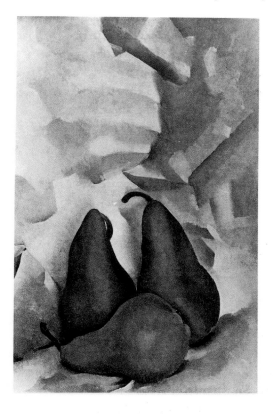

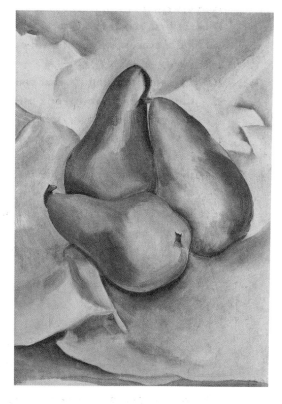

138. Georgia O'Keeffe. *Three Pears No. 1,*
c. 1924. Oil on canvas,
18 x 12 in. (45.7 x 30.5 cm).

139. Georgia O'Keeffe. *Three Pears No. 2,*
c. 1924. Oil on canvas,
18 x 12 in. (45.7 x 30.5 cm).

forms in her uncharacteristically faceted background are clearly based on those in Picasso's early Analytic Cubist work. O'Keeffe's flirtation with Cubism seems to have begun and ended with this painting. By the time she got to *Three Pears No. 2* (plate 139), the faceting can barely be seen, nor was it ever to reappear.

Mask with Golden Apple (plate 140) is even more aberrant in terms of O'Keeffe's development.[114] This is the only African mask that O'Keeffe is known to have painted. Juxtaposed as it is with an apple, it seems to embody a sort of visual argument made up of two of Stieglitz's favorite, and most enlightened, pronouncements: that the root of European modern art lies in "the statuary in wood by African savages" and that the apple is an appropriate metaphor for the native American artist's spirit.[115] The work also possesses a distinctly photographic quality because the distance between the apple and the mask looks artificially compressed, a characteristic typical of close-up photographs.

There can be little doubt that O'Keeffe's decision to magnify her flowers came from the innermost recesses of her artistic thought; that this changeover had a long preparation, going back to 1919; and that it was, at first, mostly a matter of scale. One of the most revealing letters O'Keeffe ever wrote about form-making was to Sherwood Anderson:

> I've been thinking of what you say about form—. And either I dont agree with you—or I use a different way of thinking about it to myself—Maybe we mean somewhat the same thing and have different ways of saying it.—
>
> I feel that a real living form is the natural result of the individuals effort to create the living thing out of the adventure of his spirit into the unknown—where it has experienced some-

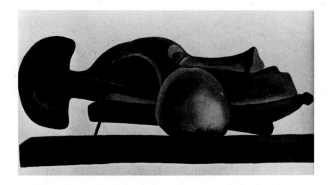

140. Georgia O'Keeffe. *Mask with Golden Apple*,
c. 1923–24. Oil on canvas, 9 x 15 in. (22.9 x 38.1 cm).
Private collection.

thing—felt something—it has not understood—and from that experience comes the desire to make the unknown—known— By unknown—I mean the thing that means so much to the person that he wants to put it down—clarify something he feels but does not clearly understand—sometimes he partially knows why—sometimes he doesn't—sometimes it is all working in the dark—but a working that must be done—Making the unknown —known—in terms of ones medium is all absorbing—if you stop to think of form—as form you are lost—The artists form must be inevitable—You mustn't even think you won't succeed. . . . Making your unknown known is the important thing —and keeping the unknown always beyond you. . . . The form *must* take care of itself if you can keep your vision clear—I some way feel that everyone is born with it clear but that with most of humanity it becomes blasted—one way or another.[116]

Passionate, groping, and authentic as these words clearly are, the essential spirit of 291 shines right through them, leading back to Stieglitz's concept of art, perhaps best defined during an interview in 1910:

We [at 291] are somewhat of the same condition as they were in the early days of the Renaissance . . . seeking for the unknown. . . . I don't know when it will be reached, but I do see that these men are alive and vital, and my object is to show to Americans who have not the opportunity of going abroad what vitality in art exists here. . . . [The men] whose works are exhibited . . . do believe in themselves—and that's an important item—but they do not believe they have reached . . . ever will reach—the point for which they are striving.[117]

The early Lake George years clearly unlocked new dimensions of artistic energy in both O'Keeffe and Stieglitz. For a time, the physical and mystical chemistry between them—call it the spirit of 291—was like a private cult. It even resulted in a hot, if good-tempered, competition for motifs: "Once Stieglitz got ahead of me. He shot the door before I could paint it."[118] After the "failure" of the *Seven Americans* show, and doubtless for personal reasons as well, the heart seemed to go out of their earth-and-sky dialogue. It did, at any rate, for O'Keeffe. By 1925 the musical duet between her paintings and his photographs had lost its original exclamatory power. In fact, it seems almost as if the two artists had agreed to pursue their endeavors independently.

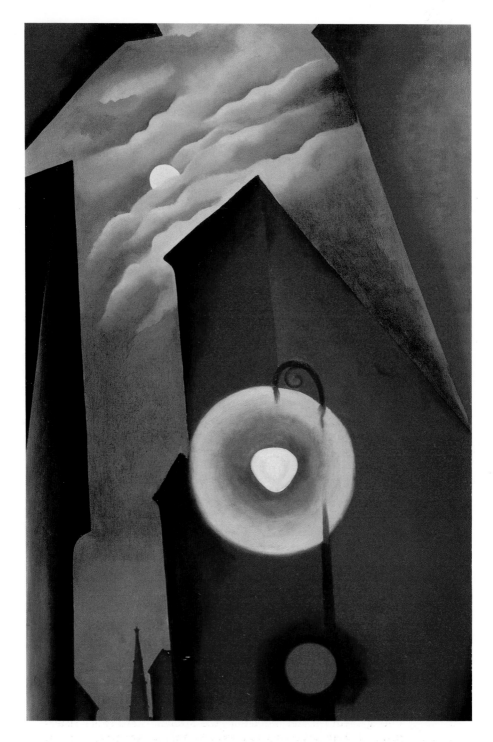

141. Georgia O'Keeffe. *New York with Moon*, 1925.
Oil on canvas, 48 x 30 in. (121.9 x 76.2 cm).
Thyssen-Bornemisza Collection, Lugano, Switzerland.

O'Keeffe and Stieglitz in New York City

I want to paint in terms of my own thinking, and feeling the facts and things which men know. One can't paint New York as it is, but rather as it is felt.

GEORGIA O'KEEFFE, 1926

[O'Keeffe] is more at home in the soil, while I am a city person.

ALFRED STIEGLITZ, 1924

During November 1925 Stieglitz and O'Keeffe moved into the new Shelton Hotel on Lexington Avenue between Forty-eighth and Forty-ninth streets. They had watched this thirty-four-story skyscraper going up for two years—it was then the tallest hotel in New York—and they would live and work in the Shelton for approximately six months of the year over the next decade.[1] O'Keeffe always liked to make the point that her right to paint New York was hard won from Stieglitz and the men of his circle because they considered the city to be a strictly masculine preserve.[2] She herself had carried on a love-hate affair with New York ever since she lived there as a student. Her feelings were divided, in large part because she always felt and slept better in the country.[3] Nevertheless, from her first stay in New York, in 1907, to her last, in 1949, O'Keeffe was an immensely successful city dweller. She worked. She walked. She went to exhibitions, operas, and concerts. And she developed some special friendships with other devout "city people" in the arts, among them Marcel Duchamp, the brilliant Stettheimer sisters (Carrie, Ettie, and Florine), Louise March, Henry McBride, Claude Bragdon, and Mitchell Kennerley. A 1928 interview in which O'Keeffe spoke in exceptionally candid terms about the excitement and challenge

of being a painter in New York leaves little doubt about her Romantic, as against Precisionist, intentions:

> When I came to live at the Shelton about three years ago I couldn't afford it. But I can now, so of course I'm going to stay. Yes I realize it's unusual for an artist to want to work way up near the roof of a big hotel, in the heart of a roaring city but I think that's just what the artist of today needs for stimulus. He has to have a place where he can behold the city as a unit before his eyes but at the same time have enough space left to work. Yes, contact with the city this way has certainly helped me as no amount of solitude in the country could. Today the city is something bigger, grander, more complex than ever before in history. There is a meaning in its strong warm grip we are all trying to grasp. And nothing can be gained by running away. I wouldn't if I could.[4]

During his early years with O'Keeffe, Stieglitz's own once-passionate feelings for New York turned negative and escapist. (Not until the 1930s would he again photograph the city—with a new vigor and commitment.[5]) Three letters in particular chart this temporary estrangement. To Rosenfeld, during the summer of 1920, he wrote: "Strand and Seligmann [are] in Nova Scotia both busy and glad to be away from the City of Terribleness. For that is what the idea of New York becomes more and more to me—Personal of course, I know."[6] In a letter to Hamilton Easter Field later that same year he was rather more ambivalent and elegiac: "I was rather surprised to see what you had to say about New York—my old love. But my New York is the New York of transition—the Old gradually passing into the New.—You never saw the Series I did—beginning 1892 and through 1915.—Not the 'Canyons' but the Spirit of something that endears New York to one who really loves it—not for its outer attractions—but for its deepest worth —& significance.—The universal thing in it."[7] Shortly after moving into the Shelton he wrote to Sherwood Anderson: "New York is madder than ever. The pace ever increasing.—But Georgia & I somehow don't seem to be of New York—nor of anywhere. We live high up in the Shelton Hotel—for a while—maybe all winter—the wind howls and shakes the huge steel frame—We feel as if we were out at midocean— All is so quiet except the wind—& the trembling shaking hulk of steel in which we live—It's a wonderful place—"[8]

O'Keeffe's strong sense of place also operated powerfully in New York. The motifs for her city paintings were all found within easy walking distance of the hotel, or else they originated from what she could see from the Shelton's height.[9] In this, certainly, she resembled Stieglitz, who told Edward Weston in 1938 (with only slight exaggeration), "All my photographic work has been done in this 50 yards of this home on The Hill [Lake George] or out of the window of the Shelton where O'Keeffe and I lived for 12 years or out of the window of An American Place."[10]

The central subject of O'Keeffe's cityscapes is the skyscraper, seen from quintessentially photographic vantage points and angles. That photography and architecture go well together has been clear from the earliest daguerreotypes and calotypes: buildings not only held still, they permitted personal as well as cultural interpretations. This traditional empathy was a leitmotiv in *Camera Work*, from photogravures by Frederick Evans and Alvin Langdon Coburn to those by Stieglitz and Strand. By 1925 the skyscraper (Louis Sullivan's "proud and soaring thing") was revered as twentieth-century America's own art form. In 1925 and 1926 more skyscrapers were going up in New York than at any other time—some forty-five of them.[11] O'Keeffe's conception of buildings as giant plant forms rising from the cement may have been nourished by her witnessing this extraordinary upward expansion of the city, but the phytomorphic metaphor had long been explored by Art Nouveau and was, in fact, as old as architecture itself.[12] O'Keeffe would certainly have been aware of Dove's early modernist work *Nature Symbolized No. 1* (1911–12), with its man-made towers poking up from the earth.[13] And the fact that she was simultaneously painting her enlarged flowers may also have to be taken into account here.

To Walt Whitman "all architecture is what you do to it when you look upon it."[14] What was it to O'Keeffe? Her first city painting, *New York with Moon* (1925), offers some major clues (plate 141). The design of this work appears to have been "adapted" from one of Stieglitz's best-known photographs, *The Flatiron Building* (plate 142). Both pictures are composed within vertical formats. Both contain a series of echoing verticals that divide the foreground, middle ground, and background. And both play with variations on the right angle, or triangle, created by their severely cropped edges. A tree has pride of place on the right side of Stieglitz's photograph, as a streetlight does in O'Keeffe's painting. At that point the formal resemblances between the two pictures cease. With her streetlight O'Keeffe went on to employ, in a particularly "innovative"

142. Alfred Stieglitz.
The Flatiron Building, 1902–3.
Photogravure,
12⅞ x 6⅝ in. (32.7 x 16.7 cm).
National Gallery of Art,
Washington, D.C.;
The Alfred Stieglitz Collection,
1949.3.272.

way, a phenomenon singular to photography: halation. Stieglitz had also used halating lights for expressive purposes in some of his earliest night views of the city, such as *An Icy Night, New York* (1898).[15] But O'Keeffe's rendition of halation is different and reveals a highly technical understanding of its cause and effects. Halation is a malfunction that occurs when a strong beam of light penetrates the film emulsion and is reflected back into the emulsion by the film base. It can yield two slightly different results: a continuous bloom around lights, as in Stieglitz's photograph, or a kind of white halo with a dark fringe, as in *New York with Moon*.[16] It was O'Keeffe's innovative use of this odd photographic truth that transformed the street lamp into the dominating form, and major light source, of her painting.

Is *New York with Moon* yet another abstract self-portrait? Possibly. For the flower had by now become O'Keeffe's emblem, and this halating light bulb hangs down like a round golden blossom from its wrought-iron stem in an unmistakably organic way. Just below it is the glow of a red traffic light. (Does the color stand for STOP, the restriction "the men" had tried to place upon her?) Just above it shines the moon, a motif recurrent in her work since 1916. How aware was O'Keeffe of the

primordial symbolic connections between woman and the moon—everything from the monthly lunar cycle to the mirror-reflector of the male to her distant, circular, self-containment? Very aware, it would seem. *New York with Moon* is one of her most joyous and optimistic paintings. In Stieglitz's photograph, architecture (the Flatiron Building) is nearly eclipsed by nature (a tree and snow). In O'Keeffe's picture, the buildings all rise up as if no end were in sight, and their powerful forms are illuminated by her metaphoric streetlight rather than the cloud-threatened moon. Architecture was becoming nature's "Other" to her in ways very different from what it was to Stieglitz.

During 1926 O'Keeffe seems to have thought a great deal about architecture, judging from her large number of canvases on this subject, and she painted the barn as searchingly as the skyscraper, although less often.[17] The results are some of her most inventive, self-revelatory, and photo-optic works. O'Keeffe wrote to Mitchell Kennerley in 1929: "The barn is a very healthy part of me—There should be more of it—It is something that I know too—it is my childhood—I seem to be one of the few people I know of to have no complaints against my first twelve years."[18] As a building of exceptional individuality and practicality—and as an archetypal symbol of shelter and abundance—the barn seems a natural, and innately personal, theme for O'Keeffe. She was not alone in considering it a metaphor for the womb. In 1926 Stieglitz would describe one of his barn photographs in this fashion: "Perhaps that dark entrance (the barn door) that seems to you mysterious is the womb, the place whence we came and where we desire when we are tired and unhappy to return, the womb of our mother, where we are quiet, and without responsibility and protected. That is what men desire, and thinking and feeling and working in my own way I have discovered this for myself."[19] It must also be remembered that the barn had been represented as indigenous American architecture by painters and photographers ever since World War I—and, as such, it had already become what the cultural historian Constance Rourke called a "source form." An obvious example is Charles Sheeler's *Bucks County Barn* (plate 143). To compare this work with O'Keeffe's *Lake George Barns* (plate 144) can be quite instructive, for there are elements in her composition that look like creative corrections of the photograph: particularly her cropping decisions and the formal relationships she developed between vertical, diagonal, and horizontal lines. Also, her barns are embedded in the landscape, whereas Sheeler's have little to do with their surroundings.

There are other important things to be noticed about *Lake George Barns*. O'Keeffe's earliest, and most enduring, artistic intention was to

simplify her forms to their essence as shapes, and by 1926 photography had become a common tool toward that end. At first glance this painting does not seem to be evoking photographic means at all, but the reduction of nearly all its forms to planes suggests that she borrowed from the photographic process the blocking of highlights.[20] Textured surfaces can be reduced to single planes, often by mistake, by manipulating the tonal scale while exposing and developing a negative and making a print. But O'Keeffe took some artistic license with a similar effect in *Lake George Barns,* which has no optical acuity at all. Photographic detail is never lost in the middle tones by such means—only in the extreme ends of light and dark. To make the point clearer, and to underline O'Keeffe's own accurate understanding of the mechanics of this developing process, we have only to look at her *Barn with Snow* of 1934 (plate 145).[21] These are the same barns that she had painted in 1926, seen from essentially the same vantage point, but they are rendered very differently. The glaring snow-covered roofs and the shadowed flanks of the 1934 barns are without detail for reasons that are consistently photographic, for the lights and darks are quite properly at opposite ends of the tonal scale. Furthermore, the only details rendered with photographic precision in

the painting are the foundation stones, which stay consistently in the middle values of light.

There is something crowded and stifling about the three shuttered buildings in *Lake George Barns*. They deprive the viewer of a sense of distance, and the low gray sky adds to the sense of being completely hemmed in. The only exit offered is through the blue crack in the clouds, suggesting a metaphysical rather than a physical escape. By 1926 O'Keeffe was becoming restless in the close and pretty greenness of upstate New York. Three summers later, she escaped to New Mexico. After 1926 there would be few barns in her work—about one a year over the next three years.[22] Then they cease, with the single exception of *Barn with Snow* in 1934, which seems to be more of a problem-solving picture than a personal statement. O'Keeffe's barns illustrate the inconvenient truth that Lake George was not her psychic homeland, a fact that even Stieglitz came to accept. "Lake G[eorge] is not for her," he wrote sadly, but with new understanding, to Dove in 1929.[23]

New York City was not her psychic homeland either. Nevertheless, during 1926 O'Keeffe painted ten of her thirty known cityscapes—the greatest number on this theme in a single year. They add up to a virtuoso display of her understanding of photo-optics, with some extraordinary syntheses of the "adoptive," the "adaptive," and the "innovative."

In *Shelton Hotel, New York, No. 1* (plate 146) O'Keeffe presents her city home symmetrically, frontally, hieratically, and with considerable flatness. This stylized iconic quality can itself be called photographic—i.e., a single frozen moment as seen by a single unmoving eye, in one-point perspective.[24] In this static and concentrated image there is an even more obvious photographic characteristic: vertical convergence. The tall buildings framing each side of the Shelton lean inward—an effect that often occurred with the old view cameras when they were pointed upward, unless laboriously corrected through "swings and tilts."[25] *The Shelton with Sunspots* (plate 147) further emphasizes and embellishes convergence, even as it presents variations on still another photographic malfunction: lens flare. Although its visual results may resemble halation, flare's causes are different, resulting from a complex of random internal reflections in the camera.[26] The multiple ghost-image spots represented in this painting happen most often when the camera is used without a lens hood. Stray light hits the lens and bounces around, getting reflected into the shadow areas of the film and sometimes even projecting an image of the lens diaphragm. Flare often dilutes, or destroys, the solidity of dark areas—completely obliterating sharp outlines—which is exactly what happens on the upper right side of O'Keeffe's building. Her 1976

remembrance of painting *The Shelton with Sunspots,* after seeing "the optical illusion of a bite out of one side of the tower made by the sun, with sunspots against the building . . . and sky," leaves out the camera's crucial part in her perceptual process.[27] (It is almost impossible for the normal naked eye to see in just the way she described.) What her statement does suggest is that by 1926 she had thoroughly integrated photo-optics into her own inner vision.

What was this vision? O'Keeffe never defined it in words. But we already know that for her, as for the French painter Maurice Denis, nature was only the "occasion" for a creation of her spirit.[28] And her frequent use of iconic properties underlines her intention to represent the timeless and the transcendent instead of the quotidian. Although documentary evidence for this goal is sparse, it can be inferred from the letter Stieglitz wrote to Anderson in 1925: "G. is doing some very fine work.—She often feels that painting has nothing to do with today—I know it hasn't.—But she does some wonderful things—and so may be that's what she best do instead of hitching up with the huge machine."[29] Turning her back on "today," O'Keeffe painted images of New York that ignore its citizens and its sores. Like Stieglitz's images of the city, hers are uninhabited. But just as architecture itself originates from a body-centered concept of space and place, so are many of O'Keeffe's cityscapes, in the profoundest sense, body-scapes. Doubtless she figured out freshly for herself that our most basic orientation as human beings is up/down, since we stand *up* and grow *up*. Like the standing human figure, the tall building is an implicit link between earth and sky.

Looking at *The Shelton with Sunspots* with such commonsensical awarenesses as these, several things become newly clear: O'Keeffe has concentrated on "up" and on the sky—traditionally, the realm of light, the ethereal, and the divine. We do not see the ground at all. Nor are we sure whether this is the front or the back of the building. An explosion seems to have taken place high up, as if caused by a bolt of lightning—a nature simile borne out by the smokelike clouds and the fire-colored flare dots. This "explosion" takes place at just about the level of their suite on the thirtieth floor. Was this some form of self-realization that O'Keeffe was recording then? We do not yet know, but to the mystic personality such epiphanies are often suggested by light.

Few of O'Keeffe's images are quite so radically photo-optic—and so disjoined from human vision—as *City Night* (plate 148).[30] Its penurious elegance and emotional drama are based on convergence: the black skyscrapers in the foreground topple toward each other—their acute convergence accented by the bisecting blue streaks of floodlights—

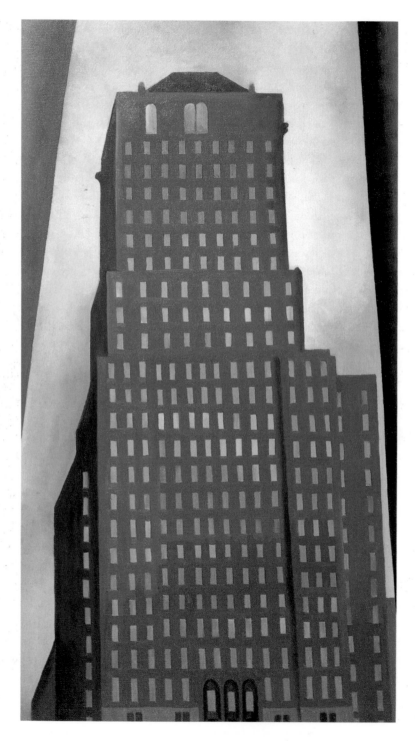

146. Georgia O'Keeffe. *Shelton Hotel, New York, No. 1*, 1926.
Oil on canvas, 32 x 17 in. (81.3 x 43.2 cm).
The Regis Collection, Minneapolis.

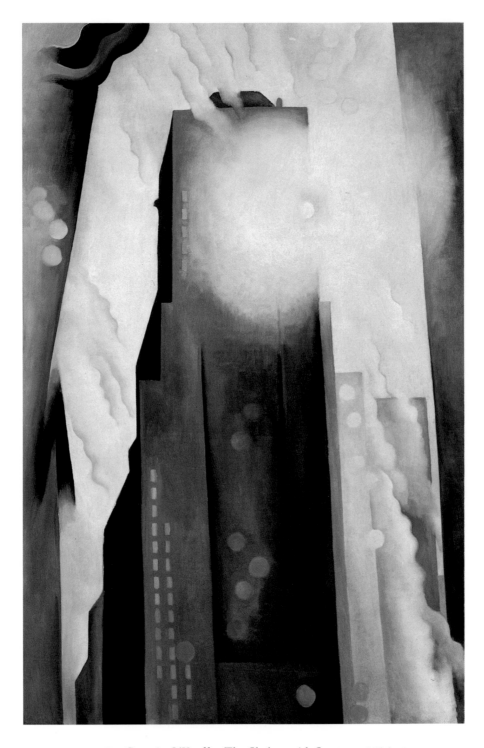

147. Georgia O'Keeffe. *The Shelton with Sunspots*, 1926.
Oil on canvas, 48½ x 30¼ in. (123.2 x 76.8 cm).
The Art Institute of Chicago; Gift of Leigh B. Block.

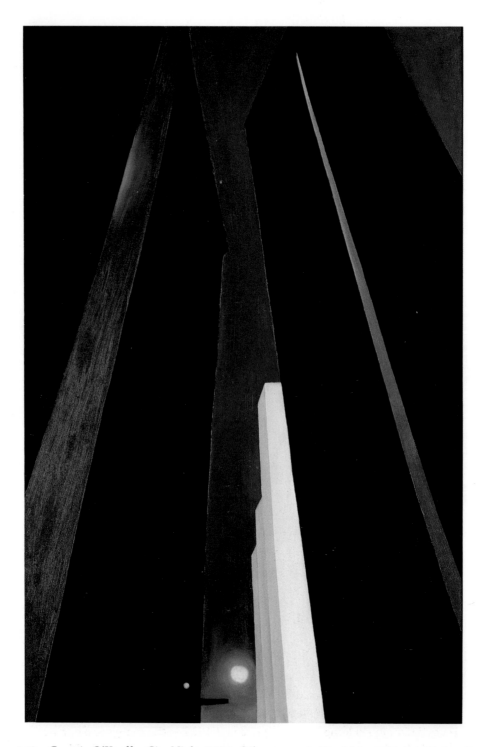

148. Georgia O'Keeffe. *City Night,* 1926. Oil on canvas, 48 x 30 in. (121.2 x 76.2 cm). The Minneapolis Institute of Arts; Gift of the Regis Corporation, Mr. and Mrs. W. John Driscoll, the Beim Foundation, the Larsen Fund, and by public subscription.

creating a threatening, canyonlike effect. The halating streetlight at the bottom of the picture acts as a beacon in this black wilderness, a beacon that seems to point the way toward the three-tiered white building in the background, whose outlines are suspiciously like the Shelton's. From this strange painting we can perhaps surmise what daily living in New York cost O'Keeffe and how necessary to survival was her inviolate sense of the Shelton as home. (She was, by this time, well aware that anxiety, and even anger, could be aestheticized.) According to the French philosopher Gaston Bachelard, the chief benefit of a house is that it "shelters day dreaming, the house protects the dreamer, the house allows one to dream in peace.... [It] is one of the greatest powers of integration for the thoughts, memories and dreams of mankind."[31] Years later, in 1962, O'Keeffe would tell Katharine Kuh: "We really haven't found enough dreams. We haven't dreamed enough."[32] In fact, O'Keeffe's city buildings—for all their references to photography—sometimes look as if they had been daydreamed rather than blueprinted and built.

During 1926 O'Keeffe also painted five known views of the East River from the Shelton, a place where she could behold "the city as a unit." Sight is apt to say too much to the mind in too short a time, and there can be little question that photographs helped her to get a grip on the city. In *East River No. 1* (plate 149), possibly the first of them all, the horizontal format is reminiscent of panoramic photography. O'Keeffe was now dealing with the "far" as opposed to the "near" of her close-ups. By comparing this painting with one of Stieglitz's photographs, *From the 30th Story, Shelton Hotel (Room 3003, Intimate Gallery), Looking East* (plate 150), taken in 1927, we can see evidence in both of a telephoto lens, since the view of the river in both pictures could not have appeared as close as it does otherwise.[33] Did she look into the ground glass of Stieglitz's large-format camera as well as at his prints? Very probably. (Apropos of this, we might also ask whether O'Keeffe's use of color was ever inspired by the preternaturally bright image reflected on the camera's viewing screen. Although we'll probably never know for sure, that possibility remains. A case in point might be the pellucid *East River from the Thirtieth Story of the Shelton Hotel*, 1928; New Britain Museum of American Art.)

During 1927 O'Keeffe apparently painted only two cityscapes, one a pastel[34] and the other an oil, *Radiator Building—Night, New York* (plate 151), which is without question one of her most elusive masterworks. The Radiator Building was completed in 1924—the year, incidentally, that O'Keeffe married Stieglitz. The architect, Raymond M. Hood, designed it as a black tower, the first black building in New York. Its

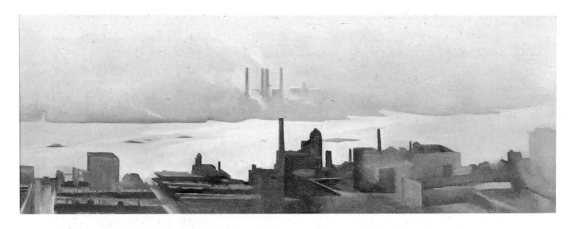

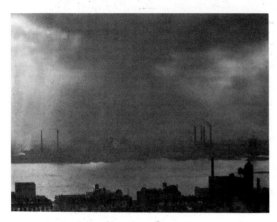

149. Georgia O'Keeffe. *East River No. 1*, 1926.
Oil on canvas, 12⅛ x 32⅛ in. (30.7 x 81.5 cm).
Wichita Art Museum, Wichita, Kansas.

150. Alfred Stieglitz. *From the 30th Story,
Shelton Hotel (Room 3003, Intimate Gallery),
Looking East*, 1927. Gelatin silver print,
3½ x 4⅝ in. (9 x 11.7 cm). National Gallery
of Art, Washington, D.C.; The Alfred Stieglitz
Collection, 1949.3.1267.

151. Georgia O'Keeffe. *Radiator Building—Night,
New York*, 1927. Oil on canvas, 48 x 30 in.
(121.9 x 76.2 cm). Carl Van Vechten
Gallery of Fine Arts, Fisk University, Nashville;
Alfred Stieglitz Collection.

gilded crown was electrically wired for illumination, another first. By the
time O'Keeffe painted it, the Radiator Building was the most eye-catch-
ing sight in New York after dark.[35] Situated at 40 West Fortieth Street
and Sixth Avenue, it was farthest from the Shelton of all O'Keeffe's
street motifs. Although we cannot be sure that she based her design for
this painting on one of the many night photographs made of it at the
time, it is probable (judging from past performance) that she did so.

Once again, we have an iconic image in a vertical format. There is,
however, a great deal of hyperactivity going on in *Radiator Building*. The
rectangular window lights in and around this skyscraper appear to glitter
and wink (caused, in part, by O'Keeffe's canny alternations of their
shapes and tones). The round halating streetlights at the bottom of the
picture look like balls bouncing up and down. And the billowing steam
at the right seems to be shifting its pattern right under our gaze. This is
a *faux-naïf* image of the twentieth-century city as perpetually in motion,

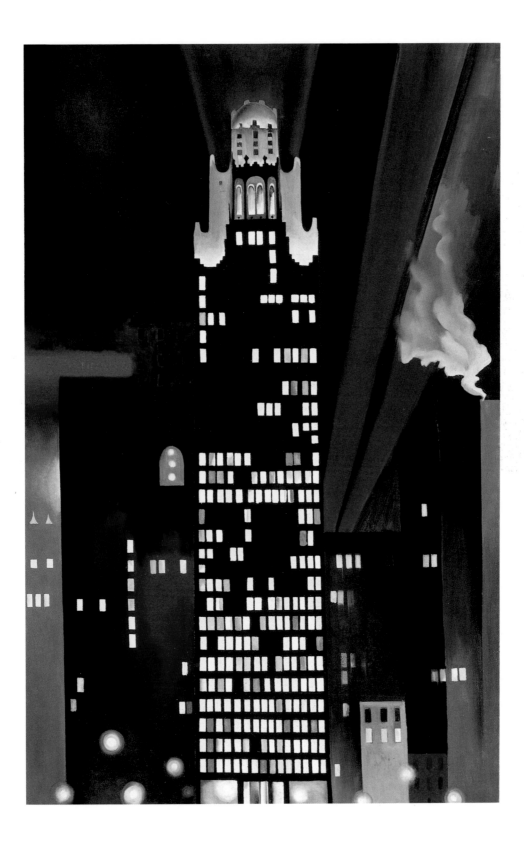

always lit, and never quiet. There is a distinctly satanic quality about O'Keeffe's Radiator Building, an impression accentuated by such hellfire connotations as the steam and the burning red sign.[36] On this same neon sign appears the name ALFRED STIEGLITZ—perhaps intended as a complimentary double play on words, for in 1927 the sign actually said SCIENTIFIC AMERICAN. Does *Radiator Building* embody Stieglitz's "City of Terribleness"? It seems not, for there is one other detail that, when finally observed, robs the picture permanently of such a dark reading. Up on Radiator Building's façade, formed by the negative space left by its unlighted windows (and pointed to by the red sign), can be perceived the silhouette of a woman. It looks as if she is sitting on a stool, with her back to us and her arm upraised—as if she is painting at an easel. This may be one of O'Keeffe's most wickedly witty self-portraits.[37] New York City might be terrible or "diabolical," but it was still an extremely exhilarating place for O'Keeffe to make her "unknown known." By signing its most original, most imaginative, most popular building with her own image, she invented a special way to say so.

 In the years between 1926 and 1929 O'Keeffe seems to have looked speculatively at Coburn's Dow-schooled photographs of New York made between 1909 and 1912.[38] Four paintings in particular suggest this. Her *Shelton Hotel, New York, No. 1* (plate 146) shares with Coburn's *House of 1000 Windows, New York* (plate 152) an obsessive concentration

*The energy and power of the American
will find expression in art—
is finding it now in many ways.
The highbuilding, for example, is a
form and construction
particularly our own.
The highbuildings are taking on
beautiful form—
they have not yet equalled
the Tower of Giotto, or the Spires
of Chartres—but when they are as
perfect as our genius can make them,
they will be great works of fine art.*

Arthur Wesley Dow, 1909,
Archives of American Art; Dow Papers.

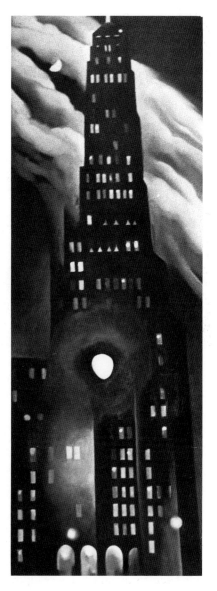

on window patterns (recalling Dow's principle of Repetition)—although Coburn was looking down and O'Keeffe up. Her *Ritz Tower, Night* (plate 154) and his *Metropolitan Tower* (plate 153) both have the same unusually skinny vertical format with an even skinnier skyscraper bisecting its space. And Coburn's abstract interest in the circular clock shape in the middle of his building looks as if it had been echoed deliberately by O'Keeffe in the central positioning of her seemingly disembodied streetlight.

In addition to *Ritz Tower, Night,* O'Keeffe made four East River pictures during 1928.[39] One of these is *Pink Dish and Green Leaves* (plate

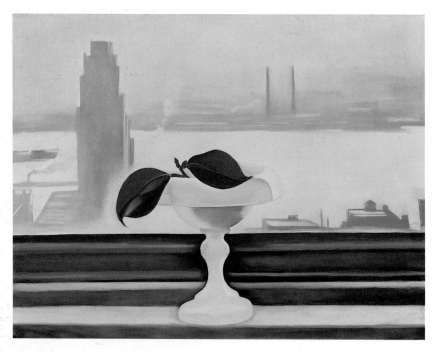

ABOVE
155. Georgia O'Keeffe. *Pink Dish and Green Leaves,* 1928. Pastel on paper, 22 x 28 in. (55.9 x 71.1 cm). Ex-Collection of Georgia O'Keeffe; Private collection.

OPPOSITE
156. Georgia O'Keeffe. *East River from the Shelton,* 1927–28. Oil on canvas, 25 x 22 in. (63.5 x 55.9 cm). New Jersey State Museum Collection; Purchased by the Association for the Arts of the New Jersey State Museum with a gift from Mary Lea Johnson.

155). A letter she wrote in 1929 to Kennerley describes this unusual work: "The pink dish with the city is frankly my foolishness—but I thought to myself—I am that way, so here goes—if I am that way I might as well put it down."[40] *Pink Dish* catches O'Keeffe in the act of playing with the discrepancies between the way the eye and the camera focus and judge perspective. Although the river view has been brought even closer than her eye could see it by a telephoto lens, it is out of focus. The still life, on the other hand, is sharp—especially the leaves. This is an early meditation on near and far. There is no middle ground, although the window sash has been left visually ambiguous. Do the subject and the eccentric perspective suggest that O'Keeffe was getting fed up with the view from her Shelton window and longing for nature, even nature in a pink vase? Plausible as this may seem at first, many of her city paintings have a kind of celestial irony about them, one that constantly defies a too-easy interpretation. In fact, we should probably be more alert to the mockery—sometimes parody—in O'Keeffe's work.

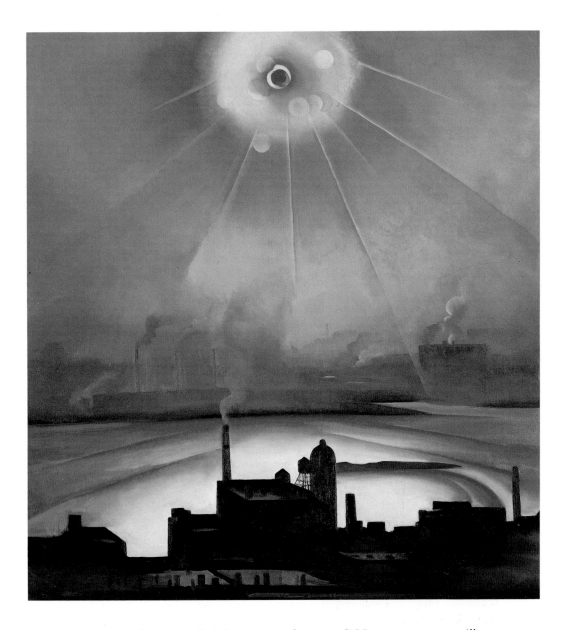

Why did she (irregularly) resort to the ironic? Her given reasons ("my foolishness," etc.) are not helpful. It is probable that irony offered her a kind of control during times of too-swift, or too-slow, outer changes with the resultant inner frustrations. Perhaps, even, it was a way of keeping herself pure. Certainly it was innate.

Earlier in 1928 O'Keeffe had completed what may be the most photo-optic and the most arcane of all her cityscapes: *East River from the Shelton* (plate 156). The painting is exceptional, in no small part, because it took so long for her to finish, from December 1927 to April 1928.

(At Lake George she often completed a canvas in one day.) This implies strongly that its making was a self-redefining operation for O'Keeffe. The scene itself is based on the evidence of a powerful telephoto lens trained from her window. It is an image of the far (the building bordering the East River) and the very far (the sun) brought quite near in an almost seamless way. To accomplish this O'Keeffe may have referred to another type of photographic data. For example, in Coburn's 1910 time exposure *The Singer Building, Twilight* (plate 157), the circles of halation are joined to each other by horizontal streaks of light caused by the lit-up traffic moving along the street. It is quite possible that O'Keeffe took this peculiar, but veristic, detail from Coburn's photograph, changed its direction from vertical to horizontal, and used it for her own expressive intent. His light lines became the spreading rays of her sun, joining sky to landscape in the upper two-thirds of the picture. To further emphasize and join these disparate elements, she used blue, with its legacy of the spiritual from Kandinsky. There is even a plume of blue smoke issuing from the highest stack in the foreground, bridging the gap of the river. The formal unity between the sun and the city is very tight and very complicated, although rigorously simplified. What did O'Keeffe intend by these joinings? From the halating circles that form a nimbus around the sun, the picture can be construed as a witty, but eloquent, visual pun on Stieglitz's Equivalents: the sun equals light equals photography. But

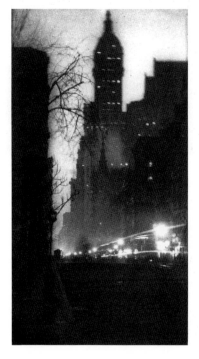

157. Alvin Langdon Coburn (1882–1966). *The Singer Building, Twilight*, 1910. Photogravure, 7⅝ x 4 in. (19.6 x 10.2 cm). International Museum of Photography at George Eastman House, Rochester, New York; Coburn Archive.

there seems to be much more to it than that. From the uncharacteristic length of time it took to paint and from its methodical rigor, we can assume that *East River from the Shelton* contains some of O'Keeffe's most deeply pondered ideas about the city.

One can argue that the total effect of this enigmatic picture is spiritual. It is structured by form and color in ways not unlike an altarpiece, and in fact, what it suggests is nothing less than an abstract Annunciation.[41] The sun, with its traces of gold, has been depicted as if it were a divine eye. One almost expects to see an angel or the dove descending from its rays. The city is shown as if plunged in darkness, although it is daytime. But the river, an element of nature with sacramental connotations, is irradiated with light that is white, red, and blue —doubtless to be read as the colors of America. An announcement of what? And by whom? O'Keeffe being O'Keeffe, there is a distinct possibility that the eye is the artist's "I." If so, perhaps she intended herself as the herald of a new American art capable of the same therapeutic power so urgently pursued by Kandinsky and the Symbolists.

In 1929 O'Keeffe did only one painting of the city, *New York Night* (plate 159)—her last major canvas on this theme. It is an aerial view from a window to Lexington Avenue, which, according to O'Keeffe, looked "like a very tall thin bottle with colored things going up and down inside it."[42] Here again it appears that she has taken direct inspiration from a Coburn photograph, his twilight vista *Fifth Avenue from the St. Regis* (plate 160). Although her format is far more vertical than the photograph is, she has divided and cut her space in ways that are nearly identical to it. The electrically lit canyons of Lexington and Fifth avenues bisect the two picture fields diagonally and disappear into the haze at upper right. In both images the darkest buildings reside in the foreground, and the tallest ones, on the left, are cropped at their tips. Whether she chose this view of Lexington Avenue because her eye had been unconsciously prepared by an earlier knowledge of the photograph, or whether she consciously drew on the precision of Coburn's planes and patterns to create order out of a vast jumble of lights and forms, hardly seems to matter. For it is her power to cause those lights and forms with paint that makes *New York Night* such a warm and resplendent city image. The scintillant windows themselves repay endless attention, for kaleidoscopic shifts of arbitrary color make each one different from the others. (They look very like miniature Mark Rothkos, Jackson Pollocks, and Barnett Newmans, some twenty years before their time.) This infinite variety adds to our sense of real lives being lived behind every one of them. The painting also holds what may be O'Keeffe's only rendition

158, 159. Georgia O'Keeffe.
New York Night (and detail),
1928–29. Oil on canvas,
40⅛ x 19⅛ in. (101.9 x 48.5 cm).
Sheldon Memorial Art Gallery,
University of Nebraska—Lincoln;
Nebraska Art Association, Thomas
C. Woods Memorial Collection.

160. Alvin Langdon Coburn (1882–1966).
Fifth Avenue from the St. Regis, 1909. Platinum print,
15⅞ x 12⅜ in. (40.3 x 31.6 cm). International Museum of Photography
at George Eastman House, Rochester, New York; Coburn Archive.

of that most ubiquitous of America's symbols, the automobile—which she painted like a yellow Tinkertoy (plate 158). Whether this parodic primitivizing was intended as an ironic comment on what she liked to call "The Great American Everything" or as her own private dig at the auto iconography of New York Dada may never be known. But her amusement in painting it this comical way seems palpable.

To sum up the overall impression made by O'Keeffe's fugal cityscapes: they were done by night and by day and in all kinds of weather. (At least one *East River* was painted in the snow.) They are outdoor views, even when seen from the inside. They are susceptible to multiple readings. Some appear to be disguised self-portraits, some spiritual statements. Some possess a sophisticated wit, others a childlike humor. All are evasive. Whenever O'Keeffe used the singular qualities of pho-

tography (especially its ability to telescope scale) it was clearly to aid her own profoundly Romantic view of the city. And this seems to set her New York landscapes well apart from those by her contemporaries who also used photography—especially the Precisionists, to whom she has so often been linked.[43] In some ways O'Keeffe's cityscapes can be characterized as "urban sublime." For, as Robert Motherwell has written, "Painting becomes Sublime when the artist transcends his personal anguish, when he projects in the midst of a shrieking world an expression of living and its end that is silent and ordered."[44]

Something of numinous significance happened to O'Keeffe in 1926, of which we know very little. It was something comparable to the new order of consciousness that came to Louis Sullivan in Ocean Springs, Mississippi, during 1890–91: " 'Twas here [he wrote] that Louis underwent the metamorphosis which is all there is of him, that spiritual illumination which knows no why and no wherefor [sic], no hither and no hence, that peace which is life's sublimation, timeless and spaceless."[45] We do know that 1926 was the year O'Keeffe and Stieglitz became friends with the architect-spiritualist Claude Bragdon, and that Bragdon must have spoken to them both about the reasons for his tremendous admiration for Sullivan. But that is all for the present. Obviously it would be naive or worse to insinuate that O'Keeffe thought in terms of metaphysics whenever she painted skyscrapers. But we have it from her own testimony that she often worked in two stages: first, "objectively," from what was before her, and then from the "memory or dream thing" that came nearest to what she thought of as "reality."[46]

One must always treat O'Keeffe's self-appraisal as an intrinsically independent artist with respect, but there is such a thing as psychological influence. And it does not detract from the stunning originality of her cityscapes to sense a link between them and the work of one whom Bragdon called "the prophet of Democracy." Sullivan, after all, thought of architecture as a "plastic art."[47] And he often spoke of the tall office building as *the* modern poem. His best work, like O'Keeffe's, came out of inner necessity rather than tradition. Both were guided by what Sullivan, a trained botanist, liked to call "a long contemplation of living things." Well-schooled in severe, straightforward design, Sullivan and O'Keeffe insisted on investing it with personal meaning. Neither could resist what Sullivan called "the imperative voice of emotion."[48] Did a Chicago memory of Sullivan's exuberant terra-cotta ornamentation on the Carson Pirie Scott store (plate 31) have anything to do with the way the halating circles and scalloped clouds dance over the façade of

O'Keeffe's *Shelton with Sunspots* (plate 147, or with the bespangled raiment of colored lights that ornament her New York-at-Night buildings (plates 148, 151, 154, and 159)? We'll never know. But the frankly botanical streetlight in *New York with Moon* (plate 141) encourages us to think so.

After *New York Night* the deep well that had been New York "the wonder city" ran almost permanently dry for O'Keeffe.[49] This failure may be intimately connected to the summer of 1929, when she went to Taos, New Mexico, for four months and became reacquainted with another kind of architecture, that of the Pueblo culture: adobe buildings, made by hand in the shapes of mountains, by an ancient people to whom nature was literally themselves. Her first trip there had been in 1917. ("I loved it immediately. From then on I was always on my way back. . . . Its a hand made world."[50])

O'Keeffe's friend Ansel Adams once described New Mexico as being "isolated in a glowing world between the macro and micro [lens]."[51] And, indeed, many of her paintings of this high, dry region with its strange white light tend to stress the very close and the very distant, with little or no evidence of the middle ground.[52] This light-and-atmosphere distortion is surprisingly similar to the telephoto viewpoint. And while it would obviously be too much to say that O'Keeffe loved New Mexico for its "photographic" qualities, many of her paintings (including her Black Crosses of 1929) do accentuate this natural lenticular characteristic.

In retrospect it seems inevitable that O'Keeffe would consider New Mexico—and its architecture—more essential to her artistic being than Lake George or the steel, glass, and concrete of New York. She did not know this all at once, however. A letter written to Ettie Stettheimer in August 1929 tells how New Mexico was and what she felt about it:

> I am on the train going back to Stieglitz—and in a hurry to get there.—I have had 4 months west and it seems to be all that I needed.—It has been like the wind and the sun—there doesn't seem to have been a crack of the waking day or night that wasn't full.—. . . I feel so alive that I am apt to crack at any moment. I have frozen in the mountains in rain and hail—slept under the stars—and cooked and burned on the desert.—I even painted —and I laughed a great deal—I'm ready to go back East as long as I have to go sometime.—If it were not for the Stieglitz call I would probably never go—but that is strong—so I am

on the way. He has had a bad summer but the summers at Lake George are always bad—that is why I had to spend one away. —I had to have one more good one before I get too old and decrepit.[53]

The 1929 painting *Lake George Window* (plate 162), probably done not long after her return from Taos, can be said to toll the final knell of O'Keeffe's symbiotic artistic relationship with Stieglitz. It is also one of the most creatively photographic of all her major works, with references as resonate as they are multifarious. First, there is an indisputable link between the window and the camera lens, in that both admit the light. O'Keeffe had always liked to explore light sources, from the sun, moon, and stars to electricity. That she fully intended this special metaphoric connection in *Lake George Window* is hard to doubt, for her joyful abstraction *At the Rodeo, New Mexico* (plate 54), painted earlier that summer, is still another visual pun on the camera lens.

As an informed modernist O'Keeffe surely took the window's intrinsic flatness into account as subject matter. Similarly, she must have been aware of its wide-ranging implications for the Symbolists, for the Post-Impressionists (so extolled by *Camera Work*), and above all, for Matisse, who investigated the window endlessly. Further, she was obviously acquainted with such *Camera Work* photographs on this theme as Clarence H. White's *Ring Toss* (1899) and *Drops of Rain,* C. Puyo's *Nude— Against the Light,* and Stieglitz's early "snapshots," *From My Window, Berlin* (c. 1886–89) and *Snapshot—From My Window, New York* (1900– 1902), as well as his many later window variations.[54] Nevertheless, *Lake George Window* is a very different kind of picture from those mentioned, despite its conventional subject matter. Like Matisse, O'Keeffe chose the window for itself. But hers is an isolated exterior architecture detail, seen straight on and so close that it becomes the rectangular canvas space:

an image within an image. Whereas Matisse was almost always indoors looking out of his (usually open) windows, primarily to gardens or the sea, O'Keeffe has stayed outside—and she does not look in.[55] Her window is closed, opaque, completely impenetrable. It has become the equal of a closed door, a barrier rather than a bridge.[56]

Lake George Window was originally titled *Portrait of a Farmhouse*. It has some interesting formal and emotional parallels to Stieglitz's profoundly psychological portrait of his young niece, Georgia Engelhard, made in 1920 (plate 161). Both these pictures have a daguerreotype frontality. And if we subtract the girl and the potted plant and add shutters, Stieglitz's door becomes, in effect, O'Keeffe's window. (Both

are from the same building.) Even the glass in the door has caught the light in such a way that it looks half opaque and half reflective of the outdoors. Whereas Stieglitz contrasted the rectilinearity of his composition with the coltish gesture of the girl's body, O'Keeffe emphasized the rhythmic curves of the upper molding as a counterpoint to the crisp frontality of the window. Stieglitz's photograph is utterly sharp in terms of resolution and contrast; the details and edges in O'Keeffe's painting —particularly the shutters—resemble those of an overexposed negative or an underexposed print. Taken overall, this seems to be yet another of her translations of photographic seeing with a personal twist.

Stieglitz has posed the adolescent Georgia Engelhard before the door in an extremely ambiguous manner. She could be entering or leaving it, or even barring access to it. (The connotations of virginity are inescapable here.) O'Keeffe's window is no less ambiguous, but for different reasons. A window is by its very nature a transparent wall. But we cannot see through this one; even the all-important light is unable to penetrate it. It is as if the inside (hers and Stieglitz's real "shelter space" at Lake George) has been sealed off, not just from ourselves but from the artist as well. Even the windowpane acts like a bar. She had left the open space of New Mexico behind her with regret. Dead ahead is the flat, reduced wall of *Lake George Window,* with its preponderant grays and blackish greens. Few, if any, of her other works are so emotionally explicit. Her despair was not with Stieglitz: "He is grand—so grand that I dont seem to see [his] family about or anything else—I just seem to think—to know—that he is the grandest thing in the world—and wonder how I ever was able to stay away from him so long."[57] It had to do with her recognition that Lake George and New York had become dead ends for her work.

Stieglitz understood this. In June 1930 O'Keeffe returned to Taos: "I couldn't decide until Stieglitz decided—. . . . He feels it the thing to do—. . . . It is almost as tho Stieglitz makes me a present of myself in the way he feels about it—Well—we will see—"[58] What she came to see was written to a friend two years later: "I am divided between my man and a life with him—and some thing of the outdoors—. . . that is in my blood—and that I know I will never get rid of—I have to get along with my divided self the best way that I can—."[59]

It would be a fruitful tension.

C O D A

O'Keeffe's use of the photographic process in her paintings was as original in concept as it was in intent. Photography gave her a new tool with which to integrate the great opposites: dark and light, inner and outer, conscious and unconscious. It aided abstraction even while it lengthened her reach to record truth: "Ones truth . . . must be your real experience—you can't make up anything as good as what happened."[1] And it helped train her to see reality with her own eye minus the agitation of her feelings—when she wished.

In the spring of 1929 O'Keeffe discovered another sort of reality in Taos, New Mexico: the geological. Volcanic mountains and empty deserts whose cosmic forms spoke to her imagination of first causes and eternal beginnings. She also found a functioning prehistoric Indian culture (the Anasazi-Pueblo), where color symbolism played a conspicuous role; where the highest manifestations of God were androgynous; where art was still made to help the sun cross the sky, to bring rain, and to cure body and spirit; where truths to live by were found in dreams; where the habits of birds and beasts engendered forms of worship and the manners of social life.[2]

At the age of forty-one O'Keeffe had come to a part of the world where she seemed almost genetically to belong: "Where I felt as grateful for my largest hurts as I did for my largest happiness."[3] She might even have recognized something of her younger self in this myth of the indigenous Jicarillo Apache:

> The earth is my body. . . .
> The sky, the seasons, the waters
> are all my body.
> I am all over.[4]

Living and working in New Mexico over the next half century, O'Keeffe would find, and complete, the person she had been before Stieglitz. But the vision they shared of nature as the supreme teacher of mankind remained—and grew ever sharper in focus.

In Texas, at Lake George, and even in New York City, O'Keeffe had sought nature forms capable of expressing her desires as a woman. During the Southwest years her art became increasingly that of a contemplative: one who had been through the fire and survived to find new gladness, new freedom, and a new kind of equipoise. It is as if O'Keeffe had decided to drop the great humanist-anthropocentric tradition of the last six hundred years for another much older—and much newer—value system: the ecological. According to the American cultural historian Thomas Berry: "Only now have we begun to listen with some attention and with a willingness to respond to the earth's demands that we cease our industrial assault, that we abandon our inner rage against the conditions of our earthly existence, that we renew our human participation in the grand liturgy of the universe."[5]

O'Keeffe's skies, rocks, Penitente crosses, adobe buildings, Pueblo ladders, birds, red mesas, and white bones all suggest a conscious re-sacralizing of the natural world: "I have wanted to paint the desert.... so I brought home the bleached bones as symbols of my desert.... The bones seem to cut sharply to the center of something that is keenly alive ... even tho' it is vast and empty and untouchable—and knows no kindness with all its beauty."[6]

Through the shapes and colors that came to her from loving the New Mexico landscape we can see—as if through an invisible lens—the impersonal, ever-changing glory of the planet Earth. We can also see O'Keeffe's mingled pain and delight in being "keenly alive" during her own brief moment in geologic time.

NOTES

Abbreviations for Frequently Cited Sources

AAA Archives of American Art, Smithsonian Institution, Washington, D.C.

NGA National Gallery of Art, Washington, D.C.

PSA Paul Strand Archive, Center for Creative Photography, University of Arizona, Tucson

SA Alfred Stieglitz/Georgia O'Keeffe Archive, Yale Collection of American Literature, Beinecke Rare Book and Manuscript Library, Yale University, New Haven, Connecticut

SAP Sherwood Anderson Papers, Newberry Library, Chicago

YCAL Yale Collection of American Literature, Beinecke Rare Book and Manuscript Library, Yale University, New Haven, Connecticut

Kandinsky, Harmony Wassily Kandinsky, *The Art of Spiritual Harmony*, trans. M.T.H. Sadler (London: Constable, 1914).

Kuh Katharine Kuh, "Georgia O'Keeffe" [interview], in *The Artist's Voice* (New York: Harper and Row, 1962).

Letters Jack Cowart, Juan Hamilton, and Sarah Greenough, *Georgia O'Keeffe: Art and Letters* (Washington, D.C.: National Gallery of Art; Boston: New York Graphic Society, 1987).

Lisle Laurie Lisle, *Portrait of an Artist: A Biography of Georgia O'Keeffe*, rev. ed. (Albuquerque: University of New Mexico Press, 1986).

Lowe Sue Davidson Lowe, *Stieglitz: A Memoir/Biography* (New York: Farrar, Straus and Giroux, 1983).

Lynes Barbara Buhler Lynes, *O'Keeffe, Stieglitz, and the Critics, 1916–1929* (Ann Arbor, Mich.: UMI Research Press, 1989).

Morgan Ann Lee Morgan, ed., *Dear Stieglitz, Dear Dove* (Newark, Del.: University of Delaware Press, 1988).

O'Keeffe Georgia O'Keeffe, *Georgia O'Keeffe* (New York: Viking, 1976).

Pollitzer Anita Pollitzer, *A Woman on Paper: Georgia O'Keeffe* (New York: Simon and Schuster, 1988).

Portrait *Georgia O'Keeffe: A Portrait by Alfred Stieglitz*, introduction by Georgia O'Keeffe (New York: Metropolitan Museum of Art, 1978).

Robinson Roxana Robinson, *Georgia O'Keeffe: A Life* (New York: Harper and Row, 1989).

Seligmann Herbert J. Seligmann, *Alfred Stieglitz Talking: Notes on Some of His Conversations, 1925–1931* (New Haven, Conn.: Yale University Library, 1966).

Stieglitz Sarah Greenough and Juan Hamilton, *Alfred Stieglitz: Photographs and Writings* (Washington, D.C.: National Gallery of Art; New York: Callaway, 1983).

Preface (pages 7–19)

1. O'Keeffe, in *Exhibition of Contemporary American Painting and Sculpture* (Urbana: University of Illinois, 1955), p. 226.

2. O'Keeffe, in Calvin Tomkins, "The Rose in the Eye Looked Pretty Fine," *New Yorker,* March 4, 1974, p. 60.

3. Carl G. Jung, *Modern Man in Search of a Soul* (New York: Harcourt, Brace, 1955), p. 198.

4. Willa Cather, "The Novel Démeublé," in *Not under Forty* (New York: Alfred A. Knopf, 1936), p. 54.

5. Stieglitz to Johnson, June 25, 1924, Royal Photographic Society, Bath, England. I am grateful to Sarah Greenough for sharing this correspondence with me.

6. Four of O'Keeffe's own snapshots (c. 1955) were published in the *Metropolitan Museum of Art Bulletin,* no. 2 (Fall 1984): 33, 43.

7. Daniel Catton Rich, *Georgia O'Keeffe* (Chicago: Art Institute of Chicago, 1943), p. 21.

8. Milton W. Brown, "Cubist-Realism: An American Style," *Marsyas* 3 (1946): 155.

 Greenberg's comments on O'Keeffe are consistently negative, and he describes her painting as "little more than tinted photography." (Clement Greenberg, "Art," *Nation,* June 15, 1946, p. 727.)

 "Edward Steichen and Paul Strand, both influenced and encouraged by Stieglitz, used in their work many of the devices that characterize O'Keeffe's painting: the sudden enlargement of an architectural detail, the close-range, intimate view of a flower section which, while all outside contours and references disappear, reveals an unsuspected, new identity." (Martin L. Friedman, *The Precisionist View in American Art* [Minneapolis: Walker Art Center, 1960], pp. 14–15.)

 "It would seem clear that O'Keeffe's use of sharply etched line finds its origin in Stieglitz's photography." (Bram Dijkstra, *The Hieroglyphics of a New Speech* [Princeton, N.J.: Princeton University Press, 1969], pp. 152–54.)

 "Although Georgia O'Keeffe has denied that photography provided the example for her enlarged close-ups of flowers, there is an undeniable similarity between certain of her compositions, both floral and abstract, and the photographs of her husband Stieglitz, and his colleagues Paul Strand and Paul Haviland." (Barbara Rose, *Readings in American Art, 1900–1975* [New York: Holt, Rinehart and Winston, 1975], pp. 54–55.) And "Contrary to what critics have concluded, photographic enlargement seems to have been more coincidental to her work than an influence on it. . . . Photography's influence on her work is more a matter of her use of 'cropping' in her compositions." (Barbara Rose, "O'Keeffe's Trail," *New York Review of Books,* March 31, 1977, p. 31.) Rose's seeming contradiction here of her own 1975 statement may have reflected her close contact with O'Keeffe at this time—a contact that O'Keeffe was to break only a little later.

 "The connection between O'Keeffe's work and the art of photography has generated more intrigue than clarification. Nowhere has the connection been more clear, yet less discussed, than in her paintings of flowers. . . . Her direct observation of lush natural details has antecedents in the photographs of de Meyer, Sheeler, and Steichen, and parallels in the contemporary photographs of Blossfeldt, Cunningham, Hagemeyer, and Strand." (Patterson Sims, *Georgia O'Keeffe: A Concentration of Works from the Permanent Collection of the Whitney Museum of American Art* [New York: Whitney Museum of American Art, 1981], pp. 21–23.)

9. Meridel Rubenstein, "The Circles and the Symmetry: The Reciprocal Influence of Georgia O'Keeffe and Alfred Stieglitz" (Master's thesis, University of New Mexico, 1977). Rubenstein presents much useful material, and she is clearly correct in her observation (p. 124) that throughout their working life together Stieglitz and O'Keeffe "picked up ideas from each other, reworking, synthesizing, incorporating opposites, shifting back and forth between realistic and abstract subjects." But she takes a broad and sometimes confusing view of their artistic relationship, and her comparative analyses of their paintings and photographs are limited.

10. O'Keeffe to McBride, February 1923; in *Letters,* p. 171.

 O'Keeffe's letters reveal her own idiosyncratic spelling and punctuation, which we have reproduced faithfully, without the distracting interpolation of [sic].

11. For a good example, see Donald B. Kuspit, "Conflicting Logics: Twentieth-Century Studies at the Crossroads," *Art Bulletin* (March 1987): 117–32.

12. O'Keeffe to Luhan, New York, 1925; in *Letters,* p. 180. Luhan did write the article but it turned out to be quite as embarrassing to O'Keeffe as anything written by "the men": "This woman's sex, Stieglitz, it becomes yours on these canvases," etc. The four-page manuscript was never published and is on file at the YCAL.

13. O'Keeffe, in Gladys Oaks, "Radical Writer and Woman Artist Clash on Propaganda and Its Uses," *New York World*, March 16, 1930, woman's sec. pp. 1, 3.

14. *O'Keeffe*, n.p.

15. For a deeply felt analysis of and lament for the accelerating disrespect for serious high culture, see Cynthia Ozick, "T. S. Eliot at 101," *New Yorker*, November 20, 1989, pp. 119–54. See also Michael Brenson, "Is Quality an Idea Whose Time Has Gone?" *New York Times*, July 22, 1990, Arts and Leisure sec., pp. 1, 27. Two books on this topic are Allan Bloom, *The Closing of the American Mind* (New York: Simon and Schuster, 1987), and Alvin Kernan, *The Death of Literature* (New Haven, Conn.: Yale University Press, 1990).

Introduction (pages 21–27)

1. For her own account of this immense task, see Georgia O'Keeffe, "Stieglitz: His Pictures Collected Him," *New York Times Magazine*, December 11, 1949, pp. 24–26, 28–30.

2. Lewis Mumford, *The Brown Decades* (1931; New York: Dover, 1955), pp. 105–6.

3. Crane's *Proem to the Brooklyn Bridge* (later called *The Bridge*), begun in 1923 and never finished, was published in 1930 by Black Sun Press, Paris. For a contemporary account of the mystic kinship Crane felt with Stieglitz and of the influence of occult ideas on his poetry, particularly those in P. D. Ouspensky's *Tertium Organum*, see Gorham Munson, *The Awakening Twenties* (Baton Rouge: Louisiana State University Press, 1985), pp. 195–231.

4. Two of O'Keeffe's and Stieglitz's letters from the 1940s testify to the nature of their enduring regard for each other. O'Keeffe to Henry McBride, c. early 1940s: "I see Alfred as an old man that I am very fond of—growing older—so that it sometimes shocks me when he looks particularly pale and tired. Aside from my fondness for him personally, I feel he has been very important to something that has made my world for me—I like it that I can make him feel that I have hold of his hand to steady him as he goes on." (*Letters*, p. 244.) Stieglitz wrote to O'Keeffe on June 3, 1946: "I greet you on your coming once more to your own country [New Mexico]. I hope it will be good to you. You have earned that. A kiss. I'm with you wherever you are. And you with me I know. . . . Thanks for all the thought and trouble." (Pollitzer, pp. 249–50.)

5. The film was commercially released on July 24, 1921, with the title *New York the Magnificent*. It ran for one week at the Rialto Theatre in New York, was next shown in Paris at a Dada festival in 1922 as *Fumée de New York* (The Smoke of New York), in New York again in 1926 as *Manhatta*, and at the London Film Society (also as *Manhatta*) in 1927. For the most recent research on *Manhatta*—all we are likely to know about its genesis, its distribution, and its significance for both artists—see Jan-Christopher Horak, "Modernist Perspectives and Romantic Desire: Manhatta," *Afterimage* (November 1987): 8–15; and Theodore E. Stebbins, Jr., and Norman Keyes, Jr., *Charles Sheeler: The Photographs* (Boston: New York Graphic Society, 1987), pp. 15–21.

6. In *Manhatta* there are homages to at least two of Stieglitz's own photographs, *City of Ambition* and *The Ferry Boat* (both 1910). There is also an echo of his *Hand of Man* (1902).

7. The anonymous caption reads, "A View of Brooklyn Bridge in which space, in the third dimension, is emphasized by the direction of the lines—indicated by cables and planes, the boundaries of which are marked off by these lines." (*Vanity Fair* [April 1922]: 51.)

8. *O'Keeffe*, n.p.

9. This phrase seems to have originated with Gertrude Stein's explanation of her rivalrous relationship with Mabel Dodge Luhan. See James R. Mellow, *Charmed Circle: Gertrude Stein and Company* (New York: Praeger, 1974), p. 179.

10. Stieglitz to Heinrich Kühn, August 6, 1928, SA. Arthur Dove commented in 1930: "With O'Keeffe there had been nothing to compare her with. . . . However, there were Stieglitz's photographs. There is something else there." (Dove to Stieglitz, March 2, 1930, SA.)

11. The concept of Pictorial photography originated in the work of the English photographer Henry Peach Robinson during the late nineteenth century. Pictorial photographers considered themselves to be artists who made interpretive pictures, as opposed to those who made scientifically accurate photographs. Peter Henry Emerson, a major influence on Stieglitz's thinking, stated the cardinal principle of Pictorialism in his paper "Photography: A Pictorial Art" (1886): "Pictorial art is man's expression by means of pictures of that which he considers beautiful in nature." For a concise history of Pictorialism, see Peter C. Bunnell's introduction to Bunnell, ed., *A Photographic Vision: Pictorial*

Photography, 1889–1923 (Salt Lake City: Peregrine Smith, 1980), pp. 1–7. See also William Innes Homer, *Alfred Stieglitz and the Photo-Secession* (Boston: New York Graphic Society, 1983).

For a summary of the issues surrounding the founding of the Photo-Secession, see Sarah E. Greenough, "Alfred Stieglitz and the Opponents of the Photo-Secession," *New Mexico Studies in the Fine Arts 2* (1977): 13–18. For a more complete description of the background, origin, and work of the Photo-Secession, see Robert Doty, *Photo-Secession: Stieglitz and the Fine Art Movement in Photography* (New York: Dover, 1978).

12. Steichen had earlier noted that the "Secessionists of Munich . . . gave, as the reason of their movement, the fact that they could no longer tolerate the set convictions of the body from which they detached themselves, a body which exists on conventions and stereotyped formulae, that checked all spirits of originality instead of encouraging them, that refused its ear to any new doctrine." (Eduard Steichen, "The American School," *Photogram* 8 [January 1901]: 4.)

13. Alfred Stieglitz, "The Photo-Secession—Its Objectives," *Camera Craft* 8 (August 1903): 81–83. For the most recent and succinct account of the blood-and-tears history of the Little Galleries and its exhibitions, see Weston Naef, *The Collection of Alfred Stieglitz: Fifty Pioneers of Modern Photography* (New York: Metropolitan Museum of Art; Viking, 1978), pp. 137–53.

14. Alfred Stieglitz, "Our Illustrations," *Camera Work* 32 (October 1910): 47. Stieglitz's original letter sent to the members of the Photo-Secession on October 14, 1905, states clearly: "These small but very select shows will consist of not only American pictures . . . but also Austrian, German, British, French and Belgian photographs, as well as other art productions other than photographic, as the Council of the Photo-Secession can from time to time secure." (Ibid.)

This is, in fact, almost a paraphrase of Charles H. Caffin's 1901 definition of the purpose of "advanced photographers [who strive] to secure in their prints the same qualities that contribute to the beauty of a picture in any other medium, and ask that their work may be judged by the same standard." (Caffin, *Photography as a Fine Art* [1901; Hastings-on-Hudson, N.Y.: Morgan and Morgan, 1971], p. vii.)

15. For the most complete account of Havi-land's career and his seven years of important work for the Photo-Secession, see William Innes Homer, *Alfred Stieglitz and the American Avant-Garde* (Boston: New York Graphic Society, 1977), pp. 50–52, 190–96.

The first mention of the name *291* in print was in *Camera Work* 37 (January 1912), when Haviland retitled his "Photo-Secession Notes" as "Notes on the Exhibitions at '291' " (even though the address was now 293 Fifth Avenue). In 1942 Stieglitz recalled that he had said to Haviland one day: "Photo-Secession won't do any more. Let's speak of the gallery as '291.' Haviland looked at me and seemed to understand." (*Twice-a-Year* 8–9 [1942]: 125.) For a diagram of the new galleries, see Homer, *Stieglitz*, p. 47.

16. For Stieglitz's retrospective account of this trip, which includes these quoted reactions to Cézanne, see Dorothy Norman, ed., "From the Writing of Alfred Stieglitz," *Twice-a-Year* 1 (Fall–Winter 1938): 79. Steichen was christened Eduard. He used *Eduard J. Steichen* in all of his early writings, but changed to *Edward J. Steichen* during World War I and kept this spelling until his death.

17. Alfred Stieglitz, *New York Evening Sun*, December 18, 1911, editorial page. Caffin was even more specific: "It is through the example of Cézanne that the younger generation of artists has discovered its triune creed: Simplification, Organization, Expression. Substitute for the last its equivalent in modern everyday affairs—efficiency—and one recognizes that Cézanne's influence is tending to bring painting once more into serious alignment with everything else that is worth while in modern civilization." (Charles H. Caffin, "A Note on Paul Cézanne," *Camera Work* 34–35 [April–July 1910]: 51.)

18. Data on what Stieglitz actually learned from Weber is sparse, and their 291 conversations were not recorded. In addition to exhibiting Weber's work twice at 291 (in 1910 and 1911), Stieglitz was clearly respectful of Weber's Dow-trained design sense, for he nominated Weber to hang the famous *Exhibition of Pictorial Photography* (1910) in Buffalo. (Weber also designed the catalog cover.) According to Dorothy Norman, "Stieglitz considered Weber extraordinarily well-informed about the major developments in modern art and felt he learned a great deal from their many talks." (Norman, *Alfred Stieglitz: An American Seer* [New York: Random House,

1973], p. 103.) But judging from the Weber–Stieglitz correspondence, Stieglitz never thought of himself as instructed by Weber. Weber's own introduction to his 1911 exhibition at 291, called "My Aim" (which was never used because he and Stieglitz decided to present the paintings without explanation), contains ideas that Stieglitz had already espoused—for example, "whenever or whatever I draw I aim to arouse the sense of touch as well as sight . . . through the objective I aim at the subjective." For what is presently known about the mutually embittered Stieglitz–Weber relationship, see Phylis Burkley North, "Max Weber: The Early Paintings (1905–1920)" (Ph.D. diss., University of Delaware, 1975), pp. 53–54, 79–80, 90–95. For Stieglitz's later, played-down account of what he owed Weber, see Stieglitz, "The Story of Weber," February 22, 1923, SA. Steichen later recalled, "Weber was the first one to argue Stieglitz into seeing that Stieglitz's early work was much better than his later 'pictorial' work." (Edward Steichen, *A Life in Photography* [Garden City, N.Y.: Doubleday, 1963], n.p.) Some of Weber's profound understanding of the art of Cézanne, Picasso, and Henri Rousseau must have rubbed off on Stieglitz, however, for work by all three artists was exhibited at 291 in 1911—as was Weber's own work.

19. Stieglitz to Hartmann, December 22, 1911, YCAL.
20. This "credo" appeared in Stieglitz's "A Statement," in *Exhibition of Stieglitz's Photographs* (New York: Anderson Galleries, 1921).
21. Stieglitz, in Norman, *American Seer*, p. 25.
22. O'Keeffe, "Introduction," in *Portrait*, n.p.
23. Stieglitz, in Paul Strand, "Alfred Stieglitz and a Machine," *Manuscripts* 2 (March 1922): 6.
24. All of this, and more, is made clear in Lowe.
25. Pollitzer, p. 35.

1. Starting All Over New
(pages 29–61)

EPIGRAPHS:
O'Keeffe to Pollitzer, October 1915; in *Letters*, pp. 144–45.

Picabia, in "A Post-Cubist's Impressions of New York," *New York Tribune*, March 9, 1913; in Arthur J. Eddy, *Cubists and Post-Impressionism* (Chicago: A. C. McClurg, 1914), pp. 96–97.

1. Willard Huntington Wright wrote about them to Stieglitz, "All these pictures say is 'I want to have a baby.' " (Quoted in Jean Evans, "Stieglitz—Always Battling and Retreating," *PM*, December 23, 1945, magazine sec., pp. 12–14.) Other contemporary comments by critics included: "Miss O'Keeffe looks within herself and draws with unconscious naiveté what purports to be the innermost unfolding of a girl's being like the germinating of a flower." And "Let's see. Are artists all supposed to 'record their emotions in their work'? If so we pause. Georgia O'Keeffe has some drawings at the '291' Gallery. We pause. O, Georgia." The first was written by Henry Tyrrell, the second by Robert J. Cole; both were reprinted in *Camera Work* 48 (October 1916): 61.

2. Anita Pollitzer and O'Keeffe shared many interests, including the suffragist movement. During the 1950s Pollitzer wrote a biography of O'Keeffe that included a large selection of their letters to each other, and a few from the Stieglitz–O'Keeffe correspondence, which is to remain sealed until 2011. O'Keeffe refused to grant permission for the book's publication because she did not think it a true picture of herself—far too sentimental. Nor was it well written. (Several publishers to whom it was submitted turned it down.) After the deaths of both women, most of it was finally published as *A Woman on Paper*. O'Keeffe's contemporaneous letters ("a young volume") to Dorothy True, another New York classmate, appear to be lost. It was to True that O'Keeffe sent the first rolls of her abstract experiments—with the expectation that they would also be critiqued by her former Teachers College professor Charles Martin and by Pollitzer. On this, see O'Keeffe to Pollitzer, October 14, 1915; in Pollitzer, p. 27.

3. O'Keeffe to Pollitzer, December 14–15, 1915, SA.
4. O'Keeffe to Pollitzer, September 1915, in Pollitzer, p. 15.
5. O'Keeffe to Pollitzer, Columbia, S.C., September 1915; ibid., pp. 17–18.
6. For her own comments on this, see *O'Keeffe*, text opposite plate 1.
7. O'Keeffe, statement in *Alfred Stieglitz Presents One Hundred Pictures, Oils, Water-colors, Pastels, Drawings by Georgia O'Keeffe, American* (New York: Anderson Galleries, 1923), n.p.
8. O'Keeffe to Pollitzer, Columbia, S.C., October 1915; in Pollitzer, p. 29.
9. O'Keeffe to Pollitzer, Columbia, S.C., October 1915, SA.

10. O'Keeffe to Pollitzer, Columbia, S.C., October 1915; in Pollitzer, p. 30. It is highly probable that this watercolor is *Red, Blue and Green,* reproduced as plate 10 in Barbara Haskell, *Georgia O'Keeffe: Works on Paper* (Santa Fe: Museum of New Mexico Press, 1985). The description in the letter fits it exactly. If so, it should be dated 1915, not 1916.

11. O'Keeffe to Pollitzer, Columbia, S.C., postmarked October 8, 1915; in Pollitzer, p. 26.

12. Pollitzer to O'Keeffe, New York, October 14, 1915; ibid., pp. 27–28. Most probably the monotype Pollitzer referred to in the letter is the one reproduced as plate 2 in Haskell, *Works on Paper.*

13. By her later account, it would be June 1916 before she "needed" color. (*O'Keeffe,* text opposite plate 1.)

14. O'Keeffe to Pollitzer, Columbia, S.C., October 26, 1915; in Pollitzer, p. 33.

15. For primary research on this, see Lisle, pp. 29–31.

16. O'Keeffe to Pollitzer, Columbia, S.C., December 13, 1915; in Pollitzer, p. 39.

17. Jackson Pollock, "My Painting," *Possibilities* (New York) 1 (Winter 1947–48): 79.

18. O'Keeffe to Pollitzer, Columbia, S.C., October 1915; in Pollitzer, p. 35.

19. Pollitzer to O'Keeffe, New York City, November 16, 1915; ibid., pp. 37–38.

20. O'Keeffe to Pollitzer, Columbia, S.C., December 1915; ibid., p. 39.

21. For primary research on Arthur Macmahon, including the important discovery of an unknown cache of letters written to him by O'Keeffe, beginning in late 1915, see Robinson, pp. 113–34, 153–68.

22. O'Keeffe to Pollitzer, Columbia, S.C., early December 1915, SA. Robinson states (pp. 126–27) that the 1915 *Special* charcoals (taken by Pollitzer to Stieglitz on January 1, 1916) are the direct result of O'Keeffe's love for Macmahon. As proof of this Robinson cites a letter dated January 6 (?), 1916, in which O'Keeffe tells Macmahon, "I said something to you in charcoal." Doubtless this was true, for she had already experimented with sending visual messages in an abstract watercolor ("that little blue mountain with the green streak across it"). And Robinson may be right. But whether O'Keeffe said that "something" in one of the drawings, or in many, is not known and probably never will be. We should therefore be cautious about accepting this letter as proof of a carnal source for all the charcoals. Further, although it is quite true that O'Keeffe often needed a surge of feeling to get herself going, she was already of the firm opinion that her sensations before nature were more reliable for creative work than her physical responses—however strong—to young men. It was a wariness she would never lose and an opinion she never revised —although she was tempted from time to time to do so. (For further documentation of this point, see O'Keeffe's love letters to Paul Strand written in 1917–18, discussed in my chapter 6.) In the end, it is the drawings themselves that do most to challenge Robinson's suggestion. The sexual feeling is clearly present in many of them, but looked at together what they seem most to convey is an abstract cross-section of who Georgia O'Keeffe was at the time.

23. Pollitzer to O'Keeffe, January 1, 1916; in Jan Garden Castro, *The Art and Life of Georgia O'Keeffe* (New York: Crown, 1985), pp. 30–31. The line "Finally a woman on paper" is in brackets because it seems to have been added to the original letter later, by a hand other than Pollitzer's. Actually, this may not have been the first time that Stieglitz saw O'Keeffe's abstract drawings. Barbara Buhler Lynes has suggested, in conversation with me, that Pollitzer may have taken some of them to 291 as early as November 1915, and I am inclined to agree with her. The opportunity was there. And O'Keeffe's letter to Pollitzer saying "I would rather have Stieglitz like anything I had done—than anyone else I know of" is dated October 11, 1915.

24. O'Keeffe to Pollitzer, Columbia, S.C., January 4, 1916; in Pollitzer, pp. 120–21.

25. It is possible that two of the surviving pastels, *Special No. 32* (plate 14) and *Special No. 33* (location unknown), should also be on this list, although they are presently dated c. 1914. But even if this should be so, what satisfied O'Keeffe most at the time were the "charcoal landscapes—and things." And Stieglitz must have felt the same way because he chose to show only the charcoals in 1916. *Special No. 13,* dated 1915 in *Letters,* plate 4, was actually done in 1916, in Texas. O'Keeffe herself cited this work in Georgia O'Keeffe, *Some Memories of Drawings,* ed. Doris Bry (New York: Atlantis, 1974), as having come "from many days in the Palo Duro Canyon, simplified from Canyon landscapes." And she dated it 1916.

 It is not known exactly what O'Keeffe meant by her private word *Special* in these titles. Also, many of the dates of her work from the 1910s and 1920s are still insecure.

The major reason for this is that O'Keeffe's pictures were not officially recorded until the spring of 1946, when she and Doris Bry dated them from Stieglitz's exhibition catalogs—some of which were lost. To quote from Bry's "Master List" in the files at the Whitney Museum of American Art: "The O'Keeffe exhibition catalogs were the main source for dating the pictures, as each exhibition [Stieglitz] held was of pictures done the previous year. In the case of pictures in the 1923 exhibition some of them were done before 1922, and in this case O'Keeffe dated them from memory. . . . Gallery photographs for 1923 and 1924 were also used. . . . O'Keeffe is fairly absent-minded and if asked to put a date offhand it is apt to be a few years off. But when she puts her mind to it . . . she has an amazingly clear memory, of where and when she painted things."

26. Stieglitz to O'Keeffe, New York City, mid-January 1916; in Pollitzer, p. 124.

27. O'Keeffe's drawings were shown with oil paintings and drawings by two long-forgotten American artists, René Lafferty and Charles Duncan. The immediate public interest in her work, expertly fanned by Stieglitz, caused him to extend the show until July 5.

28. For two well-documented accounts of this meeting, see Lisle, pp. 67–69, and Lowe, pp. 201–15. This was actually not their first meeting. O'Keeffe had already visited 291 countless times, beginning in 1908. Just before her own exhibition—probably in late April—she went to 291 alone to view the Marsden Hartley show. She and Stieglitz certainly talked at some length then, for he gave her one of Hartley's Maine paintings. As she remembered the incident sixty years later: "There was a dark one I liked very much—he handed it to me and said, 'Take it home with you, if you wish. If you get tired of it, bring it back.' " (See Portrait, n.p.)

29. O'Keeffe gave away, or destroyed, a large number of her earliest (1915–17) pictures. See, for example, O'Keeffe, text opposite plate 16.

30. Stieglitz, in James Gibbons Huneker, Camera Work 18 (April 1907): 37–38.

31. Stieglitz to Haviland, April 19, 1916, SA.

32. Henry Tyrrell, "Georgia O'Keeffe—C. Duncan—René Lafferty," Camera Work 48 (October 1916): 12–13; in Lynes, pp. 165–66.

33. Marsden Hartley, "Some Women Artists in Modern Painting," in Adventures in the Arts (1921; New York: Hacker Art Books, 1972), pp. 116, 118.

34. Paul Rosenfeld, Port of New York: Essays on Fourteen American Moderns (1924; Urbana: University of Illinois Press, 1961), p. 204. For an excellent short account of Rosenfeld's life, work, and times, see Sherman Paul's introductory essay to the 1961 edition, pp. vii–lvi. Early on, Rosenfeld was also carried away with describing O'Keeffe's work as "gloriously female." See Rosenfeld, "American Painting," Dial 71 (December 1921): 666. See also Rosenfeld, "The Paintings of Georgia O'Keeffe," Vanity Fair 19 (October 1922): 112.

35. Dove to Stieglitz, December 4, 1930; in Morgan, p. 201.

36. Lloyd Goodrich, The Decade of the Armory Show, 1910–1920 (New York: Whitney Museum of American Art, 1963).

37. For an idea of the genuine revulsion she felt, see O'Keeffe to Mitchell Kennerley, Fall 1922; in Letters, pp. 170–71.

38. O'Keeffe, in Lloyd Goodrich, introduction to Georgia O'Keeffe Drawings (New York: Atlantis, 1968), n.p.

39. See E. H. Gombrich, Art and Illusion (New York: Pantheon, 1960), p. 298; Nelson Goodman, Language of Art (New York: Bobbs-Merrill, 1968), p. 9.

40. See Lisle, pp. 29–45, 50–57.

41. O'Keeffe, in Kuh, p. 189.

42. O'Keeffe, introduction, n.p.

43. O'Keeffe to Pollitzer, February 10, 1916, SA. And O'Keeffe, interview with William Innes Homer, 1972, which he kindly let me read.

44. O'Keeffe, in Ralph Looney, "Georgia O'Keeffe," Atlantic Monthly (April 1965): 107.

45. Sanford Schwartz has briefly referred to the "Art Nouveau surface" of her art: "O'Keeffe's aesthetic is closest to Art Nouveau, but she doesn't have the conscious sense of style or the witty and romantic double awareness that we expect from figures of the fin-de-siècle." (Schwartz, "Georgia O'Keeffe Writes a Book," New Yorker, August 28, 1978, p. 90.) In Diane Chalmers Johnson, American Art Nouveau (New York: Harry N. Abrams, 1979), O'Keeffe's Spring of 1922 is included as a late example of American Art Nouveau (her plate 365). But it is presented without specific commentary, aside from the brief mention that O'Keeffe was influenced by Dow and Kandinsky. Susan Fillin Yeh's "Innovative Moderns: Arthur G. Dove and Georgia O'Keeffe" appeared in Arts Magazine 56 (Summer 1982): 68–72. At the suggestion of Professor George Hersey of Yale, Yeh looked into the

American Arts and Crafts movement as a source for O'Keeffe's early abstractions, but her findings are limited to pottery—in particular, Rookwood, Grueby Faience, Marblehead, and Tiffany. However, instances of O'Keeffe's "sparse, charged fields in which a single motif makes up the whole of the image," as described by Yeh, also abound in Art Nouveau/Jugendstil planar designs for wallpaper, bookbinding, and posters, as well as for embroidery, lace cutwork, and appliqué patterns. It therefore seems more plausible to assume that O'Keeffe took inspiration from a panoply of international Art Nouveau.

46. Lisle, pp. 28–32, 40–41. According to her sister Catherine Klenert, one of O'Keeffe's accomplishments was to create the Dutch Cleanser Girl ad, but concrete evidence for this statement is still missing. For a thorough study of the remarkable O'Keeffe-Wyckoff-Totto older generation, see Robinson, pp. 1–25.

47. I am indebted for much of this information to Oscar Lovell Triggs's *Chapters in the History of the Arts and Crafts Movements* (Chicago: Bohemia Guild of the Industrial Arts League, 1902) and to David A. Hanks's "Chicago and the Midwest," in Robert Judson Clark, ed., *The Arts and Crafts Movement in America, 1876–1916* (Princeton, N.J.: Princeton University Press, 1972), pp. 58–59.

48. *The Art Institute of Chicago Circular of Instruction of the School of Drawing, Painting, Modelling, Decorative Designing, Normal Instruction and Architecture, 1905–1906*, p. 36.

49. *O'Keeffe*, introduction, n.p.

50. *Art Institute of Chicago Circular*, p. 37.

51. Ibid. Frederick Freer and Louis W. Wilson are listed as pupils of the Royal Academy, Munich, and Louis J. Millet and Albert Fleury as having studied at the Ecole des Beaux-Arts, Paris.

52. Konrad Lange, "L'Art Nouveau—What It Is and What Is Thought of It—A Symposium," *Magazine of Art* (New York) (March–June 1904): 111.

53. S. Bing, "L'Art Nouveau," trans. Irene Sargent, *Craftsman* 5 (October 1903): 14–15. Bing may have made several different trips to the United States—including one in 1893 to see the World's Columbian Exposition in Chicago—but his only documented itinerary found so far is for 1894. Bing's enthusiasm for the achievements of Louis Sullivan, expressed in *La Culture artistique en Amérique*, may have come from reading on-the-scene reports to the French government written by Victor Champier

and André Bouilhet. On this, see Gabriel P. Weisberg, "S. Bing and 'La Culture Artistique en Amérique': A Public Report Reexamined," *Arts Magazine* 61 (March 1987): 59–63.

54. Henry McBride, "Art News and Reviews," *New York Herald*, February 4, 1923, sec. 7, p. 7; reprinted by Stieglitz in the catalog for O'Keeffe's 1924 Anderson Galleries show.

55. For an examination of the often-distorted dissemination and interpretation of Freud's ideas in America after his 1909 lectures at Clark University, see Frederick J. Hoffman, *The Twenties: American Writing in the Postwar Decade*, rev. ed. (New York: Macmillan, 1965), pp. 229–49.

56. Not until the 1950s did scholars seriously concern themselves with the rich literature of international Art Nouveau. See Richard Kempton, *Art Nouveau: Annotated Bibliography* (Los Angeles: Hennessey and Ingalls, 1977). The one contemporary review of O'Keeffe's charcoals (by Henry Tyrrell) that came close to recognizing her inventive translations of Art Nouveau appeared in the *Christian Science Monitor*, June 2, 1916: "Miss O'Keeffe looks within herself and draws with unconscious naiveté what purports to be the innermost unfolding of a girl's being, like the germinating of a flower."

57. Sue Davidson Lowe, Stieglitz's grandniece and biographer, has written that he sampled the writings of Freud "like a smorgasbord." (Lowe, p. 211.)

58. *Letters*, p. 174. As early as 1911 Benjamin De Casseres had written "The Unconscious in Art," in *Camera Work* 36 (October 1911): 17.

59. O'Keeffe to Brett, New York, mid-February 1932; in *Letters*, p. 206.

60. For discussion and illustrations of Tiffany and Company's American designs that include the scarab, see Johnson, *American Art Nouveau*, pp. 90–106.

61. Pollitzer, p. 2.

62. This iconic design reappeared in such later works as her Corn, Dark Series of 1924, the 1926 Clam Shell series, the Penitente cross series of 1929, and the Jack-in-the-Pulpit series of 1930—to name only a few.

63. See n. 51, above.

64. I combed through many issues of *Pan*, *L'Art décoratif*, and *Dekorative Kunst* (since these three periodicals published articles on Obrist's work between 1896 and 1904) but was unable to find a reproduction of *Fantastic Shell* in any of them. I also wrote to Dr. Gisela Scheffler, curator of the Staat-

liche Graphische Sammlung in Munich, for information on the earliest reproduction of this drawing but was told that their periodical collection is too frail for research because of the ravages of World War II. It is well known that Obrist (not unlike O'Keeffe) kept a hoard of natural forms—shells, stones, pods, and even microscopic photographs—in order to stoke his imagination; and, further, that he constantly called for a combination of fantasy and function in Jugendstil design. For the most complete summary of Obrist's work and thought in English, see Peg Weiss, "Wassily Kandinsky: The Formative Munich Years (1896–1914) from Jugendstil to Abstraction" (Ph.D. diss., Syracuse University, 1973), pp. 90–112. See also Weiss, *Kandinsky in Munich, 1896–1914* (Princeton, N.J.: Princeton University Press, 1979), pp. 28–34, 120–22.

65. For examples of the tendril motif in Art Nouveau embroidery, see Lewis F. Day and Mary Buckle, *Art in Needlework: A Book about Embroidery* (London: B. T. Batsford, 1900), especially figs. 11, 12, 95. For further examples of conventionalized Art Nouveau needlework patterns and designs, see *Craftsman* 8 (February 1905): 704–7; also 9 (March 1905–6): 749–50. Yeh, "Innovative Moderns," has suggested that O'Keeffe's 1915 "alphabet of shapes" (including the tendril) comes from American Arts and Crafts pottery.

66. S. Tschudi Madsen, *Art Nouveau* (New York: McGraw-Hill, 1967), p. 33.

67. For example, *Artist* (June–September 1901): 17–26, presented a laudatory article by W. Fred titled, "A Chapter on German Arts and Crafts, with a Special Reference to the Work of H. Obrist," with black-and-white illustrations of many of his best-known embroideries and sculptures.

68. O'Keeffe to Pollitzer, Columbia, S.C., October 1915; in Pollitzer, p. 28.

69. Robert Goldwater, *Symbolism* (New York: Harper and Row, 1979), p. 26.

70. *Camera Work* 36 (October 1911); special no. (August 1912); special no. (June 1913).

71. O'Keeffe, *Some Memories of Drawings*, n.p.

72. For a list of the thirty-eight known Redons chosen for the Armory Show (*La Mort* was not among them), see Milton Brown, *The Story of the Armory Show* (1963; New York: Abbeville, 1988), pp. 305–9.

73. For my brief summation of Redon and the quotations used, I am indebted mainly to John Rewald, *Odilon Redon, Gustave Moreau, Rodolphe Bresdin* (New York: Museum of Modern Art, 1961), pp. 9–45. See also Odilon Redon, *To Myself: Notes on Life, Art and Artists* (New York: George Braziller, 1986).

74. This exceptionally powerful drawing may have been Stieglitz's favorite, since his photographs of her work show that he was partial to the spiral. In a letter to O'Keeffe written July 31, 1916, he says: "Of course I knew you'd be surprised at the [installation?] photographs—I had fun in doing them. The one I want most is the one that hung on the left wall—to the right of the seething one [probably *Drawing No. 9*] —The one I considered by far the finest—the most expressive. It is very wonderful—All of it—There are others running it a close second—but none gives me what that one does." (Pollitzer, p. 141.)

75. Kandinsky, *Harmony*, pp. 82–83. Quotations from Sadler's 1914 translation of *Uber das Geistige in der Kunst, Insbesondere in der Malerei* (On the Spiritual in Art, and Painting in Particular), first published in Munich in 1912, will be used throughout this book because it was the one O'Keeffe read and studied.

76. O'Keeffe, *Some Memories of Drawings*, n.p.

77. For further persuasive visual evidence that O'Keeffe was familiar with *Dekorative Kunst*, compare her watercolor *Hill, Stream and Moon* (1916; private collection) with the commercial art design *Qirstuwxyz—Automobile* in *Dekorative Kunst* 16 (1907–8): 534. Hans Schmithals is now recognized as one of the first painters to seriously investigate abstract forms in the twentieth century. For information on Schmithals and his possible influence on Kandinsky, see Weiss, *Kandinsky in Munich*, pp. 122, 210.

78. Schmithals abstracted his nature forms by a process likened to music, which he learned at the Obrist-Debschitz School in Munich. For a description of these exercises, see Weiss, *Kandinsky in Munich*, pp. 121–22. Whether O'Keeffe knew about the methods of the Obrist-Debschitz School through members of the Art Institute school faculty who had lived and worked in Munich may always remain a question, although not a very important one, for in 1915 she would become acquainted with the same ideas filtered through Kandinsky's *Art of Spiritual Harmony*.

79. *Camera Work* 48 (October 1916): 12–13.

80. For a recent discussion on this topic, see Alessandra Comini, "Art Nouveau as Urban Ecology," *Arts Magazine* 51 (November 1976): 84–87.

81. Dorothy Norman, *Alfred Stieglitz: Introduction to an American Seer* (New York: Duell, Sloan and Pearce, 1960), p. 242.

82. Weston Naef has documented that the spirit of the Secession movement in photography during the 1890s, in Germany, Austria, and England, was "expressed in various styles including Symbolism, Jugendstil, German Impressionism, as well as the work of idiosyncratic individuals like Edvard Munch, Félicien Rops . . . Will Bradley. . . . [and] Alphonse Mucha (among others)." (Naef, *The Collection of Alfred Stieglitz: Fifty Pioneers of Modern Photography* [New York: Metropolitan Museum of Art; Viking, 1978], pp. 62–63.) And Margaret F. Harker, in examining the Linked Ring Brotherhood (of which Stieglitz was a member from 1894 to 1907), has written of the importance the Pictorialists attached to decorative values in their images: "The influence of Art Nouveau is easily discernible between 1895 and 1915." (Harker, *The Linked Ring: The Secession Movement in Britain, 1892–1910* [London: Heinemann, 1979], p. 68.)

83. Stieglitz to O'Keeffe, New York City, June 1916; in Pollitzer, p. 140.

2. *The Spirit of 291 (pages 63–79)*

EPIGRAPHS:
Stieglitz to Paul Strand, May 17, 1918, PSA.
 Margaret Anderson, "Art and Anarchism," *Little Review* (March 1916): 3.

1. Stieglitz to Dove, late July 1918; in Morgan, p. 61.

2. Kahn wrote this piece, published in *L'Evénement,* September 28, 1886, in support of Jean Moréas's Symbolist manifesto "Le Symbolisme," published in *Figaro Littéraire,* September 18, 1886. This translation of Kahn is from John Rewald, *Post-Impressionism: From Van Gogh to Gauguin,* 3d ed. (New York: Museum of Modern Art, 1978), p. 134.

3. "Russian I don't read, German is fluent and French I can read fairly well." (Stieglitz to Sherwood Anderson, July 8, 1924, SAP.) Stieglitz may have been predisposed to the Symbolist doctrine by exposure to Arthur Schopenhauer's metaphysics during his Berlin years. And he could easily have absorbed the thinking of French Symbolist writers through such periodicals as *Revue wagnérienne, Mercure de France,* and *La Revue blanche.* But the actual texts and images that early spurred Stieglitz's intellect and continued to feed his imagination throughout some fifty years of photography are still open to speculation and research.

4. For a survey of how and when American artists received French Symbolist ideas, see Charles C. Eldredge, "Americans and the Symbolist International," in *American Imagination and Symbolist Painting* (New York: Grey Art Gallery, 1979), pp. 17–37. Eldredge does not examine the Symbolist roots of 291, although he describes the work of O'Keeffe, Dove, and Hartley as "Abstract Symbolism."

5. *Camera Work* 47 (dated July 1914, published January 1915; the entire issue devoted to "What Is 291?"): 74, 37, 62, 35, 70.

6. Stieglitz, in Marius de Zayas, "How, When, and Why Modern Art Came to New York," introduction and notes by Francis M. Naumann, *Arts Magazine* 54 (April 1980): 115.

7. By Stieglitz's own count in 1914, "several thousand visitors" had come to 291. (*Camera Work* 47 [July 1914]: 3.) As Steichen was to describe the atmosphere years later: "During those winters in New York, I was able to observe the prodigious amount of work that Stieglitz did. . . . He was always there, talking, talking, talking; talking in parables, arguing, explaining. He was a philosopher, a preacher, a teacher, and a father confessor. There wasn't anything that wasn't discussed openly and continuously in the Galleries at 291. If the exhibitions . . . had been shown in any other art gallery, they would never have made an iota of the impact they did at 291. The difference was Stieglitz . . . but none learned as much there as Stieglitz did himself." (Edward Steichen, *A Life in Photography* [Garden City, N.Y.: Doubleday, 1963], n.p.) Stieglitz would probably have agreed with the whole statement, for as he said in 1921, he "was not . . . an authority of any subject. Merely a student—one still actively learning. Everywhere. Every moment." (Alfred Stieglitz, "Regarding the Modern French Masters Exhibition," *Brooklyn Museum Quarterly* 8 [July 1921]: 107.)

8. That Stieglitz was essentially a Symbolist artist has been a surprisingly recent critical assessment. In 1975 Allan Sekula (from an admitted personal bias toward photographic communication as reportage) perjoratively labeled Stieglitz's 1942 short memoir "How the Steerage Happened" (*Twice-a-Year* 8–9 [1942]: 127–31) as "pure Symbolist autobiography," going on to say that "Stieglitz invented himself in Symbolist clichés," and that "the final Symbolist hideout is in the Imagination, and in the fetishized products of the Imagination Stieglitz comes back . . . with a

glass negative [*The Steerage*] from another world." (Sekula, "On the Invention of Photographic Meaning," *Artforum* 13 [January 1975]: 41–42.) In 1978 Dennis Longwell asked the crucial question, "How did the Symbolist aesthetic influence Stieglitz's work?" But Longwell's answer was mainly concerned with mapping Stieglitz's early recognition and appreciation of Steichen's Symbolist photography. (Longwell, *Steichen, The Master Prints, 1895–1914: The Symbolist Period* [New York: Museum of Modern Art, 1978], pp. 19–20.) In 1980 Rosalind Krauss observed that Stieglitz's 1923–32 Equivalents are masterpieces of Symbolist art, primarily because they are "signs by virtue of the crop." (Krauss, "Alfred Stieglitz's Equivalents," *Arts Magazine* 54 [February 1980]: 134–37.) In 1983, after a close examination of Stieglitz's writings and editorial choices for *Camera Notes* (1897–1902) and *Camera Work* (1903–17), Sarah Greenough concluded that his aesthetic theories of "individualism"—particularly his belief that the phenomena of the world could be made to express the thoughts and feelings of the photographer—were "heavily indebted" to the Symbolist movement. (*Stieglitz*, p. 15.) However, none of these contributions inquired into the circumstances of Stieglitz's first powerful encounters with Symbolism. Fresh investigation is needed into his formative years in Germany (1882–90). Unfortunately, only a "scant handful" of Stieglitz's letters survive from his student days in Berlin. (Lowe, p. 71.)

9. For de Zayas's own explanation of his elliptical caricatures, see Marius de Zayas, "Exhibition Marius de Zayas," *Camera Work* 42–43 (April–July 1913): 20–22. See also Paul B. Haviland, "Marius de Zayas: Material, Relative and Absolute Caricatures," *Camera Work* 46 (dated April 1914, published October 1914): 33. A more recent investigation into the sources for de Zayas's abstract equivalents to portraiture is Craig R. Bailey, "The Art of Marius de Zayas," *Arts Magazine* 53 (September 1978): 136–44. Bailey explores the influence of European modernism on de Zayas's work between 1910 and 1914 and makes the important point that de Zayas mostly caricatured people he knew, liked, and admired. The repeated eyeglasses are read by Bailey as infinity signs—a particularly witty compliment to Stieglitz. Willard Bohn, "The Abstract Vision of Marius de Zayas," *Art Bulletin* 62 (September 1980): 434–52, provides the first study of the genesis and dating of de Zayas's work. Bohn enlarges on the importance of positivism and Cubist theory for de Zayas's "double abstraction," observes that his realistic and abstract styles were used interchangeably, and agrees with Bailey that Picabia's machine drawings for *291* derived from de Zayas instead of vice versa (as posited by William A. Camfield in his 1979 monograph on Picabia). Bohn labels *Alfred Stieglitz* as the first of the abstract caricatures and the source of all those to follow. For a collection of de Zayas's social and political caricatures, see Douglas Hyland, *Marius de Zayas: Conjurer of Souls* (Lawrence: Spencer Museum of Arts, University of Kansas, 1981).

10. Alfred Stieglitz, "One Hour's Sleep: Three Dreams," *291*, no. 1 (March 1915): n.p. Arnold Böcklin's *Island of the Dead* (1886) was a favorite of Stieglitz's (a reproduction hung on the wall of the Stieglitz family home at Lake George). Presumably he knew as well Böcklin's *Self-Portrait with Death Playing the Fiddle* (1872) and *The Plague* (1898). He also appreciated, and collected, the macabre, death-saturated work of Félicien Rops, whose *Le Sacrifice* (1883) is in the Stieglitz Collection at the Metropolitan Museum of Art. This dream may well have reflected Stieglitz's unhappy first marriage to Emmeline Obermeyer, which began in 1893. For an account of their difficult twenty-three-year marriage and its end, see Robinson, pp. 147–49, 207–10.

11. The German Symbolist movement itself came into being well after Stieglitz left Berlin in 1890. It was created almost single-handedly by the poet Stefan George during the mid-1890s, after his 1889 visit to Paris, where he met the French Symbolist writers at Mallarmé's Tuesday evenings. For an account of the Symbolist poetics of Stefan George and his circle in Munich during the 1890s, and their influence on Kandinsky after 1900, see Peg Weiss, *Kandinsky in Munich, 1896–1914* (Princeton, N.J.: Princeton University Press, 1979), pp. 81–91.

12. Stieglitz to Sherwood Anderson, November 28, 1923, SAP. Stieglitz to Anderson, September 18, 1923, SAP. The use of *white* in this context obviously had nothing to do with skin color.

13. *Mallarmé: Selected Prose Poems, Essays, and Letters*, trans. and with an introduction by Bradford Cook (Baltimore: Johns Hopkins University Press, 1953), pp. 43–56.

14. Mallarmé to Henri Cazalis, October 1864; ibid., p. 83. For research into the early theory of equivalents, see H. R. Rook-

maaker, *Gauguin and Nineteenth-Century Art Theory* (Amsterdam: Swets and Zeitlinger, 1972), pp. 155, 161, 164, 171, 206, 207–8.

15. For a discussion of Mallarmé and the music of poetry (which owes nothing to the influence of Wagner in France), see A. G. Lehmann, *The Symbolist Aesthetic in France: 1885–1895* (Oxford: Basil Blackwell, 1950), pp. 149–67. Also on the topic of Mallarmé and musicality, see Rookmaaker, *Nineteenth-Century Art Theory*, pp. 210–20.

16. Stieglitz did not consider this a complete switch of intent. "I had been thinking of America constantly in the days before the war. What was 291 but a thinking of America?" (Alfred Stieglitz, "Ten Stories," *Twice-a-Year* 5–6 [1940–41]: 135–63.) This statement is borne out by a letter of his to Marsden Hartley (May 4, 1915, YCAL): "So between you, de Zayas & Walkowitz it looks as if 291 would be devoted chiefly to the development of 291ers. And that is as I should like it best."

17. Paul Rosenfeld, "Alfred Stieglitz," in *Port of New York: Essays on Fourteen American Moderns* (1924; Urbana: University of Illinois Press, 1961), excerpts from pp. 257, 258, 260, 269–70. An earlier version of this article was published as "Stieglitz," *Dial* 70 (April 1921): 397–409. The most recent sources for Rosenfeld are: Hugh M. Potter, *False Dawn, Paul Rosenfeld and Art in America: 1916–1946* (Ann Arbor, Mich.: UMI Monographs, 1980); Bruce Butterfield, "Paul Rosenfeld: The Critic as Autobiographer" (Ph.D. diss., University of Illinois, 1975); and Wanda Corn, "Apostles of the New American Art: Waldo Frank and Paul Rosenfeld," *Arts Magazine* 54 (February 1980): 159–63.

18. Arthur Symons, *The Symbolist Movement in Literature* (New York: E. P. Dutton, 1919), pp. 184–88. This popular book, first published in 1899, provided the earliest introduction to French Symbolist literature for many Americans, including T. S. Eliot. It includes several of Mallarmé's more difficult poems (including *Hérodiade*) and statements, translated into English.

19. For a close study of anarchist Symbolism —its anti-intellectualism in the name of spontaneity and intuitiveness, and its elevation of the artist into a hero for rejecting the past—see Patricia Leighten, *Re-Ordering the Universe: Picasso and Anarchism, 1897–1914* (Princeton, N.J.: Princeton University Press, 1989); note especially pp. 13–20, 48–73.

20. Mallarmé, in Rewald, *Post-Impressionism*, p.

141. For more specifics on Mallarmé's brand of anarchism, see Leighten, *Re-Ordering the Universe,* pp. 13, 49–51, 117.

21. For a highly readable account of American cultural anarchism, its "myth of improvement," its roots in the American tradition of individualism, its issues, its major organ (the *Masses*), and its major spokesmen (many of whom were known to Stieglitz and O'Keeffe), see Frederick J. Hoffman, *The Twenties: American Writing in the Postwar Decade* (New York: Macmillan, 1965), pp. 24–25, 37, 389–91, 402–8, 427.

22. See, for example, Alfred Stieglitz, "The Origins of the Photo-Secession and How It Became 291," *Twice-a-Year* 8–9 (1942): 114–27.

23. Stieglitz's early (perhaps first) use of this phrase appears in a letter to O'Keeffe, March 31, 1918: "The Great Child pouring out some more of her Woman self on paper—purely—truly—unspoiled"; in Pollitzer, p. 159.

24. For a thorough study of Symbolism and esotericism, see Eda Filiz Burhan, "Vision and Visionaries: Nineteenth-Century Psychological Theory, the Occult Sciences and the Formation of the Symbolist Aesthetic in France" (Ph.D. diss., Princeton University, 1975). As used here, *mysticism* refers to the individual's personal search for a state of oneness with ultimate reality. For an inclusive history of the word's meaning, see Maurice Tuchman et al., *The Spiritual in Art: Abstract Painting, 1890–1985* (Los Angeles: Los Angeles County Museum of Art; New York: Abbeville, 1986), pp. 376–77. For a history of the term *occult*—meaning a secret body of knowledge accessible only to those who have been appropriately initiated—see ibid., pp. 380–81.

25. For two outstanding contributions toward this important, and long-neglected, facet of modern art history, see Rose-Carol Washton Long, *Kandinsky: The Development of an Abstract Style* (Oxford: Oxford University Press, 1980), and Linda Dalrymple Henderson, *The Fourth Dimension and Non-Euclidean Geometry in Modern Art* (Princeton, N.J.: Princeton University Press, 1983). For a 1910 survey of how powerfully the idea of the fourth dimension gripped American minds, see Henry Parker Manning, ed., *The Fourth Dimension Simply Explained: A Collection of Essays Selected from Those Submitted in the "Scientific American's Prize Competition"* (New York: Munn, 1910).

26. Lowe (p. 277) cites only that Stieglitz con-

sulted an astrologer on occasion and was susceptible to the superstition of numerology.

27. Max Weber, "The Fourth Dimension from a Plastic Point of View," *Camera Work* 31 (July 1910): 25. For a discussion of Matisse's immense influence on his student Weber, and on Weber's *Camera Work* piece in particular, see Jack Flam, *Matisse: The Man and His Art, 1869–1918* (Ithaca, N.Y.: Cornell University Press, 1986), p. 312. For an analysis of Weber's essay, its occult sources, and its subsequent importance for the Stieglitz circle, see Henderson, *Fourth Dimension,* pp. 167–82. Burgess's intense interest in the fourth dimension is discussed by Henderson on pp. 182–86, that of De Casseres on pp. 213–14, and that of Picabia on pp. 210–18. For Stein and Dodge, see *Camera Work,* special no. (June 1913). Stein's essays, "Henry Matisse" and "Pablo Picasso," appear on pp. 23 and 29; Dodge's "Speculation," pp. 6–9, contains a specific reference to the fourth dimension. For more on these two women in this context, see Linda Dalrymple Henderson, "Mabel Dodge, Gertrude Stein and Max Weber: A Four Dimensional Trio," *Arts Magazine* 57 (September 1982): 106–11.

28. Hartley's interest in mystical ideas waxed and waned over many years, beginning in 1907 with a visit to Green Acre, Sarah Farmer's well-known spiritual retreat in Maine, which later became a world headquarters for the Baha'i religion. In 1912 he focused on Theosophy, through the teachings of Madame Helena Blavatsky, as a direct result of having read Kandinsky's *Uber das Geistige in der Kunst.* By 1913 he had read the writings of the Christian mystics Jakob Böhme and Meister Eckehart and studied the *Bhagavad-Gita.* (Hartley to Stieglitz, 1913, YCAL.) For an account of how Hartley drew upon these and other mystical-occult sources for his art until well into the 1930s, see Gail Levin, "Marsden Hartley and Mysticism," *Arts Magazine* 60 (November 1985): 16–21.

Dove's art was not significantly influenced by occultism until the mid-1920s. His late and very secret interest in Theosophy and the fourth dimension may have begun through his friendly contacts with Claude Bragdon. For a convincing examination of the occult ideas that informed the structure and content of Dove's painting for the last twenty years of his life, see Sherrye Cohn, "Arthur Dove and Theosophy: Visions of a Transcendental Real-

ity," *Arts Magazine* 58 (September 1983): 86–91; Cohn, "The Image and the Imagination of Space in the Art of Arthur Dove, Part I: Dove's 'Force Lines, Growth Lines' as Emblems of Energy," *Arts Magazine* 58 (December 1983): 90–93; Cohn, "The Image and the Imagination of Space in the Art of Arthur Dove, Part II: Dove and 'The Fourth Dimension,'" *Arts Magazine* 58 (January 1984): 121–25. O'Keeffe owned Dove's *Golden Sunlight* (1937), one of the most Theosophical of all his paintings.

29. For more on Dow and Green Acre, see Frederick C. Moffatt, *Arthur Wesley Dow, 1857–1922* (Washington, D.C.: National Collection of Fine Arts; Smithsonian Institution Press, 1977), p. 130 n. 87. For what little is known about Dow's pilgrimage to India, see ibid., pp. 102–3. For Dow's spiritual commitments at the time O'Keeffe was his student, see ibid., p. 110.

30. For information on the Weber–Coburn relationship, see Phylis Burkley North, "Max Weber: The Early Paintings (1905–1920)" (Ph.D. diss., University of Delaware, 1975), pp. 96–97, 124–26, 142–44. The Weber–Coburn correspondence is in the AAA.

31. Kandinsky, *Harmony,* pp. 28–29.

32. I take issue, however, with Maurice Tuchman's inference that O'Keeffe's decision to draw and paint in numbered series was intentionally occult. (Tuchman, "Hidden Meanings in Abstract Art," in Tuchman et al., *Spiritual in Art,* p. 43.) It is far more likely that she came to the series concept out of her own artistic needs, directly ministered to by Whistler, Dow, and later by photography.

33. Best known for his "small but fit" houses for the urban middle class, Bragdon also designed three New York City buildings: the New York Central Railroad Station (built in 1913 and no longer extant), the Universalist Church (1907), and the Chamber of Commerce Building (begun 1915). To Bragdon, the architectural essence of a house consisted of "Simplicity, Coherence and Individuality."

34. Claude Bragdon, *More Lives Than One* (New York: Alfred A. Knopf, 1938), p. 102. See also Claude Bragdon, "The Shelton Hotel, New York," *Architectural Record* 58 (July 1925): 1–18.

35. Blanche Matthias to Claude Bragdon, February 5, 1926, Bragdon Family Papers, University of Rochester Library, Rochester, New York. Right after this visit to New York, Matthias, then an art critic for

the *Chicago Evening Post,* wrote a perceptive and admiring review of O'Keeffe's current exhibition, "Georgia O'Keeffe and the Intimate Gallery," *Chicago Evening Post Magazine of the Art World,* March 2, 1926, pp. 1, 14.

36. O'Keeffe to Matthias, New York, March 1926; in *Letters,* p. 183.

37. Bragdon to "Cleome," December 28, 1937, Bragdon Family Papers.

38. Bragdon to Stieglitz, February 18, 1932; Bragdon to Stieglitz, July 30, 1933, both Bragdon Family Papers. Between 1932 and 1943 Bragdon wrote approximately twenty-three letters to Stieglitz. There are nineteen letters to him from Stieglitz on file in Rochester and the SA.

39. Stieglitz to Bragdon, June 23, 1936, Bragdon Family Papers.

40. For an account of this remarkable occasion, see James M. Baker, *"Prometheus* in America: The Significance of the World Premiere of Scriabin's *Poem of Fire* as Color-Music, New York, 20 March 1915," in Kermit S. Champa, ed., *Over Here!: Modernism, The First Exile, 1914–1919* (Providence, R.I.: David Winton Bell Gallery, Brown University, 1989), pp. 90–109. O'Keeffe was studying in New York during this time, and given her own deep interest in music and synesthesia, she might also have gone to Carnegie Hall that night.

41. On all this, see Henderson, *Fourth Dimension,* pp. 186–201. See also her "Mysticism as the 'Tie That Binds': The Case of Edward Carpenter and Modernism," *Art Journal* (Spring 1987): 29–37.

42. Gelett Burgess, "Essays in Subjective Symbolism," *Camera Work* 37 (January 1912): 46. This incident is mentioned in Bragdon, *More Lives Than One,* p. 254.

43. Claude Bragdon, *Architecture and Democracy* (New York: Alfred A. Knopf, 1918), pp. 104–20.

44. O'Keeffe to Strand, August 16, 1917, PSA.

45. Chief among these are *City Night* (plate 148); *East River from the Shelton* (plate 156); *Shelton Hotel, New York, No. 1* (plate 146); *The Shelton with Sunspots* (plate 147); *Street, New York, No. 1* (collection of Mr. and Mrs. Harry W. Anderson).

46. Sullivan, in Bragdon, *Architecture and Democracy,* p. 144. By 1905 Bragdon had published a major article, "An American Architect, Being an Appreciation of Louis H. Sullivan," *House and Garden* 7 (January 1905): 47–55, and his "Letters from Louis Sullivan" was later published in *Architecture* 64 (July 1931).

47. For the most up-to-date history and analysis of the Carson Pirie Scott store, see William H. Jordy, "The Tall Buildings," in Wim de Wit, ed., *Louis Sullivan: The Function of Ornament* (New York: W. W. Norton, 1986), pp. 128–37.

48. Claude Bragdon, foreword to Louis H. Sullivan, *The Autobiography of an Idea* (1924; New York: Dover, 1956), p. 5.

49. Ibid., p. 7.

50. Sullivan, "The Young Man in Architecture," a speech read before the annual convention of the Architectural League of America, Chicago, June 1900. Published in Louis Sullivan, *Kindergarten Chats and Other Writings* (1918; New York: Dover, 1979), pp. 214–23. This particular speech was reprinted in its entirety in the Stieglitz–Dorothy Norman periodical *Twice-a-Year* 2 (Spring–Summer 1939): 109–21. The editors' comment: "Burning and true words in 1900. Burning and true, still, in 1939."

51. On this, see Lauren S. Weingarden, "Louis Sullivan's Metaphysics of Architecture (1835–1901): Sources and Correspondences with Symbolist Art Theory" (Ph.D. diss., University of Chicago, 1981).

52. For the basic discussion of the links between Wagner's music and the French Symbolist movement, see A. G. Lehmann, *The Symbolist Aesthetic in France, 1885–1895* (Folcroft, Pa.: Folcroft, 1950), pp. 194–206.

53. Sullivan to a client; in *Sullivan: The Function of Ornament,* p. 65.

54. Robert Goldwater, *Symbolism* (New York: Harper and Row, 1979), p. 25.

55. For the origin of this quote, see Rémy de Gourmont, *Mr. Antiphilos, Satyr,* trans. John Howard (New York: Lieber and Lewis, 1922), p. 188. The first issue of Stieglitz's new periodical *Manuscripts* appeared in February 1922. There were six issues printed—the last one in May 1923.

56. Marsden Hartley, "Some Women Artists in Modern Painting," in *Adventures in the Arts* (1921; New York: Hacker Art Books, 1972), p. 117.

57. O'Keeffe to Matthias, March 1926; in *Letters,* p. 117.

58. Louise Grützmacher March, whom O'Keeffe called "Louisa," was born in 1900, in Switzerland, and in 1926 became an exchange student at Smith College from the University of Berlin. She afterward moved to New York, where she opened and ran the Opportunity Gallery between 1928 and 1930. It was during this time that she became friends with Stieglitz and O'Keeffe. It was in New York, as well, that she first met Gurdjieff, and shortly afterward she became his German translator

and secretary. She traveled with him until 1933, when she married Walter March, a Berlin architect. In 1937 the couple relocated in America so he could study with Frank Lloyd Wright. Louise March and O'Keeffe began to correspond in the mid-1930s. (There are some fifteen letters from O'Keeffe to March, the last written in 1983.) During the 1950s March moved to Rochester, New York, where she founded the Rochester Folk Art Guild, based upon Gurdjieff's principles. It was there that I interviewed her on September 16, 1986, a year before her death. When I asked March whether O'Keeffe was ever interested in discussing Gurdjieff's ideas with her, she said O'Keeffe was "much too independent-minded" to follow his teachings. And when March sent O'Keeffe a copy of her own translation of Gurdjieff's *All and Everything,* O'Keeffe wrote back that she couldn't get through it, but would try "later." From New Mexico, O'Keeffe often wrote of her obsessional love for her chow dogs, and at her request the Folk Art Guild wove her a scarf from the fur of one of them during the 1960s.

Toomer was a leading spokesman for Gurdjieff's ideas in America, especially between 1924 and 1932. During Gurdjieff's 1932–33 visit to the United States, Toomer became estranged from the man but not the work. While O'Keeffe was still recovering from her mental breakdown, Toomer spent part of December 1933 alone with her at Lake George. Whether they discussed Gurdjieff's cosmology then is not known. In a letter to Toomer dated January 3, [1934,] O'Keeffe wrote: "You seem to have given me a strangely beautiful feeling of balance that makes the day seem very precious to me.... Something ... that has very little to do with anything you said or did." (*Letters,* p. 216.) For the background of this visit, see Lisle, pp. 212–16. For a selection of O'Keeffe's remarkably confiding letters to Toomer written early in 1934, see *Letters,* pp. 216–20. A recent biographical study of Toomer is Cynthia Earl Kerman and Richard Eldridge, *The Lives of Jean Toomer* (Baton Rouge: Louisiana State University Press, 1988).

On the nature of Gurdjieff's teaching, which owed much to Tibetan Buddhism, see James Webb, *The Harmonious Circle: The Lives and Work of G. I. Gurdjieff, P. D. Ouspensky and Their Followers* (New York: G. P. Putnam's Sons, 1980). Waldo Frank, one of Stieglitz's closest colleagues, had "a series of visionary experiences" in 1920 and turned to Gurdjieff's principles shortly thereafter—an interest that lasted until 1927. On Frank and Gurdjieff, see Webb, *Harmonious Circle,* pp. 271–77, 302–4, 344–47. During the early 1920s Frank was a frequent visitor to Stieglitz and O'Keeffe at Lake George.

59. Burgess, "Essays in Subjective Symbolism," p. 46.

60. An extract from Bergson's *Creative Evolution* appeared in *Camera Work* 36 (October 1911), and "What Is the Object of Art?," from Bergson's *Laughter,* was reprinted in *Camera Work* 37 (January 1912). After Bergson lectured at Columbia University in 1913, his ideas spread quickly through intellectual America. See Henry F. May, *The End of American Innocence* (New York: Alfred A. Knopf, 1959), pp. 226–30. "Anarchism and the essence of sex" comes from *Camera Work* 18 (April 1907): 37–38. "There is hardly any chance of Daniel's [the New York dealer] going into 'abstraction' in the near future. 291 seems to be the only place interested in the development of Today." (Stieglitz to Hartley, January 12, 1915, YCAL.

61. D. H. Lawrence, "Walt Whitman" (1922), in *The Shock of Recognition,* ed. Edmund Wilson (New York: Doubleday Doran, 1943), p. 1071. On September 29, 1923, Stieglitz wrote to Dove, "I've had a rare pleasure, D. H. Lawrence's book 'Studies in American Literature.' Read it—you'll have a great time." (Morgan, p. 92.)

3. Shared Sources (pages 81–123)

EPIGRAPHS:
Kandinsky, *Harmony,* pp. 104–5.

O'Keeffe to Pollitzer, January 4, 1916; this letter, which refers to *Camera Work,* special no. (August 1912), was published in its entirety in *Letters,* pp. 147–48.

1. See Sarah Greenough, "Alfred Stieglitz and 'The Idea Photography,'" in *Stieglitz,* pp. 12–28.

2. In order to "sing the song of myself," Whitman had resolved to "make no quotations and no references to other[s] ... take no illustrations whatever from the classics ... and forms of Europe. Make no mention or allusion to them whatever, except as they relate to the new, present things—to our country—to American character or interests." (Walt Whitman, *Notes and Fragments,* ed. Richard Maurice Burke [London, 1899], p. 56.) That Stieglitz and his circle were longtime admirers of Whitman is well documented.

3. See Lawrence W. Chisolm, *Fenollosa: The Far East and American Culture* (New Haven, Conn.: Yale University Press, 1963), pp. 177–95; Marianne W. Martin, "Some American Contributions to Early Twentieth Century Abstraction," *Arts Magazine* 54 (June 1980): 58–165.

4. Ernest F. Fenollosa, *Epochs of Chinese and Japanese Art: An Outline History of East Asiatic Design* (London and New York: William Heinemann, 1913), p. xxiv. This volume, which declared that all art is harmonious spacing, was on the reading list for Dow's course, Fine Arts 69, at Columbia Teachers College, when O'Keeffe took it in 1914–15.

5. For an account of the ways Oriental decorative principles influenced Dow's teaching exercises and his own work, see Frederick C. Moffatt, *Arthur Wesley Dow, 1857–1922* (Washington, D.C.: National Collection of Fine Arts; Smithsonian Institution Press, 1977), pp. 51–91.

6. Ernest Fenollosa, "The Significance of Oriental Art," *Knight Errant* 1 (1892): 65–70; in Clay Lancaster, "Synthesis: The Artistic Theory of Fenollosa and Dow," *Art Journal* 28 (Spring 1969): 287.

7. Arthur Wesley Dow, *Composition: A Series of Exercises in Art Structure for the Use of Students and Teachers* (New York: Doubleday, Page, 1912), p. 5. This is a later edition, probably the one known to O'Keeffe. The first was published in 1899, by Joseph Bowles, Boston.

8. Mabel Key, "A New System of Art Education, Arranged and Directed by Arthur W. Dow," *Brush and Pencil* 4 (August 1899): 258–70.

9. See Morton Hunt, "How the Mind Works," *New York Times Magazine*, January 24, 1982, p. 31.

10. My summation here is from Dow, *Composition*, pp. 21–26.

11. For this information I am again indebted to William Homer's 1972 interview with O'Keeffe.

12. Dow, *Composition*, p. 53.

13. Albert H. Munsell, *A Color Notation*, 11th ed. (1905; Baltimore: Munsell Color Company, 1969).

14. Dow, *Composition*, p. 100. Dow was, of course, familiar with the famous nineteenth-century compendium of Charles Blanc's optical precepts and techniques, *The Grammar of Painting and Engraving*, which also stated that color could be taught like music (p. 169). This partial translation of Blanc's *Grammaire des arts du dessin* (1867) was made by Kate Newell Doggett (Chicago, 1879). It was a staple in art schools across America (hence O'Keeffe was bound to be familiar with it), and a system that Dow's *Composition* was intended to counteract.

Blanc's perennially radical thesis was that the formal elements of a picture should always be adjusted to the emotions the artist wished to evoke in the spectator. In other words, expression first, visual unity second. Blanc also relied on a system of teaching color "like music" that he did not invent. His chromatic "rose," designed to achieve color harmony (which Gauguin valued enough to copy into his notebook *Vers et prose*), originated from a color wheel devised in 1852 by J. Ziegler. Color, Blanc said (p. 168), tells us "what agitates the heart," while drawing shows us "what passes in the mind," and he warned that "the taste for color, when it predominates absolutely, costs many sacrifices, often it turns the mind from its course, changes the sentiment, swallows up the thoughts." For a discussion of Blanc's strong influence on the formulation of Symbolist art theory, especially on Maurice Denis's *Théories*, see Misook Song, *Art Theories of Charles Blanc, 1813–1882* (Ann Arbor, Mich.: UMI Research Press, 1984), pp. 67–76.

15. See Dow, *Composition*, pp. 100–110.

16. For an account of this crisis, see Moffatt, *Dow*, pp. 117–19.

17. During 1914–15 O'Keeffe took Charles J. Martin's course "Modernist Painting" at Teachers College, in which colored chalks were used to develop "expression"—but only after the student had first rendered a symmetrical design to contain the color. For a description of this course, see Arthur W. Dow, "New Art Work at Columbia University," *Proceedings of the Eastern Art Teachers' Association* (April 1916): 165.

18. Arthur Wesley Dow Papers, AAA, roll 1033, frame 1310.

19. Ibid., frames 1322–24.

20. Ibid., frames 1325–26.

21. O'Keeffe's letters of the period testify to a certain impatience with "Pa Dow" and the flattering students of his color-printing class. For example, O'Keeffe to Pollitzer, February 1916, SA.

22. Kandinsky: "The strife of colours ... these make up [the] harmony [of our age]. The composition arising from this harmony is a mingling of colour and form, each with a separate existence, but each blended into a common life, which is called a picture by the force of inner need." (Kandinsky, *Harmony*, p. 86.) Matisse: "My choice of colors does not rest on any scientific theory; it is based on observation and feeling, on

the very nature of experience." (Henri Matisse, "Notes of a Painter"; in Alfred H. Barr, Jr., *Matisse: His Art and His Public* [New York: Museum of Modern Art, 1951], p. 121.)

23. Dow, *Composition*, p. 62.

24. O'Keeffe, in Marsden Hartley, "Some Women Artists in Modern Painting," in *Adventures in the Arts* (1921; New York: Hacker Art Books, 1972), p. 116.

25. Georgia Engelhard Cromwell—whose mother, Agnes, was one of Stieglitz's two sisters and who became O'Keeffe's young friend during the increasingly difficult Lake George summers—has said that during the early 1920s all O'Keeffe wanted was "for Stieglitz to hold her hand and tell her she was good." Interview with author, March 12, 1980, Unterseen, Switzerland.

26. Lowe, p. 310.

27. Cromwell, interview with author, 1980.

28. Dow, *Composition*, p. 50.

29. Alfred Stieglitz, "A Plea for Art Photography in America," *Photographic Mosaics* 28 (1892): 136; in Peter C. Bunnell, ed., *A Photographic Vision: Pictorial Photography, 1889–1923* (Salt Lake City: Peregrine Smith, 1980), pp. 24–25.

30. Alfred Stieglitz, "Pictorial Photography," *Scribner's Magazine* 26 (November 1899); in Beaumont Newhall, ed., *Photography: Essays and Images* (New York: Museum of Modern Art, 1980), p. 166.

31. Alfred Stieglitz, "Simplicity in Composition," in *The Modern Way of Picture Making* (Rochester, N.Y.: Eastman Kodak, 1905), pp. 161–64; in Bunnell, ed., *Photographic Visions*, pp. 170–71.

32. For a discussion of Dow's influence on Smith's work, see Melinda Boyd Parsons, *To All Believers—The Art of Pamela Colman Smith* (Wilmington: Delaware Art Museum, 1975), n.p.

33. Weber's opening sentence reads, "Photography is a flat space art, as is drawing, painting or printing." (Max Weber, "The Filling of Space," *Platinum Print* 1 [December 1913]: 6.) For Weber's admiring description of Dow's methods of teaching, see Holger Cahill, *Max Weber* (New York: Downtown Gallery, 1930), p. 5. Several of Dow's untitled photographs (landscapes and seascapes) are at George Eastman House, Rochester, New York.

34. *Alvin Langdon Coburn, Photographer: An Autobiography*, ed. Helmut and Alison Gernsheim (New York: Dover, 1978), p. 22. Moffatt remarks apropos of this statement: "It is rather surprising that Coburn should in later years place Dow's influence upon his work even above that of Käsebier,

Steichen and Demachy. But, as with Max Weber . . . it was Coburn's discovery of a new language of art under Dow that made all the difference." (Moffatt, *Dow*, pp. 98–99.)

35. In her dissertation Naomi Rosenblum barely mentions Dow in connection with Strand. She stresses instead the importance on Strand's earliest photography of Lewis W. Hine's teaching (at the Ethical Culture School) and Stieglitz's criticism (at 291). See Rosenblum, "Paul Strand: The Early Years, 1910–1932" (Ph.D. diss., City University of New York, 1978), pp. 74, 85–86.

36. David Travis, *Photography Rediscovered: American Photographs, 1900–1930* (New York: Whitney Museum of American Art, 1980), p. 151.

37. Rosenblum has pointed out that Strand's early photographs (1913–14) "owe something to the influence of Coburn [who] frequently selected photographic vantage points that enabled him to stress the patterns created by architectural elements as in *The Octopus* 1912." (Rosenblum, "Strand," p. 46.) Not only is this one of the most Dow-influenced of Coburn's images, but Strand's own *Forty-second Street and Fifth Avenue* (1915), with its repetitions of circular forms, may well indicate a close attention to Dow's famous Repetition principle. That American photographers were taking a new look at Dow's studies in abstract design right after the Armory Show is evident from an extract from *Composition* reprinted in *Photo-Era*, which speaks of the "one-ness of art" and the synthesizing of picture, plan, and pattern. (*Photo-Era* 5 [May 1913]: 235.) Further proof is furnished by an ad in the front section of that issue (n.p.) extolling *Composition* as "a valuable aid to the photographer in composing his picture." The challenge of the Armory Show (as it had long been at 291) was for photographers to take pictures abstract enough to hold the viewers' visual interest when seen alongside pictures painted by Kandinsky, Matisse, Picasso, and Picabia. Writing of Strand's efforts in 1916 to understand abstract painting by making abstract photographs, Rosenblum observed (p. 56) that several of the most extreme of these images "can be viewed from any side." This is, in fact, the most telltale sign of a Dow composition—and one that Coburn especially fancied. As he wrote: "Think of the joy of doing something which it would be impossible to classify, or to tell which was top and which was bottom." (Alvin Langdon Coburn, "The

Future of Pictorial Photography," in *Photograms of the Year 1916* (London: Hazell, Watson, and Viney, 1916], p. 23.)

38. Charles H. Caffin, "Of Verities and Illusions—Part II," *Camera Work* 13 (January 1906): 43.

39. Dow, *Composition*, p. 54.

40. Sadakichi Hartmann, *The Valiant Knights of Daguerre: Selected Critical Essays on Photography and Profiles of Photographic Pioneers*, ed. Harry W. Lawton and George Knox (Berkeley: University of California Press, 1978), editors' introduction, p. 12.

41. For some examples of Hartmann's acute knowledge of Japanese composition, see his *Landscape and Figure Composition* (1910; New York: Arno, 1973, Literature of Photography series), pp. 37–56, 75. For his strong interest in Symbolism, see Hartmann's short-lived avant-garde magazine the *Art Critic*, published during 1893. In his 1898 essay on Stieglitz's photography, Hartmann makes this revealing comment, " 'On the Seine' is a tribute to the undeniable truth that the future of art lies largely in decoration." (Hartmann, *Valiant Knights*, p. 163.)

42. Hartmann, *Landscape and Figure Composition*, p. 51.

43. The back of this photograph, with Stieglitz's autograph note, is reproduced in Newhall, ed., *Photography*, p. 216.

44. Stieglitz's photographs are reproduced side by side in Sarah E. Greenough, "From the American Earth: Alfred Stieglitz's Photographs of Apples," *Art Journal* (Spring 1981): 52–53. For Dow's exercises, see Dow, *Composition*, p. 25, and Arthur Wesley Dow, "Training in the Theory and Practice of Teaching Art," *Teachers College Record* 9 (May 1908): 8.

45. Alfred Stieglitz, "Is Photography a Failure?" *New York Sun*, March 14, 1922, p. 20.

46. Greenough, "American Earth," pp. 46–54.

47. The basic treatise on this topic is Sandra Gail Levin, "Wassily Kandinsky and the American Avant-Garde, 1912–1950" (Ph.D. diss., Rutgers University, 1976); see especially pp. 52–70, 79–140.

48. Levin, for example, offers only a footnote to the effect that "Georgia O'Keeffe, who was close to Dove, also read Kandinsky's treatise and 'liked his paintings.' " (Ibid., p. 209.)

49. So was Hartley: "In Kandinsky's own work I do not find the same convincing beauty as his theories hold—he seems to be a fine theorist first and a good painter after."

(Hartley to Stieglitz, received December 20, 1912, YCAL.) "Kandinsky has a most logical and ordered mind which appeals so earnestly to the instinct which has been overmastered—In other words in my heart of hearts, I think he is not creative—." (Hartley to Stieglitz, May 1912, YCAL.)

50. The relationship of Dove's art to Kandinsky remains a vexed question. Dove's six earliest known abstractions (or "extractions," as he called them), of 1909–10, were apparently made from his own independent efforts to re-create sensations of the shapes of nature through form and color. The abstract pastel series of 1911–12, known as the Ten Commandments and only recently identified as such by William Homer (*American Art Journal* 12 [Summer 1980]: 21–32), requires much more study, but the most visible influences appear to be Synthetism, Cubism, and Fauvism. See Barbara Haskell, *Arthur Dove* (Boston: New York Graphic Society, 1974), pp. 15–29. Also, Sasha M. Newman, *Arthur Dove and Duncan Phillips: Artist and Patron* (New York: George Braziller, 1981), pp. 26–29.

Whether Dove saw Kandinsky's Fauve landscapes in the 1908–9 Paris Salons is not certain, but he did see *Improvisation 27* in the Armory Show, which seems to have begun his interest in Kandinsky's painting and writing. It was Stieglitz who gave Dove a copy of the first German edition of *Uber das Geistige in der Kunst* and also the *Blaue Reiter Almanac*—the latter inscribed "Mar. 19, 1913 from Mr. Stieglitz." (See Levin, "Kandinsky and the American Avant-Garde," pp. 52–55.) Both these books clearly offered Dove theory and evidence to support his own earlier findings and perhaps more. An in-depth comparison of Dove's post-1913 abstractions with Kandinsky's canvases of 1912–14 has yet to be made. (For a start, see William Innes Homer, *Alfred Stieglitz and the American Avant-Garde* [Boston: New York Graphic Society, 1977], pp. 212–13, and Rose-Carol Washton Long, *Kandinsky: The Development of an Abstract Style* [London and New York: Oxford University Press, 1980], p. 157.)

The importance of Dove's own work for O'Keeffe—and hers for him—has just begun to be explored. See Susan Fillin Yeh, "Innovative Moderns: Arthur G. Dove and Georgia O'Keeffe," *Arts Magazine* 56 (Summer 1982): 68–72; also, Sherrye Baker Cohn, "The Dialectical Vision of Arthur Dove: The Impact of Science

and Occultism on His Modern American Art" (Ph.D. diss., Washington University, 1982), pp. 204–5, 233. O'Keeffe's regard for Dove's vision is suggested by the fact that his *Golden Sunlight* (1937; reproduced in Haskell, *Dove,* p. 79) hung in her house in Abiquiu. As she wrote to Donald Gallup in 1952, "Dove I can leave on the wall day after day—month after month—Marin I can keep on the wall longer than Hartley —but not as long as Dove—Dove stays." (*Letters,* p. 262.)

51. *Stieglitz,* p. 31. See also p. 226 for an account of the similarities between Kandinsky's and Stieglitz's artistic concerns.

52. Wassily Kandinsky, "Extracts from 'The Spiritual in Art,'" *Camera Work* 39 (July 1912): 34.

53. Stieglitz to Kandinsky: "I knew I might influence the people to look at the picture which I thought of importance to themselves." (May 26, 1913, SA.)

54. In Sadler's translation (Kandinsky, *Harmony,* p. 87), "veiling" is described as "legitimate and illegitimate combinations of colors, contrasts of various colors, the over-painting of one color with another, the definition of colored surfaces by boundaries of various forms, the over-stepping of these boundaries . . . all these open great vistas of artistic opportunity."

55. *O'Keeffe,* text opposite plate 12.

56. "I had to give a talk at the Faculty Circle . . . so I had been laboring on Aesthetics—Wright—Bell—De Zayas—Eddy." (O'Keeffe to Pollitzer, January 17, 1917; in *Letters,* p. 159.)

57. Kandinsky, *Harmony,* pp. 72–73.

58. Ibid., pp. 64–65.

59. O'Keeffe to Pollitzer, Canyon, Texas, [early] October 1916, SA. This letter was in answer to Pollitzer's letter to O'Keeffe, September 27, 1916: "Where did you do [them] . . . the pod of stuff standing quite erect and without assistance—near the other shape—is the one I call cucumber. It's rather self-evident in meaning—I've known it always—but as art (Dow's darn art) its O.K.—very good [Does a tiny sketch of "Blue No. 4" and describes it as "very beautiful"]. . . . Where did you keep the rest of yourself while you were doing it? It's right—I *wouldn't* like one line different—There are dozens almost like it in this bunch—I wonder if this came first or last." (First published in Jan Garden Castro, The *Art and Life of Georgia O'Keeffe* [New York: Crown, 1985], p. 36.)

60. See the 1917 Stieglitz installation photograph published in Homer, *Stieglitz,* p. 241.

61. Kandinsky, *Harmony,* pp. 75–76.

62. W. H. Wright, "The Future of Painting," *Freeman* 22 (November 1922): 256.

63. Dow, *Composition,* p. 16.

64. Pollitzer to O'Keeffe, December 21, 1916, SA.

65. Kandinsky, *Harmony,* p. 58. Although Kandinsky would change his mind on the potential of pure abstraction by 1914, his revisions did not appear in print until the fourth German edition of *Uber das Geistige.*

66. Ibid., p. 71.

67. Ibid., pp. 88, 103.

68. Ibid., p. 102.

69. See Eda Filiz Burhan, "Vision and Visionaries: Nineteenth-Century Psychological Theory, the Occult Sciences and the Formation of the Symbolist Aesthetic in France" (Ph.D. diss., Princeton University, 1975), pp. 237–57. Seminal to this general topic is Robert Goldwater, *Primitivism in Modern Art,* rev. ed. (New York: Random House, 1966). See especially his pp. 125–42 on the primitivism of Kandinsky and Franz Marc's *Blaue Reiter Almanac.*

70. Wassily Kandinsky, "On the Question of Form," in the *Blaue Reiter Almanac,* Documents of Twentieth-Century Art (New York: Viking, 1974), p. 178. Kandinsky reproduced seven of Rousseau's paintings in the almanac and Eddy reproduced two others, so O'Keeffe would have been well aware of Rousseau's stylistic constants.

71. For example, Herbert J. Seligmann, "Georgia O'Keeffe, American," *Manuscripts* 5 (March 1923): 10. Later that same year Seligmann wrote, "No other woman has ever painted so, and except for the intensity of Greco and the song-like serenity of Rousseau, no man among the painters occurs for comparison with this singularly gifted woman [O'Keeffe]." (Seligmann, "Why Modern Art?" *Vogue* 62 [October 15, 1923]: 112.) In Strand's 1924 draft manuscript "Georgia O'Keeffe: A Woman in Painting" (PSA), later published in *Playboy* 9 (July 1924), he too speaks of O'Keeffe's painting as "yet akin to that of Rousseau."

72. Sadler, introduction to Kandinsky, *Harmony,* pp. xxi, xxiii. For an important recent discussion on the practical problems encountered by Kandinsky himself, see Peter Vergo, "Music and Abstract Painting: Kandinsky, Goethe and Schoenberg," in *Towards a New Art* (London: Tate Gallery, 1980), pp. 41–63. In fact, says Vergo, color is *not* similar to music, but strikingly different. He finds Kandinsky's account of color "curious in the extreme" and shows

the ways in which it was based on the difficult new music of Arnold Schoenberg. The crucial question remained: what was to replace the object and/or sense of key? In throwing out the rules for their arts, these avant-garde artists were confronted with new problems of clarity and organization—which were not finally solved.

73. Kandinsky, *Harmony,* pp. 34, 41. Whether or not this was the case, O'Keeffe would soon become aware, through Stieglitz, that American Pictorial photography had also benefited from music. The Buffalo Photo-Pictorialists (inspired by, and contemporary with, Stieglitz's Photo-Secession in New York) frequently compared their landscape photography to "absolute music," and many of them specialized in "non-narrative," or nonassociative, compositions. On this, see Anthony Bannon, *The Photo-Pictorialists of Buffalo* (Buffalo: Buffalo Media Study, 1981), pp. 23–24. See also Howard Risatti, "Music and the Development of Abstraction in America: The Decade Surrounding the Armory Show," *Art Journal* (Fall 1979): 8–13.

74. Fenollosa, *Chinese and Japanese Art,* p. xxv.

75. It has not been recorded whether (as seems probable) O'Keeffe read Eddy's widely known *Recollections and Impressions of James A. McNeill Whistler* (Philadelphia and London: J. B. Lippincott, 1903)—which quoted whole sections from Whistler's *Gentle Art of Making Enemies* on the relationship between music and art. In Eddy's own summation (pp. 183–84): "There is a music of color even as there is a music of sound, and there should be delight in color composition even as there is delight in sound composition; and this delight should be something fundamentally distinct from any interest in the subject of the composition."

76. The question arises as to whether Stieglitz was influenced by Whistler's tiny (9-by-10-inch) oil sketches of Chelsea landscapes, which were framed and exhibited as "Notes" (as opposed to "Symphonies"), when he painstakingly framed his own 4-by-5-inch cloud photographs, the Equivalents.

77. For two recent studies on Whistler as a Symbolist, and fresh insight into his relationship with Baudelaire, see Ron Johnson, "Whistler's Music Modes: Symbolist Symphonies," and Johnson, "Whistler's Musical Modes: Luminous Nocturnes," *Arts Magazine* 55 (April 1981): 164–76.

78. For a history of the additive title of this painting, see A. McL. Young, M. MacDonald, R. Spencer, and H. Miles, *The Paintings of James McNeill Whistler,* 2 vols. (New Haven, Conn.: Yale University Press, 1980), text vol., pp. 17–18. Mantz's remark is cited on p. 18.

79. Other examples of O'Keeffe's title changes: *A Celebration* (1924; private collection) was illustrated under the title *Cloud Forms* in *Creative Art* (January 1928). The Whitney's *Abstraction* (1926), originally a Lake George view turned on its side, was mistakenly hung upside down for a decade after being acquired by the museum. On this, see Patterson Sims, *Georgia O'Keeffe: A Concentration on Works from the Permanent Collection of the Whitney Museum of American Art* (New York: Whitney Museum of American Art, 1981), p. 19.

80. The connection with Collins was made by F. G. Stephens in *Athenaeum* (June 28, 1862), after the painting's first exhibition in London at the Berner's Street Gallery. The comment about the bride was made by the French critic Jules-Antoine Castagnary, after *The White Girl*'s sensational success in 1863 at the Salon des Refusés, Paris.

81. Whistler, letter to the *World,* May 22, 1878, reprinted by him in *The Gentle Art of Making Enemies* (1890; New York: Dover, 1967), pp. 127–28. For new research on Whistler's art of the early 1860s and the ways these paintings functioned as an analogue to his intimate feelings, see Elizabeth Broun, "Thoughts That Began with the Gods: The Content of Whistler's Art," *Arts Magazine* 62 (October 1987): 36–43.

O'Keeffe was also acquainted with the notion of art-for-art's sake through William Merritt Chase, her teacher at the Art Students League. Chase had an unswerving faith in the ultimate triumph of "the right of the painter to make pictures that stand or fall not by reason of their subject, but by reason of their style," as Duncan Phillips wrote in "William M. Chase," *Magazine of Art* (U.S.) 8 (December 1916): 45.

82. O'Keeffe to Pollitzer, [Fall 1915]; in Pollitzer, p. 17. Kandinsky, *Harmony,* pp. 91, 107.

83. "From Whistler's Ten O'Clock," *Camera Work* 5 (January 1904): 52–53. In fact, Stieglitz may have been familiar with Whistler much earlier than 1904, for Whistler's paintings were well known in Germany during the 1890s, through reproduction in such periodicals as *Studio* and *Die Kunst.*

84. Sadakichi Hartmann, "White Chrysanthemums," *Camera Work* 5 (January 1904): 19–20. In 1899 Hartmann considered Whistler "the greatest artist of his cen-

tury." (Hartmann, "Portrait Painting and Portrait Photography"; in Hartmann, *Valiant Knights,* p. 38.) He also made frequent comparisons between photography and the bellwether of Whistler's painting and lithography. (Ibid., pp. 54, 73, 76, 127, 310.) Curiously, although Hartmann wrote in 1898 that "Alfred Stieglitz is to me indisputably the foremost artistic photographer of America" (Hartmann, "Alfred Stieglitz, an Art Critic's Estimate"; in *Valiant Knights,* p. 159), he never compared their work in depth—except to complain that the skirts of the Dutch women in Stieglitz's *Scurrying Home* (1897) are "too opaque [because] it seems almost impossible to attain Whistlerian subtleties of tone in a dark object." (Ibid., p. 164.) In his "Recent Conquests in Night Photography" (1909), Hartmann commented, "Night gained a deeper pictorial significance only with Whistler's nocturnes" (ibid., p. 127), but he swerved from the still-unanswered question of whether Stieglitz's pioneer city-night photographs might have been inspired by Whistler's paintings.

85. Stieglitz, "Simplicity in Composition," pp. 161–64.

86. Peter C. Bunnell, "Some Observations on a Collection of Stieglitz's Early New York Photographs," *Center for Creative Photography Journal* 6 (April 1978): 3, has pinpointed the three prevailing characteristics of Stieglitz's style in his early New York photographs (taken in the decade after 1893): (1) an oblique angle view with a one-sided balance, (2) various triangular forms throughout the composition, and (3) a basic architectural structure with human subjects intersecting as if in a stage setting. Although Bunnell does not specify them as such, all three are familiar Whistlerian composition types. For example: *Wapping* (1860–64) and *Harmony in Green and Rose: The Music Room* (1860) fall easily into the first category. In the second is *At the Piano* (1858–59). And in the third, *Cremorne Gardens, No. 2* (c. 1875). Each of these works by Whistler was well known enough to have been familiar to Stieglitz.

87. Charles H. Caffin, "Of Verities and Illusions, Part I," *Camera Work* 12 (October 1905): 56.

88. Charles H. Caffin, "A New Thought Which Is Old," *Camera Work* 31 (July 1910): 22.

89. For a general discussion of Stieglitz's intentions for his "composite portrait," see *Stieglitz,* pp. 22 and 231 n. 30.

90. Stieglitz to Sherwood Anderson, November 28, 1923, SAP.

91. Paul Rosenfeld, "Stieglitz," *Dial* 71 (December 1921): 408.

92. Stieglitz to Hartley, October 1923, YCAL.

93. *Portrait,* plates 25 and 26.

94. Rosenblum, "Strand," p. 77. See also John Pultz and Catherine B. Scallen, *Cubism and American Photography,* 1910–1930 (Williamstown, Mass.: Sterling and Francine Clark Art Institute, 1981), p. 52.

95. Proof of Stieglitz's serial intent lies in many of his statements, including this one: "To demand *the* portrait that will be a complete portrait of any one person is as futile as to demand that a motion picture be condensed into a single still." (Quoted in Dorothy Norman, *Alfred Stieglitz: Introduction to an American Seer* [New York: Duell, Sloan and Pearce, 1960], p. 35.) Furthermore, the photographic effect of "faceting" (caused by superimposition) in Stieglitz's often-reproduced double-exposure portrait of Dorothy True (1919) was apparently accidental in origin. In any case, it was never repeated in the O'Keeffe *Portrait.*

96. Out of the 329 finished portraits of O'Keeffe in the key set at the National Gallery of Art, at least 140 concentrate on the action of her hands.

97. Although these sixteen watercolors are routinely dated 1917, it is almost certain that they were made early in 1918, for they were sent to Stieglitz that spring. (Robinson, p. 199.) Three of these watercolors are published in *Letters,* plates 24, 25, and 27; two others appear in Lisa Mintz Messinger, *Georgia O'Keeffe* (New York: Metropolitan Museum of Art; Thames and Hudson, 1988), pp. 22–23. Leah Harris, with whom O'Keeffe was then staying in Waring, Texas, may have been the model for some, if not all, of these works. There is also the interesting possibility that a few are self-portraits.

98. Rodin, in Elizabeth Chase Geissbuhler, *Rodin—Later Drawings* (Boston: Beacon, 1963), p. 20.

99. The "Rodin number," *Camera Work* 34–35 (April–July 1911). The illustrations appear on pp. 25, 27, 37, 39, 41, 43, 57, 59, and Rodin's method is discussed with admiration in a short essay, "Arthur Symons on Rodin's Drawings," p. 63. For a more complete description of Rodin's late draftsmanship, see Albert Elsen and J. Kirk T. Varnadoe, *The Drawings of Rodin* (New York: Praeger, 1971), pp. 84–102.

100. Rodin to his secretary, Anthony Ludovici, 1906; in Ludovici, *Personal Reminiscences of Auguste Rodin* (Philadelphia: Lippincott, 1926), pp. 138–39.

101. On Rodin as a Symbolist, see Arthur Symons, *From Toulouse-Lautrec to Rodin* (London: Bodley Head, 1929).

102. A letter from Stieglitz to Arthur B. Carles (April 11, 1913, SA) confirms this: "Picabia left yesterday. All at '291' will miss him. He and his wife were about the cleanest propositions I have ever met in my career. They were one hundred percent purity. . . . Picabia came to '291' virtually daily. . . . Even [he] was astonished at de Zayas's ability." For a recent study of the symbiotic artistic relationship between Picabia and de Zayas in New York and Paris, see Willard Bohn, "The Abstract Vision of Marius de Zayas," *Art Bulletin* 62 (September 1980): 434–35, 447–52.

103. "Samuel Swift in the 'N.Y. Sun,'" *Camera Work* 42–43 (April–July 1913): 18.

104. Paul B. Haviland, "Notes on '291,'" *Camera Work* 42–43 (April–July 1913): 18.

105. Ibid., p. 24.

106. Sue Davidson Lowe (Stieglitz's grandniece and biographer), telephone conversation with author, July 20, 1985, confirmed that Stieglitz spoke French without difficulty—that, in fact, the whole family did and that they prided themselves on being "language conscious." For a résumé of Picabia's extremely various artistic influences between 1908 and 1912, including the leitmotiv of Symbolism, see William Camfield, *Francis Picabia* (Princeton, N.J.: Princeton University Press, 1979), pp. 17–39.

107. Gabrielle Buffet, "Modern Art and the Public," *Camera Work,* special no. (June 1913): 10. Her argument of the superiority of painting over music was picked up later by Willard Huntington Wright. Writing in defense of Synchromist painters for *Forum,* he described their art as superior to music because "it is more intimately attached to reality." (Wright, "Impressionism to Synchromism," *Forum* 50 [July–December 1913]: 770.) Kandinsky had written about the superiority of painting to music in *Harmony* (p. 42): "Painting can present to the spectator the whole content of its message in one moment."

108. According to Marcel Duchamp, "Picabia was above all an Abstractionist, a word he invented. . . . He thought about nothing else." (Pierre Cabanne and Marcel Duchamp, *Dialogues with Marcel Duchamp* [New York: Viking, 1969], p. 39.)

109. Francis Picabia, *New York Times,* February 16, 1913, part 5.

110. Buffet, "Modern Art and the Public," p.12.

111. Picabia, in Samuel Swift, "Art Photographs and Cubist Painting," *Camera Work* 42–43 (April–July 1913): 16.

112. Stieglitz to Heinrich Kühn, October 14, 1912; in *Stieglitz,* p. 194.

113. Francis Picabia, "How New York Looks to Me," *New York American,* March 30, 1913, magazine sec., p. 11.

114. Charles H. Caffin, "The International— Yes—But Matisse and Picabia?," *New York American,* March 30, 1913, magazine sec., p. 11.

115. "Oddly enough, I was going to call the series of my sky pictures 'Music of the Spheres'—but feel it too ambitious a title." (Stieglitz to Rosenfeld, September 6, 1924, YCAL.)

116. "Technically, every work of art comes into being in the same way as the cosmos —by means of catastrophes, which ultimately create out of the cacophony of the various instruments, that symphony we call the music of the spheres. The creation of the work of art is the creation of the world." (Reprinted in *Kandinsky: Complete Writings on Art,* 2 vols., ed. Kenneth C. Lindsay and Peter Vergo [Boston: G. K. Hall, 1982], vol. 1, p. 373.)

117. La Section d'Or was a Cubist-oriented group of artists, including Juan Gris, Albert Gleizes, Jean Metzinger, Jacques Villon, Marcel Duchamp, and Roger de La Fresnaye, who banded together to exhibit at the Galerie La Boétie, Paris, October 10–30, 1912.

118. "It is only after I have put down an equivalent of what has moved me, that I can begin to think about its meaning." (Stieglitz, in Norman, *Introduction to an American Seer,* p. 36.)

119. For what is known about this revealing incident, see *Stieglitz,* pp. 29–30.

120. For a discussion of Stieglitz's "Cubist" composition in the 1915–16 photographs, see Pultz and Scallen, *Cubism and American Photography,* pp. 16–27. For Stieglitz's own opinion of what he had done, see his letter to R. Child Bayley, November 1, 1916: "I have done quite some photography recently. It is intensely direct. Portraits. Buildings from my back window at 291, a whole series of them, a few landscapes and interiors. All interrelated. I know of nothing outside Hill's work which I think so direct, and quite so intensely honest. . . . Just the straight goods. . . . But everything simplified in spite of endless detail." (*Stieglitz,* p. 201.)

121. The National Gallery of Art, Washington, D.C., has three 4-by-5-inch platinum

prints from this series in the key set: Stieglitz's self-portrait and two others, less abstract, of himself and Walkowitz.

122. This uncharacteristic and rarely exhibited photograph appeared on the cover of the 1958 catalog *Alfred Stieglitz,* published by the Smithsonian Institution, Washington, D.C.

123. One of these is reproduced in *Portrait,* as plate 28.

124. A diagram of the forms in this photograph is presented as plate 83 instead of a reproduction. My request to reproduce the photograph was denied by Juan Hamilton (who controls the copyright) because it is a "nude."

125. Lowe, pp. 212, 169. The history of the Picabia–Stieglitz artistic relationship after 1915 (which includes the founding and demise of *291* magazine and the brief glory of New York Dada) is not really germane here. Among the most useful recent contributions to this period are: William A. Camfield, "The Machinist Style of Francis Picabia," *Art Bulletin* (September–December 1966): 309–22; William Innes Homer, "Picabia's 'Jeune fille américaine dans l'état de nudité' and Her Friends," *Art Bulletin* 58 (March 1957): 110–15; Jan Thompson, "Picabia and His Influence on American Art, 1913–17," *Art Journal* (Fall 1979): 14–21. The last article does not mention Picabia's influence on O'Keeffe—nor do any of the others.

126. O'Keeffe was not in New York or Chicago during Picabia's notorious Armory Show visit to the United States in 1913 (January–April). His second trip across the Atlantic (June 1915–summer 1916) is poorly documented, but O'Keeffe's life as a student in New York during the spring of 1916 certainly never put her into contact with the glittering circle around Walter Arensberg, where Picabia often held sway. (O'Keeffe never mentioned meeting Picabia in her letters to Pollitzer.) During his third visit to New York (March–September 1917), O'Keeffe was teaching in Texas. Picabia never again returned to America.

127. The Stieglitz–Picabia correspondence is in the SA. Steichen, in Paris, wrote to Stieglitz in New York (received December 19, 1913): "Picabia very likely is an attempt at expressing the *theory* of modern art but the theory does not express Picabia. ...His pictures are colossally rotten." (Steichen Archive, Museum of Modern Art, New York. I am especially indebted to Grace M. Mayer for making it so easy to examine Steichen's correspondence at the museum.)

128. For some specific examples, see Thompson, "Picabia and His Influence," pp. 16–21.

129. Meraud Michael Guinness, "Francis Picabia," n.p., in the catalog for *The Picabia Exhibition,* Intimate Gallery, New York, April 19–May 11, 1928.

130. Picabia, in Arthur Jerome Eddy, *Cubists and Post-Impressionism* (Chicago: A. C. McClurg, 1914), pp. 96–97.

131. *Black Spot III* is reproduced in *O'Keeffe,* plate 15, with the artist's commentary: "There are three paintings of the *Black Spot.* I never knew where the idea came from or what it says. They are shapes that were clearly in my mind—so I put them down." *Black Spot II* was illustrated in *Dial* 71 (December 1921): 664. *Black Spot I* is in O'Keeffe's estate and has not, to my knowledge, been reproduced. It is possible that this work is more revealing of its original source than the other two. I am not the only one to have noticed a connection between O'Keeffe's morphology and Picabia's. See Lawrence Alloway, "Notes on Georgia O'Keeffe's Imagery," *Womanart* 1 (Spring–Summer 1977): 18–19.

132. Stieglitz to Carles, April 11, 1913, SA. These five works by Picabia became part of Stieglitz's personal collection, which O'Keeffe donated to the Art Institute of Chicago after his death.

133. *O'Keeffe,* text opposite plate 41.

134. William Rubin, "From Narrative to 'Iconic' in Picasso," *Art Bulletin* (December 1983): 615.

135. *O'Keeffe,* text opposite plate 41.

136. Not surprisingly, Stieglitz observed this characteristic of O'Keeffe's before anyone else. In a letter to Sherwood Anderson, dated October 27, 1924, he says: "Georgia's done some amazing canvases. Intimately related to the early drawings which so overwhelmed me when brought to me the first time back in 1916. I know of nothing like them." (SAP.)

137. Caffin, "The International—Yes—But Matisse and Picabia?," p. 11.

138. Matisse, in Eddy, *Cubists and Post-Impressionism,* p. 45. Earlier, in "Notes of a Painter" (1908), Matisse had severely condemned the artist who turns his back on nature.

139. O'Keeffe, in John I. H. Baur, *Nature in Abstraction* (New York: Whitney Museum of American Art; Macmillan, 1958), p. 77.

140. O'Keeffe, in Kuh, p. 194. Although O'Keeffe was always extremely secretive about the mechanics of her painting method, a number of friends and critics have made the following observations. In

1927 Frances O'Brien noted: "Beside her is a glass palette, very large, very clean, each separate color on its surface remote from the next. As soon as a tone has been mixed and applied to the canvas its remains are carefully scraped off the palette, which thus retains its air of virginity." (O'Brien, "Americans We Like: Georgia O'Keeffe," *Nation,* October 12, 1927, p. 361.)

In 1929 Robert M. Coates wrote: "She paints as she feels, impulsively. She does no underpainting on her canvases; she rarely even blocks out her design in advance. Sometimes, in the midst of an evening's conversation, she will be seen furtively sketching a few lines on a bit of paper or the back of an envelope; when she sets up her canvas, she begins at one corner and paints right across it, as one would write a letter." (Coates, "Profiles: Abstraction—Flowers," *New Yorker,* July 6, 1929, p. 22.)

According to Pollitzer: "The image is clear in her mind before she begins to paint. The idea of the painting comes quickly, but then follows a long period of preparation. She usually makes a small line composition in pencil which structures the form a painting is to have—at times, maybe several versions of the composition. She plans the scheme of colors on the palette before touching the canvas. If several pictures are painted on the same theme, in the last one painted, more is suggested, less is stated." (Pollitzer, p. 265.)

Georgia Engelhard Cromwell, who painted frequently with O'Keeffe in 1932, confirmed much of this in the interview with me, March 12, 1980. She also added that O'Keeffe stretched her own canvases, used a separate brush for each color, did not thin colors with turpentine, and rarely overpainted. In a subsequent letter to me, dated April 22, 1980, Cromwell wrote: "When OK painted small objects—flowers, leaves, clam shells, stones etc., she did paint from a model. The first paintings were usually small and then later she would develop the motif into something larger. She definitely worked from realism to abstraction on many occasions. . . . When we were on the Gaspé and [she] did the barn and cross series, these were painted from nature—she would paint the most important sections [on the motif] and then finish the work later from memory. But many of her landscapes were NOT painted directly from nature—and they are largely the impressions that certain scenes made on her. . . . But she never talked much about

her painting. . . . She was an excellent draughtsman—which I feel is due to her conservative art training. I always feel that so many modern artists can't draw—but she certainly COULD." From my own observation, it is clear that O'Keeffe sometimes used tape for her straight-line boundaries. This can be seen in *Radiator Building— Night* (plate 151), among others.

141. Lisle, p. 39. Also, O'Keeffe interview with Homer, September 1972.
142. Lewis Mumford, "O'Keefe [*sic*] and Matisse," *New Republic,* March 2, 1927, pp. 41–42. In a cryptic letter to me on February 14, 1980, Mumford wrote, "Stieglitz was pleased by my piece on Matisse and O'Keeffe—mistakenly supposing that I was thus elevating her!" The relationship of O'Keeffe's art to Matisse's begs for a more thorough evaluation; my text offers only preliminary notes toward that end.
143. For recent writing on Matisse's underestimated interest in Japanese woodcuts and crépons, see Robert Reiff, "Matisse and Torii Kiyonaga," *Arts Magazine* 55 (February 1981): 164–67.
144. Henri Matisse, "My Curves Are Not Mad," in *Jazz* (Paris, 1947), n.p.
145. On this aspect of Matisse's work, see Pierre Schneider, *Matisse* (New York: Rizzoli, 1984), pp. 10, 659. O'Keeffe never recorded her intentions in quite the revealing way that Matisse did, but there is enough visual evidence to make a similar claim for her. At the end she could have said, as honestly as he, that her life had been devoted to "the essential thing for which I am made and which may bring a little happiness to the great family, the greatest spiritual family." (Matisse to A. Rouveyre, September 4, 1942; in Schneider, *Matisse,* p. 706.)
146. Matisse, in "Pictorial Photography—A Series of Interviews," *Camera Work* 24 (October 1908): 22. In a 1933 statement to the critic E. Tériade on creativity, Matisse said, "Photography has greatly disturbed the imagination because one has seen things devoid of feeling. When I wanted to get rid of all influences which prevented me from seeing nature from my own personal view, I copied photographs." (Reprinted in Jack D. Flam, *Matisse on Art* [New York: Phaidon, 1973], p. 66.)

4. The Painter and the Photographer (pages 125–45)

EPIGRAPHS:
O'Keeffe, in *Manuscripts* 4 (December 1922): 17; in Lynes, p. 182.

Stieglitz, "Is Photography a Failure?" *New York Sun,* March 14, 1922, p. 20.

1. Two thorough studies on the individualistic nature of early American modernism and how it differed from the radical European "isms" of the same period are Ann Lee Morgan, "Toward the Definition of Early Modernism in America: A Study of Arthur Dove" (Ph.D. diss., University of Iowa, 1973), pp. 114–29, 161–70; and Judith Katy Zilczer, "The Aesthetic Struggle in America, 1913–1918: Abstract Art and Theory in the Stieglitz Circle" (Ph.D. diss., University of Delaware, 1975), pp. 26–33, 222–33. For a more recent survey of the period, see Kermit S. Champa, ed., *Over Here!: Modernism, the First Exile, 1914–1919* (Providence, R.I.: David Winton Bell Gallery, Brown University, 1989).

2. Stieglitz to Seligmann, August 9, 1923; in *Stieglitz,* p. 206.

3. For recent writing *against* this reconceptualizing of photography according to the selective interpretation of images and a creator-centered lineage, see Rosalind Krauss, "Photography's Discursive Spaces: Landscape/View," *Art Journal* (Winter 1982): 311–19; Abigail Solomon-Godeau, "Calotypomania," *Afterimage* (Summer 1983): 7–12; and Christopher Phillips, "A Mnemonic Art?," *October* 26 (Fall 1983): 35–62.

4. W. H. Fox Talbot, *The Pencil of Nature* (1844–46; New York: Da Capo, 1969), text accompanying plate 111. Lady Elizabeth Eastlake's 1857 essay, "Photography," is reprinted in Beaumont Newhall, ed., *Photography: Essays and Images* (New York: Museum of Modern Art, 1980), p. 93. Alvin Langdon Coburn also presented a powerful case for photography's modernity in 1911: "[Photography] is the most modern of the arts [because it] is more suited to the art requirements of this age of scientific achievement." (Coburn, "The Relation of Time to Art," *Camera Work* 36 [October 1911]: 72.) And Stieglitz's 1923 letter to Seligmann ("It appeals more to the consciousness of to-day") is in much this same vein. (*Stieglitz,* p. 206.)

5. Alfred Stieglitz, "Pictorial Photography," *Scribner's Magazine* 26 (November 1899): 529; in B. Newhall, *Photography,* pp. 163–66. Stieglitz was, of course, perfectly aware that even though Emerson had decided in 1891 that photography was *not* a fit medium for art, he went right on experimenting compulsively with art photography. For a study of the respectful but contentious relationship between Stieglitz and Emerson,

and an extensive account of their correspondence from 1888 to 1933 (the letters are mostly Emerson's), see Nancy Newhall, *P. H. Emerson: The Fight for Photography as a Fine Art* (New York: Aperture, 1975), pp. 53–69, 112–34.

6. Stieglitz, in B. Newhall, *Photography,* p. 164.

7. Stieglitz, in Charles H. Caffin, *Photography as a Fine Art* (1901; Hastings-on-Hudson, N.Y.: Morgan and Morgan, 1971), p. 36.

8. The conceptual and technical effort made by Stieglitz and some of his colleagues—particularly Coburn, Paul Haviland, Morton Livingston Schamberg, Charles Sheeler, Paul Strand, and Karl Struss—to unite these different systems of abstraction requires further probing. And so do the glaring similarities between many of their experimental photographs from the mid- and late 1910s—a task beyond the scope of this discussion. An early effort to examine abstraction in photography is Nina Howell Starr, "American Abstract Photography to 1930" (Master's thesis, University of Florida, 1963).

9. For a summary of the scholarly difficulties in defining the term *straight*—since every photograph is, in effect, manipulated in the process between negative and print—see Patricia D. Leighten, "Critical Attitudes toward Overtly Manipulated Photography in the 20th Century," *Art Journal* (Winter 1977–78): 133–38. For the purposes of my discussion I have accepted Leighten's definition that straight photography allows the subject to speak for itself without being overtly manipulated in the printing process. I am aware, of course, that Stieglitz never went quite straight himself when printing his photographs because of his constant struggle to find the elusive balance between the desired art form and the object. His letters (especially to R. Child Bayley, Strand, and Seligmann) are full of complaints about the problems involved. In the first two decades of the twentieth century, to be a straight photographer did not mean to be a modernist one. It wasn't until the late 1910s and 1920s that Schamberg, Sheeler, and Strand, among others, made straight photography synonymous with modernism.

Spring Showers is on p. 63 and Picasso's *Nude* is on p. 71 of *Camera Work* 36 (October 1911). Stieglitz's admiration for Picasso's work was reciprocated. In a letter from London dated June 11, 1914, Marius de Zayas wrote: "The day I left Paris, I was with Picasso . . . we had a very interesting and intimate talk on art and on his

latest manner of expression. . . . The sum and total was that he confesses that he has absolutely enter [sic] into the field of photography. I showed him your photograph [The Steerage]. . . . He came to the conclusion that you are the only one who has understood photography." Stieglitz replied on June 22: "It was mighty interesting to hear what Picasso had to say about my photographs. Of course I value his opinion tremendously . . . to me the Steerage . . . comes nearest to expressing the thing I wanted to express." (Both letters, SA.)

For a recent examination of Stieglitz's presumed experiments with Cubist composition in his 1915–16 photographs from the rear window of 291, see John Pultz and Catherine B. Scallen, *Cubism and American Photography, 1910–1930* (Williamstown, Mass.: Sterling and Francine Clark Art Institute, 1981), pp. 16–22.

10. Stieglitz to Kühn, October 14, 1912; in *Steiglitz,* p. 194. Kühn was a German-Austrian photographer whose work Stieglitz had published in *Camera Work* and had shown at 291 in April 1906. Kühn had written on October 2, 1912, to ask Stieglitz what the abstract art of Matisse and Picasso (reproduced and written about in the August 1912 *Camera Work*) had to do with photography's "absolute reality."

11. Stieglitz to Pratt, December 7, 1912; in *Steiglitz,* p. 195. Greenough has noted that this was Stieglitz's first use of the term *anti-photography*. (Ibid., p. 255.) It may have originated in a *Camera Work* statement of 1910: "The Photo-Secession can now be said to stand for those artists who secede from the photographic attitude toward representation of form." ("Photo-Secession Notes," unsigned, but habitually written by Haviland, *Camera Work* 30 [April 1910]: 54.)

12. Francis Picabia, "A Paris Painter" (interview by Hutchins Hapgood), *Camera Work* 42–43 (April–July 1913): 19. Hapgood summarized the "spirit" of Picabia's words, based on an interview conducted three days after the Armory Show opened.

13. Several of Stieglitz's autochromes can be seen at the National Gallery of Art, Washington, D.C. For Stieglitz's account of his experiments, see "The New Color Photography—A Bit of History," *Camera Work* 20 (October 1907): 20.

14. Paul Rosenfeld, *Port of New York: Essays on Fourteen American Moderns* (1924; Urbana: University of Illinois Press, 1961), pp. 255–56. Rosenfeld's statement might have made even more sense if he had not stipulated "modern color," which implies the use of hues unadulterated by white and black begun by the Impressionists. In nineteenth-century academic painting the "effect" was always defined in terms of light and dark values.

15. Whether Stieglitz realized it or not, this richly contradictory aesthetic was at the nucleus of late nineteenth-century avant-garde Realism, which included, and sometimes fed upon, photography. On this, see Linda Nochlin, *Realism* (Harmondsworth, England: Penguin, 1971), pp. 149–50, 167–69, 179–206.

16. De Zayas's two 1913 articles for *Camera Work* (drawing on discussions with Stieglitz) are well known to be important documents in 291's new effort to separate photography from painting. It was in the first one, "Photography" (*Camera Work* 41 [January 1913]: 17), that photography was announced as "the plastic verification of a fact." And it was in "Photography and Artistic Photography" (*Camera Work* 42–43 [April–July 1913]: 13–14) that de Zayas divided the two by arguing that only the former can present reality so that forms express their own spirit naturally ("pure objectivity"). Another document important to the history of this separation of art and photography is Picabia's interview with Hapgood, "A Paris Painter," cited above (n. 12).

17. An almost perfect example is his 1916 portrait of Marie Rapp, reproduced in *Stieglitz,* plate 25.

18. Stieglitz to Hartmann, April 27, 1919; ibid., p. 205.

19. It might be reasonable to ask whether these uncharacteristic photographs by Stieglitz were made in response to Coburn's clarion call for "fresh and untried" abstract photography in his widely read essay "The Future of Pictorial Photography," *Photograms of the Year 1916* (London: Hazell, Watson, and Viney [1916]), pp. 23–24, or even to Coburn's own experimental Vortographs.

20. O'Keeffe to Anderson, February 1924; in *Letters,* p. 176.

21. The lexical definition of *objective* derives from optics: the *objectif* is the lens through which the rays of light pass from an object to focus on chemically sensitized surfaces. For a succinct discussion of the reasons photography can never be purely "objective," see Joel Snyder and Neil Walsh Allen, "Photography, Vision and Representation," *Critical Inquiry* (Autumn 1975): 143–69.

22. See R. L. Gregory, *Eye and Brain: The Psychology of Seeing* (New York: McGraw-Hill, 1973), pp. 164–76. This crucial difference was also noted as early as 1889 by P. H. Emerson in *Naturalistic Photography*, in his discussions distinguishing camera vision from human vision (pp. 170–90).

23. Arthur Jerome Eddy, *Cubists and Post-Impressionism* (Chicago: A. C. McClurg, 1914), pp. 133–34.

24. Picabia's conclusion was that "the qualitative conception of reality can no longer be expressed in a purely visual or optical manner: and in consequence pictorial expression has had to eliminate more and more objective formulae from its convention in order to relate itself to the qualitative conception. . . . This new expression in painting is 'the objectivity of a subjectivity.' " (*Camera Work* 42–43 [April–July 1913]: 20.) For de Zayas's full discussion, see "Photography and Artistic Photography," ibid., p. 13.

25. Paul Strand, "Photography," *Seven Arts* (August 1917): 524–25. Also printed in *Camera Work* 49–50 (June 1917): 3–4.

26. O'Keeffe met Strand at 291 in May 1917. For her own account of this, see the letter to Pollitzer dated June 20, 1917; in *Letters*, pp. 162–63.

27. Somewhat ironically, and certainly by design, this standard was set by two of Stieglitz's closest male colleagues. Marsden Hartley wrote that O'Keeffe "sees the world of a woman turned inside out. . . . [Her] pictures . . . are probably as living and shameless private documents as exist, in painting certainly, and probably in any other art." (Hartley, "Some Women Artists in Modern Painting," in *Adventures in the Arts* [1921; New York: Hacker Art Books, 1972], p. 116.) Paul Rosenfeld described her art as "gloriously female. Her great painful and ecstatic climaxes make us at last to know something man has always wanted to know. . . . etc." (Rosenfeld, "American Painting," *Dial* 71 [December 1921]: 666.)

 Describing herself as "full of furies" about these responses to her work, O'Keeffe mused to Anderson that she wondered "if man has ever been written down the way he has written woman down—I rather feel that he hasn't been—that some woman still has the job to perform—and I wonder if she will ever get at it—I hope so—." (O'Keeffe to Anderson, September 1923?; in *Letters*, p. 174.)

28. Two letters offer some direct proof for this statement. "Self control is a wonderful thing," O'Keeffe wrote to Pollitzer (October 1915): "I think we must even keep ourselves from feeling too much—often—if we are going to keep sane and see with an unprejudiced vision. . . . I have to keep my head for purely physical reasons—it wears me out too much not to." Stieglitz's words to Strand (October 1919) are even more graphic: "Georgia had heard her father had been killed. . . . I don't know the actual facts. You know she is not a talker . . . don't mention G's father's death to her or anyone else—don't write—you know she prefers silence on all such matters." (Both letters, SA.)

29. On this with regard to Cézanne, see Lawrence Gowing, *Cézanne: The Early Years, 1859–1872* (Washington, D.C.: National Gallery of Art, 1988), p. 18.

30. See Arthur K. Wheelock, Jr., *Perspective, Optics, and Delft Artists around 1650* (New York: Garland, 1977).

31. One of the earliest articles to do this was Charles H. Caffin's "A Note on Paul Cézanne," wherein he remarks that Cézanne's art is "scientific" because "it is based upon the geometric figures of the sphere, cone and cylinder," which are "inherent" in nature. (*Camera Work* 34–35 [April–July 1911: 47.) Marius de Zayas compared Picasso's work to the abstract sensation of a Gothic cathedral, an "ensemble of geometrical figures" whose significance and real form have a universal appeal even if we do not understand them immediately. (*Camera Work* 34–35 [April–July 1911]: 67.) And Sadakichi Hartmann, in an article titled "Structural Units," wrote: "In the past, as should be the case today, geometric shapes form the intelligent and austere understructure of all arts. . . . A rhomb, an isosceles triangle, an ellipse are beautiful in themselves." (*Camera Work* 36 [October 1911]: 18.)

 The first American understanding of Picasso's Cubism was based partly on its geometric structure and partly on its equivalence to natural objects—thanks primarily to the de Zayas interview with Picasso published in *Camera Work* 34–35 (April–July 1911). During the landmark Picasso exhibition at 291, a writer friend sent Stieglitz the following quotation from Plato's *Philebus*: "I do not mean by beauty of form such beauty as that of animals or pictures . . . understand me to mean straight lines and circles and the plane or solid figures that are formed out of them by turning lathes and rulers and measurers of angles; for these I affirm to be not only relatively

beautiful like other things, but they are eternally and absolutely beautiful." (This incident, and the quotation, are recounted in de Zayas's "How, When, and Why Modern Art Came to New York," first published in *Arts Magazine* 54 [April 1980]: 102.) It is surely significant that this particular Dialogue of Socrates appeared (in another translation) in *Camera Work* 36 (October 1911): 68, and that it also was quoted just after Picabia's "Preface" in his 291 catalog statement of 1913. What all these citations suggest is that objectivity as a methodology came to mean the use of geometric forms—in composition and, quite frequently, in subject matter as well.

32. E. H. Gombrich, *The Image and the Eye* (Ithaca, N.Y.: Cornell University Press, 1982), p. 60. The use of open triangles and ellipses was not wholly new for O'Keeffe. It may be seen in embryo in such earlier works as *Calla Lily in Tall Glass No. 1* (1923; plate 122) and *Spring* (c. 1922; Vassar College). But her truly astonishing array of variations on it did not really begin until 1924. At least twelve of these compositions appeared in the *Seven Americans* show put on by Stieglitz in 1925—the quintessential expression of what 291 stood for in painting and photography. Among the 1924 triangle/ellipse compositions by O'Keeffe that I have so far managed to identify as having appeared in the *Seven Americans* show are: *Eggplant* (listed as "The Egg Plant"; location unknown); *Corn, Dark II* (listed as "Corn—No. 2"; plate 36); *Petunias in Oval No. 2* (private collection); *The Chestnut Grey* ("Autumn Trees—The Chestnut-Grey"; plate 57); *From the Lake—No. 3* (location unknown); *Leaf Motif No. 1* (location unknown); *Leaf Motif No. 2* (plate 130); *A Celebration* (location unknown); *Petunia and Coleus* ("Petunia No. 1"; plate 132); *Petunia No. 2* (plate 133); *Calla Lilies* (private collection); *Portrait of a Day—Third Day* (location unknown). There may well be others. The Whitney Museum of American Art was given access to O'Keeffe's records in 1981 and from this now believes that *Flower Abstraction* (plate 56) also appeared in the *Seven Americans* show and was listed in the catalog as "Abstraction."

33. The contribution of literature to this joining has been brilliantly traced by Patrick Leonard Stewart, "Charles Sheeler, William Carlos Williams and the Development of the Precisionist Aesthetic, 1917–1931" (Ph.D. diss., University of Delaware, 1981). For a useful overview of Imagism in American literature, and of Ezra Pound's role as prime catalyst, see Frederick J. Hoffman, *The Twenties: American Writing in the Postwar Decade* (New York: Macmillan, 1965), pp. 197–204. For a rich summary of Williams's fertile connections with Imagism and with later Precisionist poetry, see Mike Weaver, *William Carlos Williams: The American Background* (London: Cambridge University Press, 1971), pp. 23–36, 39–42, 55–64. The pioneer study on Williams's early connections with the visual arts is Bram Dijkstra, *The Hieroglyphics of a New Speech: Cubism, Stieglitz, and the Early Poetry of William Carlos Williams* (Princeton, N.J.: Princeton University Press, 1969).

34. Rosenfeld, "American Painting," p. 649. In 1927 Lewis Mumford would attempt (with some reason) to link O'Keeffe's painting with that of Ryder. "Albert Pinkham Ryder . . . too, in his landscapes and in his more deliberately symbolic pictures, sought to use the objective fact as a means of projecting a more interior and less articulate world." (Mumford, "O'Keefe [sic] and Matisse," *New Republic*, March 2, 1927, p. 42.)

The idea that art must have a local character in order to be timeless had already surfaced in Williams's essay, "Whitman and the Art of Poetry," *Poetry Journal* 8 (November 1917): 27–36, wherein he made his first published plea for "new canons" of "place." Williams had been even more specific for himself in an earlier, unpublished manifesto, "Vortex" of 1915: "I will express my emotions in the appearances: surfaces, sounds, smells, touch of the place in which I happen to be." (See *A Recognizable Image: William Carlos Williams on Art and Artists*, ed. Bram Dijkstra [New York: New Directions, 1978], p. 58.) The idea had also appeared in John Dewey's "Americanism and Localism": "The *Locality* is the only universal." (*Dial* 68 [June 1920]: 684–88.)

35. Quotations excerpted from Williams, *Contact I* (1920) and *Contact IV* (1921); in *Recognizable Image*, pp. 64, 66, 68.

36. There were, in fact, two separate articles on Imagism published in the same issue of *Poetry* (March 1913)—one by Pound and one by F. S. Flint. But it is generally accepted that the ideas in both articles were Pound's. By the late 1910s Imagism had come essentially to mean a visual form of writing. Its alleged derivation from Cézanne's conception of painting as a unique act of direct seeing remains murky. (For as lucid a discussion of this heritage as seems to exist, see Dikjstra, *Hieroglyphics of a*

New Speech, pp. 24–25.) But its aims, as developed from Pound through Williams, are very clear.

37. Pound to Monroe, January 1915; in Hoffman, *Twenties,* p. 199.

38. Pound to Stieglitz, January 1925, YCAL.

39. For negative criticism on this view of photography, see Abigail Solomon-Godeau, "Formalism and Its Discontents," *Print Collector's Newsletter* (May–June 1982): 44. In her article Solomon-Godeau says that the lineage of 291's "Anglo-American photographic formalism started in the early 1920s with the writings of Roger Fry and Clive Bell." But judging from the statements Stieglitz made in 1897, 1899, and 1901 (already quoted in my text), it began much earlier. Even if Stieglitz had read Fry's "An Essay in Aesthetics" when it was first published in the *New Quarterly* in 1909 (reprinted in *Vision and Design* in 1920), his own formalist leanings were already apparent, and functioning. How much Stieglitz's repression of subject matter in the 1915–16 photographs from 291 stemmed from Picabia or de Zayas's theory of "pure objectivity" in *Photography and Artistic Photography* (1913), and how much from his readings in, or awareness of, Fry and Bell, is a topic for further investigation. Certainly the meanings of Fry's and Bell's special terms *plasticity, significant form,* and *musicality* were well known to Stieglitz, as was their joint insistence that the originality of a work of art lay not in its subject but in its formal expression of a vision (or idea). Among the books that Stieglitz sent to O'Keeffe in 1916 was Bell's *Art* (1913), but *she* was not impressed. Her letter to Pollitzer of October 30, 1916, says: "I've been reading Wright's *Creative Will.* . . . Have been reading Clive Bell again too. He seems so stupid beside Wright." (SA.)

40. Stieglitz, statement in *Third Exhibition of Photography by Alfred Stieglitz* (New York: Anderson Galleries, 1924), n.p.

41. Stieglitz, in Seligmann, p. 83.

42. Ibid., p. 3. Seligmann himself notes (p. 15): "At The Exhibition of Seven Americans . . . hundreds of children had been running about enjoying themselves during one or two of the days of the exhibition and they had invariably chosen the things that Stieglitz and O'Keeffe had themselves preferred."

43. Leo N. Tolstoy, *What Is Art?* (first translated from Russian in 1899; New York: Bobbs-Merrill, 1960), p. 51. I have not come upon any specific references to Tolstoy by Stieglitz in his correspondence. Nor does Joseph Schiffman ("The Alien-

ation of the Artist: Alfred Stieglitz," *American Quarterly* 3 [Fall 1951]: 244–58), Robert E. Haines (*The Inner Eye of Alfred Stieglitz* [Washington, D.C.: University Press of America, 1982]), or F. Richard Thomas (*Literary Admirers of Alfred Stieglitz* [Carbondale: Southern Illinois University Press, 1983]) mention *What Is Art?* in examining Stieglitz's literary sources. But Tolstoy was himself steeped in the writings of the French Symbolists—particularly Stéphane Mallarmé. And many of Stieglitz's comments suggest that he knew and agreed with the major premise of the book. For example, this letter of criticism to John G. Bullock, March 26, 1917: "In most of [your work] I am conscious primarily of photographs, and not of the thing you felt." (*Stieglitz,* pp. 199–200.) It is quite possible that Stieglitz was originally alerted to Tolstoy's premise by Kandinsky's writing: "A work of art consists of two elements, the inner and the outer. The inner is the emotion in the soul of the artist. This emotion had the power to arouse a similar feeling in the soul of the observer." (As quoted in Eddy, *Cubists and Post-Impressionism,* p. 119.) That Stieglitz's notion of the activity of art was close to Tolstoy's has also been observed by Estelle Jussim, "Icons or Ideology: Stieglitz and Hine," *Massachusetts Review* (Winter 1978): 686–92.

44. "Is Photography a New Art?" *Camera Work* 21 (January 1908): 17–18. This article must still be regarded as anonymous, though Peter Bunnell believes the author may be Roland Rood.

45. Sadakichi Hartmann, *Landscape and Figure Composition* (1910; New York: Arno, 1973, Literature of Photography series), p. 120.

46. See Weston's letters to Stieglitz, beginning July 24, 1939; in *Photo-Notes* (Spring 1949): 15. The photographs Stieglitz chose for reproduction in the *Encyclopaedia Britannica* were *New York City* and *Georgia O'Keeffe.*

47. Weston [E. Wn.], "Photographic Art," *Encyclopaedia Britannica,* 1941 ed., 17: 798–99. Thanks to Simon Heifetz for alerting me to this reference.

48. See William M. Ivins, Jr., *Prints and Visual Communication* (Cambridge, Mass.: MIT Press, 1953), pp. 158–80.

49. Alfred Stieglitz, "Our Illustrations," *Camera Work* 32 (October 1910): 47.

50. O'Keeffe, in *Manuscripts* 4 (December 1922): 17–18; in Lynes, p. 183.

51. Ibid.

52. Stieglitz to Strand, August 18, 1922, and September 12, 1922, both PSA.

53. For a small selection from the wide range of opinion on these issues, see Max Kozloff, *Photography and Fascination* (Danbury, N.H.: Addison House, 1979); Roland Barthes, *Camera Lucida,* trans. Richard Howard (New York: Farrar, Straus, and Giroux, 1981); Robert Adams, *Beauty in Photography* (Millerton, N.Y.: Aperture, 1981); Rosalind Krauss, "A Note on Photography and the Simulacral," *October* 31 (Winter 1984): 49–68; Mike Weaver, ed., *The Art of Photography: 1839–1989* (New Haven, Conn.: Yale University Press, 1989).

 Consensus on what a photograph should look like seems even more remote now than it was in 1922. Several recent publications that offer a useful survey on the "true nature" of photography are: Alan Trachtenberg, ed., *Classic Essays on Photography* (New Haven, Conn.: Leete's Island Books, 1980), which documents a chronological record of thinking about the medium from the early nineteenth century to the present. Also, Thomas F. Barrow, Shelley Armitage, and William E. Tydeman, eds., *Reading into Photography: Selected Essays, 1959–1980* (Albuquerque: University of New Mexico Press, 1982), which presents a sampling of criticism particularly concerned with the nature of photographic meaning. The general conclusion from these two volumes: the photograph continues to defy interpretation. For an overview of what photographers have been doing between 1946 and 1989, see Colin Westerbeck, "Beyond the Photographic Frame," in Sarah Greenough et al., *On the Art of Fixing a Shadow: One Hundred Fifty Years of Photography* (Washington, D.C.: National Gallery of Art; Boston: Bulfinch, 1989), pp. 345–79. See also John Szarkowski, *Photography until Now* (New York: Museum of Modern Art, 1989).

54. For a virtual compendium of seventeenth-century ideas on vision, optics, and picture making, see Svetlana Alpers, *The Art of Describing: Dutch Art in the Seventeenth Century* (Chicago: University of Chicago Press, 1983). Much of the information for this summary comes from her useful collection of sources for the "descriptive" tradition. Alpers also argues (pp. 243–44 n. 37) that the ultimate origins of photography do *not* lie in the fifteenth-century invention of perspective, as proposed by Peter Galassi in *Before Photography* (New York: Museum of Modern Art, 1981), p. 12, but rather in the "descriptive" mode of the north: "If we want historical precedence for the photographic image it is in the rich mixture of seeing, knowing and picturing that manifested itself in seventeenth century images." (Alpers, *Art of Describing,* p. 244.)

55. Alfred Stieglitz, foreword to the *Wanamaker Exhibition Catalogue* (Philadelphia, 1913); later reprinted in *Photo-Miniature* (March 1913).

56. There are some small pieces of documentary evidence to suggest that Stieglitz was aware of a visual kinship between his "new" photographs and the northern tradition of image making. In an entry dated January 27, 1926 (Seligmann, p. 30), is the following: "Stieglitz remarked that Memling was the first 'photographic painter' who had lived before the days of 'pictorial photography' and 'illustration.' O'Keeffe said she thought the Van Eycks should be named also." And during my 1980 interview with Georgia Engelhard Cromwell, Cromwell's husband, Eaton (Tony), remembered that in 1940, when he was inspected by the Stieglitz family as a prospective husband for young Georgia, Stieglitz quizzed him as to the painters he liked. "When I said Vermeer, Stieglitz was pleased. Neither he nor O'Keeffe liked Rembrandt, Raphael, or Botticelli. The Renaissance was not for them. O'Keeffe loved the Dutch flower painters and Vermeer too."

 For an interesting discussion of the affinities of O'Keeffe's painting with the domain of the later Northern Romantic painters, see Robert Rosenblum, *Modern Painting and the Northern Romantic Tradition* (New York: Harper and Row, 1975), pp. 207–8, 214. He notes especially (p. 20) her "characteristic Romantic sense of scale which leaps from the microcosm to the macrocosm, from the infinitely large to the infinitely small." This, of course, can also be regarded as a photographic characteristic.

57. Charles H. Caffin, "The Camera Point of View in Painting and Photography," *Camera Work* 24 (October 1908): 26. As a highly educated and progressive critic of modern art, Caffin was undoubtedly familiar with Baudelaire's "Salons" and with his famous statement: "It is time, then, for [photography] to return to its true duty, which is to be the servant of the sciences and arts. . . . If it be allowed to encroach upon the domain of the impalpable and the imaginary, upon anything whose value depends solely upon the addition of something of a man's soul, then it will be so much the worse for us." ("The Salon of 1859," in Charles Baudelaire, *Art in Paris, 1845–1862,* trans. and ed. Jonathan Mayne [New York: Phaidon, 1965], p. 154.) Caf-

fin, it need hardly be said, disagreed with the bottom line of Baudelaire's statement —having supported the cause of photography as an art form since 1899. In the 1908 *Camera Work* article, Caffin proposed the province of the camera to be objective fact, whereas painting should concern itself with "conceptions existing only in the inner vision."

58. This phrase was also used by Roger Fry, in his 1912 preface to the catalog of *The Second Post-Impressionist Exhibition:* The logical extreme of [the Post-Impressionist] method would undoubtedly be the attempt to give all resemblance to natural form, and to create a purely abstract language of form—a visual music, and the later works of Picasso show this clearly enough." (Reprinted in Fry, *Vision and Design* [1920; New York: Meridian, 1956], p. 239.)

59. Stieglitz, in Seligmann, pp. 61–62. The actual photograph referred to by Stieglitz has not been identified.

60. A recent essay to take up this endlessly debatable issue is Allan Sekula, "Photography between Labor and Capital," in *Mining Photographs and Other Pictures, 1948–1968* (Halifax, Canada: Press of Nova Scotia College of Art and Design, 1983). Sekula (p. 201) sees photography as neither art nor science but "suspended between the discourse of ... [the two], staking its claims to cultural value on both the model of truth upheld by empirical science and the model of expressiveness offered by romantic esthetics."

61. A recent essay that explores these historical facts vis-à-vis our habits of perception and depiction with remarkable probity and clarity is Joel Snyder, "Picturing Vision," in *The Language of Vision,* ed. W.J.T. Mitchell (Chicago: University of Chicago Press, 1980), pp. 219–46.

62. Stieglitz to Crane, December 19, 1923; in *Stieglitz,* p. 208.

63. For a cogent discussion of how and when this happened, see *Stieglitz,* pp. 24–25. Stieglitz never explained why he suddenly used the term *Equivalents* in the 1925 *Seven Americans* catalog to describe his increasingly abstract photographs of clouds. Years later he would say that all his prints were equivalents, and, finally, that "all art is an equivalent of the artist's most profound experience of life." (Dorothy Norman, *Alfred Stieglitz: An American Seer* [New York: Random House, 1973], p. 144.) Among the more probable factors in his decision to do so were his early (1890s) commitment to Symbolism; his memory of de Zayas's quote from Picasso that "the picture

should be the pictorial equivalent of the emotion produced by nature" (in *Camera Work* 34–35 [April–July 1911]: 29); and his exposure to T. S. Eliot's influential concept of the "objective correlative," which was common currency among many American writers by the early 1920s.

64. Charles H. Caffin, "A Note to Paul Cézanne," *Camera Work* 34–35 (April–July 1911): 47.

65. For a useful overview of the developing arguments of American critics and artists on this important topic, including the "science" of musical analogy, see Howard Anthony Risatti, "American Critical Reaction to European Modernism, 1908–1917" (Ph.D. diss., University of Illinois, Urbana–Champaign, 1978), pp. 138–48.

66. Stieglitz served on a six-man selection committee and contributed a rather depressed essay to the voluminous catalog, lamenting America's continued lack of interest in "painting as a life expression." Of the sixteen artists represented, seven had already exhibited at 291 and all had ties to Stieglitz.

67. There were others who had already come to the same conclusion by 1916, such as Thomas Hart Benton: "I make no distinction as to the value of subject matter. I believe that the representation of objective forms and the presentation of abstract ideas of form to be of equal artistic value." (*The Forum Exhibition of Modern American Painters* [New York: Anderson Galleries, 1916], p. 35.) For a discussion of the artistic relationship between Stieglitz and Benton, see Edward Abrahams, "Alfred Stieglitz and/or Thomas Hart Benton," *Arts Magazine* 55 (June 1981): 108–13. Hartley had his own way of putting it: "Objects are incidents: [an] apple does not for long remain an apple if one has the concept. Anything is therefore pictural [*sic*]; it remains only to be observed and considered. All expression is illustration— of something." (*Forum Exhibition,* explanatory notes section, n.p.)

68. I am grateful to Naomi Rosenblum for alerting me to the typescript of Strand's final draft of "Georgia O'Keeffe: A Woman in Painting" (1924), in PSA. (The published version was considerably shortened.) This quotation, which shows several corrections by him, is from pp. 5–6 of the draft. It was subsequently published in *Playboy* 9 (July 1924): 16–20; in Lynes, pp. 216–20.

69. *O'Keeffe,* text opposite plate 88.

70. Stieglitz to R. Child Bayley, October 9, 1919; in *Stieglitz,* p. 204.

71. Stieglitz to Ananda Coomaraswamy, February 14, 1924; ibid., p. 218.

72. Stieglitz to Edward Weston, September 3, 1938; ibid.

73. *The Daybooks of Edward Weston*, ed. Nancy Newhall, 2 vols. (New York: Aperture, 1973), vol. 1, p. 6.

74. O'Keeffe, in the anonymous article, "I Can't Sing, So I Paint! Says Ultra Realist; Art Is Not Photography—It Is Expression of Inner Life!: Miss Georgia O'Keeffe Explains Subjective Aspect of Her Work," *New York Sun*, December 5, 1922, p. 22; in Lynes, p. 180.

5. *Portrait of Georgia O'Keeffe (pages 147–81)*

EPIGRAPHS:
Stieglitz, "Woman in Art," notes sent to Stanton Macdonald-Wright, October 9, 1919; published in Dorothy Norman, *Alfred Stieglitz: An American Seer* (New York: Random House, 1973), pp. 136–38.

O'Keeffe, introduction, *Portrait*, n.p.

1. For an extremely useful compilation and evaluation of art criticism and art history from the feminist perspective since 1971, see Thalia Gouma-Peterson and Patricia Mathews, "The Feminist Critique of Art History," *Art Bulletin* 69 (September 1987): 326–57.

2. *O'Keeffe*, text opposite plate 16.

3. Stieglitz to Strand, January 5, 1919, PSA. Stieglitz to Strand, January 23, 1919, ibid. Stieglitz to Strand, June 8, 1919, ibid.

4. An identification of this drawing is still to be made. It appears to be a later variant of *Special No. 1* of 1915, with a much more explicit connotation of intercourse.

5. For a perceptive analysis of *Paula* as Stieglitz's own definition of a photographic image, see Rosalind Krauss, "Stieglitz/ Equivalents," *October* 11 (Winter 1978): 131–35.

6. This number is approximate because some of the 1918 dates in the key set are still insecure.

7. Stieglitz, "Woman in Art," p. 137.

8. Marsden Hartley, "Some Women Artists in Modern Painting," in *Adventures in the Arts* (1921; New York: Hacker Art Books, 1972), p. 116. Paul Rosenfeld, "American Painting," *Dial* 71 (December 1921): 666. For a very valuable chronological collection and analysis of the criticism on O'Keeffe's early work, see Lynes. For an evaluation of the effect of the *Portrait* on the articles by Hartley and Rosenfeld, with which I am in almost total agreement, see Lynes, pp. 44–53, which also discusses how Stieglitz manipulated the content of the articles and how they have distorted the public's understanding of O'Keeffe's work to this day. More recently, Anna C. Chave has suggested, from a feminist point of view antagonistic to Stieglitz, that he relished O'Keeffe's art being described in Rosenfeld's and Hartley's terms because the world would then know that "none other than Alfred Stieglitz" had given her those sexual experiences. (He may have, indeed, but the facts seem to have been far richer than that.) See Chave, "O'Keeffe and the Masculine Gaze," *Art in America* 78 (January 1990): 123.

9. For a fascinating discussion of images that mobilize the senses, including photographs, see David Freedberg, *The Power of Images: Studies in the History and Theory of Response* (Chicago: University of Chicago Press, 1989), pp. 317–77.

10. It would be interesting to consider the androgynous photographs in the *Portrait* in light of the cross-gender female types seen increasingly in American fashion magazines after World War I.

11. Rodin's *Standing Female Nude Squeezing Breasts Together* (c. 1900) is reproduced in Albert Elsen and J. Kirk T. Varnadoe, *The Drawings of Rodin* (New York: Praeger, 1971), p. 129. Steichen also owned a variation by Rodin on this same gesture titled *Egypte* (1900–1908; George Eastman House; collection of Joanna T. Steichen). Stieglitz made three more photographs of O'Keeffe on this specific theme of Rodin's in 1919 (NGA accession nos. 1980.70.111–13). In later years he would be more subtle about it.

12. For others in the 1921 Hands and Grapes series, see NGA 1980.70.163, 165, and 166.

13. The most blatant example of this assumption is Benita Eisler, "Scenes from a Marriage," *Mirabella* (July 1989): 182. For a knowledgeable rebuttal to O'Keeffe's putative bisexuality, see Sue Davidson Lowe's letter dated November 11, 1989, to the editor of the *New York Times Book Review*.

14. Wendy Doniger O'Flaherty, *Women, Androgynes and Other Mythical Beasts* (Chicago: University of Chicago Press, 1980), pp. 292–93.

15. Mary Anne Warren, "Is Androgyny the Answer to Sexual Stereotyping?," in Mary Vetterling-Braggin, ed., *"Femininity," "Masculinity" and "Androgyny": A Modern Philosophical Discussion* (Totowa, N.J.: Lit-

57. Reprinted in Norman, *American Seer,* pp. 144, 161.

58. These were *The Terminal, New York* (1892); *The Asphalt Paver* (1892); *Spring Showers* (1901); *The Flatiron Building* (1901); *The Hand of Man* (1902); and *The Steerage* (1907).

59. Stieglitz to Johnson, April 3, 1925; in *Stieglitz,* p. 209.

60. O'Keeffe to Anderson, February 11, 1924; in *Letters,* pp. 175–76.

61. Henry McBride, "Stieglitz–O'Keefe [sic] Show at Anderson Galleries," *New York Herald,* March 9, 1924, sec. 7, p. 13.

62. Helen Appleton Read, "News and Views on Current Art: Georgia O'Keefe [sic] Again Introduced by Stieglitz at the Anderson Galleries," *Brooklyn Daily Eagle,* March 9, 1924, p. 2B.

63. Forbes Watson, "Stieglitz–O'Keeffe Joint Exhibition," *New York World,* March 9, 1924, p. 11E.

64. Elizabeth Luther Cary, "Art: Exhibitions of the Week," *New York Times,* March 9, 1924, sec. 8, p. 10.

65. See Lowe, p. 262. Lowe does not cite what was paid for the Stieglitzes and O'Keeffes, but she does say that Stieglitz sold a Marin watercolor for $1,500—$300 more than he had expected.

66. According to the catalog, it occurred during the twentieth-anniversary year of the opening of 291, as "a part of that Progression." It is more than likely that installation photographs were taken of the *Seven Americans* show, since there are so many precedents for them. (In *Camera Work,* for example, Stieglitz often reproduced his own photographs of important 291 shows.) In response to my inquiry as to their whereabouts, Doris Bry wrote, "I don't believe there are any, but I could be wrong." (Letter dated January 8, 1990.) Although I was given permission by O'Keeffe to have study prints made of them (April 21, 1980), they have so far not been found.

67. Forbes Watson, "Seven American Artists Sponsored by Stieglitz," *New York World,* March 15, 1925, p. 5M; in Lynes, pp. 235–36.

68. Naomi Rosenblum, conversation with author, winter 1980. That Strand installed his own work is noted in Rosenblum, "Paul Strand: The Early Years, 1910–1932" (Ph.D. diss., City University of New York, 1978), p. 223.

69. *O'Keeffe,* text opposite plate 18.

70. Stieglitz to Tofel, February 5, 1924, SA.

71. Stieglitz to Anderson, March 11, 1925, SAP.

72. Stieglitz to Anderson, March 23, 1925, ibid.

73. Presumably all of Stieglitz's Equivalents in the show were taken in 1924–25, but no specific record of his choices exists. The same is true of Strand's untitled photographs. (The catalog lists five of New York, three of leaves, and ten of machines.) O'Keeffe's paintings are titled, but some confusingly (e.g., *Abstraction*) and other titles were changed later. (*Petunia No. 1* is now *Petunia and Coleus.*) The catalog notes that Hartley's twenty-five paintings were part of the 1921 Hartley auction at the Anderson Galleries and categorizes them simply as "landscape and still life." Marin's last five paintings all have exactly the same title *(New York).* Dove's twenty-five titles appear to be more reliable, and the identification of Demuth's six abstract portrait posters is secure.

74. The reviews of the show were: Margaret Breuning, "Seven Americans," *New York Evening Post,* March 14, 1925; H.C., *Art News,* March 14, 1925; Elizabeth Luther Cary, "Art: Exhibitions of the Week: Seven Americans," *New York Times,* March 15, 1925; Royal Cortissoz, "291: Mr. Alfred Stieglitz and His Services to Art," *New York Herald Tribune,* March 15, 1925; "Comment," *Dial* 79 (August 1925): 177–78 (unsigned); R.F., *Christian Science Monitor,* March 20, 1925; Deogh Fulton, "Cabbages and Kings," *International Studio* 81 (May 1925): 144–47; Henry McBride, "Crowds at Stieglitz Opening," *New York Sun,* March 14, 1925; also by McBride, "Seven Alive," *Dial* 78 (May 1925): 435–36; Glen Mullin, "Alfred Stieglitz Presents Seven Americans," *Nation,* May 20, 1925, pp. 577–78; *New Yorker,* March 28, 1925 (unsigned); Helen Appleton Read, "Alfred Stieglitz Presents Seven Americans," *Brooklyn Daily Eagle,* March 15, 1925; also by Read, "Seven Americans," *Arts* 7 (April 1925): 229–31; Forbes Watson, "Seven American Artists Sponsored by Stieglitz," *New York World,* March 15, 1925; Edmund Wilson, "Greatest Triumphs: The Stieglitz Exhibition," *New Republic,* March 18, 1925, pp. 97–98. Most of the above are reprinted in Lynes, pp. 224–40; the exceptions are: *Art News* (H.C.); *Christian Science Monitor* (R.F.); "Comment," *Dial;* Fulton; and McBride, *Dial.*

75. Edmund Wilson, "The Stieglitz Exhibition," in *The American Earthquake* (New York: Farrar, Straus and Giroux, 1979), p. 101.

member of the selection committee for this show, which was organized to present "only the best" in modern art, by means of the jury system. The committee also included Thomas Hart Benton, Arthur B. Carles, and Joseph Stella.

45. The critics were Alexander Brook, Alan Burroughs, Elizabeth Luther Cary, Royal Cortissoz, Henry McBride, Helen Appleton Read, Herbert J. Seligmann, Paul Strand, and Henry Tyrrell. Their articles are reprinted in Lynes, pp. 185–97.

46. Kennerley Papers, New York Public Library. Unfortunately, they are not a complete set—only two walls are seen partially.

47. An installation photograph for this historic show is reproduced in William Innes Homer, *Alfred Stieglitz and the Photo-Secession* (Boston: New York Graphic Society, 1983), p. 54. In all likelihood, these similarities in hanging were caused by the restrictions of space rather than by any intention on Stieglitz's part to connect O'Keeffe's 1923 show with the successful emergence of the Photo-Secession—however inspiriting it is to think otherwise.

48. Paul Rosenfeld, "The Paintings of Georgia O'Keeffe: The Work of the Young Artist Whose Canvases Are to Be Exhibited for the First Time This Winter," *Vanity Fair* 19 (October 1922): 112; in Lynes, pp. 175–79. Increasing and enriching this article for his book *Port of New York: Essays on Fourteen American Moderns* (1924; Urbana: University of Illinois Press, 1961), Rosenfeld even added (p. 203), "Much of her work has the precision of the most finely machine-cut products." But he still did not specify photography.

49. The only exception was Helen Appleton Read, who inexplicably found O'Keeffe's palette "strangely limited" to red and white.

50. Rosenfeld, "Paintings of Georgia O'Keeffe," pp. 56, 112. It is of piquant interest that Rosenfeld collaborated on this article "like an exciting game of battledore and shuttlecock" with Florence Cane, a painter friend (whom Stieglitz had once photographed). See Rosenfeld to Stieglitz, September 1922, YCAL (quoted courtesy the Estate of Paul Rosenfeld). What Rosenfeld did *not* specify was that O'Keeffe probably intended the early abstract oils he was writing about (such as Series I of 1918–19 and the Black Spot series of 1919) to be visual songs—hence their "close harmonies" and dissonances—color juxtapositions that often "hurt the eyes" of critics. One of many questions that so far

cannot be answered is: Did Stieglitz in 1918 discuss with O'Keeffe Sherwood Anderson's *Mid-American Chants,* published that year? In speaking of America's spiritual heritage, Anderson wrote, "To catch this song and sing it would do much— make much / clear." ([New York: John Lane, 1918], p. 16.) We know without a doubt that Stieglitz cherished and respected O'Keeffe's midwestern American roots—as she did herself.

51. Rosenfeld to Stieglitz, September 14, 1922, YCAL (quoted courtesy the Estate of Paul Rosenfeld).

52. Rosenfeld to Stieglitz, [late] September 1922, YCAL (quoted courtesy the Estate of Paul Rosenfeld).

53. A year later, when Rosenfeld was preparing *Port of New York,* he wrote to Stieglitz: "Your letters have been fresh and warming. Georgia's letter remarkable. . . . She uses words etc. but it is all like her painting. One feels mountains & bright color & pleasant fruit, all without quite knowing why. She is so nice and gentle! I am glad she is reading Rosenfeld." (October 12, 1923, YCAL, quoted courtesy the Estate of Paul Rosenfeld.) Six months after that Stieglitz informed Rosenfeld, "Georgia delighted with what you wrote about her." (April 25, 1924, YCAL.)

54. Rosenfeld, "Paintings of Georgia O'Keeffe," p. 114.

55. Whether there were nudes of O'Keeffe in this exhibition does not seem to have been recorded. In any event, they had already had their effect.

Among the many notables who saw the *Second Exhibition* was Ananda K. Coomaraswamy, keeper of Indian and Muhammadan art at the Museum of Fine Arts in Boston. Coomaraswamy had an experienced eye for photography, having used it as a record-keeping tool in his work since 1903. He saw in Stieglitz's ten cloud photographs "the grand tradition . . . precisely the right values stressed. Symbols are used correctly. His photographs are 'absolute' art in the same sense that Bach's music is 'absolute' music." (Quoted in Norman, *American Seer,* p. 175.) This led him to propose that Stieglitz donate twelve of his most comprehensive and representative prints to the museum. Over the fourteen-month period that Stieglitz spent printing, mounting, and framing this historic gift, the number grew from twelve photographs to twenty-seven.

56. O'Keeffe to Anderson, February 11, 1924; in *Letters,* pp. 175–76. This is a very rich letter in terms of understanding O'Keeffe's intentions for her art.

trotted up 4 flights a short time ago to see O'Keeffe's work and my photographs.— We spent 3 hours together." (Access to the Stieglitz–Haviland correspondence was granted to me courtesy of the Lunn Gallery, formerly Washington, D.C.)

35. The flyer of *Exhibition on Modern Art* lists the following:

1. Wasp	Arthur G. Dove
2. Nature Forms	Arthur G. Dove
3. Pueblo Mountain N.M.	Marsden Hartley
4. Sage Brush Summer	Marsden Hartley
5. Still Life	Conrad Kramer
6. Landscape— Massachusetts	John Marin
7. Landscape	A. McFee
8. Still Life	Geo. F. Of
9. Landscape	Georgia O'Keeffe
10. Blue and Yellow	Georgia O'Keeffe
11. Hands—G.O.	Alfred Stieglitz
12. Head—G.O.	Alfred Stieglitz
13. Photograph	Paul Strand
14. Landscape	A. Walkowitz
15. Synchromy	S. Macdonald-Wright

Unfortunately, it is not possible to identify most of these works. Not only are they all undated, but even the titles are suspect, since they were often changed over the years. Unfortunately, also, the Archives of the Ninety-second Street Young Men's and Young Women's Hebrew Association has nothing in their files as to its public reception. This was not Stieglitz's first show at the YWHA. In March 1918 he had arranged an exhibition there of twenty-nine American and European Pictorial photographs, which included his own *The Terminal* (1892) and *The Steerage*; Steichen's 1898 *Rodin* and *Bernard Shaw*; Sheeler's *Interior* (1917); Strand's *Blind Woman* and *The Auto* (both 1916); and a 1917 portrait by Schamberg. A letter to Strand dated March 9, 1918, says: "The evening at the YWHA was about the most perfect I ever spent in New York. It was really very beautiful. I don't think anyone who participated will ever forget it. Rich and poor. I spoke on the spur of the moment ... the whole affair was an inspiration." (PSA.)

36. The first and only American precedent for this milestone was the *Special Exhibition of Contemporary Art* held at the National Arts Club during January 1908 by the Photo-Secessionist photographers and the Ashcan School painters, whose large debt to photography was well understood by Stieglitz. For a review of this exhibition by J. Nilsen Laurvik, see *Camera Work* 22 (April 1908): 33.

37. The business of the Anderson Galleries was to "appraise, catalogue, exhibit and offer for sale" all objects of art. Some of the rooms in the gallery were available for rent by individual artists.

38. In the rest of his now-famous catalog statement Stieglitz informed the public that over half (seventy-eight) of the prints had been made since July 1918 (when O'Keeffe came into his life); that his ideal (clearly unattainable, given his materials, methods, and perfectionism) was "to achieve the ability to produce numberless prints from each negative, prints all significantly alive, yet undistinguishably alike, and to be able to circulate them at a price of ... a daily paper"; and that "I am an American. Photography is my obsession. The search for truth my obsession." The thought behind this last personal pronouncement was undoubtedly influenced by the postwar temper in literature, which preached that Americans need not feel inferior to Europe in their attainments of mind and moral probity.

39. Lowe, pp. 241–42.

40. Ibid., p. 241.

41. The two most influential of these were Hartley, "Some Women Artists in Modern Painting," and Rosenfeld, "American Painting." O'Keeffe wrote about these articles to Mitchell Kennerley, in fall 1922: "You see Rosenfeld's articles have embarrassed me—[and] I wanted to lose the one for the Hartley book when I had the only copy of it to read—so it couldn't be in the book." (*Letters*, pp. 170–71.)

42. See Sarah E. Greenough, "From the American Earth: Alfred Stieglitz's Photographs of Apples," *Art Journal* (Spring 1981): 49–50.

43. "I Can't Sing, So I Paint! Says Ultra Realistic Artist; Art Is Not Photography—It Is Expression of Inner Life!: Miss Georgia O'Keeffe Explains Subjective Aspect of Her Work," *New York Sun*, December 5, 1922, p. 22. The interviewer is unknown.

44. It was called *The Later Tendencies in Art*. The O'Keeffe paintings were then titled *Pink*, *Red* and *The Black Spot* (whether *I*, *II*, or *III* is not known). Stieglitz was a

tlefield, Adams, 1982), p. 170. For relevant examples from the Stieglitz *Portrait,* see *Portrait,* plates 45–50.

16. The Brancusi show at 291 (March 12–April 1, 1914) included six heads in marble and bronze, one figure in wood, and a bird in brass. *Sleeping Muse* was among the heads.

17. Linda Nochlin, *Women, Art and Power and Other Essays* (New York: Harper and Row, 1988), p. 2.

18. O'Keeffe, introduction, *Portrait,* n.p.

19. Peter Minuit [Paul Rosenfeld], "291 Fifth Avenue," *Seven Arts* 1 (November 1916): 64.

20. Male Symbolist artists were prone to image women according to their own greatest fears and desires. Favorites among this typecasting were the Sphinx, the dreamer, the invalid, Eve, and the Madonna. See Carol Duncan, "Virility and Domination in Early Twentieth-Century Vanguard Painting," in Norma Broude and Mary D. Garrad, eds., *Feminism and Art History: Questioning the Litany* (New York: Harper and Row, 1982), pp. 293–313. See also Griselda Pollock, *Vision and Difference: Femininity, Feminism and Histories of Art* (London and New York: Routledge, 1988), pp. 91–154. During the first decade of the *Portrait,* Stieglitz seems to have borrowed liberally from this fin-de-siècle iconography, but always with transforming intent. And O'Keeffe is never a nameless woman. She is always O'Keeffe.

Since I was denied permission by Juan Hamilton to reproduce the nudes, I will identify them by their plate numbers in *Portrait.*

21. See, for example, *Portrait,* plates 25–27. We have only to compare the relative decorum of the nude torso in plate 27 with Gustave Courbet's frankly pornographic painting *The Origin of the World* (1866)—an image so similar in composition that one wonders whether Stieglitz had seen a reproduction of it. But Stieglitz had no intention of making obscene images. For him these photographs were art—and *high* art at that. For a reproduction and discussion of the Courbet, see Sarah Faunce and Linda Nochlin, *Courbet Reconsidered* (New Haven, Conn.: Yale University Press, 1988), pp. 176, 178.

22. O'Keeffe, introduction, *Portrait,* n.p.

23. Stieglitz to Strand, September 15, 1918, PSA.

24. O'Keeffe, introduction, *Portrait,* n.p.

25. See *Portrait,* plates 12, 15, and 22.

26. Stieglitz to Stanton Macdonald-Wright,

October 9, 1919; in Norman, *American Seer,* p. 137.

27. See *Portrait,* plates 18, 19, and 22.

28. Georgia O'Keeffe, *Some Memories of Drawings,* ed. Doris Bry (New York: Atlantis, 1974), plate 9.

29. For an enthralling discussion of how "the eroticized body of woman became the late nineteenth-century male's universal symbol of nature," see Bram Dijkstra, *Idols of Perversity: Fantasies of Feminine Evil in Fin-de-Siècle Culture* (New York: Oxford University Press, 1986), pp. 94–100.

30. Stieglitz to Strand, February 7, 1919, SA.

31. *Georgia O'Keeffe: A Portrait—Head and Hands,* 1919 (NGA 1980.70.104 and 105); *Georgia O'Keeffe: A Portrait,* 1919 (NGA 1980.70.125); *Georgia O'Keeffe: A Portrait, 1920* (NGA 1980.70.144); *Georgia O'Keeffe: A Portrait, 1920* (NGA 1980.70.145); *Georgia O'Keeffe: A Portrait—Eating Corn,* c. 1920–22 (*Portrait,* plate 37); *Georgia O'Keeffe: A Portrait—Swimming,* c. 1924 (NGA 1980.70.201).

There are only five nude prints in the key set for 1919—all of her breasts. (Stieglitz was never immune to the resonance of the breast, as his 1922–23 photographs of Rebecca Salsbury Strand and Georgia Engelhard attest.) Apparently the last O'Keeffe nudes were made in 1922, for there is only one print from that year at the National Gallery of Art, an extremely abstract partial-figure photograph titled *Thighs and Buttocks* (accession no. 1980.70.184). It may actually be from a series of negatives taken that year on the same theme—some of which Stieglitz seems not to have printed for the *Portrait* until 1932. Several in the later series take on flowerlike designs that look astonishingly like some of O'Keeffe's flower paintings. See, for example, *Morning-Glory with Black* (1926; Cleveland Museum of Art) and *Purple Petunia* (1927; Mr. and Mrs. Graham Gund).

32. For an idea of just how difficult and how successful an artistic task the *Portrait* was, for both Stieglitz and O'Keeffe, one might compare it with the more problematic series Paul Strand took of Rebecca Salsbury Strand between 1920 and 1932. See Belinda Rathbone, "Portrait of a Marriage: Paul Strand's Photographs of Rebecca," *J. Paul Getty Museum Journal* 17 (1989): 83–90.

33. Romain Rolland, "America and the Arts," *Seven Arts* 1 (November 1916): 48–49.

34. A letter from Stieglitz to Paul Haviland dated April 2, 1920, says: "Agnes Meyer

76. Ibid., p. 108.

77. Strand's photographs fared less well, receiving poor or lukewarm reviews by Mullin, Fulton, and Cary. Wilson and Cortissoz did not even mention Strand's name, and McBride mistook his work for Stieglitz's. (See Stieglitz to McBride, March 14, 1925, YCAL.) All others were favorable to him.

78. From Breuning ("Seven Americans"), who detested everything in the exhibition except the photographs: "A few good flower studies . . . [but] the rest of her show might be termed a flop both in color and design."

79. Egmont Arens, "Alfred Stieglitz: His Cloud Pictures," *Playboy* 9 (July 1924): 15.

80. The catalog statements and essays are all reprinted in Lynes, pp. 221–24. Rönnebeck, the German sculptor whose bronzes were exhibited at 291 in 1914, was a lifelong friend of Hartley's.

81. Stieglitz, in *Alfred Stieglitz Presents Seven Americans* (New York: Anderson Galleries, 1925), p. 2.

82. Stieglitz to Rosenfeld, September 5, 1923, YCAL.

83. Rönnebeck, in Lynes, pp. 222–23.

84. O'Keeffe, in Calvin Tomkins, "The Rose in the Eye Looked Pretty Fine," *New Yorker*, March 4, 1974, p. 44.

85. Barbara Novak, *American Painting of the Nineteenth Century* (New York: Harper and Row, 1979), pp. 7–10. For a recent critique of Novak's work and an overview of the revisionist studies currently going on in American art, see Wanda M. Corn, "Coming of Age: Historical Scholarship in American Art," *Art Bulletin* (June 1988): 188–207.

86. Novak, *American Painting*, pp. 59, 15, 55.

87. R. J. Coady, *Soil* (January 1917): 54–55. For more on Stieglitz, Coady, and *Soil*, see Judith Katy Zilczer, "The Aesthetic Struggle in America, 1913–1918: Abstract Art and Theory in the Stieglitz Circle" (Ph.D. diss., University of Delaware, 1975), pp. 143–53; Dickran Tashjian, *Skyscraper Primitives: Dada and the American Avant-Garde, 1910–1925* (Middletown, Conn.: Wesleyan University Press, 1975), pp. 71–84; and Gorham Munson, *The Awakening Twenties* (Baton Rouge: Louisiana State University Press, 1985), pp. 39–46.

88. Herbert J. Seligmann, "291, A Vision through Photography," in Waldo Frank et al., eds., *America and Alfred Stieglitz: A Collective Portrait* (New York: Literary Guild, 1934), p. 121. Seligmann had met Stieglitz through Strand in 1917.

89. Gertrude Stein, "An American and France," *What Are the Masterpieces?* (Los Angeles: Conference Press, 1940), p. 62.

90. Leo Marx, *The Machine in the Garden: Technology and the Pastoral Ideal in America* (New York: Oxford University Press, 1964), p. 195. For a brilliant discussion of the history of the machine as a sign of modern life in literature and art, see ibid., pp. 24–33, 145–226.

91. As already noted, it is not certain which of Strand's photographs these were. Most probably they included *Drilling Machine* (1923) and *Akeley Camera* (1922), to judge from an unsigned *Dial* review (August 1925, p. 178), which described them as an "orientally perfect combining of discs, parabolas, and verticals—when we perceive the silver flexibility of skin or the depth of tone upon the anaconda-like curves of central bearings."

92. The word *style* is used here according to Meyer Schapiro's definition: "Style is, above all, a system of forms with a quality and a meaningful expression through which the personality of the artist and the broad outlook of the group are visible. It is also a vehicle of expression with the group communicating and fixing certain values of religious, social and moral life through the moral suggestiveness of forms." (Schapiro, "Style," in Morris Philipson, ed., *Aesthetics Today* [Cleveland: Meridian, 1961], p. 81.)

93. Marsden Hartley, catalog statement, 1914; in Hartley, *On Art*, ed. Gail R. Scott (New York: Horizon, 1982), pp. 62–63. The extent of Stieglitz's influence on Hartley's 1914 declaration may never be known. Scott has rightly emphasized (p. 29) the importance for Hartley in having Stieglitz for a "sounding board" correspondent during the years he was imbibing modernism in Europe.

94. Marsden Hartley, "Modern Art in America," 1921; in Hartley, *Adventures in the Arts*, p. 60. For a recent discussion of American conservatism, see Theodore E. Stebbins, Jr., *A New World: Masterpieces of American Painting, 1760–1910* (Boston: Museum of Fine Arts, 1983), p. 160.

95. O'Keeffe, in Blanche Matthias, "Stieglitz Showing Seven Americans," *Chicago Evening Post: Magazine of the Art World*, March 2, 1926, p. 16. Matthias and O'Keeffe were the same age. In an interview prepared by me and carried out by Margaret Peters in San Francisco, November 24, 1980, Matthias said that she had seen the *Seven Americans* show. She had loved the O'Keeffes in it and thought them very different from the Marins, Doves, and Hartleys, but could not remember any other details. That she

understood Stieglitz's goals well at the time is clear from another statement in the same article: ". . . and so the Seven Americans follow the idea of Stieglitz, and so Stieglitz will follow for all time to come and whenever he finds it, the unchangeable, yet ever changing life that gives itself to him in the guise of art."

96. Several of the American attributes cited are similar to those observed by Denis Donoghue and convincingly developed in his essays on and reviews of American literature, from Emerson to John Ashbery, collected in Donoghue, *Reading America* (New York: Alfred A. Knopf, 1987). See also Larzer Ziff, *Literary Democracy: The Declaration of Cultural Independence in America* (New York: Viking, 1981).

97. When the printing fit was upon him, Stieglitz, in his search for perfection, usually threw away more photographs than he kept. At some point during the 1920s O'Keeffe began to retrieve them (with his knowledge, if not his approval), and it is these prints that constitute her "wastebasket" collection. They are in the Stieglitz/O'Keeffe Archive at Yale, filed under the title *My Collection of Alfred Stieglitz Photographs—Georgia O'Keeffe.*

6. O'Keeffe's Encounters with Strand, Sheeler, and Steichen (pages 183–221)

EPIGRAPHS:

O'Keeffe to Strand, postmarked July 11, 1917, Canyon, Texas, PSA. In the formerly restricted folder of correspondence from O'Keeffe to Strand, PSA, there are forty-five letters and three postcards, dating from June 1917 to September 1931. In the unrestricted folder there are three of her letters from December 1933 to April 1934, written from Lake George and Bermuda.

Georgia O'Keeffe, letter to the editor, *Manuscripts* 4 (December 1922): 17; in Lynes, pp. 182–84.

Steichen, in Sidney Allan [Sadakichi Hartmann], "Eduard J. Steichen, Painter-Photographer," *Camera Notes* 1 (1902): 15.

1. For a documentary account of these important early years, see Naomi Rosenblum, "Paul Strand: The Early Years, 1910–1932" (Ph.D. diss., City University of New York, 1978), pp. 44–54.

2. Strand, quoted by Calvin Tomkins, in *Paul Strand: Sixty Years of Photographs* (Millerton, N.Y.: Aperture, 1976), p. 144; this "Profile" by Tomkins originally appeared in a slightly different form in the *New Yorker*, September 16, 1974, pp. 44–94.

For an examination of these later abstract images, their dating to 1916 (instead of 1915, as Strand himself remembered), and their probable visual connections to the abstractions of Marsden Hartley and Arthur Dove—instead of French Cubism—see Rosenblum, "Strand," pp. 55–58.

3. O'Keeffe to Strand, postmarked June 12, 1917, Canyon, Texas, PSA.

4. O'Keeffe to Strand, in a second letter postmarked June 12, 1917; in *Letters*, p. 161.

5. O'Keeffe to Strand, in a third letter postmarked June 12, 1917, PSA.

6. O'Keeffe to Strand, postmarked June 25, 1917, PSA.

7. O'Keeffe to Strand, July 23, 1917, PSA.

8. O'Keeffe to Strand, July 23, 1917; in *Letters*, p. 165.

9. O'Keeffe to Strand, August 16, 1917, PSA.

10. I am most grateful to Gerald Peters (no kin) for letting me see his recently acquired cache of previously unknown watercolors by O'Keeffe from the Reid estate when I was in Santa Fe, July 21, 1989. Left untitled by the artist, they are important missing links to such well-known 1916–17 watercolor series as Palo Duro Canyon, Train in the Desert at Night, and Light Coming on the Plains, to cite but three. And they show beyond question what a virtuoso at abstraction O'Keeffe already was in this medium.

11. O'Keeffe to Strand, October 24, 1917, PSA. The article she mentions is "What Was 291?" typescript by Strand, dated October 1917, PSA; it was never published.

12. O'Keeffe to Strand, October 30, 1917, PSA.

13. O'Keeffe to Strand, November 12, 1917, PSA.

14. O'Keeffe to Strand, December 5, 1917, PSA.

15. O'Keeffe to Strand, postmarked December 29, 1917, PSA.

16. O'Keeffe to Strand, in a second letter postmarked December 29, 1917, PSA.

17. O'Keeffe to Strand, January 15, 1918, PSA.

18. O'Keeffe to Strand, March 3, 1918, PSA.

19. O'Keeffe to Strand, April 21, 1918, PSA.

20. O'Keeffe to Strand, April 22, 1918, PSA.

21. Stieglitz to Strand, May 17, 1918, PSA.

22. Stieglitz to Strand, May 1918, PSA. The day of the month is too blurry to read, but it must have been written during the third or fourth week of May.

23. Stieglitz to Strand, May 27, 1918, PSA. This photograph of O'Keeffe by Strand has been routinely dated c. 1930 because

of its adobe background and because it is known that Strand and O'Keeffe were both in New Mexico in 1930. But Stieglitz's 1918 letters written to Strand between May 17 and 27 give incontrovertible evidence that Strand did indeed photograph O'Keeffe in Waring, Texas, that spring. Further, adobe is common in upper south Texas, and O'Keeffe's round, *young* face in this photograph is very different from the one seen in Stieglitz's photographs taken twelve years later. None of Strand's plates have survived, and there are only two prints of this photograph extant. One is in the Aperture Foundation, Millerton, New York, and the other is in the National Portrait Gallery, Washington, D.C. Strand's own version of what happened during the first two weeks of his visit to Texas is recounted in the twenty-eight-page "Letter X" (SA), received by Stieglitz in New York on or about May 19.

24. O'Keeffe to Strand, December 29, 1917, PSA.

25. O'Keeffe to Pollitzer, June 20, 1917, SA. In a letter written over a quarter of a century later to Carl Zigrosser, O'Keeffe said, "I have always thought that in those things like 'Dishes' . . . that Strand was the first to consciously use in photography the abstract idea that came to us through Cubism." (April 1944; in *Letters,* p. 236.)

26. These were 8-by-10-inch contact prints. Strand used an Ensign camera at that time. About 1911 he began to enlarge negatives by projection at the Camera Club and continued to do so until 1918, when he went into the army. I am grateful to Naomi Rosenblum for this information.

27. The 1915–16 photographs O'Keeffe mentioned to Pollitzer (June 20, 1917) are perfect examples of this. Their present-day titles are *Abstraction; Porch Shadows; Abstraction—Bowls;* and *Snow, Backyards, New York.*

28. The 1917 watercolor *Abstraction* is reproduced in Barbara Haskell, *Georgia O'Keeffe: Works on Paper* (Santa Fe: Museum of New Mexico Press, 1985), p. 37. There is a photograph of the charcoal drawing *Set II* in the Whitney files, but no further information about it was available from the O'Keeffe Foundation, as of December 1990. It is published as plate 8 in Georgia O'Keeffe, *Some Memories of Drawings,* ed. Doris Bry (New York: Atlantis, 1974).

29. This comparison has been noted by Sarah Greenough in *Letters,* p. 277 n. 17. Regarding Strand's possible influence on *Trees and Picket Fence,* I would also suggest that O'Keeffe might have noted his compositional partiality for reiterated framing devices in *From the Viaduct* (1916). For even as Strand's fence and billboard double and triple the rectangular boundaries of his photograph, so did O'Keeffe repeat her framed edges several times with the outlines of the door (or window) behind the central tree. This striking similarity could, of course, have resulted from Dow's influence on them both.

30. The earliest prototype for these many citations is Milton W. Brown, "Cubist-Realism: An American Style," *Marsyas* 3 (1946): 155. Among the most recent is Lisa Mintz Messinger, "Georgia O'Keeffe," *Metropolitan Museum of Art Bulletin* (Fall 1984): 18.

31. The phrase "brutally direct" is Stieglitz's, in "Our Illustrations," *Camera Work* 49–50 (June 1917): 36.

32. O'Keeffe's earliest experiments with nature-form close-ups date from about 1919, whereas Strand's first ones were made in Nova Scotia in August 1920. (Rosenblum, "Strand," p. 139.) In 1921, at Twin Lakes, Connecticut, Strand made some close-up studies of a mullein plant (ibid., p. 140), but these are quite different in character from O'Keeffe's blown-up leaves and flowers of 1923–24—in part because her forms, unlike Strand's, have been isolated from their backgrounds. Certain formal similarities have also been noted between O'Keeffe's later magnified flowers and Strand's Georgetown Island, Maine, flora photographs of 1925–28 (many made in Isabel Lachaise's garden). But even if we allow for dating problems—Strand kept no records during this period (ibid., p. 152) —O'Keeffe's paintings on this topic seem to predate his photographs. One familiar comparison may suffice to make the point: her *Black Iris III* (1926; Metropolitan Museum of Art) and his *Garden Iris* (1928). I am grateful to Michael E. Hoffman, director of the Aperture Foundation, Millerton, New York, for permitting me to look closely, in June 1980, at Strand's early work—some of it unpublished.

33. Strand, in Tomkins, "Profile," p. 146.

34. Stieglitz's letters to Seligmann are full of such worries. "In many ways [Strand] is certainly developing. In others the development is not so certain." (September 7, 1921, SA.) "To be a master of the [photographic] process is no mean achievement —And [Strand] has that. The rest may still come.—In the meantime I still hope

he'll be able to find *himself* fairly soon." (October 1, 1921, SA.)

35. Paul Strand, "The Art Motive in Photography," *British Journal of Photography,* October 5, 1923, p. 614. This would change drastically in the later 1920s, when Strand turned increasingly from an idealist synthesis of nature and the machine to an aesthetic of remorseless cultural and political realism.

36. That Strand sometimes referred to O'Keeffe's abstractions can hardly be doubted after comparing his *Driftwood, Maine* (1928) with her *Pink and Blue, I* (1919; Barney Ebsworth Collection). Further, as Sasha Newman has rightly observed, many of Dove's paintings of the 1920s are also closely related in composition and subject to Stieglitz's Lake George photographs. (Newman, *Arthur Dove and Duncan Phillips: Artist and Patron* [Washington, D.C.: Phillips Collection, 1980], p. 37.)

37. Stieglitz to Seligmann, October 16, 1927, SA.

38. O'Keeffe's *Ranchos Church* is reproduced in *O'Keeffe* as plate 63. Strand's *Ranchos de Taos Church* is in Paul Strand, *Paul Strand: A Retrospective Monograph, The Years 1915–1968* (Millerton, N.Y.: Aperture, 1971), p. 87.

 With *Ranchos de Taos Church,* Strand even went to the effort of removing a basketball stanchion close to the rear buttress of the church so that he could present it (as O'Keeffe had done) without any signs of contemporary civilization. (Rosenblum, "Strand," p. 162.)

39. There is some evidence that Strand's romantic feelings for O'Keeffe lasted longer than hers for him. In a letter dated November 1919 Stieglitz wrote to Strand, "Someday I hope you and [O'Keeffe] will be at ease again with each other." And in a later one written October 4, 1922, he said, "I hope Georgia's reading her MS to you didn't cause any heartache—except passing ones." (Both PSA.) This last was written many months after Strand's marriage to Rebecca Salsbury on January 21, 1922. Although O'Keeffe often got impatient with the rather literal, slower-moving Strand, and they sometimes quarreled (as Stieglitz's letter to Seligmann of July 30, 1924, SA, makes plain), their basic esteem for each other remained intact over the years. On this point, see O'Keeffe's warm and friendly letters to Strand of May 1929 and December 26, 1933 (both PSA). O'Keeffe also remained grateful to Strand for his tireless contributions to 291 and to

Stieglitz personally. In a letter to Carl Zigrosser of April 1944, she paid tribute to Strand in her own honest way: ". . . about Strand—Stieglitz was as much his father as his own father—He started going to 291 when he was 16—It takes nothing from Stieglitz to let [Strand] have full credit—as a matter of fact it adds to Stieglitz. . . . If it had not been for Strand 1710 [An American Place] would not have opened as it did. When I saw that Stieglitz wanted a place again I started pushing Strand—and Strand helped me then as you help me now." (*Letters,* p. 237.)

40. Stieglitz to Sheeler, March 1, 1917, SA.

41. On this see Rosenblum, "Strand," p. 66. The whereabouts of these historic photographs is presently unknown. Rosenblum herself has never seen them, and none are reproduced by Theodore E. Stebbins, Jr., and Norman Keyes, Jr., in *Charles Sheeler: The Photographs* (Boston: New York Graphic Society, 1987).

42. It is likely that Sheeler's prizewinning photographs were *Open Window* and *Side of White Barn,* respectively.

43. It stands to reason, I think, that Sheeler would have sent Stieglitz prints entirely different from those shown by de Zayas in *Photographs by Sheeler, Strand and Schamberg* at the Modern Gallery, March 29–April 9. According to Stebbins and Keyes, *Sheeler: The Photographs,* Sheeler exhibited five pictures, four of works of art and one of New York (p. 53 n. 25).

44. Sheeler took the first known of the so-called Doylestown house photographs c. 1914–16. It is reproduced ibid., p. 13, fig. 22. For more information on this house, which still stands, see Karen Davies, "Charles Sheeler in Doylestown and the Image of Rural Architecture," *Arts Magazine* 59 (March 1985): 135–39.

45. Naomi Rosenblum now believes that Sheeler and Strand met in 1915 (either at 291 or the Modern Gallery) rather than in 1916, as traditionally assumed. See her letter to the editor, *Afterimage* (January 1988): 2.

46. Sheeler, who began corresponding with Stieglitz on December 22, 1914, from Philadelphia, didn't begin to mention O'Keeffe's name till c. late 1918: "It is so rarely that one meets a personality of the calibre of O'Keefe's [*sic*] that one does not soon forget it." (Dated only November 30, but probably 1918 because the letter is more familiarly addressed "Dear Stieglitz," instead of "Dear Mr. Stieglitz," as the earlier ones had been.) Another letter (undated, but with Sheeler's letterhead of 160

East Twenty-fifth Street, New York, indicating that it was written sometime after his move there in 1919) says: "I am glad if you and O'Keefe [sic] enjoyed the evening —for I haven't spent a more enjoyable one since I have been here." (These letters are at the AAA.) We do not yet know what O'Keeffe thought of Sheeler during that time.

47. Among the topics for further study are the ways Sheeler and O'Keeffe absorbed and jettisoned the teachings of William Merritt Chase in their still lifes and landscapes. Sheeler studied the longest with Chase— from 1904 to 1906 at the Pennsylvania Academy of the Fine Arts—but it was O'Keeffe who held on to Chase's guiding principle of recording spontaneous impressions and who often kept to the strictest of all his instructions, the completion of a canvas in one day. Also worth exploring is their commitment to modernist abstraction: Sheeler's was quite brief (at its zenith between 1913 and 1915), but O'Keeffe's lasted all her life. Their very different uses of primitivism: Sheeler never lost his visual interest in the spare, useful elegance of colonial Shaker forms, whereas O'Keeffe drew instead on the expressive power of children's drawings, Henri Rousseau, and the Indian artifacts of New Mexico. Their seemingly contradictory reasons for choosing native architecture and plant forms as subjects. (Sheeler made these choices well before O'Keeffe did.) The extreme importance of the extra-pictorial idea of "place" for them both, and the dissimilar ways they incorporated this notion into their works. The polar differences between their artistic sensibilities, as revealed in the diverse ways they used photography in their paintings (perhaps most fruitfully understood within the nineteenth-century concepts of Romanticism and Realism). Was either artist ever directly influenced by the other's drawings and paintings? It would seem not at all. But it is likely that Sheeler, too, was a close student of Arthur Wesley Dow's *Composition*—although he never said so.

48. *Manuscripts* 4 (December 1922): 3.

49. "Autobiography," unpublished manuscript, 1937, Charles Sheeler Papers, AAA, roll NSH, frame 66.

50. For more details, see Charles Millard, "Charles Sheeler, American Photographer," *Contemporary Photographer* 6, no. 1 (1967): n.p.

51. For everything we are likely to know about the dating and making of the Doylestown house negatives and prints, see Stebbins and Keyes, *Sheeler: The Photographs*, pp. 8–

13. For a selection of the excellent critical reviews Sheeler received for these shows (most of which approved of the "Cubism" he found in nature), see Marius de Zayas, "How, When, and Why Modern Art Came to New York," with introduction and notes by Francis M. Naumann, *Arts Magazine* 54 (April 1980): 104–5, 121.

52. Sheeler to Stieglitz, November 22, 1917, SA. Limiting these prints to only "three sets" was, of course, one more way of encouraging their value as works of art. Although this series has traditionally been dated c. 1914–17, Stebbins and Keyes are convinced that none of the photographs were made before 1917. (*Sheeler: The Photographs*, pp. 8–9.)

53. Steichen, in Constance Rourke, *Charles Sheeler, Artist in the American Tradition* (New York: Harcourt, Brace, 1938), p. 67.

54. *New York Evening World*, December 9, 1917; in de Zayas, "Modern Art Came to New York," p. 105.

55. For a juxtaposition of Sheeler's painting with the original photograph by White, see Stebbins and Keyes, *Sheeler: The Photographs*, p. 4. It is not at all clear, though, whether O'Keeffe, or indeed anyone else at the time, recognized that Sheeler's abstraction had been designed from a photograph. On Sheeler's use of his own prints as a source, see ibid., p. 11.

56. Although Sheeler had already used a sequence from *Manhatta* for his 1920 painting *Church Street El*, the earliest oils to be based on the Doylestown set of photographs may be *Interior with Stove* (1932; Joanna T. Steichen), and *Staircase, Doylestown* (1925; Hirshhorn Museum and Sculpture Garden). There is also the possibility that these were painted directly from the motif itself, for Sheeler did not use his photographs regularly for his paintings until 1929. Davies cites seven paintings and drawings from 1931 as the first to be based on the Doylestown prints. ("Sheeler in Doylestown," p. 137.)

57. On December 2, 1917, Sheeler had proposed an exchange of several of his Doylestown house prints for one of Stieglitz's: "Give me Hell, if, as I anticipate, you consider it colossal presumption upon my part." But Stieglitz agreed to the exchange, choosing *Open Window* and *Stairs from Below*, in addition to *Stairwell* and *The Stove*. What Sheeler received from Stieglitz is not known.

58. Sheeler, in Rourke, *Sheeler*, p. 109.

59. Sheeler, "Autobiography," frame 67.

60. Henry McBride, *Sun and New York Herald*,

February 22, 1920. Did O'Keeffe remember McBride's comments on Sheeler's barn photographs when she painted *Lake George Barns* (1926; plate 144)? If this painting was indeed a sort of creative correction of Sheeler's *Bucks County Barn* (1915; plate 143), as I suggest in chapter 8, perhaps so. O'Keeffe was very respectful of McBride, as their correspondence indicates.

61. Stieglitz to the editor of *Sun and New York Herald,* March 21, 1920, sec. 4, p. 4. Stieglitz's phrase "Sheeler is always the artist" is one that O'Keeffe would use in her 1922 *Manuscripts* article.

62. There is still great uncertainty about the dating and titles of these three known charcoals. *New York* (plate 87), which belongs to Doris Bry, is presently dated c. 1925–29. *New York Rooftops* (Fine Arts Museums of San Francisco) is dated c. 1925–30. And *Backyard at Sixty-fifth Street* (location unknown) has been dated c. 1920 in O'Keeffe's 1966 notebooks at Abiquiu. Judging by the similarities of their style and size, I believe that these three drawings were all made about the same time, probably when O'Keeffe and Stieglitz were living at 60 East Sixty-fifth Street (December 1920–spring 1924). I think also that she probably did the two downward angle views from tall buildings under the creative impetus of Strand and Sheeler's film *Manhatta* (made spring–summer 1920), which had its first public showing in New York on July 24, 1921. I am therefore inclined to date all three c. 1920–22. Doris Bry does not agree with me on this. In a letter to me of January 8, 1990, she wrote: "About the dating of the *New York Rooftops* drawing, I have no real arguments about this, but my entire sense is against the 1920–22 date you suggest. I think it would not have been done until the years when O'Keeffe and Stieglitz were living at the Shelton [after November 1925], and I think this could be figured out if one worked at the dating of the high buildings in the East 40s and 50s during the 1920s. I haven't done this yet, but I intend to."

63. Strand to Mrs. Shreve, August 9, 1920, PSA.

64. Examples of this type of outlining can be seen in at least two of Sheeler's 1920 photographs titled *New York,* reproduced in Martin Friedman et al., *Charles Sheeler* (Washington, D.C.: Smithsonian Institution Press, 1968), pp. 84, 147.

65. Sheeler, in "A Painter's Solution with a Camera of a Problem Usually Deemed Solvable with Paint Alone" (unsigned), *Vanity Fair* (May 1920): 80.

66. For a judicious account of the artistic and commercial reasons for their breakup in 1923, from Strand's intimate vantage point, see Rosenblum, "Strand," pp. 103–5.

67. In 1916 Sheeler wrote a statement for the Forum Exhibition catalog that said, in part, "I believe that human intellect is far less profound than human sensibility: that every thought is mere shadow of some emotion which casts it." This contradicts the influential 1924 comparison of his work with O'Keeffe's made by Virgil Barker, who wrote: "Miss O'Keeffe's pictures are the clean-cut result of an intensely passionate apprehension of things; Mr. Sheeler's, the clean-cut result of an apprehension that is intensely intellectual." (*Arts Magazine* 4 [April 1924]: 222.)

68. Sheeler, in Rourke, *Sheeler,* p. 175.

69. Ibid., pp. 177–78, 181.

70. Two excellent examples are *Black Iris III* (1926) and *Ranchos Church* (1930), both in the Metropolitan Museum of Art. It is a little-known fact that O'Keeffe often ground her own pigment in the Southwest. Her friend and colleague Ansel Adams reported from his own firsthand observation that "a lot of [O'Keeffe's] paintings in New Mexico are done from the stones she's just picked up in the desert. [This way] she gets the kind of thing she wants—directly and perceptively." (Ansel Adams, Berkeley Oral History tapes, interviews conducted by Edward Teiser, 1972, p. 82.) These remarks were verified and developed further by Adams in my interview with him in Carmel, California, October 19, 1978.

71. O'Keeffe, taped interview with Sarah Greenough, November 28, 1983.

72. Sheeler to Leslie Cheek, n.d., Sheeler Papers.

73. *O'Keeffe,* text opposite plate 104, *Road Past the View I* (1954).

74. Harold Bloom has written: "Poetic influence . . . always proceeds by a misreading of the prior poet, an act of creative correction that is actually and necessarily a misinterpretation." (Bloom, *The Anxiety of Influence* [New York: Oxford University Press, 1973], p. 30 and passim.)

75. The classic survey of Steichen's early photography is Dennis Longwell, *Steichen: The Master Prints, 1895–1914: The Symbolist Period* (New York: Museum of Modern Art, 1978). For a study of Steichen's early paintings, see William Innes Homer, "Eduard Steichen as Painter and Photographer, 1897–1908," *American Art Journal* 6 (November 1974): 45–55.

76. Sadakichi Hartmann, "A Monologue,"

Camera Work 6 (April 1904): 25.

77. Steichen to Stieglitz, August 27, 1914, Steichen Archive, Museum of Modern Art, New York. Again, I wish to thank Grace M. Mayer for her many kindnesses in facilitating my research. On occasion she even helped me to decipher Steichen's difficult handwriting.

78. For a sensitive account of the painful and complex breakup of the historic Stieglitz–Steichen relationship, see Lowe, pp. 185–94. See also the folder marked "Rift with Stieglitz," Steichen Archive.

79. See Steichen's irritable response to the "What Is 291?" issue of *Camera Work* 47 (July 1914): 65–67.

80. Edward Steichen, *A Life in Photography* (Garden City, N.Y.: Doubleday, 1963), n.p. This must have taken place during spring–summer of 1916, when O'Keeffe sent Stieglitz an occasional roll from Columbia, South Carolina.

81. It is not entirely certain whether Steichen took any of the existing anonymous AEF photographs, although some have recently been attributed to him. For an account of this issue—unfortunately an extremely biased, even vitriolic one—see Allan Sekula, "The Instrumental Image: Steichen at War," *Artforum* 13 (December 1975): 26–35. For an account of Steichen's remarkable photographic contribution to World War II, see Christopher Phillips, *Steichen at War* (New York: Portland House, 1987).

82. The three letters quoted here are in the Steichen Archive.

83. That the O'Keeffe–Steichen relationship never really progressed beyond this early stage is borne out by the letters she wrote thanking him for his flowers and thoughts during Stieglitz's final illness in 1946. (Steichen Archive.) They are warm and friendly but signed formally "Sincerely, Georgia O'Keeffe."

84. On the "systems" of Cook and Hambidge, and their popularity for American artists during the first decades of this century, see Milton W. Brown, "Twentieth Century Nostrums: Pseudo-Scientific Theory in American Painting," *Magazine of Art* (March 1948): 98–101. As Brown rightly points out, Stieglitz was suspicious of any kind of system making where art was concerned. Whether O'Keeffe herself ever looked into Cook's "principles of growth and beauty," or Hambidge's "dynamic symmetry"—or, later, D'Arcy Wentworth Thompson's *On the Growth of Form* (with its diagrammatic investigations into shell spirals, horns, pelvic bones, flowers, and leaves)—remains a topic for research.

85. Steichen, *Life*, n.p.

86. Grace Mayer believes that Steichen showed his work in many more exhibitions than have so far been recorded. Stieglitz, of course, had no gallery during these years.

87. Steichen, in Paul Strand, "Steichen and Commercial Art," *New Republic,* February 19, 1930, p. 21. Fashion photography was not new to Steichen in 1923. Thirteen of his photographs of Paul Poiret gowns appeared in the April 1911 issue of *Art et décoration* (Paris).

88. Stieglitz to Rosenfeld, October 21, 1923, YCAL.

89. In *A Life in Photography* (opposite plate 44), Steichen refers to Dove as "Stieglitz's favorite 'wild man.' "

90. For some early contemporary opinions on Steichen's painting, see Sidney Allan [Sadakichi Hartmann], "A Visit to Steichen's Studio," *Camera Work* 2 (April 1903): 25–28, and Charles Fitzgerald, "Eduard Steichen: Painter and Photographer," *Camera Work* 10 (April 1905): 42–43. Three of Steichen's paintings were reproduced in *Camera Work* 42–43 (April–July 1913).

91. In the Steichen Archive there is one of his trade-card designs, for "Cascarets," a candy cathartic (c. 1890s).

92. In addition to the famous *Cyclamen* (1905), there are the 1902 pigment print *Figure with Iris;* the 1907 portrait of Mrs. Condé Nast; *Mary and Her Mother, Long Island* (1905); the autochrome *Young Girl Standing beside a Vase of Flowers* (c. 1908); and *Kate Steichen* (c. 1917), among others.

93. In the chronology of Grace Mayer's unpublished manuscript "Steichen's Way" (from which she graciously shared information with me), Steichen is listed as having exhibited in several shows during 1926–27. There is, however, no mention of *Heavy Roses* in any of them.

94. Maurice Maeterlinck, *The Intelligence of Flowers* (New York: Dodd, Mead, 1907), p. 12.

95. O'Keeffe's 1966 notebooks list nothing with *rose* in the title before this work in 1926. Among the crucial things we do not know about *Calla Lily with Roses* (plate 94) is the month it was painted. There are four rose canvases listed in 1927 (including the great *Abstraction—White Rose III*) and three for 1928. It may be significant, in terms of meaning, that *Calla Lily with Roses* was first titled *L.K. White Calla and Roses.* The initials L.K. stood for the critic Louis Kalonyme. Steichen also

photographed a calla lily at Voulangis. Information on the dating of this beautiful close-up photograph (Joanna T. Steichen Collection, George Eastman House) is sparse. On the back of the mount is written, in Steichen's hand: "Voulangis, France Platinum print early date? before I lived there." So far there is no evidence to suggest that O'Keeffe ever saw this photograph, but its composition is not dissimilar to her earliest calla series of 1923.

96. Steichen began hybridizing delphiniums in his gardens at Voulangis as early as 1910. In 1928 he established the Umpawaug Plant Breeding Farm at West Redding, Connecticut. For more on the fin-de-siècle attitude toward flowers in the decorative arts, see Elizabeth Aslin, *The Aesthetic Movement* (New York: Frederick A. Praeger, 1969).

97. According to Lowe (p. 280), O'Keeffe exhorted the women at the convention to run their own lives, earn their own support, develop their own capabilities—and end their dependency on men. Her deeply felt feminism is well known to have been encouraged by Anita Pollitzer. O'Keeffe could also have been influenced by the radical feminism of Randolph Bourne through her close friend Arthur Macmahon (a former roommate of Bourne's at Columbia University). For a study of Bourne's advanced ideas on cultural feminism, see Edward Abrahams, *The Lyrical Left* (Charlottesville: University Press of Virginia, 1986), pp. 68–78.

98. Stieglitz to Seligmann, August 22, 1926, SA. Among the almost transparently autobiographical paintings done during O'Keeffe's traumatic time away from Stieglitz were *Light Blue Sea, Maine; Open Clam Shell; Closed Clam Shell; Seaweed; Tan Clam Shell with Kelp; Tan Clam Shell with Seaweed; Slightly Open Shell;* and the Shell and Old Shingle series (nos. 1–7).

99. O'Keeffe to Frank, January 10, 1927; in *Letters*, p. 185.

100. Her first rendering of this flower, *Red Poppies* of 1925, is listed in her 1966 notebooks as destroyed. She apparently did not paint one again until 1927, and we do not yet know which of the three she made that year—*Oriental Poppies, Red Poppy,* and *Poppy*—was done first. Steichen had also painted a single poppy in a bowl with leaves at Voulangis in 1920 (collection of Mary Steichen Calderone), but there is no resemblance between it and O'Keeffe's close-ups.

101. Although this statement was first published in an undated clipping (summer 1902) that has been preserved in the Steichen scrapbook (collected by his mother) in the Steichen Archive, it sounds like a statement Steichen might have made frequently over the years, out of his permanent devotion to photography.

102. For an exquisitely reproduced panorama of O'Keeffe's flower paintings, see Nicholas Callaway, ed., *Georgia O'Keeffe: One Hundred Flowers* (New York: Callaway; Alfred A. Knopf, 1987).

103. Other comparisons that might profitably be made are her *Peach and Glass* (1927; Philadelphia Museum of Art) with his *Pear on a Plate* (c. 1920); her *Shell I* (1928; National Gallery of Art, Washington, D.C.) with his *Spiral, France* (c. 1921); and her *Lily-White with Black* (1927; private collection) with his *Calla Lily* (see n. 95, above). All photographs are in the Joanna T. Steichen Collection, George Eastman House.

104. Steichen, "The Fighting Photo-Secession," *Vogue* (June 15, 1941): 74.

105. Stieglitz to Steichen, June 15, 1941, Steichen Archive.

106. Paul Valéry, *Les Merveilles de la mer;* in Gaston Bachelard, *The Poetics of Space* (Boston: Beacon, 1969), pp. 104–5.

7. O'Keeffe and Stieglitz at Lake George (pages 223–75)

EPIGRAPHS:
Stieglitz to Seligmann, Lake George, New York, summer 1920, SA.

O'Keeffe to Anderson, Lake George, June 11, 1924; in *Letters*, pp. 177–78.

1. Stieglitz to Strand, August 11, 1919, PSA.

2. O'Keeffe to Anderson, February 11, 1924; in *Letters*, p. 176.

3. See, for example, J. E. Cirlot, *A Dictionary of Symbols* (London: Routledge and Kegan Paul, 1962), pp. 136–37; Joseph Campbell, *The Masks of Primitive Mythology* (New York: Viking, 1959), pp. 66–67, 88–89. See also Marija Gimbutas, *The Language of the Goddess* (San Francisco: Harper and Row, 1989).

4. In the opening chapter Lawrence wrote: "Heaven and earth was teeming around them, and how should this cease? . . . They knew the intercourse between heaven and earth. . . . Their life and inter-relations were such; feeling the pulse and body of the soil that opened to the furrow for the grain and became smooth and supple after their ploughing and clung to their feet with a weight that pulled like desire. . . . It was enough for the men, that the earth heaved

and opened its furrows to them." (D. H. Lawrence, *The Rainbow* [1915; New York: Viking, 1961], pp. 2–3.) Lowe has documented that by 1918 Stieglitz had already reveled in Lawrence's novels, because they had something "true" to offer. She also adds (p. 212) that Stieglitz did not often refer to his voracious reading of contemporary fiction in letters to his friends.

5. According to Lowe (p. 253), Stieglitz turned the old potting shed on The Hill into a real darkroom for himself in 1922. It was referred to as the "Little Building." As later described by O'Keeffe, it was "a small square house that had been the wooden part of a large greenhouse. Two electric wires ran to it from the farm house and there was a fine weathervane on top of it. In front of the little house was a tall white flag pole. Stieglitz used the little house as a darkroom for his photographic work." (*O'Keeffe,* text opposite plate 36.)

6. For a glowing account of this halcyon period just before their marriage, see Stieglitz to Rosenfeld, November 9, 1924, YCAL.

7. Both these works were exhibited in O'Keeffe's 1917 show at 291.

8. O'Keeffe, introduction, *Portrait,* n.p.

9. O'Keeffe to Pollitzer, November 27, 1916, SA. In the NGA key set there is a print of O'Keeffe's *Drawing No. 9* (1915; Menil Foundation, Houston).

10. Stieglitz to Strand, November 17, 1918, PSA.

11. Stieglitz to Strand, April 23, 1919, PSA.

12. Stieglitz to Rosenfeld, September 20, 1920, YCAL.

13. Stieglitz to Rosenfeld, July 22, 1922, YCAL. Prints are spotted by hand to clean up any errors, mostly those caused by dust. O'Keeffe used a brush dipped in india ink. For a technical discussion of spotting, see David Vestal, *The Craft of Photography* (New York: Harper and Row, 1974), p. 353.

14. O'Keeffe, introduction, *Portrait,* n.p.

15. For data on this point, see *Stieglitz,* p. 203.

16. O'Keeffe had mostly neglected the oil medium since her Art Students League classes with William Merritt Chase. Among the very few exceptions extant are *Painting No. 21* and *Painting No. 22;* both 1916, oil on board, approximately 22 by 18 inches (they look as if she had been practicing Cézanne's constructive brush stroke); locations unknown. Also, *Canyon Landscape,* 22 by 18 inches, c. 1916–17, and *Series I, No. 4,* 1918; both Estate of Georgia O'Keeffe. Some of O'Keeffe's neglect of oil was practical. She had little time free from her teaching duties, and watercolor was quicker

—and easier—to work with during her many excursions by foot into the north Texas countryside.

17. Stieglitz to Strand, November 17, 1918, PSA.

18. See Lisle, p. 75.

19. Stieglitz to Dove, September 18, 1919; in Morgan, p. 66.

20. Stieglitz to Dove, August 22, 1922, SA.

21. Strand to Stieglitz, March 20, 1919, PSA. Unfortunately, it is not known, and may never be, which works "the grey painting and portrait" are.

22. Dove to Stieglitz, September 16, 1919; in Morgan, p. 64. For a revealing description of Stieglitz's close-up method and rationale during this period, there is his own account to Edward Weston, as recorded in the latter's *Daybooks* in 1922: "You see that in my work I have broken every photographic law, optics included. I have put a lens a foot from the sitter's face because I thought when talking intimately one doesn't stand ten feet away; and knowing that it takes time to get deep into the very innermost nature of matter, I stopped way down. You see [in] my prints, the eye is able to wander all over them, finding satisfaction in every portion, the ear is given as much consideration as the nose, but it is a task, this desire to obtain detail and simplification at the same time. To make your subject forget a headrest during such long exposures is heartbreaking." (*The Daybooks of Edward Weston,* ed. Nancy Newhall, 2 vols. [New York: Aperture, 1961], vol. 1, p. 5.)

23. Stieglitz's earliest surviving landscape prints were made in Italy during 1887. In 1894 he photographed the picturesque countrysides of Gutach, Germany, and Katwijk, Holland. But between 1895 and 1917, as Sarah Greenough has documented, he made fewer than a dozen landscape photographs. (Greenough, "From the American Earth: Alfred Stieglitz's Photographs of Apples," *Art Journal* [Spring 1981]: 54.) Lowe has recorded (p. xix) that from the age of nine to the age of eighty-two, Stieglitz missed only eleven summers at Lake George.

24. Stieglitz to Anderson, July 5, 1925, SAP.

25. Stieglitz to Strand, August 22, 1918, PSA.

26. That this photograph was a very special one to Stieglitz is reinforced by Lowe's statement (p. xiii) that it was among the family "fragments" that he had apparently chosen for his own personal album (which he had planned but never made). This photograph (cropped so that it showed the head only) was also chosen for B. Vladimir

Berman's article, "She Painted the Lily and Got $25,000 and Fame for Doing It!" *New York Evening Graphic*, May 12, 1928, p. 3M.

27. Seligmann, p. 73.

28. See, for example, *Portrait*, plate 37, and Greenough, "From the American Earth," p. 49, figs. 3 and 4. Greenough's persuasive argument that Stieglitz considered the apple tree to be symbolic of the long-neglected American artist, and its fruit an expression of the artist's soul, does not preclude my suggestion here. And Waldo Frank would seem to add to it by this description: "For O'Keeffe is a peasant—a glorified American peasant. Like a peasant, she is full of loamy hungers of the flesh. Like a peasant, she is full of star dreams." (Frank, "White Paint and Good Order," in *Time Exposures by Search Light* [New York: Boni and Liveright, 1926], p. 32.)

29. For example, Henry McBride quotes Stieglitz's use of this phrase in a review of O'Keeffe's painting in his "Art News and Reviews," *New York Herald*, February 4, 1923, sec. 7, p. 7. The same review was later reprinted in O'Keeffe's 1924 catalog.

30. Stieglitz to Strand, May 16, 1918, PSA.

31. Stieglitz to Strand, November 17, 1918, PSA.

32. On this important point there is a letter from Stieglitz to Rosenfeld dated November 5, 1920 (YCAL), which may describe his original inspiration. He speaks of taking a walk with O'Keeffe before sundown on Bolton Road: "An evening that reminded of last year's Passionate autumn [their first together].—We were wishing you could see the mountains and the trees—the sky—the rainbow—the hills gradually turning from warm gold into a great blackness."

33. Kandinsky, *Harmony*, pp. 41–42.

34. Stieglitz to Strand, August 9, 1920; Stieglitz to Strand, September 20, 1920; Stieglitz to Strand, September 21, 1920; all PSA.

35. Stieglitz to Rosenfeld, August 28, 1920, YCAL. See also Lowe, pp. 234–35.

36. Stieglitz to Rosenfeld, September 20, 1920, YCAL.

37. See Greenough, "From the American Earth," reproduced on p. 49.

38. Stieglitz to Marie Rapp Boursault, October 6, 1920, SA. Unfortunately, it is not yet possible to know which ones he was referring to. O'Keeffe's 1966 notebooks dated all fifteen of her earliest apple paintings as c. 1921.

39. On this, see Meridel Rubenstein, "The Circles and the Symmetry: The Reciprocal Influence of Georgia O'Keeffe and Alfred Stieglitz" (Master's thesis, University of New Mexico, 1977), p. 31.

40. The composite *Portrait of Georgia O'Keeffe* was not Stieglitz's first portrait series. He had already made hundreds of pictures of his daughter, Kitty, as she grew up.

41. Stieglitz to Rosenfeld, October 2, 1921, YCAL. For an account of why the 1921 summer and fall were difficult for Stieglitz, see Lowe, pp. 245–47.

42. Stieglitz to Seligmann, September 16, 1921, SA. The following two quotes are also from letters in the SA.

43. Stieglitz to Strand, August 4, 1921, PSA.

44. Explication of this consequential and not well-known series is greatly needed. That Stieglitz particularly valued O'Keeffe's apple portraits and wanted them to be brought to public attention is clear from his choice of *Apple Family 1* (Estate of Georgia O'Keeffe) to be reproduced in Rosenfeld's 1922 article for *Vanity Fair*, "The Paintings of Georgia O'Keeffe." (The painting appears as *Still Life* on p. 56.) It is also evident from several of these canvases that O'Keeffe was still casting among the great European modern masters for her own style. For example, *The Green Apple* (c. 1921; location unknown) shows striking similarities to Matisse's *Les Pommes sur la table sur fond vert* (1916; Chrysler Museum of Norfolk, Virginia).

45. This Stieglitz photograph was reproduced in *Camera Work* 20 (October 1907): 41.

46. O'Keeffe and Stieglitz often climbed this mountain together, and the view from the top offers a similar orientation, but without the extreme angle obtained by an aerial photograph. I am indebted to Sue Davidson Lowe for this information, in a letter of February 2, 1984. Lowe also recalled that the view from the attic window of the farmhouse faced east—as does O'Keeffe's key position in *Lake George with Crows* (plate 104).

47. Compositions with dominant ovoids like this one would become increasingly prevalent in O'Keeffe's work—no matter what the subject. The ovoid or spherical form is an ancient symbol for creation (the All in One, the Cosmogenic Egg), which appears in Western art and thought from Plato to Brancusi. In *Lake George with Crows* the textured blue ovoid is opaque, suggesting deep water. In her 1940s pelvis-bone series the ovoids are empty holes—bone shapes that act as natural visual metaphors for the eye, through which O'Keeffe would peer to render the infinite blue of the New Mexico

sky: for example, in *Pelvis I (Pelvis with Blue)* (1944; Milwaukee Art Museum). As she wrote: "When I started painting the pelvis bones I was most interested in the holes of the bones—what I saw through them—particularly the blue from holding them up in the sun against the sky as one is apt to do when one seems to have more sky than earth in one's world.... They were most wonderful against the Blue—the Blue that will always be there as it is now after all man's destruction is finished." (O'Keeffe, "About Painting Desert Bones," in *Georgia O'Keeffe: Paintings, 1943* [New York: An American Place, 1944].)

48. The O'Keeffe–Stettheimer correspondence is at the Art Institute of Chicago.

49. Stieglitz to Frank, August 25, 1925, SA.

50. Stieglitz to Strand, September 15, 1925, PSA.

51. Published first in *Amateur Photographer and Photography* 56 (September 19, 1923): 225, and reprinted many times thereafter.

52. For more on this, see Seligmann, p. 58.

53. Stieglitz to Rosenfeld, August 16, 1922, YCAL.

54. For an enlightening account of this curious incident, see Naomi Rosenblum, "Paul Strand: The Early Years, 1910–1932" (Ph.D. diss., City University of New York, 1978), pp. 205–7. Whether Strand's usurpation of Stieglitz's own "turf" had anything to do with his sudden concentration on the sky above may always remain a question. The resentment Stieglitz felt toward Strand for photographing *his* Lake George motifs contrasts with Stieglitz's eagerness to share them with O'Keeffe.

55. Stieglitz to Seligmann, October 29, 1922, SA.

56. For a discussion of the Waldo Frank incident and for the first close study of Stieglitz's cloud photographs, see Sarah E. Greenough, "Alfred Stieglitz's Photographs of Clouds" (Ph.D. diss., University of New Mexico, 1984), pp. 150–98. On Stieglitz's lifetime interest in weather, see Dorothy Norman, *Alfred Stieglitz: An American Seer* (New York: Random House, 1973), p. 20.

57. Stieglitz to Rosenfeld, August 8, 1922, YCAL.

58. Stieglitz to Rosenfeld, November 5, 1920, YCAL.

59. In *Harmony* (p. 14), Kandinsky wrote: "The life of the spirit may be fairly represented in diagram as a large acute-angled triangle divided horizontally into unequal parts with the narrowest segment uppermost. The lower the segment the greater it is in breadth, depth and area."

60. In the words of Alphonse de Lamartine, "[Photography] is better than an art; it is a solar phenomenon in which the artist collaborates with the sun." (1859; in *After Daguerre: Masterworks of French Photography [1848–1900] from the Bibliothèque Nationale* [New York: Metropolitan Museum of Art, 1980], p. 72.) Other examples of Stieglitz's probable symbolic "homages" to photography are: *Sunlight and Shadows: Paula/Berlin* (1889; reproduced in Rosalind Krauss, "Stieglitz/Equivalents," *October* 11 [Winter 1979]: 131–33) and *Little House* (c. 1933; in *Stieglitz*, p. 231).

61. *Stieglitz*, p. 233. A small possibility exists that he took some 4-by-5-inch photographs of clouds during the summer of 1922, a time when he was intensively searching through nature for forms to express his emotions. This possibility rests on a letter to Anderson from Stieglitz, dated July 30, 1923 (SAP). All in the same paragraph, he writes: "The sun's disc sharply defined through a vaporous atmosphere, most curious in color & movement. Is the day to be one of bright sunlight—or is it to be gray? There was a marvellous full moon last night—very still—& the hills very tranquilly dark guarding the Lake so peacefully still—dark too & inviting—Towards midnight vapors began to rise & settle here & there along the sides of the hills—& gradually some seemed to play about the moon disc like the Rhine daughters played about the Rhinegold guarding it with their laughter & song.—I had been fooling all day with small prints made a year ago—prints I frequently took a peep at during the year & wondered why I took such an interest in them—such fool things many —yet fascinating each—I wondered how could I place them properly on the thing one calls mount—just a piece of paper. Frequently hopeless—they seemed merely to remain prints—beginning—and yet I knew someday there might be a little more than that if I felt just right.—And yesterday somehow I again began playing & by night I had 14 of the prints virtually placed each on a piece of paper—established a life between print & paper—and some of these tiny pictures give much pleasure—There is life.—So simple—what is it?"

I have discussed with Greenough the possibility that these "small photographs" were of clouds, but she thinks it more likely they were of apples—despite the general weather subjects of the above paragraph. She also thinks this because none of the

Songs of the Sky in the key set were dated earlier than 1923 by Stieglitz. But the fact remains that he sometimes did not "see" his photographs until well after they were exposed, and therefore he might not have considered such experimental snapshots datable until they had been finally selected and mounted. The issue, admittedly a minor one, is of interest mainly because of the inspiration and timing for Music: A Sequence of Ten Cloud Photographs.

62. O'Keeffe to Anderson, February 11, 1924; in *Letters,* p. 176.

63. Stieglitz to Seligmann, October 6, 1923, SA.

64. Stieglitz to Strand, October 15, 1923, PSA.

65. Stieglitz to Anderson, September 2, 1923, SAP.

66. Stieglitz to Seligmann, October 12, 1923, SA.

67. I am indebted for this information to Sarah Greenough, whose careful study of the NGA cloud photographs has helped disclose the extent to which Stieglitz sometimes went in his spotting. When questioned by Greenough about her own spotting of Stieglitz's prints, O'Keeffe said that she always wanted to be *"requested* not asked" to do so. Usually she painted during the day, but "I could spot until midnight." This information is from the November 28, 1983, taped interview with O'Keeffe by Greenough, which she kindly shared with me.

68. To avoid any visual confusion, I shall stick to the numbers for Stieglitz's five photographs published in Doris Bry, *Alfred Stieglitz: Photographer* (Boston: Museum of Fine Arts, 1965). Greenough has informed me, however, that Bry's published numbers do not all tally with Stieglitz's original ones; therefore, each photograph will also be referred to by its NGA accession number.

69. According to Greenough, Stieglitz made three abstract photographs of O'Keeffe in 1923: a series titled Songs of the Sky: Portrait of G.O. That same year he also made six photographs of trees and clouds titled Songs of the Sky: Portrait of K.N.R. (Katharine N. Rhoades).

70. For more evidence of Stieglitz's intent here, there is a letter to Anderson dated September 2, 1923 (SAP): "Somehow it doesn't happen that I am photographing persons this summer—or at any rate not *persons as persons.* Maybe that will come later."

71. In support of this comparison is the fact that Stieglitz published selections from van Gogh's letters as early as 1912, in *Camera Work* 40.

72. Stieglitz to Hartley, October 27, 1923, YCAL.

73. Seligmann, p. 58.

74. This photograph is reproduced in Waldo Frank et al., *America and Alfred Stieglitz: A Collective Portrait* (New York: Literary Guild, 1934), as plate XXVII, D, with the title *Lake George,* 1924. It also appears in Norman, *American Seer* (p. 153), as *Equivalent: Mountains and Sky, Lake George,* 1924. Greenough thinks the 1924 date is correct, despite Stieglitz's own date of 1919 written on the back of the NGA mount. But she believes it should have the title *Lake George,* not *Equivalent* (letter to me of November 13, 1985).

75. Kandinsky, *Harmony,* pp. 47–52.

76. Stieglitz to Rosenfeld, November 14, 1923, YCAL.

77. Stieglitz, "Woman in Art"; in Norman, *American Seer,* p. 137.

78. This incident is well documented in Lisle, pp. 107–8, and Lowe, pp. 247–49, and both authors suggest that the postpartum illness of Kitty Stieglitz Stearns, in June 1923, was what made Stieglitz's decision not to have a child with O'Keeffe final.

79. *O'Keeffe,* text opposite plates 30 and 31.

80. *Calla Lily in Tall Glass No. 1* (plate 122) and *2* (location unknown); *Calla* (location unknown); *Calla Lily* (location unknown); *Calla Lily with Red Background* (private collection); *Calla Lily Turned Away* (private collection); *Calla Lilies* (private collection); and *Two Calla Lilies* (private collection). Seven of the above were in her 1924 Anderson Galleries show listed in the catalog only as "8–14 calla lillies" [*sic*].

81. For some examples, see Ella M. Foshay, *Reflections of Nature: Flowers in American Art* (New York: Whitney Museum of American Art; Alfred A. Knopf, 1984), p. 107.

82. Demuth made an undated, unfinished, and, to my knowledge, unreproduced poster portrait of Hartley with a conspicuous calla in it (c. 1920–22; location unknown). Emily Farnham described it as "Framed in open window, large flowerpot holding red calla lily with yellow and green leaves. On left, letters of the name HARTLEY give vertical emphasis. Various notations inscribed on work; all red, snow winter, quite blue, white clouds." (Farnham, "Charles Demuth: His Life, Psychology and Works" [Ph.D. diss., University of Ohio, 1960], p. 674.) Hartley's own callas appear to have begun about 1917; among them are *Red*

Calla in Blue Vase, Still Life No. 9, and *Atlantic Window.*

83. O'Keeffe to Pollitzer, October 1915, SA.

84. Among these four varieties, the canna was O'Keeffe's overwhelming favorite between 1918 and 1922—approximately thirteen watercolors and oils exist of it. She also seems to have taken a special interest in the form and color of the lowly wild skunk cabbage, because four oils were done in 1922 with that title, including *Cos Cob* (formerly titled *Skunk Cabbage;* location unknown).

85. One such description out of many is in *The Language of Flowers,* written anonymously in 1913 and printed in England by Beric Press in 1968. For a discussion on American nineteenth-century flower symbolism, see William H. Gerdts and Russell Burke, *American Still Life Painting* (New York: Praeger, 1971), pp. 89–92. For a more recent exploration of this popular but hard to pin down material, see Foshay, *Reflections of Nature,* pp. 35–36. Assuredly known to O'Keeffe was Maurice Maeterlinck's widely read Symbolist meditation *The Intelligence of Flowers,* illustrated by Alvin Langdon Coburn's photographs in 1907.

86. For an unmatchable discussion of some of these differences, see Paul Rosenfeld, "The Paintings of Marsden Hartley," *Vanity Fair* 18 (August 1922): 47, 84. Hartley's early understanding and admiration of O'Keeffe's painting is well known, but O'Keeffe's attentiveness to Hartley's work deserves a much closer study, starting from such preliminary observations as the following. Both Hartley and O'Keeffe had William Merritt Chase for a teacher in their formative periods; both combined mystical and romantic qualities with an expressive realism; both were, in Hartley's phrase, "hermit radicals"; both were profoundly influenced by Kandinsky and Matisse; both liked to minimize (and deny outright) their stylistic sources; both felt the need to work in series; both swung in and out of the "objectivist" philosophy; and both succumbed to the spell of the New Mexico landscape. Both artists preferred not to sign their pictures. The estrangement between Hartley and Stieglitz that began in 1923, partly for financial reasons, does not seem to have operated between Hartley and O'Keeffe. Thus, Stieglitz to Hartley, "Georgia has always been a champion of yours and continues to be so." (From a letter dated February 5, 1929, YCAL.) Hartley and O'Keeffe carried on a correspondence of their own that has yet to be catalogued—if indeed it still exists. (A letter from Stieglitz to Hartley dated October 27, 1923, says, "I read your letter to Georgia. . . ." [YCAL].) Whether O'Keeffe and Hartley shared a secret interest in the occult remains an open question, although Hartley's own interest in the occult does not. (On this, see Gail Levin, "Marsden Hartley and the European Avant-Garde," *Arts Magazine* 54 [September 1979]: 160; and Levin, "Marsden Hartley and Mysticism," *Arts Magazine* 60 (November 1985): 16–21.)

87. O'Keeffe, in Gladys Oaks, "Radical Writer and Woman Artist Clash on Propaganda and Its Uses," *New York World,* March 16, 1930, women's sec., p. 1. For a contemporary Marxist-Foucauldian discussion of the contradictions facing women when they attempted to represent themselves in art as artists, see Rozsika Parker and Griselda Pollock, *Old Mistresses: Women, Art and Ideology* (London: Pandora, 1981), pp. 114–33.

88. Among the superabundant sources available to O'Keeffe on this particular motif from the time of her student years at the Art Institute of Chicago were Walter Crane's *Flora's Feast: A Masque of Flowers* (1889); Eugène Grasset's *Estampes décoratives* (1896–98); Paul Berthon's turn-of-the-century posters, ceramics, and decorative panels; and, above all, Alphonse Mucha's posters and frequently reproduced decorative panels (1896–1903). *La Plume,* for instance, devoted its entire issue for July 1897 to Mucha's work.

89. Both of them appeared in *Camera Work* 42–43 (April–July 1913). The woman in *The Lotus Screen* was Stieglitz's sister, Selma Stieglitz Schubart.

90. In the NGA key prints from the *Portrait* there is a series of three taken in 1918, in which O'Keeffe is posed on the porch of the Lake George house holding a few leaves and flowers in her left hand (accession nos. 1980.70.79–81). There are also three 1934 exposures of her standing in a field holding some ferns and daisies (accession nos. 1980.70.326–28). And that is all. In his later years Stieglitz was fond of saying that he loved flowers but had "never felt himself worthy of either picking them or photographing them." (Norman, *American Seer,* p. 204.)

91. See *Portrait,* plates 19, 29, and 32.

92. None of the buttocks photographs has been published, and apparently none has ever been exhibited.

93. Sarah Greenough has suggested that in their abstract portraits Stieglitz, Demuth, and Dove were analyzing the personalities of their immediate artistic community for the express purpose of creating new forms and symbols for America. (Greenough, "Equivalents as Portraits; Portraits as Equivalents," lecture at the Henry Luce Foundation Symposium, Institute of Fine Arts, New York University, April 5, 1986.) If so, then I think O'Keeffe's early fruit and plant self-portraits may have been a direct spur for that idea.

94. These were listed in the exhibition catalog simply as "35–42 leaves."

95. This watershed work has been variously dated from c. 1923 to 1926. Since, however, the artist's notebooks are unequivocal about dating it 1923, and note its appearance in the March 1924 Anderson Galleries show as definite, I find no good reason (style included) not to accept 1923 as the firm date.

96. "I had been walking for a couple of weeks with a girl in the big woods somewhere in the North Carolina mountains. One morning before daylight, I was combing my hair. I saw her lying there—one arm thrown back, hair a dark mass against the white, the face half turned, the red mouth. It all looked warm with sleep." (O'Keeffe, *Some Memories of Drawings,* ed. Doris Bry [New York: Atlantis, 1974], n.p.)

97. As he described it to Strand: "I tried to coax a leaf into keeping still a little while —and was wishing for a head rest for it." (Stieglitz to Strand, August 6, 1922, PSA.) Further, Stieglitz's Dada-educated side may have regarded leaves as "found objects" par excellence. Hartley, for one, understood Stieglitz's Dada proclivities very well. In a 1921 essay, "The Appeal of Photography," he wrote: "Incidentally it may be confided [Stieglitz] is an artistic idol of the Dadaists which is at least a happy indication of his modernism. . . . Perhaps he will not care to be called Dada, but it is nevertheless true." (Reprinted in Hartley, *Adventures in the Arts* [1921; New York: Hacker Art Books, 1972], p. 111.)

98. Ironically, perhaps, considering their veneration for "place," the artists and writers in Stieglitz's orbit do not seem to have extolled (or read) Thoreau or Emerson quite as much as Whitman. Thoreau's name does not, for example, appear on Stieglitz's lifetime-favorite reading list, as compiled and separately examined by Joseph Schiffman, Robert E. Haines, Sue Davidson Lowe, and Sarah Greenough. Nevertheless, Stieglitz was certainly aware that Benjamin De Casseres had named Thoreau, Emerson, and Whitman as the real fathers of the Cubists and Futurists, "for they reported what they *felt,* not what they *saw.*" (De Casseres, "The Renaissance of the Irrational," *Camera Work,* special no. [June 1913]: 23.) Van Wyck Brooks regarded the same three as "the accepted canon of American literature" and therefore prime grist for America's "usable past." (Brooks, "On Creating a Usable Past," *Dial* [April 1918]: 337–41.) Nor would it have escaped Stieglitz's notice that Waldo Frank in *Our America* called *Walden* "America's first great prose . . . the first conscious 'yea' of the Puritan world." (Cited by Gorham Munson, *The Awakening Twenties* [Baton Rouge: Louisiana State University Press, 1985], p. 65.) For a discussion of why Whitman's work was preferred to that of the Transcendentalists by intellectuals during the 1920s, see Frederick J. Hoffman, *The Twenties: American Writing in the Postwar Decade* (New York: Macmillan, 1965), pp. 144–56. And for a comparative study of Stieglitz's "romantic" attitude toward Lake George with Thoreau's descriptions of his days at *Walden,* see Richard N. Masteller, "Romanticisms in a Modern Mode" (Ph.D. diss., University of Minnesota, 1978), pp. 29–42.

99. Henry David Thoreau, *Walden, or, Life in the Woods* (1854; New York: Peter Pauper, n.d.), pp. 291–94. Although the connection between this passage from *Walden* and O'Keeffe's leaves has never to my knowledge been noted before, I am not the first to pick up on the probable influence of Thoreau on her art. In 1977 Barbara Rose stated categorically (based on her interviews with O'Keeffe?) that O'Keeffe "began reading Emerson and Thoreau when she was young." But Rose's conclusion that O'Keeffe's flower enlargements originated *not* from photography but from Thoreau's essay "The Method of Nature" (1841), and even more directly from Martin Johnson Heade's flower paintings, is far from my own. (For all of Rose's arguments, see Rose, "O'Keeffe's Trail," *New York Review of Books,* March 31, 1977, pp. 29–33.) The question as to whether O'Keeffe drew upon Thoreau because he was considered part of America's "usable past" by the Stieglitz circle or because she had always cherished his values for her art may never be known for certain. Both would seem to have figured—but well transformed by her own fiercely independent mind.

100. This work was shown at the Madison

(Wisconsin) Art Center's exhibition *Georgia O'Keeffe Paintings, 1919–1977* (March 3–April 29, 1988), where I first saw it.

101. *Petunia No. 2* (plate 133) belonged to O'Keeffe's sister Anita O'Keeffe Young, who acquired it directly from the artist. It was exhibited in the *Seven Americans* show and not seen publicly again until it was exhibited for auction at Sotheby's, New York (November 28–December 3, 1987), where I was able to see it at last. It was published in Nicholas Callaway, ed., *Georgia O'Keeffe: One Hundred Flowers* (New York: Callaway; Alfred A. Knopf, 1987), plate 12. In a September 26, 1976, interview with Meridel Rubenstein, O'Keeffe said that she thought her first magnified picture was a "horizontal painting of two huge pinkish flowers that a sister owns." (Rubenstein, "Circles and the Symmetry," p. 72.) And that is all she ever cared to say.

102. Stieglitz to Strand, June 1924, PSA.

103. Stieglitz to Rosenfeld, September 6, 1924, YCAL. The work mentioned may well be *Red Canna,* which belongs to the University of Arizona Museum of Art and is presently dated c. 1923. But O'Keeffe, to my knowledge, painted no work as advanced as this in 1923. Further, *Red Canna* has a strong stylistic kinship to the Whitney Museum's 1924 *Flower Abstraction* (plate 56). In all probability, *both* were painted during those amazingly creative weeks of the autumn of 1924, judging from Stieglitz's letters to Rosenfeld and Strand.

104. Stieglitz to Strand, September 14, 1924, PSA. Probably what Stieglitz meant by her "old" order was that these two large canvases were related to her 1915 charcoal abstractions.

105. Stieglitz to Rebecca Salsbury Strand, June 18, 1924, SA.

106. O'Keeffe, in Kuh, pp. 190–91.

107. Examples of O'Keeffe's urbane wit and love of parody abound. One of the more recent concerns her *Cow's Skull—Red, White and Blue* (1931): "How was the Great American Thing going to happen? So as I painted along on my cow's skull on blue I thought to myself, 'I'll make it an American painting. They will not think it great with the red stripes down the sides— Red, White and Blue—but they will notice it.' " (*O'Keeffe,* text opposite plate 58.) O'Keeffe also tells a nicely mocking story about herself and Duchamp—two of the more autobiographical artists of their time. "[Duchamp] was at my first large show in 1923 on the top floor of the Anderson Galleries . . . he came up to me quickly and said, 'But where is your self-portrait? Everyone has a self-portrait in his first show.' Well, I didn't have a self-portrait and we laughed about it and that's all I remember about that." (Quoted in Anne d'Harnoncourt and Kynaston McShine, eds., *Marcel Duchamp* [New York: Museum of Modern Art, 1973], pp. 212–13.)

108. *Single Alligator Pear* was first reproduced in *Dial* 79 (August 1925): 120. De Meyer met Stieglitz sometime between 1905 and 1906. His photographs were first exhibited at 291 (with those of George H. Seeley) in January–February 1907. He received solo shows at 291 in February 1909 and in December–January 1911–12. Seven of his photographs were published in *Camera Work* 24 (October 1908), and in 1912 an entire section of *Camera Work* 40 was given over to fourteen of his photogravures. The friendship between de Meyer and Stieglitz was unusual in that it never faltered. De Meyer died January 6, 1949, by then almost forgotten by his colleagues. For more monographic information, see Robert Brandau, ed., *De Meyer,* essay by Philippe Jullian (New York: Alfred A. Knopf, 1976).

109. Charles Caffin, "The de Meyer and Coburn Exhibitions," *Camera Work* 27 (July 1909): 29.

110. Two of Stieglitz's letters in particular reveal his aesthetic regard for de Meyer: "[De Meyer's] work is distinguished, and the medium is fully mastered from one point of view. His work is sincere. No man cannot see beyond himself. Should de Meyer develop personally his work will develop with him." (Stieglitz to Sadakichi Hartmann, December 22, 1911, YCAL.) "Outside of Baron de Meyer, who is here in New York very busy photographing society, and doing it in a masterful fashion, I see none of the photographers . . . because they have not developed mentally but have stood still during the past six or seven years." (Stieglitz to Ward Muir, January 30, 1913, SA.)

111. *O'Keeffe,* text opposite plate 31.

112. A letter from Stieglitz to Anderson seems to confirm O'Keeffe's seesaw state of mind during this intensively creative period: "Georgia has her ups and downs—if she could only tone down and not be upset by so many meaningless things." (September 5, 1924, SAP.)

113. *Three Pears No. 2* (plate 139) appeared in O'Keeffe's 1924 Anderson Galleries show as *Pears.* Cézanne's still life of a sugar bowl and pears (Venturi #624) was painted in 1893–94 and is now in a private

collection in Boston. I am grateful to John Rewald for this information (letter to author, April 11, 1989).

114. This curious small oil painting also appeared in O'Keeffe's 1924 Anderson Galleries show. I first saw it in New York, in a Zabriskie Gallery exhibition titled *Alfred Stieglitz and An American Place, 1929–1940,* May 2–June 3, 1978.

115. For the first of these arguments, see Stieglitz as quoted by Henry Tyrrell (critic of the *Christian Science Monitor*) and reprinted in *Camera Work* 48 (October 1916): 20; for the second, see Greenough, "From the American Earth," p. 48. Among the very few works of art by others that O'Keeffe liked to have around her were two African masks from Stieglitz's collection, which still hang on the walls of her studio at Abiquiu.

116. O'Keeffe to Anderson, Lake George, September 1923?; in *Letters,* pp. 174–75. The relationship between O'Keeffe and Anderson deserves much more investigation. She wrote him ten extraordinarily candid letters between 1923 and 1924. (All are in the SAP.) Five out of six of Stieglitz's 1923 photographs of Anderson are posed in front of her paintings; three clearly show *Lake George with Crows* in the background. In her letters to Anderson, O'Keeffe often expressed the pleasure she felt in reading his work, possibly recognizing in it a style as deceptively simple and spare as that of her own painting. The letters disclose that she felt she was writing to a kindred spirit. But Anderson never really responded in kind (his letters to Stieglitz are much more forthcoming), and this may be why O'Keeffe's simply stopped. For an informative short summary of the Stieglitz–Anderson relationship, see *Stieglitz,* p. 232, note for entry no. 33.

117. Stieglitz, interview with B. P. Stephenson, *New York Evening Post,* n.d.; in *Camera Work* 30 (April 1910): 45.

118. O'Keeffe, in Dorothy Seiberling, "Horizons of a Pioneer," *Life,* March 1, 1968, p. 52.

8. O'Keeffe and Stieglitz in New York City (pages 277–304)

EPIGRAPHS

O'Keeffe, in Blanche Matthias, "Georgia O'Keeffe and the Intimate Gallery," *Chicago Evening Post Magazine of the Art World,* March 2, 1926, p. 14.

Stieglitz to J. B. Neumann, June 18, 1924, J. B. Neumann Papers, AAA.

1. For the details on this decision and its advantages for both artists, see Lowe, 276–77.

2. See, for example, *O'Keeffe,* text opposite plate 17. The 291 idea of the "masculinity" of New York may have begun in March 1910, when Stieglitz presented *Younger American Painters,* an exhibition that included Arthur B. Carles, Arthur Dove, Marsden Hartley, John Marin, Alfred Maurer, and Max Weber—most of whom were obsessed with painting the modernity of the city. Marin's frankly muscular language in the catalog statement for his 1913 exhibition no doubt contributed to this idea: "I see great forces at work; great movements; the large buildings and the small buildings; the warring of great and small. . . . Feelings are aroused which give me the desire to express the reaction of these 'pull forces,' those influences which play with one another." (Reprinted in *Camera Work* 42–43 [April–July 1913]: 18.)

3. For some specifics on this, see her letter to Sherwood Anderson from Lake George dated June 11, 1924; in *Letters,* pp. 177–78.

4. O'Keeffe, in B. Vladimir Berman, "She Painted the Lily and Got $25,000 and Fame for Doing It! Not in a Rickety Atelier But in a Hotel Suite on the 30th Floor, Georgia O'Keefe [sic], New Find of Art World, Sets Her Easel," *New York Evening Graphic,* May 12, 1928, p. 3M; in Lynes, pp. 285–88.

5. For a short discussion of Stieglitz's important 1930s city photographs and the subjective order he was able to impose on the chaotic growth he saw going on outside his own windows, see *Stieglitz,* pp. 25–27.

6. Stieglitz to Rosenfeld, August 28, 1920, YCAL.

7. Stieglitz to Field, November 16, 1920, SA; published, in part, in *Stieglitz,* p. 202.

8. Stieglitz to Anderson, December 9, 1925; in *Stieglitz,* p. 214. There are other letters in this vein, such as the one he wrote to Rebecca Salsbury Strand: "I feel more & more 'out' of New York—maybe 'out' of the so-called world." (March 4, 1925, SA.)

9. Her *Brooklyn Bridge* (plate 2) seems to be the major exception to this rule.

10. Stieglitz to Weston, September 3, 1938; in *Stieglitz,* p. 218.

11. On the skyscraper as America's art form, see Ada Louise Huxtable, *The Tall Building Artistically Reconsidered: The Search for a Skyscraper Style* (New York: Pantheon, 1984). The name *skyscraper* for the tall office buildings going up in the late nine-

teenth century in Chicago came into use about 1890. For the skyscraper in New York, see Cervin Robinson and Rosemary Haag Bletter, *Skyscraper Style: Art Deco New York* (New York: Oxford University Press, 1975), p. 12. See also W. Parker Chase, *New York: Wonder City: 1932* (New York: Wonder City Publishing, 1932).

12. See P. A. Michelis, "Form in Architecture: Imitation and Abstraction," in Gyorgy Kepes, ed., *Sign, Image, Symbol* (New York: George Braziller, 1966), pp. 252–72.

13. This pastel of Dove's was exhibited at 291 in 1912 and at the Forum Exhibition, which O'Keeffe saw, in 1916.

14. Walt Whitman, "A Song for Occupations," *Leaves of Grass*, 1st ed. (1855; Harmondsworth, England: Penguin, 1959), p. 92.

15. Writing about Stieglitz's late nineteenth-century night photographs in *Photography as a Fine Art*, Caffin speaks of "the combined effects of brilliant and of diffused light" and says that *An Icy Night* "amply justifies [Stieglitz's] contention that a certain amount of 'halation' (the muzzy halo surrounding some of the lights) is true to facts and pictorially pleasant." (Caffin, *Photography as Fine Art* [1901; Hastings-on-Hudson, N.Y.: Morgan and Morgan, 1971], p. 45.) The first night photographs of streetlight reflections on wet pavement were made by the English photographer Paul Martin in February 1896. Stieglitz saw these and began his own experiments with New York at night in 1897.

16. For photographic illustrations of these two forms of halation, see C. I. Jacobson and R. E. Jacobson, *A Focal Manual of Photo-Technique: Developing the Negative Technique* (London and New York: Focal, 1970), pp. 186–87. I am indebted to Simon Heifetz for my knowledge of this useful source, which also includes a lucid discussion of the causes and prevention of halation (pp. 56–60).

17. There are three known pictures by O'Keeffe of barns from 1926. They are *Barn* (location unknown); *The Barns, Lake George* (formerly, *Side of the Barn No. 1*; location unknown); and *Lake George Barns* (formerly, *Side of the Barn No. 2*; Walker Art Center). The last is the most familiar of the three, although O'Keeffe thought that *Barn* (7 by 7 inches) was "maybe the best." (*O'Keeffe*, text opposite plates 44 and 45.)

18. O'Keeffe to Kennerley, January 20, 1929; in *Letters*, p. 187.

19. Stieglitz, February 26, 1926, in Seligmann, pp. 60–61.

20. For a technical discussion of this topic, see Ansel Adams, *The Negative* (Boston: New York Graphic Society, 1948), pp. 104–5, 109–10.

21. *Barn with Snow* is reproduced, tellingly, with *Lake George Barns* on the same page of *O'Keeffe*, plates 44 and 45.

22. In 1927 she painted *Red Barn in Wheat Field* (9 by 12 inches; location unknown); in 1928, *Red Barn, Wisconsin* (24⅛ by 37⅛ inches; location unknown), during a four-week visit to her old aunts there; and in 1929, *Lake George Barn*. Also painted was a huge mural (11 feet 2 inches by 35 feet 2 inches), apparently based on *Red Barn, Wisconsin*, but further information, including its present whereabouts, is so far unknown to me. Of these later works I have seen only the bright and cheerful *Red Barn, Wisconsin*.

23. Stieglitz to Dove, June 11, 1929; in Morgan, p. 176.

24. The iconic had also loomed large in Symbolist art theory. Used ideologically to represent the structure and the metaphorical meaning of things with the greatest possible clarity, the iconic frankly aimed to emphasize the spiritual over the material. For a classic discussion of the iconic element in Symbolist painting, see H. R. Rookmaaker, *Gauguin and Nineteenth-Century Art Theory* (Amsterdam: Swets and Zeitlinger, 1972), pp. 204–10. For a study of the iconic in twentieth-century painting (in which O'Keeffe is mentioned only for her crosses), see Joseph Masheck, "Iconicity," *Artforum* 17 (January 1979): 30–41.

25. On the problems of convergence with view cameras, and their corrections, see *Photography with Large-Format Cameras* (Rochester, N.Y.: Eastman Kodak, 1977), pp. 19–20, 24–26.

26. On lens flare, its distortions, and its advantageous aspects, see Adams, *Negative*, pp. 53–56.

27. *O'Keeffe*, text opposite plates 18 and 19.

28. Denis first expressed this famous idea in "De Gauguin et de Van Gogh au classicisme," *L'Occident* (Paris), May 1909: "Art is no longer only a visual sensation which we record, only a photograph, however refined it may be of nature. No, it is a creation of our spirit of which nature is only the occasion." The translation is from Herschel B. Chipp, *Theories of Modern Art: A Source Book for Artists and Critics* (Berkeley: University of California Press, 1968), p. 106.

29. Stieglitz to Anderson, August 9, 1925, SAP. "The huge machine" remark probably refers to the art market and Stieglitz's worry that O'Keeffe may have been sailing against the current compared, say, to what the "immaculates" Charles Sheeler, Charles Demuth, Louis Lozowick, and Joseph Stella—later called the Precisionists—were doing.

30. *City Night* (plate 148) followed the little-known *A Street in New York* (1926; first titled *Street, New York, No. 1;* Mr. and Mrs. Harry W. Anderson). They were, in fact, a series of two: *City Night* was exhibited at the Intimate Gallery in 1927 as *Street, New York, No. 2.* In the former the canyon effect is more marked and the convergence almost nonexistent.

31. For more on this, see Kent C. Bloomer and Charles W. Moore, *Body, Memory and Architecture* (New Haven, Conn.: Yale University Press, 1977), pp. 37–44. See also Gaston Bachelard, *The Poetics of Space,* first published in French under the title *La Poétique de l'espace* (1958; Boston: Beacon, 1969), pp. 5–6.

32. O'Keeffe, in Kuh, p. 202.

33. I know this for certain because in 1979, when the Shelton was being refurbished as the Halloran House, I received permission to visit suite 3003 and took a series of photographs out of O'Keeffe and Stieglitz's windows and also from the thirtieth floor of 777 Third Avenue (the new building that now blocks their once clear view of the river), using a normal focal length lens and telephotos of three different strengths. Stieglitz's photograph must have been taken with his 180mm Goertz Double Anastigmatic.

34. *East River, New York, No. 11,* owned by Flora Stieglitz Straus, who most generously allowed me to photograph it and her other works by O'Keeffe.

35. For more details on the construction and reception of this building, see Elizabeth Duvert, "Georgia O'Keeffe's 'Radiator Building': Icon of Glamorous Gotham," *Places* (Boston) 2, no. 2 (1985): 3–17. Duvert links O'Keeffe's painting with the transformation going on in the city streets, but she does not mention photography. She also sees *Radiator Building* as a celebration and parody of the city's new commercial image but did not notice O'Keeffe's self-portrait in it. Seligmann has written that O'Keeffe's painting was derived from "four years of study" of the motif. (Herbert J. Seligmann, "Georgia O'Keeffe," transcript of an essay, SA.)

36. Stieglitz described New York as a "mag-nificently *diabolical* place" in a letter to J. Dudley Johnson, June 25, 1924, Royal Photographic Society, London.

37. At first I thought O'Keeffe's idea of putting her silhouette on the Radiator Building's façade came from one of the electrically animated advertising signs on Broadway. But when I called the New-York Historical Society to inquire about when these signs first appeared, they told me that 1927 was several years too early. Therefore, O'Keeffe was, in effect, predicting the future. One suspects that later she was more amused than amazed by this.

38. Coburn's Pictorial photographs had been published in *Camera Work* 6 (April 1904), 15 (July 1906), and 21 (January 1908). Stieglitz, however, turned against Coburn personally about 1910, because Coburn tried to take too much credit for the Lumière process in London and for other reasons well enough described by Mike Weaver in *Alvin Langdon Coburn, 1882–1966: Man of Mark* (London: Royal Photographic Society, 1982), pp. 5–6. Stieglitz's opinion of Coburn's later work may have reflected this personal animosity. In a letter to J. Dudley Johnson of June 24, 1924, Stieglitz wrote: "I do believe Coburn had it in him to be much more than he is." (Royal Photographic Society.) O'Keeffe surely knew that Coburn had attended Dow's Summer School of Art at Ipswich, Massachusetts, in 1903 and that the two men felt close enough to each other to have visited the Grand Canyon together in 1911.

Strand and Sheeler's *Manhatta* was also influenced by Coburn's New York photographs. See Theodore E. Stebbins, Jr., and Norman Keyes, Jr., *Charles Sheeler: The Photographs* (Boston: New York Graphic Society, 1987), p. 19.

39. Three of these are: *East River from the Shelton* (plate 156); *East River from the 30th Story of the Shelton Hotel* (New Britain Museum of American Art); and *River, New York* (location unknown).

40. O'Keeffe to Kennerley, January 20, 1929; in *Letters,* p. 187.

41. During her fourteenth year O'Keeffe was taught by Dominican nuns, and she later attended the Chatham Episcopal Institute for two years. Her formative period would thus have included an easy familiarity with traditional religious art.

42. *O'Keeffe,* text opposite plate 20.

43. See, for example, Milton W. Brown, "Cubist-Realism: An American Style," *Marsyas* 3 (1946): 139–60; Martin L. Friedman, *The Precisionist View in American Art* (Minneapolis: Walker Art Center,

1960), pp. 11–52; Susan Fillin Yeh, *The Precisionist Painters, 1916–1949: Interpretations of a Mechanical Age* (Huntington, N.Y.: Heckscher Museum, 1978), pp. 9–15; Karen Tsujimoto, *Images of American Precisionist Painting and Modern Photography* (Seattle: University of Washington Press, 1982), pp. 13–106; Rick Stewart, "Charles Sheeler, William Carlos Williams, and Precisionism: A Redefinition," *Arts Magazine* 58 (November 1983): 111–12.

44. Robert Motherwell, "The Ides of Art—A Tour of the Sublime," *Tiger's Eye* 1 (December 1948): 48.

45. Louis H. Sullivan, *The Autobiography of an Idea,* foreword by Claude Bragdon (1924; New York: Dover, 1956), p. 298.

46. O'Keeffe to Dorothy Brett, New York, mid-February 1932; in *Letters,* p. 206.

47. Sullivan, *Autobiography of an Idea,* p. 328.

48. Louis H. Sullivan, *Kindergarden Chats and Other Writings* (1918; New York: Dover, 1979), p. 206.

49. In 1932 O'Keeffe was invited by the Museum of Modern Art to submit a design for their spring mural exhibition. She accepted and titled her three-panel design *Manhattan.* (The sketch is reproduced in *American Magazine of Art* 25 [August 1932]: 97.) These skyscraper forms look more Precisionist in their jagged linearity than anything else she ever did. The design was well received but led to the traumatic episode of her abortive large-scale mural project for Radio City and her subsequent mental breakdown. (See Lisle, pp. 207–12.) O'Keeffe's dogged desire to paint a mural in the face of Stieglitz's disapproval seems puzzling until we remember that Fenollosa and Dow thought of the mural as the acme of artistic endeavor.

50. O'Keeffe, in Bill Marvel, *National Observer,* October 19, 1970. (Whitney Museum's O'Keeffe files, under "clippings—newspapers.")

51. Adams in Paul Richard, "Ansel Adams: Appreciation," *Washington Post,* April 24, 1984; in Charles C. Eldredge et al., *Art in New Mexico, 1900–1945: Paths to Taos and Santa Fe* (Washington, D.C.: National Museum of American Art; New York: Abbeville, 1986), p. 179.

52. As Hartley wrote to Stieglitz, "[New Mexico] is not a country of light on things. It is a country of things on light. Therefore it is a country of form, with a new presentation of light as a problem." (August 26, 1918, YCAL.)

53. O'Keeffe to E. Stettheimer, August 24, 1929, Art Institute of Chicago. For an on-the-spot observer's account of O'Keeffe's 1929 summer in New Mexico, see Mabel Dodge Luhan, "Georgia O'Keeffe in Taos," *Creative Art* (June 1931): 406–10. The prodigious amount of work that O'Keeffe accomplished in those four months is seen in nineteen canvases: *Trees at Glorietta, New Mexico; Taos Pueblo, New Mexico; Ranchos Church I, N.M.; Ranchos Church II, N.M.; Ranchos Church III, N.M.; After a Walk Back at Mabel's, N.M.: White Flower, N.M.: Two Yellow Flowers, N.M.; Gray Cross with Blue; Black Cross with Stars and Blue; Black Cross with Red Sky; Black Cross, Arizona; After the Las Vegas Rodeo, N.M.; Pine Tree with Stars at Brett's, N.M.; Trees by Camp at Bear Lake, N.M.; The Wooden Virgin; Porcelain Rooster; Sand Hills, N.M.; Sand Hills, Alcalde, N.M.*

54. Such tenuous Symbolist images as Redon's *Light of Day* (1891) and *The Reader* (1892) were undoubtedly known to O'Keeffe, and perhaps, also, Mallarmé's poem *Les Fenêtres* (1863), which speaks so powerfully of liberation from the quotidian. Among the countless Post-Impressionist works using windows that O'Keeffe could easily have been familiar with—even if only through reproduction—are Cézanne's Card Player series (1890–92) and van Gogh's 1889 views from his window in the Saint-Rémy asylum. White's *Ring Toss* and *Drops of Rain* appeared in *Camera Work* 3 (July 1903): 14 and *Camera Work* 23 (July 1908): 41, respectively. Puyo's *Nude* appeared in *Camera Work* 16 (October 1906): 29. Stieglitz's *Snapshot—From My Window, New York* appeared in *Camera Work* 20 (October 1907): 41.

55. Matisse's unusually abstract *Open Window at Collioure* (1914) is the one work that might be compared to O'Keeffe's *Lake George Window.* Their formal similarities are quite startling, and both have a despairing quality due to their opaqueness and somber, black-dominated palettes. (Matisse's uncharacteristic work may have reflected his anguish over the onset of World War I.) It is, however, extremely unlikely that O'Keeffe knew Matisse's painting. It was owned by a private collector in Paris until recently and was not exhibited in the United States until 1966. It belongs now to the Musée National d'Art Moderne, Centre Georges Pompidou, Paris.

56. O'Keeffe may have known Duchamp's *Fresh Widow* (1920), his visual pun based on a miniature French window, with panes covered in black leather. She and Stieglitz were great admirers of Duchamp and his alter ego "Rrose Sélavy."

57. O'Keeffe to Mabel Dodge Luhan, Lake

George, September 1929; in *Letters,* p. 196.

58. O'Keeffe to Dorothy Brett, New York, early April 1930; ibid., p. 200.
59. O'Keeffe to Russell Vernon Hunter, New York, spring 1932; ibid., p. 207.

Coda (pages 305–6)

1. O'Keeffe to Dorothy Brett, September 1932; in *Letters,* p. 210.
2. For a brief history of what is known about the eleven-thousand-year-old Anasazi culture up to the present-day (still largely secret) practices in Pueblo villages, see Dewitt Jones and Linda S. Cordell, *Anasazi World* (Portland, Ore.: Graphic Arts Center, 1985).
3. O'Keeffe to Mabel Dodge Luhan, September 1929; in *Letters,* p. 196.
4. As quoted in Joseph Campbell, *The Hero with a Thousand Faces* (New York: Pantheon, 1949), pp. 349–50.
5. Thomas Berry, *The Dream of the Earth* (San Francisco: Sierra Club Books, 1988), p. 215.
6. O'Keeffe, in the catalog for *Georgia O'Keeffe: Exhibition of Oils and Pastels* (New York: An American Place, 1939).

ACKNOWLEDGMENTS

First of all I wish to pay tribute to some of the extraordinary teachers I have had the luck to study with over the years. No one could have received greater inspiration or more patient guidance, and I mention their names with the most profound gratitude: Rudolf Arnheim, Dore Ashton, Robert Branner, Otto Brendel, Milton Brown, Joseph Campbell, William Gerdts, Evelyn Harrison, Rose-Carol Washton Long, Linda Nochlin, Robert Pincus-Witten, John Rewald, William Rubin, Meyer Schapiro, and Leo Steinberg. I owe special thanks to my thesis adviser, Eugene Goossen, for his wisdom, his concern for accurate prose, and his unflagging encouragement. Special thanks also to Peter C. Bunnell of Princeton University, who generously took on the task of being my second adviser. His help has been as continuous as it was invaluable, and his own deep understanding of Stieglitz's work was a reliable compass throughout my far-ranging explorations.

Lacking O'Keeffe's cooperation, I faced many formidable problems. My work would not have been possible in the same way—perhaps not possible at all—without the timely aid of two people: Lloyd Goodrich, the late director emeritus of the Whitney Museum of American Art, who arranged permission for me to photograph the museum's private research file of O'Keeffe's paintings (begun by Rosalind Irvine), which enabled me gradually to construct a working visual chronology. And the artist Patricia Johanson, who freely shared the catalogue raisonné of O'Keeffe's oeuvre that she compiled in 1966, working from the notebooks at Abiquiu with the artist's permission and cooperation. Although not conclusive, because numerous works have turned up since then, it has nonetheless been an extremely important tool. I am deeply grateful to them both.

Many people who had known O'Keeffe and Stieglitz for a long time agreed to be interviewed, including Ansel Adams, Georgia Engelhard

Cromwell, Louise March, Blanche Matthias, Dorothy Norman, Dorothy Schubart, and Flora Stieglitz Straus. Of additional value were the well-researched biographies by Laurie Lisle (*Portrait of an Artist: A Biography of Georgia O'Keeffe*) and Sue Davidson Lowe (*Stieglitz: A Memoir/Biography*), which came out midway through my task. More recently, Roxana Robinson's *Georgia O'Keeffe: A Life,* has presented much new information about O'Keeffe's youth (before Stieglitz) and her stalwart ancestors on both sides of the family. All three authors have been most generous with their time in answering my extra questions. And, early on, Sue Lowe made it possible for me to see some of the wonderful paintings by O'Keeffe then still owned by the Stieglitz family. I wish to express particular appreciation to Doris Bry, who recently took time from her own work to answer my long list of questions. She also gave me kind permission to reproduce in this book two of her works by O'Keeffe.

Without Sarah Greenough's primary scholarship on Stieglitz's writings and, later, O'Keeffe's letters, my work would have been far more difficult. We met in May 1978, when I first went to the National Gallery of Art in Washington, D.C., to study the "key set" of Stieglitz's photographs and she was a Kress Foundation fellow charged with cataloguing it. Over the years we have exchanged a number of ideas in true collegial spirit, and I, for one, have benefited greatly from our discussions and from her always generous and straightforward help.

I was aided in diverse ways by many others to whom I owe warm thanks: Dr. Mary Steichen Calderone, Nicholas Callaway, Susan Cohn, William C. Dove, Charles Eldredge, Simon Heifetz (who taught me about the photographic process), Katherine Hoffman, William Innes Homer (who, in 1976, let me read the transcript of his important 1972 interview with O'Keeffe), David McAlpin, Lewis Mumford, Gerald P. Peters, Terence R. Pitts of the Center for Creative Photography, and Mrs. Frederick Reinert of the Ipswich Historical Society. To Georgia Engelhard Cromwell (Stieglitz's niece, herself a fine photographer), to Nina Howell Starr, photographer and scholar, and to Grace M. Mayer, of the Steichen Archive at the Museum of Modern Art, my heartfelt appreciation for help and courtesies beyond all expectation.

I wish to thank Patricia M. Howell and Anne Whelpley, librarians of the Beinecke Rare Book and Manuscript Library of Yale University; Patricia C. Willis, curator of American Literature at the Beinecke; and Donald Gallup, curator emeritus of the Beinecke and agent for the Estate of Georgia O'Keeffe. Also, Cecilia Chin, formerly of Ryerson Library, Art Institute of Chicago; May Fitzgerald of the Whitney Museum of American Art library; Diana Haskell of the Newberry Library,

Chicago; and the incredibly knowledgeable staffs of the Archives of American Art, the George Eastman House, in Rochester, New York, and the New York Public Library. Also, the co-representatives of the Estate of Georgia O'Keeffe for the permissions they did grant to me.

Still others to whom I owe special debts of thanks are: Elizabeth C. Baker, Irwin R. Berman, Roland Buffat, Marcel Burri, Laura Coyle, Sandra D'Emilio, John Driscoll, Frederick J. Fisher of the Hyde Collection, Jean France, Thomas Garver, John Gernand, Elizabeth Glassman, Frederick Golomb, Lynn Gould, Christopher Hewat, William Alexander Hewitt, Ronald Hill, Michael E. Hoffman, Jack and Margaret Huyler, Estelle Jussim, Anne Kennedy, Gail Levin, Harry Lunn, Barbara Buhler Lynes, Nancy Merritt, Caroline Sheahan Meyer, Charles Millard, Anthony Montoya, Peggy Davidson Murray, Carlotta Owens, Susan Dodge Peters (who sent me much useful material, including some of her original research on Elizabeth McCausland), Christopher Phillips, Elizabeth Pollock, Martha S. Price, Joyce Rosa, Ned Rosenthal, Roberta W. Rossetter, Cynthia Lukens Schoen, Patterson Sims, Margaret W. Snare, Joanna T. Steichen, Kate Rodina Steichen, Hazel Strand, Alan Trachtenberg, Andrea Turnage, Malcolm Varon, Richard York, and Virginia Zabriskie.

I have been sustained and stretched by discussions with my colleagues at the City University of New York, especially Julia Ballerini, Taube Greenspan, Sandra S. Phillips, and Naomi Rosenblum.

Although in the text I have mainly referred to photographic criticism of the period, my eye and mind have also benefited greatly from recent writings on the nature of photographic meaning. From Robert Adams, Rudolf Arnheim, Hollis Frampton, Peter Galassi, Rosalind Krauss, Christopher Phillips, Henry Holmes Smith, Joel Snyder, Abigail Solomon-Godeau, Susan Sontag, John Szarkowski, and Kirk Varnedoe, I have learned and pondered much. Respectful thanks to them all.

I am most appreciative of the friends who listened patiently to my ideas, read sections of the manuscript, and offered practical advice and encouragement—especially Thomas Cassilly, Anne C. Fredericks, George Hamlin, and Greg Schwed.

Warmest thanks go to Mark Flower, Mike Peters, and John Von Sneidern, who helped photograph some of my material; to Lila Brooks, Deborah Glaser Henry, Maggie Peters, and Heide Waleson, who with great calm and skill, under terrific pressure, typed successive handwritten drafts of the dissertation; and to Gloria Lorenzo of Jackson, Wyoming, who cheerfully and accurately met every deadline in keying the book manuscript into the computer.

I am very grateful to Annie Martin, Vivian Munroe, and Dorothy S. Norman for the many reasons they (and I) know best.

For making this book happen, I owe everything to the extremely able, never-say-die staff and free-lancers at Abbeville Press. Especially to Adrienne Aurichio, Theresa Czajkowska, Sharon Gallagher, Sue Heinemann, Hope Koturo, Philip Reynolds, Karen Sherman, and particularly to the fine designer Joel Avirom. I only wish I had words big enough to thank my remarkable editor, Nancy Grubb. It was she who first thought the dissertation should be a book and she who, with great sensitivity, suggested how to recast a vast amount of unruly material in ways to better interest "the gentle reader." If I have succeeded it is in part because of what I learned from Nancy.

Last, but far from least, I wish to express my deepest gratitude to my large and wonderful family, who helped in all sorts of ways and who somehow kept and communicated their strong faith in what I was doing for so long. Most especially my husband, Arthur King Peters, and our children, Robert Bruce Peters and Susan Dodge Peters, Margaret Peters Schwed and Peter Gregory Schwed, and Michael Whitaker Peters. To Bruce I owe special thanks for editorial and technological help all along the line.

SELECTED BIBLIOGRAPHY

For a much-expanded bibliography, including numerous sources related to photography, American cultural history, and criticism, see Sarah Whitaker Peters, "Georgia O'Keeffe and Photography: Her Formative Years, 1915–1930" (Ph.D. diss., City University of New York, 1987).

ARCHIVAL SOURCES

Archives of American Art, Smithsonian Institution, Washington, D.C. The Papers of Arthur Dove, Arthur Wesley Dow, Marsden Hartley, Henry McBride, Elizabeth McCausland, J. B. Neumann, Charles Sheeler, and Max Weber.

The Art Institute of Chicago. The Papers of Daniel Catton Rich and Ettie Stettheimer.

Columbia Teachers College Art Department, New York. Georgia O'Keeffe files.

Museum of Modern Art, New York. Edward Steichen Archive.

Newberry Library, Chicago. Sherwood Anderson Papers.

New York Public Library, Astor, Lenox, and Tilden Foundations, Rare Books and Manuscripts Division. Mitchell Kennerley Papers.

Royal Photographic Society, Bath, England. J. Dudley Johnson Papers.

University of Arizona, Center for Creative Photography, Tucson. The Archives of Ansel Adams, Ernest Bloch, and Paul Strand.

University of California, Berkeley, Regional Oral History Office. Ansel Adams, transcript of interviews by Edward Teiser, 1972.

University of Pennsylvania, Philadelphia, Special Collections, Van Pelt Library. Waldo Frank Collection.

Whitney Museum of American Art, New York. Georgia O'Keeffe files.

Yale Collection of American Literature, Beinecke Rare Book and Manuscript Library, Yale University, New Haven, Conn. The Archives of Mabel Dodge Luhan, Henry McBride, Paul Rosenfeld, Gertrude Stein, and Alfred Stieglitz/Georgia O'Keeffe.

GEORGIA O'KEEFFE

Writings by O'Keeffe

"Can a Photograph Have the Significance of Art?" *Manuscripts* 4 (December 1922): 17–18.

Statement. In *Alfred Stieglitz Presents One Hundred Pictures, Oils, Water-colors, Pastels, Drawings by Georgia O'Keeffe, American.* New York: Anderson Galleries, 1923.

Statement. *Alfred Stieglitz Presents Fifty-one Recent Pictures, Oils, Water-colors, Pastels, Drawings by Georgia O'Keeffe, American.* New York: Anderson Galleries, 1924.

Catalogue of the 14th Annual Exhibition of Paintings with Some Recent O'Keeffe Letters. New York: An American Place, 1937. Includes eight letters written to Alfred Stieglitz from Ghost Ranch, New Mexico, 1937.

About Myself. New York: An American Place, 1939.

Statement. In *Georgia O'Keeffe: Exhibition of Oils and Pastels.* New York: An American Place, 1939.

Statement. In *Georgia O'Keeffe: Exhibition of Oils and Pastels*. New York: An American Place, 1940.

Letter to the editor. "Opinions under Postage." *New York Times,* February 23, 1941, art sec., p. 9.

"About Painting Desert Bones." In *Georgia O'Keeffe: Paintings—1943*. New York: An American Place, 1944.

"A Letter from Georgia O'Keeffe." *Magazine of Art* 37 (February 1944): 70.

"Stieglitz: His Pictures Collected Him." *New York Times Magazine,* December 11, 1949, pp. 24–26, 28–30.

Statement. In *Exhibition of Contemporary American Painting and Sculpture*. Urbana: University of Illinois, 1955.

Statement. In John I. H. Baur. *Nature in Abstraction*. New York: Whitney Museum of American Art; Macmillan, 1958.

Statement. In *Art USA Now,* I. Edited by Lee Nordness. Lucerne, Switzerland: C. J. Bucher, 1962.

Letter. In "Letters from Thirty-one Artists to the Albright-Knox Art Gallery." *Gallery Notes* 31 (Spring 1970): 28.

"My Collection of Alfred Stieglitz Photographs—Georgia O'Keeffe," c. 1970. Stieglitz/O'Keeffe Archive, Yale Collection of American Literature, Beinecke Rare Book and Manuscript Library, Yale University, New Haven, Conn.

Some Memories of Drawings. Edited by Doris Bry. New York: Atlantis, 1974.

Georgia O'Keeffe. New York: Viking, 1976.

Introduction. In *Georgia O'Keeffe: A Portrait by Alfred Stieglitz*. New York: Metropolitan Museum of Art, 1978.

Books and Catalogs

Bluemner, Oscar. "A Painter's Comment." In *Georgia O'Keeffe: Paintings, 1926*. New York: Intimate Gallery, 1927.

Callaway, Nicholas, ed. *Georgia O'Keeffe: One Hundred Flowers*. New York: Callaway; Alfred A. Knopf, 1987.

——— and Doris Bry, eds. *Georgia O'Keeffe: In the West*. New York: Alfred A. Knopf, 1989.

Castro, Jan Garden. *The Art and Life of Georgia O'Keeffe*. New York: Crown, 1985.

Cowart, Jack, Juan Hamilton, and Sarah Greenough. *Georgia O'Keeffe: Art and Letters*. Washington, D.C.: National Gallery of Art; Boston: New York Graphic Society, 1987.

Eldredge, Charles C. *American Imagination and Symbolist Painting*. New York: Grey Art Gallery, 1979.

Frank, Waldo. "White Paint and Good Order." In *Time Exposures by Search Light*. New York: Boni and Liveright, 1926.

Georgia O'Keeffe and Her Contemporaries. Amarillo, Tex.: Amarillo Art Center, 1985.

Georgia O'Keeffe Drawings. Introduction by Lloyd Goodrich. New York: Atlantis, 1968.

Georgia O'Keeffe: An Exhibition of Oils, Watercolors and Drawings. Lincoln, Neb.: Sheldon Memorial Art Gallery, 1980.

Georgia O'Keeffe: Paintings, 1919–1977. Madison, Wis.: Madison Art Center, 1984.

Goodrich, Lloyd, and Doris Bry. *Georgia O'Keeffe*. New York: Whitney Museum of American Art, 1970.

Goossen, E. C. *The Art of the Real: U.S.A., 1948–1968*. New York: Museum of Modern Art, 1968.

Hartley, Marsden. "Some Women Artists in Modern Painting." In *Adventures in the Arts*. 1921; New York: Hacker Art Books, 1972.

———. *Georgia O'Keeffe: Exhibition of Recent Paintings, 1935*. New York: An American Place, 1936.

Haskell, Barbara. "Georgia O'Keeffe, Works on Paper: A Critical Essay." In *Georgia O'Keeffe: Works on Paper*. Santa Fe: Museum of New Mexico Press, 1985.

Kuh, Katharine. "Georgia O'Keeffe" [interview]. In *The Artist's Voice*. New York: Harper and Row, 1962.

Lawrence, Ruth. *Five Painters*. Minneapolis: University Gallery, Minnesota University, 1937.

Lisle, Laurie. *Portrait of an Artist: A Biography of Georgia O'Keeffe*. 1980. Revised edition. Albuquerque: University of New Mexico Press, 1986.

Lynes, Barbara Buhler. *O'Keeffe, Stieglitz and the Critics, 1916–1929*. Ann Arbor, Mich.: UMI Research Press, 1989.

M. Carey Thomas Awards to Hannah Arendt and Georgia O'Keeffe. Bryn Mawr, Pa.: Bryn Mawr College, October 1971.

Messinger, Lisa Mintz. *Georgia O'Keeffe*. New

York: Metropolitan Museum of Art; Thames and Hudson, 1988.

Munro, Eleanor. *"Georgia O'Keeffe."* In *Originals: American Women Artists*. New York: Simon and Schuster, 1979.

Northrop, F.S.C. *The Meeting of East and West: An Inquiry Concerning World Understanding*. New York: Macmillan, 1946.

Norwood, Vera, and Janice Monk, eds. *The Desert Is No Lady: Southwestern Landscapes in Women's Writing and Art*. New Haven, Conn.: Yale University Press, 1987.

O'Keeffe: Paintings in Pastel, 1914–1945. New York: Downtown Gallery, [1952].

Peters, Sarah W. *"Georgia O'Keeffe."* In *Women Artists: 1550–1950*. Edited by Ann Sutherland Harris and Linda Nochlin. Los Angeles: Los Angeles County Museum of Art; New York: Alfred A. Knopf, 1976.

————. *"Georgia O'Keeffe."* In *Portraits of American Women: From Settlement to the Present*. Edited by G. J. Barker-Benfield and Catherine Clinton. New York: St. Martin's, 1990.

Pincus-Witten, Robert. *"Georgia O'Keeffe: From Icon of Nature to the Transsubstantive Photograph."* In *Georgia O'Keeffe: Selected Paintings and Works on Paper*. New York: Hirschl and Adler Galleries, 1986.

Pollitzer, Anita. *A Woman on Paper: Georgia O'Keeffe*. New York: Simon and Schuster, 1988.

Rich, Daniel Catton. *Georgia O'Keeffe*. Chicago: Art Institute of Chicago, 1943.

————. *Georgia O'Keeffe*. Worcester, Mass.: Worcester Museum of Art, 1960.

Robinson, Roxana. *Georgia O'Keeffe: A Life*. New York: Harper and Row, 1989.

Sims, Patterson. *Georgia O'Keeffe: A Concentration of Works from the Permanent Collection of the Whitney Museum of American Art*. New York: Whitney Museum of American Art, 1981.

Wilder, Mitchell A., ed. *Georgia O'Keeffe: An Exhibition of the Artist from 1915 to 1966*. Fort Worth: Amon Carter Museum of Western Art, 1966.

The Work of Georgia O'Keeffe: A Portfolio of Twelve Paintings. Essays by Leo Katz and James W. Lane. New York: Knight, 1937.

Dissertations and Master's Theses

Cohn, Susan F. "An Analysis of Selected Works by Georgia O'Keeffe and a Production

of Drawings by the Researcher Relating to the Work of the Artist Studied." Ph.D. diss., New York University, 1974.

Eldredge, Charles Child, III. "Georgia O'Keeffe: The Development of an American Modern." Ph.D. diss., University of Minnesota, 1971.

Hoffman, Katherine A. "A Study of the Art of Georgia O'Keeffe from 1916–1974." Ph.D. diss., New York University, 1975.

Peters, Sarah Whitaker. "Georgia O'Keeffe and Photography: Her Formative Years, 1915–1930." Ph.D. diss., City University of New York, 1987.

Rubenstein, Meridel. "The Circles and the Symmetry: The Reciprocal Influence of Georgia O'Keeffe and Alfred Stieglitz." Master's thesis, University of New Mexico, 1977.

Articles

Abrahams, Edward. "The Image Maker." *New Republic,* January 30, 1989, pp. 41–45.

Agee, William C. " 'Helga' and Other Problems." *New Criterion* (April 1988): 47–52.

Baker, Kenneth. "What Went Wrong?" *Connoisseur* (November 1987): 170–75.

Berman, B. Vladimir. "She Painted the Lily and Got $25,000 and Fame for Doing It! Not in a Rickety Atelier But in a Hotel Suite on the 30th Floor, Georgia O'Keefe [sic], New Find of the Art World, Sets Her Easel." *New York Evening Graphic,* May 12, 1928, p. 3M.

Brenson, Michael. "How O'Keeffe Painted Hymns to Body and Spirit." *New York Times,* November 8, 1987, pp. 37, 43.

Bry, Doris. "Georgia O'Keeffe." *Journal of American Association of University Women* 34 (January 1952): 79–80.

Burroughs, Alan. "Studio and Gallery." *New York Sun,* February 3, 1923, p. 9.

Canaday, John. "O'Keeffe Exhibition: An Optical Treat." *New York Times,* October 8, 1970, p. 60.

————. "Georgia O'Keeffe: The Patrician Stance as Esthetic Principle." *New York Times,* October 11, 1970, sec. 2, p. 3.

Cary, Elizabeth Luther. "Art: Exhibitions of the Week." *New York Times,* March 9, 1924, sec. 8, p. 10.

Chave, Anna C. "O'Keeffe and the Masculine Gaze." *Art in America* 78 (January 1990): 115–25, 177, 179.

Coates, Robert M. "Profiles: Abstraction—Flowers." *New Yorker,* July 6, 1929, pp. 21–24.

Crimp, Douglas. "Georgia Is a State of Mind." *Artnews* (October 1970): 48–51, 84–85.

Davis, Douglas. "Return of the Native." *Newsweek,* October 12, 1970, p. 105.

Duvert, Elizabeth. "Georgia O'Keeffe's 'Radiator Building': Icon of Glamorous Gotham." *Places* (Boston) 2, no. 2 (1985): 3–17.

Eisler, Benita. "Scenes from a Marriage." *Mirabella* (July 1989): 178–86.

Fisher, William Murrell. "The Georgia O'Keeffe Drawings and Paintings at '291.'" *Camera Work* 49–50 (June 1917): 5.

Forman, Nessa. "Georgia O'Keeffe and Her Art: 'Paint What's in Your Head.'" *Philadelphia Museum Bulletin,* October 22, 1971.

"Georgia O'Keeffe—C. Duncan—René Lafferty." *Camera Work* 48 (October 1916): 12–13.

Gilpin, Laura. "The Austerity of the Desert Pervades Her Home and Her Work." *House Beautiful* (April 1963): 144–45.

Glueck, Grace. "Art Notes: 'It's Just What's in My Head.'" *New York Times,* October 18, 1970, sec. 2, p. 24.

———. "O'Keeffe, Once an Icon, Is Now an Industry." *New York Times,* November 14, 1989, pp. C19–20.

Goossen, E. C. "O'Keeffe." *Vogue* (March 1967): 174–79, 221–24.

Greenberg, Clement. "Art." *Nation,* June 15, 1946, p. 727.

Gruen, John. "Galleries and Museum: Georgia on Our Mind." *New York Magazine,* October 19, 1970, p. 60.

Hobhouse, Janet. "A Peculiar Road to Sainthood." *Newsweek,* November 9, 1987, pp. 74–78.

Hoffman, Donald. "An Unfulfilled Promise from Georgia O'Keeffe." *Kansas City Star,* May 8, 1988, pp. 1–2E.

Hughes, Robert. "Art Loner in the Desert." *Time,* October 12, 1970, pp. 64–67.

———. "A Vision of Steely Finesse." *Time,* March 17, 1986, p. 83.

"I Can't Sing, So I Paint! Says Ultra Realist; Art Is Not Photography—It Is Expression of Inner Life!: Miss Georgia O'Keeffe Explains Subjective Aspect of Her Work." *New York Sun,* December 5, 1922, p. 22.

Israel, Franklyn. "Architectural Digest Visits Georgia O'Keeffe." *Architectural Digest* (July 1981): 76–85, 136, 138.

Janos, Leo. "Georgia O'Keeffe at 84." *Atlantic Monthly* (December 1971): 114–17.

Jewell, Edward Alden. "O'Keeffe: Thirty Years." *New York Times,* May 11, 1946, sec. 2, p. 6.

———. "Georgia O'Keeffe, Mystic." *New York Times,* May 19, 1946, sec. 2, p. 6.

Kalonyme, Louis. "Georgia O'Keeffe: A Woman in Painting." *Creative Art* (January 1928): 35–40.

Kotz, Mary Lynn. "Georgia O'Keeffe at 90." *Artnews* 76 (December 1977): 37–45.

Kramer, Hilton. "Georgia O'Keeffe." Review of *Georgia O'Keeffe* (1976). *New York Times Book Review,* December 12, 1976, pp. 1, 30–32.

Lane, James W. "Notes from New York." *Apollo* (April 1930): 209.

Larson, Kay. "Made in the Trade." *New York Magazine,* December 5, 1988, pp. 186–88.

Looney, Ralph. "Georgia O'Keeffe." *Atlantic Monthly* (April 1965): 106–10.

Luhan, Mabel Dodge. "The Art of Georgia O'Keeffe." Undated typescript, Luhan Archive, Yale Collection of American Literature, Beinecke Rare Book and Manuscript Library, Yale University, New Haven, Conn.

———. "Georgia O'Keeffe in Taos." *Creative Art* (June 1931): 406–10.

McBride, Henry. "Art News and Reviews." *New York Herald,* February 4, 1923, sec. 7, p. 7.

———. "Georgia O'Keefe's [sic] Work Shown." *New York Sun,* January 15, 1927, p. 22B.

———. "Georgia O'Keefe's [sic] Recent Work." *New York Sun,* January 14, 1928, p. 8.

———. "Paintings by Georgia O'Keefe [sic]: Decorative Art That Is Also Occult at the Intimate Gallery." *New York Sun,* February 9, 1929, p. 7.

McCausland, Elizabeth. "Georgia O'Keeffe Exhibits Skulls and Roses of 1931." *Springfield Sunday Union and Republican,* May 1, 1932, p. 6E.

———. "Georgia O'Keeffe Is 'Practical' Too." *Springfield Daily Republican,* January 16, 1935, p. 6E.

———. "Georgia O'Keeffe's Flower Paint-

ings." *Springfield Daily Republican*, April 28, 1935, p. 6E.

————. "A Painter's Development: Georgia O'Keeffe's Annual Exhibition." *Springfield Daily Republican*, January 12, 1936, p. 6E.

————. "New York Realists at Whitney Museum." *Springfield Daily Republican*, February 14, 1937, p. 6E.

————. "Georgia O'Keeffe Shows Her Latest Paintings." *Springfield Daily Republican*, January 8, 1938, p. 6E.

————. "Georgia O'Keeffe in a Retrospective Exhibition." *Springfield Sunday Union and Republican*, May 26, 1946, p. 6C.

Masheck, Joseph. "Iconicity." *Artforum* 17 (January 1979): 30–41.

Matthias, Blanche. "Georgia O'Keeffe and the Intimate Gallery—Stieglitz Showing Seven Americans." *Chicago Evening Post Magazine of the Art World*, March 2, 1926, pp. 1, 14.

Millikin, William M. " 'White Flower' by Georgia O'Keeffe." *Bulletin of the Cleveland Museum of Art* 24 (April 1937): 51–53.

Mumford, Lewis. "O'Keefe [sic] and Matisse." *New Republic*, March 2, 1927, pp. 41–42. Reprinted in *O'Keeffe Exhibition*. New York: Intimate Gallery, 1928.

————. "The Art Galleries." *New Yorker*, January 21, 1933, pp. 48–49.

————. "The Art Galleries: Sacred and Profane." *New Yorker*, February 10, 1934, pp. 47–49.

Nochlin, Linda. "Why Have There Been No Great Women Artists?" *Artnews* (January 1971): 22–39, 67–71.

————. "Some Women Realists: Part I." *Arts Magazine* 48 (February 1974): 46–51.

Oaks, Gladys. "Radical Writer and Woman Artist Clash on Propaganda and Its Uses." *New York World*, March 16, 1930, women's sec., pp. 1, 3.

O'Brien, Frances. "Americans We Like: Georgia O'Keeffe." *Nation*, October 12, 1927, pp. 361–62.

Perl, Jed. "O'Keeffe in the Capital." *New Criterion* (January 1988): 22–26.

Plagens, Peter. "A Georgia O'Keeffe Retrospective in Texas." *Artforum* (May 1966): 27–31.

Pollitzer, Anita. "That's Georgia." *Saturday Review of Literature*, November 4, 1950, pp. 41–43.

Read, Helen Appleton. "Georgia O'Keeffe's Show an Emotional Escape." *Brooklyn Daily Eagle*, February 11, 1923, p. 2B.

————. "News and Views on Current Art: Georgia O'Keefe [sic] Again Introduced by Stieglitz at the Anderson Galleries." *Brooklyn Daily Eagle*, March 9, 1924, p. 2B.

Rose, Barbara. "Georgia O'Keeffe: The Paintings of the Sixties." *Artforum* (November 1970): 42–46.

————. "Visiting Georgia O'Keeffe." *New York Magazine*, November 9, 1970, pp. 60–61.

————. "O'Keeffe's Trail." *New York Review of Books*, March 31, 1977, pp. 29–33.

Rosenfeld, Paul. "American Painting." *Dial* 71 (December 1921): 649–70.

————. "The Paintings of Georgia O'Keeffe: The Work of the Young Artist Whose Canvases Are to Be Exhibited for the First Time This Winter." *Vanity Fair* 19 (October 1922): 56, 112, 114.

————. "After the O'Keeffe Show." *Nation*, April 8, 1931, pp. 388–89.

Schjeldahl, Peter. "She Would Not Yield." *7 Days*, January 18, 1989, pp. 51–52.

Schwartz, Sanford. "Georgia O'Keeffe Writes a Book." *New Yorker*, August 28, 1978, pp. 87–91.

Scott, Nancy. "The O'Keeffe–Pollitzer Correspondence, 1915–1917." *Source* 3 (Fall 1983): 34–41.

Seiberling, Dorothy. "Horizons of a Pioneer." *Life*, March 1, 1968, pp. 40–53.

Seligmann, Herbert J. "Georgia O'Keeffe, American." *Manuscripts* 5 (March 1923): 10.

Solomon, Deborah. "Inspired Illustrator." *New Criterion* (June 1990): 78–81.

Strand, Paul. "Georgia O'Keeffe: A Woman in Painting." 1924. Draft. Paul Strand Archive, Center for Creative Photography, University of Arizona, Tucson.

————. "Georgia O'Keeffe: A Woman in Painting." *Playboy* 9 (July 1924): 16–20.

Tomkins, Calvin. "The Rose in the Eye Looked Pretty Fine." *New Yorker*, March 4, 1974, pp. 40–66.

Tyrrell, Henry. "New York Art Exhibitions and Gallery News." Review of the exhibition *Georgia O'Keeffe—C. Duncan—René Lafferty*. *Christian Science Monitor*, June 2, 1916, p. 10.

————. "New York Art Exhibition and Gallery Notes: Esoteric Art at 291." Review of

the exhibition *Georgia O'Keeffe. Christian Science Monitor,* May 4, 1917, p. 10.

Watson, Ernest W. "Georgia O'Keeffe." *American Artist* (June 1943): 7–11.

"Woman from Sun Prairie." *Time,* February 8, 1943, pp. 42, 44.

Yau, John. "O'Keeffe Misfocus." *Artnews* 87 (February 1988): 114–19.

Yeh, Susan Fillin. "Innovative Moderns: Arthur G. Dove and Georgia O'Keeffe." *Arts Magazine* 56 (Summer 1982): 68–72.

ALFRED STIEGLITZ

Writings by Stieglitz

"Extracts Etc., Begun November, 1884." Stieglitz Archive, Yale Collection of American Literature, Beinecke Rare Book and Manuscript Library, Yale University, New Haven, Conn.

"A Plea for Art Photography in America." *Photographic Mosaics* 28 (1892): 135–37.

Camera Notes 1 (July 1897): 3.

"Our Illustrations." *Camera Notes* 3 (July 1899): 24.

"Pictorial Photography." *Scribner's Magazine* 26 (November 1899): 528–37.

"The Photo-Secession at the National Arts Club, New York." *Photograms of the Year 1902,* pp. 17–20.

"The Photo-Secession." In *Bausch and Lomb Lens Souvenir.* Rochester, N.Y.: Bausch and Lomb Optical Company, 1903.

"The Photo-Secession—Its Objectives." *Camera Craft* 8 (1903): 81–83.

"Simplicity in Composition." In *The Modern Way of Picture Making.* Rochester, N.Y.: Eastman Kodak, 1905.

"The New Color Photography—A Bit of History." *Camera Work* 20 (October 1907): 20.

"Our Illustrations." *Camera Work* 32 (October 1910): 47.

Interview. In "The First Great 'Clinic' to Revitalize Art." *New York American,* January 26, 1913, p. 5CE.

Foreword. In *Wanamaker Exhibition Catalogue.* Philadelphia, 1913.

"One Hour's Sleep: Three Dreams." *291,* no. 1 (March 1915): n.p.

Foreword. In *The Forum Exhibition of Modern American Painters.* New York: Anderson Galleries, 1916.

"Photographs by Paul Strand." *Camera Work* 48 (October 1916): 11–12.

Letter to the editors. *Evening Sun,* December 18, 1918, editorial page.

Letter. *New York Herald,* March 21, 1920, sec. 4, p. 4.

"A Statement." In *Exhibition of Stieglitz's Photographs.* New York: Anderson Galleries, 1921.

"Regarding the Modern French Masters Exhibition." *Brooklyn Museum Quarterly* 8 (July 1921): 105–13.

"Is Photography a Failure?" *New York Sun,* March 14, 1922, p. 20.

"My Dear McBride." *New York Herald,* November 5, 1922, p. 7.

Second Exhibition of Photographs by Alfred Stieglitz. New York: Anderson Galleries, 1923.

"The Story of Weber," February 22, 1923. Stieglitz/O'Keeffe Archive, Yale Collection of American Literature, Beinecke Rare Book and Manuscript Library, Yale University, New Haven, Conn.

"How I Came to Photograph Clouds." *Amateur Photographer and Photography* 56 (September 19, 1923): 255.

"Chapter III." In *Third Exhibition of Photography by Alfred Stieglitz.* New York: Anderson Galleries, 1924.

"Sky-Songs." *Nation* 118 (May 14, 1924): 561–62.

"Ten Stories." *Twice-a-Year* 5–6 (1940–41): 135–63.

"The Origins of the Photo-Secession and How It Became 291." *Twice-a-Year* 8–9 (1942): 114–17.

Letters. *Twice-a-Year* 8–9 (1942): 174–78.

"Six Happenings." *Twice-a-Year* 14–15 (Fall–Winter 1946–47): 188–202.

"Stieglitz–Weston Correspondence." Compiled by Ferdinand Reyher. *Photo-Notes* (Spring 1949): 11–15.

Books and Catalogs

Alfred Stieglitz Presents Seven Americans: 159 Paintings, Photographs, and Things Recent and Never Before Publicly Shown by Arthur G. Dove, Marsden Hartley, John Marin, Charles Demuth, Paul Strand, Georgia O'Keeffe, Alfred Stieglitz. New York: Anderson Galleries, 1925.

Beginnings and Landmarks: "291" 1905–1917. New York: An American Place, 1937.

Bry, Doris. *Alfred Stieglitz: Photographer.* Boston: Museum of Fine Arts, 1965.

Caffin, Charles H. *Photography as a Fine Art.* 1901; Hastings-on-Hudson, N.Y.: Morgan and Morgan, 1971.

Dijkstra, Bram. *The Hieroglyphics of a New Speech: Cubism, Stieglitz, and the Early Poetry of William Carlos Williams.* Princeton, N.J.: Princeton University Press, 1969.

Doty, Robert. *Photo-Secession: Photography as a Fine Art.* Rochester, N.Y.: George Eastman House, 1960.

Frank, Waldo, Lewis Mumford, Dorothy Norman, Paul Rosenfeld, Harold Rugg, eds. *America and Alfred Stieglitz: A Collective Portrait.* New York: Literary Guild, 1934.

Gee, Helen. *Stieglitz and the Photo-Secession.* Trenton: New Jersey State Museum, 1975.

Green, Jonathan, ed. *Camera Work: A Critical Anthology.* Millerton, N.Y.: Aperture, 1973.

Greenough, Sarah, and Juan Hamilton. *Alfred Stieglitz: Photographs and Writings.* Washington, D.C.: National Gallery of Art; New York: Callaway, 1983.

Haines, Robert E. *The Inner Eye of Alfred Stieglitz.* Washington, D.C.: University Press of America, 1982.

Homer, William Innes. *Alfred Stieglitz and the American Avant-Garde.* Boston: New York Graphic Society, 1977.

————. *Alfred Stieglitz and the Photo-Secession.* Boston: New York Graphic Society, 1983.

Lipsey, Roger. *Coomaraswamy: His Life and Work.* Princeton, N.J.: Princeton University Press, 1977.

Lowe, Sue Davidson. *Stieglitz: A Memoir/Biography.* New York: Farrar, Straus and Giroux, 1983.

Margolis, Marianne Fulton, ed. *Camera Work: A Pictorial Guide.* New York: Dover, 1978.

Morgan, Ann Lee. *Dear Stieglitz, Dear Dove.* Newark, Del.: University of Delaware Press, 1988.

Naef, Weston. *The Collection of Alfred Stieglitz: Fifty Pioneers of Modern Photography.* New York: Metropolitan Museum of Art; Viking, 1978.

Norman, Dorothy. *Alfred Stieglitz: Introduction to an American Seer.* New York: Duell, Sloan and Pearce, 1960.

————. *Alfred Stieglitz: An American Seer.* New York: Random House, 1973.

Seligmann, Herbert J. *Alfred Stieglitz Talking: Notes on Some of His Conversations, 1925–1931.* New Haven, Conn.: Yale University Library, 1966.

Thomas, Richard F. *Literary Admirers of Alfred Stieglitz.* Carbondale: Southern Illinois University Press, 1983.

Dissertations and Master's Theses

Greenough, Sarah E. "The Published Writings of Alfred Stieglitz." Master's thesis, University of New Mexico, 1976.

————. "Alfred Stieglitz's Photographs of Clouds." Ph.D. diss., University of New Mexico, 1984.

Hull, Roger Piatt. "*Camera Work,* An American Quarterly." Ph.D. diss., Northwestern University, 1970.

Masteller, Richard Nevin. "Romanticisms in a Modern Mode: The Photography of Alfred Stieglitz and Edward Weston." Ph.D. diss., University of Minnesota, 1978.

Articles

Abrahams, Edward. "Alfred Stieglitz and the Metropolitan Museum of Art." *Arts Magazine* 17 (June 1979): 86–89.

Arens, Egmont. "Alfred Stieglitz: His Cloud Pictures." *Playboy* 9 (July 1924): 15.

"Art." *New Yorker,* March 28, 1925, p. 17.

"Art Exhibitions of the Week." *New York Times,* March 9, 1924, sec. 8, p. 10.

Breuning, Margaret. "Seven Americans." *New York Evening Post,* March 14, 1925, sec. 5, p. 11.

Bry, Doris. "The Stieglitz Archive at Yale University." *Yale University Library Gazette,* April 1951.

Bunnell, Peter C. "Alfred Stieglitz and 'Camera Work.' " *Camera* 12 (December 1969): 8.

————. "Some Observations on a Collection of Stieglitz's Early New York Photographs." *Center for Creative Photography Journal* 6 (April 1978): 1–6.

————. "Stieglitziana." *Print Collector's Newsletter* (November–December 1983): 178–82.

Cary, Elizabeth Luther. "Art-Exhibitions of the Week: Seven Americans." *New York Times,* March 15, 1925, sec. 8, p. 11.

"Comment." *Dial* 79 (August 1925): 177–78.

Coomaraswamy, Ananda K. "A Gift from Mr. Alfred Stieglitz." *Museum of Fine Arts Bulletin* 22 (1924): 14.

————. "Samvega: Aesthetic Shock." *Aperture* 16 (1972): n.p.

Cortissoz, Royal. " '291': Mr. Alfred Stieglitz and His Service to Art." *New York Herald Tribune*, March 15, 1925, sec. 4, p. 11.

De Zayas, Marius. "Stieglitz—The Steerage." *291*, nos. 7–8 (September–October 1915): n.p.

Engelhard, Georgia. "The Face of Alfred Stieglitz." *Popular Photography* 19 (September 1946): 52–55, 120–26.

Evans, Jean. "Stieglitz—Always Battling and Retreating." *PM*, December 23, 1945, magazine sec., pp. 12–14.

R. F. *Christian Science Monitor*, March 20, 1925, p. 5.

Fulton, Deogh. "Cabbages and Kings." *International Studio* 81 (May 1925): 144–47.

Greenough, Sarah E. "Alfred Stieglitz and the Opponents of the Photo-Secession." *New Mexico Studies in the Fine Arts* 2 (1977): 13–18.

————. "From the American Earth: Alfred Stieglitz's Photographs of Apples." *Art Journal* (Spring 1981): 46–54.

Haines, Robert E. "Alfred Stieglitz and the New Order of Consciousness in American Literature." *Pacific Coast Philology* 6 (April 1971): 26–34.

Hamilton, George Heard. "The Alfred Stieglitz Collection." *Metropolitan Museum Journal* 3 (1970): 371–92.

Horak, Jan-Christopher. "Modernist Perspectives and Romantic Desire: Manhatta." *Afterimage* (November 1987): 8–15.

Jussim, Estelle. "Icons or Ideology: Stieglitz and Hine." *Massachusetts Review* (Winter 1978): 680–92.

————. "Technology or Aesthetics: Alfred Stieglitz and Photogravure." *History of Photography* 3 (January 1979): 81–92.

Krauss, Rosalind. "Stieglitz/Equivalents." *October* 11 (Winter 1979): 129–40.

————. "Alfred Stieglitz's Equivalents." *Arts Magazine* 54 (February 1980): 134–37.

Leonard, Neil. "Alfred Stieglitz and Realism." *Art Quarterly* 29 (1966): 277–86.

Lifson, Ben. "O'Keeffe's Stieglitz, Stieglitz's O'Keeffe." *Village Voice*, December 11, 1978, p. 107.

Lipsey, Roger. "Double Portrait: Alfred Stieglitz and Ananda Coomaraswamy." *Aperture* 16 (1972): n.p.

McBride, Henry. "Stieglitz–O'Keefe [sic] Show at Anderson Galleries." *New York Herald*, March 9, 1924, sec. 7, p. 13.

————. "Crowds at Stieglitz Opening." *New York Sun*, March 14, 1925, p. 13.

————. "Seven Alive." *Dial* 78 (May 1925): 435–36.

McCausland, Elizabeth. "Alfred Stieglitz." *Complete Photographer* 9, no. 51 (1943): 3319–22.

Malcolm, Janet. "Photography: Artists and Lovers." *New Yorker*, March 12, 1979, pp. 118–20.

Minuit, Peter [Paul Rosenfeld]. "291 Fifth Avenue." *Seven Arts* 1 (November 1916): 64.

Mullin, Glen. "Alfred Stieglitz Presents Seven Americans." *Nation*, May 20, 1925, pp. 577–78.

Norman, Dorothy. "From the Writings and Conversations of Alfred Stieglitz." *Twice-a-Year* 1 (Fall–Winter 1938): 79.

————. "From the Writings and Conversations of Alfred Stieglitz." *Twice-a-Year* 8–9 (1942): 125.

Read, Helen Appleton. "Alfred Stieglitz Presents Seven Americans." *Brooklyn Daily Eagle*, March 15, 1925, p. 2B.

————. "Seven Americans." *Arts* 7 (April 1925): 229–31.

Rosenfeld, Paul. "Stieglitz." *Dial* 70 (April 1921): 397–409.

————. "Stieglitz." *Dial* 71 (December 1921): 649–70.

Schiffman, Joseph. "The Alienation of the Artist: Alfred Stieglitz." *American Quarterly* 3 (Fall 1951): 244–58.

Seligmann, Herbert J. "Burning Focus." *Infinity* 16 (December 1967): 15–17, 26–32; and *Infinity* 17 (January 1968): 29–34.

Sheeler, Charles. "Recent Photographs by Alfred Stieglitz." *Arts* 3 (May 1923): 345.

Solomon-Godeau, Abigail. "Back to Basics: The Return of Alfred Stieglitz." *Afterimage* (Summer 1984): 21–25.

Stein, Gertrude. "And Now." *Vanity Fair* (September 1934): 35, 65.

Strand, Paul. "Alfred Stieglitz and a Machine." *Manuscripts* 2 (March 1922): 6–7.

Trachtenberg, Alan. "Camera Work: Notes toward an Investigation." *Massachusetts Review* (Winter 1978): 834–57.

Tyrrell, Henry. " '291' Exhibitions: 1914–1916." *Camera Work* 48 (October 1916): 20.

Watson, Forbes. "Seven American Artists Sponsored by Stieglitz." *New York World,* March 15, 1925, p. 5M.

Wilson, Edmund. "Greatest Triumphs: The Stieglitz Exhibition." *New Republic,* March 18, 1925, pp. 97–98.

THE 291 CIRCLE

Books and Catalogs

Abrahams, Edward. *The Lyrical Left.* Charlottesville: University Press of Virginia, 1986.

The Arthur Jerome Eddy Collection of Modern Paintings and Sculpture. Introduction by Daniel Catton Rich. Chicago: Art Institute of Chicago, 1932.

Bannon, Anthony. *The Photo-Pictorialists of Buffalo.* Buffalo: Media Study, 1981.

Bragdon, Claude. "The Language of Form [1917]." In *Roots of Contemporary American Architecture,* edited by Lewis Mumford. New York: Reinhold, 1952.

———. *Architecture and Democracy.* New York: Alfred A. Knopf, 1918.

Bruccoli, Matthew J. *The Fortunes of Mitchell Kennerley.* New York: Harcourt Brace Jovanovich, 1986.

Cahill, Holger. *Max Weber.* New York: Downtown Gallery, 1930.

Champa, Kermit S., ed. *Over Here!: Modernism, The First Exile, 1914–1919.* Providence, R.I.: David Winton Bell Gallery, Brown University, 1989.

Chisolm, Lawrence W. *Fenollosa: The Far East and American Culture.* New Haven, Conn.: Yale University Press, 1963.

Clark, Robert Judson, ed. *The Arts and Crafts Movement in America.* Princeton, N.J.: Princeton University Press, 1972.

Coburn, Alvin Langdon. *New York.* Foreword by H. G. Wells. London: Duckworth, 1910.

———. *Men of Mark.* London: Duckworth, 1913.

———. *Alvin Langdon Coburn, Photographer: An Autobiography.* Edited by Helmut and Alison Gernsheim. New York: Dover, 1978.

Corn, Wanda M. *The Color of Mood: American Tonalism, 1880–1910.* San Francisco: M. H. De Young Memorial Museum, 1972.

De Wit, Wim, ed. *Louis Sullivan: The Function of Ornament.* New York: W. W. Norton, 1986.

De Zayas, Marius, and Paul Haviland. *A Study of the Modern Evolution of Plastic Expression.* New York: "291," 1913.

Dow, Arthur Wesley. *Composition: A Series of Exercises in Art Structure for the Use of Students and Teachers* (New York: Doubleday, Page, 1912).

———. *Theory and Practice of Teaching Art.* New York: Teachers College, Columbia University, 1912.

Eldredge, Charles, Julie Schimmel, and William H. Truettner. *Art in New Mexico, 1900–1945: Paths to Taos and Santa Fe.* New York: Abbeville, 1986.

The Forum Exhibition of Modern American Painters. New York: Anderson Galleries, 1916.

Frank, Waldo. *Our America.* New York: Boni and Liveright, 1919.

Goodrich, Lloyd. *The Decade of the Armory Show, 1910–1920.* New York: Whitney Museum of American Art, 1963.

Green, Nancy E. *Arthur Wesley Dow and His Influence.* Ithaca, N.Y.: Herbert F. Johnson Museum of Art, 1990.

Greenough, Sarah. *Paul Strand: An American Vision.* Washington, D.C.: National Gallery of Art; New York: Aperture Foundation, 1990.

Hartley, Marsden. *Adventures in the Arts.* 1921; New York: Hacker Art Books, 1972.

———. *On Art.* Edited and with an introduction by Gail R. Scott. New York: Horizon, 1982.

Hartmann, Sadakichi. *Landscape and Figure Composition.* 1910; New York: Arno, 1973, Literature of Photography series.

Haskell, Barbara. *Arthur Dove.* Boston: New York Graphic Society, 1974.

———. *Marsden Hartley.* New York: New York University Press, 1980.

Hyland, Douglas. *Marius de Zayas: Conjurer of Souls.* Lawrence: Spencer Museum of Art, University of Kansas, 1981.

Johnson, Arthur Warren. *Arthur Wesley Dow, Historian, Artist, Teacher.* Ipswich, Mass.: Ipswich Historical Society, 1934.

Johnson, Dorothy R. *Arthur Dove: The Years of College.* College Park: University of Maryland Art Gallery, 1967.

Leonard, Sandra E. *Henri Rousseau and Max Weber.* New York: R. I. Feigen, 1970.

Longwell, Dennis. *Steichen: The Master Prints, 1895–1914: The Symbolist Period.* New York: Museum of Modern Art, 1978.

McBride, Henry. *The Flow of Art: Essays and Criticism of Henry McBride.* Edited by Daniel Catton Rich. New York: Atheneum, 1975.

Mumford, Lewis. *The Brown Decades: A Study of the Arts in America, 1865–1895.* 1931; New York: Dover, 1955.

Newhall, Nancy. *Alvin Langdon Coburn: A Portfolio of Sixteen Photographs.* Rochester, N.Y.: George Eastman House, 1962.

Newman, Sasha M. *Arthur Dove and Duncan Phillips: Artist and Patron.* New York: George Braziller, 1981.

Parsons, Melinda Boyd. *To All Believers—The Art of Pamela Colman Smith.* Wilmington: Delaware Art Museum, 1975.

Paul Strand: Sixty Years of Photographs. Millerton, N.Y.: Aperture, 1976.

Pultz, John, and Catherine B. Scallen. *Cubism and American Photography: 1910–1930.* Williamstown, Mass.: Sterling and Francine Clark Art Institute, 1981.

Rosenfeld, Paul. *Port of New York: Essays on Fourteen American Moderns.* 1924; Urbana: University of Illinois Press, 1961.

Rourke, Constance. *Charles Sheeler, Artist in the American Tradition.* New York: Harcourt, Brace, 1938.

Snyder, Joel. "Picturing Vision." In *The Language of Images.* Edited by W.J.T. Mitchell. Chicago: University of Chicago Press, 1980.

Stebbins, Theodore E., Jr., and Norman Keyes, Jr. *Charles Sheeler: The Photographs.* Boston: New York Graphic Society, 1987.

Steichen, Edward. *A Life in Photography.* Garden City, N.Y.: Doubleday, 1963.

Strand, Paul. *Paul Strand: A Retrospective Monograph, The Years 1915–1968.* Millerton, N.Y.: Aperture, 1971.

Sullivan, Louis H. *Kindergarten Chats and Other Writings.* 1918; New York: Dover, 1979.

————. *The Autobiography of an Idea.* Foreword by Claude Bragdon. 1924; New York: Dover, 1956.

Symbolism of Light: The Photographs of Clarence H. White. Wilmington: University of Delaware, 1977.

Szarkowski, John. *The Idea of Louis Sullivan.* Minneapolis: University of Minnesota Press, 1956.

————. *American Landscapes: Photographs from the Collection of the Museum of Modern Art.* New York: Museum of Modern Art, 1981.

Tashjian, Dickran. *Skyscraper Primitives: Dada and the American Avant-Garde, 1910–1925.* Middletown, Conn.: Wesleyan University Press, 1975.

————. *William Carlos Williams and the American Scene, 1920–1940.* New York: Whitney Museum of American Art, 1978.

Trachtenberg, Alan. *Brooklyn Bridge: Fact and Symbol.* Chicago: University of Chicago Press, 1979.

Travis, David. *Photography Rediscovered: American Photographs, 1900–1930.* New York: Whitney Museum of American Art, 1980.

Triggs, Oscar Lovell. *The History of the Arts and Crafts.* Chicago: Bohemia Guild of the Industrial Arts League, 1902.

Troyen, Carol, and Erica E. Hirschler. *Charles Sheeler: Paintings and Drawings.* Boston: New York Graphic Society, 1987.

Vortographs and Paintings by Alvin Langdon Coburn. London: Camera Club, 1917.

Ward, John L. *The Criticism of Photography as Art: The Photographs of Jerry Uelsmann.* Gainesville: University of Florida, 1970.

Weaver, Mike. *Alvin Langdon Coburn, 1882–1966: Man of Mark.* Bath, England: Royal Photographic Society, 1982.

Weber, Max. *Essays on Art.* New York: William E. Rudge, 1916.

Werner, Alfred. *Max Weber.* New York: Harry N. Abrams, 1975.

Weston, Edward. *The Daybooks of Edward Weston.* Edited by Nancy Newhall. 2 vols. New York: Aperture, 1961.

Williams, William Carlos. *A Recognizable Image: William Carlos Williams on Art and Artists.* New York: New Directions, 1978.

Wright, Willard Huntington. *Modern Painting: Its Tendency and Meaning.* New York: John Lane, 1915.

————. *The Creative Will.* New York: John Lane, 1916.

Dissertations and Master's Theses

Butterfield, Bruce Augustus. "Paul Rosenfeld: The Critic as Autobiographer." Ph.D. diss., University of Illinois at Urbana–Champaign, 1975.

Carter, Nancy Corson. "The Inner-Circle: Portraits in Alfred Stieglitz's *Camera Work.*" Ph.D. diss., University of Iowa, 1972.

Cohn, Sherrye Baker. "The Dialectical Vision of Arthur Dove: The Impact of Science and Occultism on His Modern American Art." Ph.D. diss., Washington University, 1982.

Dochterman, Lillian Natalie. "The Stylistic Development of the Work of Charles Sheeler." Ph.D. diss., State University of Iowa, 1963.

Henderson, Linda Dalrymple. "The Artist, 'The Fourth Dimension,' and Non-Euclidian Geometry: 1900–1930." Ph.D. diss., Yale University, 1975.

Levin, Sandra Gail. "Wassily Kandinsky and the American Avant-Garde, 1912–1950." Ph.D. diss., Rutgers University, 1976.

Moak, Peter van der Huyden. "Cubism and the New World: The Influence of Cubism on American Painting." Ph.D. diss., University of Pennsylvania, 1979.

Morgan, Ann Lee. "Toward the Definition of Early Modernism in America: A Study of Arthur Dove." Ph.D. diss., University of Iowa, 1973.

North, Phylis Burkley. "Max Weber: The Early Paintings, 1905–1930." Ph.D. diss., University of Delaware, 1975.

Risatti, Howard Anthony. "American Critical Reaction to European Modernism, 1908–1917." Ph.D. diss., University of Illinois at Urbana–Champaign, 1978.

Rosenblum, Naomi. "Paul Strand: The Early Years, 1910–1932." Ph.D. diss., City University of New York, 1978.

Starr, Nina Howell. "American Abstract Photography to 1930." Master's thesis, University of Florida, 1963.

Stewart, Patrick Leonard. "Charles Sheeler, William Carlos Williams and the Development of the Precisionist Aesthetic, 1917–1931." Ph.D. diss., University of Delaware, 1981.

Szekely, Gillian M. Hill. "The Beginnings of Abstraction in America: Art and Theory in Alfred Stieglitz's New York Circle." Master's thesis, University of Edinburgh, 1971.

Underwood, Sandra Lee. "Charles H. Caffin: A Voice for Modernism, 1897–1918." Ph.D. diss., Indiana University, 1981.

Zilczer, Judith Katy. "The Aesthetic Struggle in America, 1913–1918: Abstract Art and Theory in the Stieglitz Circle." Ph.D. diss., University of Delaware, 1975.

Articles

Allan, Sidney [Sadakichi Hartmann]. "A Visit to Steichen's Studio." *Camera Work* 2 (April 1903): 25–28.

Bailey, Craig R. "The Art of Marius de Zayas." *Arts Magazine* 53 (September 1978): 136–44.

Bluemner, Oscar. "Audiator et Altera Pars: Some Plain Sense on the Modern Movement." *Camera Work,* special no. (June 1913): 25–38.

———. "Walkowitz." *Camera Work* 44 (October 1913): 25–38.

Bohn, Willard. "The Abstract Vision of Marius de Zayas." *Art Bulletin* 62 (September 1980): 434–52.

Brace, Ernest. "Charles Sheeler." *Creative Art* 11 (October 1932): 96–104.

Breuning, Margaret. "Modern Photography Raises Question to Baffle Artists." *New York Evening Post,* March 8, 1924, p. 15.

Brown, Milton W. "Cubist-Realism: An American Style." *Marsyas* 3 (1946): 139–60.

———. "Twentieth Century Nostroms: Pseudo-Scientific Theory in American Painting." *Magazine of Art* (March 1948): 98–101.

Burgess, Gelett. "Essays in Subjective Symbolism." *Camera Work* 37 (January 1912): 46–47.

Caffin, Charles. "Some Prints by Alvin Langdon Coburn." *Camera Work* 6 (April 1904): 17–19.

———. "Of Verities and Illusions—Part I." *Camera Work* 12 (October 1905): 25–29.

———. "Of Verities and Illusions—Part II." *Camera Work* 13 (January 1906): 41–45.

———. "The Camera Point of View in Painting and Photography." *Camera Work* 24 (October 1908): 23–26.

———. "Some Impressions." *Camera Work* 28 (October 1909): 34.

———. ["Paul Strand in 'Straight' Photos."] *Camera Work* 48 (October 1916): 57–58.

———. "Walkowitz." *Camera Work* 48 (October 1916): 53.

Coburn, Alvin Langdon. "The Relation of Time to Art." *Camera Work* 33 (January 1911): 72.

———. "The Future of Pictorial Photography." In *Photograms of the Year 1916*. London: Hazell, Watson, and Viney, 1916, pp. 23–24.

Cohn, Sherrye. "Arthur Dove and Theosophy: Visions of a Transcendental Reality." *Arts Magazine* 58 (September 1983): 86–91.

———. "The Image and the Imagination of Space in the Art of Arthur Dove, Part I: Dove's 'Force Lines, Growth Lines' as Emblems of Energy." *Arts Magazine* 58 (December 1983): 90–93.

———. "The Image and the Imagination of Space in the Art of Arthur Dove, Part II: Dove and 'The Fourth Dimension.'" *Arts Magazine* 58 (January 1984): 121–25.

———. "Arthur Dove and the Organic Analogy: A Rapprochement between Art and Nature." *Arts Magazine* 59 (Summer 1985): 85–89.

Davies, Karen. "Charles Sheeler in Doylestown and the Image of Rural Architecture." *Arts Magazine* 59 (March 1985): 135–39.

De Casseres, Benjamin. "The Unconscious in Art." *Camera Work* 36 (October 1911): 17.

———. "The Renaissance of the Irrational." *Camera Work,* special no. (June 1913): 22–24.

De Zayas, Marius. "Photography." *Camera Work* 41 (January 1913): 17.

———. "Exhibition Marius de Zayas." *Camera Work* 42–43 (April–July 1913): 20–22.

———. "Photography and Artistic Photography." *Camera Work* 42–43 (April–July 1913): 13–14.

———. "Modern Art Theories and Representation." *Camera Work* 44 (October 1913): 13–19.

———. "Caricature: Absolute and Relative." *Camera Work* 46 (April 1914): 19–27.

———. *291,* nos. 7–8 (September–October 1915): n.p.

———. "How, When, and Why Modern Art Came to New York [c. 1940s]." With introduction and notes by Francis M. Naumann. *Arts Magazine* 54 (April 1980): 96–126.

Dow, Arthur Wesley. "A Note on Japanese Art and What the American Artist May Learn Therefrom." *Knight Errant* 1 (January 1893): 114–16.

———. "Art Studies in Photography." *Pratt Institute Monthly* (March 1897): 221–22.

———. "Mrs. Gertrude Käsebier's Portrait Photographs." *Camera Notes* 3 (July 1899): 22–23.

———. "Training in the Theory and Practice of Teaching Art." *Teachers College Record* 9 (May 1908): 1–54.

———. "Talks on Appreciation of Art." *Delineator* (January 1915): 15.

———. "Designs from Primitive American Motifs." *Teachers College Record* 16 (March 1915): 33.

———. "Talks on Art Appreciation, No. II, Rhythm." *Delineator* (April 1915): 15.

———. "Talks on Art Appreciation, No. III, Dark—and—Light." *Delineator* (July 1915): 15.

———. "Talks on Art Appreciation, No. IV, Toning." *Delineator* (February 1916): 15.

———. "Printing from Wood Blocks." *International Studio* 59 (July 1916): xv–xvi.

———. "Modernism in Art." *American Magazine of Art* 8 (January 1917): 113–16.

———. "Art Teaching in the Nation's Service." *Journal of Proceedings of the Fifty-fifth National Education Association of the United States* 40 (July 1917): 91–96.

———. "The Ideps." *Soil* 1 (July 1917): 202–5.

"Exhibition on Modern Art." *Young Women's Hebrew Association* (March 1919): n.p.

[Fenollosa, Ernest F.] "Arthur W. Dow." *Lotos* 9 (March 1896): 709–10.

Fitzgerald, Charles. "Eduard Steichen: Painter and Photographer." *Camera Work* 10 (April 1905): 42–43.

Frampton, Hollis. "Meditations around Paul Strand." *Artforum* 10 (February 1972): 52–57.

Hammen, Scott. "Sheeler and Strand's 'Manhatta': A Neglected Masterpiece." *Afterimage* (January 1979): 6–7.

Hartley, Marsden. "Foreword to His Exhibition." *Camera Work* 45 (January 1914): 17.

———. "Dissertation on Modern Painting." *Nation,* February 9, 1921, pp. 235–36.

———. "Art and the Personal Life." *Creative Art* 2 (June 1928): 31–37.

Hartmann, Sadakichi. "On Composition." *Camera Notes* (April 1901): 257–62.

———. "A Monologue." *Camera Work* 6 (April 1904): 25.

————. "On the Possibility of New Laws of Composition." *Camera Work* 30 (April 1910): 23–25.

————. "What Remains." *Camera Work* 33 (January 1911): 30–32.

[Attributed to Hartmann, Sadakichi.] "Unphotographic Paint—The Texture of Impressionism." *Camera Work* 28 (October 1909): 20–23.

Haviland, Paul. "Marius de Zayas—Material, Relative and Absolute Caricatures." *Camera Work* 46 (dated April 1914, published October 1914): 33.

[Attributed to Haviland, Paul.] "Photo-Secession Notes." *Camera Work* 30 (April 1910): 54.

————. "Notes on 291." *Camera Work* 42–43 (April–July 1913): 18–20.

Homer, William Innes. "Eduard Steichen as Painter and Photographer, 1897–1908." *American Art Journal* 6 (November 1974): 45–55.

————. "Stieglitz, 291, and Paul Strand's Early Photography." *Image* 19 (June 1976): 10–19.

————. "Identifying Arthur Dove's 'The Ten Commandments.'" *American Art Journal* 12 (Summer 1980): 21–32.

Huneker, James Gibbons. *Camera Work* 18 (April 1907): 37–38.

Key, Mabel. "A New System of Art Education, Arranged and Directed by Arthur W. Dow." *Brush and Pencil* 4 (August 1899): 258–70.

Lancaster, Clay. "Synthesis: The Artistic Theory of Fenollosa and Dow." *Art Journal* 28 (Spring 1969): 286–87.

Laurvik, J. Nilsen. "New Tendencies in Art." *Camera Work* 22 (April 1908): 33.

Levin, Gail. "Marsden Hartley and the European Avant-Garde." *Arts Magazine* 54 (September 1979): 158–63.

————. "Marsden Hartley and Mysticism." *Arts Magazine* 60 (November 1985): 16–21.

McCausland, Elizabeth. "Paul Strand's Photographs Show Medium's Possibilities." *Springfield Union and Republican,* April 17, 1932, p. 6E.

Marin, John. "Statement on His Show." *Camera Work* 42–43 (April–July 1913): 18.

Martin, Marianne W. "Some American Contributions to Early Twentieth Century Abstraction." *Arts Magazine* 54 (June 1980): 158–65.

Millard, Charles. "Charles Sheeler, American Photographer." *Contemporary Photographer* 6, no. 1 (1967): n.p.

Munro, Thomas. "The Dow Method and Public School Art." *Journal of the Barnes Foundation* 12 (January 1926): 35–40.

Parker, R. A. "The Art of the Camera: An Experimental Movie." *Arts and Decoration* 15 (October 1921): 369.

Phillips, Christopher. "The Judgment Seat of Photography." *October* 22 (Fall 1982): 27–63.

Powell, Edith W. "The Introspectives." *International Studio* 61 (May 1917): xcii–xciii.

Rathbone, Belinda. "Portrait of a Marriage: Paul Strand's Photographs of Rebecca." *J. Paul Getty Museum Journal* 17 (1989): 83–98.

Risatti, Howard. "Music and the Development of Abstraction in America: The Decade Surrounding the Armory Show." *Art Journal* (Fall 1979): 8–13.

Rolland, Romain. "America and the Arts." *Seven Arts* 1 (November 1916): 48–49.

Rood, Roland. *Camera Work* 12 (October 1905): 59.

————. "The Little Galleries of the Photo Secession." *American Amateur Photographer* 17 (December 1905): 566–69.

————. *Camera Work* 14 (April 1906): 48.

[Attributed to Roland Rood.] "Is Photography a New Art?" *Camera Work* 23 (July 1908): 17–22.

Rosenfeld, Paul. "American Painting." *Dial* 71 (December 1921): 649–70.

————. "The Paintings of Marsden Hartley." *Vanity Fair* 18 (August 1922): 47, 84, 94, 96.

————. The Water-colours of John Marin." *Vanity Fair* 19 (October 1922): 48, 92, 114.

————. "The World of Arthur Dove." *Creative Art* 10 (June 1932): 426–30.

Seligmann, Herbert J. "Why Modern Art?" *Vogue* 62 (October 15, 1923): 76–77, 110, 112.

Steichen, Eduard J. "The American School." *Photogram* 8 (January 1901): 4–9.

————. "Painting and Photography." *Camera Work* 23 (July 1908): 5.

———. "The Fighting Photo-Secession." *Vogue* (June 15, 1941): 22, 74.

Stewart, Rick. "Charles Sheeler, William Carlos Williams, and Precisionism: A Redefinition." *Arts Magazine* 58 (November 1983): 100–114.

Strand, Paul. "Photography." *Seven Arts* (August 1917): 524–25.

———. "What Was '291'?" October 1917. Paul Strand Archives, Center for Creative Photography, University of Arizona, Tucson.

———. "Photography and the New God." *Broom* 3 (November 1922): 252–58.

———. "The Art Motive in Photography." *British Journal of Photography* 70 (October 5, 1923): 613–15.

———. "Steichen and Commercial Art." *New Republic,* February 19, 1930, p. 21.

Thompson, Jan. "Picabia and His Influence on American Art, 1913–1917." *Art Journal* (Fall 1979): 14–21.

Tomkins, Calvin. "Profile [Paul Strand]: Look to the Things around You." *New Yorker,* September 16, 1974, pp. 44–94.

Trachtenberg, Alan. "Weston's 'Thing Itself.'" *Yale Review* 65 (October 1975): 105–15.

Weber, Max. "The Fourth Dimension from a Plastic Point of View." *Camera Work* 31 (July 1910): 25.

———. "The Filling of Space." *Platinum Print* 1 (December 1913): 6.

Weichsel, John. "Cosmism or Amorphism." *Camera Work* 42–43 (April–July 1913): 69–82.

———. "The Rampant Zeitgeist." *Camera Work* 44 (October 1913): 20–24.

Weston, Edward [E. Wn.]. "Photographic Art." *Encyclopaedia Britannica,* 1941 ed., vol. 17, pp. 796–99.

"Weston to Hagemeyer: New York Notes [Winter 1922–23]." *Center for Creative Photography* 3 (November 1976): 1–12.

"What Is 291?" Entire issue of *Camera Work* 47 (dated July 1914; published January 1915).

Wright, Willard Huntington. "Impressionism to Synchromism." *Forum* 50 (July–December 1913): 757–70.

———. "The Aesthetic Struggle in America." *Forum* 55 (February 1916): 201–20.

Zilczer, Judith. "Synaesthesia and Popular Culture: Arthur Dove, George Gershwin, and the 'Rhapsody in Blue.'" *Art Journal* (Winter 1984): 361–66.

INDEX

(Page numbers in *italics* refer to illustrations.)

Guinness, Meraud Michael, 116–17
Gurdjieff, G. I., 73, 78, 320n–21n

Hagemeyer, Johan, 308n
halation, 280, 289, 296, 300–301, 359n
Hambidge, Jay, 213, 349n
Hand of Man, The (Stieglitz), 127, 193, 225, 309n, 342n
Hansen, Marcus Lee, 32
Hapgood, Hutchins, 139
Hardy, Thomas, 30
Harker, Margaret F., 316n
Harmony (Kandinsky), 353n
Harmony in Green and Rose: The Music Room (Whistler), 327n
Harnish, Maud: work by, 46
Harris, Leah, 327n
Hartley, Marsden, 36, 41, 65, 88, 93, 181, 313n, 333n, 337n, 358n, 361n; calla motifs and, 257, 258–59, 354n–55n; on essential unity of art and life, 180, 343n; on Kandinsky, 324n, 325n; mysticism as interest of, 71, 78, 319n, 355n; *Seven Americans* show and, 175, 176, 177, 342n, 343n; and sexual reading of O'Keeffe's works, 37–38, 154, 338n, 340n; Stieglitz's cloud photographs and, 241–44; Stieglitz's correspondence with, 108, 251, 318n; on Stieglitz's Dada proclivities, 356n; works by, 242, 259
Hartmann, Sadakichi, 26, 68, 129, 210, 324n, 333n; Dow's teachings and, 91, 92; on fundamental principles of composition, 137, 138; on Rodin's Balzac, 109; Whistler and, 104, 326n–27n
Haviland, Paul, 37, 112, 212, 308n, 339n–40n; reopening of 291 and, 24, 310n; work by, 131
Heade, Johnson, 356n
Heavy Roses (Steichen), 215–18, 216, 219, 349n
Heffernan, Jo, 108
Hersey, George, 313n–14n
Hidden Order of Art, The (Ehrenzweig), 9
Hill, John Henry, 256
Hill, Stream and Moon (O'Keeffe), 192, 231
Hine, Lewis W., 323n
Hinton, Charles Howard, 74
Hiroshige, Ichiriyusai, 86
Homer, Winslow, 177
Hood, Raymond M., 289
Hotel Brevoort (New York), 114
House Beautiful, 42
House of 1000 Windows, New York, The (Coburn), 292–93, 292
House with Tree—Green (O'Keeffe), 95, 96
"How I Came to Photograph Clouds" (Stieglitz), 115, 139, 240
"How the Steerage Happened" (Stieglitz), 316n–17n
Hull House (Chicago), 41, 83

Huneker, James, 68
Hydrangea (de Meyer), 270–73, *271*

Ibsen, Henrik, 30
Icy Night, New York, An (Stieglitz), 280, 359n
Imagism, 134, 334n–35n
Impression No. 4, Moscow (Kandinsky), 94
Improvisation 27: The Garden of Love (Kandinsky), 94, 96, 324n
Improvisation 29 (Kandinsky), 94
Improvisation 30 (Kandinsky), 94, 95
Industrial Arts League, 41
In Exaltation of Flowers (Steichen), 215
Inside Red Canna (O'Keeffe), 228, 229
Intelligence of Flowers, The (Maeterlinck), 355n
Interior (Sheeler), 340n
Interior with Stove (Sheeler), 347n
"Interview with François Picabia" (Eddy), 117
Intimate Gallery (New York), 69, 116–17, 120, 141
Introduction to Yoga (Bragdon), 74
Ipswich, Mass.: Dow's summer school at, 72, 83, 91
"Is Photography a New Art?," 137

Jack-in-the-Pulpit series (O'Keeffe), 119, 314n
James, Henry, 9
James, William, 72
Japanese art, 17, 82, 85–86, 91–92, 122
Jazz (Matisse), 122
Je revois en souvenir ma chère Udnie (Picabia), 41, 117
Johnson, Diane Chalmers, 313n
Johnson, J. Dudley, 14, 173
Joyce, James, 38
Jugendstil, 48–52, 56, 61, 314n–16n
Jung, Carl G., 12, 13

Kahn, Gustave, 64–65, 113
Kandinsky, Wassily, 8, 29, 36, 41, 56, 78, 81, 82, 104, 180, 240, 313n, 323n, 328n, 335n, 355n; Blue series and, 95–99; color theory of, 13, 86, 95, 99, 100, 231, 232, 252, 322n, 325n–26n; music analogies and, 102; mystical ideas of, 72, 100, 319n; New York cityscapes and, 296, 297; on objectivity, 130; Rousseau admired by, 101–2, 325n; as source for O'Keeffe, 13, 22, 94–102, 315n, 324n; Stieglitz influenced by, 93–94, 115, 252–53, 325n, 353n; on triangular compositions, 168, 252, 353n; work by, 96
Käsebier, Gertrude, 64, 323n
Kate Steichen (Steichen), 349n
Keiley, Joseph, 168
Kelly, Ellsworth, 19
Kennerley, Mitchell, 168, 277, 281, 294, 340n
Kerfoot, J. B., 139
Klenert, Catherine, 314n
M. Knoedler and Company (New York), 103, 198, 215

334n, 335n, 337n, 342n–44n, 357n;
 catalog of, 177–78; critical response to,
 176, 177–78, 342n; hanging of, 175–76;
 idea of indigenous American art and, 178–
 80, 181; lack of sales at, 176, 180–81
Seven Arts, 164–66
Shad-Blow Tree series (Steichen), 217
Shadow on the Lake: Self-Portrait (Stieglitz),
 115–16
Shadows on the Lake series (Stieglitz), 115–16
Shakespeare, William, 230–31
Sheeler, Charles, 18, 116, 140, 196–210, 214,
 219, 331n, 340n, 346n–48n; background
 of, 198–99, 347n; Bucks County, Pa.,
 architecture photographed by, 197–98,
 199–203, 281, 347n, 348n; first New
 York cityscapes by, 203–6; interest in
 O'Keeffe's work lacked by, 207–9;
 Manhatta and, 22, 203, 309n, 347n, 348n,
 360n; O'Keeffe's lack of personal
 relationship with, 206–7; on photography
 as art, 198, 199; photography used in
 painting by, 199–200, 206, 347n;
 sensibility valued over intellect by, 207,
 348n; as source for O'Keeffe, 171, 183,
 198, 199–206, 210, 220–21, 308n, 347n;
 works by, *24, 197, 200, 204, 207, 282*
Shell and Old Shingle series (O'Keeffe), 350n
Shell I (O'Keeffe), 56, 350n
Shelton Hotel (New York), 16, 73–74, 277,
 278, 279, 289, 294, 360n
Shelton Hotel, New York, No. 1 (O'Keeffe)
 284, *286*, 292–93, 320n
Shelton with Sunspots, The (O'Keeffe), 206,
 284–85, *287*, 301, 320n
Side of the Barn No. 1 (later known as *Lake
 George*), 359n
Side of the Barn No. 2 (later known as *Lake
 George Barns*), 281–82, *283*, 284, 348n,
 359n
Side of White Barn (Sheeler), 346n
"Simplicity in Composition" (Stieglitz), 90,
 104–5
Sims, Patterson, 15, 308n
Singer Building, Twilight, The (Coburn), 296
Single Alligator Pear (O'Keeffe), 270–73, *271*
Skunk Cabbage (later titled *Cos Cob*)
 (O'Keeffe), 355n
skyscrapers, 279, 358n–59n
Sleeping Muse (Brancusi), *159*, 160, 339n
Slightly Open Shell (O'Keeffe), 350n
Small Joys (Kandinsky), 94
Small Torso with Head (La Vie) (Matisse), 120
Smith, Pamela Colman, 40, 90
Snapshot—From My Window, New York
 (Stieglitz), 238, 302
Soil: A Magazine of Art, The, 178–79
Solomon-Godeau, Abigail, 335n
Some Memories of Drawings (O'Keeffe), 15, 56
"Some Women Artists in Modern Painting"
 (Hartley), 340n

Songs of the Sky No. 1 (Stieglitz), 245, *246*
Songs of the Sky No. 2 (Stieglitz), 173, 250–
 51, *250*
Songs of the Sky No. 3 (Stieglitz), *143*, 251
Songs of the Sky No. 4 (Stieglitz), 245, *248*
Songs of the Sky No. 5 (Stieglitz), 245–50, *249*
Songs of the Sky series (Stieglitz), 244–53,
 354n; abstraction and objectivity
 synthesized in, 142; exhibition of, 172–73,
 174, 224; Kandinsky's theories and, 115,
 252–53; references to O'Keeffe's works
 in, 245–52; Stieglitz's working methods
 and, 245; as visual conversations with
 O'Keeffe, 252
Special charcoals (O'Keeffe), 29–30, 31–37,
 38, 41, 43, 314n; dating of, 312n–13n;
 first shown to Stieglitz, 26, 27, 35, 36, 37,
 61, 212, 312n; meaning of word "Special"
 in, 312n; O'Keeffe's absorption of Art
 Nouveau principles and, 44–56, 59–60
Special Exhibition of Contemporary Art
 (Washington, D.C., 1908), 340n
Special No. 1 (O'Keeffe), 37, 44, 45–47, *45*,
 48–49, 60, 338n
Special No. 2 (O'Keeffe), 37, 44, 45–49, *47*,
 60
Special No. 3 (O'Keeffe), *28*, 37, 49, 53, 60
Special No. 4 (O'Keeffe), 37, 49, *50*, 53, 60
Special No. 5 (O'Keeffe), 37, 49–55, *51*, 59
Special No. 6 (O'Keeffe), 53
Special No. 7 (O'Keeffe), 37, *52*, 53, 60
Special No. 8 (O'Keeffe), 37, 53–56, *55*, 60,
 77, 315n
Special No. 32 (O'Keeffe), *48*, 49, 312n
Special No. 33 (O'Keeffe), 312n
Spiral, France (Steichen), 350n
spiral motifs, 53–56, 77, 315n
"spirit of 291," 44, 176, 275; O'Keeffe as, 63,
 79, 148, 159, 164; Stieglitz's definition of,
 65–66; Symbolism and, 63–71, 79
"Spiritual in Art, The" (Kandinsky), 94
spiritualism, 71–72
spotting, 351n, 354n
Spring (O'Keeffe), 117, 313n, 334n
Spring Showers (Stieglitz), 127, 342n
Staircase, Doylestown (Sheeler), 347n
Stairs from Below (Sheeler), 347n
Stairwell (Doylestown House) (Sheeler), 200–
 202, *200*, 347n
*Standing Female Nude, Squeezing Breasts
 Together* (Rodin), *156*, 157
Starlight Night (O'Keeffe), 103, 224–25
Starry Night (van Gogh), 251
Stearns, Kitty Stieglitz, 253, 352n, 354n
Steerage, The (Stieglitz), 115, 127, 332n, 340n,
 342n
Steichen, Eduard, 61, 109, 116, 199, 210–21,
 259, 323n, 338n, 340n; abstraction
 disdained by, 214; on atmosphere at 291,
 316n; calla motifs and, 349n–50n;
 European modernism and, 24, 26; as

fashion photographer, 214, 349*n;*
O'Keeffe's relationship with, 213, 349*n;*
photograph of, *211;* on Photo-Secession,
310*n;* postwar artistic crisis of, 213; as
source for O'Keeffe, 183, 214–19, 220–
21, 308*n;* spelling of first name of, 310*n;*
Stieglitz's correspondence with, 210, 212–
13; Stieglitz's friendship with, 210–12,
213, 214, 219–20; Symbolism and, 64, 68,
210, 216, 219, 317*n;* works by, *62, 110,
211, 216, 221, 242;* in World War I,
210–12
Stein, Gertrude, 23, 71, 173, 179, 216, 309*n*
Stein, Leo, 149
Stella, Joseph, 341*n,* 360*n*
Stettheimer, Carrie, 18, 277
Stettheimer, Ettie, 18, 277, 301–2
Stettheimer, Florine, 18, 277
Stieglitz, Alfred, 11, 13, 21–27, 29, 30, 33,
38, 41, 44, 53, 59, 123, 125–29, 135–45,
186, 193, 215, 285, 300, 303–4, 320*n,*
321*n,* 323*n,* 324*n,* 328*n,* 332*n,* 340*n*–41*n,*
346*n,* 349*n;* abstraction and objectivity
synthesized by, 142, 143–44;
abstractionist experiments of, 114–16,
129, 141, 142, 149; aesthetic link between
Matisse and O'Keeffe encouraged by,
120; African masks collected by, 274,
358*n;* apple portraits by, 234; Art
Nouveau and, 61; on art by women vs. art
by men, 147, 153; avant-garde European
art as interest of, 24–26, 40, 86, 311*n;*
background of, 26–27; barn photographs
by, 281; borrowings of, 81, 232; city life
and, 277, 278, 292; close-up method of,
351*n;* cloud photographs by, 16, 92, 114–
15, 142, 240–53, 296–97, 337*n,* 341*n,*
353*n*–54*n (see also* Equivalents; Songs of
the Sky series); Coburn's falling out with,
360*n;* formalism of, 135–38, 335*n;*
communal expression called for by, 195;
Dada proclivities of, 356*n;* and "the
development of Today," 79, 321*n;* Dow as
source for, 90–93; earliest surviving
landscape by, 351*n;* exhibitions presented
by *(see* Anderson Galleries; Little
Galleries of the Photo-Secession);
Freudian theory and, 12, 47, 314*n;* goal
of, for modern photography, 22;
indigenous American art as interest of, 92,
178–80, 181; journey to abstraction of,
63, 129; Kandinsky's influence on, 93–94,
115, 325*n;* at Lake George, N.Y., 223–
75, 350*n*–58*n (see also* Lake George,
N.Y.); Lawrence's novels and, 224, 350*n*–
51*n;* leaf motifs considered by, 264, 356*n;*
legend of O'Keeffe as native/naive
American genius nurtured by, 37, 70–71,
81–82; *Manuscripts* published by, 60;
metaphysical ideas and, 71, 74–75, 318*n*–
19*n;* de Meyer and, 357*n;* New York

cityscapes by, 16, 112–13, 278, 279, 280,
281, 285, 289, 359*n;* and notion of
photography as art, 126–27, 138–41,
331*n;* objectivity notion and, 129, 132;
O'Keeffe influenced by, 15, 183, 221, 225;
O'Keeffe offered financial help by, 61;
O'Keeffe proclaimed "spirit of 291" by,
63, 79, 148, 159, 164; O'Keeffe's *Brooklyn
Bridge* and, 21–22; O'Keeffe's
correspondence with, 8, 37; O'Keeffe's
differences of opinion with, 14; O'Keeffe's
first meeting with, 37, 313*n;* O'Keeffe's
influence on, 231–32, 241, 244, 245–52;
O'Keeffe's joint exhibitions with, 129–30,
138, 144, 148–49, 172–74, *224, 258, 262,*
339*n*–40*n,* 356*n,* 357*n,* 358*n;* O'Keeffe's
relationship with, 15, 22–23, 218, 302,
309*n;* O'Keeffe's shift to oils and, 226–
27; O'Keeffe's tree paintings as abstract
portraits of, 88–90; O'Keeffe's works first
encountered by, 26, 27, 35, 36, 37, 61,
212, 312*n;* Picabia and, 112–17, 118, 119,
328*n,* 329*n;* Pictorialism and, 23, 104–5,
309*n*–10*n,* 316*n;* picture making as
conceived by, 141; portrait photographs of
O'Keeffe by *(see Portrait of Georgia
O'Keeffe);* portraits of, *62, 64,* 317*n;*
printing practices of, 226, 344*n;* prints of,
spotted by O'Keeffe, 351*n,* 354*n;*
Prospero compared to, 230–31;
radicalization of perception of, 24–26;
reciprocal influence of O'Keeffe and, 15–
16, 23, 135, 142, 308*n;* reconceptuali-
zation of photography as goal of, 127–28;
restrospective of (1921), 166–67, 340*n;*
Rodin's influence on, 109, 112; Rousseau
and, 101, 102; series concept and, 109,
144–45, 235–36, 327*n;* seventeenth-
century Dutch painters compared to, 141,
336*n;* sex and anarchism regarded as
energizing forces by, 44, 70; and sexual
reading of O'Keeffe's works, 44, 154,
338*n;* Sheeler and, 196–97, 198, 199,
200, 202, 203, 206, 346*n*–47*n,* 348*n;*
sources shared by O'Keeffe and, 81–123;
spiritualism and, 74–75; Steichen's
correspondence with, 210, 212–13;
Steichen's friendship with, 210–12, 213,
214, 219–20; Strand dispatched to visit
O'Keeffe in Texas by, 190–91; Strand
influenced by, 195, 345*n*–46*n;* Strand-
O'Keeffe relationship and, 184–85, 189,
190; Symbolism and, 17, 63–71, 78, 113,
141, 142, 316*n*–17*n,* 337*n;* Tolstoy's
concept of artist and, 137, 335*n;* 291
founded by, 23–24, 310*n;* refusal to have
child with O'Keeffe, 253, 260–62, 354*n;*
"wastebasket" prints by, collected by
O'Keeffe, 181, 344*n;* Weber's influence
on, 26, 310*n*–11*n;* Whistler and, 104–9,
112, 326*n,* 327*n;* works by, *113, 136, 143,*

CREDITS

For specific sources of individual quotations and additional credits to both archival and published sources, see the Notes. Grateful acknowledgment is made for permission to use quotations by the following writers. Georgia O'Keeffe and Alfred Stieglitz: Copyright © 1991 The Georgia O'Keeffe Foundation. Claude Bragdon: Bragdon Family Papers, University of Rochester Library, Rochester, N.Y. Arthur Dove: Arthur Dove Papers, Archives of American Art, Smithsonian Institution. Charles Sheeler: Charles Sheeler Papers, Archives of American Art, Smithsonian Institution. Edward Steichen: Joanna T. Steichen. Paul Strand: Copyright © Aperture Foundation, Inc., Paul Strand Archive, Millerton, N.Y. Grateful acknowledgment is also made to the Waldo Frank Papers, Special Collections, Van Pelt Library, University of Pennsylvania, Philadelphia; and the Sadakichi Hartmann Estate, courtesy, Special Collections Department, Rivera Library, University of California, Riverside.

Every effort has been made to contact the current owners of the works reproduced and mentioned in this volume. We would appreciate hearing about any changes in ownership or credit lines so that we may update future editions and notify the Georgia O'Keeffe Foundation for their projected catalogue raisonné. Please send this information to: Becoming O'Keeffe, c/o Abbeville Press, 488 Madison Avenue, New York, N.Y. 10022. Works by Georgia O'Keeffe may not be reproduced without proper authorization.

The photographers and the sources of photographic material other than those indicated in the captions are as follows:

All rights reserved, copyright © 1990 The Art Institute of Chicago: plates 10, 20, 106, 118, 125, 147. Bayerische Staatsbibliothek, Munich, Germany: plate 23. Peter C. Bunnell, The Art Museum, Princeton University, Princeton, N.J.: plate 51. Jacob Burckhardt, New York: plate 7. Geoffrey Clements, Staten Island, N.Y.: plates 21, 56. Courtesy The Gerald Peters Gallery, Santa Fe, N.Mex.: plates 1, 132. Hedrich-Blessing, Chicago: plate 31. Copyright © 1986 Paul Hester: plate 22. International Museum of Photography at George Eastman House, Rochester, N.Y.: plates 19, 49, 135, 136, 137. Hans Kaczmarek: plate 95. Diagrams by Sophie Kittredge: plates 83, 120. Aida and Robert Mates, New York: plates 4, 87. Michael McKelvey, Atlanta, Ga.: plate 45. All rights reserved, The Metropolitan Museum of Art, New York: plates 11, 26, 27, 28, 40, 61, 72, 85, 129. Jack Meyer: plate 133. Copyright © 1990 Museum of Fine Arts, Boston: plates 59, 84, 90, 105, 108, 111, 113, 115. Henry Nelson/Wichita Art Museum, Wichita, Kans.: plate 149. Philadelphia Museum of Art: plates 68, 100. Copyright © The Phillips Collection, Washington, D.C.: plates 107, 127 (Edward Owen). Courtesy Richard York Gallery, New York: plate 91. Rochester Historical Society, Rochester, N.Y.: plate 30. Copyright © 1990 Malcolm Varon, New York: plates 5, 8, 13, 14, 16–18, 24, 41, 42, 103, 104, 116, 134, 141, 151, 155. Courtesy Zabriskie Gallery, New York: frontispiece, plate 101.